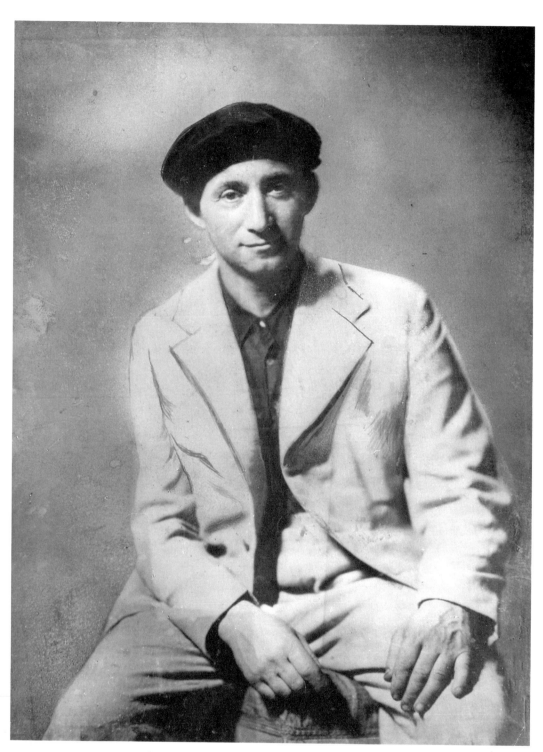

Photograph of David Bomberg *c.* 1930, at 10 Fordwych Road, London NW2

Richard Cork

# David Bomberg

YALE UNIVERSITY PRESS
NEW HAVEN AND LONDON · 1987

*In memory of Lilian*
*and with heartfelt gratitude to Dinora*

Designed by Faith Glasgow
Set in Linotron Bembo and printed in
Great Britain by The Bath Press, Avon

**Library of Congress Cataloging-in-Publication Data**
Cork, Richard.
    David Bomberg.
    Bibliography: p.
    Includes index.
    1. Bomberg, David, 1890–1957.      2. Painters—England—
Biography. I. Title.
ND497.B62C67   1987      759.2[B]      86-23402
ISBN 0-300-03827-5

# Contents

|  | Acknowledgements | vii |
|  | Introduction | 1 |
| ONE | An East End Childhood | 5 |
| TWO | The Slade Rebel | 23 |
| THREE | A Prodigious Year | 53 |
| FOUR | 'I APPEAL to a *Sense of Form*' | 78 |
| FIVE | War and its Aftermath | 103 |
| SIX | Palestine: The Years of Transition | 133 |
| SEVEN | Spain, Britain and Russia | 175 |
| EIGHT | The Discovery of Ronda and Escape to London | 202 |
| NINE | Bomb Store and Blitz | 231 |
| TEN | Teaching and Travelling | 258 |
| ELEVEN | The Final Years | 287 |
|  | Afterword | 320 |
|  | Notes | 322 |
|  | Bibliography | 334 |
|  | Index | 340 |

# Acknowledgements

Although Lilian Bomberg never lived to see the completion of this book, her help in its initial stages was both heroic and invaluable. So I want to begin these acknowledgements by offering her my special thanks, and by paying tribute to the role she played not only during Bomberg's lifetime but after his death as well.

I first visited Lilian in 1969 while researching into Bomberg's early work, and I was immediately won over by her warmth of feeling, her devotion to his art and her scrupulous regard for the truth. We became friends at once, for Lilian had a marvellous ability to cut through formalities and make me imagine I had known her all my life. But over the next fourteen years I came to realize just how remarkable she really was. Lilian had become a considerable artist in her own right after Bomberg suggested that she attend his legendary classes at the Borough Polytechnic in the late 1940s. As her outstanding 1928 charcoal study of Bomberg attests (Plate 228), she was already an assured draughtswoman who had been passionately interested in painting and drawing since childhood. But during the early years of Lilian's life with Bomberg, her desire to make art remained subsumed in the task of providing him with support. He relied on her encouragement and sympathy very heavily. Painting became an activity he sometimes experienced intense difficulty in pursuing, and I think he was lucky to be fortified by a woman who understood his work so well.

Throughout the first two decades of their life together, all the vitality and imaginative intensity which could have fed her own painting was channelled instead into nurturing his art. Only later did Lilian recognize how much of a sacrifice she had made, but she never expressed any bitterness about it. On the contrary: her commitment to Bomberg's work remained just as wholehearted after his death as it had been while he was alive. With tireless determination she opened more and more eyes to the true stature of his painting. Bomberg's art suffered from an appalling amount of indifference during his lifetime, and Lilian made herculean efforts to gain him the posthumous recognition he deserved.

She succeeded, very effectively, in rectifying the imbalance. The high standing which he enjoys today is a tribute to her resolve, love and redoubtable courage. But Lilian never felt complacent about the crusade she had undertaken on his behalf. The immense task of sorting out all his work, showing it to an ever-increasing number of enthusiasts, helping with exhibitions and answering enquiries about their life continued throughout the 1970s. With a growing amount of help from her daughter Dinora, who shouldered more of the burden as Lilian's strength declined, the full complexity and significance of Bomberg's art became clearer still.

In her eightieth year, when she was beginning to lose her formidable energy, Lilian told me how much she wanted to write her own memoir of life with Bomberg. Ill-health prevented her from fulfilling that ambition, and the loss is ours. But she had already achieved so much, fighting for his reputation and at the same time pursuing her own love of painting. I am particularly glad that she was able, near the end of her life, to join me in an extensive series of conversations about her years with Bomberg. Lilian's memories naturally proved crucial to the book I had decided to write about him, and I am grateful that she managed to share them with me before it was too late. Over a lengthy period we met on a regular basis

in her wonderfully idiosyncratic Hampstead flat. Surrounded by Bomberg's paintings as well as work by other members of the family, we discussed each phase of their turbulent life together. Lilian's frank recollections were at once touching and revelatory, confirming my belief that Bomberg's career urgently needed re-examining in its entirety.

Now that the book is completed, I can appreciate the value of those conversations more clearly than ever. Although Lilian's health was deteriorating with frightening rapidity, so that she experienced increasing difficulty with her speech as the months went by, we managed to explore the Bomberg years in absorbing detail. It was often a great struggle, and Lilian would sink back in exhaustion after pushing herself to recount events which had occurred so long ago. Sometimes, too, the memory of painful occasions overwhelmed her with a force which revealed how acutely distressing the past could still be. If Dinora had not been kind enough to attend these arduous sessions, constantly helping Lilian through the moments of physical and spiritual tribulation, we would never have been able to complete them. But we succeeded, and it is a measure of Lilian's astonishing resilience that I heard no word of complaint about the effort our conversations must have cost her. She knew, only too well, that it was her last chance to share her memories and thereby to illuminate the career of a man whose achievements had invariably been overlooked or scorned during his lifetime. These meetings constituted Lilian's final brave attempt to help Bomberg receive the recognition he was once denied, and it seems miraculous that she sustained her strength throughout. Soon after we finished, she lost the capacity to speak altogether.

Dinora then assumed the full burden of helping me with my researches into the family collection and archive. I am enormously grateful to her for the steadfast and unstinting way in which she made herself available. All my enquiries have been treated with a care and understanding which proves that she takes her responsibility towards Bomberg's art just as seriously as Lilian did. Working with Dinora has been a continuous delight, not only among the pictures, writings and other records so scrupulously preserved at her house, but also on journeys to collections of Bomberg's work elsewhere. Our trip to see the Vint Trust pictures was particularly memorable, revealing a whole range of important images which neither of us had ever seen before even in reproduction. Subsequently, when Dinora kindly accompanied my wife and me on a Spanish expedition to explore the sites Bomberg had painted there, she was able to provide unique insights into the work he produced at Ronda. Indeed, she has contributed to this book in so many ways that I could not possibly enumerate them all here. Suffice to say that Dinora has been a selfless and invaluable support during the years of preparation and writing. Her friendship and generosity never failed to sustain me.

I must also thank her husband Bernard for his good-humoured encouragement, his forbearance over my perpetual invasions of his home, and his willingness to photograph many items for the book with great skill. Dinora's daughter Juliet deserves my gratitude too, not only for talking about her memories of Bomberg but also for showing me her collection of his work. Other members of the family proved equally co-operative. The late John Bomberg and his wife Olive welcomed me at their house in Hove, where I learned a great deal about Bomberg's parents and his early East End years. Their daughter Cecily has likewise been helpful, and a special word of thanks must go to Bomberg's sister Kitty and her husband Jimmy. They entertained me at their home with friendliness and warm hospitality, throwing light onto many aspects of Bomberg's life and continuing to respond to my additional queries for several years afterwards. I also owe a debt to Bomberg's lifelong friend, the late Joseph Leftwich, who with his wife helped me to understand the Whitechapel period more fully than I could otherwise have done. Clare Winsten, another friend of Bomberg's from the East End days and his Slade contemporary, was kind enough to share her memories with me.

Towards the end of her life, Bomberg's first wife, Alice Mayes, corresponded with me from Australia despite failing health. Her son Denis Richardson proved very helpful as well, and so did John Mayes, who shared his memories of both Alice and David. I am grateful to Sarah and John Roberts for talking to me about Bomberg, and I also learned a great deal about his early life from Sonia Cohen Joslen. Three people now deceased – Kate Lechmere, Frederick Etchells and Dame Rebecca West – discussed their recollections of Bomberg with me. And Louis Behr,

who has lived in the Whitechapel area for many years, provided me with a valuable first-hand description of Schevzik's Vapour Baths, the starting-point for Bomberg's youthful masterpiece *The Mud Bath*.

The late Ben Nicholson corresponded with me about his appreciation of Bomberg's early work, and Professor James King alerted me to Paul Nash's stated admiration for Bomberg's paintings of the early 1920s. During my trip to Ronda I was entertained with great kindness by Mayor Julian de Zulueta and his wife Gillian. Martin Shuttleworth also gave me his help; and when I heard about the 1944 explosion at the bomb store, James Major provided me with crucial first-hand evidence about the catastrophe and its effect on people in the locality. While studying Bomberg's period as a teacher at the Borough Polytechnic, I was lucky enough to receive illuminating help from many different witnesses. Roy Oxlade allowed me to read his admirable MA thesis on the Borough years and to quote from it in this book. Other former pupils were equally co-operative. Frank Auerbach talked at considerable and fascinating length about Bomberg the teacher, as did Leon Kossoff. Dennis Creffield shared his memories of the Borough years and subsequently corresponded with great helpfulness. Leslie Marr has talked to me about Bomberg on several occasions, as well as providing several important photographs, and Peter and Nora Richmond discussed both the Borough period and their final years with Bomberg at Ronda.

Private collectors fortunate enough to own Bomberg's work tend, understandably, to be devoted to his pictures. I have received help from many owners, foremost among them Colin St John Wilson. His enthusiasm for Bomberg is matched by an admirable willingness to share his delight in the paintings and drawings he has acquired. I am also grateful to Sam and Carole Sylvester for showing me their collection with such infectious pleasure, to David Sylvester who alerted me to the late Ronda drawing in his possession, and to Eunice Kossoff who let me examine her paintings. Lady Alexandra Trevor-Roper showed me round her Bomberg collection, and so did Alan Rowlands and Vik Advani. Other owners who freely offered their assistance were Edgar Astaire, Harry Barr, Lyndon Brook, Abram Games, Anne Gray, Arnold van Praag, Erich Sommer, Pamela Sylvester and Douglas Woolf. Special thanks are due to Ronald Vint and his son, who went to considerable trouble to show me the remarkable collection of Bomberg's work in the Vint Trust.

I am also grateful to many museum officials who assisted me with enquiries. At the Tate Gallery, Richard Morphet has been helpful on a number of occasions, as have Michael Compton, Ruth Rattenbury, Corrine Bellow and Michael Fraser. Iain Bain proved very generous with the provision of colour transparencies, and Roy Perry of the Conservation Department responded promptly to my query about the Tate's version of *Sappers at Work*. Agi Katz showed me the Bombergs at the Ben Uri Gallery while she was the Curator there, and her successor Yael Hirsch helped with photographs. Sarah Brown of the National Gallery and Jean Liddiard of the National Portrait Gallery deserve my thanks, as do several officials at regional museums. Timothy Stevens, Director of the Walker Art Gallery in Liverpool, was most generous. Louise West of the Ferens Art Gallery, Hull, alerted me to a fascinating Bomberg letter in the Ferens archive, and Deirdre Heywood of Oldham Art Gallery went to considerable trouble to show me the Toledo canvas in her charge. Caroline Krzesinska of the Cartwright Hall in Bradford most kindly assisted me with the photographing of items from the Vint Trust; Angela Weight dealt very helpfully with several queries about pictures and letters in the Imperial War Museum; and Anne Goodchild and Mike Tooby of Sheffield City Art Galleries allowed me to examine the Bombergs in their collections. Jane Farrington helped me to locate Bomberg's correspondence with F. C. Kaines Smith, and Robert Hall of Huddersfield Art Gallery and G. G. Watson of Middlesborough Art Gallery also gave assistance. At the Victoria & Albert Museum, the Textiles Department allowed me to examine Bomberg's painted silk shawl. In other countries, Stephanie Rachum of the Israel Museum was a delight to work with when the *Bomberg in Palestine* exhibition was being planned, and I am grateful to her for spurring on my work on this book by commissioning an essay for the catalogue of that pioneering show. Miriam Stewart of the Fogg Museum helped me with my Sargent enquiries, and Catherine Johnston of the National Gallery of Canada was quick to assist with information about Ottawa's version of *Sappers at Work*.

Several dealers provided me with crucial help. At Fischer Fine Art, Jutta Fischer,

Anita Besson and Jeffrey Solomons have all been generous with their time. At Anthony d'Offay's, Anthony himself has shown me many Bombergs over the years and shared his enthusiasm with me. Judy Adam and Robin Vousden have also proved unfailing in their assistance. Ivor Braka showed me his splendid Bomberg collection, and Cavan O'Brien was always eager to give his help. Joe Wolpe of the Wolpe Gallery in Cape Town helped me track down an important Bomberg of the Cornish years, and I also enjoyed working with Gillian Jason when she mounted her Bomberg exhibition in 1983.

A number of other institutions supplied invaluable help. At the Arts Council, assistance and encouragement was provided by the Director of Art Joanna Drew, who contributed so much to the success of the 1967 Bomberg exhibition at the Tate Gallery. I also benefited from the assistance of Isobel Johnston, Curator of the Arts Council collection, Exhibition Organizer Susan Ferleger Brades, and Pamela Griffin of Art Records, all of whom provided help with photographs. D. Kasher and Mrs Lightbown of University College, London, both helped with enquiries about Bomberg at the Slade, and my researches into East End history were aided by D. T. Elliott, Chief Librarian at Tower Hamlets Library. Patrick Baird, Acting Librarian at the Local Studies Department of Birmingham City Reference Library, assisted me over Bomberg's years in Birmingham; and A. R. Neate, Record Keeper for the Director-General at the Greater London Record Office, supplied valuable information about Bomberg's schooldays. Robert Thorne of the Historic Buildings and Monuments Commission for England came to my aid with information about Robert van't Hoff's house for Augustus John, and the GLC Photograph Library provided me with a photograph of Bomberg's home at Tenter Buildings. Janet Green of Sotheby's and Francis Farmar of Christie's also gave me their help.

Among those responsible for restoring Bomberg's work in recent years, I am especially grateful to the Drown brothers. David Drown in particular has been enormously helpful, discussing the restoration of important pictures on many occasions and supplying photographs of works which he triumphantly brought back to life. I must also thank John Bull for showing me work-in-progress on several other Bombergs in his charge. A number of these newly-restored pictures were the subject of my William Townsend Memorial Lecture at University College, London, in 1985. I would like to thank Lawrence Gowing, the Slade Professor of Fine Art at that time, for inviting me to deliver the lecture, and Richard Shone for so enthusiastically agreeing to publish the text in the *Burlington Magazine* the following year.

I would never have been able to devote so much time to this book without the financial assistance of the Elephant Trust. Thanks are due to Nicholas Serota, who originally suggested that I apply to the Trust, and to the Trustees themselves for so generously granting me the funds I needed. I only hope the book persuades them that their money was well spent.

Finally, I am grateful to John Nicoll of Yale University Press for the enthusiasm he has given to this project ever since I first told him about it. I am lucky to have such a supportive publisher, and to have worked with Faith Glasgow on the editing and designing of the book. My wife Vena also deserves a special tribute, for allowing Bomberg to invade both our lives and never complaining when he claimed so much of my attention. My debt to her is immeasurable.

# Introduction

When Bomberg died in August 1957 he was a tragically neglected artist. His work was not discussed even in books as prominent and comprehensive as Herbert Read's *Contemporary British Art* and John Rothenstein's *Modern English Painters*. He had no dealer, sold very few of his works, and had last held a London one-man show fourteen years earlier which, like most of the exhibitions he appeared in, was ignored by critics and collectors alike.[1] Nor had the directors of public galleries demonstrated any more enthusiasm. During Bomberg's lifetime the Tate Gallery bought only two minor works, a student watercolour and a First World War drawing.[2] These acquisitions were made in 1923, and the Tate then waited until two years after his death before purchasing another work.[3]

In the Second World War he was unable, despite repeated requests, to secure more than a token commission for a single painting from the War Artists' Advisory Committee, which lavished patronage on many painters of far less ability. During the same period he applied for hundreds of teaching posts and was rejected, before finally receiving permission to teach drawing to gun crews in Hyde Park. The crowning humiliation came in 1956 when the Tate Gallery mounted an exhibition devoted to *Wyndham Lewis and Vorticism*. Although Bomberg had never regarded himself as a Vorticist, the organizers represented him in a section called 'Other Vorticists' with one exhibit – a drawing executed while he was at the Slade, and markedly less adventurous than the outstanding work he went on to produce in the 1914 period.[4] The acute and prolonged distress Bomberg suffered when he heard about the Tate survey undoubtedly hastened his death the following year. Forced to realize just how forgotten he had become, the ageing painter brooded over his fate with rage, bitterness and a terrible despair which helped to precipitate his final illness.

Now that Bomberg is widely recognized as one of the finest twentieth-century painters in Britain, the neglect he suffered seems almost incomprehensible. How could he have been overlooked for so long, while many of his contemporaries enjoyed increasing critical and financial success as their careers proceeded? The answer is complex, and involves a consideration of the dramatic change which his work underwent after the Great War. Before he enlisted in the Royal Engineers and went off to active service in France, the young Bomberg had achieved an extraordinary amount within a very short period. He succeeded in pursuing a singleminded path, using his intelligent awareness of Cubism, Futurism and Vorticism to develop a radically simplified and yet multi-layered art. The stark rigidity of his formal language, signifying a fascination with both the harshness and the vitality of modern urban existence, was animated by a fierce energy. He managed to fuse the Jewish culture of his impoverished East End childhood with an alert understanding of the international avant-garde, and the precocious work he executed with such stubborn assurance between 1912 and 1914 won widespread admiration from innovative artists and critics alike. At the age of twenty-three, only a few months after leaving the Slade School, his leading position in the new generation of British painters seemed assured.

After Bomberg's return from a harrowing period in the trenches of the Great War, when he had at one stage been driven to administer a self-inflicted wound,[5] this youthful buoyancy gave way to chronic restlessness and doubt. In the catalogue

of his 1914 one-man show at the Chenil Gallery he had defined his principal objective as 'the *construction of Pure Form*', explaining that his '*steel city*' environment impelled him to 'completely abandon *Naturalism* and Tradition'.[6] He also declared, in a rare and revealing interview published by the *Jewish Chronicle*, that 'the new life should find its expression in a new art, which has been stimulated by new perceptions. I want to translate the life of a great city, its motion, its machinery, into an art that shall not be photographic, but expressive.'[7] This interview, which appeared under the headline 'A Jewish Futurist', was recorded only a few months before the war broke out. But first-hand experience of the devastation wrought by machine-age weapons at the Front shattered his belligerent involvement with the dynamism of modern urban life. The bare, angular, near-abstract forms he had explored in pre-war canvases like *The Mud Bath* now seemed inadequate to deal with Bomberg's new consciousness. Mechanistic imagery, which had once been associated in his mind with radical construction, became inextricably linked with the spectacle of destruction. In an extended sequence of wash drawings he began to develop a different vision, admitting a greater sense of organic, rounded humanity to figures who were formerly so schematized.

This search for an authentic alternative was pushed off course by Bomberg's unfortunate clash with the officials of the Canadian War Memorial Fund, who had commissioned him to paint a monumental canvas of *Sappers at Work*. They summarily rejected his first version of the picture because of its experimental elements, and the repudiation had a traumatic effect on the already vulnerable artist. Still recovering from the horror of war, he acceded to the officials' demand for a more realistic interpretation of the *Sappers* theme. Although he completed the second version very rapidly in 1919, and its skill was praised by traditionalists, the compromise excluded too much of Bomberg's own individuality as a painter.

His confidence was profoundly shaken by the episode. Over the next couple of years his work veered from the near-abstraction of the so-called 'Imaginative Compositions', to a far more orthodox idiom which can be seen at its most naturalistic in a pair of small self-portraits. The style he had employed in the final *Sappers* picture was avoided, but Bomberg appeared unable to settle on a language which satisfied him as completely as his early extremism had once done. His faith in painting wavered so badly at one point that he moved to the Hampshire countryside with his first wife Alice and took up chicken farming. The studio which he had prepared for himself in the house remained empty, and Bomberg stopped painting altogether for many months. Although subsequent canvases like the monumental *Bargee* prove that he was still capable of formidable expressive power when he did resume painting, his despondency grew. A tentative attempt to paint a canal landscape in a more naturalistic idiom prophesied the direction he would pursue, but only after moving to Palestine in 1923 did he consistently develop this new interest.

The landscapes and city views he painted during the Palestine period, most of which exclude the figures dominating his earlier work, seem diametrically opposed to Bomberg's pre-war vision. Like so many other avant-garde artists of his generation, he felt a strong desire in the 1920s to return to a more traditional way of seeing. But it was characteristic of Bomberg's all-or-nothing temperament that he should swing from one extreme over to another, adopting a mimetic approach based on a far closer and more meticulous study of nature than any of his erstwhile allies now wanted to undertake. His earlier admirers were understandably perplexed by the course Bomberg's art took in the Palestine years. They could not comprehend why, alongside small studies of Jerusalem and Petra which retain all his previous vivacity, other paintings now adhered very doggedly to the facts of a given scene. Some of them are almost topographical in their fidelity to an observed view, and only the firmness of the overall structure links them with his earlier work.

No wonder they baffled supporters of the pre-war Bomberg when he held an exhibition of the Palestine pictures at the Leicester Galleries in 1927. His wife Alice told him that the general comment seemed to be: '"So many styles, how is one to know the real Bomberg." Damn them. It would make you sick if I repeated all the twaddle people talk about your work.'[8] With hindsight, we can now understand that for all its limitations and disappointments, the Palestine work laid the foundations for his subsequent commitment to scrutinizing all his subjects at first hand, concentrating in the main on landscape subjects for the rest of his career. But at the time, Bomberg's startling shift from pre-war innovation to post-war

conservatism must have been hard to understand, and one friend pinpointed the difficulties by stressing that 'it is almost like the work of a new man who has to gain a new circle.'[9]

Bomberg's dramatic apostasy in Palestine goes some way towards explaining why he found support so hard to obtain over the years ahead. But this change of direction does not excuse the lack of sympathy which greeted the remarkable work he now went on to produce. For Bomberg's development from the late 1920s until his death adhered to a consistent course. Having grown rightly dissatisfied with the tight, literal approach of his more topographical paintings, he soon began to recover the vitality of the handling first investigated around 1920. At Toledo in 1929, and then at Cuenca and Ronda during the 1930s, every painting arose from intense observation of the motif. At the same time, however, the forms of the houses and the surrounding landscape were now charged with a new sense of personal urgency, as he allowed himself to fuse close study of nature with his own passionately subjective response.

By 1935 Bomberg had succeeded in evolving the urgent and eloquent language he was to employ, broaden and enrich for the rest of his career. He was encouraged in this bravely unfashionable exploration by Lilian Holt, who later became his second wife. But the reception of his exhibitions in London proved consistently disappointing. Most gallery visitors failed to understand the reason why Bomberg had decided to 'break altogether' from the Palestine style and aim instead at what he described as 'the more unrestricted expression which after all is the fundamental quality of an artist's work'.[10] Critics, collectors, dealers and even fellow-artists no longer seemed capable of grasping his intentions, let alone sympathizing with them. English taste of the period, which shied away from German Expressionism and any exclamatory display of emotion, could not stomach the wild and ardent feeling in Bomberg's new work. It upset the traditionalists' reticence and also became unfashionable in avant-garde circles, where the dominant enthusiasms centred either on Surrealism or geometrical abstraction. Add to that the severe economic hardship suffered by so many English artists during the Depression period, and the neglect Bomberg encountered seems more understandable.

His belligerent and fiercely independent personality also contributed to the difficulties he confronted. Even his most faithful allies admitted that Bomberg was in some respects his own worst enemy. Incapable of ingratiating himself with those best placed to further his career, he often alienated dealers by stating his opinions with an aggressive bluntness which they found insulting. Apart from a few collectors in the north of England, who provided him with some much-needed support, the British art establishment increasingly shunned both Bomberg and his work. But adversity did not prevent him from remaining faithful to his sturdily individual vision. Wounded by critical and curatorial disdain, and sometimes so depressed that he abandoned painting for years at a stretch, he always succeeded in reviving himself in order to continue his tenacious and obstinate pursuit of a goal which he came to define as 'the spirit in the mass'.[11]

Bomberg experienced perhaps his most humiliating rejection during the Second World War. Anxious to serve as a war artist, he made repeated attempts to secure an official commission. But the War Artists' Advisory Committee refused to let him paint the large-scale *Bomb Store* canvas which he envisaged in 1942 after receiving a grudging invitation to visit an underground mine where the bombs were stacked. Bomberg may well have guessed that the committee would be disturbed by his vision of the assembled armaments, their capacity for titanic destruction conveyed in paintings which uncannily prophesy a terrible explosion at this very bomb store two years later. But he was determined not to compromise the imperatives of his imagination by repeating the mistake he had made during the Canadian commission for a First World War painting over twenty years before. This time, he went defiantly ahead with an extensive series of *Bomb Store* oil studies, even painting some of them on grease-proof paper because an acute shortage of money prevented him from purchasing the canvases he would have liked to employ. As a result of this refusal to modify his art and curry favour with officialdom, the *Bomb Store* images are among the most vibrant and haunting of his later works. The sight of these lethal objects nestling at the mine seems to have awakened memories of his traumatic experiences in the trenches of the Great War. Bomberg knew how much destruction modern combat entailed, and the *Bomb Store* pictures are alive with a disquieting

intensity of emotion. Unacceptable they may have been to the committee, but their warning message now seems admirable in its foresight and moral authority.

The price he paid for his integrity was a high one. For these powerful images were never shown to anyone outside Bomberg's immediate family. Most of them remained unseen in storage for the next three decades, and only recently has careful restoration revealed their outstanding significance. Throughout the later decades of his life, Bomberg was hampered by a chronic inability to exhibit the work he produced. No one knew the extent of his achievement because dealers were unwilling to show anything more than fragments of his output. He should, ideally, have been granted a full-scale museum retrospective during his lifetime, so that the entire range of his oeuvre could be grasped in all its fullness and complexity. But Bomberg was never granted that crucial privilege, and without it his achievement remained largely unknown.

The penury which had dogged him all his life was slightly alleviated, after the war, by a part-time teaching post at the Borough Polytechnic. And if his work was unrecognized by the world at large, he was at least admired by the students who attended his classes. Frank Auerbach, one of his youngest pupils, afterwards described Bomberg as 'probably the most original, stubborn, radical intelligence that was to be found in art schools'.[12] His extraordinary powers as a teacher rapidly became legendary, and enabled him to define his mature convictions about the value of art with an almost Messianic fervour. He was certain, now, that the development of a mechanized civilization posed an ever-increasing threat to humanity's relationship with nature. Bomberg's disenchantment with the machine age had grown steadily since the Great War first precipitated his move away from the urban inspiration of his early work. In 1914 he had placed 'the great city' at the very centre of his art; but three decades later he argued that the artist should attempt to save the world from the dehumanization of the technological era. Emphasizing now the importance of combating the alienation so alarmingly evident in post-war society, he believed that salvation could be found by rooting his work in an avid involvement with nature. 'We have no need to dwell on the material magnificence of man's achievement', he wrote, 'but with the approach of scientific mechanization and the submerging of individuals we have urgent need of the affirmation of his spiritual significance and his individuality.'[13]

Bomberg did not confine himself to theoretical pronouncements during his years as a teacher. Although he painted only intermittently, and devoted a generous amount of energy to nurturing his students, expeditions to Devon, Cornwall and Cyprus yielded progressively more convincing results. He emerged from the subterranean world of his *Bomb Store* pictures and blitzed London cityscapes into the dazzling sunlight of the Mediterranean, and his most magnificent landscapes were executed in Cyprus during a burst of sustained exhilaration. If these prodigious canvases had ever been displayed in a proper one-man show at a supportive gallery, the size of Bomberg's mature achievement might well have received wider acknowledgement. But he failed to secure an exhibition for himself, and only placed a few of his paintings on public view in mixed surveys of work by his Borough students. The success of the Cyprus trip should have led to a period of consistently impressive painting. In reality, it was the prelude to nearly four unproductive years. Rarely seeing his art in gallery exhibitions, and hearing perhaps that he had been unable to work for an alarmingly long time, collectors and critics found it all too easy to imagine that Bomberg had long since exhausted himself as an artist.

The truth was that, despite all the difficulties he endured, Bomberg's art did enter a very impressive late phase. Some remarkable and moving figure paintings were executed during this period, none more powerful than the tragic *Last Self-Portrait*. But most of his work concentrates on the dramatic Ronda landscape to which he and Lilian returned in 1954. In a few paintings and a superbly sustained series of charcoal drawings, he brought together the 'spirit' of his own passionate responses and the 'mass' of the terrain itself in a memorable synthesis. These grand images triumph over the frustrations and ill-health he suffered, and their monumental sense of form links them directly with the work of the young Bomberg half a century before. 'It is all one', he wrote of his life's achievement, pointing out how the variety of styles he had explored all showed 'the way of youth to age'.[14] They may have been greeted with scorn and incomprehension at the time, but now the full significance of Bomberg's art is at last receiving the admiration it deserves.

CHAPTER ONE  # An East End Childhood

The small Birmingham house rented by the Bomberg family at the time of David's birth in 1890 could scarcely be described as a propitious home for a child. It was situated at 18 Florence Street, a blighted working-class area near the city's centre and composed mainly of back-to-back houses, shops and small factories.[1] Other industrial conurbations in late Victorian England had more acute problems with overcrowded slums than Birmingham, but the Bombergs were still forced to endure unacceptable hardship. No green spaces alleviated the press of buildings in a neighbourhood where a tin-plate works, a large warehouse and two brass foundries abutted the rows of mean dwellings.[2] Inside this bleak accommodation, life was often reduced to an almost intolerable level. 'A horse-shoe is nailed over many of their doors, but it has not brought them as yet any good luck', declared the *Borough of Birmingham Report of the Artizans' Dwellings Committee* in 1884.

> They are very much what circumstances have made them. Music, which brightens every house in Edgbaston, has been excluded from their lives; so has beauty, and so has knowledge; so too has all healthy rejoicing, except that depraved imitation of it which the various stages of intoxication produce ... If they have been disinherited of all that makes life worth living, it is natural and inevitable that their habits should be bad. I allude specially to the habits of *uncleanness*, *overcrowding*, and *drunkenness*.[3]

Bomberg's father Abraham, a Jewish leather-craftsman whose fear of the pogroms made him abandon his native Poland and emigrate to England, struggled to ensure that his family maintained a tolerable standard of living. On his arrival in London from Warsaw, where his father once made leather handbags,[4] he had hoped to earn a living as a saddle-maker. Bomberg later recalled that Abraham 'brought his Trade of Saddlery to England – which he had heard in reliable authority was the one country in the world in advance of all others for supreme perfection of craftsmanship'.[5] In 1884 Abraham was described as a saddle-maker in Whitechapel,[6] but by 1890 he had been obliged to give up this proud ambition. Since England did not prove as hospitable as he had imagined, Abraham was forced to become a journeyman portmanteau-maker[7] and travel elsewhere in the country for the work he could not find in the East End. His problems were accentuated by the rapid growth of his own family. Abraham and his wife Rebecca already had four children when Bomberg was born, and houses in the Florence Street area provided pitifully little space for the families they contained. A photograph of nearby Ellis Street shows just how cramped accommodation really was in a part of Birmingham where a three-roomed house sometimes contained as many as ten residents (Plate 1). The 1884 *Report* cited the abject case of 'a man and wife living in the kitchen 12 by 10 by 8 feet, where the woman had lately been confined, where seven others also slept, and where the baby, to quote the poor mother's own words, had "just died of the Will of God and Dr Jones".'[8]

Bomberg, born just three weeks before Christmas, fortunately possessed a strong constitution. He needed it in order to withstand the ever-present threat of disease from a district ill-served by sanitation. The author of a book on *The Housing Problem in Birmingham* recorded that in one part of the Florence Street area there was 'but

1. Houses in No. 5 Court, Ellis Street, Birmingham, 1905.

one drain to the 12 houses, and this is situated so near the back door of one of the front houses ... that in summer especially the effluvia is very unpleasant, and the door has to be kept shut.'[9] However diligent the Bombergs may have been in maintaining a clean house, they were constantly threatened by the inadequacies both of the civic sewage system and of a neighbourhood where other people often failed to observe hygienic standards. 'I must tell you that many, I think most, of the bedrooms I visited were noisome, filthy, and so rancidly foul, that continuous visitation would make many of us unwell', complained the 1884 *Report*, which also referred to 'the impossibility of exterminating vermin, for if one house is cleansed and purified, another colony of vermin comes in from next door.'[10]

The Bomberg family did not, mercifully, suffer Birmingham's inner-city wretchedness for more than a few years. By 1893 they had moved to the less densely populated streets of Cardiff, where a certificate records the birth of another son, Israel.[11] But Abraham's career as a portmanteau-maker does not appear to have flourished as vigorously as he hoped. Two years later, with the help of a donkey to transport his ever-burgeoning family, he returned to Whitechapel. The urban squalor of the East End must have been hard to bear, especially at this critical period when successive outbreaks of brutal pogroms were forcing more and more persecuted, fearful and disorientated immigrants to settle there. From a great diversity of countries the hapless exiles clamoured to gain entry, and Lloyd P. Gartner has described how 'waves of Rumanian wanderers, fleeing conscripts, Pogrom victims and, above all, Jews who simply despaired of improvement in Russia, streamed into the British Isles in proportions which bewildered those who tried to organize the flow.'[12] Photographs of the period reveal how appalling the conditions were on board the immigrant ships, and how the passengers continued to endure terrible overcrowding when they began work in the Whitechapel sweat-shops. Between 1881 and 1914 as many as 150,000 Jewish immigrants settled in Britain, where a large proportion was housed in sub-standard East End tenements. Whitechapel became an area swollen with refugees who endured long working hours, high rents and disgracefully low wages (Plate 2).

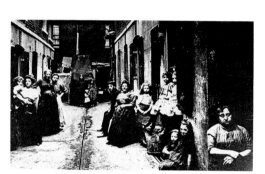

2. An immigrant street in the East End, 1905. GLC Photograph Library.

Bomberg's mother came from a family who had kept an inn and reared horses, but the teeming streets of Whitechapel offered no space for anything other than the most rudimentary of family requirements. She initially came to London hoping that her rich uncle, who lived in Prescot Street, would help them rebuild the shattered life they had left behind in Warsaw.[13] The fact that the Bombergs temporarily abandoned Whitechapel to search for an alternative life in Birmingham and Cardiff suggests the disappointing limits of her uncle's assistance. He failed to shield Rebecca and her children from the struggle experienced by the majority of the exiled Jews who found themselves confronted by the difficulties of surviving in the East End. Each new influx of refugees was forced to accept wages even more meagre than the remuneration its predecessors had received for their sweated labour. Bomberg afterwards remembered that his father had left Warsaw because he 'did not like the curtailment of civil liberties experienced by Polish-born Jews under Czarist-dominated Poland'.[14] But London's poorest Jewish inhabitants also found themselves oppressed by existence in a ghetto where they felt deprived and isolated from the rest of the city. In 1896, around the time when the Bombergs returned to Whitechapel and settled there permanently, Charles Booth reported that in the East End, 'nearly all available space is used for building, and almost every house is filled up with families'. Sanitation in many streets was as poor as in Birmingham, and Booth maintained that the desperate overcrowding was exacerbated by 'the building of workshops' which 'obstruct the light, and shut out the air'[15] from the people whose houses gave access to these ramshackle structures. The grotesque inadequacies of London's poorest areas became so notorious that by 1900, as Raymond Williams has pointed out, 'a predominant image of the darkness and poverty of the city, with East London as its symbolic example, became quite central in literature and social thought.'[16]

Despite the drawbacks involved in returning to such a locale, Abraham and Rebecca must have reached the conclusion that a Whitechapel existence was marginally preferable to the life they had endured elsewhere in England. There was, after all, a sense of solidarity among the East End's Jewish community, and the immigrants' morale remained remarkably steady in the teeth of the hardship they were obliged to withstand. Synagogues were established in eighteenth-century buildings

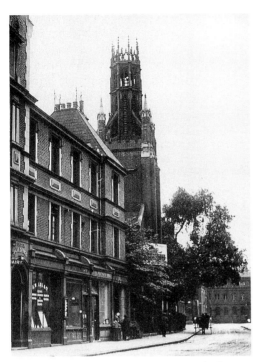

3. Tenter Buildings (on left) in St Mark Street, Whitechapel, c. 1926. GLC Photograph Library.

4. Photograph of Abraham and Rebecca Bomberg with two of their younger children, c. 1905. Collection of the artist's family.

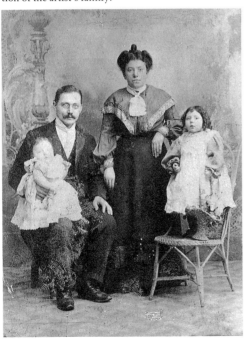

converted for the purpose, kosher shops appeared on street corners, and Jewish culture was respected in the local school curriculum. Moreover, the top-floor flat in the tenement where the Bombergs finally made their home provided them with adequate accommodation of sorts. It was situated in St Mark Street, to the south of Whitechapel High Street and only a short walk from St Katherine Docks by the Thames. The tenement itself, Tenter Buildings, no longer exists, but an old photograph indicates that it was a forbidding structure with a row of shops on the ground floor and a tree-fringed Victorian church nearby (Plate 3). While in no sense as squalid as Birmingham had been, and less poverty-stricken than some other East End districts, St Mark Street was a far from ideal locality in which to rear an enormous family. Joseph Leftwich, a Whitechapel contemporary of Bomberg's, remembered it as a 'very poor neighbourhood' taken up largely by once-imposing houses whose owners had become wealthy and moved to more desirable areas of London. 'As the immigrants moved in', Leftwich explained, 'they came to occupy single rooms in houses originally inhabited by one family who had by then moved westwards.'[17] Abraham and Rebecca eventually produced eleven children, and they must have felt constricted by the acute lack of space in a flat with no bathroom or lavatory of its own. It was never intended to house so many people, let alone the workshop where their father made his leather suitcases on a long bench. The only green space where they could play was around the Tower of London to the south.[18] Most of the time Bomberg and his brothers and sisters had no alternative but to roam the streets, where they encountered a lot of anti-semitism and toughened themselves in order to combat it effectively.[19] Through contact with other Jewish children they acquired an instinctive sense of solidarity, and Bomberg's sister Kitty recalled that 'we were a wandering lot, exploring all round the city.'[20]

As the nineteenth century came to a close, Abraham's career improved at last. Working now for a number of leading leather-goods shops in the West End, including Aspreys of Old Bond Street, he established a considerable reputation for crocodile suitcases with engraved designs. Bomberg's younger brother John proudly remembered that Abraham introduced the so-called Revelation Case, which enabled its owner to adjust the size according to the amount it carried.[21] 'He was very inventive and worked hard',[22] Kitty testified, and many years later Bomberg declared that he had inherited from his father 'design & craftsmanship'.[23] Bomberg's elder brother helped his father with the stitching and lining of the locks. Abraham's professionalism won him a measure of admiration in the neighbourhood, and his children respected him for it. He was capable of dominating the household with his stern patriarchal insistence on quietness and discipline.

But Abraham liked to play just as hard as he worked. John considered that 'father was not a happy man in his work, and he got his excitement from gambling.'[24] Making suitcases satisfied him only to the extent that the outcome of his labours provided him with money which he often frittered away far too quickly. One day, when Abraham won a substantial amount, he celebrated by taking Rebecca and the two youngest children off to a photographer's studio in nearby Leman Street, where the dapper and mustachioed head of the family posed in resplendent evening dress beside his small, homely wife (Plate 4). But on the occasions when his gambling luck ran out he became very aggressive, and his tempestuous behaviour inevitably made the children grow wary of him. 'I can't recall any of our family coming straight in the door when we arrived home', related Kitty; 'we'd put our heads round the door first.'[25] Their caution was understandable, for John admitted that his father 'could be violent. When he smacked my mother one day, my brother Wolf hit him back and so the other brothers took Wolf out to the back room and pretended they'd beaten him to placate my father.'[26]

Abraham's unpredictable and turbulent personality, which must have been exacerbated by the frustrations of a Polish immigrant in British society, eventually turned Rebecca into his antagonist. 'She was the protector of the whole family against my father', John explained, describing how she rebelled against Abraham's espousal of the orthodox Jewish faith. John even maintained that his mother was 'irreligious, and managed to convince her children. Admittedly, every Friday evening she'd light candles, put them on the table and say prayers over the food. But David was influenced by his mother not to be an orthodox Jew.'[27] Even so, Rebecca resisted the idea of becoming too closely assimilated with British culture. 'I was always aware of my mother's injunction never to accept any food or clothing from the

5. Old Castle Street School, off Aldgate High Street, *c.* 1934. GLC Photograph Library.

Mission for the Conversion of the Jews', recalled Kitty, adding that 'some Jews did accept it but my family shunned it.'[28] Bomberg remained strongly conscious of being Jewish throughout his life, and Abraham ensured that anyone entering the flat in Tenter Buildings passed on the right side of the door a *mezuzah* – the small ornamental container made of metal, wood and glass which displayed on a parchment scroll the daily prayer beginning 'Hear O Israel, the Lord our God, the Lord is one.' Two years before his death Bomberg painted an outstandingly eloquent canvas which takes as its title the first three words of that prayer (Colour Plate 63). The memory and meaning of the *mezuzah*, which was displayed on the front door of every Jewish home to be kissed by the devout, remained vividly in his imagination to the very end.

Abraham must likewise have been responsible for deciding to send most of his children to the Jews' Free School in Spitalfields. He knew that a limited amount of orthodox Jewish education would be reliably provided there, even though the government hoped to Anglicize immigrant offspring and avoid separatism by supporting such an institution through public funds. An official report on the Jews' Free School in 1894 concluded that children 'enter the school Russians and Poles and emerge from it almost indistinguishable from English children',[29] but Abraham and many of his neighbours seemed satisfied that the fundamental aspects of Jewish culture were not overlooked in the curriculum. Bomberg himself did not attend the Free School, and nobody in the family remembers why. He was probably refused admission for the simple reason that no room could be found for him. By the turn of the century the intake of children had swollen the school so far beyond its proper capacity that Isaac Rosenberg, who would later become Bomberg's friend, likewise failed to gain entrance.[30] Abraham may well have felt annoyed at his inability to send David there, for the alternative turned out to be the Old Castle Street School just off Aldgate High Street.[31] 'It wasn't as good as the Jews' Free',[32] John Bomberg maintained, and surviving photographs reveal a grim building which cannot have inspired much optimism in the pupils obliged to penetrate its looming brick frontage (Plate 5). One of the earliest institutions built by the School Board for London, it was also among the most cheerless in appearance.

Old Castle Street School's extant records yield no specific information about Bomberg's career there. But he probably attended this elementary school from the age of five to fourteen, when children normally left. The education he received was largely non-denominational in character, and provision was made for pupils to be excused scripture lessons and attendance at assembly if their parents desired it on religious grounds. Moreover, a number of the teachers at Old Castle Street School had Jewish names at this period, including the headmaster Abraham Levy. They would undoubtedly have exerted an influence over the delicate matter of ensuring that children's ethnic origins were respected. But did any members of staff encourage Bomberg's emergent interest in art? Even the most orthodox Jewish teacher at the school would not have persisted by this time in upholding what Charles Spencer has described as 'the Mosaic injunction against depiction of living forms, including the human form'.[33] The progressive effect of secularization had eroded the old Jewish mistrust of graven images throughout the nineteenth century; and besides, the syllabus of London's elementary schools included periods of no more than two hours a week devoted to 'Drawing'. Instruction in the theory of art played only a marginal role during these lessons, which concentrated instead on the straightforward drawing of objects placed before the class. Specialist art teachers were rare, and Bomberg is unlikely to have benefited from the particular attention of any one master. But in 1903 six out of the ten teachers at Old Castle Street School's Boys Department held a certificate in 'elementary drawing', so the subject certainly did not lack staff qualified in some measure to teach observation and delineation of the motif as a fundamental discipline.[34]

Towards the end of his schooldays, when he was bahmitzvahed at the Alie Street synagogue,[35] Bomberg began displaying remarkable abilities as a draughtsman. His brother John remembered that 'Old Castle Street School was proud of him',[36] and everyone's admiration seems to have centred particularly on a copy he executed of a Holbein portrait, around the age of fourteen. Although the drawing was unfortunately destroyed during the Second World War, it impressed several members of his family as an astonishingly faithful and assured exercise.[37] Kitty recalled that the Holbein taken by Bomberg as his model was a portrait of Sir John Godsalve,[38]

7. David Bomberg. *Portrait of the artist's sister, Rachel*, 1905–6. Charcoal, 35 × 28.7 cm. Collection of the artist's family.

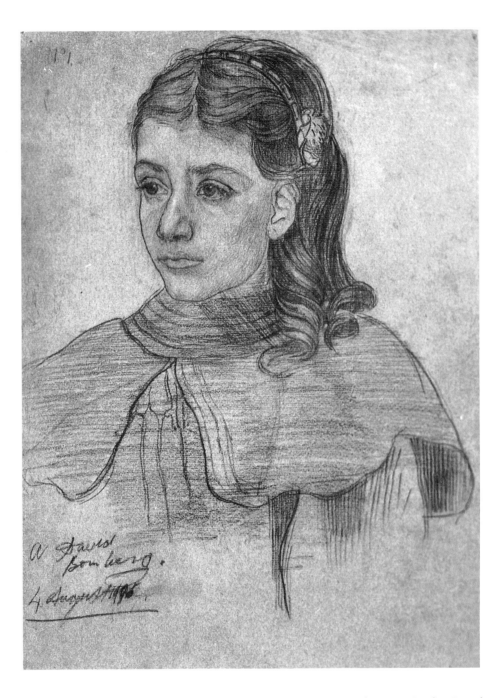

6. Hans Holbein the Younger. *Sir John Godsalve, c.* 1532. Chalks, brush, ink, watercolour and body-colour, 36.7 × 29.6 cm. Royal Collection, Windsor Castle.

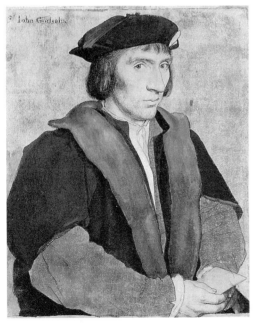

and he probably copied a reproduction of the preparatory drawing in the Royal Collection at Windsor Castle (Plate 6). Its clarity of definition, monumental structure and simplified masses must all have appealed to the young Bomberg, who would soon manifest similar qualities in his own draughtsmanship. Indeed, within a year or so he carried out two studies of his sister Rachel[39] which possess a Holbein-like emphasis on lucid contours and precise, uncluttered scrutiny of the girl's face, ringlets and coat. The charcoal version (Plate 7) is a finer and more completely realized drawing than the larger but unfinished pencil-and-wash portrait, which concentrates on the umber coat at the expense of her faintly delineated facial features. Nevertheless, the insistent flatness and overall organization of this wash drawing is especially reminiscent of Holbein's Godsalve, who clutches a letter in much the same way that Rachel holds a book in her small white hands. The position of Godsalve's arms was even echoed half a century later, in '*Hear O Israel*' (Colour Plate 63).

From now on Bomberg devoted an increasing amount of his energies to the making of drawings which have not, in the main, survived. 'All I ever saw David do was draw', Kitty recalled, 'and he didn't even join us at meals. He was always singing "I Know That My Redeemer Liveth" from the Old Testament, whereas the rest of us would sing music-hall songs while waiting for dinner.'[40] The young Bomberg was conspicuous for a mop of fair curly hair, just as his father had been at the same age, and they also shared an ability to channel their fiery temperaments

9

into the exacting, concentrated work which their respective activities demanded. But these points of resemblance did not mean that father and son were at all compatible in other ways. 'David must have been affected by the strain of living with a father who gambled and a mother who resisted him', said John. 'My father didn't understand David's attitude to art, and no pictures were ever hung in the family flat. But David was a special child for the mother.'[41] Bomberg was acutely conscious of the tension between his parents. He once told John that 'mother was a thorn in father's side', and at times found himself used as a tactical weapon in Rebecca's attempts to persuade Abraham out of his rages. On at least one occasion Bomberg's father became wildly hysterical, gripped by the delusion that people were taking money from him. Imagining that there was a burglar in the house, Abraham threatened to jump out of a window twenty feet from the ground. The temporarily deranged man was placed in an asylum for a few days.[42] But most of the time Rebecca had to deal with these distressing eruptions at home, and Bomberg was sometimes placed at the centre of the conflict. 'When his father was having these attacks his mother used to put David into bed with him', said Lilian Bomberg; 'David had a calming effect on him.'[43]

Such regular exposure to the instability of his father must have alarmed and unsettled Bomberg, who in later life became prey to sudden fits of explosive emotion and bouts of serious depression. But as long as Rebecca remained alive, he was always able to count on her unstinting love and protection (Plate 8). 'David was very close to his mother and very dependent on her', said John. 'She believed in him as an artist, and anything he wanted she'd see that he got – frames, canvases and paints.'[44] Rebecca even succeeded in finding him a space of his own where he could work without fear of distraction from the rest of the large and boisterous Bomberg family. 'The people next door vacated a one-room flatlet', Kitty remembered, 'and my mother took that room over for David.' Here Rebecca created an inviolate haven for her son, ordering the other children never to enter the studio, bringing him meals when he did not want to interrupt work in progress, and telling young John to post letters through the door rather than disturb David while he was busy. Bomberg became so completely absorbed in painting and drawing that he could not even bear to pause when his small sister did break the rules and invade this hallowed retreat. 'I used to get in his way rather', admitted Kitty, 'and he would gently edge me out of the way with his foot because his hands were filled with palette and brushes.'[45] The extraordinary concentration he gave to his art impressed itself on everyone who witnessed him at work there. Many years later John declared that 'I can still see David sitting on a high stool with his easel, and I don't think you could divert him from what he wanted to do. He always said it was important to be singleminded if you wanted to do anything with your life.'[46]

Rebecca gave him the calmness and facilities he needed to pursue this aim without suffering constant diversions or brooding unduly on the strange volatility of the man who dominated the family. As a result, Bomberg seemed to John a very stable character in his youth, and when he did eventually stop working his high spirits often proved irresistible. 'David was always laughing', said Kitty, describing how his 'great sense of humour would transform very delicate situations into fits of laughter. We were a singing family, well-read but not well-educated. Dickens was very important to us, and so were Mrs Gaskell, *Middlemarch* and Walter Scott. David taught me Browning's poem *In Three Days* and Swinburne – we knew miles and miles of Swinburne.'[47] But Bomberg's youthful energy also sought outlets beyond the confines of the claustrophobic flat in Tenter Buildings. His older brothers were all attracted to boxing and wrestling, and the pugilistic Mo used to protect him whenever danger threatened on the rough Whitechapel streets. Bomberg, however, soon grew sturdy enough not to rely on Mo for help. 'All my brothers were natural fighters, classic fighters, and Manny, they say, was invincible', related John. As Bomberg grew up, he naturally absorbed the pugnacious view of the world adopted by all the male members of his family. Although he never became a professional boxer like Mo, preferring to be a spectator at matches rather than climb into the ring himself, he would eventually show no hesitation in bringing all his aggressive vitality to bear on developing a defiant attitude towards the English art establishment.

But how could this assertive young man pursue his own work, now that he had left school and urgently needed to earn a living? Although the Bomberg children were all well looked after while their mother was alive, Abraham's fecklessness

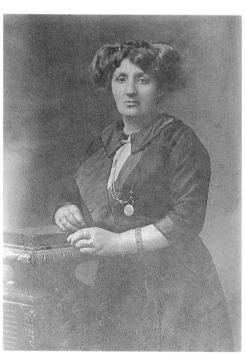

8. Photograph of Rebecca Bomberg, the artist's mother, *c.* 1908. Collection of the artist's family.

meant that the family was constantly beset by money problems. No funds could be spared to support a student artist at Tenter Buildings for long, so Bomberg took an assortment of short-lived jobs to subsidize his attendance at the evening classes held by Walter Bayes at the City and Guilds Institute. Starting in 1905, when he was only fifteen and inevitably ill-informed about the state of contemporary art, Bomberg studied 'in the life class'[48] with Bayes for two years. As art critic of *The Athenaeum* and a contributor to the New English Art Club, Bayes would have provided his pupil with an articulate, well-informed and open-minded view of art in this first crucial decade of the new century. He stressed the importance of organizing the structure of a painting with elaborate preliminary drawings, a practice to which Bomberg adhered throughout the first half of his career. Moreover, Bayes was sympathetically disposed towards many innovative developments of the period. The New English exhibitions, which Bomberg now started to visit and scrutinize with care, encouraged a far more independent attitude than those of the Royal Academy. Bayes's own involvement with French painting was grounded in a brief period of study at the Académie Julian in Paris, and he shared his friend Sickert's involvement with Degas.[49] Indeed, Bayes became a founder-member of the Allied Artists' Association when it opened in 1908 as an English equivalent of the Paris Salon des Indépendants, and within a year Kandinsky's work made its first appearance in England on the walls of the AAA's enormous annual salon. Alongside his alert interest in modernist experimentation, though, Bayes always retained a formidably knowledgeable interest in the history and technical resources of painting. 'It might be an overstatement to say Bayes was too intellectual for a painter', declared his obituarist in *The Times*, 'but it is certainly true to say that he excelled in what has been called the science of picture making, including perspective and the proportioning and balancing of colour.'[50]

This austere, pedagogic and yet broad-minded man surely gave Bomberg excellent instruction, stressing the importance of historical awareness and craftsmanship even as he pointed his restless student towards audacious contemporary developments. It was a propitious beginning, laying the foundations of the mature Bomberg's abiding respect both for his teachers and for the vital legacy of tradition. He was also beginning to contact other young artists who shared this dual involvement with the past and the avant-garde: Ossip Zadkine became a friend when he stayed briefly in London towards the end of 1906 and was introduced by Bomberg to the Elgin Marbles. Years afterwards Zadkine stressed the 'shy and sensitive'[51] aspects of his young friend's character – an assessment which suggests that Bomberg felt considerably less sure of himself when away from his familiar East End territory and in contact with someone whose views on art he respected. In order fully to develop his own work, Bomberg needed a spell of uninterrupted study at a proper art college. His chances of realizing such an ambition looked remote, for he had no means of subsidizing a prolonged studentship. Besides, Abraham Bomberg believed very firmly in 'teaching each of his sons a trade – including David'.[52] The economic logic of his father's argument was difficult to resist, and around 1906 the family decided that Bomberg should become an apprentice in chromolithography under the German immigrant Paul Fischer, at a shop in Islington. Although the technical skills he learned there were to prove useful during his subsequent career (Colour Plates 18, 19, 20; Plates 150, 152–154),[53] Bomberg can hardly have found the work very fulfilling. At this crucial stage in his adolescent life, it seemed as if he might never be able to achieve his real aim and become a painter.

But Bomberg was a stubborn individual. Sustained, no doubt, by the encouragement he received at Bayes's evening classes, he refused to abandon his highest ambitions. Whenever he could, Fischer's apprentice escaped from the shop and pitted himself against the art he most admired, by copying old masters in the major national collections. While working from a sculpture cast at the Victoria & Albert Museum, a happy accident decreed that he met an artist who succeeded in transforming his future prospects: John Singer Sargent. 'One Saturday afternoon [in] 1907', Bomberg recalled, 'he asked whether he might have a glance at the drawing I was making of the Cast of Michelangelo's the "Bound Slave". He had come from [the] V & A Museum Grill Room, and before returning to the Albany Studios where he was painting the murals for the Boston Library . . . he wanted to study Michelangelo's rendering.' Sargent was impressed by Bomberg's draughtsmanship, and sensed perhaps that the young man was in no position to enjoy the benefits of an art-school

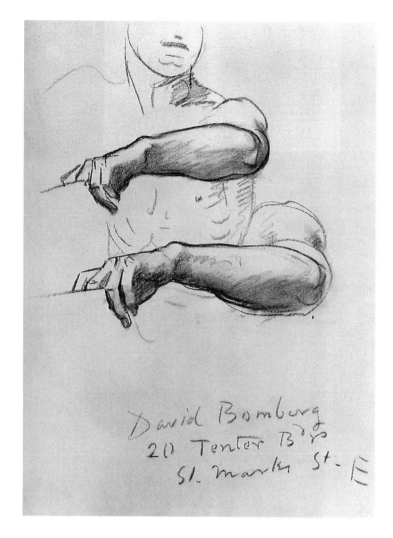

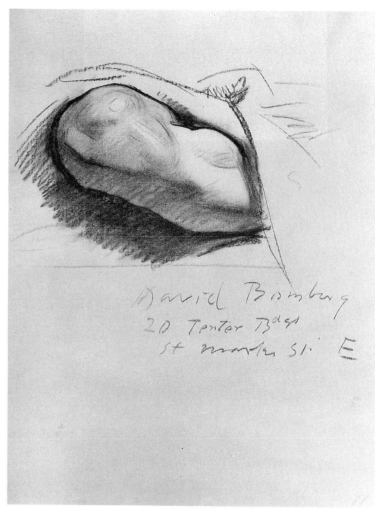

9. John Singer Sargent. *Two Studies of Bomberg's Left Arm, for Israel and the Law*, 1907. Charcoal, 62 × 46.7 cm. Fogg Art Museum, Cambridge, Mass., gift of Mrs Francis Ormond.

10. John Singer Sargent. *Study of Bomberg's Knee Emerging from Drapery, for Israel and the Law*, 1907. Charcoal, 61.6 × 46.6 cm. Fogg Art Museum, Cambridge, Mass., gift of Mrs Francis Ormond.

education. Bomberg must have been gratified by the attention this discerning stranger gave him, but he had no idea of his admirer's identity. 'Sargent made an appointment for the following Saturday afternoon', Bomberg remembered. 'The address he gave did not give the name, and arriving at the number plate of the Studios in Fulham Road with more work he had asked to see, I read John Singer Sargent.'[54]

Overcoming his astonishment at finding that he had been befriended by such a celebrated painter, Bomberg entered the studio and found him finishing a sitting with the octogenarian Earl of Wemyss, whose bewhiskered features fired Sargent to paint one of his liveliest male portraits.[55] Bomberg recalled that 'Sargent presented me to the Earl as an artist of promise: "I would like him to study drawing at the Slade – but he cannot go because he is bound apprentice to serve his time."'[56] Bomberg subsequently posed for Sargent, who was working on his epic mural scheme for the Boston Library and needed models to help him with the arduous task of planning the enormous figure compositions. At least two charcoal drawings have survived, with Bomberg's name and address prominently inscribed on them, to show how carefully Sargent studied arms and legs in preparation for the decorations (Plates 9, 10). Appropriately enough, the drawings were intended to help Sargent develop a composition called *Israel and the Law*, and he might have carried out at least a dozen other studies of Bomberg's body for the same purpose.[57] Bomberg privately thought that the murals were 'a very ill-conceived emulation of the Florentine', and he 'was not impressed as much as thankful at being permitted to view the works in progress'.[58] But he probably admired the dedication with which Sargent scrutinized the posed model for every figure in his ambitious scheme. Indeed, twenty years later Bomberg proposed a mural scheme of his own for the Library of the Hebrew University in Jerusalem;[59] and the conspicuous fluency of Sargent's finest brushwork might also have affected Bomberg's handling when he started landscape painting in Palestine. In 1907, though, his conversations with Sargent focused on the importance of drawing as an essential discipline. Sargent convinced him that the Slade 'was the finest School for Draughtsmanship in the world', and took practical steps to help the young man on his way there.

Having already advised his friend William Rothenstein to establish a studio in Whitechapel and paint scenes of Jewish life,[60] Sargent knew exactly who to contact over the question of Bomberg's future. Solomon J. Solomon, first President of a group of Jewish intellectuals called The Maccabeans, was only the second Jewish artist to be appointed a Royal Academician.[61] He was as influential in the Jewish community as he was eminent in the world of fashionable Edwardian portrait painting. Bomberg was therefore duly introduced to him by Sargent, who 'showed the highest esteem'[62] for Solomon, and the meeting proved fortuitous in the long run. Only a year before, Solomon had organized the Jewish Exhibition at the Whitechapel Art Gallery. He was committed to giving young Jewish artists as much help as his prestige could provide. Sharing Sargent's favourable response to the work Bomberg showed him, he quickly arranged for his new protégé to meet Professor Fred Brown at the Slade. The interview took place in 1908, and Bomberg recalled that 'Brown examined my drawings, paintings & compositions – among the drawings were Ballet dancers showing strong Degas-Sickert affinity. He hardly glanced at the oil paintings before he began rubbing them with his finger – Brown's way of attesting the blood stock of the horse.'[63] Their discussion ranged widely, from Bayes and Sargent to Berenson's theory of tactile values. Bomberg told Brown how much he valued Berenson's book on the Florentine draughtsmen of the Renaissance, over which he had pored in the V & A Museum's Library. They also talked about the book on the Slade published the previous year, with its reproductions of student work by Augustus John, William Orpen and Wyndham Lewis, whose 1901 drawing of a male nude remained in Bomberg's memory for the rest of his life. Brown and his interviewee even spoke about the philosophical writings of Bishop Berkeley, whose *Theory of Vision* became increasingly important to Bomberg as his career developed.[64]

After such an intensive meeting Bomberg must have hoped that a place at the Slade might be offered to him at once. But it was not immediately forthcoming, presumably because Brown felt that the young man needed further study elsewhere before his work could meet the Slade's high standards. Bomberg's inevitable disappointment would have been partially offset by the realization that he might make a successful future application if he worked hard. The interview with Brown surely acted as a spur to Bomberg's ambition, giving him the confidence to take the drastic step of breaking his indentures to Paul Fischer only a year after he had commenced the apprenticeship. He cannot have known in 1908 how he would survive if the Slade place proved unobtainable, but the risk was clearly worth taking. The lithographic training must have seemed far too narrow an experience to an artist with Bomberg's high ambitions. Only by concentrating his energies on drawing and painting would he ever be able to qualify as a student in London's most respected art college.

Abandoning his apprenticeship with Fischer still meant, of course, that he was obliged to take part-time jobs wherever they could be found. Posing for Sargent had already made Bomberg realize that his physique qualified him to work as an artist's model, and he seems to have found favour with the successful academic sculptor James Havard Thomas. Bomberg is supposed to have 'stood for the statue of Lycidas that Havard Thomas made, when he and his family lived in one of Sir Cyril Butler's cottages in Bourton in Berkshire'.[65] But most of Bomberg's modelling work was carried out for London colleges like St Martin's School of Art, where he was hired by the school's teacher William Robins for sessions in the evening classes. Bomberg's advent at St Martin's was vividly recalled by William Roberts, who attended the classes in 1909. 'One evening while drawing a cast of the head of Michael Angelo's "David"', wrote Roberts many years later, 'Robins came to me and said "Take a look in the Life Room, there is a male model posing there with a marvellous figure." I did not know, as I took a look, that the model was David Bomberg, or that in a year's time I would be drawing him as he posed in the Life Room at the Slade.'[66]

Despite his success as a model, Bomberg would only have undertaken the amount of work he needed to subsidize the far more important task of drawing and painting on his own behalf. He demonstrated the seriousness of his aims by enrolling for a comprehensive series of evening classes at institutions where the teaching upheld the most exacting standards. One of the courses he attended between 1908 and 1910 was W. R. Lethaby's book production and lithography class at the Central

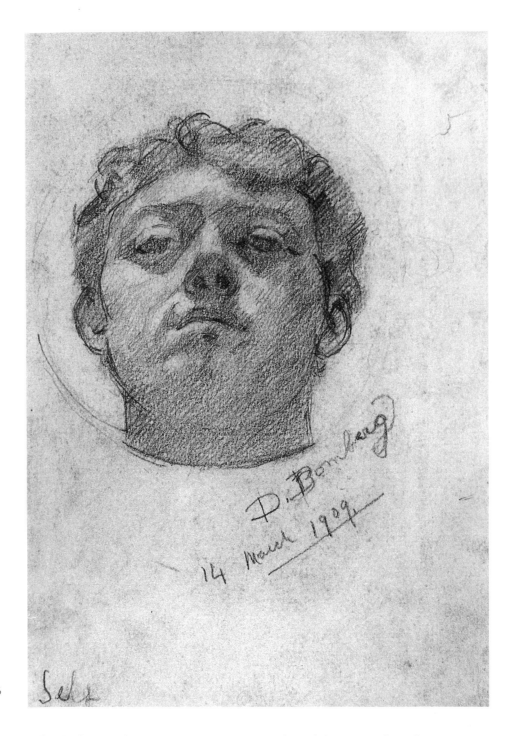

11. David Bomberg. *Self-Portrait*, 1909. Pencil, 16 × 12 cm. Collection of the artist's family.

School of Art and Design. A prominent member of the Arts and Crafts movement and an outstanding educationalist, Lethaby would have provided a model of intensity and dedication in teaching which Bomberg emulated – albeit according to his own very different convictions – when establishing classes at the Borough Polytechnic several decades later. Lethaby was the Central School's first Principal, and his belief that 'science and modern industry have given the artist many new opportunities' was applied with a sustained commitment which won him a wide reputation. Bomberg was soon to share Lethaby's awareness of machine-age developments and incorporate them in his art, but the Central School classes also stressed the importance of craft. Departments of painting and sculpture were not established there until 1941, and Lethaby always insisted on retaining the interrelationship between the Fine Arts and the 'Arts Not Fine'. Studying book production and lithography would have made Bomberg very aware of this emphasis, and Lethaby may likewise have been responsible for instilling in Bomberg's mind the interest in architecture which flowered during his Jerusalem period. But he never showed any great interest in the crafts. Bomberg only turned to poster designing in later life when financial need drove him to attempt it (Plate 180),[67] and he derived more immediate inspiration from his attendance on other evenings at Sickert's classes in drawing and painting from life.

Bomberg's retrospective description of the 'Degas–Sickert affinity' in the drawings he showed Professor Brown at the Slade suggests that, for a while, his new teacher exerted a potent influence. He later maintained that 'it was at Westminster that Sickert got at [*sic*] grips with me over the "cliché", regarding it as the old rut of expression.'[68] The loss of almost all Bomberg's pre-Slade work prevents us from discovering precisely how this influence affected him, but it was only to be expected that Sickert would be impressive. He was, after all, one of the few prominent English artists conversant with developments in France, and his friendship with Degas gave him privileged access to the artists who had forged the Impressionist revolution. Degas, however, was in some crucial respects opposed to the central tenets of Impressionism, and Sickert shared his master's preference for a relatively subdued palette which never allowed firmness of structure to be wholly dissolved in shimmering optical effervescence. Bomberg's subsequent work displays an even more marked bias in favour of linear and volumetric organization, and he may also have been in sympathy with the preference for low-life subjects which Sickert inherited from Degas. Some of Bomberg's Slade works would take mundane Whitechapel themes as their starting-point, just as Sickert had earlier savoured music-hall interiors and slices of dowdy existence in Mornington Crescent.

But Sickert's evening courses concentrated on working from life-class models, and one of the few drawings to survive from this period of Bomberg's life is a quietly attentive study of his own features (Plate 11). Doubtless drawn in his Tenter Buildings studio, from the reflection in a mirror placed on the table below him, this small pencil drawing shows how the eighteen-year-old Bomberg restricted himself to a straightforward account of the face he scrutinized in the glass. His handling of contours, especially where they swell on the sides of the head to accommodate cheekbones before curving inward and almost disappearing beneath the chin, has a robust authority which seizes instinctively on essentials and leaves secondary detail alone. Although at first this self-portrait seems preoccupied with facial minutiae, close examination reveals that Bomberg employs remarkably few structural lines. They are sparingly applied throughout the drawing, and the substance of the head is created by a form of shading which adheres very strictly to a sequence of parallel strokes. Sweeping across his face in an orderly progression, their geometric regularity contrasts with the rounded contours Bomberg uses to denote ears, hair, eyes and mouth. Indeed, the drawing seems far less concerned with conveying emotion than with establishing a formal interplay between these two distinct methods of defining form. Bomberg's face remains almost expressionless as he absorbs himself in a lucid analysis of the modes of draughtsmanship deployed here. The self-portrait's reserve, amounting almost to a sense of remoteness, becomes even more evident when compared with his friend Gerald Summers's roughly contemporaneous painting of Bomberg (Plate 12), which conveys tousled warmth and humour rather than the Olympian detachment so evident in the drawing.

Attendance at Sickert's classes seems to have encouraged Bomberg to pursue this interest in formal analysis, even to the point of subverting the naturalistic conventions on which his self-portrait drawing still rested. Indeed, he afterwards remembered that 'my relaxation while acquiring Sickert's manner' at the Westminster classes sometimes took the form of flouting representational codes altogether. While he was engaged on constructing the 'voids and solids' in a drawing, Bomberg discovered to his delight that 'the juxtaposition of the patterns forming the entity could suitably be inverted to form a non-figurative composition.'[69] Throughout his life he continued to be stimulated by looking at his designs from every conceivable angle, turning them sideways and upside-down in order to help him detect any formal weaknesses and convince himself of their complete structural viability. It is surely no accident that he should have developed this habit while studying at the Westminster, for Sickert was himself forever questioning and transforming his own *modus operandi*. 'While he had no use for intellectual aesthetics, and shunned close involvement with any of the movements which revolutionized art during his lifetime', emphasized Wendy Baron, 'he was always inventing and adapting recipes for painting, experimenting with technique and exploring all aspects of style and design.'[70] To watch such a restless and inquisitive intelligence at work must have been a rewarding experience for Bomberg, whose own appetite for innovation was surely whetted during these formative years under Sickert's idiosyncratic tutelage.

Soon after his period at the Westminster classes drew to a close, however, Bomberg

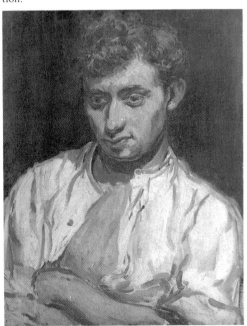

12. Gerald Summers. *Portrait of David Bomberg, c.* 1909. Oil on canvas, 55.9 × 43.2 cm. Private collection.

13. H. M. Bateman. *Post-Impressions of the Post-Impressionists*, 1910. Reproduced in the *Bystander*, 23 November 1910.

encountered an exhibition which challenged his received ideas about art far more dramatically than Sickert had done. In November 1910 Roger Fry's seminal survey of *Manet and the Post-Impressionists* opened at the Grafton Galleries, and the thousands of visitors who examined the 228 images on display were brought face to face with the disturbing continental developments that Britain had done its best to ignore. Bomberg's response to the exhibition would not, of course, have been remotely in agreement with the apoplectic hostility of its most conservative viewers. Bayes and Sickert had already alerted him to some manifestations of late nineteenth-century avant-garde art in France, and he may perhaps have seen the under-publicized yet representative exhibition of modern French painting organized by Robert Dell at Brighton in the summer of 1910.[71] But his straitened finances had not yet permitted Bomberg to make a trip to Paris, let alone the regular visits which might have enabled him to become properly acquainted with the most radical activities pursued there. Writing long afterwards about how the Grafton show helped to bring 'the revolution towards Mass ... to fruition', he admitted that 'I had never hitherto seen a work by Cézanne.'[72] So Fry's exhibition, as well as confirming some of Bomberg's existing interests, was bound to have provided him with some disorientating surprises. It excluded the Impressionists and Degas altogether, leaping very summarily from Manet to the great triumvirate whom Fry chose at the last minute to call the Post-Impressionists: Cézanne, Van Gogh and Gauguin. If any of these painters had been exhibited on his own in London, he might not by this time have aroused such a venomous and hysterical reaction. But because Fry decided to present them as the cornerstone of the contemporary direction in painting which he most fervently admired, they were regarded by a large proportion of the British art establishment as heretical miscreants.[73] As for the progeny they were supposed to have sired, the opponents of Post-Impressionism aimed some of their most vituperative remarks at the work by Picasso and Matisse. Although they were only represented by a few paintings each, their images were enough to convince the diehard critics that they had forfeited the fundamental right to be considered legitimate artists. Mature Cubism did not penetrate Fry's show at all – Picasso's *Portrait of Clovis Sagot* looked back to Cézanne more than it anticipated the hermetic Cubist period – but the works he did display were enough to incense many of the visitors. In their enraged eyes, Picasso and Matisse seemed to be the perpetrators of a crime against painting, and their pictures were widely condemned as barbaric excrescences lying far outside all reasonable definitions of art (Plate 13).

Even the more liberal and open-minded viewers stopped short of admiring the younger painters in the exhibition. Eric Gill declared that he had 'a right to feel superior to Mr Henri Matisse',[74] and Sickert was particularly offended by Picasso's contributions. Having written a review which congratulated Fry for his initiative in organizing the show, he became conspicuously tepid when discussing Cézanne and then waxed indignant about a Picasso as unassuming as the 1905 *Girl with a Basket of Flowers*. The disgruntled Sickert took this quiet and appealing canvas as a cue for proclaiming that 'I understand the tip has gone round that pictures need have no sense.'[75] It was a ridiculously overheated reaction, but Sickert's beliefs about the importance of realistic subject-matter led him to dismiss Picasso's attenuated and waif-like nude as a wanton irrelevance. It is not known whether Bomberg agreed with his teacher. Judging by the audacious work he began to execute little more than a year after visiting Fry's exhibition, both Picasso and Matisse might well have excited his approval. But we should be wary of speculating with hindsight. At this stage in his development Bomberg might easily have felt affronted by the Fauvist and pre-Cubist works on display, even if he could otherwise be placed among the young English artists who found much to admire in *Manet and the Post-Impressionists*. He certainly would not have agreed with the members of the 'cultured public' who henceforth regarded Fry 'as either incredibly flippant or, for the more charitable explanation was usually adopted, slightly insane'.[76] So far as the most adventurous emergent painters were concerned, the Grafton Galleries housed an epochal event which made the new movement identified by Fry quite impossible to ignore. Although Bomberg veered between diligent observation and bold experiment at this period, he would still have sympathized with the principal thrust of the argument published in the exhibition's catalogue. For Desmond MacCarthy here maintained, with help from 'a few notes' supplied by Fry himself, that 'it is the boast of those who believe in this school, that its methods enable the individual-

14 (below). David Bomberg. *Classical Composition*, 1910. Crayon and charcoal, 27.7 × 37.3 cm. Anthony d'Offay Gallery, London.

16. Paul Gauguin. Detail from *The Seaweed Harvesters*, 1889. Oil on canvas, 87 × 122.5 cm. Folkwang Museum, Essen.

ity of the artist to find completer self-expression in his work than is possible to those who have committed themselves to representing objects more literally.'[77] However many reservations Bomberg may have felt about some of the catalogue's wilder assertions, he is likely to have approved of the general course of action outlined by MacCarthy when he explained that the artist 'begins to try to unload, to simplify the drawing and painting by which natural objects are evoked, in order to recover the lost expressiveness and life. He aims at *synthesis* in design; that is to say, he is prepared to subordinate consciously his power of representing the parts in his picture as plausibly as possible, to the expressiveness of his whole design.'[78]

————

Just how prepared Bomberg was to commence this process of exploration can be gauged from a remarkable crayon-and-charcoal drawing of 1910, probably executed after visiting the Post-Impressionist survey (Plate 14). Its precise subject has not been recorded. But the disposition of figures suggests that the Judgement of Solomon might have been his theme, and Bomberg certainly took the Old Testament as a springboard in several of his early works. The downcast woman brooding in the foreground may well personify the mother whose claims have been rejected by the King. Moreover, the protagonist seated on the throne appears to be holding a baby in his arms. He leans towards a graceful figure who rests one hand on his shoulder and might reasonably be identified as the true mother. The attendants surrounding this central group certainly seem to applaud their ruler's verdict.

But even if the subject of this drawing remains a matter for speculation, its severe formal organization is beyond dispute. With brusque confidence, Bomberg divests his figures of everything except their essential attributes. Although the pervasive angularity so evident in his subsequent work has not yet stiffened their rounded contours, they are shorn of facial features and reduced to block-like masses by the heavy shadows with which Bomberg invests their bodies. The dejected woman

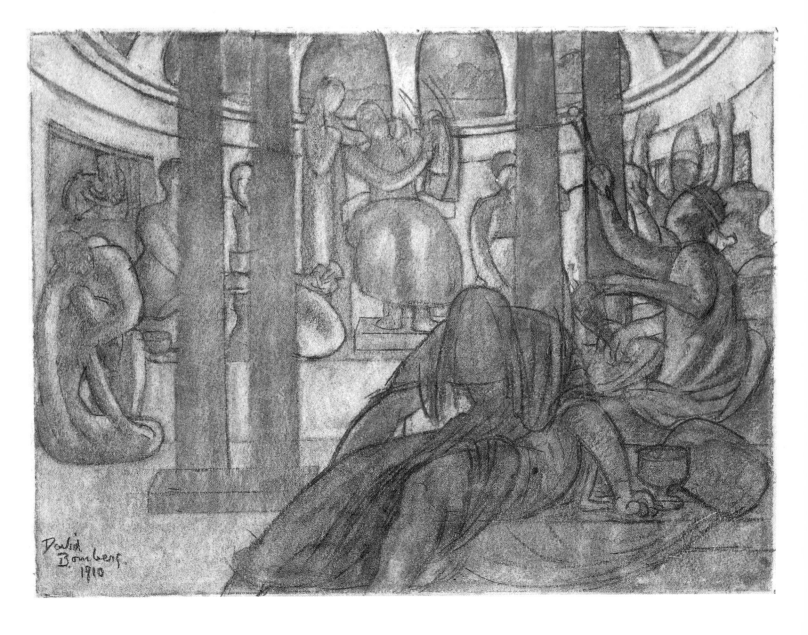

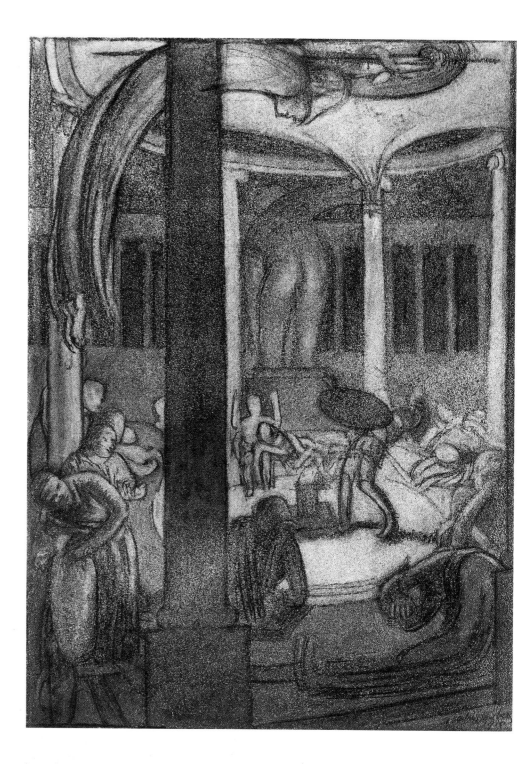

15. David Bomberg. *Classical Composition*, 1910.
Charcoal and crayon, 37.5 × 27.5 cm. Anthony
d'Offay Gallery, London.

has almost become a silhouette as she lurks in her isolated place, symbolically
deprived of the light which floods across the chamber behind her. This illumination
strikes the limbs of all the other figures, but it does not tempt Bomberg to delineate
their individual anatomies or drapery folds in any detail. The participants in his
drama are constructed with the stark monumentality of the columns so decisively
dividing the inner court from the outcast woman beyond. Bomberg is already mani-
festing the tendency which came to dominate his pre-war work, enclosing a group
of gesticulating figures within a powerfully defined architectural space. The structure
of this building is not as rigorously geometrical as his subsequent settings would
be, and the figures lack the forcefulness of their successors in the Slade period.
But the clarity with which he announces his future direction in this early drawing,
and in a related composition where the foreground column is given a daringly forceful
role (Plate 15), proves that Bomberg could already be quite singleminded in his
determination to concentrate on a particular line of pictorial enquiry.

Visiting the Post-Impressionist exhibition may therefore have hastened a move
away from the immediate orbit of Sickert, whose direct influence is hard to discern

in the putative Judgement of Solomon drawing. As an elevated Biblical composition which arranges its figures in an unashamedly theatrical setting, its subject-matter has more in common with a grand Royal Academy set-piece than with the modern urban preoccupations of Camden Town painting. But Bomberg's stylistic simplification suggests a debt to the French artists whose work incensed so many Academicians at the Grafton Galleries. Gauguin, represented in the show by forty-six works, must have made an overwhelming impression on the more open-minded visitors. He was in many respects the star of the survey, with twice as many exhibits as either Van Gogh or Cézanne, and his work impressed Sickert so much that he singled Gauguin out for special praise. Setting aside his reservations about the show, Sickert even proposed that Gauguin's work deserved to be acquired by the National Gallery. Bomberg would probably have agreed with this suggestion, and his willingness to let heavily defined contours carry so much pictorial significance in his 'Solomon' drawing may well be indebted to Gauguin's example. The use of simple yet boldly declared gestures, monumental simplification and an overall planar flatness which drives Bomberg to accentuate distant windows almost as powerfully as the nearest figures, all point towards an underlying kinship with Gauguin. Indeed, the foreground 'mother' figure in Plate 14 could have its origins in a similar pose adopted by the Breton woman at the front of *The Seaweed Harvesters*, an important Gauguin painting which Bomberg may have seen reproduced in a book or magazine of the period (Plate 16).[79]

At this stage in his development Bomberg would have been unlikely to support the full implications of MacCarthy's remarks about Gauguin, who was held to have believed that modern art 'to a great extent neglected the fundamental laws of abstract form, and above all had failed to realise the power which abstract form and colour can exercise over the imagination of the spectator'. Nor would Bomberg have aligned himself completely with the younger French artists who, according to MacCarthy, were pushing these ideas 'further and further. In the work of Matisse, especially, this search for an abstract harmony of line, for rhythm, has been carried to lengths which often deprive the figure of all appearance of nature.'[80] Bomberg's 1910 drawings stopped well short of such a drastic departure from representation, and even the most abstract-seeming of his subsequent works always retained a fundamental link with the perceived world. So did those of Matisse, of course, and the essay in the Grafton Galleries catalogue tended to push him – along with the rest of Post-Impressionism – too far down the road to Pure Form. By stressing the proto-abstractionist aspect of the exhibition's content, Fry and MacCarthy alienated artists like Sickert who might otherwise have been prepared to take Matisse more seriously. Bomberg probably found himself caught between a growing commitment to the principle of expressive freedom supported by the Grafton show, and an unwillingness to see Post-Impressionism through Fry's eyes as the movement which paved the way for 'the artist who would use abstract design as his principle of expression'.[81] In these pre-Slade days Bomberg must still have felt that there was much to learn before he could think of forsaking his love of close and sensitively observed life-drawing, exemplified by a 1911 *Head of a Girl* which searches for essential structure even as it remains faithful to the specific reality of the model he scrutinized (Plate 17). Such an activity remained very important to him, although his rebellious instincts had undoubtedly been aroused by the excitement and effrontery of a show described by its co-organizer as an 'Art-Quake' aiming at 'no gradual infiltration, but – bang! an assault along the whole academic front of art.'[82]

Such a forthright and full-blooded attack would have appealed very directly to the most militant side of Bomberg's personality. His boyhood friend Joseph Leftwich remembered that Bomberg was at this time becoming 'very "blasty" – pugnacious is too mild a word. He wanted to dynamite the whole of English painting.'[83] Both Leftwich and Bomberg belonged to a disputatious yet tightly-knit circle of intelligent young Whitechapel Jews, who inhabited the same neighbourhood and shared a general involvement with literature, art and left-wing politics. Leftwich pointed out that Bomberg himself 'hadn't any political beliefs – he was too wrapped up in his painting'.[84] But several of his closest friends were ardent members of the Young Socialists League and involved with the nascent Zionist cause. Hampered by poverty and resentful of their hardship, they gravitated towards institutions like the Whitechapel Art Gallery and the Library, where they could meet without having to find the price of a drink. On other occasions they felt too restless to stay indoors,

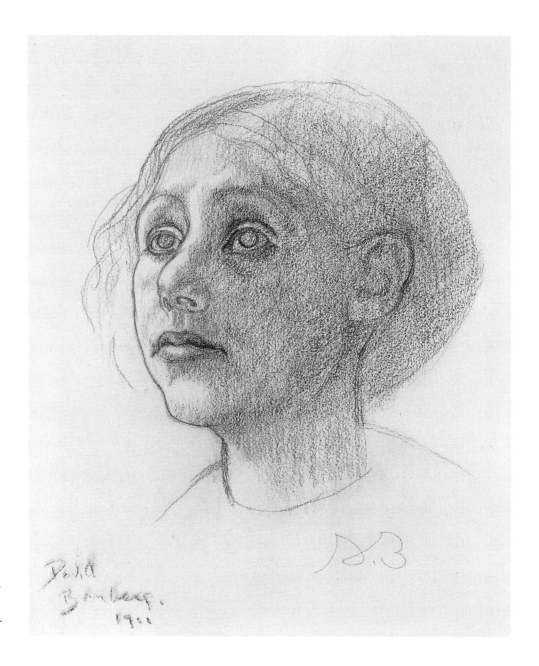

17. David Bomberg. *Head of a Girl*, 1911. Pencil, 27 × 21.2 cm. Anthony d'Offay Gallery, London.

18. Isaac Rosenberg. *Self-Portrait*, 1911. Oil on canvas, 49.5 × 38.7 cm. Tate Gallery, London.

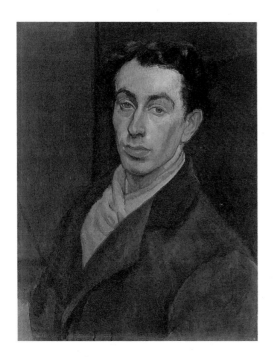

and drifted aimlessly through the East End instead. 'We used to mooch around the streets of Whitechapel completely wrapped up in our own misery', Leftwich remembered; 'we didn't care where we were going because walking and talking were all we could do.'[85] Their frustration centred not only on economic deprivation but also on their ambiguous status as the children of Jewish immigrants. Torn between loyalty to family traditions and an ambitious urge to move outside these limits and participate in the artistic or political life of Britain as a whole, these energetic friends constantly found themselves fighting contradictory impulses.

The inevitable tensions they experienced sometimes erupted into outright antagonism. Leftwich kept a diary during this period, and in March 1911 he recorded going out with the painter and poet Isaac Rosenberg for one of their interminable walks. 'We meet Goldstein and Bomberg', Leftwich wrote, before describing how 'we stop for a while to speak with them. Rosenberg is very sarcastic about their artistic claims.'[86] But such differences of opinion could not alter the fact that Bomberg and Rosenberg were united in many respects by their commitment to art. Although Rosenberg was busy painting a relatively orthodox self-portrait in March 1911, with the idea of submitting it to the Royal Academy summer show (Plate 18),[87] he was sufficiently aware of new developments to be pondering the implications of the Post-Impressionist exhibition as well. He must have argued about the contents of Fry's show not only with Bomberg but also with Mark Gertler, at whose studio in Commercial Street they would all meet to discuss painting (Plate 19). Gertler, a year younger than Bomberg, was precocious enough to have gained entry to

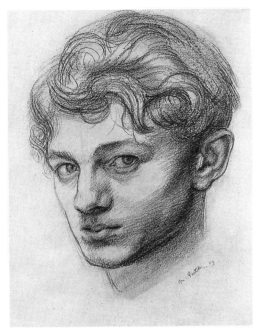

19. Mark Gertler. *Self-Portrait*, 1909. Pencil, 25 × 20.3 cm. Edgar Astaire, London.

the Slade as early as 1908. His initial support from the Jewish Education Aid Society was swiftly succeeded by a Slade scholarship once his unusual abilities became recognized, and he would have been able to tell Bomberg and Rosenberg a great deal about the school they both entered in 1911.[88]

At this stage Gertler and Rosenberg were in their different ways far more attached to tradition than the restless Bomberg, who was one of the most belligerent members of the rebellious East End group centred on the Young Socialists League. His defiant irreverence was much to the fore when the YSL gathered for a special meeting in 1911. Frank Rutter, whose recent book on *Revolution in Art* placed him among the most forward-looking critics in Britain,[89] had agreed to deliver a lecture on 'Socialism and Art'. The organizer of the event was Jimmy Rodker, an aspiring poet who was a close friend of both Bomberg and Rosenberg, but he must have been disconcerted to find that Rutter did not give a talk on the expected subject. 'He spoke about the New Art Club instead', Leftwich reported in his diary. 'But he was good. He spoke for about ten minutes and then asked us to question him as that would be the best way of explaining what we want to know – which is an excellent way of doing things.' But Rutter's unruly audience, no doubt irritated by his decision to talk on a different theme, refused to respond. During the course of the discussion most of the Young Socialists were openly rude, making no attempt to hide their lack of interest. 'The whole evening was a failure, from the YSL or from Jimmy's point of view as organiser', wrote Leftwich. 'Dave [Bomberg] joked about all the time, Shulman was busy working out some chemistry problem which Sig purposely put to him, Marcovitch was reading the "Clarion" and Marks "Justice". Nobody seemed to be in the least attending to Rutter except Jimmy, who

20. David Bomberg. *Head of a Girl*, *c.* 1911. Pencil, 31.4 × 23.7 cm. Private collection, Washington.

had put himself in the chair, and Lily Chris. I wonder what Rutter thought of the gathering and of Jimmy for bringing him down to it.'[90]

Bomberg's partiality for subversive satire was, however, only the surface bravado of a young man determined to keep his insecurities to himself. Rosenberg's biographer Joseph Cohen considered that poverty affected Bomberg, Gertler and Rosenberg so deeply that 'their personalities in young adulthood were permanently scarred by the deeply inbred conviction of certain failure.'[91] But the depressive side of Bomberg's temperament only surfaced after the First World War, and before then he was buoyed up by the excitement of realizing that his strength as an artist continually grew. Two more drawings of girls' heads survive from this period to demonstrate how his sense of certitude had developed since the self-portrait executed two years before (Plate 20). Each face is now grasped in its totality by a powerful defining line, which emphasizes underlying form while still taking incisive account of the sitters' individual peculiarities. By the time he made these imposing and almost sculptural studies Bomberg was pursuing a girl of his own as well. Sonia Cohen, who had spent most of her childhood in a charity home and now worked gruelling hours at a sweat-shop, liked to meet Bomberg's circle of friends at the Whitechapel Library during the evening. In 1911 Rosenberg and Bomberg vied for her attention, and on one occasion they both drew her as she sat opposite them at the Library. Bomberg revealed the romantic impulses beneath his outward toughness by asking Rosenberg to write a poem for him to give Sonia. She remembered Bomberg shyly pushing the poem across to her side of the Library table, and finding that its opening lines declared the two rivals' infatuation in the most outspoken and highflown manner:

> Lady, you are my God –
> Lady, you are my heaven.[92]

But neither Bomberg nor Rosenberg were successful in their clumsy, inexperienced attempts to win her love. Far more advanced in knowledge of art than in experience of life, Bomberg had long since insisted on devoting the greater part of each day to his own work. He therefore led a very solitary existence for much of the time, moving with great determination towards attaining the standard of draughtsmanship required by the Slade. Most of the drawings he produced during this arduous period were later destroyed. But the making of them gave Bomberg, and the wealthy Jewish philanthropists responsible for aiding him at the Slade, impressive proof of his prowess. It afforded him a sense of satisfaction which he was unable to find in most other aspects of his existence. The realization that his art was developing well provided Bomberg with the impetus to withstand the adversities which crushed so many of his contemporaries in the East End ghetto. To Leftwich, he appeared to be 'supremely confident, full of himself and completely different from Rosenberg who was taciturn'.[93] But Bomberg must still have been deeply relieved when he finally heard that the Slade was prepared to register him as a student in April 1911.[94]

The legal agreement between Bomberg and the Jewish Education Aid Society was drawn up the same month, providing him with the means to attend the School. It was a crucial act of support for the impoverished student, but his copy of the contract survives to prove that the funds did not take the form of an outright grant (Plate 21). Signed by Robert Waley-Cohen, the Chairman of the Society, it insisted that 'the student shall repay to the Society all sums of money which may from time to time be advanced to the Student by the Society or expended by them for his benefit.' So Bomberg faced the formidable prospect of repaying a considerable debt after his studentship had been completed. The obligation inflicted a substantial burden on him, for the work he went on to produce attracted few buyers. But he could at least comfort himself with the knowledge that the Slade had finally accepted him. It was a felicitous and well-timed event. His increasing assurance as an artist needed to be fortified and broadened by an education which would bring the isolation of Whitechapel life to an end.

21. Bomberg's copy of the *Agreement* between himself and The Jewish Education Aid Society, signed and dated on 6 April 1911. Bomberg has added several sketches to the document. Collection of the artist's family.

# CHAPTER TWO  The Slade Rebel

Bomberg came to the Slade at a time of momentous upheaval. The triumvirate of painters who dominated the School's teaching had started their careers in the late nineteenth century as dissidents: Wilson Steer and Fred Brown were both founder-members of the 'London Impressionists' group in 1889, and Henry Tonks shared many of their enthusiasms.[1] But by 1911 Impressionism had been superseded by the altogether more disturbing developments which Fry championed. Although Tonks and his colleagues disapproved of the Post-Impressionist invasion, their most exuberant and enquiring students were swiftly becoming involved with the issues raised by the Grafton Galleries exhibition. A remarkable cluster of young men, including Stanley Spencer, Edward Wadsworth, Christopher Nevinson, William Roberts and, to a lesser extent, Bomberg's friend Gertler, had already begun to absorb the heretical precepts of the new French avant-garde. The Slade staff, who had always been opposed to the conservatism of the Royal Academy, now found themselves regarded as an increasingly reactionary force by the students they attempted to teach.

The School only reached its greatest ferment about a year after Bomberg arrived, and for a while he probably curbed his instinctive ebullience in order to find out what the Slade could teach him. Like all the other students who had begun to question the limits of the School's approach, he was expected to undertake a gruelling programme of study in the life class. Professor Brown was convinced, despite a devotion to a quasi-Impressionist mode of painting in his own work, that all aspiring artists should be securely grounded in draughtsmanship with a strong structural bias. 'The matter resolves itself into a question whether art should be taught on a basis of science, or of something vague, indefinable and varying with the bias of the teacher', Brown maintained, concluding that 'structure, the laws of optics, the relation of parts to the whole *et cetera* can be taught.'[2] Tonks agreed, having been a Demonstrator in Anatomy at the London Hospital Medical School before joining the Slade. His teaching stressed the importance of the skeletal framework when drawing the human figure. If modelling was seen by Tonks as the means of discovering form, contour remained the final instrument of definition. It was an essentially Florentine view of draughtsmanship, and accorded well with Bomberg's own predilections. But his patience must soon have been stretched to the limit by the Slade's insistence on subjecting all the new students to a rigorously academic initiation.

Adrian Allinson, one of Bomberg's more compliant contemporaries at the Slade, described how 'our professors rightly decided that the first year men should draw

C1. David Bomberg. *Sleeping Men*, 1911. Watercolour, 22.2 × 90.2 cm. Tate Gallery, London.

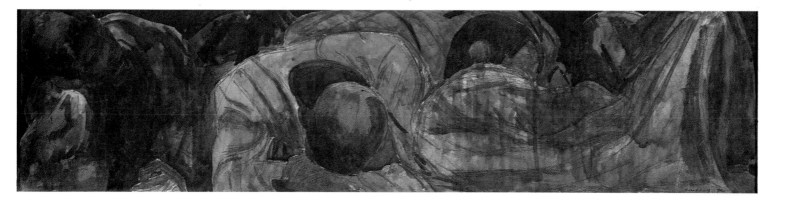

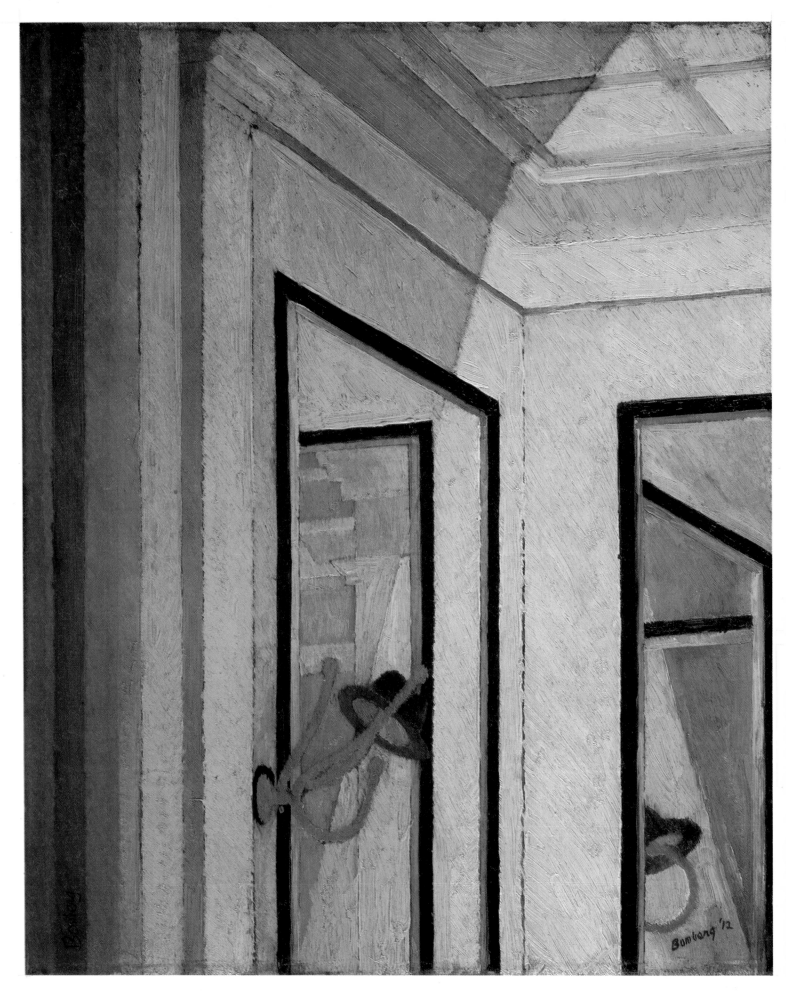

C2.  David Bomberg. *Lyons Café*, 1912. Oil on panel, 39.9 × 32.6 cm. Anthony d'Offay Gallery, London.

from the plaster cast before being permitted to work in the life room.' All the new arrivals were expected to comply with this somewhat forbidding procedure, and none was allowed even to attempt drawing from the posed model until the art of copying classical statues had first been mastered. 'If, after the first term, the young student had made the requisite progress, he was allowed in his second to attend the life room classes for the last hour of the afternoon session', explained Allinson, who saw nothing objectionable about such a strict system.

> The basic dogma inculcated by our teachers was to the effect that 'We don't pretend to be able to make artists of you, but we can teach you to draw, and learning to draw is really learning to see.' They showed us how to record form by analysing its construction, proportion and direction. In the controlled co-ordination of these elements lay the whole secret of significant draughtsmanship.[3]

Only the most adventurous of Bomberg's Slade drawings exist today. He later admitted to destroying 'a hundred weight'[4] of student works, and they doubtless included orthodox plaster-cast studies which gratified Tonks's stern eye as he conducted his regular, much-feared invigilations. However adept Bomberg may initially have been at satisfying his teachers' requirements, though, he is likely to have found greater stimulus reading the arguments about draughtsmanship advanced by John Fothergill, the elegant and idiosyncratic editor of the Slade magazine. During the course of a long and complex essay on 'Drawing' published in the 1910–11 edition of the *Encyclopaedia Britannica*, Fothergill declared that 'the drawing of a hand, for instance, by Hokusai, Ingres or Dürer, revives in us our own impressions of the forms and aspects of real hands.' Although he went on to maintain that 'there is manifest in all good drawings, whatever their difference of medium or superficial appearance, an entire dependence upon the forms of nature', Fothergill certainly did not wish to imply that the artist should copy nature with literal or mechanical fidelity. He wanted to advance the cause of 'pure drawing', and insisted that 'just as a fragment of good sculpture pleases the connoisseur without any reference either to the whole original or to its spiritual significance, fine drawing can appeal to the lover of nature independently of indirect considerations.' Bomberg, who knew Fothergill well[5] and surely read this essay with the closest attention, may have intended his studies to attain the independence that Fothergill recommended. He would undoubtedly have warmed to the central thrust of the 'Drawing' essay, which emphasized that 'a masterly outline drawing of a figure or landscape does not pretend to be an illusion. If then the draughtsman does not, and cannot hope to imitate nature, he is compelled to state only his *ideas* of it, ideas of three-dimensional form.'

In developing his formalist theories of drawing, Fothergill openly acknowledged a debt to the writings of Professor Wundt and Emanuel Loewy's *The Rendering of Nature in Early Greek Art*, which he had translated in 1906. He proposed that 'the draughtsman in full possession of a feeling for the corporeity of the object ... conceives the length, breadth and depth of an object and all its parts as solid wholes.' Bomberg's progress during the Slade period towards an ever-greater concentration on monumental mass indicates that he found Fothergill's arguments very congenial, especially when the essay on 'Drawing' declared that

> the act (generally, but by no means always, an unconscious one) of visually touching a form must necessarily take place before we can apprehend the third dimension of a form ... therefore all drawing of forms that merely reproduces the image on the retina, and leaves unconsulted the ideas of touch, is incomplete and primitive, because it does not express a conception of form which is the result of an association of the two senses; in other words, it does not contain an idea of the object's relief or solidity.

Throughout his life the tactile element in art was of immense importance to Bomberg, even though he expressed it in widely contrasted ways. So far as his early work was concerned, he probably learned most from the passage in Fothergill's essay which explained how

> our combined sense of vision and touch comprehends very easily certain elementary solid forms, the sphere, the cube, the pyramid and the cylinder. No forms but these, and their modifications, can be apprehended by the mind in one and the same act of vision. Every complex form ... must first be broken up into its component parts before it can be fully apprehended or remembered.

22. David Bomberg. *Studies of the Posed Model and other Compositions*, 1911–12. Pencil, 37.7 × 28 cm. Collection of the artist's family.

In Fothergill's view the process of reducing objects to their fundamental constituents was crucial, for 'all good drawing is stamped with this kind of structural insight … It is, indeed, the virtue peculiar to the artist, as interpreter of form, that he instinctively comprehends the real elemental character of complex forms.'[6]

When Fothergill wrote this intriguing essay he cannot have envisaged the kind of 'elemental' drawings which Bomberg would eventually produce at the Slade. Although the essay seems to be anti-Impressionist in its sympathies, Andrew Forge has pointed out that Fothergill 'was fairly close to Tonks'[7] and therefore unlikely to support any extreme departure from representation. Bomberg took what he needed from Fothergill rather than attempting in any way to produce drawings which satisfied all the requirements set out by the essay. But he must have found many of his instinctive beliefs confirmed by Fothergill's forcible argument, and acted on them when the Slade permitted him to graduate from plaster-cast copying.

The life room was a chilling and fearful place to many of the students. Even the socially assured Lady Diana Manners was disconcerted by the 'very cold and livid' nudes with their 'goose-fleshed bodies', and admitted that 'the alarming figure of Professor Tonks would set me trembling as though he were Justice itself.'[8] But Bomberg, possibly because he had already become familiar with the Slade life room as a model himself,[9] was not at all cowed by its daunting atmosphere. William Roberts, who had entered the Slade a year before, witnessed the immediate impact Bomberg made on the life class. Having only seen him as a model before, Roberts admitted that

> it was a surprise one morning to see Bomberg walk into the Life Room, a drawing board under his arm, bestride a donkey and start to draw. When Nevinson left, Bomberg became the official wit of the Life Class, but with a more aggressive style. This sometimes led to a 'punch-up'. A young Frenchman named Detry, a newcomer to the Life Class, liked to boast about his strength, saying 'I am very strong here and here', indicating at the same time different parts of his anatomy. Thus when the class was quiet, except for the scratching of charcoal on Michelet paper, Bomberg would suddenly shout 'I am very strong here and here!' This he repeated from time to time until the exasperated Frenchman could bear it no longer. Leaving his donkey he went over to Bomberg and a fight began. During the scuffle Detry received a punch that put him on the floor, but scrambling up at once he seized a drawing board and hurled it at Bomberg, who promptly jumped clear in time. Quiet was restored with the arrival of Tonks to find out the cause of the disturbance.[10]

Tonks would not have been reassured by some aspects of the work his belligerent student was now beginning to make. A fascinating sheet of studies has survived from this period to reveal how Bomberg, commencing in the middle with a relatively orthodox outline drawing of the model crouching on a bed, treated it as a springboard for his own experiments (Plate 22). A host of small designs surround the central model, in several cases replacing the bed with a prone figure who appears to be suffering an assault. All these little studies are restricted to minimal summaries of form which almost seem to implement Fothergill's conviction that 'every complex form … must first be broken up into its component parts before it can be fully apprehended or remembered.'[11] On the evidence of his drawing, Bomberg felt an overwhelming urge to participate in this breaking-up process, and he pushed the simplification of the human figure much further than either Fothergill or Tonks would have wished. 'As the immediate purpose and content of drawing there remains the representation of form only', Fothergill declared in his essay, but he had no intention of encouraging Slade students to divest their drawings of everything except their most skeletal contours. Bomberg's hunger for essential form impelled him, in this sheet of drawings, to jettison most of the representational cargo which life-class draughtsmanship was still expected to retain.

Even when the Slade Sketch Club set the students a subject from the Old Testament, Bomberg refused to produce an image which illustrated the theme in either a direct or a detailed way. The watercolour of *Sleeping Men* is so removed from any desire faithfully to depict recumbent bodies that it must have been greeted with bewilderment by his teachers (Colour Plate 1). Nor does it seem concerned with anything but the most oblique response to the passage from Ecclesiastes specified by the Sketch Club: 'Also when they shall be afraid of that which is high, and

23. Stanley Spencer. *'Man goeth to his Long Home'*, 1911. Pencil, pen and wash, 43.2 × 31.8 cm. Tate Gallery, London.

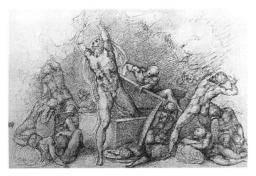

25. Michelangelo. *The Resurrection*, 1532–3. Black chalk, 24.2 × 34.6 cm. Royal Library, Windsor Castle.

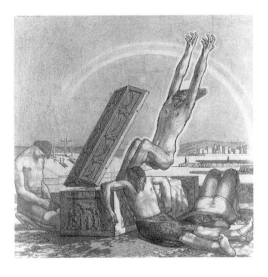

26. William Roberts. *The Resurrection*, 1912. Pencil and ink, 30.5 × 30.5 cm. Private collection.

24. Andrea Mantegna. Detail from *The Agony in the Garden*, c. 1455. Oil on wood, 62.9 × 80 cm. National Gallery, London.

fears shall be in the way, and the almond tree shall flourish, and the grasshopper shall be a burden, and desire shall fail; because man goeth to his long home, and the mourners go about the streets.'[12] Taking his cue from the overall melancholy of the quotation rather than any specific references it contains, Bomberg decided to convey an elegiac mood by concentrating on three inert bodies. Embroiled in a sleep so sombre and profound that they could almost be mistaken for corpses, these monumental figures are pushed to the very forefront of a composition filled with their assertive bulk. Bomberg applies his watercolour in an unusually free manner, dispensing with the specific representation of anatomical features or drapery. His sweeping washes make the looming forms look more like a mountainous landscape than a frieze of reclining limbs, and he flattens them out on the picture-surface with a forcefulness which impresses itself on the viewer's vision. The tactile identity of his sleepers is thereby enhanced even as Bomberg prevents them from receding into space and establishing any conventional sense of two-dimensional solidity.

*Sleeping Men* is a far more adventurous and concentrated image than the Old Testament drawing he had executed the previous year (Plate 14). The startling brusqueness of this watercolour becomes still clearer when it is compared with Stanley Spencer's response to the same Sketch Club subject (Plate 23). His drawing seizes on the phrase 'man goeth to his long home', and depicts a Giottesque traveller standing in a landscape based very largely on a corner of Spencer's native Cookham.[13] Only the tree and chain fence were invented by Spencer, who uses pencil, pen and wash to give the foliage a painstaking intensity that derives from the Pre-Raphaelites. Both Brown and Tonks would have understood why Spencer had fallen under the Pre-Raphaelite spell: they were reared on Ruskin, and gained their profound respect for nature from his impassioned writings. That is why *Sleeping Men* must have disturbed them, for Bomberg had not even based the composition on posed models. He revealed many years afterwards that it 'was drawn not from sleeping men but from a row of pillows. During the process of drawing, the elements that have hitherto been identified as pillows reassemble and are invested with a new identity.'[14]

The innovatory side of *Sleeping Men*, which shows his continuing interest in Gauguin, is nevertheless countered by a profound regard for tradition. These recumbent figures contain echoes of the three apostles sprawling in many distinguished Renaissance paintings of *The Agony in the Garden*. Two superb examples, by Bellini and Mantegna, were readily available to Bomberg at the National Gallery (Plate 24), and his awareness of them may have helped to shape the construction of *Sleeping Men*. But he reserved an even greater veneration for Michelangelo, and the nude soldiers occupying the foreground of a black chalk study for *The Resurrection* are more directly reminiscent of Bomberg's figures (Plate 25). The parallels are in no sense exact, and Bomberg is likely to have seen a reproduction of Michelangelo's drawing rather than incurring the expense of a trip to Windsor Castle to study the original. All the same, *Sleeping Men* does possess a Michelangelesque feeling for massive grandeur, and the resurrection theme was indeed set as a Slade Sketch Club subject around this time. Roberts, by now one of Bomberg's closest friends, drew a densely considered drawing in response to this theme,[15] and the gesticulating power with which Christ thrusts himself out of the coffin recalls the soaring muscular energy of Michelangelo's prototype (Plate 26).

At this early stage in Bomberg's Slade period, his admiration for Michelangelo reached the proportions of outright hero-worship. Clare Winsten, one of his fellow-students, recalled that 'he wanted to be a second Michelangelo, and he thought I looked like a Sibyl.' Bomberg was for a while captivated by the girl who in his view personified the statuesque female figures of the Sistine ceiling. 'He used to waylay me at the station and follow me everywhere', remembered Winsten, who lived in Bomberg's area of Whitechapel. She resisted his advances at first, 'because I didn't like his manner – he was too forward'. But then one day she

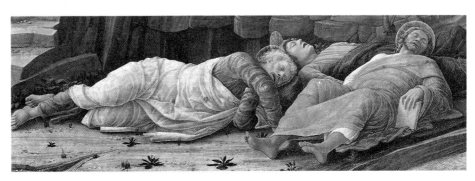

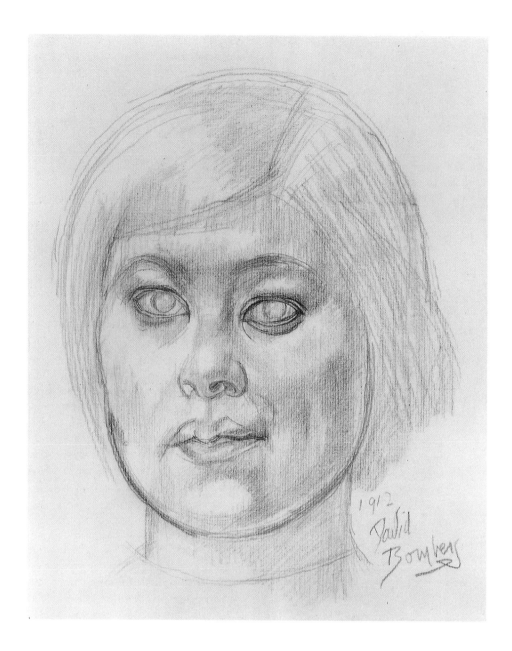

27. David Bomberg. *Head of a Girl*, 1912. Pencil, 27 × 22 cm. Anthony d'Offay Gallery, London.

28. Henry Tonks. *Head and Shoulders of a Girl Holding Apples*, n.d. Pencil, 27.4 × 27.4 cm. University College, London.

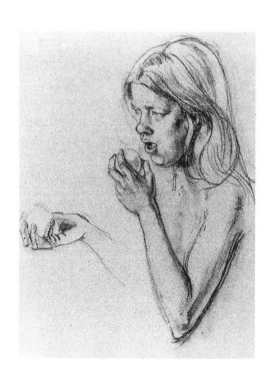

relented. 'He cornered me in the Library and asked me to pose for him. He said: "I want to do a great painting of you in the style of Michelangelo." I agreed to sit, because Tonks was a woman-hater and made me feel miserable. I sat for a while at his home in Tenter Buildings, wearing Greek clothes which fitted the Michelangelo idea.'[16]

The truth is that Bomberg's eagerness to experiment at the Slade was always underpinned by his profound respect for the Italian Renaissance. In later life he often paid tribute to Tonks, 'who had laid upon himself the task of initiating his followers in all he had discovered in his lifework, founded as it was on the Traditions of Great Draughtsmanship.'[17] Although Bomberg was far less willing to acknowledge Tonks's example at the time, he benefited from the firm and committed stance adopted by the Slade staff. Some indication of the discipline he derived from their teaching can be seen in the powerful *Head of a Girl* (Plate 27). It returns to a close and penetrating engagement with the facts of a posed model, thereby demonstrating how Bomberg alternated throughout the Slade period between rebellion and acceptance of the continuing need to root his experiments in a study of nature. For all its frontal toughness and severity, *Head of a Girl* is not so very far removed from Tonks's softer drawing of a similar subject (Plate 28). Nor would Bomberg necessarily have objected to the general burden of Tonks's advice, for the awesome Professor never wanted his students to produce literal records of their sitters. In 1911 Spencer told his brother Sydney about the lessons he received at the Slade:

This is what Tonks says: 'Don't copy, but try and express the shape you draw;

don't think about the paper and the flatness of it; think of the form and the roundness of form ... Think of those bones, those beautiful sweeps and curves they have ... Photos don't express anything, and your drawing is too much of a photograph.[18]

Nobody could claim that Bomberg's *Head of a Girl* was in danger of vying with the camera, and his consciousness of the bones beneath the flesh and hair gives the drawing a tenacious structural authority which Tonks might well have admired.

Many other drawings once testified to Bomberg's diligent study in the life room, but he subsequently decided to get rid of them. In 1915, just before enlisting in the army, he conducted a ruthless review of his student achievements. His first wife Alice described how he became determined to

> go over his drawings and destroy many which were not his best work, so many evenings were spent going through his old 'Slade' drawings and the grate each night was filled with old drawings which, after thoroughly studying, he decided to discard. There came a day when he took time off to finish the job, and together we spent days destroying years of careful work ... He said in his Jewish way he had of summing up a situation, 'There – in flames, goes three years' work of sitting on a low donkey stool from ten to four drawing worm's eye views of the nude.'[19]

Any assessment of Bomberg's activity at the Slade has to take this unfortunate destruction into account. For he is likely to have burned all the most representational and painstaking examples of his student draughtsmanship, only leaving behind the images in closer accord with the radical preoccupations which he pursued to the limit in 1914. The lost drawings would have testified to the other side of his Slade period, the 'careful work' which Bomberg seems to have executed with great seriousness at the same time as his experimental art.

These two coexisting concerns fed each other, and the tension between them can clearly be seen in the earliest of Bomberg's oil paintings to have come to light so far (Plate 29). Its date is uncertain, but the stylistic conflict within the picture suggests that he worked on it over an extended period. It may even have been commenced before his arrival at the Slade, for its subject and some aspects of its handling are indebted to Sickert, whose influence on Bomberg waned soon after he left the Westminster School evening classes in 1910. The iron bedstead is often an indispensable prop in Camden Town interiors, and so is the device of a figure staring from a window (Plate 30). The most Sickertian passage is found in the mirror, where a reflection of the bed-head with its crumpled salmon-pink sheets is freely rendered with heavily encrusted pigment. But Bomberg did not borrow this scene wholesale from Mornington Crescent or the other shabby interiors explored in so many Camden Town paintings. His sister Kitty later confirmed that 'it is definitely the bedroom at Tenter Buildings'. She vividly remembered sleeping in the iron bed, identified the figure as 'my sister Raie', and explained that 'the door by the window is that to his studio'.[20] So the angular forms seen beyond the door surely depict a canvas on a stretcher. Their austerity anticipates Bomberg's 1914 work, as does the stern construction of the entire design with its insistent reliance on severe uprights and diagonals.

All the same, the most prophetic element in the painting is the figure, whose sharp-edged angularity marks her out from the rest of the interior. Bomberg may have reworked and simplified her body, swathed in a stark black dress which borders on silhouette, when he completed the painting. In 1914 the critic T. E. Hulme drew particular attention to the stylistic disparity between Raie and her surroundings, after claiming that it exemplified a 'transitional period' in Bomberg's development. For Hulme pointed out that 'the bed and room are quite in the Sickert tradition, quite realistic and with Sickert's ideas about paint, but the figure of the girl in it is treated quite differently, very much simplified, getting on to abstraction, and looking consequently very unreal in the midst of the other very solid realistic things.' In Hulme's eyes, the figure in *Bedroom Picture*[21] proved that Bomberg 'has all the time, and apparently quite spontaneously, and without imitation, been more interested in form than anything else'.[22] Hulme was right to stress the rigour of Bomberg's structural preoccupations even at this stage of his career as a painter, but *Bedroom Picture* is not simply a formal exercise. It also conveys much of the pent-up atmosphere of Tenter Buildings, where the Bomberg children spent their adolescence

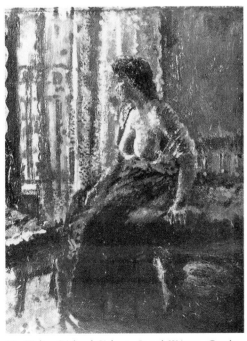

30. Walter Richard Sickert. *Seated Woman, Granby Street*, 1908. Oil on canvas, 51.6 × 40.2 cm. Private collection.

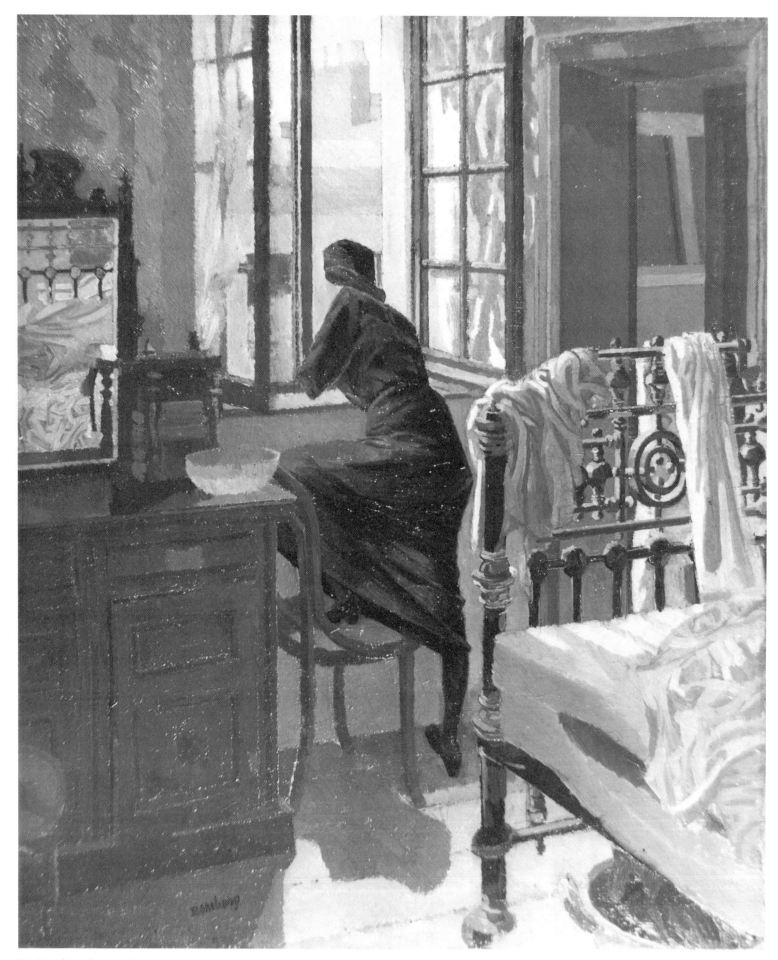

29. David Bomberg. *Bedroom Picture*, c. 1911–12. Oil on canvas, 75 × 72 cm. Private collection, Bradford.

yearning to escape from the claustrophobic constraints of Whitechapel life. Leaning out of the window in her funeral dress, Raie seems to personify the sense of longing which Bomberg himself experienced more and more keenly as he grew older. He hankered after an alternative existence, unshackled by the hardship of the immigrants' ghetto, and *Bedroom Picture* signifies his desire to break free even as it acknowledges that Tenter Buildings did at least contain a studio where he could pursue his art undisturbed. The door of the bedroom is deliberately left open so that Bomberg can include an enticing glimpse of this inner haven beyond, with its stretched canvas waiting to be painted.

The quietness and isolation of his studio contrasted with the life room at the Slade, where the concentrated effort of drawing sometimes gave way to boisterousness after the day's session had finished. Roberts remembered a 'friendly contest, in which Bomberg took part; this was a wrestling match – when the class was ended – with the Italian model. After rolling about a good deal on the dusty floor of the Life Room, locked together in a tight embrace, Bomberg finally managed to come out on top.'[23] Not all Bomberg's conflicts at the Slade were lighthearted, however. He and the other Jewish students became reluctantly aware of class and racial prejudice among their contemporaries. Gertler had already felt the full, cruel force of English derision when he entered the Slade, for Allinson recalled that 'Mark was sensitive about his origin and background . . . Lacking the education which the rest of us had received, his ignorance was expressed with a naivety and solemnity that sent us into fits of laughter.'[24] The effect on Gertler's vulnerable character must have been devastating, especially when he realised that this scorn was sometimes laced with anti-semitism. One student admitted afterwards that 'I was silly enough to feel some antipathy to Gertler because he was a Jew',[25] and this prejudice had not faded by the time the other Jewish students arrived at the Slade. Rosenberg, whose pacifist parents had instilled in him an aversion to fighting, was bullied by anti-semitic students. Alvaro Guevara was the worst offender, assaulting Rosenberg without mercy until Jacob Kramer came to his defence. Guevara also attempted to taunt Bomberg, but without success. 'Bomberg blackened Guevara's eye, refusing to submit to his torments', wrote Joseph Cohen, who explained that the Jewish students' counter-attack eventually ensured that 'Guevara troubled Rosenberg no more'.[26]

Even so, life remained exceptionally hard for the small group of East End friends. The help they received from the Jewish Educational Aid Society did not enable these working-class students to share the comfortable existence enjoyed by so many of their contemporaries. Jean Liddiard has described how Rosenberg

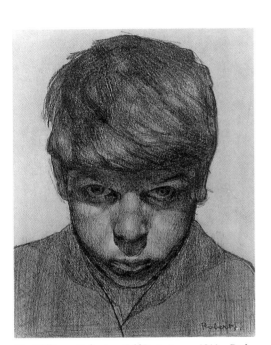

31. William Roberts. *Self-Portrait*, *c*. 1911. Red chalk, 24.1 × 19 cm. Anthony d'Offay Gallery, London.

> walked with Goldstein and Bomberg daily to and from Stepney and Gower Street to save the tube fare. They brought food from home and perhaps could afford a halfpenny for a cup of coffee at Lockhart's, a cheap tearoom near the Slade. Most spare cash was rigorously saved to be spent on materials, charcoal, paints, brushes, canvas. They were cut off from the wealthier students because they could not afford to repay hospitality.[27]

So most members of the East End group tended to stick together, spending their time not only at Lockhart's but at any local café where they were allowed to sit and talk without running up large bills. Jacob Kramer's sister Sarah, who later married Roberts (Plate 31), met her future husband for the first time 'in the ABC teashop in the Tottenham Court Road'. And Bomberg, whom she remembered as a 'stocky little bombastic person, very friendly with Bobby [Roberts]',[28] paid tribute to another of their haunts in a remarkable 1912 oil painting called *Lyons Café* (Colour Plate 2).

Although Bomberg was almost wholly preoccupied with the human figure in his early work, this small panel leaves the café's occupants out of the composition. The only hint that people might inhabit this enigmatic interior is conveyed by the hat perched so wittily on its curving peg. Since Bomberg was fond of wearing similar hats himself, he may have included it here as an oblique reference to the artist's habitual presence in the café. But the painting is primarily concerned with the corner of one room, using the white and gold Lyons *décor* as the starting-point for a lucid meditation on the ambiguity of appearances. Even though Bomberg reduces the room to its most austere essentials, treating the rigid uprights and diagonals like components in scaffolding, there is nothing predictable about this stern

architecture. The most firmly defined lines turn out to enclose two mirrors, and Bomberg chooses a vantage-point which enables him to fill their expanses of glass with bewildering reflections. They open the painting outwards, revealing fragments of wall and cornice elsewhere in the café. These glimpses are at once playful and disorientating, for we cannot assemble them with complete confidence into a coherent view of the space they reflect. The mirrors undermine our concept of the room as a series of solid surfaces, leading us into a baffling region of infinite illusion. Bomberg employs the stark structure of the café corner as a foil for his subversive purposes, and the strangeness of the world within the mirrors is intensified by the sunlight slanting through them. For these triangular shafts have a life of their own, running counter to the directional lines established by the architecture and teasing the eye even more mysteriously than the reflections shimmering in the glass.

For all its modest dimensions, *Lyons Café* stands as a sturdily independent achievement. Its fascination with reflections was heralded by Bomberg's earlier *Bedroom Picture*, where the single mirror occupied a far more subordinate position in the composition (Plate 29); and also by Sickert's fondness for mirrors in some of his Camden Town interiors. But the extent to which reflections are allowed to dominate *Lyons Café* cannot readily be related to the work of any other young English painter, whether within the Slade or outside it. Bomberg's painting antedates Harold Gilman's interpretations of *An Eating House*, two of which display a comparable involvement with the room rather than the people it contains.[29] Moreover, *Lyons Café* was executed well over a year before Wyndham Lewis extolled the virtues of ordinary London teashops in the first issue of the Vorticist magazine *Blast*. Lewis may even have borne Bomberg's little painting in mind when he declared that the ABC teashops were exceptionally stimulating places for the painter of modern urban life:

> Every one admits that the interior of an ABC shop is not as fine as the interior of some building conceived by a great artist. Yet it would probably inspire an artist today better than the more perfect building. With its trivial ornamentation, mirrors, cheap marble tables, silly spacing, etc., it nevertheless suggests a thousand great possibilities for the painter.[30]

In the second issue of *Blast* Lewis included 'Lyons shops (without exception)'[31] in a list of institutions to be damned, but he could easily have admired Bomberg's interpretation of their ambience. After all, *Lyons Café* departs so radically from a literal depiction of the room that it is tempting to wonder if Bomberg displayed the painting under the title *Reflection* in January 1913.[32] Such a name would have suited the picture admirably, for Bomberg seems more captivated by the mirrors than by the interior they enhance.

He needed now to test his fast-developing ideas about art on a large scale, and the Slade's summer competition for 1912 gave him the opportunity to do so. The subject was *Joy*, which left the students free to develop their own visions untrammelled by the Biblical themes they were usually expected to interpret. They also appear to have been asked to produce an oil painting of substantial dimensions: Bomberg's canvas is nearly seven feet in width, while Rosenberg described his own entry for the competition as 'a fairly big picture'.[33] Rosenberg's final painting, which used a number of female models in a design containing a dozen figures, was described as 'a fantasy of ecstatic representations'.[34] But the picture itself has since disappeared, and only a charcoal-and-wash drawing called *Hark, Hark, the Lark* appears to afford some notion of its appearance (Plate 32). Joseph Cohen believed that this drawing, 'the first compositional study for "Joy"', was 'intended to represent a group of nude figures of both sexes responding to the song of the bird winging overhead'.[35] But Rosenberg's drawing shows these men and women reacting with strangely agitated gestures and grimacing expressions. The bird's song seems to presage disaster rather than delight; and in this respect, as in the harsh, angular simplification of their limbs, Rosenberg's figures appear to have been directly affected by the work Bomberg was executing for the summer competition. Around this time Rosenberg felt increasingly attracted to his friend's powerful new work. Cohen wrote that

> Bomberg's studio at 20 Tenter Buildings became temporarily the rendezvous for the Whitechapel painters, and vigorous discussions went on amid Bomberg's experimental designs. Rosenberg saw these in their various stages of completion and listened to Bomberg's aggressive expositions of his aims and objectives . . . Their impact was not overwhelming, but it was pervasive and persistent, kept

32. Isaac Rosenberg. *Hark, Hark, the Lark*, 1912. Charcoal and wash, 35.6 × 33.5 cm. Private collection.

33. David Bomberg. *Island of Joy, c.* 1912. Oil on canvas, 137 × 204.5 cm. Private collection.

34. Wassily Kandinsky. *Composition 1*, 1910. Oil on canvas, 120 × 140 cm. Destroyed.

at bay only by Rosenberg's stubborn resolve not to be engulfed.[36]

The militant energy which formed so prominent a part of Bomberg's character led him to turn his competition entry into an enormous dramatization of struggle (Plate 33). Although he entitled it *Island of Joy*,[37] the figures whose frenetic movements fill the canvas all appear to be embroiled in an epic battle. The warlike mood accelerates as our eyes move up the composition, too. At its base a languorous mood is conveyed by the naked man lounging in a triangular pool – the first indication of the interest in bathing scenes which would eventually be defined by *The Mud Bath* (Colour Plate 10). But the scene which this reclining figure so blithely surveys is far from joyful. The nearest men lunge rapaciously at women Amazonian enough to repel their advances, and further up the picture Bomberg progressively discards anatomical features in order to stress the criss-cross interplay of their simplified limbs. He appears to have worked from the bottom of the painting to the top, gradually divesting his figures of everything except their essential form as he proceeded. The outcome is a clamorous stylistic clash which more than matches the discordancy of Bomberg's warlike subject. He could not resolve in his own mind the claims of the rival idioms exposed with such rawness on the surface of his picture. So he left them in all their unruly conflict, abandoning the painting before it was complete and thereby making a frank admission of his troubled search for a pared-down, elemental language.

This time, Bomberg seems to have drawn his principal inspiration from the most experimental European painters he could find. *Island of Joy* is a very personal work, which shows all too clearly how determined he felt to conduct his own formal investigations rather than borrowing other painters' styles. But it does contain echoes of an important Kandinsky canvas, *Composition 1*, which had been exhibited in London two years before at the Allied Artists' Association (Plate 34).[38] Bomberg was bound to have visited the show, and although Kandinsky's work had no imme-

diate effect on him, the memory of *Composition 1* may still have subliminally affected Bomberg when he worked on *Island of Joy*. After all, both paintings contain riders in primitive settings, and the simplification of Kandinsky's figures is strikingly similar to the even more minimally defined fighters in the upper section of Bomberg's picture.

Although he started *Island of Joy* in the summer of 1912, Bomberg could have been continuing to work on the canvas when he saw Matisse's full-scale oil study for *La Danse* in a London exhibition. The figures filling the upper half of *Island of Joy* are far more angular than the dancers who hurl their curvilinear limbs around Matisse's dithyrambic design. But Bomberg could hardly fail to have been impressed by the boldness with which Matisse stripped his figures of everything he considered superfluous. Nor was Matisse the only painter who excited Bomberg at this exhibition. For the preliminary version of *La Danse* formed a part of Fry's *Second Post-Impressionist Exhibition*, which opened at the Grafton Galleries in October 1912 to the same heated response as its notorious predecessor. This time Fauvism and Cubism were represented by paintings from Picasso, Braque, Derain, Vlaminck and other prominent members of the Parisian avant-garde. But Fry's aim now was to examine Post-Impressionism 'in its contemporary development not only in France, its native place, but in England, where it is of very recent growth'.[39] Bomberg was able to see a whole cluster of works by young artists, including Wyndham Lewis, Frederick Etchells, Vanessa Bell and Duncan Grant, who shared Fry's enthusiasm for the new movement in painting. Although their differences would soon become as apparent as their areas of agreement, Clive Bell tried to emphasize solidarity by christening them 'The English Group' in the exhibition's catalogue. He also contributed a defiant essay which declared his radicalism in language rousing enough to stir the ambitions of students like Bomberg. 'The battle is won', cried Bell, like a victor trampling on the corpse of the vanquished establishment. 'We all agree, now, that any form in which an artist can express himself is legitimate. We have ceased to ask, "What does this picture represent?" and ask instead, "What does it make us feel?" We expect a work of plastic art to have more in common with a piece of music than with a coloured photograph.'[40]

A growing number of the Slade's most adventurous students agreed with these revolutionary sentiments. Paul Nash, who admitted that he 'was left untouched by the second Post-Impressionist exhibition, as by the first', found that his loyalties to the Romantic past now left him marooned among his rebellious contemporaries. 'The Slade was then seething under the influence of Post-Impressionism', recalled Nash, describing how Fry's latest exhibition ensured that 'now all the cats were out of the bag. The first demonstration had caused quite enough disturbance one might think. But it was nothing to what followed the second opening. It seemed, literally, to bring about a national upheaval. Probably it was the relentless distortion of the human figure which was responsible . . . every canon of art, as understood, was virtually shattered.' The visitors most threatened by Fry's renewed onslaught were, inevitably, the artists and critics who allied themselves with the standards upheld by the Royal Academy. Nash remembered that Sir Claude Phillips, the redoubtable art critic of the *Daily Telegraph*, 'threw down his catalogue upon the threshold of the Grafton Galleries and stamped on it'.[41] But the teachers at the Slade also felt that their qualified support for innovation was now being stretched beyond endurance by the most extreme work displayed at the Grafton show. When Tonks's old friend George Moore told the Professor that he ought to be more open-minded about the new developments, the response was curt. 'My dear Moore', snapped Tonks, 'you're untroubled by a conscience, and will never understand a certain side of life. I cannot teach what I don't believe in. I shall resign if this talk about Cubism doesn't cease; it is killing me.'[42]

Far from dwindling under Tonks's disapproval at the Slade, the talk increased. The vehemence of his reaction was itself a measure of Cubism's potency among the students, and no one was more committed to exploring its implications than Bomberg. Although his close ally Roberts was almost as enthusiastic about Fry's show, the work he executed in 1912 remained markedly more orthodox than Bomberg's. Many years later Roberts recalled that 'at the Slade we were all familiar with the work of the French Cubists',[43] but most students still felt there was an appreciable difference between admiring continental innovation and allowing its influence to penetrate their work. Bomberg was the first of them to translate this

35. Photograph of the Slade picnic, *c.* 1912. Back row: 3rd from left, Bomberg; 4th from left, Prof. Fred Brown; 5th from left, C. Koe Child, Slade Secretary. Kneeling on left: Isaac Rosenberg. Front row: left, Dora Carrington; 3rd from left, Nevinson; 4th from left, Gertler; 5th from left, Roberts; 6th from left, Allinson; 7th from left, Stanley Spencer.

knowledge into images which ruthlessly cast aside any lingering involvement with elaboration, and he became an increasingly isolated figure. During his earliest days at the Slade he had found common cause with a group of fellow-students who delighted in taking visitors on conducted tours of the Royal Academy exhibitions. They all terminated their talks with a vigorous denunciation of the Academy's values, and Bomberg's tirade caused such offence that a furious correspondence ensued between Burlington House and the Slade.[44] Now, however, the Slade teachers were as much of a target as the Academy, and their opposition to Bomberg's most uncompromising work eventually made him erupt into protest. One day in 1912 Professor Brown apparently made some disparaging remark about Bomberg's current painting. Incensed by the lack of understanding, Bomberg completely lost his temper and 'brought his palette down on Professor Brown's head'.[45]

Commenting on the incident soon afterwards, Rosenberg placed himself firmly on his impulsive friend's side. 'I don't think the proffessor [*sic*] was at all fair to Bomberg', he wrote to Ruth Löwy, adding that Brown 'may have been perfectly right from his point of view, but not to enter into Bomberg's at all I don't think was just.'[46] All the same, Rosenberg did not feel able to follow Bomberg in his pursuit of an art shorn of everything except the naked essentials of representation. Nor did the other students, and it is surely significant that Bomberg stands quite apart from them in the photograph of the Slade's summer picnic (Plate 35). With his hat tipped forward at a defensive angle, and his right hand thrust deep into the pocket of workmanlike trousers, he gazes at the camera with a wary yet implacable air. His rough-and-ready clothes contrast not only with the suits, boaters and ties worn by the teachers standing next to him, but also with the students elsewhere in the group. Rosenberg, kneeling on the left, is dressed with conspicuous correctness, and in the front row both Allinson and Nevinson sport bow-ties. As for Gertler, he had by this time acquired an elegance which mirrored his desire to distance himself from the old Whitechapel circle. Dining regularly with Nevinson's family at Hampstead widened Gertler's social horizons, and he told William Rothenstein that one of the main reasons for his new-found happiness was 'my nice friends amongst the upper class. They are so much nicer than the rough "East Ends" I am used to.'[47] Bomberg, by contrast, made no attempt to rid himself of the natural belligerence he had inherited from his family and childhood environment. Instead, he channelled it into the development of an increasingly defiant art, and even his

36. David Bomberg. *Illustration for 'Richard Feveral'*, 1913. Pencil, 53.3 × 44.2 cm. Private collection, London.

mother's sudden death in October 1912 did not deflect him from the course he had chosen to explore.

It was, nevertheless, a traumatic event for Bomberg. His life until then had been dominated by her beneficent maternal attention. During the years when he might have felt obliged to abandon all his hopes of becoming a painter, she enabled him to ignore his father's hostility and concentrate on art. The unremitting effort involved in bringing up a large family and dealing with a tempestuous husband, however, finally grew too onerous. Towards the end of Rebecca's life, exhaustion caused her to become bedraggled and distracted, and a neighbour in St Mark Street remembered seeing her 'with trailing clothes coming home from the shops shouting at the top of her voice'.[48] The official reason for her death at the age of forty-eight was pneumonia,[49] but her children John and Kitty believed that she had been worn out by a hard life dedicated to her family.[50] 'Until my mother died we were all very well looked after', remembered Kitty, who soon discovered that family life now changed irrevocably. 'She died in her sleep, and our neighbours were very helpful. One of our friends took me by the hand into the room where she was still in the bed where she died, and said in Yiddish: "Look at your mother – she's on her last journey." It was a most unusual thing to do to Jewish children.'[51]

Bomberg was profoundly affected by the tragedy. His younger brother remembered that 'David was a special child for the mother',[52] and she seems always to have lavished particular attention on her imaginative yet demanding son. He was fortunate indeed to enjoy the support of a woman who provided him with special studio space, materials and – perhaps most important of all – an unswerving belief in his ability as an artist. While his father 'didn't understand David's attitude to art, and only wanted to see the outcome of his labours in cash',[53] she had a far less materialistic viewpoint. Rebecca encouraged him to continue producing work

which nobody wanted to buy, and even gave him welcome advice when he was drawing. Years later Bomberg remembered with affection how she offered him practical help in 1912[54] when he was executing 'an illustration to George Meredith's "Richard Feveral", the riders in the park'. The theme had probably been set by the Slade, for Roberts also produced a lost work called *Lucy's Dream from 'Richard Feveral'*.[55] But Bomberg's decision to settle on the horse-riding episode in the book may well have been influenced by his mother's enthusiasm. Her parents were familiar with horse-rearing in Poland, and she once took her own children to Rotten Row 'on the afternoon of the Sabbath and as their Sabbatical holiday – to watch good horsemanship'. Bomberg seems to have based his drawing on memories of the scene he witnessed at Rotten Row, but while he was making the illustration Rebecca pointed out 'the faults in my composition'. It appeared to her lacking in authenticity, and Bomberg recalled that 'my mother showed me how a natural born & trained rider should manage a mount in Rotten Row ... Taking up a stick as the riding stock & a couple of thongs for the bridle reins she neatly held them between the fingers of the right hand.' Then, 'grasping my painter's "Donkey"', she mounted it and said: '"This is how it's done when a Lady rides, & when a Gentleman rides it's like this."'[56]

A large and careful drawing, probably identifiable as the Meredith illustration, has now come to light (Plate 36). It is dominated by a horsewoman who could well be modelled on the pose adopted by Bomberg's mother. This figure is the most convincing part of a strange design which relegates the other riders to a distant space beyond the railings. Their confinement gives Bomberg enough room to attempt his first surviving study of trees, and one of their branches scythes across the drawing's uppermost part in a menacing diagonal. But landscape, which was to become Bomberg's major concern in later life, plays an insignificant role in his early work. Even this drawing concentrates rather on the massive sculptural strength of two imposing pillars, contrasting their upright rigidity with the arc of top-hatted gentlemen and well-wrapped ladies who bob at each other and stare somewhat enviously at the oblivious horsewoman riding past. She possesses a serenity which appears almost idealized in comparison with the grimacing spectators behind her, and it is not over-fanciful to conclude that she reflects Bomberg's passionate devotion to the woman who helped him with the composition. Kitty explained that 'he adored my mother',[57] and her untimely death intensified his feeling of isolation as well as subjecting him to a grief he had never known before.

But his art did not falter. It seemed, in fact, to grow stronger and more capable

37. David Bomberg. *Family Bereavement*, 1913. Pencil and charcoal, 56 × 47 cm. Fischer Fine Art, London.

38. David Bomberg. *Family Bereavement*, c. 1913. Charcoal and conté, 54.5 × 46.2 cm. Private collection.

of conveying profound emotion. The change is evident in *Family Bereavement*, the work which refers most directly to the loss he had suffered. Three drawings and a watercolour attest to Bomberg's determination to explore this theme as thoroughly as possible. They range in style from the most refined simplification to a high degree of representational detail, and we do not know which version was executed first. But the only one Bomberg dated, with an unusually elaborate signature alongside, is the highly finished drawing (Plate 37). He may therefore have regarded this image as the final statement,[58] even though the less painstaking versions possess an austere beauty which the more literal study partially fails to retain. It spells out the deep shadows engulfing the death-chamber, the folds in draperies, and the form of the man stretched out on the coffin-like bed. With eyes open and clasped hands raised above his head, this bald figure seems to be in his death-throes. When Augustus John saw the drawing he concluded that the man had already died, and wrote an enthusiastic letter to the great American collector John Quinn, describing it as 'extremely good and dramatic representing a man died with mourning family, very simplified and severe. I'd like you to have it.'[59]

Bomberg may have given this figure a male gender in order to distance the drawing from the death he had recently witnessed, but in other versions of the subject the dying figure could well be identified with his mother. They make us realize, too, how close this bleak setting could be to the scene that Kitty saw when she was led in to Rebecca's death-bed. Although Bomberg has reduced the surroundings to their barest essentials, the composition still appears rooted in the kind of family tragedy which occurred at Tenter Buildings in October 1912. The sparest of the drawings is, paradoxically, the most eloquent expression of Bomberg's emotion (Plate 38). It is a distillation of the event, and his refusal to elaborate on the taut framework of charcoal lines gives the image a fierce conviction. The room and the people it contains are welded together so closely that the side of the arch appears to be united with the large standing mourner, and the geometrical funnel of the lamp continues the upward thrust of the dying figure's arms. The bodies of the grief-stricken relatives slumped on the floor are likewise constructed with the same severity as the stark plinth next to them. They are overwhelmed by the melancholy of an occasion which seems to have frozen them into helpless immobility. But the most arresting part of the design refuses to accept the inevitability of death. For the tall woman who provides such firm support for her bereft companion does not give way to despair. Instead, she extends her left arm in an imperious gesture, as if seeking to prevent death from coming any closer to the recumbent figure. In this sense she is, perhaps, an embodiment of Bomberg's own response to his bereavement. He may well have found himself longing to reverse the process and restore his lost mother to the central position she had occupied in his life.

A desire of this kind also lies behind the most ambitious amd impressive painting Bomberg undertook in 1912: *Vision of Ezekiel*. The earliest preliminary drawing for the composition indicates that he did not at first intend to depict a passage from Ezekiel at all (Plate 39). The leaping, embracing and kneeling figures who fill so much of the design with their exuberant movements are overshadowed by the bulk of an enormous animal. Bomberg could have derived this idea from the decorations in the Cave of The Golden Calf, London's first cabaret club, which opened in June 1912 with spectacular avant-garde decorations by several leading painters and sculptors.[60] He is known to have visited this subterranean centre,[61] and doubtless found much to admire in the large-scale murals and sculpture installed there. They celebrated the spirit of Post-Impressionism with exhilarating vitality, and several of the decorations dealt directly with the Old Testament story of the Israelites' idolatrous involvement with the golden calf (Plate 40). So Bomberg's drawing may represent his first excited attempt to interpret the same theme, hoping perhaps that his own work would find its way into a club he remembered with affection as 'the Cave of Harmony'.[62] Around the same period Spencer drew his own interpretation of *Moses and the Brazen Calf*, which suggests that the theme aroused the interest of those Slade students most likely to have been impressed by the Cave and its compelling images.[63]

In compositional terms Spencer's drawing bears no resemblance to Bomberg's study. Roberts, however, executed a complex design in 1912 called *David Choosing the Three Days' Pestilence* which contains, at its centre, a platform filled with gesticulating figures and sacrificial cows (Plate 41). It strikingly resembles Bomberg's draw-

39. David Bomberg. *Struggling Figures: Study for Vision of Ezekiel*, c. 1912. Charcoal, 48 × 68 cm. Victoria & Albert Museum, London.

40. Spencer Gore. *Study for mural of calf worshipped by a procession of figures*, 1912. Pencil, chalk and crayon, 10 × 27 cm. Yale Center for British Art.

41. William Roberts. *David Choosing the Three Days' Pestilence*, 1912. Lost.

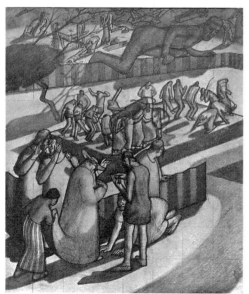

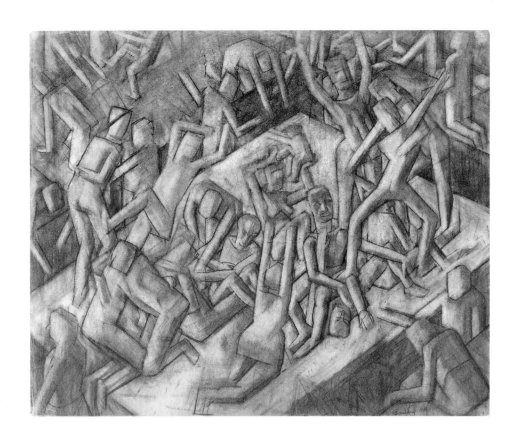

42. David Bomberg. *Study for Vision of Ezekiel, c.* 1912. Charcoal and pencil, 56 × 68 cm. Anthony d'Offay Gallery, London.

ing, and shows how closely involved the two friends had by now become with each other's work. But Roberts never took the platform idea any further, whereas Bomberg decided in his next drawing to dispense with the massive animal and allow the figures to spread across the entire surface of his composition (Plate 42). More than a dozen protagonists have been added to the outer section of this study, and they could easily have choked it with their exclamatory motion. Bomberg averts the danger not only by defining the platform with a new geometrical clarity, but also by surrounding it with a dark border which gives the entire design a much-needed structural reinforcement. Within this rigidly compartmentalized arena he could afford to let his figures clamber, wave and jostle with as much uninhibited fervour as the occasion required.

But what exactly was the theme Bomberg had now decided to depict? Although he never explained which part of the Book of Ezekiel had fired his imagination,[64] the most plausible answer must be the passage where the prophet finds himself transported by 'the hand of the Lord' to a 'valley which was full of bones'.[65] The entire space was strewn with dry fragments of human skeletons, and God said to Ezekiel: 'Son of man, can these bones live? And I answered, O Lord God, thou knowest. Again he said unto me, Prophesy upon these bones, and say unto them, O ye dry bones, hear the word of the LORD.' Ezekiel did as he was commanded, and the outcome of his fidelity to God's instructions was miraculous:

> As I prophesied, there was a noise, and behold a shaking, and the bones came together, bone to his bone. And when I beheld, lo, the sinews and the flesh came up upon them, and the skin covered them above: but there was no breath in them. Then he said unto me, Prophesy unto the wind, prophesy, son of man, and say to the wind, Thus saith the Lord God; Come from the four winds, O breath, and breathe upon these slain, that they may live. So I prophesied as he commanded me, and the breath came into them, and they lived, and stood up upon their feet, an exceeding great army.[66]

If the unexpected death of Bomberg's mother occurred when he was at work on these drawings, the tragedy would have played a crucial role in their development. For the adoration of the golden calf probably lost its significance in the face of such a traumatic event. Shocked and urgently needing consolation, the bereaved son may well have turned to the Old Testament for solace. This passage from Ezekiel, with its revelatory prospect of an after-life, provided Bomberg with the hope he required. Interpreting such a theme, and focusing on the moment when all the dead bodies underwent their resurrection, he could allow himself to indulge in the

belief that his lost mother might likewise be granted an existence beyond the grave. The final drawing emphasizes the miraculous nature of Ezekiel's vision by relieving each body of the solidity it possessed in earlier studies (Plate 43). Bleached and almost ghostly, these stick-like figures now approximate more closely to the dry, bony apparitions who rose up before the prophet's astonished gaze. Bomberg still models their limbs with the lightest of shadows, but the increased angularity of their construction stresses their skeletal origins. They really do look like people whose bones have only just been clothed in flesh, and the squared-up lines ruled across this drawing prove that he now felt prepared to turn his carefully considered composition into a large-scale painting.

The completed canvas shows how conscious he remained, right up to the end, of the need to prune and clarify his design (Colour Plate 3). The facial features which still lingered in the final drawing are now completely expunged, and along with them any doubts about the space occupied by the people outside the platform. Bomberg has ensured that the dark band running round the sides of the platform is perceived as a sunken area, where figures stand like sentinels staring and pointing at the activity around them. But the space beyond reverts to the platform's level, thereby retaining the overall impression of a composition which honours the flatness of the picture-surface. The strength and clarity of these outlying bands increase the painting's geometrical rigour, and Bomberg knew how important this new lucidity would be. For he wanted to take extraordinary risks with the colours of the figures springing to life all over the platform. Painting most of them in a dazzling combination of light yellow and pale pink, he removed them even further from full corporeal substance. They are caught half-way between disembodied spirit and reincarnated flesh. The glare created by their incandescent limbs enhances the sense of a blinding revelation. It also intensifies the exalted mood which Bomberg wanted to celebrate.

The conflict evident among some of the figures in his preparatory drawings has dropped away entirely. Rather than jostling and struggling, the reborn figures all seem transported by a feeling of communal delight. Two of them run their arms over each other's bodies, as if touching were the only way to convince themselves of their renewed existence. Nearby another figure leaps into the air, ecstatic with the discovery that life has been restored to him; and in the platform's centre a mother rejoices in the baby she holds up triumphantly in front of her. Everywhere reviving humanity revels in the unexpected bestowal of a vitality which makes their bodies blaze with the sudden, astonishing access of heat and light. The darker clothed figures placed among them, especially in the corners where they give the design a much-needed stability, serve to accentuate the overwhelming brightness of the people who exult as 'the breath came into them, and they lived, and stood up upon their

43. David Bomberg. *Study for Vision of Ezekiel, c.* 1912. Chalk and pencil, 56 × 68 cm. Tate Gallery, London.

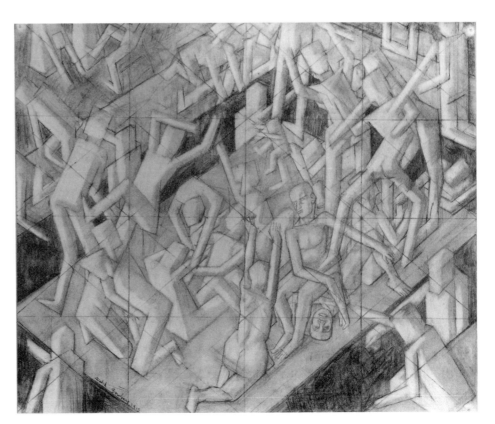

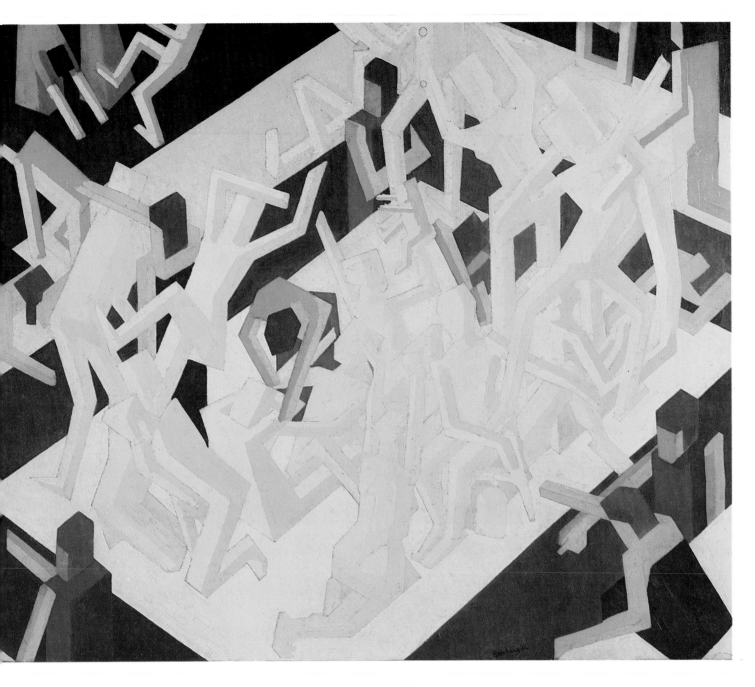

3. David Bomberg. *Vision of Ezekiel*, 1912. Oil on canvas, 114.5 × 137 cm. Tate Gallery, London.

4. Marc Chagall. *Cemetry Gates*, 1917. Oil on canvas, 87 × 68.6 cm. Private collection.

feet'. For *Vision of Ezekiel* is above all a splendidly resilient painting, filled with Bomberg's stubborn refusal to accept the numbing finality and deprivation of death.

Despite its ruthless simplification and apparently arbitrary use of colour, this audacious canvas therefore remains faithful to the literary source which Bomberg was aiming to interpret. Indeed, by departing so radically from representational norms, he succeeded in conveying the fundamental meaning of Ezekiel's vision with greater directness and force. Sir Claude Phillips, who jeeringly gave the painting the Whistlerian nickname *Symphony in Pink*, could not have been more mistaken when he dismissively described it as 'really a very pretty pattern, but one in which we can distinguish nothing of the prophet or his sublime vision'.[67] For Bomberg employs stylistic innovations in order to arrive at the heart of Ezekiel's experience. Although he later described the painting as 'Pure Decoration',[68] his heartfelt attraction to the idea of resurrection in 1912 ensured that *Vision of Ezekiel* is primarily concerned with a joyful awakening from the dead. It also possesses the intensity of a man who was, according to his sister, 'very conscious of being Jewish and loved being Jewish'.[69] Bomberg may have refused to embrace religious orthodoxy, but he was profoundly interested in the Old Testament and Jewish history – as was Chagall when he inscribed another passage from Ezekiel on his painting *Cemetry Gates* five years later (Plate 44). Chagall's canvas is intended as a memorial to all the Jews who perished in the Pale of Settlement before the Russian Revolution, and Susan Compton has argued that the Ezekiel quotation is used by Chagall to refer to 'the

41

45. Francis Picabia. *Dances at the Spring*. 1912. Oil on canvas, 118.8 × 118.8 cm. Arensberg Collection, Philadelphia Museum of Art.

46. Augustus John. *Moses and the Brazen Serpent*, 1898. Oil on canvas, 170 × 233 cm. Slade School of Fine Art, London.

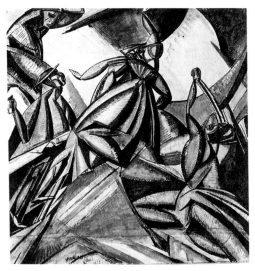

47. Wyndham Lewis. *Kermesse*, 1912. Ink, wash and gouache, 30 × 29 cm. Phillips family collection, Montreal.

problem of pogroms and possible emigration to Palestine, the Land of Israel, in the nineteenth century'.[70] Bomberg might likewise have responded to the full Israelite meaning of Ezekiel's story, for the prophet made clear that his vision centred on the restoration of a promised land. After the miraculous event in the valley of bones, God said to Ezekiel:

> Son of man, these bones are the whole house of Israel: behold, they say, Our bones are dried, and our hope is lost: we are cut off for our parts. Therefore prophesy and say unto them, Thus saith the Lord GOD; Behold, O my people, I will open your graves, and cause you to come up out of your graves, and bring you into the land of Israel. And ye shall know that I am the LORD, when I have opened your graves, O my people, and brought you up out of your graves, and shall put my spirit in you, and ye shall live, and I shall place you in your own land.[71]

But the formal organization of *Vision of Ezekiel* shows that Bomberg was now deeply involved in a pictorial exploration which allied him with the European avantgarde. Wyndham Lewis pointed to two possible sources of inspiration for the picture when he wrote that 'David Bomberg's painting of a platform announces a colourist's temperament, something between the cold blond of Severini's earlier paintings and Vallotton.'[72] Bomberg would have acquainted himself with Severini's work when it was included in the Futurists' first London exhibition, held at the Sackville Gallery in March 1912. The contents of this notorious show probably excited him as much as the *Second Post-Impressionist Exhibition* later in the year, and of all the Futurists, the rigorously organized Severini certainly seems the painter most likely to appeal to Bomberg. All the same, *Vision of Ezekiel* is closer to Parisian Cubism than Italian Futurism, and in particular to the work of a painter associated with the Duchamp brothers. In the early months of 1912 Picabia painted an exuberant canvas called *Dances at the Spring*, based on his encounter with peasants dancing in the countryside near Naples (Plate 45). The figures are more integrated with their surroundings than *Vision of Ezekiel*'s protagonists, and Picabia feels free to distort anatomy with a zest which makes Bomberg's painting appear comparatively faithful to the bodies he simplifies. But there are enough similarities between the two paintings' block-like handling of form to indicate Bomberg's awareness of Picabia's work, and in 1915 Lewis drew attention to the relationship between them. 'Picabia, in France, reducing things to empty but very clean and precise mathematical blocks, coldly and wittily tinted like a milliner's shop-front ... is on a par with a tendency in the work of several excellent painters in England', Lewis wrote. Although he did not mention the names of these artists, Lewis went on to describe the 'sculpturesque groups of lay figures' which reveal a debt to the teaching 'inculcated at the Slade'.[73] His words fit Bomberg's work more completely than that of anyone else.

Lewis, who had studied at the same school of art a decade before Bomberg, was in a good position to realize that behind *Ezekiel*'s radicalism lay a far more traditional notion of monumental figure compositions. In Lewis's day a large prize painting by Augustus John, *Moses and the Brazen Serpent*, was hung in a prominent position at the Slade (Plate 46)[74] Its frankly eclectic yet bravura reliance on masters as diverse as Rubens, Tintoretto, Watteau and Michelangelo was an example to be emulated. However far removed Bomberg may have been from John's dependence on tradition, the wildly gesticulating bodies who fill so much of *Vision of Ezekiel*'s surface might owe a subliminal debt to the equally exclamatory figures in *Moses and the Brazen Serpent*.

But so far as Bomberg's conscious intentions were concerned, John seemed irrelevant. The only contemporary English artists capable of winning his admiration were painters like Lewis himself, who had exhibited at the Allied Artists' Salon in the summer of 1912 a huge canvas widely regarded by the critics as a landmark in modern British painting.[75] It became known as *Kermesse*, and Frank Rutter asserted that 'here for the first time London saw by an English artist a painting altogether in sympathy with the later developments in Paris.'[76] Although it was subsequently described as a 'cubistic rendering of three festive figures, the central in rich yellow, the others in varying shades of red and purple',[77] the canvas itself has since disappeared. An elaborate ink-and-wash study called *Kermesse* contains five figures and cannot therefore be a wholly faithful guide to the lost painting (Plate 47). But this study does show clearly enough how Lewis drew on Cubism, Futurism and even

Expressionism to forge his singularly fierce, energetic vision of the wild dances he had witnessed during his earlier travels through Brittany.[78] The painting seems to have been a great deal more abstract than this study, for Roger Fry's review of the Allied Artists' exhibition stressed that *Kermesse*'s 'quantities and volumes have decisive relation to one another: long before one has begun to inquire what it represents, one has the impression of some plastic reality brought about by deliberately intentional colour oppositions.' The same observations could be applied to *Vision of Ezekiel*, and Fry's remarks about the figurative basis of *Kermesse* also reveal the links between the two paintings: 'when we begin to look more closely, we find indeed that the rhythm of these elementary geometric forms is based upon the rhythm of the human figure. The rhythm is not merely agreeable and harmonious, but definitely evocative of a Dionysiac mood.'[79] So was the rhythm of Bomberg's canvas, which must have been commenced soon after *Kermesse* went on display at the Allied Artists' show. The differences between the two paintings are as great as their similarities, of course: *Vision of Ezekiel* lacks the caustic and eruptive quality which Lewis's art always possesses, offering instead a more stable and imposing vision which contains Bomberg's gesticulating figures firmly within the heraldic structure of the platform. But the 'Dionysiac' *Kermesse* can hardly have failed to impress Bomberg at a time when he was struggling to define his unique response to the continental developments which inspired Lewis's art.

Around the time that Bomberg completed *Vision of Ezekiel*, at the end of 1912, this connection between the two artists was reinforced by a meeting. Eager to discover like-minded young painters with whom he could establish a common area of concern, Lewis took the trouble to seek out Bomberg when 'the East End of London . . . was under snow.' Lewis may have experienced some difficulty in locating the Tenter Buildings studio, for Bomberg remembered that his visitor arrived at an extraordinarily late and almost conspiratorial hour. 'At past twelve midnight I was engaged on completing the drawing "Jewish Theatre" [when] I heard a peremptory knuckle on the door', Bomberg recalled. 'To Lewis's knock I responded "this is an inconvenient hour to tramp through the snow and mount three flights of stairs with the gas-jets off – anyhow, how did you know I lived up here?" – "Nothing is impossible for Wyndham Lewis – Bomberg! I have come to see what you are doing."' The Slade student, who had not yet exhibited his work in a gallery, must have felt flattered by this attentive visit from one of the most hotly-debated young artists in England. Lewis had clearly been informed that Bomberg was a man of exceptional promise, and the work in the studio amply confirmed what he had heard. 'He expressed admiration of the Jewish Theatre and a number of things', Bomberg wrote, describing how he was 'courteous to a man who inverted

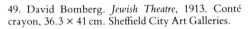

49. David Bomberg. *Jewish Theatre*, 1913. Conté crayon, 36.3 × 41 cm. Sheffield City Art Galleries.

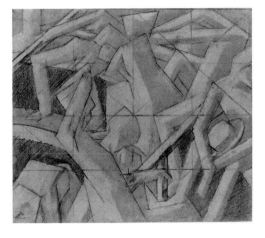

48. David Bomberg. *Jewish Theatre*, 1913. Chalk, 55 × 60.5 cm. Leeds City Art Galleries.

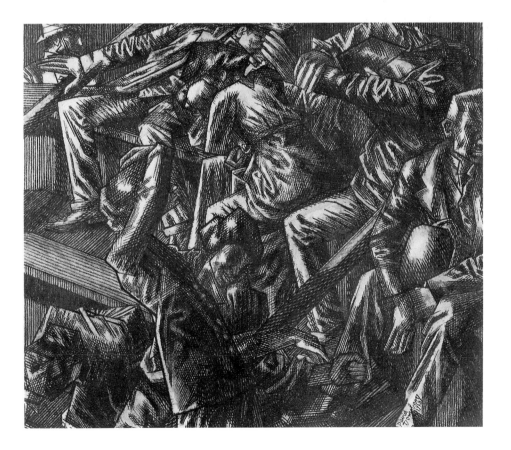

conceptual precepts in imitation of GBS such as "It's too true to be good."'' Although Lewis was adept at antagonizing people he regarded as his opponents, he also possessed an infectious capacity for friendship. On this occasion he seems to have impressed Bomberg with his superior knowledge of 'the pioneers of the advance movement of the visual arts and literature in Paris'. Lewis was almost a decade older than the twenty-two-year-old student, but they shared the same restless desire for renewal. Bomberg remembered that 'we had talked ourselves silly when he left – dawn, the next morning. I recognised in the conversation, a Slade man honouring the same pledge to which I was staking my life – namely, a Partizan.'[80]

As it happened, one of the *Jewish Theatre* drawings in Bomberg's studio was considerably less radical than *Vision of Ezekiel* (Plate 48). Although the bodies of the audience have been organized into a thrusting, dynamic cluster of outspoken limbs, Bomberg resisted any urge he may have felt to divest these forms of anything which detracted from their muscular interplay. The action of light on drapery folds has everywhere been delineated with immense precision, and Bomberg wields his chalk like a pen-nib to build up a dense network of hatched lines. They cover the entire composition with a scaffolding which gives his drawing an awesome tautness, but they also prevent it from possessing the skeletal strength which Bomberg achieves in his most pared-down work. Perhaps his natural desire to win the Slade competition

50. David Bomberg. *Head of a Poet* (Isaac Rosenberg), 1913. Pencil, 72.6 × 27.9 cm. Lost.

51. David Bomberg. *Self-Portrait*, *c*. 1913. Chalk, 55.9 × 38.1 cm. National Portrait Gallery, London.

52. Sandro Botticelli. *Portrait of a Young Man*, 1470s. Oil on wood, 37 × 28.2 cm. National Gallery, London.

of January 1913, for which *Jewish Theatre* was entered, drove him to invest the image with a richness of descriptive elaboration he had elsewhere managed to discard. Another version of the drawing, far more simplified in style, less agitated in mood, and squared-up as if in readiness for a painting of the same subject, shows how fascinated Bomberg had become by the metamorphosis that a single image undergoes when executed in radically different idioms (Plate 49).

Taken together, these two versions of *Jewish Theatre* constitute an impressive display of Bomberg's draughtsmanship, and they also indicate that the heightened gestures he employs throughout his early work may derive from the stylized acting to be seen at the Pavilion Theatre in Whitechapel. Bomberg enjoyed visiting the Pavilion, which probably furnished him with the starting-point for the *Jewish Theatre* drawing. Like Gertler before him, he was developing a consistent tendency to root his work in the East End locality he knew best, but unlike Gertler he concentrated on scenes of frenetic activity and stress. Although the grotesquely exaggerated poses adopted by the audience in *Jewish Theatre* may well reflect the body-language deployed on the Pavilion stage, there is a strain of barely contained violence in this feverish group of spectators. In the highly finished version of the drawing they recoil from the play with almost desperate urgency, as if the emotions aroused by the drama were too painful to contemplate. The figure clutching his head in the foreground appears to be leaning on the shoulder of a woman who guides him away from his seat. Perhaps he has been overcome by claustrophobic tension in a confined space where anyone might suddenly give vent to the most explosive emotions. The enigmatic helmeted head in the drawing's upper left corner may signify the presence of a policeman, patrolling the premises in case the excitable crowd is transformed into an ugly riot.

The works which survive from Bomberg's final terms at the Slade, before he left in the summer of 1913, veer between his lingering involvement with tradition and an ever more extreme desire to innovate. In January he succeeded in showing work for the first time at a London gallery. The Friday Club accepted three of his pictures[81] for a show at the Alpine Club Gallery, and the controversial reputation of this exhibiting society might suggest that Bomberg displayed his most radical work. After all, the Friday Club's 1912 show had prompted *The Observer* to declare that its members 'are celebrating their Mardi Gras at the Alpine Gallery, and behave as if the notoriety gained by the Futurists in Paris had aroused their jealousy. It is a very Witches' Sabbath of fauvism or post-impressionism.'[82] But by 1913 Fry and his Bloomsbury associates had transferred their support from the Friday Club to the newly-formed Grafton Group,[83] and so there is no guarantee that Bomberg's contributions to the Friday Club were particularly audacious. Although fellow-students at the Slade as rebellious as Wadsworth and Nevinson participated in the show, Bomberg's work may not have shown him at his most uncompromising. *Vision of Ezekiel* was conspicuous by its absence, and the title of one of his exhibits – *Boy's Head* – suggests a relatively orthodox study from life.

It may even have been executed in the same vein as the *Head of a Poet*,[84] a pencil portrait of Isaac Rosenberg which gratified Bomberg's teachers enough to gain him the Henry Tonks Prize (Plate 50). This large drawing demonstrates with convincing authority that Bomberg had developed into a consummate traditional draughtsman by the time he entered his final year at the Slade. Rosenberg's face is constructed with rock-like finality, and his impassive gaze reflects the unwavering confidence with which Bomberg defined his friend's rugged features. The Florentine inspiration lying behind *Head of a Poet* becomes still more evident when the drawing is set beside a less impressive but similar *Self-Portrait*, probably executed around the same period (Plate 51). This study, which suffers from Bomberg's inability to subject himself to the magisterial scrutiny commanded by the Rosenberg portrait, seems to be a deliberate act of homage to a Quattrocento painting Bomberg particularly admired. His sister Kitty recalled that 'David took me when I was young to the National Gallery, to see one of his favourite paintings, Botticelli's *Portrait of a Young Man*' (Plate 52). The *Self-Portrait* drawing certainly echoes the organization of Botticelli's portrait, and both images share the same direct, frontal pose and frank expression. 'David wanted to draw himself based on the Botticelli painting', Kitty remembered, 'and he asked his father to design a shirt like the Botticelli garment.'[85] The shirt can be seen in the *Self-Portrait*, its severity acting as an overt reference to the clothes worn by the unknown Florentine.

45

While Bomberg was establishing his conventional prowess with drawings as impressive as *Head of a Poet*, he continued to explore adventurous alternatives as well. A series of *Racehorses* studies, the finest of which is a large chalk-and-wash drawing,[86] reveal his determination to pursue the austere formal experiments he had already begun the previous year (Plate 53). Compared with the relative naturalism of the '*Richard Feveral*' drawing (Plate 36), *Racehorses* displays a defiant desire to escape from literal representation. In the earlier drawing Bomberg had been at great pains to achieve a convincing depiction of the woman's pose as she rides her mount, but in *Racehorses* he no longer sought authenticity of that kind. On the contrary: the animals galloping down the track are all toy-like and 'primitive' in structure, as if reinforcing the view expressed in the catalogue of Fry's *Manet and the Post-Impressionists* exhibition that 'a good rocking-horse is more like a horse than the snapshot of a Derby winner.'[87] When Bomberg's friend John Rodker reproduced *Racehorses* in a magazine article on 'The New Movement in Art', the caption maintained that 'the scene is in a paddock at a race meeting. Note the two "bookies" on right, at bottom, and spectators on left centre.'[88] But without Rodker's information, nobody could confidently identify either the paddock or the bookies. Bomberg's drawing excludes that kind of precise information; and by concentrating instead on the unadorned essence of the theme he provoked the *Jewish Chronicle* into complaining that the picture depicted 'horses that could never possibly win races'.[89]

Sometimes, though, Bomberg moved from a figurative idiom to a more abstract alternative as he worked on successive versions of a composition. One drawing of this period, an assured *Return of Ulysses* in black crayon which may have originated as a Slade subject,[90] employs a bold degree of simplification but retains broad anatomical fidelity, facial features and even the utensils laid out on a table (Plate 54). Bomberg often took such a design and progressively refined it, by turning over the paper to work on the outlines visible on the back. He would either develop them into a revised version or trace them on another sheet to make a new image. His fascination with the whole process of metamorphosis can be seen in a double-sided variant on *The Return of Ulysses*, which delineates the design in charcoal and

53. David Bomberg. *Racehorses*, 1912–13. Chalk and wash, 42 × 65 cm. Nuffield College, Oxford.

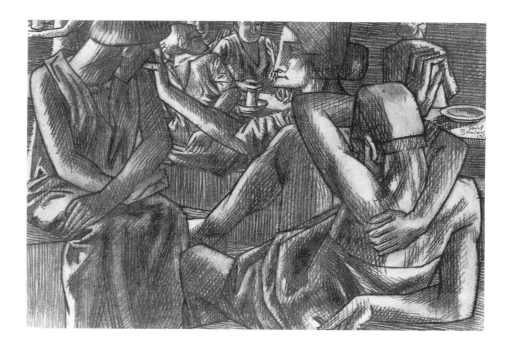

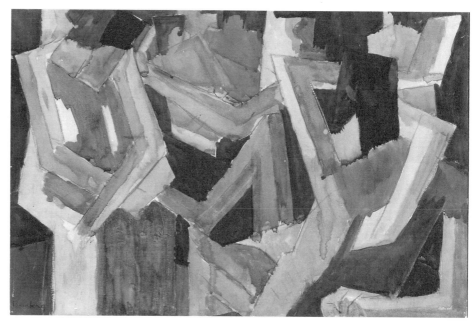

54. David Bomberg. *The Return of Ulysses, c.* 1913. Black crayon, 30 × 46.5 cm. Museum of Modern Art, New York.

55. David Bomberg. *The Return of Ulysses, c.* 1913. Watercolour, 31 × 46.3 cm. Fischer Fine Art, London.

56. William Roberts. *Study for The Return of Ulysses,* 1913. Chalk and watercolour, 30.5 × 45.5 cm. Tate Gallery, London.

then, on the reverse, develops a free variation on the theme in watercolour (Plate 55). Its relationship with the black crayon drawing is clear enough, but the angular contours and brusque watercolour washes purge the design of its detail. Only the principal figures remain, and their massive Bombergian bulk becomes even more evident when compared with Roberts's version of the same subject (Plate 56). Although his watercolour study for *The Return of Ulysses* employs a similar process of simplification, Roberts's figures do not impress their size and weight on the viewer with as much looming insistence as the *dramatis personae* in Bomberg's assembly.

Such works prove that he was still firmly allied with the most innovative developments in European art as his Slade studentship came to an end. But he had never been abroad, presumably because his meagre finances did not enable him to travel. Bomberg needed a more comprehensive first-hand knowledge of the continental avant-garde, so he must have been delighted when the Director of the Whitechapel Art Gallery invited him to accompany Epstein on a trip to Paris around May 1913. Their brief was to select painting and sculpture for a large exhibition called *Twentieth Century Art. A Review of Modern Movements,* to be held at the Gallery in the summer of 1914. Bomberg was particularly requested to organize a 'Jewish section' for the survey, and he recalled contacting Soutine, whom he described in retrospect as 'a superb manipulator of oil paint as he was a great and individual stylist'.[91] But Soutine's example would only become important to Bomberg later in his career

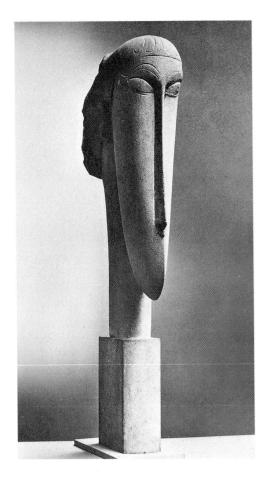

(Plate 240), and in the early summer of 1913 other Parisian painters were of more immediate relevance to his own work. Epstein had already spent a great deal of time in the city, and he was able to introduce his young friend to a wide range of the most important artists. 'Picasso was appreciative of my aims', Bomberg remembered, 'Derain more comprehending and Modigliani gave me a roll of his drawings ... to commemorate our meeting and my appreciation of his approach. I advised two of my friends visiting Paris with me at the time to acquire two of the negroid-style Egyptian-looking heads – these two sculptures came to England.'[92] One of the carvings, a superbly elongated stone *Head* now in the Tate Gallery, was included in the Whitechapel show (Plate 57).[93] Although its elegant attenuation did not influence Bomberg directly, it probably reinforced his belief in the power of minimal austerity.

The entire Paris visit would have been an enormously stimulating experience, and it came at a vulnerable time in Bomberg's life when he was about to confront life outside the Slade. Since he needed a considerable amount of self-confidence in order to withstand the hostility of critics and acute economic uncertainty, the inspiration provided by the artists he met in France must have been especially valuable. Bomberg had no reason to suppose that his most personal work would be readily understood in London, let alone admired or purchased. But he brought his student period to a defiant close by executing *Ju-Jitsu*, a painting even more subversive of pictorial conventions than *Vision of Ezekiel*.[94] It turned, like the earlier *Bedroom Picture* and *Jewish Theatre*, to the locality Bomberg knew best, and writers have always assumed that Schevzik's Steam Baths were the most likely setting.[95] The reference to wrestling in the painting's title, however, suggests that he would more plausibly have taken as his starting-point an East End gym or a hall where matches were held. Bomberg's elder brother Mo was a boxer, and Joseph Leftwich recalled that Mo and his friends 'had a place called The Judaeans – an ordinary shop in Cable Street which was converted into a gymnasium. Ju-jitsu was practised

57. Amedeo Modigliani. *Head*, c. 1911–12. Stone, 63.5 × 12.7 × 35.2 cm. Tate Gallery, London.

58. David Bomberg. *Wrestlers*, 1912–13. Black chalk, 61.3 × 52.9 cm. Private collection.

60. David Bomberg. *Study for Ju-Jitsu*, *c*. 1913.
Chalk, 54.5 × 56 cm. University of East Anglia Art
Collection, Norwich.

59. Henri Gaudier-Brzeska. *The Wrestlers*, 1914.
Plaster, 71.4 × 90.5 cm. Museum of Fine Arts,
Boston.

there.' Leftwich did not think Bomberg was himself an exponent of ju-jitsu, but
they all enjoyed watching wrestling and boxing. 'We knew Kid Lewis very well,
he was the hero of the East End',[96] recalled Leftwich, and it is not surprising that
Bomberg should have been especially attracted to the Japanese art of wrestling.
The precision of ju-jitsu, its highly stylized, clear-cut and angular repertoire of move-
ments, paralleled the formal language he was developing in his own work. A drawing
of *Wrestlers* shows how the abrupt gestures and complex tangle of limbs lent them-
selves to his structural style, and he may have spent hours making studies of ju-jitsu
sessions at The Judaeans (Plate 58). Indeed, Bomberg probably relished the comic
ambiguity of the title he chose for his painting: in his circle of East End friends
it could easily have been turned into a private joke to stand for 'Jew-Jitsu'.

But the *Ju-Jitsu* painting does not just arise from a localized preoccupation with
wrestling at The Judaeans. Bomberg shared this enthusiasm with other European
artists of the period. In the summer of 1913, when he was working on *Ju-Jitsu*,
Gaudier-Brzeska exhibited at the Allied Artists' salon a powerful painted plaster
figure of a *Wrestler* which particularly impressed Ezra Pound.[97] It was based on
Gaudier's observation of wrestlers in action, and after seeing them he declared in
an ecstatic letter: 'My God I have never seen such a beautiful sight – two typical
athletes – large shoulders, taut, enormous necks like bulls, small in build, firm
thighs, slender ankles, feet as sensitive as hands and not tall but they fight with
a fantastic vivacity and spirit, turning in the air and falling back on their hands
so as to jump up on the other side.'[98] This description, which vividly conveys the
excitement Bomberg may also have felt, helps to explain why Gaudier returned
to the theme in 1914 and executed a plaster relief which stressed the pliable elasticity
of the wrestler's bodies (Plate 59). Their convoluted poses echo the interlocking
complexity of Bomberg's *Wrestlers* drawing, but Gaudier's figures now lack the
tense, coiled muscularity which Bomberg favoured. In this respect, his drawing
is closer in sympathy with Archipenko's bronze *Boxers*, a major sculpture of 1914
which transforms the combative bodies into a gleaming, semi-abstract cluster of
mechanistic components.

Even so, Bomberg's chalk *Study for Ju-Jitsu* does not concentrate on two figures alone (Plate 60). At least eight people can be discerned, and the group in the foreground are wearing loose robes. They appear to be engrossed in conversation, whereas the more agitated figures beyond them are all involved in dramatic and violent action. Rather than watching an orderly contest between two practitioners of ju-jitsu, most of the men look as though they are joining in a fight. One figure is being lifted up and projected in a horizontal direction, perhaps towards the precipitous edge of a platform. The step-ladder on the right descends to a lower area, signifying that a split-level interior is depicted in this drawing. But Bomberg deliberately thwarts a straightforward interpretation of his design, employing spatial ambiguity and refusing to clarify the protagonists' movements. In a discussion of the drawing, T. E. Hulme pointed out that 'wherever it was felt to be necessary, representation has been sacrificed. The body line of one figure, which would be in reality hidden behind another figure in the foreground, is clearly shown.'[99]

All the same, the perceptual doubt induced by *Study for Ju-Jitsu* seems mild when compared with the disturbance created in the final painting (Colour Plate 4). For Bomberg now made the sixty-four-square grid dividing up the drawing into a major force. He had originally been introduced to this device by Sickert, who often used it as a compositional aid in the transition from preparatory drawing to painting. However visible the grid may still be in Sickert's oils, he never dreamed of using it to interrupt and confuse the image. But Bomberg, with characteristic rebelliousness, decided to let the grid's geometry dominate *Ju-Jitsu*. He divided each square into triangles, and allowed their colours to play a role almost independent of the scene depicted in the painting. The triangles do, admittedly, change colour in accordance with the different parts of the composition: warm brown for the large upper wall, green for the floor below, ochre for the ladder and so on. But they are forceful enough to set up a pattern which threatens to become autonomous and override the representational content of the picture. Figures and room alike are shattered by the intervention of the grid. Without the *Study for Ju-Jitsu* to help, it would be difficult even to guess what was happening in the painting. Unlike the drawing, which looks like a scene from a strange ritualist drama enacted on a gaunt stage, the *Ju-Jitsu* oil actively prevents us from identifying either the performers' actions or the setting they inhabit. Bomberg creates a splintered tension between the grid and the staccato antics of the figures caught in its prism-like structure.

He called the painting *Japanese Play* when it was first exhibited,[100] and on the back a label reads: 'Ju-Jitsu, Japanese Play in the Integration of the Parts in the Mass'. This description suggests that Bomberg wanted the picture's complex formal structure to act as an *equivalent* to ju-jitsu movements, not as a direct illustration of wrestling at The Judaeans. The kinetic interplay between the grid's particles and the limbs they disrupt sets up its own optical energy. This abrupt, leaping and consistently fragmented activity can be seen as the pictorial essence that Bomberg wanted to extract from his figurative subject, and the joyful vitality of the colours employed in this painting are a measure of the elation he felt at discovering his own individuality. The chequerboard grid also implies that Bomberg equated a ju-jitsu match with the moves in a chess game. Indeed, *Ju-Jitsu* could well have helped to provide Ezra Pound with the initial inspiration for his poem 'Dogmatic Statement on the Game and Play of Chess', which he subtitled 'theme for a series of pictures':

> Red knights, brown bishops, bright queens
> Striking the board, falling in strong "L's" of colour,
> Reaching and striking in angles,
> 　　　　　　　　Holding lines of one colour:
> This board is alive with light
> These pieces are living in form,
> 　　　　　　　Their moves break and reform the pattern:
> Luminous greens from the rooks,
> 　　　　　Clashing with "x's" of queens,
> 　　　　　　　　Looped with the knight-leaps.
> "Y" pawns, cleaving, embanking,
> Whirl, centripetal, mate, King down in the vortex:
> Clash, leaping of bands, straight strips of hard colour,
> Blocked lights working in, escapes, renewing of contest.[101]

C4. David Bomberg. *Ju-Jitsu*, *c.* 1913. Oil on card-board, 62 × 62 cm. Tate Gallery, London.

Pound, who was about to become a crucial supporter of the experimental English painters and sculptors closest to Bomberg's concerns, could not have seen *Ju-Jitsu* on public display before the spring of 1914. But he might easily have been introduced to Bomberg and his work the previous year by either Lewis or Epstein, both of whom Pound stoutly defended against hostile criticism. At all events, the preoccupations shared by *Ju-Jitsu* and Pound's poem show how much Bomberg now had in common with a writer who would soon play a leading role in naming and promoting the Vorticist movement.

The grid structure employed in this painting also indicates the avidity of Bomberg's involvement with the continental avant-garde. It may owe something to the recent work of Juan Gris, who experimented in paintings like *The Watch* with a similar

61. Juan Gris. *The Watch*, 1912. Oil on canvas, 65 × 92 cm. Private collection.

geometrical framework (Plate 61). Bomberg could have seen Gris's work during his French trip: after returning to London he jokingly told a friend that 'I've been to Paris, and you know all the artists leave their doors open.'[102] But the flamboyant chequerboard pattern used in *Ju-Jitsu* is very different from the partial and discreet grid employed by Gris in some of his 1912 and 1913 paintings. Even though Bomberg was still completing his student period he had already, at the age of twenty-two, digested some of the most radical developments in contemporary art and defined a path of his own to explore. Over the next twelve months it would lead him towards achievements of such confidence and power that they seem altogether astonishing for a painter whose career had only just begun.

# CHAPTER THREE A Prodigious Year

*Cubist Artist (who is being arrested for espionage by local constable).* "MY DEAR MAN, HAVE YOU NO ÆSTHETIC SENSE? CAN'T YOU SEE THAT THIS PICTURE IS AN EMOTIONAL IMPRESSION OF THE INHERENT GLADNESS OF SPRING?"

*Constable.* "STOW IT, CLARENCE! D'YER THINK I DON'T KNOW A BLOOMIN' PLAN WHEN I SEES ONE?"

62. E. E. Briscoe. *So Vast is Art, So Narrow Human Wit*, 1915. Reproduced in *Punch*, 9 June 1915.

63. David Bomberg. *Landscape Study, c.* 1913. Ink, 11 × 10.5 cm. Anthony d'Offay Gallery, London.

Soon after Bomberg left the Slade in the summer of 1913 he found himself under police arrest. His old friend Isaac Rosenberg had persuaded him to take a holiday at Sandown on the Isle of Wight, where they stayed cheaply at a house owned by a regular client of Rosenberg's father called Mrs Haydon. At this period Bomberg was far too preoccupied with the human figure to consider painting either the sea or the landscape, but he became intrigued by the island's military fortifications near Mrs Haydon's home. Rosenberg agreed that they would be a rewarding subject to study, so both artists duly attempted to gain an adequate view of the buildings. The police noticed them, grew suspicious of their activities, and arrested them in the belief that they could be spies. Interrogation ensued at the local gaol, where they were detained until Mrs Haydon managed to satisfy the senior police officer of their innocence.[1] The whole event curiously anticipated the atmosphere of the war years, when *Punch* published a cartoon showing an avant-garde artist arrested by a constable who believed the painting was 'a bloomin' plan' (Plate 62).

Although it was a farcical episode, the treatment they underwent can have done nothing to alter Bomberg's view of his position within the English social structure. He was an impecunious outsider who had always been obliged to struggle for the rights which more privileged members of society enjoyed without difficulty. Police harrassment, especially when it was so groundless, may well have intensified his feeling that life was a perpetual battle against the forces which condemned communities like the East End Jewish ghetto to such relentless deprivation. But Bomberg and Rosenberg were both resilient individuals, and they managed to enjoy the rest of their holiday scrutinizing less dangerous localities. Although the subjects Bomberg chose are not recorded, he subsequently exhibited pictures, now lost, called *Allotment Grounds* and *Wind and Water*[2] which may have been made during the Isle of Wight trip. He could also have executed here a small ink drawing which deals in a very schematic manner with a village set against a rolling hillside, trees and sky (Plate 63). Almost the only image of the countryside which survives from this period of Bomberg's life, its modest summary of form gives no hint of the importance landscape was to assume in his later work.

On his return to London, Bomberg was confronted by the task of introducing himself to the avant-garde circles where his work stood the best chance of gaining a sympathetic response. His previous contact with Lewis and Epstein must have helped him to establish a reputation, even though he later recalled the 'clashes that followed from [Lewis's] repeated unsolicited visits to the East End to keep himself in touch with what I was doing and thinking'.[3] Right from the outset Bomberg regarded Lewis's art-political machinations with instinctive mistrust. But the two men had considerable respect for each other's work, and Bomberg needed the help which such an influential artist could provide. In the summer of 1913 the only exhibition where Bomberg's work could be viewed was the relatively orthodox New English Art Club show, and even here he was only granted a single exhibit in the 'drawings and watercolours' section.[4] A few months later he succeeded in displaying three works on paper at the New English's winter exhibition,[5] but Bomberg needed to be accepted by more adventurous exhibiting outlets where his experimental work would be more fully appreciated.

He ought to have been included in the major *Post-Impressionist and Futurist Exhibition* organized by Frank Rutter at the Doré Galleries in October 1913. It was, after all, a wide-ranging survey of the European avant-garde, and generously represented a lively new generation whom Rutter thought would prove 'that "cubism" and "futurism" have already stirred English artists'.[6] Several of these painters – Lewis, Wadsworth, Etchells and Hamilton – had just stormed out of the Omega Workshops after a furious dispute with Fry. Their growing Cubo-Futurist affiliations set them apart from Bloomsbury Post-Impressionism, for Fry disliked Marinetti's rumbustious insistence on the need for a new art to express the mechanistic dynamism of the emergent century. But Bomberg was at this stage attracted to the Futurists' militant vitality, shying away from their involvement with blurred movement and yet sharing their desire to embody the energy of the machine age in the images

C5. David Bomberg. *Cubist Composition, c.* 1913. Pencil, watercolour and gouache, 27.5 × 25.5 cm. Anthony d'Offay Gallery, London.

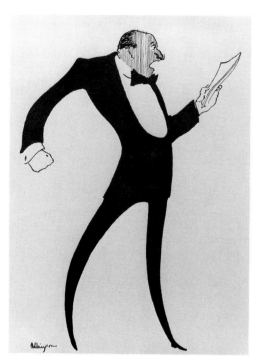

64. Adrian Allinson. *Marinetti Reciting one of his Restful Futurist Poems*, *c.* 1913. Ink, 25 × 19 cm. Private collection.

they produced. He would have been eager to attend the volcanic lectures and performances which Marinetti gave in London, at Nevinson's request, in November 1913 (Plate 64). The charismatic Futurist leader was fêted at a dinner held in his honour by a whole group of young English artists at the Florence Restaurant on 18 November. The organizing committee, consisting of Etchells, Hamilton, Lewis, Nevinson and Wadsworth, was rewarded by a typically clamorous evening. 'It was an extraordinary affair', recalled Nevinson, the most devoted English follower of Futurism. 'Marinetti recited a poem about the siege of Adrianople, with various kinds of onomatopoeic noises and crashes in free verse, while all the time a band downstairs played, "You made me love you. I didn't want to do it".' It was an intoxicating occasion, and even the most sceptical guests found themselves impressed by Marinetti's magnetism and revolutionary verve. 'Most people had come to laugh', wrote Nevinson, 'but there were few who were not overwhelmed by the dynamic personality and declamatory gifts of the Italian propagandist.'[7]

Bomberg was not, by inclination, a man who ever regarded himself as a disciple, and he always resisted Marinetti's attempts to rally English artists round the Futurist cause. But he was quite willing to associate himself for a while with the general interest in the Italian movement, and visit the carbaret club for a Marinetti performance in the Cave of the Golden Calf. Once again, the uninhibited vigour with which Marinetti exhorted his English audience to embrace the thrusting optimism and power of the new century proved memorable, and even the sceptical Lewis admitted that 'Marinetti declaimed some peculiarly bloodthirsty concoctions with great dramatic force.'[8] Bomberg remembered that 'the Cave of Harmony' housed a riotous party after the performance. 'Marinetti was present at the Round Table', he wrote, describing how 'all of us wined & dined to contentment. Lewis was threatening to punch Nevinson for daring to claim that when Marinetti stepped off the Golden Arrow bringing him into the Victoria platform No. 19 it was Lewis & not Nevinson who kissed Marinetti's hand first.'[9] Bomberg was clearly gratified to find himself in the company of so many like-minded artists, all sharing in their distinct ways the general desire for an extreme renewal in art to convey the rapidly changing condition of modern existence.

Bomberg's association with the Cubo-Futurist circle did not prevent him from attempting to find employment at the Omega Workshops. After all, Fry's offer of regular payment for part-time work, making designs which ranged from fabrics to painted boxes, was attractive to an ex-student who had not yet found a market for his own work. The abrupt departure of Lewis and his allies obliged Fry to seek out other young artists capable of applied design, and Bomberg later recalled that 'I had already done a good deal in that line for carpet-hand-weaving small establishments.'[10] Besides, his close friend Roberts had recently found a job at the Omega 'with a letter of recommendation from Laurence Binyon, at the British Museum Print Room'. For a while Roberts was happy with the Workshops. 'I got employment painting designs on paper knives, lampshades, tabletops and silk scarves, three mornings a week at a salary of a half-sovereign a visit', he wrote, recalling how, 'with no rent to pay, and a salary of thirty shillings, in those days that was independence.'[11] Bomberg presumably agreed, for he likewise seems to have been employed by the Omega soon after Roberts joined. But not for long. Robert's wife Sarah remembered 'Bobby telling me that he got very bored with the Omega work',[12] and he may also have felt increasingly out of sympathy with the designs produced there. His Slade contemporary John Currie mentioned to a friend that Roberts had been painting Omega objects 'specially to please Fry so that he could get work';[13] and Bomberg probably came to resent the same constraints.

He even appears to have instigated a revolt, with the help of Roberts and others, against the prevailing conditions at the Omega, asking no doubt for a greater degree of artistic independence and financial reward. But Vanessa Bell viewed their demands as a presumptuous threat to the Workshops, and curtly told Fry:

I think Bomberg and Co. are intolerable. You must simply treat them in a perfectly cold business-like way. After all it is purely a business matter and you haven't really any choice. You are bound to use the money as economically as you can and to get the best value possible and none of these people are [*sic*] dispensable. Roberts is very good but I believe you will be able to get hold of all sorts of quite good people now and it's absurd they should give themselves these airs.[14]

Bell's irritable letter indicates that she gravely underestimated the potential ability of Bomberg, who did not deserve to be regarded as such a dispensable asset. After all, he later painted a shawl for Kitty which displayed a gift for exuberant decoration (Plate 230). But there may have been a clash of personalities between the fiery working-class Jewish artist and the refined middle-class Bloomsbury coterie dominating the Omega. Moreover, by the time Bell wrote her letter on 26 December, Bomberg was closer to Lewis and his allies than to Fry. Roberts afterwards explained that an approach from Lewis 'brought about my departure from the Omega',[15] and the same was probably true of Bomberg. Although he always maintained his distance from Lewis, an important exhibition had opened on 16 December with a section which brought the two men into contact with each other again. The show was staged at the Brighton Public Art Galleries and given the unwieldy title *Exhibition by the Camden Town Group and Others*. But it marked a momentous attempt to create greater solidarity among various rival factions of the English avant-garde. The former Camden Town Group, having merged with the so-called 19 Fitzroy Street Group, now consented to join the Cumberland Market Group and the Cubo-Futurists in an association which eventually became known as the London Group. Although they were united by their opposition to the Royal Academy and their impatience with the pallid conservatism of the New English Art Club, they also made a point of excluding Fry's Post-Impressionist circle from the association. The Bloomsbury artists were conspicuous by their absence from the Brighton exhibition, which was staged as a dress rehearsal for the first official London Group show the following year. But J. B. Manson's diplomatic introduction to the Brighton catalogue did not mention the absence of Fry and his friends, emphasizing instead that in the London Group, 'Cubism meets Impressionism, Futurism and Sickertism join hands and are not ashamed, the motto of the Group being that sincerity of conviction has a right of expression . . . It is well, perhaps, that the vital qualities in modern art should be concentrated on one definite group, instead of being scattered in the medley of modern exhibitions.'[16]

But these conciliatory remarks were somewhat undermined by a second introduction to the catalogue by Lewis. It was entitled 'Room III. (The Cubist Room)', and concentrated exclusively on the artists gathered in that section of the show. Apart from Lewis himself and the three painters who had walked out of the Omega with him, the Cubist Room also embraced Nevinson, Epstein and a newcomer to avant-garde exhibitions: Bomberg. Although the youngest artist in the show, he was extensively represented with six works[17] – including a large *Primeval Decoration* which, at £50, was far more expensive than anything else in the Cubist Room.[18] *Vision of Ezekiel* was also included in the show (Colour Plate 3), even though Lewis apparently made a last-minute attempt to ensure that it was not displayed at Brighton. Bomberg later claimed that Lewis hid the canvas when the exhibits were being prepared for transportation in London, and that Spencer Gore finally 'rescued my painting from Oblivion & himself ran it down to the van already moving off to Brighton with the collection of paintings for exhibition'.[19] Even then the bizarre feuding continued, for Lilian Bomberg recalled that 'David told me how Lewis placed *Ezekiel* behind a door so that it could hardly be seen. So David angrily took the painting away with him on the roof of a taxi during the exhibition.'[20]

Despite these unpleasant hostilities, which suggest that Lewis felt threatened when confronted by Bomberg's best work, the Cubist Room established the young painter at the forefront of the English avant-garde. Even Lewis, who wrote in his catalogue introduction that 'the form and subject-matter are academic' in 'Bomberg's painting of a platform',[21] could not prevent himself from ending the essay by declaring that 'the structure of the criss-cross pattern' was 'new and extremely interesting'. Elsewhere in the introduction he announced the dramatic emergence of a 'group of painters' consisting of Etchells, Hamilton, Wadsworth, Nevinson and Lewis himself, who

> are not accidentally associated here, but form a vertiginous, but not exotic, island in the placid and respectable archipelago of English art. This formation is undeniably of volcanic matter and even origin; for it appeared suddenly above the waves following certain seismic shakings beneath the surface. It is very closely knit and admirably adapted to withstand the imperturbable Britannic breakers which roll pleasantly against its sides.

Although Bomberg was not yet cited as a member of this eruptive and impregnable new force, his inclusion in the Cubist Room implied that he might soon be admitted to the group. Moreover, the arguments put forward by Lewis in the rest of his catalogue introduction were broadly compatible with Bomberg's beliefs. Not yet ready to christen the Vorticist movement, Lewis called this section 'the Cubist Room' partly because he wanted to acknowledge a debt to 'the genius of Cézanne', who had prompted so many young artists to work towards organizing 'the character of the works he threw up in his indiscriminate and grand labour'. The Cubist Room's name also signified Lewis's desire to distance the artists he supported from the Futurism 'practised by the five or six Italian painters grouped beneath Marinetti's influence'. But Lewis still preferred the Futurist name to any alternative which had lingering associations with Fry. 'To be done with terms and tags', wrote Lewis, 'Post Impressionism is an insipid and pointless name invented by a journalist, which has been naturally ousted by the better word "Futurism" in public debate on modern art.' Bomberg would have agreed, for he gave qualified support to the Futurist cause in its most general sense when interviewed by the *Jewish Chronicle* a few months later.[22] He would also have assented to Lewis's views on the inspiration which the clangorous modern world gave the artist: 'a man who passes his days amid the rigid lines of houses, a plague of cheap ornamentation, noisy street locomotion, the Bedlam of the press, will evidently possess a different habit of vision to a man living amongst the lines of a landscape.' Bomberg, who was now placing his intensely urban East End experiences at the very forefront of his art, possessed the 'habit of vision' which Lewis was trying to define. So he could hardly have objected to the main burden of Lewis's argument, which reached its climax with the declaration that

> the work of this group of artists for the most part underlines such geometric bases and structure of life, and they would spend their energies rather in showing a different skeleton and abstraction than formerly could exist . . . All revolutionary painting to-day has in common the rigid reflections of steel and stone in the spirit of the artist; that desire for stability as though a machine were built to fly or kill with; an alienation from the traditional photographer's trade and realisation of the value of colour and form as such independently of what recognisable form it covers or encloses. People are invited, in short, to entirely change their idea of the painter's mission, and penetrate, deferentially, with him into a transposed universe, as abstract as, though different to, the musician's.[23]

Except for the strangely sinister reference to a destructive machine, Lewis's passage contained nothing that contradicted the beliefs held by Bomberg at this period. For he was likewise searching for 'geometric bases and structure of life' which would reflect the 'steel and stone' of his metropolitan environment, and he shared the 'desire for stability' which impelled so many of the English avant-garde to shun the blurred, multiple motion explored by the Italian Futurists. Indeed, Bomberg pursued the idea of 'a transposed universe' as tenaciously as any of the young painters who wanted to free themselves from photographic literalism. Whether he liked it or not, Bomberg had for the time being become associated with the group of Cubo-Futurists whom Lewis was now beginning to promote as the most vigorous new force in English art.

So far, however, Bomberg had concentrated on figure compositions rather than

65. David Bomberg. *Procession, c.* 1913. Crayon and watercolour, 24.8 × 68 cm. Anthony d'Offay Gallery, London.

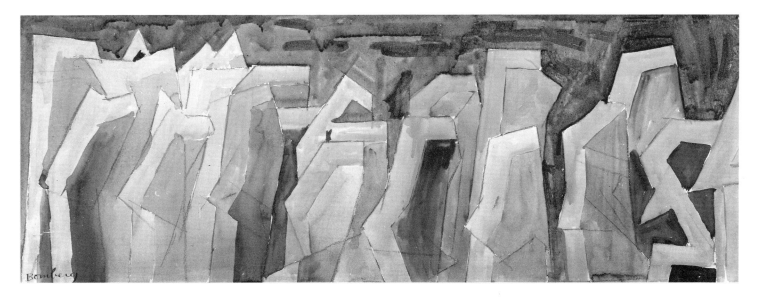

69. David Bomberg. *Cubist Composition, c.* 1913. Ink, 28 × 25.5 cm. Anthony d'Offay Gallery, London.

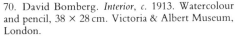

70. David Bomberg. *Interior, c.* 1913. Watercolour and pencil, 38 × 28 cm. Victoria & Albert Museum, London.

overtly depicting the modern, machine-age world which the other exhibitors in the Cubist Room were admitting to their work. *Jewish Theatre* excluded any reference to the Pavilion's architecture (Plates 48, 49), and even *Ju-Jitsu* had not, in the painted version, been at all specific about the protagonists' surroundings (Colour Plate 4). A watercolour like *Procession* shows how Bomberg preferred to depict groups of figures in unidentifiable settings (Plate 65).[24] Despite extreme simplification, the long train of advancing mourners still manages to convey a very human sense of melancholy as they parade with drooping heads and bent backs across the extensive width of the paper. Several small yet imposing oil-on-board studies also survive from this period (Plates 66, 67, 68). They show how Bomberg, concentrating on either one figure or clusters of two or three, reduced them to the most spare equations of form and colour without sacrificing their inherent vitality. Although brusque in handling and unprecedentedly austere in construction, these little panels retain Bomberg's very personal feeling for compact, animated drama. His reluctance to consider anything apart from the taut interplay of bodies caught up in arresting encounters is a characteristic evident in most of his pre-war work.

But a few pictures do reveal Bomberg's attempt to encompass the urban environment which all his block-like, mechanistic figures implicitly inhabit. Two versions of an image called *Cubist Composition* demonstrate the beginning of this process by setting their seated protagonist in an architectural context. One of them is an incisive ink-drawing where Bomberg juxtaposes several different methods of handling line, organizing the principal structure with confident strokes of the nib, experimenting with densely packed ranks of parallel lines near the top, and scattering a loose shower of tiny particles throughout the interstices of the design (Plate 69). The principal figure is here surrounded by large foreground forms which, although impossible to decipher in representational terms, contain hints of bodily action. But the second version of *Cubist Composition*, a far less hectic and more resolved image employing washes of high-keyed watercolour and gouache, clarifies the setting (Colour Plate 5).[25] The figure now appears to be surrounded by a complex of walls, girders and geometricized furniture. Although constructed from the same primary shapes as the figure, they have been solidified into objects which set up an impregnable defence around him.

The gusto with which Bomberg deploys these sturdy ramparts, steps and other primary architectural forms helps to explain why he also decided to execute a brilliantly coloured study of a stairwell (Plate 70). Here, for once, people are nowhere to be seen. Probably based on the gaunt approach to his third-floor flat at Tenter Buildings, and yet irradiated by the exuberance of scarlet, lemon, emerald and light blue, *Interior* is a very assured design which subjects walls, floor, ceiling and staircase to the drastic paring he had previously carried out on figures alone. Bomberg retains a sense of volume and recession even as he stresses the flatness of the design and reduces its component parts to their starkest essentials. The handrail, twisting its snake-like way up from one level to another, plays a crucial role in conveying this spatial complexity, but at the top it is flattened out to accord with the schematic pattern of steps and banisters. Although the chequerboard structure in this small area of the picture echoes the grid Bomberg employed in *Ju-Jitsu* (Colour Plate 4), the rest of *Interior* proves that he resisted the temptation to eradicate its links with a particular stairwell. Now that figures had been temporarily banished from his work, he felt free to delineate the eerily deserted character of this space without splintering it into rigid geometrical segments.

Bomberg's involvement with architecture, which would become so important during the Palestine period, was surely spurred on by his friendship with the Dutch architect Robert van't Hoff. Then at the beginning of a career which later led him to join the De Stijl group for a few years, van't Hoff had the good fortune to receive a commission to design a house for one of Britain's leading painters. Early in 1913 he happened, quite fortuitously, to be drinking in a Chelsea pub when Augustus John appeared and asked whether any architects were present. Van't Hoff introduced himself and John, with typical impulsiveness, commissioned him to draw up designs for a house in Mallord Street near the King's Road. After preparing himself for the task in Holland, van't Hoff returned with the plans in May 1913; John told a friend that 'my Dutch architect has done his designs for my new studio with living rooms – and it will be a charming place.'[26] A year passed before the building itself was completed, and it is not known precisely when Bomberg

68. David Bomberg. *Figure Composition*, c. 1913. Oil on board, 35.1 × 25.8 cm. City Art Gallery, Manchester.

66 (above right). David Bomberg. *Figure Study*, c. 1913. Oil on board, 40.5 × 32 cm. Fischer Fine Art, London.

67. David Bomberg. *Composition with Figures*, 1912–13. Oil on panel, 41 × 32.8 cm. Whitworth Art Gallery, University of Manchester.

71. Robert van't Hoff's house for Augustus John, 28 Mallord Street, London. Photograph by the author.

72 (centre). David Bomberg. *Study of a Door*, 1913–14. Crayon and ink, 28 × 19 cm. Anthony d'Offay Gallery, London.

73 (right). David Bomberg. *Architectural Studies*, 1913–14. Crayon and ink, 31 × 34.3 cm. Anthony d'Offay Gallery, London.

74 (below). Piet Mondrian. *Demolished buildings, Paris, c.* 1912. Pencil, 17.2 × 10.5 cm. Marlborough Fine Art, London.

befriended van't Hoff. In a memoir written decades later, Bomberg claimed that the two men knew each other 'between 1912–13', but his account suggests that they met while the house was being constructed: Bomberg recalled that he came across van't Hoff 'when he arrived in London to build, for Augustus John, 28 Mallard [*sic*] Street, Chelsea, and it was with a group of adventurous young painters that the former gathered at his Studio, that I met Van T'Hoff [*sic*].' Apart from mentioning that the Dutch architect 'was my friend', Bomberg did not explain why they appreciated one another's company. He only remembered that van't Hoff 'took his own estimations of the contribution I was making, back to Holland'.[27] But it is safe to assume that van't Hoff was intrigued to find an English artist exploring a direction which paralleled Mondrian's contemporaneous work, and Bomberg would in turn have been able to study the stage-by-stage development of John's new house (Plate 71).

Bomberg's opinion of the finished building, with its elongated windows, panelled interior, roof garden and graceful staircase copied from Rembrandt's house, is unknown. But he probably admired van't Hoff's austere, rectilinear and simplified style, summarized so aptly by John as a 'passion for rectangles'.[28] Bomberg had a similar passion, and he would surely have warmed to a house which John described as 'rather Dutch' but with 'a solidity and tautness unmatched in London – a little stronghold'.[29] Bomberg, who had earlier been fascinated by the fortifications on the Isle of Wight, shared van't Hoff's predilection for an architecture of uncompromising severity. He even started making studies of structures which look like partially built or half-demolished buildings, filling them with windows and in one instance superimposing a strange upright drawing of a door on a diagonal facade (Plates 72, 73). These images recall the small pencil-sketches which Mondrian made a little earlier of demolished buildings in Paris, most of which record their particular sites rather more faithfully than Bomberg's studies appear to do (Plate 74). But Mondrian departed very radically from his starting-point when he executed a series of facade paintings on this theme, whereas Bomberg adhered more closely to the facts of a building when he made a gouache version of his architectural drawings.

Although it is now called *Composition (Green)*, this intriguing work takes its design from three little sketches of a building seemingly viewed in cross-section. Watching the progress of van't Hoff's house may have made Bomberg realize the pictorial potential inherent in the half-finished stage of a building, before its framework became clothed in a final layer of brick or stone which invariably hid its original raw strength. The philosopher and poet T. E. Hulme, who soon afterwards became a friend of Bomberg's, declared in January 1914 that the modern artist 'passively admires' the 'superb steel structures which form the skeletons of modern buildings, and whose gradual envelopment in a parasitic covering of stone is one of the daily tragedies to be witnessed in London streets'.[30] Perhaps *Composition (Green)* can be seen as Bomberg's attempt to resist the tragedy by making one of these 'skeletons' the subject of a picture.

In the preliminary sketches, Bomberg certainly appears to be noting down room-

75. David Bomberg. *Study for Composition (Green)*, 1913–14. Pen and ink on newspaper, 8.2 × 11.2 cm. Anthony d'Offay Gallery, London.

76. David Bomberg. *Study for Composition (Green)*, 1913–14. Pencil, 10 × 13.5 cm. Anthony d'Offay Gallery, London.

77. David Bomberg. *Study for Composition (Green)*, 1913–14. Pencil, 10 × 15.3 cm. Anthony d'Offay Gallery, London.

78. Wyndham Lewis. *Composition*, 1914–15. From the 'Vorticist Sketch-Book'. Ink, pencil and chalks, 31 × 26 cm. Anthony d'Offay Gallery, London.

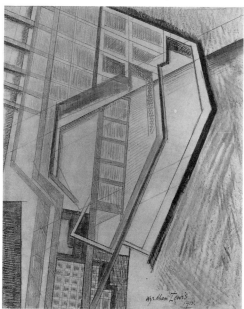

by-room details of a building he had either seen or imagined. The smallest drawing, executed on newspaper, even contains abbreviated words which seem to describe the function of each room (Plate 75). But at the same time as he adopts this almost documentary approach, Bomberg is already assessing how this cross-section might best be used in his own work. Each of the other two studies encloses the building in an uninterrupted rectangular contour, dispenses with the abbreviated words labelling the rooms, and turns most of the curves into angles (Plates 76, 77).

The structure which he outlines here is carried over with remarkable fidelity to *Composition (Green)* (Colour Plate 6). Although the building in this gouache looks more like a figment of Bomberg's imagination than a real piece of architecture, its internal divisions stay close to the sketches. Everything may now be more refined, and the contrasted blocks of colour make the picture look superficially like an abstract design, but its resemblance to a network of rooms remains inescapable. Bomberg even keeps the strange area near the centre of the drawings, where a serpentine curve is juxtaposed with a dark horizontal rod. Compared with the restless studies of modern buildings made by Lewis in the 1914–15 period, which stress vertiginous dynamism and concentrate on external forms alone (Plate 78), Bomberg's gouache seems calm, stable and determined to penetrate the facade in search of internal structure. But it also suggests that he was considering, like Lewis and Mondrian, the possibility of painting images based on urban architecture, and in this respect *Composition (Green)* stands as Bomberg's most overt attempt to depict the 'steel city'[31] he wrote about in the summer of 1914.

Ultimately, though, his obsession with the human figure prevented him from making pictures of a metropolis devoid of its population. *Composition (Green)* was an isolated and probably unexhibited experiment by an artist who soon returned to groups of figures engaged in forceful actions. As a sign of his continuing commitment to this central subject, he included *Vision of Ezekiel* in the Friday Club show of February 1914 (Colour Plate 3).[32] It was the first time this painting had been displayed in a London gallery, and the perplexed critics found themselves obliged to admit that Bomberg possessed a distinctive talent. *The Athenaeum*'s reviewer remarked on the 'ingenuity' of *Ezekiel*, where 'Dutch dolls engage in an elaborate gymnastic act in imitation of a Greek fret.'[33] Even artists whose work lay a long way from Bomberg's concerns now began to recognize his unusual ability: Augustus John told the leading American collector John Quinn, who purchased *Head of a Poet* (Plate 50), 'you ought to get more Bombergs, he is full of talent'.[34] The equally prominent English collector Edward Marsh arrived at a similar conclusion, planning to include Bomberg in a volume of 'Georgian Drawings' as well as purchasing one of his works for £10 after hearing from Gertler that 'they are undoubtedly extremely good drawings and certainly show great power . . . he put an enormous amount of work into them and did innumerable studies for them!'[35]

Bomberg's growing reputation was fortified when the first official exhibition of the newly-formed London Group opened at the Goupil Gallery in March 1914. It was a major event, solidifying the tentative alliance announced at Brighton four months earlier, and marking a new spirit of confidence and adventurousness among the disparate young painters who had agreed to become members. Writing in *The Observer*, P. G. Konody was accurate enough when he declared that the London Group 'appears to be made up of the former "Camden Town Group", the seceders from Mr Roger Fry's "Omega Workshops" and other English Post-Impressionists, Cubists and Futurists'. But the diverse origins of the group did not prevent it from mounting a concerted onslaught on accepted ideas about the form which a work of art might legitimately take, and Bomberg was among the most extreme contributors to the show. Konody commented that

> The very aggressive blue of the invitation card might have been taken as an indication of the defiant attitude of the members, although it would need a whole combination of crude hues to prepare one for the violent assaults that have been planned by these London 'Indépendants.' Both the Grafton and the Doré Galleries are left miles behind; and even the once disconcerting jigsaw puzzles of the Italian Futurists would appear childishly simple beside the latest geometrical obfuscations upon which Mr David Bomberg and Mr Wyndham Lewis have expended their energies.[36]

Bomberg was represented at the London Group by five exhibits, including *Ju-Jitsu*

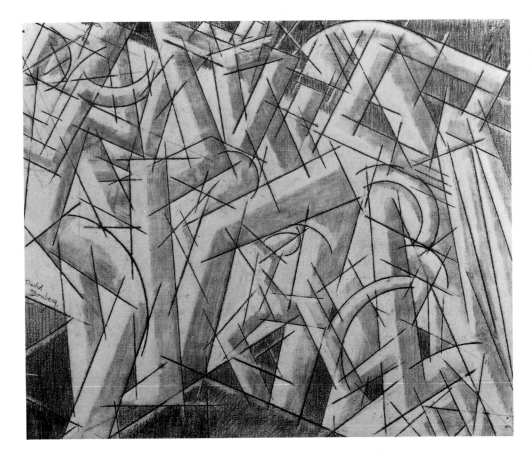

79 (right). David Bomberg. *Acrobats*, 1913–14. Chalk, 47 × 57 cm. Victoria & Albert Museum, London.

80 (top). Christopher Nevinson. *The Arrival*, 1913–14. Oil on canvas, 76 × 63.5 cm. Tate Gallery, London.

81 (bottom). Edward Wadsworth. *Cape of Good Hope*, 1914. Oil on canvas (?). Lost.

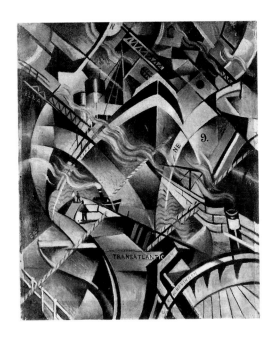

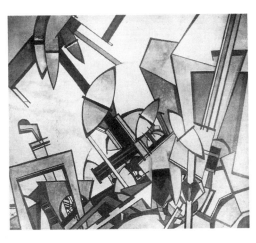

and an outstanding chalk drawing called *Acrobats* (Plate 79).[37] It demonstrated with awesome conviction how many liberties he was now prepared to take with the figures, who take up an unprecedented amount of the design. Many have been deprived of their facial features, hands and feet; one body is truncated so that only the legs parade across the picture; and in several places limbs are turned into arcs and cylinders which cannot be anatomically identified with any precision. Bomberg allows the contours to take on a life of their own, almost independent of the bodies they enclose. Their incisive lines dominate the composition, often travelling beyond the legs and arms to which they belong. As a result, a crisp network of intersecting diagonals establishes its angular vitality, softened by a few curves but never allowing the design to stabilize itself with horizontals and uprights. Everything is tilting, balancing and straining, just as acrobats would when practising their performances. Despite the degree of abstraction in this drawing, which prompted one baffled reviewer to remark that *Acrobats* 'would have stood a better chance of being understood had it been renamed "Railway Smash"',[38] Bomberg's modelling never loses sight of the bodies' weight and solidity. Nor is their humanity forgotten. The occasional eye or nose is included, and the welter of intercutting contours does not prevent the form of a child emerging just below the composition's centre. With arms and legs outstretched in an ecstatic leap, this little figure reflects the elation Bomberg must have felt as his own art developed with such authority and poise.

———

The enormous new painting which he displayed at the London Group show, *In the Hold*, revealed just how formidable the twenty-three-year-old artist was becoming. It was the most sustained attempt Bomberg had so far made to produce a masterpiece in the Renaissance sense of the word – a bravura work intended to demonstrate the prowess of a newly mature painter. The theme he chose possessed a potent appeal for other artists in the London Group exhibition: Etchells displayed a picture, subsequently lost, called *On Board Ship*; Nevinson's *The Arrival* used clamorous Futurist simultaneity to convey the sensation of a steamer docking in port (Plate 80); and Wadsworth was commencing his prolonged sequence of images inspired by modern industrial ports.[39] But *In the Hold* shows no overt interest in the mechanized environment which impelled Wadsworth to make aerial views of ports the starting-point for paintings like *Cape of Good Hope* (Plate 81), with its comprehensive evocation of the world described so fervently in *Blast No. 1*'s mani-

festo: 'scooped out basins, heavy insect dredgers, monotonous cranes, stations, light-houses blazing through the frosty starlight, cutting the storm like a cake, beaks of infant boats, side by side, heavy chaos of wharves, steep wall of factories'.[40] Although Bomberg was probably attracted as a child to the dockland district near his old Whitechapel home, where he would have watched ships from many parts of the world unloading at the wharf, *In the Hold* focuses with great singlemindedness on a confined area of one ship. And most of the space is occupied, not by picturesque details of cargo or maritime equipment, but by massive figures engaged in strenuous activity.

An impressive crayon drawing indicates that Bomberg originally included only the most summary reference to the ship itself (Plate 82). The strongly handled clusters of parallel lines modelling the bodies also define an oblong area of shadow which constitutes, at this early stage, Bomberg's sole allusion to the structure of the hold itself. He is far more interested in the energetic movements of the men, and their efforts are intensified by the bristling contours which, as in *Acrobats*, extend beyond the limbs in order to cross swords with each other throughout the composition.

C6. David **Bomberg**. *Composition (Green)*, 1914–15. Gouache and varnish, 28.3 × 31.4 cm. Anthony d'Offay Gallery, London.

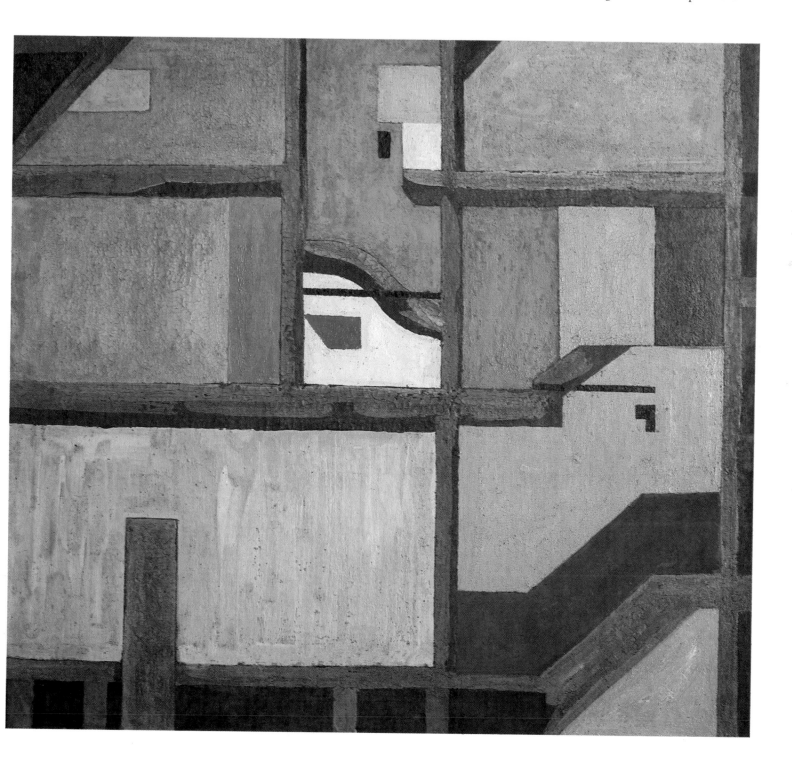

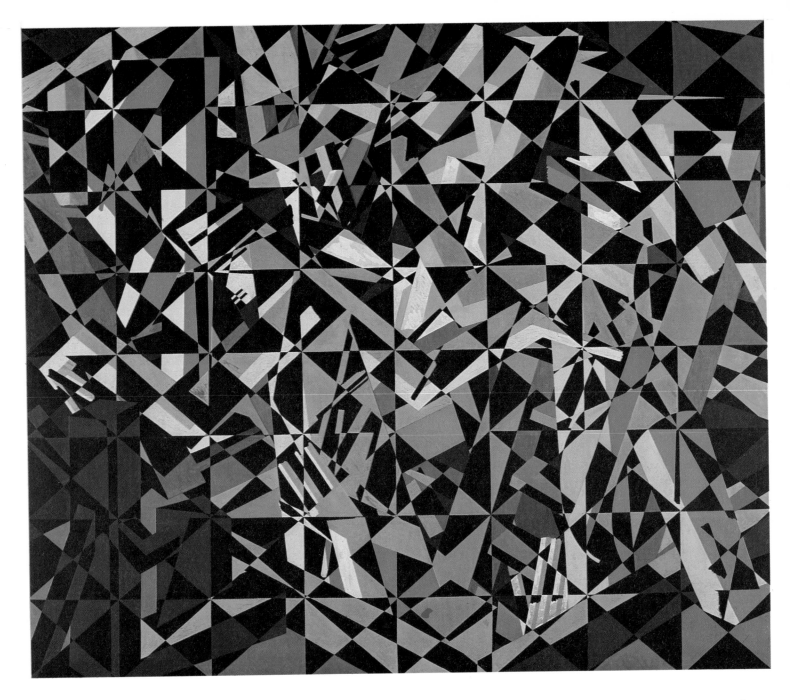

C7. David Bomberg. *In the Hold*, 1913–14. Oil on canvas, 198 × 256.5 cm. Tate Gallery, London.

This sharpness is softened in a conté-crayon drawing which goes some way towards clarifying each of the protagonists in the frenetic group (Plate 83). It enables us to realize that they are engaged in lifting a figure rather than a crate of merchandise, and that the tangle of limbs is not so far removed from Bomberg's earlier images of wrestling (Plate 58). But the identity of the hold remains as indeterminate as before, therefore implying his unwillingness to encumber the design with the ship's apparatus.

Possibly acknowledging that the painting would need to be rooted more securely in a specific context, Bomberg admitted a certain amount of environmental detail into his final drawing (Plate 84). But he made sure that the sturdy post, the broad frames of the hatches and the equally robust step-ladders possess the same formal substance as the figures they surround. Human arms and wooden struts all appear to be constructed from raw material of great strength, giving the entire composition a robust resilience. Bomberg must have witnessed at first hand the muscular capacity of the workers who spent their days shifting cargo at the docks, and he gives his figures a comparable aura of power. But he also knew that the men were in a position to create considerable political impact. This tough work-force was quite capable of alarming the government by calling strikes in the Port of London, where a tradition of radical protest had flourished since the later decades of the nineteenth

64

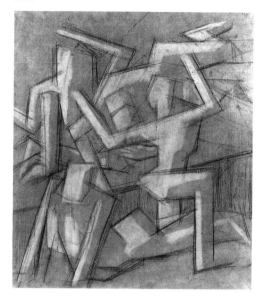

83. David Bomberg. *Study for In the Hold*, 1913–14. Conte crayon, 58.5 × 51 cm. Fischer Fine Art, London.

82. David Bomberg. *Study for In the Hold*, 1913. Crayon, 58 × 51 cm. Anthony d'Offay Gallery, London.

century. Less than three years before *In the Hold* was painted, the industrial unrest ignited by a miners' strike over pay at Tonypandy in South Wales spread to other parts of Britain, including the Port of London. The dockers there did not suffer any casualties from the intervention of troops, as they had at Tonypandy and Llanelli, but everyone in the East End was aware of the disturbances. In August 1911 Bomberg's Whitechapel friend Joseph Leftwich wrote in the middle of a heatwave that 'there is a strike epidemic abroad. It is as bad as most epidemics in such heat. Dockers, Lightermen, Stevedores, Carmen – all connected with the loading and unloading of ships – are on a strike and today the railway-men are out too'.[41] Leftwich went on to note that the strike had brought trade to a standstill, and Bomberg could hardly have failed to be aware of the dock-workers' ability to threaten the nation with industrial paralysis. Indeed, there was further disruption in the Port of London the following year, when lightermen, carters and dockers called a strike to protest against working with non-union labour. Their action was part of a growing realization that working-class solidarity could be an effective way of creating strength in industrial action.

In such a context, it is not surprising that the two huge figures whose looming bulk takes up so much of the final drawings are heroically presented. Although Bomberg did not share the fervent left-wing convictions held by Leftwich and many of his other East End friends, he sympathized with them and understood the importance of struggling to break free from the limitations of working-class life. After all, his own energies had been directed at becoming an artist in the teeth of the pressure imposed by poverty and racial origins, so the dockers' efforts to extend

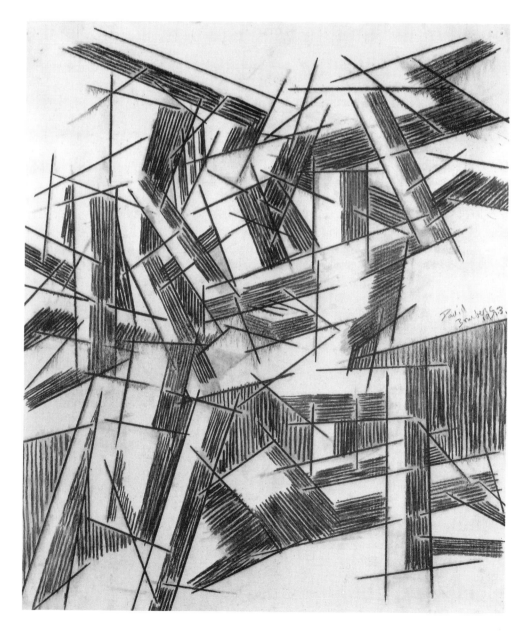

85. Ford Madox Brown. Detail from *Work*, 1852, 1856–63. Oil on canvas, arched top, 137 × 197.3 cm. City Art Gallery, Manchester.

their rights would have met with his instinctive approval. *In the Hold* belongs to a tradition of depicting the heroism of manual labour which extends at least as far back as Ford Madox Brown's *Work* (Plate 85). Here, as Linda Nochlin has pointed out, Brown's dignified portrayal of the excavating navvies expressed 'a concept which was fairly novel at the time. Before the middle of the nineteenth century, and indeed well past it in certain circles, to work with one's hands was considered degrading.'[42] Bomberg certainly did not agree with this view, and his figures stretch their huge arms across the picture with the same expansive energy as the two men wielding shovels in *Work*. Indeed, the step-ladders in Bomberg's drawing are oddly reminiscent of the wooden implement propped up so prominently in the foreground of Brown's painting.

Apart from its proud emphasis on the worker's physical prowess, however, *In the Hold* also hints at another meaning which may relate in a very personal way to Bomberg's family history. For Plate 84 reveals, quite unequivocally, that the figures are engaged in directing and lifting people from one part of the ship to another. Moreover, the passenger carried aloft in the upper part of the design is small enough to be a boy, and he clings with distinct signs of anxiety to the head of the man who clutches him. Who is this human cargo, and why did Bomberg not depict the unloading of inanimate freight instead? Most of the ships moored in the dockland area would not have been carrying passengers, and the grim, strenuous scene in the drawing for *In the Hold* could not possibly depict the landing of a pleasure-boat. The more this picture is examined, in fact, the stranger its implications become. There seems to be an element of urgency and jostling strain which has nothing to do with the leisurely disembarkation of sightseers after a trip down the Thames. The two hands which thrust up from the floor below appear to be waving for help, and behind the two principal figures a partially obscured tangle of limbs suggests that someone has fallen.

The possibility grows that the people in the hold of this ship have been enduring considerable discomfort, and that their journey is terminating in an atmosphere of bewilderment, harshness and apprehension. Bomberg knew about such events not only from the testimony of his parents, who had emigrated to the East End some thirty years before, but also from personal observation of the forlorn boatloads which continued to arrive at the docks throughout his childhood. Joseph Leftwich recalled that 'immigrants landing at the docks were a common sight' during this period, and he agreed that they were 'quite possibly the subject of *In the Hold*. I remember seeing a dozen or more groups of outlandish, exotically dressed men, women and children just off the ship and looking for shelter.'[43] Charles Booth's *Life and Labour of the People of London* vividly described the hectic activity to be

84. David Bomberg. *Study for In the Hold*, 1913–14. Chalk, 55.5 × 66 cm. Tate Gallery, London.

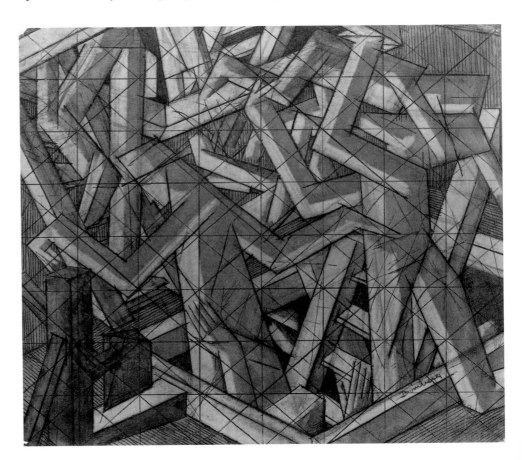

witnessed whenever a consignment of tired and harrassed newcomers arrived at the landing-stage:

> For a few moments it is a scene of indescribable confusion; cries and counter-cries; the hoarse laughter of the dock loungers at the strange garb and broken accent of the poverty-stricken foreigners; the rough swearing of the boatmen at passengers unable to pay the fee for landing. In another ten minutes eighty of the hundred newcomers are dispersed in the back slums of Whitechapel.[44]

If Bomberg was indeed inspired by the unloading of immigrants in his drawing, he obscured this starting-point when the big canvas was executed (Colour Plate 7). Pursuing the method he had first explored in *Ju-Jitsu*, Bomberg transferred the elaborate grid on the final drawing to the surface of the painting and allowed the squared-up pattern to disrupt his figurative composition. The outcome was far more spectacularly fragmented than *Ju-Jitsu* had been (Colour Plate 4). For in the earlier painting Bomberg only divided its squares in half, allowing simple triangular sequences to assert themselves wherever the composition remained devoid of people. Each square of *In the Hold*, by contrast, is divided into quarters, and the gigantic figures are so omnipresent that the entire painting is agitated by a restless conflict between the abstract grid and the representational scene it shatters. The geometrical hailstorm raging through this canvas makes *Ju-Jitsu* appear relatively sedate. Bomberg has not allowed anything to escape the highly organized splintering process, and our eyes are caught up in a ceaseless struggle to understand how the shower of broken fragments can be related to the subject announced by *In the Hold*'s title. Without the final drawing to act as a guide, we would have great difficulty deciphering either the figures or their surroundings in this optical maelstrom.

Why did Bomberg subject his composition to such a ferocious and disorientating onslaught? In an interview given to the *Jewish Chronicle* around this time, he sounded quite categorical about his desire to free the painting from its representational origins:

> My methods are the result of an attempt to emancipate myself from the theme that in itself has no interest for me, and to concentrate upon form which may be contemplated from innumerable aspects. Take my picture 'In the Hold' which is being shown at the Goupil Gallery. It depicts some men emerging from one trap-door and entering another in the hold of a ship. Over this subject I have superimposed a scheme of sixty-four squares, whereby the subject itself is resolved into its constituent forms which henceforth are all that matter. Art has too long suffered from what I may call a literary romanticism, from which I desire to emancipate it.[45]

The question begged by this apparently cut-and-dried statement centres on the meaning attached by Bomberg to the word 'form'. Although he professes no interest in the painting's 'theme', the fact remains that *In the Hold* takes as its starting-point a highly energized moment in the bustling activities of a great metropolitan port. The choice of this subject arises from Bomberg's almost programmatic desire to involve his art with modern urban existence. Elsewhere in the *Jewish Chronicle* interview, he explained that 'I want to translate the life of a great city, its motion, its machinery, into an art that shall not be photographic, but expressive.' In other words, the 'constituent forms' on which he wished to concentrate did not prevent this huge painting from remaining 'expressive' of its quintessentially dynamic subject. When Bomberg told his interviewer that these forms 'may be contemplated from innumerable aspects', he was surely implying that *In the Hold* opened itself to a wider range of interpretations than a more literal picture would have done. Far from confining his painting to a narrow, abstractionist obsession with 'pure' form, Bomberg aimed at offering a multi-faceted set of insights into the world he knew best. 'Life is very different today from what it was in the Middle Ages', he emphasized in his interview, 'and the new life should find its expression in a new art, which has been stimulated by new perceptions.'[46]

*In the Hold* implements Bomberg's stated intentions with absorbing complexity. On one level, the dramatic fragmentation of the figures on the ship reinforces the vigour with which they work. To look at this painting is to be caught up in a kinetic field which parallels the vitality of the men themselves. The whole design is alive with an electric energy which seems to flash its way into the limbs and shipboard props like jagged strokes of lightning. The incandescent colours accentuate

this sense of a scene radiating heat from a high-voltage discharge, and yet they do not result in complete kaleidoscopic confusion. Although the chequerboard grid seems at first glance to have been employed in a ruthlessly schematic manner, Bomberg ensures that the splintering caused by the triangles within each square fails to disperse the painting's most important element. The main figure stretching his arms across the picture-surface may be shot through with fierce particles, but his glaring blue presence refuses to disintegrate; rather is he transformed by the action of the grid into a far more active and powerful agent than the final drawing suggested. In the study he seemed a somewhat stolid worker, whereas the painting presents him as an almost superhuman force capable of titanic exertions on behalf of the people disembarking from the ship.

Apart from this one dominant and masterful presence, however, the figures who filled the final drawing with their massive bulk have all been fragmented to a virtually unrecognizable extent by the painting's grid. This iconoclastic element cannot be ignored, and it points to another level of meaning which must have been in Bomberg's mind. At the same time as he celebrates and indeed magnifies the central protagonist's power, Bomberg subjects the rest of the picture to a shattering so ferocious that it may well signify the incipient breaking-up of the old manual work process. The action of the chequerboard squares at once intensifies the sense of energy and, quite literally, smashes the figures into a myriad small pieces. Machine-age geometry is here presented as the agent of explosive renewal, threatening to replace the muscular prowess of the men with a hard-edged grid which evokes the impersonal world of industrial mechanization. Linda Nochlin has emphasized that Ford Madox Brown's *Work* already seemed 'ironically, somewhat nostalgic in extolling physical prowess at just the time when, as Michelet had sadly pointed out as early as 1846, the machine was making manly strength an anachronism'.[47] The labourers that Bomberg painted over half a century later were even more threatened by mechanization than Ford's navvies had been, and *In the Hold* appears to dramatize the imminent supercession of manual labour by the alternatives which machine-age inventiveness was introducing to dockland.

Bomberg was not alone in creating a modernist painting which simultaneously affirmed and dispersed the presence of the modern worker. In March 1912 he had been confronted at the Futurist exhibition in the Sackville Gallery with Boccioni's *The City Rises*, an equally large canvas devoted to the heroic labour of men and horses on a Milanese construction site (Plate 86). The painting impressed Nevinson so much that he paid overt homage to it in the title of his picture *The Rising City*, shown at the Friday Club in January 1913. Although Nevinson's painting is now lost, it would have been more wholeheartedly Futurist than *In the Hold*. Bomberg's canvas is a sturdily independent achievement, and shows no interest in emulating either the blurred movement or the pulsating light which permeates *The City Rises*. But Boccioni and Bomberg were united by their concern with the dynamism of the modern city, and the outstretched arms of *In the Hold*'s principal worker do echo the pose of the falling labourer whose arms are flung so arrestingly across the foreground of *The City Rises*. Moreover, Boccioni's decision to show the driver dragged by his horse focuses on the destructive side of the painting, where men, animals and buildings are all caught up in a consuming action which he described as 'a great synthesis of labour, light and movement'.[48] It is as engulfing in its effect as the grid which splinters Bomberg's workers, and Marianne Martin has speculated that *The City Rises* may even convey the idea of annihilation and rebirth. Pointing out 'the similarity of Boccioni's immense horse and falling man to the image of the conversion of Saint Paul, from Michelangelo to Caravaggio', she argues that 'Saint Paul's mystical death which led to his conversion, is suggested by Boccioni's wish to embody in this painting the "fatal striving of workers". He seems to have been referring to the "death" of the individual worker – his expendability and insignificance as an individual – in the service of the greater aspirations of modern life.'[49]

The connections with the destructive aspects of *In the Hold* are intriguing, even if the forces disrupting the labourers in Bomberg's painting are more rigidly mechanistic in their angular, glittering geometry. But manual work is not the only victim assailed by machine-age clamour in the relentless slicing of the triangles throughout the sixty-four-square grid. The people being unloaded from the ship are caught in it too, and their discomfort is accentuated by its cruel action. *In the Hold*'s vehement visual cacophony reinforces the stress and bewilderment experienced by the pas-

86. Umberto Boccioni. *The City Rises*, 1910–11. Oil on canvas, 199.3 × 301 cm. The Museum of Modern Art, New York. Mrs Simon Guggenheim Fund.

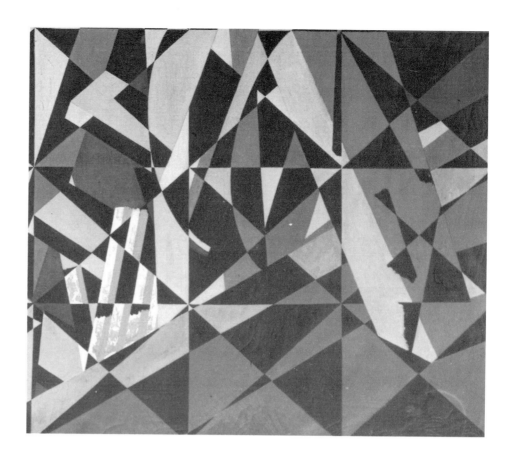

87. David Bomberg. Detail from *In the Hold*, 1913–14 (see Colour Plate 7).

sengers struggling to leave the ship. Since Bomberg takes great care to highlight the expectant pair of hands waving from below-deck, the possibility that immigrants are represented in his painting becomes more plausible still. For the fragmentation of the grid seems to imply that the lives of the disembarking people are shattered too, and Bomberg would have known that the landing was the most unnerving moment endured by the immigrants.

Quite apart from his own parents' experiences, he may well have heard Mark Gertler relate a graphic account of his family's traumatic arrival at the end of a journey which 'was, for the most part, like a nightmare. We travelled in some sort of cattle boat herded very close together, the journey lasting for weeks, and most of the time in rough seas, when they were all sick and in a dreadful plight.' Significantly enough, Gertler emphasized that 'it is quite at the end of the journey, our landing, in fact, when my memory comes to life.' Describing a moment not so very far removed from the point in time which Bomberg may have chosen for *In the Hold*, Gertler described how

I am standing on a wooden floor; there is land, England; England is moving towards me – not I to it. It is sort of *gyrating* towards me. I am standing by my family all ready with heavy packages straining from their necks – pressing their backs – all available limbs are grasping rebellious packages. My mother strains her eyes and says, 'Oh, woe is me, but I cannot see your father! He is not there, he is not there, what shall I do?' Everybody is pushing and shoving. It doesn't feel friendly. All is chaos, selfish and straining. I am being pushed and hustled. Some women are screaming and men shouting roughly.[50]

Bomberg did not, of course, allow *In the Hold* to provide a direct representation of such a harrowing experience. He was far too suspicious of what he called 'literary romanticism'[51] to do anything more than provide a metaphor for the immigrants' broken lives through the splintering of his grid. But he did want his art to be 'expressive',[52] and the splitting of *In the Hold*'s composition into so many 'constituent forms' has an almost expressionistic ferocity. The systematic method employed by Bomberg ends up, paradoxically, launching a headlong assault on our sensibilities as he forces us to experience the energy, vulnerability and disgruntled emotions of the figures who find themselves assailed by *In the Hold*'s relentless geometrical fusillade. The richness of meaning in this extraordinary painting is as prodigious as the formal variations which Bomberg discovers within the subdivisions of his turbulent grid (Plate 87).

Aside from Boccioni's *The City Rises*, the only other picture which might pertinently be compared with *In the Hold* is Lewis's lost painting *Christopher Columbus*. No photographic record has survived to show what it looked like, but Lewis may have chosen its title in response to Clive Bell's remark that Cézanne – one of Lewis's heroes – was 'the Christopher Columbus of a new continent of form'.[53] The painting was prominently displayed at the first London Group show, and reviewers' comments indicate that its pictorial organization bore a resemblance to *In the Hold*. *The Westminster Gazette* described *Christopher Columbus* as a 'highly coloured tesselated pavement', and Sir Claude Phillips declared that it was 'a huge kaleidoscopic design painted ... with a rare decision of the brush. With no great confidence in our guessing powers – which are poor enough when games are in question – we had imagined that here was perhaps a symbolical representation of the Integral Calculus.'[54] Such descriptions, maddeningly vague though they remain, suggest that Lewis's painting shared some at least of Bomberg's enthusiasm for geometrical fragmentation. Moreover, Lewis himself admitted that he wanted to assault the viewer with the aggressive relish which *In the Hold* displays. 'Our object is to bewilder', he told one reporter at the London Group opening; 'we want to shock the senses and get you into a condition of mind in which you'll grasp what our intentions are.' Judging by the reaction of the *Daily News and Leader*, Lewis startled his audience with spectacular success. 'Lewis's chef-d'oeuvre is entitled "Christopher Columbus"', declared the reviewer, 'which is precisely what you will exclaim when you see it.'[55]

Without even a photograph of Lewis's painting, its resemblance to *In the Hold* must remain speculative. But the sense of rivalry between the two artists certainly seems to have reached a new pitch of jealousy when they displayed their respective paintings in the London Group show. 'At the hanging of the pictures', Roberts remembered, 'Bomberg had secured himself an excellent central position for his painting and was feeling very happy indeed about it. But on the day of the Private View he made a discovery that left him speechless: astounded, he saw hanging in this much-coveted spot on the wall a painting by Wyndham Lewis, and his own rehung in a less prominent position.' As it happened, Bomberg and Roberts had agreed to have supper with Lewis that evening at a Jewish restaurant in Whitechapel. It seemed a perfect opportunity to obtain revenge, and Bomberg 'laid plans for a showdown with Lewis at our dinner party'. Although he was 'in a fury', Bomberg knew that he stood little chance of winning a straight fight. Roberts described the scene:

> Bomberg, although pugnacious and spirited, is but half the stature of Lewis, so instead of beautiful brunettes Bomberg brought to our rendezvous his boxer brother, 'American Mowie'. After the soup, Bomberg, raising his voice to a loud strident pitch, said suddenly to Lewis, 'Say, Wyndham, what do you mean by taking my painting down and sticking your own up in its place?' If 'American Mowie' was expecting to be able to display his pugilistic talents he was disappointed, for although at first Lewis made an attempt to protest, he stopped, rose suddenly from his seat, and throwing his theatre ticket upon the table abruptly left the restaurant in haste to escape from the hostile atmosphere of the East End back to the friendly gaiety of Soho.[56]

Despite Lewis's machinations, Bomberg's work did succeed in commanding attention at the London Group show. The *Daily Telegraph* dismissively reported that 'Mr Bomberg is less happy in his dazzling – alas! too dazzling and pyrotechnic – design for floor-cloth, entitled with unusual simplicity, "In the Hold".' But even the *Telegraph* admitted that Bomberg's other exhibits were 'novel and interesting patterns',[57] and *The Athenaeum*'s critic was caught uncomfortably between admiration and scepticism. *In the Hold*, he claimed, 'is the most entirely successful painting in the exhibition, and has the attraction which belongs to complete success; but then it means little, being a well-balanced design of forms and colours almost without significance.'[58] *The Athenaeum*'s reviewer could not help feeling that *In the Hold*'s degree of abstraction was too extreme, and that it would appear more appropriate if 'carried out in textiles'. But Bomberg's dissatisfaction with the Omega had indicated his desire to concentrate on easel painting rather than fabric design, and Fry's review of *In the Hold* paid a guarded tribute to its ambition. 'Of Mr Bomberg it would be rash to prophesy as yet', wrote Fry, with a caution probably influenced

by his skirmish with Bomberg at the Omega,

> but this much may be said, that he has the ambition, the energy and brain power to strike out a line of his own. He is evidently trying with immense energy and concentration to realize a new kind of plasticity. In his colossal patchwork design, there glimmers through a dazzling veil of black squares and triangles the suggestion of large volumes and movements. I cannot say that it touched or pleased me, but it did indicate new plastic possibilities, and a new kind of orchestration of colour. It clearly might become something, if it is, as I suspect, more than mere ingenuity.[59]

The most sustained and thoughtful of all the critical responses came, however, from T. E. Hulme (Plate 88). Although he had only just begun his short and memorable career as a reviewer for *The New Age*, Hulme proved himself capable of grappling with the new art in an over-theoretical yet incisive manner. *In the Hold* had a particular fascination for him, because it seemed the outcome of a fanatical desire 'to exclude even the general emotion conveyed by abstract form, and to confine us to the appreciation of form in itself tout pur'. Hulme acknowledged that *In the Hold* 'appears to have started off as a drawing of an actual subject', but he entirely discounted the role this subject continued to play in the final painting. Like the other critics, he could discern no figurative elements in the canvas itself and proceeded to speculate about 'the theory on which it is based'. Hulme argued that

> in looking at a picture one never sees it as a whole, one's eye travels over it. In doing so, we continually find certain expectations fulfilled – a boot is followed by a leg, and even when there is no representation at all, certain abstract forms are naturally continued by other forms. Apparently this fulfilled expectation is an added non-aesthetic emotion, and must be excluded by those who wish to take an absolutely 'pure' pleasure in form itself. Mr Bomberg therefore cuts his picture up into sixty-four squares, and as each square is independent of its neighbours, the 'fulfilled expectation' I spoke of above is excluded, and whatever pleasure we take must be in the arrangement of shapes inside each square.[60]

While Hulme was right to stress the subversive impact of *In the Hold*, with its refusal to allow viewers the gratification of fitting the composition together in uninterrupted sequences, he placed far too much emphasis on the autonomy of the individual square. For the principal tension in Bomberg's picture arises from the tussle between the underlying representational scene and the splintering grid imposed on it. The struggle is fought all over the canvas, and has certainly not been resolved in favour of what Hulme described as the 'entirely accidental and "unexpected" shape' found within each square. His account overlooked the fact that Bomberg had chosen *In the Hold*'s theme for a specific purpose, and that he wanted 'to translate the life of a great city, its motion, its machinery, into an art that shall not be photographic, but expressive'.[61] Such an aim was far removed from Hulme's reading of *In the Hold*, which led him to conclude that 'all the general emotions produced by form have been excluded and we are reduced to a purely intellectual interest in shape. This particular picture, then, is certainly the *reductio ad absurdum* of this heresy about form. I see no development along such lines, though such work may be an excellent discipline.' But Hulme's misinterpretation of the painting did not prevent him from realizing that Bomberg was an artist well worth studying with the greatest seriousness, and he added: 'I look forward, however, to Mr Bomberg's future work with interest; he is undoubtedly an artist of remarkable ability.'[62]

Bomberg had probably met Hulme some months before the London Group show. The two men may have been introduced at the Café Royal by Epstein, who was Hulme's favourite artist among the emergent generation in Britain. During the course of 1913 Hulme had become increasingly interested in the development of visual art, and young painters made a point of meeting him in order to listen to his intellectually bracing opinions. On 10 November 1913 Gertler took Rosenberg along to the Café Royal and introduced him to Hulme,[63] so Bomberg would surely have experienced a similar encounter around the same time. Hulme was a very gregarious man who thrived on expounding his views to anyone unafraid of engaging in contentious debate, and every Thursday he held court at Mrs Kibblewhite's house in Frith Street. The first-floor salon, adorned with 'First Empire mirrors and chandeliers',[64]

88. G. C. Beresford. Photograph of T. E. Hulme, *c.* 1914–15. Private collection, London.

provided a splendid setting for parties where a lively cross-section of prominent figures from London's political, literary and artistic worlds relished the chance to argue with each other. 'Hulme had the most wonderful gift of knowing everyone and mixing everyone', remarked Nevinson, explaining that 'there were journalists, writers, poets, painters, politicians of all sorts, from Conservatives to New Age Socialists, Fabians, Irish yaps, American bums, and Labour leaders.'[65] Bomberg's long-standing friendship with Rosenberg and John Rodker meant that he was well able to hold his own in the fiery discussions about modern literature which Hulme, a leading supporter of drastic renewal in English poetry, loved to hold. But Bomberg's singleminded views on painting were even more forcibly expressed, and he must soon have succeeded in adding his own militant voice to the hubbub at Hulme's salon. Lewis recalled Gaudier threatening 'to sock Bomberg on the jaw, and when I asked him why, he explained that he had an imperfect control over his temper, and that he must not be found with Bomberg, for the manner adopted by that gentleman was of a sort that put him beside himself. I had therefore to keep them apart.'[66]

By the beginning of 1914 Hulme's involvement with visual art had become an overriding concern. The hostile critical reaction to Epstein's one-man show at the Twenty-One Gallery in December 1913 prompted him to write a passionate defence of the sculptor for the Christmas Day issue of *The New Age*,[67] and he followed it with a series of equally controversial articles on 'Modern Art'. But the most comprehensive attempt to set Hulme's views on painting and sculpture in the context of his philosophical beliefs occurred when he gave a lecture to the Quest Society on 22 January 1914. Bomberg was probably among the most attentive members of the audience who gathered at Kensington Town Hall to hear this important talk. For Hulme proposed, with the aid of ideas drawn in particular from Wilhelm Worringer's influential book *Abstraction and Empathy*, that the 'new modern geometrical art' decisively rejected the 'soft and vital' lines of 'Greek art and modern art since the Renaissance'. Worringer had maintained that the stylized rigidity of so-called primitive art was the result, not of inferior technical ability, but of a distinct spiritual urge. Hulme agreed, declaring that today's new art turned away from the 'sloppy dregs' of redundant romanticism and found itself in sympathy with 'other arts like Egyptian, Indian and Byzantine, where everything tends to be angular, where curves tend to be hard and geometrical, where the representation of the human body . . . is . . . distorted to fit into stiff lines and cubical shapes of various kinds'. When Hulme's lecture was eventually published,[68] it was prefaced by the remark that 'the fright of the mind before the unknown created not only the first gods, but also the first art.' He believed that humanity once again felt divorced from nature, alienated and burdened by an awareness of Original Sin. The death of naturalistic art signified this profound change in attitude, and the new art took an uncompromising form because 'pure geometrical regularity gives a certain pleasure to men troubled by the obscurity of outside appearance. The geometrical line is something absolutely distinct from the messiness, the confusion, and the accidental details of existing things.'

Bomberg may not have fully agreed with Hulme's thesis, for it deprecated 'the materialist explanation' of the geometrical style and insisted that 'the use of mechanical lines in the new art is in no sense merely a reflection of mechanical environment.' As his *Jewish Chronicle* interview revealed, Bomberg thought his work was directly expressive of machine-age life, and in this respect he was closer to Lewis's 'Cubist Room' essay and the theories of the Futurists. But Bomberg did agree with Hulme's complaint that Italian Futurism 'is, in its logical form, the exact opposite of the art I am describing, being the deification of the flux, the last efflorescence of impressionism'. He would also have broadly approved of Hulme's claim that 'the specific differentiating quality of the new art' could be found in images 'having an organization, and governed by principles, which are at present exemplified unintentionally, as it were, in machinery'. Hulme drew a clear distinction between an art which merely used machinery as a subject, and an art which used a 'clean, clear-cut and mechanical' language. It coincided with Bomberg's own beliefs, for he usually avoided machines in his work and preferred to reflect them indirectly through an art which, in Hulme's words, demonstrated its 'admiration for the hard clean surface of a piston rod'. The only British artists mentioned in Hulme's lecture were Epstein and Lewis. But Bomberg had at that stage not executed his most important pre-war

paintings, and before long they led Hulme to hail him as one of the most convincing exponents of the 'new geometric and monumental' work which 'seems to me beyond doubt . . . the character of the art that is coming'.[69]

For his part, Bomberg savoured the support he received from such an influential critic. Most reviewers, even if they admitted the striking individuality of his work, ended up by echoing the *Pall Mall Gazette*'s judgment that 'Mr Bomberg has a semi-mathematical theory that sometimes results in very pleasant patterns suitable for neckties and carpets.'[70] Designs which would be acceptable in applied art were deemed illegitimate and incomprehensible when exhibited as easel paintings, and Hulme's growing admiration acted as a welcome corrective to the general disapproval. As well as writing about art in *The New Age*, where he was quick to praise any 'composition based on hard, mechanical shapes in a way which previous art would have shrunk from',[71] Hulme published a series of 'Contemporary Drawings' by the young English artists whom he respected. Altogether he reproduced work by Epstein, Gaudier, Roberts, Wadsworth, Nevinson and Bomberg, and only pressure of space seems to have prevented him from implementing his initial promise to publish drawings by Lewis, Etchells and Hamilton too.[72] Significantly enough, Hulme chose to start the series on 2 April with Bomberg, whose large chalk drawing called *Chinnereth* showed him at his best (Plate 89). Although Hulme's commentary revealed that 'Mr Bomberg's drawing contains four upright figures in various attitudes', he completely dismissed their figurative significance. 'If you ask me why the legs look like cylinders and are not realistically treated', wrote Hulme, 'the answer I should give you would be this – the pleasure you are intended to take in such a drawing is a pleasure not in representation, but in the relations between

89.  David Bomberg. *Chinnereth, c.* 1914. Chalk, 45.5 × 53.5 cm. Nuffield College, Oxford.

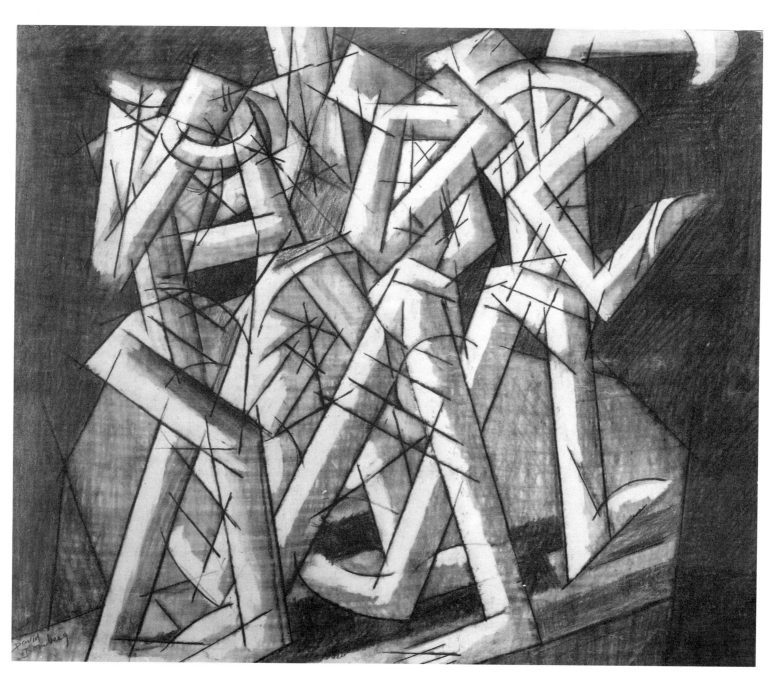

certain abstract forms.'[73] While his determination to stress the drawing's freedom from literal representation is understandable, Hulme goes too far in his emphasis on abstraction. The fact remains that Bomberg's extreme liberties with anatomy manage to reinforce the strength and tactile solidity of the figure's strutting limbs. If he had wanted to make them unrecognizable as human presences, Bomberg would not have shaded in a dark background which invests them with an almost sculptural force.

To our eyes *Chinnereth* is one of the most figurative of the 1914 drawings, but its distortions and network of extended contours were enough to incense *The New Age*'s readers. One of them, who signed himself 'Vectis', was so perplexed that he wrote a long satirical poem published by the magazine two weeks later. The most lively section of the poem vividly conveys the bewilderment and hilarity which Bomberg's art aroused even in people whose intelligent and forward-looking views prompted them to read *The New Age*:

> I mark each form and stand agape,
> Amazed at each eccentric shape,
> Devoid of garments – cloak or cape,
> > Or any rag that cumbereth.
> Marvels of eccentricity,
> I own they but appear to me
> Perversions of geometry
> > That tread the road to Chinnereth.
> . . . If this be not Euclidean
> What is't, of all the arts of man?
> Is it Mephistophelian?
> > I wait for one who answereth!
> Lines, angles, segments, senseless curves,
> Suggesting naught of blood or nerves,
> Or any limb that moves or swerves
> > On any road to Chinnereth.[74]

As a beautiful drawing now called *Composition* amply demonstrates, such criticisms were wide of the mark (Plate 90). Despite the audacious freedom with which Bomberg now moved between figuration and abstraction, claiming the right to detach limbs from figures and allow their contours to enjoy a life of their own in a linear

90. David Bomberg. *Composition*, 1914. Crayons, 55.5 × 59.5 cm. Ivor Braka Ltd, London.

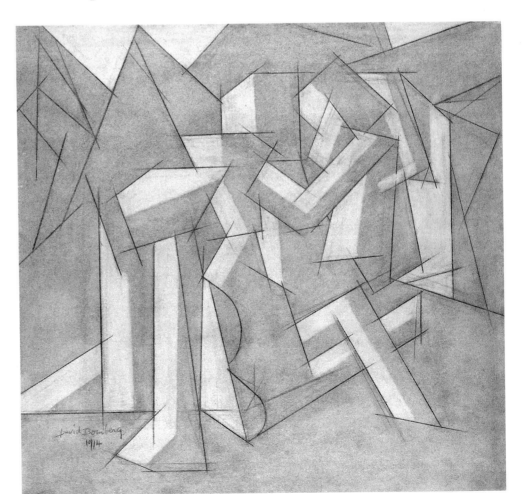

Mr. David Bomberg, a recognised leader in the futurist move...ent, has been invited to form a specifically Jewish section at the forthcoming Art Exhibition at the Whitechap/i Art Gallery. Above is seen a sample of his work.

91. Photograph of Bomberg and *Ju-Jitsu* near the time of the Whitechapel Art Gallery's *Twentieth Century Art* exhibition. Reproduced in the *Jewish World*, 18 March 1914, under the headline 'Jews And Cubism'.

scaffolding which spreads across the design at will, *Composition* still remains rooted in a tactile, sensuous grasp of the human form. Rather than 'suggesting naught of blood or nerves', such a drawing retains a remarkably warm and palpable sense of the living bodies who inspired most of Bomberg's work at this period. Many years later, attempting to describe his youthful aims as an artist, he explained: 'I then was in a phase of geometrical abstraction and working out a purist theory of colour light and form as an integrated organic unity relating to an inherent sense of mass.'[75] In 1914 Bomberg would not have chosen to express himself in this way, but *Composition* shows clearly enough that even at his most schematic and austere, the 'sense of mass' presents itself with great organic conviction.

Quite apart from completing a prolific body of work in the first half of 1914, Bomberg was exceptionally busy as an exhibitor and an organizer. Soon after the London Group opened, a massive survey called *Twentieth Century Art. A Review of Modern Movements* was staged at the Whitechapel Art Gallery, right at the heart of the neighbourhood where he had grown up. Among the hundreds of exhibits, which amounted to a comprehensive survey of avant-garde developments in Britain and abroad, Bomberg displayed *Vision of Ezekiel*, *Ju-Jitsu* and *In the Hold* among a group of his works which, as one critic observed, 'covers a wall to itself' (Plate 91).[76] But he had also played a very important part in the show's formation. The *Jewish Chronicle* reported that the exhibition contained

> a Jewish section which has been organized by Mr David Bomberg, a talented representative of the 'Futurist' art that has aroused such fierce controversy among the critics. Mr Bomberg has secured contributions for the exhibition from Messrs Mark Gertler, Albert Rothenstein, Horace Brodzky, Alfred Wolmark, Bernard Meninsky, Isaac Rosenberg, and several other Jewish artists . . . so that the exhibition should be very representative of the younger school of Jewish artists in this country.[77]

But Bomberg was not prepared to be confined within any narrow ethnic or nationalist boundaries. The fifty-four exhibits in the 'Jewish Section' also included work by artists whom he had met during his trip to Paris with Epstein the previous year: Kisling, Nadelman, Pascin and most notably of all Modigliani, who was represented by a *Drawing for Sculpture* and a superbly refined and elongated stone *Head* (Plate 57).[78] While doubtless enjoying the high reputation he had secured among emergent Jewish painters in Britain, Bomberg stressed in his interview with the *Jewish Chronicle* exactly how he related to one of the broadest currents in radical European art. 'Mr Bomberg is a Futurist, but he does not fully subscribe to all the theories of the Futurist school', commented the *Jewish Chronicle*, before reporting on a conversation with the artist which clarified Bomberg's ambivalent attitude towards the Italian movement:

It is easier for me to tell you what I think of Futurism than to explain for what it is that Futurist art stands, because the Futurist school is so largely destructive in its aims. Futurist art largely arose as a protest against the convention that all that is old, all that is antique, is the last word on art, it is a revolt against a worn-out tradition. The desire arose to create a new tradition. Where I part company from the leaders of the Futurist movement is in this wholesale condemnation of old art. Art must proceed by evolution. We must build our new art life of today upon the ruins of the dead art life of yesterday.'[79]

This refusal to denounce the past was shared by the artists who were about to form the Vorticist movement. 'The vorticist has not this curious tic for destroying past glories',[80] wrote Ezra Pound, who also declared that 'the futurists are evidently ignorant of tradition ... We do not desire to cut ourselves off from the past.'[81] Bomberg agreed, but he had already decided against too close an alliance with the nascent Vorticists. He spoke for himself alone when informing the *Jewish Chronicle* that 'I went to the Slade school, and learnt to draw correctly. I studied the old masters, but they soon bored me, and I began to look out for something new, some new ideas that the old masters knew nothing of.' Although Bomberg refrained from telling the interviewer that he had drawn specifically on East End Jewish life in some of his work, he was prepared laughingly to answer a question about 'the Jewish aspects of Futurism'. With tongue lodged firmly in cheek, Bomberg remarked that 'for one thing, Futurism is in accordance with Jewish law, for its art resembles nothing in heaven above, the earth beneath, nor the waters under the earth.' But he did make the surprising claim that 'Futurist art owes much to Jewish pioneers', as well as confidently predicting that 'the school will gain many new recruits and the exhibition at Whitechapel will show the public what is being done in this genre by Jewish artists.'[82]

92. Mark Gertler. *Jewish Family*, 1913. Oil on canvas, 66 × 50.8 cm. Tate Gallery, London.

When the *Jewish Chronicle*'s art critic published his review of the show, however, he could hardly have been more damning. While acknowledging that 'piquant interest lends itself to this exhibition, because we believe this is the first time any real attempt has been made to organise a collection of work by Jewish artists', the critic found himself bitterly out of sympathy with the experimental nature of the work on view. He admired Wolmark's brand of Fauvism, and singled out Gertler's *Jewish Family* for its 'real psychological insight and feeling' (Plate 92), but most of the Jewish section earned his displeasure. Bomberg's exhibits were the most unforgiveable of all, and he roundly anathematized them. 'We certainly do not feel justified in praising work which, in our opinion, seems merely a waste of good pigment, canvas, and wall space ... which could have been better utilised by an exhibition of paintings that would not have been hurtful to our reason and common sense', he stormed, adding that 'we have no desire to be thought uncharitable, but if "In the Hold" is a work of art, we never wish to pen another criticism.'[83]

Bomberg had to face the uncomfortable fact that most members of the Jewish community agreed with this withering verdict. None of his exhibits was sold, and the whole experience must have confirmed his most pessimistic suspicions. There was no point in expecting any support from Jewish benefactors, even though they had originally aided him at the Slade. For all his sudden notoriety he was widely regarded as a cynical hoaxer whose paintings did not deserve to be given the status of art. Even his old friend Rosenberg was now coming to the conclusion that Bomberg's 'undoubtedly interesting' new work 'has crude power of a too calculated violence – and is mechanical'.[84] The only friends who really understood and admired his work were the young artists rapidly becoming associated with the Vorticist cause, and Bomberg could not bring himself to join a group so heavily under the influence of Lewis.

When the Rebel Art Centre was established as an alternative to the Omega Workshops in the spring of 1914, most of the former Slade students who respected Bomberg's art affiliated themselves with it. But Bomberg later remembered that 'I was not a Member or even went near the Rebel Art Centre',[85] while Kate Lechmere confirmed that 'he never came to our teas, and I can still see him, a timid, thin little man who looked starving, waiting for Lewis outside the Centre. He always refused to come in.'[86] Lechmere's account shows Bomberg in an unusually vulnerable light, and beneath his assertive facade he was a very isolated young man who still keenly missed the support his mother had provided with such unfailing generosity.

He seems to have suffered from a deep-seated emotional insecurity which impelled him to cloak it in arrogance, a strategy calculated to bring him into head-on conflict with the belligerent Lewis. Moreover, Lechmere believed that there was 'a class war' between 'Lewis the Rugby School product and Bomberg the East End Jew'.[87] The two men were frankly incompatible, and Bomberg's former girlfriend Sonia Cohen explained that 'Lewis was a bit anti-semitic, whereas Bomberg was very bombastic and pugnacious.'[88] Etchells maintained that 'Bomberg was just as aggressive as Lewis: he used to taunt Lewis the whole time, and whenever the two of them met Bomberg would say: "Well, Percy, how's old Perce, then?", deliberately using the name Lewis hated.'[89]

But Bomberg was even less willing to adopt Nevinson's course of action and align himself with Marinetti instead. Although the Futurist leader's attempts to recruit English disciples had reached a climax by the early summer of 1914, Bomberg remained determined to resist all advances. In June Marinetti and Nevinson published an outspoken declaration of faith entitled 'Vital English Art. Futurist Manifesto' in several leading newspapers, declaring war on the conservatism of British culture and calling for the development of an 'Art that is strong, virile and anti-sentimental'.[90] But at the end of this tirade, after crying 'HURRAH for lightning!' in full-blown Futurist style, the co-authors made a tactical blunder. They rashly concluded by calling on 'the English public to support, defend, and glorify the genius of the great Futurist painters or pioneers and advance-forces of vital English Art – ATKINSON, BOMBERG, EPSTEIN, ETCHELLS, HAMILTON, NEVINSON, ROBERTS, WADSWORTH, WYNDHAM LEWIS'. It was a clumsy ruse, implying that all these artists had joined Nevinson in wholeheartedly embracing the Futurist cause. At that very moment Lewis and his friends were poised to launch their own alternative movement through the publication of *Blast*, and they were in no mood to forgive Marinetti's barefaced take-over bid. Without delay they sent a rebuttal to *The Observer*, accusing Marinetti of 'an impertinence' and concluding: 'We, the undersigned, whose ideals were mentioned or implied, or who might by the opinions of others be implicated, beg to dissociate ourselves from the "Futurist" manifesto which appeared in the pages of THE OBSERVER of Sunday, June 7.' The signatories, who now included Richard Aldington, Gaudier and Pound but excluded Epstein, gave the Rebel Art Centre as their joint address. Bomberg, however, only agreed to add his name on condition that it carried a postscript explaining how 'he signed the letter not as a member of the Art Rebel Centre (being unconnected with that group), but independently.'[91]

Bomberg's statement was wholly consistent with the attitude he had adopted a couple of months before, when Lewis approached him with an unacceptable request. Lilian Bomberg recalled 'David once telling me that Lewis wanted to take some photographs of his pictures at the first London Group show, and reproduce them in *Blast*; but David was adamant. He not only told Lewis that he did not want any of his work published in *Blast* – he also threatened to sue Lewis if anything did appear in the magazine.'[92] When the first issue of the Vorticists' publication finally appeared at the beginning of July 1914,[93] Bomberg's work was therefore conspicuous by its absence from the range of images illustrated in *Blast*'s insurrectionary pages. Although the equally independent Epstein had agreed to reproduce some drawings in the magazine, Bomberg remained obdurate. His close friend Roberts was one of *Blast*'s signatories, and found himself represented in the magazine by work stylistically similar to Bomberg's (Plate 93).[94] But nothing could persuade Bomberg to become the member of a movement dominated so heavily by another man's theories. He stayed outside, mounting in the very same month a one-man show which demonstrated just how sturdily he could now stand alone. Not even Lewis had succeeded in staging an exhibition devoted solely to his own work, and the fifty-five pictures displayed under the sober title *Works by David Bomberg* at the Chenil Gallery in Chelsea surveyed his precocious achievements at full stretch.

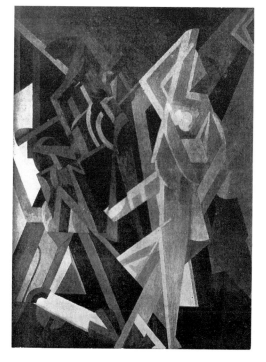

93. William Roberts. *Dancers*, 1913–14. Oil on canvas (?). Lost. Reproduced in *Blast No. 1*, 1914, illus. xiii.

# CHAPTER FOUR  'I APPEAL to a *Sense of Form*'

By no means all the exhibits in the Chenil Gallery show represented Bomberg's art at its most radical. The *Head of a Poet* which had earned him the Tonks Prize at the Slade was included (Plate 50), and several nude studies and heads of women and children demonstrated his prowess as a relatively traditional draughtsman.[1] He even displayed the early *Bedroom Picture*, presumably in order to reveal how his work had progressed since student days (Plate 29).[2] But the majority of the exhibits, positioned in the first room encountered by visitors to the show, consisted of Bomberg's work at its most audacious. His polemical 'foreword' to the catalogue concentrated on his reasons for pursuing such an extremist course. He recalled later that 'one minute was allowed to dictate a few words for insertion as an introduction to the exhibition before the typed copy of the catalogue went to the printers',[3] and speed made him couch the statement in sentences as compressed as they were urgent. 'I APPEAL to a *Sense of Form*', Bomberg announced, as if passionately arguing his case in court with a row of judges from the Royal Academy lined up against him. 'In some of the work I show in the first room, I completely abandon *Naturalism* and Tradition. I am *searching for an Intenser* expression. In other work in this room, where I use Naturalistic Form, I have *stripped it of all* irrelevant matter.'

It was a terse summary of his overriding desire to attain a pared-down distillation of pictorial essentials, refusing to allow any superfluities to soften the hard, bare and energetic nature of his uncompromising vision. The rest of his 'foreword' suggested that the impact of the machine-age environment decisively affected his way of seeing. 'I look upon *Nature*, while I live in a *steel city*', he declared. 'Where decoration happens, it is accidental. My object is the *construction of Pure Form*. I reject everything in painting that is not Pure Form. I hate the colours of the East, the Modern Mediaevalist, and the Fat Man of the Renaissance.'[4] Bomberg's reference to the '*steel city*' removed him immediately from the aesthetic theories of Clive Bell, although the latter's book on *Art* had boldly proposed a few months before Bomberg's exhibition[5] that 'significant form' was the 'common quality' found in all successful works of art.[6] Neither Bell nor Fry had any time for Italian Futurism, and their concept of 'significant form' had no connection with the urban context which Bomberg found so stimulating. Far from seeing 'pure form' as an end in itself, he wanted it to convey '*an Intenser* expression' of life in the modern city. Nowhere was this aim realized with more arresting conviction than in *The Mud Bath*, the largest[7] and most expensive painting displayed at the Chenil Gallery show.

This boisterous canvas, listed as the first exhibit and priced at £50, was given the most prominent position imaginable: a note at the beginning of the catalogue explained that *The Mud Bath* 'has been hung *outside* the Gallery premises that it may have every advantage of lighting and space'. Perhaps Bomberg took this unusual step in order to place his canvas as close as possible to the '*steel city*' he cherished. Whatever his motive, visitors approaching the exhibition would have been assailed by its most important painting before they even crossed the threshold. Like an inn-sign festooned with decorations to celebrate a memorable local event, Bomberg's painting was decked out with flamboyant embellishments. 'What, I wonder, would the Fat Man of the Renaissance think of Mr Bomberg's "The Mud Bath" which

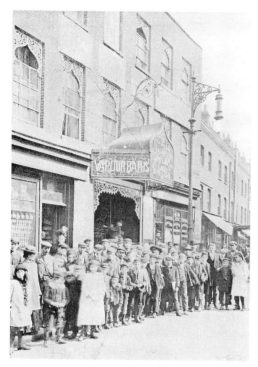

94. Photograph of Schevzik's Vapour Baths in Brick Lane, Whitechapel, n.d.

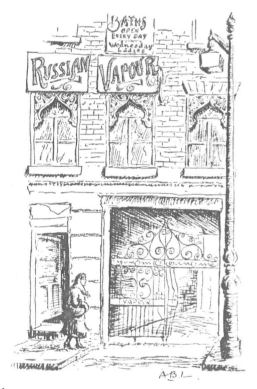

95. A. B. Levy. *Schevzik's, Brick Lane*. Reproduced in Levy's *East End Story*, London n.d. (*c.* 1951).

hangs outside the Chenil Galleries, on the outer wall of the house, rained upon, baked by the sun, and garlanded with flags?' asked the *Daily Chronicle*'s bewildered reviewer. He disapprovingly pointed out that 'art is love, we used to say, and art should be reticent. Happily many of us think and say so still. But some of the new spirits seem to be inspired by the idea that art is hate and must be aided by advertisement.' Although Bomberg may have wanted to take his art out on the street in order to reach the non-gallery public, the *Daily Chronicle* claimed that it aroused scant controversy among the residents of Chelsea: 'The passers-by make no comment, because they do not recognise it as a picture.'[8] But the incensed reaction of most newspaper reviewers proved that *The Mud Bath* hit them with the force of a fist; and it threatened on occasion to cause traffic jams outside the gallery. Bomberg enjoyed remembering how 'the horses drawing the 29 bus used to shy at it as they came round the corner of King's Road.'[9]

But why had such a strange title been given to a painting which Bomberg clearly regarded as the most important image in his exhibition? The most likely explanation is that he once again turned for inspiration, as in *Ju-Jitsu* and *In the Hold*, to a scene witnessed in the East End area. One of the landmarks of Whitechapel during Bomberg's boyhood was Schevzik's Vapour Baths in Brick Lane. An old photograph shows how the baths, hemmed in by a silver shop on one side and a 'foreign money exchange' on the other, nevertheless managed to assert its own exotic identity (Plate 94). The words 'Russian Vapour Baths' were proudly inscribed on an elaborate canopy projecting into the street, and the entrance beneath was adorned with decorative ironwork. So were the windows above, where the iron twisted itself into evocative architectural forms. Schevzik also furnished his premises with a grand iron gate full of ornamental flourishes, and it was still *in situ* when A. B. Levy sketched the fast-decaying facade in 1951 (Plate 95). He reproduced the drawing in his book *East End Story*, explaining that

until the war, next to godliness at the Machzike Hadass there was cleanliness at Schevzik's. These popular baths were just opposite the synagogue in the narrow Brick Lane. The large sign there, like many another East London sign, belies 1951 circumstances. It reads: 'Russian Vapour [the word 'Baths' has fallen off] Open Every Day, Wednesday Ladies'. They were, in fact, closed after a fire – not caused by a bomb – about the beginning of the war. Yet in the courtyard to the extensive and dilapidated rest rooms and tiled baths you are informed that you can get here the 'Best Massage in London: Invaluable Relief for Rheumatism, Gout, Sciatica, Neuritis, Lumbago, and Allied Complaints. Keep fit and well by regular visits.' The orthodox of the East End certainly looked fit as they emerged from the gates of Schevzik's after their regular eve-of-Sabbath visit, displaying pink cheeks and stroking soft beards. Some of them, to continue cooling off, would drop in at the shop of Moshé the Scribe, a few doors away, to exchange *shool* gossip or listen to the latest record of American Cantor, Yossele Rosenblatt . . . The late Rev. B. Schevzik, who ran the baths, also led thousands in prayer on the holy-days, when he conducted the services, first at the Great Assembly Hall at Mile End, and then, for many years, at the Shoreditch Town Hall.[10]

The religious convictions of the Reverend Schevzik are significant, for they influenced the character of the establishment he ran in Brick Lane. Recalling the Vapour Baths many years later, Bomberg's younger brother confirmed that 'David went there' and described it as a place people visited for 'purification'.[11] James Newmark, Bomberg's brother-in-law, related how as a boy he 'went there once a year with my father just before the holy day, the Yom Kippur. You went into a normal bath and then into the Mikvah, a small pool where you descended into the water. It was used by males and females on different days and became a ritual. You swam round, immersed yourself. It wasn't like a public swimming bath at all, and only intended for the orthodox Jewish community.'[12] Louis Behr, another Whitechapel resident who remembered visiting Schevzik's, explained that although there was 'no bar to non-Jewish clientele', they 'in the main preferred the nearby and far more hygienic Nevill's Turkish Baths'. So the Russian Vapour Baths remained a Jewish preserve, where patrons could gather for 'a good natter' and enjoy pickled herrings, beigels and lemon tea. On Fridays it became so crowded that Schevzik had to insist on 'strict adherence to "improvised" time limit'. But the 'turmoil' of his clientele still made the Baths unpleasant enough for Behr to list the disadvan-

96. Photograph of the staircase in the former premises of Schevzik's Vapour Baths, leading from below-ground level containing the steam baths to bathing rooms on the upper floor.

C8 (facing above). David Bomberg. *Bathing Scene*, 1912–13. Oil on drawing panel, 56 × 68.5 cm. Tate Gallery, London.

C9 (facing below). David Bomberg. *Gouache Study for The Mud Bath I* (recto), *c.* 1914. Gouache, 53.5 × 71 cm. Private collection.

97. David Bomberg. Detail of bathing man from *Island of Joy*, 1912. Oil on canvas, 137 × 204.5 cm. Private collection (see Plate 33).

tages of the atmosphere there as 'bleak, immense condensation, unhygienic, stench deplorable'.[13]

Despite the unsavoury aspects of Schevzik's, its vitality and idiosyncratic character might well have fascinated Bomberg. His first wife Alice thought that 'he was intrigued by the attitudes of the various figures as they clambered out of the bath and ran their hands along their bodies.'[14] When Lilian Bomberg visited the Baths in 1969, and found that they were used as workshops by a firm called Miller's Rings Ltd, she was still able to see the old tiled staircase which led from Schevzik's steam rooms below ground-level to the bathing rooms on the floor above (Plate 96). She was also able to locate the brick seating and tiled walls of a bathing room: 'I thought, my God, no wonder David was so excited by this place. He must have stood on the balcony above the bath and observed the figures in movement down below, surrounded by those bare, tiled walls – it was a perfect subject for him'.[15] The pool provided Bomberg with a rectangular form similar to the platform in *Vision of Ezekiel* (Colour Plate 3), or the open trap-door at the bottom of *In the Hold* (Colour Plate 7). The stark surroundings of Schevzik's contained nothing to distract attention from the frenetic motion of the bodies climbing in and out of the water.

But why did Bomberg decide to call his painting *The Mud Bath*? The Borough Librarian of Tower Hamlets stressed that at Schevzik's 'there was no *mud bath*. Two residents in this area, aged sixty-five and eight-four, remember the Baths very well, and have confirmed this.'[16] One answer may be that Bomberg wanted to refer to the filthiness of the setting. Louis Behr wondered if Bomberg's 'inspiration may have been prompted by the surroundings, which especially in the "Second Class", with the improvised diverse "matting", "sacking" etc., on stone (extremely cold) floors accumulated a mud surface'. Indeed, Behr was at pains to 'earnestly emphasize the environment of sludge', and Bomberg cannot have remained unaware of the unpleasant dirt his feet encountered as he splashed through the Baths.

He may also have been thinking about another aspect of Schevzik's when he gave *The Mud Bath* its title. For although Behr confirmed that 'no provision for "mud pack massage" existed' in the second-class area he used to visit, different services were available elsewhere in the building. 'With the "first class" clientele of the far more affluent class', wrote Behr, 'possibly an enterprising masseur applied their "exclusive" brand of "mud bath".'[17] The whole point of a massage with mud, if it was indeed on offer at Schevzik's, lay in its purifying properties. After such a treatment the recipient was supposed to emerge in a more cleansed state, purged of impurities and gratified by the tautening of skin which had sagged or wrinkled with age. As a lithe twenty-three-year-old Bomberg had no need of such remedies himself, and Joseph Leftwich laughingly recalled that 'he didn't look as if he were a frequenter of baths.'[18] But he may have observed the mudpack treatment at Schevzik's and realized, when planning his large new painting for the Chenil show, that the purification engendered by the massage paralleled his own attempt to purge art of its superfluities. In this sense, *The Mud Bath* was a very deliberate attempt to celebrate the clean-cut, dynamic *élan* of figures who had shed all the fatty deposits obscuring the energy at their core. Just as Schevzik's clientele hoped they would be leaner and fitter after their visit, so the bodies in Bomberg's painting benefit from his zealous determination to simplify human anatomy until he could claim to 'have *stripped it of all* irrelevant matter'.[19] No wonder he gave *The Mud Bath* such a public position outside the front wall of the Chenil Gallery. The picture dramatized a cleansing process which Bomberg saw as an appropriate metaphor for his aims as an artist, and the limbs jerking their way across its surface had been purified by a painter whose avowed 'object is the *construction of Pure Form*'.[20]

He had first depicted a naked figure in water two years earlier, when *Island of Joy* included a man leaning against the side of a pool which stretches along the base of the composition (Plate 97). But most of this pool, along with the shallow water it contained, was omitted from the painting in a strangely arbitrary manner, and the bather's body is handled with far more naturalism than his counterparts in *The Mud Bath*. Moreover, he reclines in the pool with a languor not shared by any of the figures who animate the later painting with their frantic energy. They fling themselves around with an abandon which is closer to the frenzied movements of the people in the so-called *Bathing Scene*, a small panel probably painted

C10. David Bomberg. *The Mud Bath*, 1914. Oil on canvas, 152.5 × 224 cm. Tate Gallery, London.

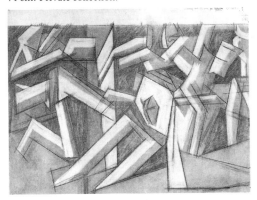

100. David Bomberg. *Conté Study for The Mud Bath* (verso), *c.* 1914. Charcoal and conté crayon, 53.5 × 71 cm. Private collection.

towards the end of Bomberg's Slade period (Colour Plate 8). Because the disposition of the pool is so similar to *The Mud Bath*'s rectangle of red 'water', *Bathing Scene* has often been regarded as a study for the later painting.[21] But its softer colours and less angular contours indicate that it was executed long before Bomberg began work on his big Chenil canvas, and the poses assumed by its semi-draped figures are very different from the configurations in *The Mud Bath*. The club-like form brandished by a figure on the right of *Bathing Scene* has led to speculation that it may be connected with activities at Schevzik's, where light beating was carried out 'to increase circulation of the blood, the skin being flicked with stout leaves, twigs and something resembling a loofah'.[22] But the animals at the top of the composition indicate that *Bathing Scene* was intended as a primitive, mythological fantasy rather than a direct representation of the Vapour Baths in Brick Lane.

So Bomberg can only have found *Bathing Scene* useful to a limited extent when he was planning *The Mud Bath*. This little panel should not be confused with the extended sequence of drawings, watercolours and gouaches carried out in 1914 as a preparation for the large painting. They testify to the care and intense imaginative concentration which Bomberg devoted to a picture he knew would be the crucial image in his one-man show. No less than three studies for *The Mud Bath* were exhibited at the Chenil Gallery, an array which suggests that Bomberg saw them as powerful compositions in their own right.[23] His confidence was justified: even the most tentative of the surviving studies, a watercolour brushed around a framework of unusually hesitant charcoal contours, establishes the main components of the design with surprising completeness (Plate 98).[24]

The pillar, which Bomberg's brother John believed 'would be holding up the next tier'[25] of Schevzik's building, already occupies the position it inhabits in the final painting. But it is less dominant here, and cut through by the projecting limbs of the figures who hurl themselves around the pillar like primitive dancers at the base of a totem pole. The rectangular bath structure, which plays such an important

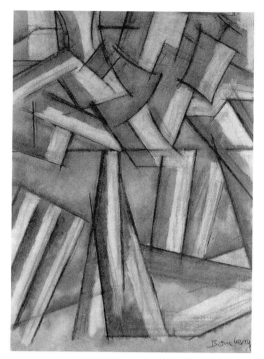

101. David Bomberg. *Study for The Mud Bath*, 1914. Chalk and wash, 68.5 × 50 cm. Private collection, USA.

98. David Bomberg. *Study for The Mud Bath* (recto), *c.* 1914. Pencil and watercolour, 28.6 × 34.9 cm. Tate Gallery, London.

99. David Bomberg. *Study for The Mud Bath* (verso), *c.* 1914. Charcoal, 28.6 × 34.9 cm. Tate Gallery, London.

role in the painting itself, is scarcely visible. Its absence surely means that Bomberg did not take his cue from *Bathing Scene*'s similar area of water until a later stage of the composition had been reached. For the bath is no more apparent in the charcoal drawing he carried out on the back of his first study, although the lines now take on a firmer and more insistently angular character (Plate 99).

Bomberg's growing excitement with the potential of his complex design is evident in the first gouache study (Colour Plate 9). Apart from the confused jumble of forms on the left side, the figures assert themselves with greater panache and tactile conviction. Bomberg also employs colour in a far more exhilarating manner than he had dared to display in the previous watercolour. He is not afraid to set a blaring red against an equally strident blue, and the rich emerald brushed in so vigorously on the right of the composition shows that Bomberg wanted the ground to play as positive a role as the limbs leaping their way across it. But he still seems to see the picture in terms of two separate areas divided by the pillar, and only in the conté drawing on the back of this gouache does he begin to see the composition as one coherent space (Plate 100). Building up his forms with more solidity and dispensing with unresolved details like the cluster of small particles in the middle of the gouache, Bomberg lets a strong light carve into the limbs he manipulates with such resolution. He appears to have decided now that the dark area of the bath should occupy most of the design, tilted in the same diagonal direction as the platform in *Vision of Ezekiel* (Colour Plate 3). The bath is bordered by a ledge running round its base, and pictorial tension centres on the exertions of the figures as they run across this ledge, kneel on the side of the bath and plunge into the water below. But compared with the final painting, this conté study still looks cluttered with massive forms, none of which is given enough room to inject Bomberg's design with the athletic vitality it eventually achieves.

At this point in the development of *The Mud Bath*, the obsession with weight and mass which distinguishes so much of Bomberg's early work threatened to make the composition too inert. Perhaps that is why he then drew an outstandingly powerful chalk-and-wash study which focused on one section of the right half of the design, allowing its bulky contents to fill the paper with their forceful authority (Plate 101). The degree of abstraction which Bomberg employs here has led writers to link it with either the *Acrobats* drawing or the studies for *In the Hold*.[26] It does indeed bear a resemblance to both those works, and there is a strong generic connection between all the figures who inhabit his work at this period. Bomberg's habit of executing alternative versions on the reverse of his drawings shows how willing he was to let one image grow out of another, and this powerful chalk-and-wash study demonstrates the essential continuity between *In the Hold* and *The Mud Bath*. But it also proves that Bomberg was now prepared to depart even more radically from representation than ever before. The drawing is dominated by forms as ambiguous and difficult to decipher as the limbs which were subsequently to populate

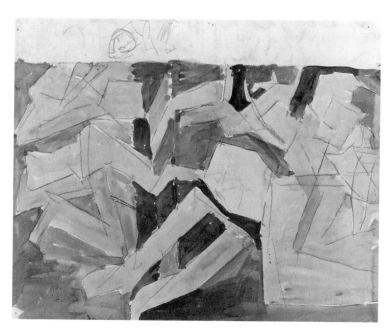

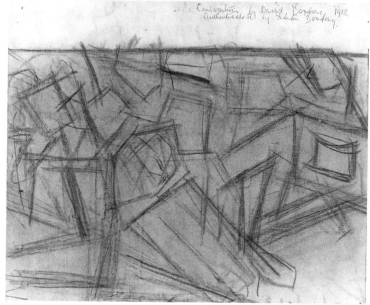

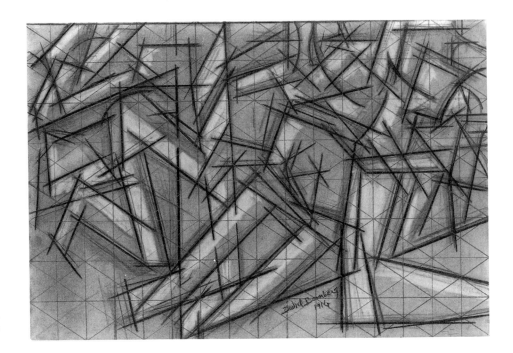

102. David Bomberg. *Study for The Mud Bath*, 1914.
Crayons, 48.5 × 68.5 cm. Israel Museum, Jerusalem.
Gift of the 'Hanadiv' Foundation, London.

*The Mud Bath*. Their looming gravity impresses itself on our senses with a certainty which relieves us of the need to see in them precise figurative identities.

The execution of such an elaborate drawing doubtless helped Bomberg to clarify the unresolved elements in his design. In a vigorous crayon study, squared up in red as if ready for transfer to the canvas, everything has more space in which to breathe (Plate 102). But the figures are removed still further from anatomical propriety than they were in the conté drawing. Bomberg declares his wilful truncations, enlargements and distortions with brazen frankness. He no longer attempts to align them with a readily recognizable anatomical norm. They are independent entities, the product of his ardent response to the bulk, strength and agility of the human form. The superimposition of the grid on this drawing suggests that he toyed with the notion of subjecting these proud limbs to the fragmentation already employed in *Ju-Jitsu* and *In the Hold*. But Bomberg concluded that he no longer wanted to assail the tightly constructed protagonists of his new composition. The application of a grid, however ingenious and spectacular it may have been, could easily degenerate into a formula. Bomberg probably felt that *In the Hold* had taken the splintering process as far as he wanted it to go, and that 'Pure Form' should now be permitted to attain an almost sculptural wholeness without any disruptions.

Besides, the figures he invented for *The Mud Bath* did not need a grid to rob them of the 'literary romanticism' from which Bomberg wanted to 'emancipate' his art. His interview with the *Jewish Chronicle* had revealed that the 'scheme of sixty-four squares' was imposed on *In the Hold* in order to ensure that 'the subject itself is resolved into its constituent forms'.[27] But *The Mud Bath*, seemingly from the outset, had concentrated on the self-sufficiency of those 'constituent forms' to the exclusion of all else. Although the squared-up *Study for In the Hold* deals with figures and ship in a relatively representational style (Plate 84), none of the preparatory studies for *The Mud Bath* displays any interest in naturalism. Bomberg appears to have seen it as a radically schematized work even in the earliest stages, and Hulme remarked on this aspect of the *Mud Bath* studies when he reviewed the Chenil Gallery show. Identifying an exhibit called *Drawing for a painting* as 'the first drawing' for *The Mud Bath*, he wrote that 'the artist probably got the lines of his main design from some accidental material arrangement. The suggestions of form this contained were then probably continued and developed by thinking of them as human figures.'[28] Whether or not Hulme was correct to assume that the starting-point for *The Mud Bath* was an 'accidental material arrangement', the studies do indicate that Bomberg completely removed himself from any direct reliance on the activities he had witnessed at Schevzik's. The stern imperatives of his own imagination shaped *The Mud Bath*'s structure, and Bomberg never allowed it to be impaired by thoughts of producing a faithful documentary image of life at the Vapour Baths.

In the final pair of studies for the painting, he asserted his independence even

more overtly than before. On one side, a crayon drawing blackens the whole bath area which the previous study had left pale (Plate 103). Now Bomberg aims at a strong contrast between the dark bath and the light floor running round it in the foreground. He also experiments with shading the figures in sequences of bold parallel lines, a method previously used in one of the drawings for *In the Hold* (Plate 82). Their leaping limbs stand out against the bath with a new clarity, but they still lack the full plastic significance which the painting eventually achieves. Bomberg knew that he needed to discover how colour could help him realize a greater tactile conviction, and on the back of the crayon drawing he carried out one more study in gouache (Plate 104). It clearly enabled him to decide how the canvas should be tackled, for he uses a weighty combination of ochre and dull maroon to model each limb with far greater firmness. Their solidity is further enhanced by the whiteness of the bath area, although there are signs on the right of the gouache that Bomberg is still wondering whether a darker colour might not be more appropriate for the pool. But most of the painting's components have now been definitely established. The small form at the centre of the design is given full palpability at last, and for the first time Bomberg places the figure in the upper left corner outside the bath altogether. He also permits the pillar to assume a more substantial form, no longer interrupted by so many flailing limbs.

All the same, nothing quite prepares us for the incisive and exuberant vitality

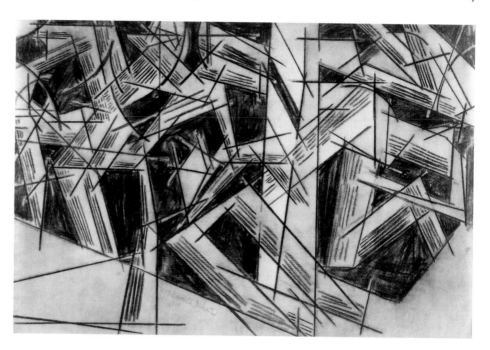

103. David Bomberg. *Crayon Study for The Mud Bath* (verso), 1914. Conté crayon, 45 × 68 cm. Ivor Braka Ltd, London.

104. David Bomberg. *Gouache Study for The Mud Bath II* (recto), 1914. Gouache, 45 × 68 cm. Ivor Braka Ltd, London.

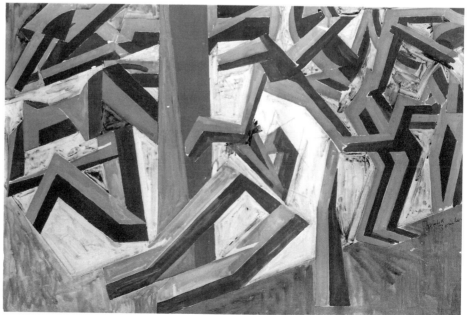

of *The Mud Bath* itself (Colour Plate 10). The final gouache still looks uncertain in comparison with the lucidity and razor-edge sharpness of this unashamedly clangorous painting. The pillar has been changed from pink to a surprisingly subdued brown, sliced through by a deep black shadow. But Bomberg has only provided this column of dark, unshakeable stability so that he can make the rest of the canvas even more frenetic than before. Everything seems to be caught off-balance, embroiled in some strenuous activity. The pair of giant legs in front of the pillar are tilted at a precipitous angle, as if about to fall over. Further along the edge of the bath another, slimmer pair of limbs appear to be poised for a plunge, and above them a figure spreads exclamatory legs outwards as it falls back into the water. There is a sense of unleashed energy about these zestful forms, as if they are celebrating the 'purification' of their bodies by leaping in and around the bath with newly-discovered gusto. Even the figure crouching on the right edge of the canvas seems to contain within its huddled pose a coiled tension, ready at any moment to be released and join in the *mêlée* elsewhere.

There is nothing clumsy about the antics of these strange, impulsive beings. Although they often seem to be colliding with each other, or enmeshed in a complex tangle of limbs from which they cannot extricate themselves, Bomberg allows their bodies to move with balletic poise and precision. The small form near the centre of the painting, probably meant to signify a child, displays the delicacy of a tightrope walker as he balances one sharp point on the giant legs below. There is an elegance about the exactitude with which the two white triangles near the top of the pillar touch one another at their tips. All over the canvas similar encounters are organized with great finesse: the shadow extending to the lower right edge of the painting is likewise shaped into a pair of blue triangles which meet in the middle, echoing the white triangles above. The extreme thinness of this shadow is astonishing, and shows how well Bomberg achieved his desire to escape from predictable forms. A composition like *The Mud Bath*, which subjects everything to such a drastic degree of structural simplification, might easily have become generalized and dull. But none of these figures fulfils our expectations. Limbs consistently refuse to attach themselves to the rest of a body, and strike out on their own. Many of them cannot even be identified with certainty as arms or legs. They have an independent existence, and Bomberg lets them twist, turn and cluster with a freedom which flouts all accepted notions of anatomical propriety.

The use of colour reinforces this ability to startle and confound, for Bomberg's clamorous combination of red, white and blue was calculated to provoke accusations of tastelessness from disconcerted viewers. Moreover, his decision to festoon *The Mud Bath* with flags on the Chenil's outer wall was probably meant to jolt visitors into realizing that he had employed the colours of the Union Jack in his painting. Nevinson had recently included several representations of the British flag in his huge Futurist painting *Tum-Tiddly-Um-Tum-Pom-Pom* (Plate 105), and one reviewer of Bomberg's Chenil show pointed out that both artists shared a preoccupation with the Union Jack: 'Like Mr Nevinson, Mr Bomberg accepts it, or at any rate, its flagrant . . . colours.'[29] But the flag had been employed joyously in Nevinson's painting, where it is waved by people in a crowd enjoying a bank holiday on Hampstead Heath. Patriots would have found little to disturb them in *Tum-Tiddly-Um-Tum-Pom-Pom*, whereas they might easily be upset to discover *The Mud Bath* employing the national colours with such presumption. Bomberg had no intention of respecting the proper symbolic significance of red, white and blue. Indeed, he may well have wanted to cock a snook at jingoism by redeploying the colours in a sacrilegious manner.

Hulme, however, thought of another and in the end more important reason why *The Mud Bath* had been painted in such brazen colours. By taking them from an image as uncompromisingly abstract as the British flag, Bomberg had stressed his painting's total emancipation from naturalistic colour. Hulme was impressed by the difference between *The Mud Bath* and an earlier work called *The Song of Songs*, a lost picture which he described as a 'very beautiful' example of Bomberg's 'older use of colour'. In *The Song of Songs*, Hulme wrote,

> the combination of greys, dead black and gold strikes one as distinguished, but at the same time the pleasure it gives may be partly the pleasures of association; it is the kind of colour that might occur in nature at times of the day which have a certain emotional accompaniment. In the 'Mud Bath', on the contrary,

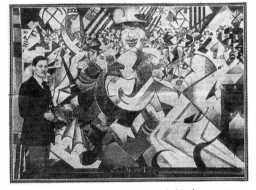

105. Photograph of Nevinson with his lost canvas *Tum-Tiddly-Um-Tum-Pom-Pom*, 1914. Reproduced in the *Western Mail*, 15 May 1914.

the colour is used in an entirely constructive way, and in no sense derivative from nature.[30]

Bomberg's most extraordinary decision was to use red as the colour of the bath. In the final gouache study, this area of the picture had been an inoffensive white, but now it was inflamed by a colour at the furthest possible remove from the idea of water. Red suited Bomberg's purposes very well. Although it allows the figures to stand out with knife-edge clarity, it carries enough pictorial force to make the bath an active rather than a passive element in the painting. We become acutely aware of the shapes formed by the gaps between each figure: even the tiny red triangle on the pillar's left edge sings out sharply, and throughout the canvas the garish colour of the bath prevents it from receding into the distance. It stays on the same pictorial plane as the figures, and helps to push the whole image towards us with a fierce insistence.

Ultimately, though, Bomberg does not allow the forcefulness of the bath to detract from the vitality which his figures display. The bright light carves into their limbs so decisively that each one blazes with white-hot clarity. Deep blue shadows prevent these brilliant forms from appearing too thin and metallic: even as he flattens them out on the picture-surface, Bomberg lets them retain a sense of solidity. But their bodies do have a mechanistic gleam and rigidity which recalls Hulme's prediction, in his Quest Society lecture, that 'the new "tendency towards abstraction" will culminate, not so much in the simple geometrical forms found in archaic art, but in the more complicated ones associated in our minds with the idea of machinery.' The forms defined by Bomberg with such awesome finality in *The Mud Bath* are as 'clean, clear-cut and mechanical' as Hulme could have wished. Human limbs everywhere take on the character of levers, suggesting that Bomberg shared Hulme's admiration for 'the hard clean surface of a piston rod'.[31] Indeed, *The Mud Bath* and the other new pictures displayed at the Chenil show must have seemed to Hulme like a fulfilment of his prophecy in March 1914 that 'it is not the emphasis on form which is the distinguishing characteristic of the new movement, then, but the emphasis on this particular kind of form' – the machine-age language which produced work 'based on hard, mechanical shapes in a way which previous art would have shrunk from'.[32]

But *The Mud Bath*'s clear connections with these theories does not mean Bomberg was over-dependent on Hulme. The likelihood is that Bomberg's involvement with machinery was an instinctive interest pursued by many young men of his generation. Ezra Pound maintained in 1915 that 'a feeling for . . . machines' was 'one of the age-tendencies, springing up quite naturally in many places and coming into the

106. David Bomberg. *Figures watching clock work machine, c.* 1914. Ink, 20 × 23 cm. Anthony d'Offay Gallery, London.

107. Jacob Epstein. *Rock Drill* (original and partially incomplete state), 1913–15. Plaster and ready-made drill photographed in Epstein's studio. Dismantled.

108. Archipenko's, *The Dance*, 1913, reproduced on the cover of *The Sketch*, 29 October 1913.

arts quite naturally and spontaneously in England, in America, and in Italy'. Pound was surely right to argue that 'this enjoyment of machinery is just as natural and just as significant a phase of this age as was the Renaissance "enjoyment of nature for its own sake", and not merely as an illustration of dogmatic ideas.'[33] One sheet of Bomberg's ink sketches shows how fascinated he may have been by a particular aspect of the machine age. Among the studies on the page is a little drawing which appears to depict an audience looking at a booth or a box with puppet-like figures performing inside it (Plate 106). Bomberg inscribed this drawing with the observation, 'this is a clock work machine', and it could well testify to his enjoyment of automata. No doubt their jerky movements and often aggressive behaviour appealed to him enormously, giving him some of the inspiration he needed to develop the amalgam of organic and mechanical forms found in *The Mud Bath*.

All the same, automata were not the only source for the strange beings, half-machine and half-human, whose actions galvanize this formidable painting. Another important stimulus was provided by his friend Epstein, whom Hulme regarded as the finest of the new English artists. Epstein afterwards distanced himself from Hulme's preoccupation with machinery, wryly recalling how the sight of the *Tomb of Oscar Wilde* immediately prompted Hulme to 'put his own construction on my work – turned it into some theory of projectiles'.[34] But Epstein certainly became very preoccupied with mechanistic imagery during this period, and it culminated in the extraordinary first version of *Rock Drill* (Plate 107). This ambitious sculpture, subsequently dismantled by its maker, brought together a plaster figure of a driller and a ready-made machine. Epstein was daring enough to decide on 'the purchase of an actual drill, second hand, and upon this I made and mounted a machine-like robot, visored, menacing, and carrying within itself its progeny protectively ensconced'.[35] Bomberg was privileged to see this powerful work before its completion, for he later wrote to Roberts asking:

> Did we not call on Jacob Epstein, about December 1913, at a garage in Lamb's Conduit Street, which he was using as a workshop, finishing the large white plaster 'Rock Drill', or was it Lewis and I, or the three of us together – I do remember however perched near the top of the tripod which held the Drill a tense figure operating the Drill as if it were a Machine Gun, a Prophetic Symbol, I thought later of the impending war.[36]

Quite apart from Epstein's astonishing readiness to incorporate a real machine in an otherwise man-made work of art, Bomberg would have been especially impressed by the construction of the driller. For Epstein turned the head into a metallic visor, like the shield a driller might use to protect his face from flying fragments of rock. His arms have become pistons, and even his rib-cage is schematic enough to look like the component parts of a machine. This sinister white apparition has taken on many of the attributes of the black drill he straddles, and the figures on the left of *The Mud Bath* bear an unmistakeable resemblance to him. Epstein's sculpture was only exhibited for the first time in March 1915, when Lewis watched with amusement while 'Epstein and David Bomberg kissed, to seal a truce, beneath the former's "Rockdrill" . . . in the salons of the Goupil.'[37] But encountering the sculpture in Epstein's studio in 1913 may have been an experience powerful enough to help Bomberg formulate his own mechanistic vision, and the forms cranking their way across *The Mud Bath* have a more pronounced sculptural character than any of the figures in his previous work.

Not that Epstein was the only sculptor to express an obsession with the machine world. In 1914 Archipenko produced an impressive bronze interpretation of *Boxers*, which transformed their thrusting aggression into a decidedly mechanistic structure. Archipenko's work became notorious in England when *The Sketch* reproduced his 'futurist sculpture' *The Dance* as a full-page cover illustration and asked fearfully: 'Shall we see this in our streets?' (Plate 108).[38] But Bomberg did not need to rely solely on such sensationalist sources for his knowledge of Archipenko's work. He probably saw it at first hand during his visit to Paris; and in 1914 he singled out Archipenko when he told the *Jewish Chronicle* about the artists he particularly admired (the others were Picasso and Matisse).[39] *Boxers* looks strikingly akin to the forms in *The Mud Bath*, and the muscular attack of Archipenko's sculpture makes us appreciate the strain of combative energy driving the figures in Bomberg's picture.

At the same time as they revel in the pleasures of the Vapour Baths, and in

109. Sir Lawrence Alma-Tadema. *A Favourite Custom*, 1909. Oil on panel, 66 × 45.1 cm. Tate Gallery, London.

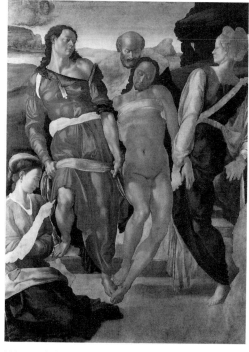

110. Michelangelo. Detail from *The Entombment* (unfinished), *c.* 1505–6. Oil on panel, 162 × 150 cm. National Gallery, London.

111. David Bomberg. Detail from *The Mud Bath*, 1914 (see Colour Plate 10).

the pared-down athleticism of bodies newly purified by mud massage, the forms in this canvas tilt at each other with strenuous zest. A struggle could even be in progress on the right of the painting, where several bodies seem to be entangled in a scrum of straining limbs. In this respect, *The Mud Bath* is informed by Bomberg's vision of the '*steel city*' as a tough and arduous place, where people are forced to engage in a struggle for survival. In a district like Whitechapel, where Schevzik's was situated, life could be merciless for the poorest members of the ghetto. Even in the baths, they might find themselves trampled on, and the hectic crowding of forms in Bomberg's composition signifies his awareness of the Brick Lane area as a narrow, jostling, over-populated centre filled with danger and the clash of conflicting interests.

There is an abrasiveness about *The Mud Bath* which sets it in implicit opposition to the kind of bathing image favoured by the academic artists whom Bomberg despised. He could easily have been familiar with Alma-Tadema's painting *A Favourite Custom*, which was purchased by the Chantrey Bequest at the 1909 Royal Academy exhibition and entered the Tate Gallery in the same year (Plate 109). Although this meticulously executed panel reflects the fact that public baths were proliferating in the Edwardian period, Alma-Tadema pretends to remove himself from modern life by evoking Roman civilization. The carefully reconstructed classical setting makes the titillation of the foreground nudes irreproachably respectable, and *A Favourite Custom* dwells with care on the delights of Roman pleasure at its most luxurious. Alma-Tadema's brush is expert at simulating the textures of silver, marble, mosaic and flowing drapery. His virtuoso attempt to produce a beguiling facsimile of classical life at its most languorous stands at the opposite extreme to Bomberg's brusque rejection of a mimetic approach. Alma-Tadema takes particular pride in providing an illusion of spatial recession, whereas Bomberg refuses to allow anything to wander away from the planar integrity of his picture-surface. Above all, *The Mud Bath*'s harsh energy has no time for the ingratiating playfulness of *A Favourite Custom*. Indeed, Bomberg's painting could almost be seen as a headlong assault on Alma-Tadema's art, and when the latter's Memorial exhibition was held in 1913 it was heartily despised by supporters of the avant-garde. After Fry wrote a scathing review of the show, asking how long it would take 'to disinfect the Order of Merit of Tadema's scented soap',[40] Bomberg's Slade contemporary Wadsworth wrote to *The Nation* declaring that 'everyone who is sincerely interested in the aims and spirit of modern art will have thanked Mr Fry for having so vigorously and lucidly defined Sir Alma-Tadema's position.'[41] To young British artists like Wadsworth and Bomberg, Alma-Tadema represented everything that was rotten about the state of Royal Academy art, and the 'Pure Form' in *The Mud Bath* had been thoroughly purged of the perfumed prettiness which *A Favourite Custom* exuded.

The comparison with Alma-Tadema serves to emphasize just how bracing was Bomberg's involvement with the stress and dynamism of contemporary urban life. But his scorn for 'the colours of the East, the Modern Mediaevalist, and the Fat Man of the Renaissance'[42] did not mean that he had abandoned all his earlier respect for the art of the past. Bomberg's *Jewish Chronicle* interview was careful to point out that he disagreed with the Futurists' 'wholesale condemnation of old art',[43] and he certainly retained a profound enthusiasm for Michelangelo. His future wife Alice recorded how, in December 1914, he rushed her

off to the bus stop and while we waited for the bus, he informed me that we were going to see a *real* picture. That's all he would tell me, so we sat quietly till the bus took us to the National Gallery. He hurried me through the rooms, I was not allowed to look at anything – I was to keep my eyes for the picture and so we came to Michael Angelo's 'Entombment' (of Christ). He pointed out to me the wonderful composition of the picture and marvellous proportions of the figures and other details which were quite beyond my comprehension. I kept very quiet and so I passed the test. David explained then, that the modern pictures that were such a revelation to me, had their beginning with the Old Masters and Michael Angelo was the chief of these.[44]

The muscular vitality and monumental grandeur of the unfinished *Entombment* would have made a direct appeal to Bomberg (Plate 110). Its dramatic design centres on the hauling of Christ's inert body, and the straining figures are defined as convincingly as the burdensome weight of the corpse. Indeed, the diagonal tilt of Christ's

112. Aristotile da Sangallo. Detail from *Copy after Michelangelo's cartoon for the 'Battle of Cascina'*, 1542. Holkham Hall, Earl of Leicester.

113. Ivan Puni. *Baths*, 1915. Oil on canvas, 73 × 92 cm. Private collection.

legs is echoed by the leaning limbs placed so prominently in front of *The Mud Bath*'s pillar (Plate 111). The correspondence suggests that the formal organization of *The Entombment* affected Bomberg's thinking as he developed the equally thrusting components of his own painting. Unlike Lewis, who announced in 1915 that 'Buonarotti is my Bete-Noir',[45] Bomberg continued to hero-worship Michelangelo. Indeed, the idea of concentrating on lithe, exclamatory figures in a bathing area may also owe a debt to the lost cartoon for the *Battle of Cascina* (Plate 112). Ultimately, though, the driving power of Bomberg's painting does not convey the overt fear and martial violence displayed by the surprised soldiers in the *Cascina* cartoon. The overriding characteristic of *The Mud Bath* is its taut exhilaration, and Bomberg was faithfully expressing the heightened pulse of life in the district where Schevzik's was located. Gertler recalled that when he returned to Brick Lane from the West End, 'there was definitely "something different" – a greater vitality, perhaps: the rich dark-complexioned boys and girls seemed to move and talk with unusual intensity – as if life was fearfully important – momentous. The whole long narrow street itself seemed to vibrate with a quickened pulse, and a life of its own.'[46] Having been brought up in this environment and participated in its vigour, Bomberg managed to make *The Mud Bath* convey the maximum amount of hard-hitting energy.

At the same time he demonstrated a zealous determination to overhaul the language of painting, and by an intriguing quirk of art history the Russian Futurist Ivan Puni also chose the 'baths' theme when he painted an even more experimental canvas the following year (Plate 113). Included in the December 1915 show *0.10 – The Last Futurist Exhibition*, where Suprematism emphatically announced its existence, Puni's *Baths* was purified to such a provocative extent that the word itself ('Bani') stood in for an image. Stripped of everything except four black letters on a stark white ground, and bordered by a band of red strangely reminiscent of the colour Bomberg employed for his bath area, Puni's painting was almost as iconoclastic as a Duchampian ready-made. Its total extremism sets it apart from *The Mud Bath*'s involvement with the western figurative tradition, and Bomberg was never prepared to go as far as Puni in his search for pictorial renewal.

All the same, the most experimental paintings on view at the Chenil Gallery show were audacious enough to earn the condemnation of most reviewers. A withering review in the *Pall Mall Gazette* typified this hostile response under the headline 'Mr Bomberg's Futurist Bombshells'. The critic refused to regard them as legitimate works of art, and dismissed Bomberg as 'nothing but a designer who escapes from the difficulties of naturalism and "imitation" by short cuts which have nothing to do with the inner significance of form'. The *Pall Mall Gazette* concluded its review with the pronouncement that

> his paintings suggest that he has energy without patience; a great self-confidence without the power of expressing it . . . Had Mr Bomberg allowed his art to develop in close study of natural forms he might have been longer in attracting attention, but his artistry would have gained. One may remind Mr Bomberg that it is a pure artistry alone, and not any theoretical juggling with shapes, that is the constant element in a work of art.[47]

Even the formerly admiring Augustus John was disconcerted by the new work. Although he praised *The Mud Bath*, most of the images strained his sympathy. 'Would you like to invest in the unfathomable?' he asked Quinn in a letter which clearly revealed John's ambivalent feelings. 'Bomberg has talent and ingenuity, but frankly his latest things are too, too inhuman to provoke my wholehearted enthusiasm. Still he is an amusing little type, and you might be amused to have some of his inventions.'[48] But John's doubts were certainly not echoed by the artists who shared Bomberg's commitment to drastic renovation. The members of the Vorticist movement were impressed by the Chenil show, and its vitality also made a lasting impression on a Slade contemporary who was not, as yet, ready to explore an experimental direction. Looking back on the innovative energy of 1914, Ben Nicholson recalled that 'Bomberg I suppose was a part of it & early work by him I found v. interesting.'[49] So did artists from abroad whom Bomberg had probably first met when he went to Paris. Visitors to the Chenil included Brancusi and Duchamp-Villon, and Marinetti was so impressed that he renewed his attempt to convert Bomberg to the Futurist cause. Bomberg later described how he 'flatly

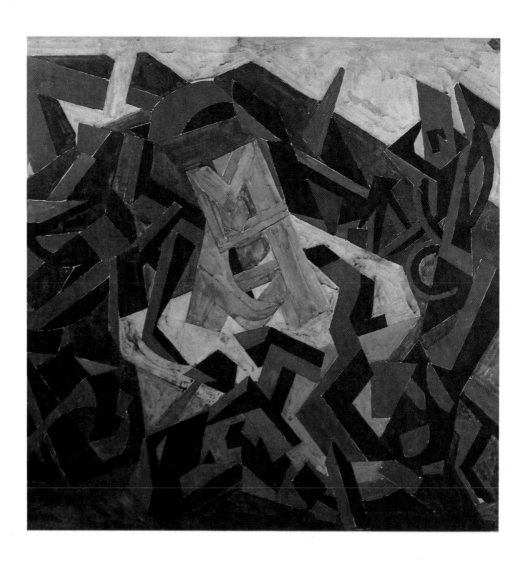

C11. David Bomberg. *Composition: Study for Reading from Torah* (?) (recto), *c.* 1914. Gouache, 52.5 × 59 cm. Private collection.

114. David Bomberg. *Composition: Study for Reading from Torah* (?) (verso), *c.* 1914. Crayon, 52.5 × 59 cm. Private collection.

rejected' Marinetti's advances, telling the Futurist leader that 'this show of mine does not owe anything to Italian "Futurism". You can no more make a claim on me than on Bernard Berenson or for that matter, Michelangelo.'[50]

In the summer of 1914 Bomberg felt more certain of his singular powers than at any other time in his career. Sonia Cohen Joslen, still a close friend, remembered that 'one of the most characteristic things David ever told me then was that he lacked ambition. He said he didn't *need* it: he *knew* success and acclaim were his due, like the Chenil Gallery show.'[51] This precocious confidence enabled him to withstand the hostility of the reviewers, secure in the realization that his certitude was rewarded by the approval of artists whom he respected. Besides, the anger of the press did at least mean that his work was eliciting a response. 'The imputations daily in the press that the reason the English cubists painted cubistically was incompetence, though damaging to ourselves we regarded as the natural public prejudice against any change in the art forms of the day', he wrote afterwards, adding that 'it seemed to me preferable to the calculated indifference of the polite gentlemanly critics.'[52]

The worst fate would have been total neglect, and he was immensely gratified when *The New Age* published a long, thoughtful and supportive review of the Chenil show by Hulme. By this time Lewis had fallen out with Hulme, who did not hesitate to express his dissatisfaction with the newly-fledged Vorticists at the beginning of his article. Praising Bomberg for his wisdom in disassociating himself from the Rebel Art Centre, Hulme declared that 'his work is certainly much more individual and less derivative than the work of the members of that group. The tendency to abstraction does seem in his case to have been a logical development of tendencies which were always present even in his earlier drawings, and not merely the result of a feverish hurry to copy the latest thing from Paris.' To accuse artists as substantial as Lewis, Wadsworth, Gaudier and Roberts of mere plagiarism was manifestly unfair, but Hulme was right to decide that Bomberg's work 'justifies much more than is generally the case a one-man show'. Just as Hulme had previously risen to the defence of Epstein's exhibition when it was attacked by the critics, so he now refuted

115. David Bomberg. *Drawing: Zin* (?), *c.* 1914. Chalk, 56 × 63.5 cm. Anthony d'Offay Gallery, London.

the jibes of Bomberg's hostile reviewers: 'These judgements I consider to be entirely unjust', he wrote, arguing that both the earlier and the more recent exhibits showed 'emphasis on, and understanding of, that quality which, while it may only be one element in the excellence of a naturalistic drawing, is yet the whole of a more abstract one – a sense of form. That seems to have been always excellent. He has all the time, and apparently quite spontaneously, and without imitation, been more interested in form than anything else.'

Bomberg's concentration on form prompted Hulme to examine 'the assumption that an interest in pure form is a sufficient basis in itself'. His conclusion was ambivalent. He maintained at first that 'the best answer is, of course, that certain people do find it enough. They find that they are moved by, and interested in, the suggestions of abstract form they see about them, and do feel themselves prompted either to then organise these suggestions, or to look for them in art.' But Hulme, who elsewhere made a close study of Volkelt's argument against the theory of 'aesthetic emotion', then went on to contradict the idea that 'we contemplate form for its own sake – that it produces a particular emotion different from the ordinary everyday emotion'. Although he did not mention Clive Bell by name, Hulme implicitly refuted the notion in Bell's *Art* that 'the rapt philosopher, and he who contemplates a work of art, inhabit a world with an intense and peculiar significance of its own; that significance is unrelated to the significance of life. In this world the emotions of

life find no place.' Hulme completely disagreed with this Bloomsbury standpoint, maintaining that 'there is no such thing as a specific *aesthetic* emotion, a peculiar kind of emotion produced by *form* alone, only of interest to aesthetes. I think it could be shown that the emotions produced by abstract form, are the ordinary everyday human emotions – they are produced in a different way, that is all.'

Hulme maintained this resolutely commonsensical approach to the question all the way through his review. He was dealing with a problem which presented formidable difficulties to every serious writer on art at the time, struggling to define a coherent attitude towards the whole phenomenon of abstraction and its viability. But he refused to let himself stray from his firm belief that the 'possibility of living our own emotions *into* outside shapes and colours is the basic fact on which the whole of plastic art rests'. Holding this belief enabled him to accept the possibility that 'abstract form' could become 'the *porter* or *carrier* of internal emotions'. He even went so far as to insist:

> there is nothing esoteric or mysterious about this interest in abstract forms. Once he has awakened to it, once it has been emphasized and indicated to him by art, then just as in the case of colour perception and impression the layman will derive great pleasure from it, not only as it is presented to him organised in Cubism, but as he perceives it for himself in outside nature.

Only when he attempted to define Bomberg's use of abstraction did Hulme's level-headed argument begin to falter. For although Bomberg himself never claimed that his work must be regarded as completely abstract, Hulme appeared to imagine that it should. His review categorically asserted that 'the only element of the real scene which interests the artist is the abstract element; the others are for that interest irrelevant, and, if reproduced, would only damp down the vigour of the naked form itself.' Hulme was obviously mistaken in believing that the 'abstract element' in a painting like *The Mud Bath* could somehow be isolated from its manifold connections with a figurative subject. Because he was relatively unfamiliar with the language which Bomberg employed in such a work, Hulme seemed incapable of appreciating how deeply rooted it really was in the artist's response to the human body. Even though he declared that *The Mud Bath* was 'one of the best things Mr Bomberg has done', he believed that its figurative origins 'are of no importance, the controlling interest all the time being the selection and production of abstract form'.

That is why Hulme preferred a painting, since lost, called *Reading from Torah*, which had in his view been developed from the drawing responsible for generating *The Mud Bath*.[53] Hulme thought that *Reading from Torah*'s 'abstract shapes here do reinforce a quite human and even dramatic effect, at the same time being interesting in themselves merely as a construction of shapes'. Several elaborate studies have survived for a composition which may well have been *Reading from Torah*, most notably a drawing and a gouache carried out on either side of a single sheet (Colour Plate 11, Plate 114). The chain of animated forms who encircle a pair of fighting or embracing figures are all identifiably human, which helps to explain Hulme's response. But the painting that Bomberg developed from these impressive studies cannot have been a great deal more figurative than their counterparts in *The Mud Bath*, and Hulme was wrong to insist too strongly on Bomberg's interest in 'abstract form'. After all, even the most minimal of the works that Bomberg executed during this period stopped short of total abstraction.

It is significant that his 'foreword' to the Chenil exhibition catalogue did not use the word 'abstract', and his profound involvement with the figure is still evident in a study as economically organized as *Drawing: Zin (?)* (Plate 115). It may be identical with the drawing of that name displayed at the Chenil show, for Hulme singled out a 'remarkable drawing, "Zin" (No. 26), which contains hardly any respresentative element at all. In the upper part, which strikes me as best, there are no recognisable forms at all, but only an arrangement of abstract lines outlining no object . . . Perhaps the best way of describing it would be to say that it looks like a peculiarly interesting kind of scaffolding.'[54] It is symptomatic of Hulme's overall approach to Bomberg's work that he did not specify what 'representative element' the rest of the drawing contained. To our eyes, the central form in the lower part of *Drawing: Zin (?)* can readily be seen as a dancing figure, arms outstretched and body clothed in a garment. Bomberg even highlights this

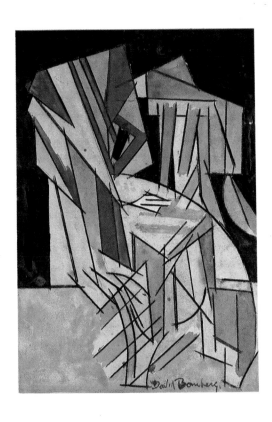

figure slightly with white, but Hulme stopped short of speculating about its likely identity.

His tendency to read Bomberg's images in exclusively abstract terms is understandable enough. Hulme had not been conversant with the young artist's work for very long, and he needed time to absorb the full implications of the Chenil exhibition. But he showed great percipience in recognizing the stature of Bomberg's art and discussing it with the seriousness it deserved. At the end of his extended review Hulme summed up by pointing out how 'in my notice of the London Group I said that I thought Mr Bomberg was an artist of remarkable ability. This show certainly confirms that impression. It also adds something. It convinces me that his work has always been personal and independent – much more independent than that of most Cubists – and never reminiscent. If I am to qualify this, I should add that as yet this use of form satisfies a too purely sensuous or intellectual interest. It is not often used to intensify a more general emotion ... In any case, I think he will develop remarkably, and he is probably by this kind of work acquiring an intimate knowledge of form, which he will utilise in a different way later.'[55] The prediction was remarkably accurate, although Hulme could never have guessed how 'different' Bomberg's subsequent work would be. Hulme's prophecy may even have prompted Bomberg to begin considering how his art could best 'intensify a more general emotion.' Looking back on this period, he maintained that Hulme's interpretations 'were in terms of speech and therefore had no influence on the artists'. But he admitted that Hulme 'helped innovators by trying to explain the deeper significance of visual form', and Bomberg always warmly appreciated that Hulme 'did me much honour'.[56]

C12 (facing above). David Bomberg. *The Dancer*, 1913–14. Pencil, watercolour and gouache, 27.5 × 18.5 cm. Anthony d'Offay Gallery, London.

C13 (facing below). David Bomberg. *The Dancer*, 1913–14. Crayon, watercolour and gouache, 67.5 × 55.5 cm. Anthony d'Offay Gallery, London.

116. William Roberts. *The Toe Dancer*, 1914. Ink and gouache, 72 × 54 cm. Victoria & Albert Museum, London.

Despite the encouragement he received from Hulme and artist friends, Bomberg sold very little from the Chenil exhibition. Although Quinn purchased a work on the recommendation of Augustus John, most of the exhibits remained in Bomberg's possession for the rest of his life. He was therefore faced with the problem of earning a living by some other means; but when the Chenil show closed at the end of July a cataclysmic event suddenly changed everything. 'On the night of August 4, 1914', he recalled, 'I was in the Cáfe Royal sitting at a table with Augustus John when the news . . . of the declaration of war was carried by one of our friends among the waiters to where we were. John, very perturbed said: "David, this . . . is going to be bad for art."'[57] It certainly made Bomberg's economic plight even more precarious. His first impulse was to enlist, but he found himself rejected because of his accent and hirsute appearance. So the problem of subsidizing his existence in a city dominated by thoughts of war, and less interested in avant-garde art than it was before, grew acute. Roberts remembered that

> when the war began in August 1914, I was living in a room at Chalcot Crescent, Chalk Farm, and fellow artist David Bomberg had a room on the corner of St George's Square nearby . . . The first three months of the war were particularly difficult for us. Money was conspicuous by its absence, for there were no student's grants in those days. In this situation of penury, Bomberg wrote to Lady Otteline Morel [*sic*] and the Artists Benevolent Fund, but without result.[58]

Eventually, however, Augustus John came to Bomberg's aid. Always willing to help the impecunious painters whom he respected, John joined forces with an eccentric character called Stewart Gray who, according to Epstein, 'had been a respectable lawyer in Edinburgh, and "kicked over the traces"'. Gray 'led a contingent of "hunger marchers" to London',[59] where he met John and befriended him. John warmed to Gray, describing him as 'a dear old humourist with a passion for vegetables',[60] and the two men hatched an ingenious plan. 'After they had had a talk together at the Café Royal over a bottle of wine', wrote Alice Mayes, subsequently to become Bomberg's first wife, 'they discussed the plight of young artists in war time when no one had time for pictures, and even to consider painting them was "hindering the war effort".' They found a derelict house with a short lease in Ormonde Terrace, overlooking Primrose Hill, and bought it very cheaply. 'The purpose of buying this large house was to provide a home for young artists', Alice explained, 'so that they might be able to carry on, in spite of war conditions and so keep themselves free from the need to join up as a means of livelihood. As well as painters, singers and dancers whose work had been stopped by war conditions were offered a home.'[61] Bomberg was among them, and at first he was probably delighted to find such cheap accommodation. But conditions at Ormonde Terrace were primitive. 'This refuge was without gas or electric light, so that candles were used, and it seldom had water', Epstein recalled.

> No room had a lock, as most of the metal work had been carried away. Here the artists lived, and there was a life class at which I sometimes drew, and sometimes the artists, among others Roberts and Bomberg, a mysterious Indian artist, and some models, would have parties. Whether Stuart [*sic*] Gray ever received any rent was a question, but the old man who resembled a Tolstoy gone wrong would prowl about at night in a godfatherly fashion and look over his young charges.[62]

Although John refused to become President of the house's committee, explaining that 'I can't go and identify myself publicly with a narrow group with which I have no natural connexion', he persisted in thinking that '*the idea is a very good one*'.[63] In the short term it certainly was, and Bomberg stayed at these strange premises for several months after moving there in the autumn of 1914. Roberts was particularly excited by 'the dances performed by the wife of Stewart Gray'[64] at the parties they held there. Her semi-naked movements inspired him to execute a large, mesmerizing gouache called *The Toe Dancer*, where the bizarre atmosphere of the gatherings at Ormonde Terrace is dramatized by the vertiginous floorboards, the harsh lighting and the distorted attitudes of the figures lined up on either side of the narrow room (Plate 116). According to John's favourite model Helen Rowe,[65] the performances of Maria Wajda, a Russian ballet dancer who frequented Ormonde Terrace, intrigued Bomberg so much that he executed his *Dancer* watercolours there.

But the likelihood is that Wajda rekindled an interest in dancing which Bomberg had first discovered the previous year. For Sonia Cohen, who had been ardently pursued by both Bomberg and Rosenberg during their Slade days, later recalled the part she played in the genesis of the *Dancer* series:

> I always enjoyed dancing at this period. And in 1913, when I went down to Southborne to join a summer school dancing out-of-doors on the cliffs with Margaret Morris, Bomberg followed me down there with a few friends. He was in love with me at the time, and thought it a great lark to watch us all cavorting around at this open-air camp. The *Dancer* watercolours came out of his interest in all this, and I think you can see the bodies' movements clearly in the designs.[66]

Towards the end of 1913 Sonia moved into John Rodker's flat at 1 Osborn Street, London, and at first Bomberg refused to visit them there.[67] But Rodker, then an aspiring poet and later the publisher of Eliot, Pound and Joyce, soon regained Bomberg's friendship. In May 1914 Rodker reproduced Bomberg's *Racehorses* drawing (Plate 53) in an article on 'The New Movement in Art' for the *Dial Monthly*, and the two men remained lifelong friends. As a token of his high regard for Bomberg's work, Rodker asked him in 1914 to design the cover of *Poems by John Rodker*, a privately printed book published in an edition of fifty copies and dedicated 'To Sonia'.[68] Bomberg accepted the invitation, although it is not known whether he produced a design specially for the book or simply adapted an existing work. A lyrical watercolour, which Sonia subsequently owned and always referred to as *The Dancer*, is very close to the cover design (Plate 117). It may have been executed

117. David Bomberg. *The Dancer, c.* 1914. Watercolour and chalk, 36 × 26 cm. Sonia Joslen, London.

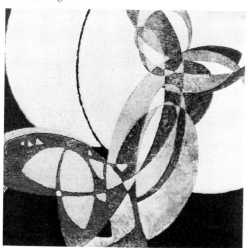

118. David Bomberg. *The Dancer*: Cover of *Poems by John Rodker*, 1914. Printed paper, 20.5 × 15 cm. Collection of the artist's family.

119. František Kupka. *Amorpha, Fugue in Two Colours*, 1912. Oil on canvas, 211 × 220 cm. Národní Galerie, Prague.

as a study for the cover, although the composition has already been fully defined and has the air of a complete statement. It is also one of the most agile pictures Bomberg made at this period. Using only a minimal framework of chalk contours, which outline the graceful interplay of arcs and spirals, he then applied washes of orange, yellow, pale blue and pink with an unusual looseness. As if in response to the poise and fluency of a dancer's movements, both the washes and the curving lines are handled with great buoyancy. Bomberg deployed a tenderness and delicacy he had never achieved before. The forms soar through space like thin tracks left in the sky by an aerobatic display. Bomberg's familiar preoccupation with a sense of mass here gives way to a far more ethereal vision, and the colours convey the exuberance of an artist who let the dance theme emancipate him from his obsession with monumental solidity.

In the cover design itself, the densely woven texture of the print and its overall greyness convey less of this airborne *élan* (Plate 118). But it was still a striking image for Rodker's book, which contained twenty-two poems of wildly uneven quality. None of them deals with a dancing theme, and Rodker only approaches the ecstatic liberation of Bomberg's design in a long poem called 'London Night', an Eliot-like exploration of urban despair, which briefly soars with joy when the poet hears the sound of a band playing in the park:

> Over the wind I mount on wings
> And swing and gleam and sheer and
> float . . .[69]

So it is unlikely that Bomberg took his cue from any of the poems in this book when he prepared the cover. But Rodker himself may well have been inspired by Bomberg when he wrote a poem called *Dancer* the following year, turning the lightness and optimism of Bomberg's design into an agitated alternative:

> This is Niobe
> whirling in anguish
> over her dead ones!
> gathering the poor strayed limbs
>
> Whirling she sucks them into her,
> they fade through and into her;
> Her swiftness whirls the air into one large round sob.
>
> Now a bitter ellipse – wickedly whirling:
> so tight          so crushed by air:
> so shaped by the thumb of air
> and levered on humming heels;
> her pointed head
> drills the skiey vault:
> makes heaven's floor tremble![70]

Despite a lingering fondness for awkward archaisms, Rodker uses *vers libre* with a vitality which parallels the radical language employed by Bomberg in *The Dancer*. The poem's references to drills and levers suggest, too, that he shared some of Bomberg's involvement with mechanistic imagery. Rodker's interest in making verbal equivalents of his friend's pictures continued at least until 1918, when he published in the *Little Review* a 'prose poem' called *Dancer* which still appears indebted to Bomberg's interpretation of the theme.[71]

Although *The Dancer* can be seen as a graceful refinement of the formal investigation Bomberg pursued in 1914, its attenuation sets it somewhat apart from the main body of his work at this time. Perhaps he was aware of the precedent created by Kupka's *Amorpha, Fugue in Two Colours*, which had been shown in the Paris Salon d'Automne of 1912 (Plate 119). Bomberg did not visit that exhibition, but both of the paintings Kupka displayed there were filmed by Gaumont for a newsreel screened throughout Europe and America.[72] Bomberg could easily have seen the film, for he was an avid cinema-goer: Alice Mayes remembered that 'always in our reckoning was the fourpence each for the cinema show – once a week'[73] Kupka's paintings could likewise have been familiar to Rodchenko when he started making his series of compass-and-ruler drawings in 1915 (Plate 120). The resemblance they bear to Bomberg's *The Dancer* may therefore be accidental, but it is possible that

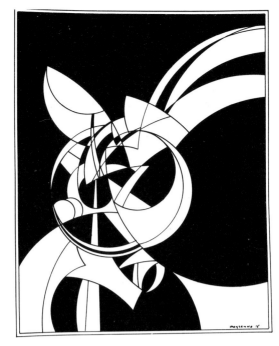

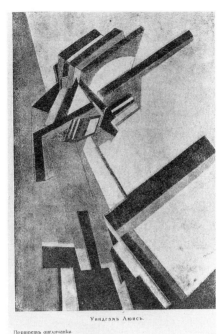

120 (right). Alexander Rodchenko. *Compass and Ruler Drawing*, 1915–16. Ink on paper. Rodchenko Archive, Moscow.

121 (far right). Reproduction of Wyndham Lewis's *Portrait of an Englishwoman* from *The Archer*, 1915.

122. E. O. Hoppé. Tamara Karsavina in *The Firebird*, 1911. Department of English, University of Reading.

123. Reproduction of Francis Picabia's *Danseuse étoile sur un transatlantique* from *Les Soirées de Paris*, March 1914.

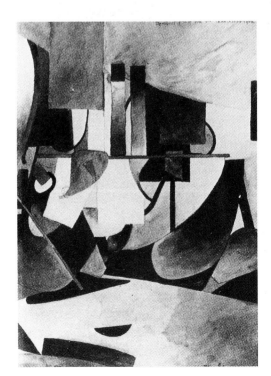

Rodker's cover design was known in Russia. After all, *Blast* was widely circulated there, and in February 1915 Mayakovsky's new experimental magazine *The Archer* published an interview with Pound on Vorticism and a reproduction of Lewis's *Portrait of an Englishwoman* (Plate 121).[74] Marinetti could also have alerted Russian artists to Bomberg's work, and so the possibility that *The Dancer* influenced Rodchenko should not be entirely discounted.

Bomberg was not, of course, the only English artist who became fascinated by dance subjects. After the Russian Ballet held its triumphant first season at Covent Garden in 1911, many young painters succumbed to its potent appeal (Plate 122). The critic Frank Rutter sat next to Spencer Gore at one of the performances, and never forgot his companion's enraptured response. 'At the fall of the curtain', wrote Rutter, 'he turned to me, his eyes shining with moisture, and whispered: "I've often dreamt of such things – but I never thought I should see them!"'[75] Bomberg could well have experienced similar feelings of delight, and in 1919 he paid his own tribute to Diaghilev's brilliant company by producing a booklet of lithographs entitled *Russian Ballet* (Colour Plates 18, 19, 20; Plates 152–154). But the majority of his *Dancer* watercolours were produced a few years earlier, around the time when the same theme was dealt with by Gaudier's *Red Stone Dancer*, Lewis's *Kermesse* (Plate 47), the Omega's murals at the Ideal Home exhibition and Roberts's lost *Dancers* (Plate 93). All these artists were instinctively attracted to a subject which lent itself so readily to the formal simplification they desired. In the second issue of *Blast* Pound selected some passages from Laurence Binyon's *The Flight of the Dragon*, a book published in 1914 which Pound thought was 'otherwise unpleasantly marred by his [Binyon's] recurrent respect for inferior, very inferior people'. One of the passages argued that 'every statue, every picture, is a series of ordered relations, controlled, as the body is controlled in the dance, by the will to express a single idea.'[76]

Bomberg would also have approved of Binyon's statement, for his *Dancer* pictures are likewise informed by the conviction that a human body in disciplined motion could best be expressed by 'a series of ordered relations'. Another of Binyon's remarks quoted by Pound asserted that 'art is not an adjunct to existence, a reproduction of the actual',[77] and Bomberg's *Dancer* pictures are remarkable for their freedom from overt representational intentions. He was surely aware of Picabia's treatment of the same theme, for Apollinaire's magazine *Les Soirées de Paris* reproduced in March 1914 a Picabia watercolour called *Danseuse étoile sur un transatlantique* (Plate 123). Wadsworth, for one, is known to have subscribed to *Les Soirées de Paris*, and Bomberg is likely to have studied the illustrations in this influential periodical with great interest.

Even so, his *Dancer* pictures are far less satirical and nihilistic than Picabia's images, and at least one was executed well before March 1914 (Plate 124). Clearly dated 1913, it contains some of the arched, spiralling elements which reappeared in the

design for Rodker's *Poems*. But it also includes more massive rectilinear forms which bear no obvious relation to the movements of a dance. In the 1913 picture Bomberg may, perhaps, have wanted to place his dancer in a larger context: the huge upright in grey, and the red fence-like structure at the top, are both architectual enough to suggest that the figure is curving through the interstices of the *'steel city'*. Bomberg could even have intended to contrast the organic spiral of the dancer with the stern rectilinear forms, implying that the figure's rhythmic vitality is threatened by the machine-age structures of modern urban life.

Within the group of pictures which have been known as *Dancer* images, there is considerable compositional variety. Sometimes, in the pictures closest to the Rodker design, Bomberg is at his most summary and relies on a spare statement of essentials (Plate 125). On other occasions the forms swell and multiply, stretching outwards until they assume a complex grandeur which is difficult to relate to the simplicity of the Rodker picture (Colour Plate 12, Plate 126). The curves are still there, but they seem vastly outweighed by the almost sculptural solidity of the structure which Bomberg has built around them. Although the degree of abstraction makes any attempt to identify these images very difficult, an intriguing clue to his intentions is provided by a hitherto unpublished sheet of studies (Plate 127). In the centre, a pencil drawing outlines a design very similar (in reverse) to a water-colour known for some time as *The Dancer* (Colour Plate 13). But on the left, Bomberg drew a much smaller version of the same image and inscribed it with the title 'Mother & Child'. Over on the right, yet another version is given the name 'Horse & Rider'. It is as if Bomberg, fascinated with the metamorphosis which 'pure form' can undergo, set out to discover just how well his central design lent itself to these alternative readings. He probably concluded that it suited these different possibilities very readily, for above the study on the right he drew a more representational horse and rider.

Do these inscriptions therefore mean that the watercolour of *The Dancer* (Colour Plate 13) has been known by the wrong title? It is difficult to tell. The ease with which Bomberg changed the design to a maternity subject, and then to an equestrian scene, means that he did not consider the image possessed a single, fixed identity.

127. David Bomberg. *Studies of The Dancer, Mother and Child and Horse and Rider*, 1913–14. Pencil and ink, 23 × 20 cm (irregular). Anthony d'Offay Gallery, London.

124. David Bomberg. *The Dancer*, 1913. Crayon, watercolour and gouache, 60 × 50.5 cm. Thyssen-Bornemisza Collection.

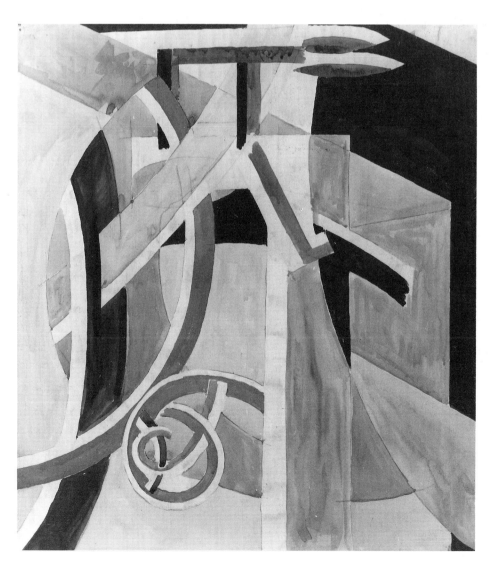

125 (right). David Bomberg. *The Dancer*, 1913–14. Pencil and watercolour, 37.5 × 21 cm. Private collection.

126 (far right). David Bomberg. *The Dancer*, 1913–14. Watercolour, 38 × 28 cm. Cecil Higgins Art Gallery, Bedford.

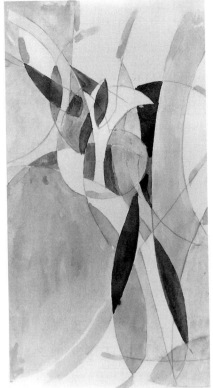 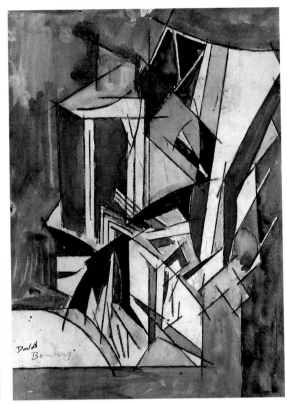

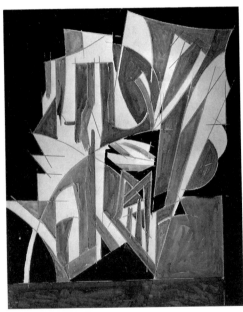

128. David Bomberg. *The Dancer*, 1913–14. Wax crayon and watercolour, 68.5 × 56 cm. Victoria & Albert Museum, London.

It was able to convey several startlingly different meanings, and Bomberg seems to have delighted in its capacity to signify dancing, motherhood and riding. Nor was he alone in relishing the multi-referential richness which an abstract language could yield. The Vorticists also enjoyed making their images at once precise and open-ended. When Wadsworth exhibited a large painting called *Blackpool* in 1915, Lewis declared that its 'striped ascending blocks' signified 'the elements of a seaside scene, condensed into the simplest form possible for the retaining of its vivacity.' But Wadsworth's reduction of this scene to such minimal components did not mean that he had sacrificed the multiplicity of subjects available to him at Blackpool. For Lewis maintained that although 'its theme is that of five variegated cliffs', Wadsworth had also succeeded in ensuring that 'the striped awnings of Cafés and shops, the stripes of bathing tents, the stripes of bathing machines, of toy trumpets, of dresses, are marshalled into a dense essence of the scene.'[78]

Bomberg, on the evidence of the small yet subversive sheet where he changed the meaning of his *Dancer/Mother and Child/Horse and Rider* design, went further. The range of references in Wadsworth's painting all arose from one locale, whereas Bomberg was apparently prepared to allow a single image to stand for several widely diverse subjects. So the most elaborate of the watercolours called *The Dancer* should perhaps be seen as exhilarating invitations issued on Bomberg's behalf, their complexity encouraging us to speculate with great freedom on the other meanings they could yield (Plate 128). They are not, emphatically, the work of an artist who explores abstraction in order to strip his images of all figurative significance. On the contrary: Bomberg saw 'Pure Form' as a means of enlarging the representational field which his work could legitimately encompass. In this sense, he used an abstractionist vocabulary in order to broaden and intensify his art's relationship with the observable world.

Bomberg's interest in dance also led him to the woman who would, before long, become his wife (Plate 129). The daughter of a London wholesale stationer whom she 'adored', Alice Mayes was sent to school in Switzerland when she was eight years old. There, according to her son, Denis Richardson, she 'acquired French and a capacity to live on her own resources from an early age'.[79] Her first marriage was to Jack Richardson, a Socialist who described himself as a 'general dealer'.[80] But their relationship soon deteriorated. Alice was energetic, unconventional and restless. A theatrical strain ran through the Mayes family, and her brother Frank was an actor who spent many years with the Forbes Robertson Shakespeare Company. 'Both my uncle Frank and my Mother were dedicated to art', wrote her son, 'but both inclined to neurasthenia which led at times to insane rages.' Denis

would have seen the temperamental side of Alice more sharply than most people, for he witnessed the irretrievable breakdown of her marriage to his father Jack. 'I remember her as a boy as beautiful but completely without affection',[81] he remarked, and after leaving Richardson she made little attempt to contact her son for many years.

At one point she ran off to Montreal with the travel book illustrator C. G. Lowther. But before long she returned to England 'to deal with a legacy in which she was a beneficiary. Lowther was to follow on the next boat. He boarded a ship but is said to have jumped overboard approaching the coast of Newfoundland and was never seen again.'[82] Dancing now became Alice's passion. She had already fallen under the influence of Isadora Duncan, for her son remembers that she 'started to adopt Greek dress, corsetless, as a protest against the corsetted monstrosities that fashion decreed for women in those times. As she was slim and rather beautiful she could get away with it. A photograph of her and companion in Greek dress appeared in one of the London dailies around this time.'[83] Now Alice began to experiment with dance and make clothes inspired by the Russian Ballet. She lived in a freewheeling way and, in the words of another relative, 'didn't care tuppence for anyone's opinions once she got an enthusiasm.'[84]

Although Alice was almost a decade older than Bomberg, she was strongly attracted to him soon after they met at Ormonde Terrace in 1914. 'Stewart Gray arranged for a Christmas party, so as to start things off well in the "home for artists"', she recalled, 'and [he] invited me to give a demonstration of Russian dance steps which I had been learning while working with Kosslov's Ballet Company – standing in for Diaghilev's Company, who were kept abroad owing to war conditions. After I had done my "little steps", I was naturally roped in to handle the coffee and sandwiches, and so I met the young Bomberg.' Their mutual interest in the Russian Ballet and experimental dance in general may well have helped bring them together, for Alice 'went to Ormonde Terrace the next day to help clean up and naturally saw David's pictures which were stacked round the walls of his room, three deep, just as they had come from the show at Chenil Galleries'. Her admiration for Diaghilev's audacious set-designs and costumes did not prepare her for the sight of *The Mud Bath* and all the other startling images which Bomberg had failed to sell. He seems to have been despondent about his inability to earn a living from his work.

> David had not had the heart to look at them, but as I began turning them over, I was astonished to see such pictures, such as I had never seen before. He also got interested in showing them to me, and he told me afterwards, that I was not only good at 'bossing about' with tea and coffee, but also had an unbiased view towards paintings. This led to further conversation about his work, and gradually I discovered that he was completely out of cash, owing money for food at the local dairy, had no clean shirts, as they were all at the laundry awaiting payment of the bill, as also was his spare suit. Luckily, I had some money and this state of affairs was soon rectified, until such time as he should sell a painting.[85]

129. Photograph of Alice Mayes, Bomberg's first wife, c. 1923. Collection of the artist's family.

Whether or not they fully realized it then, Alice's burgeoning affection for Bomberg was very maternal in character. She saw him as a brilliant but vulnerable young man who urgently needed someone to look after him, and she had the capacity as well as the desire to fulfil such a role. Many years later, after her marriage to Bomberg had long since ended, her son noticed that 'her bedside book was "The Wife of Rossetti" which she read and re-read ... I think my mother identified herself with Elizabeth Siddal – a life of dedication and suffering in the name of Art.'[86] By that time, of course, her memories were clouded by the bitterness of their marriage's failure, but in the winter of 1914 she was happy to accept the responsibility of caring for Bomberg. Indeed, Alice must have suspected at an early stage in their relationship the kind of part she would play in his life, for the day after their conversation she dropped in 'to see how things were going, and on my way, I happened to gather a bunch of broken twigs to start a fire going. This simple action on my part brought to his memory, a saying of his Mother, namely that a visitor should always bring something, no matter how small, something she had remembered from her life in Poland. Talking about his Mother, who had died two years before, led to his talking about the uselessness of his life at Ormonde Terrace and how people came in and out of his room and now he had no privacy in which

to work.'[87] It probably sounded to Alice like a plea for help, and she responded without much hesitation. Joseph Leftwich described her as 'very able, very devoted and very considerate of his success. Bomberg was a great believer in Alice's ability – he'd always say: "Leave it to Alice".'[88]

But Alice did not adopt a servile attitude towards Bomberg, humbly ministering to his needs. She was a powerful personality in her own right, and all the evidence suggests that she had a considerable influence on his character. Bomberg's sister Kitty, who was then very young, recalled that 'Alice wanted to mould me, and change me from a scatty working-class girl into a proper middle-class girl.' Kitty was impressed by Alice's sophistication, and thought that she knew 'exactly where she was going, with no humbug'. After Alice got to know Bomberg she 'looked after him very well', and Kitty 'never saw him looking scruffy'.[89] It sounds as if Alice tried hard to turn Bomberg into a 'proper middle-class' man, for their relationship soon had a transforming effect on his appearance. A few days after they met, Alice remembered, a sudden change came over him. Meeting Bomberg at Ormonde Terrace, she was astonished to find that 'I hardly knew him, for he had been to the barbers and had his beard trimmed to a reasonable shape and was wearing his freshly pressed suit and a newly laundered shirt.'[90] But she would not have been prepared to devote so much of herself to Bomberg had he not been, in his own way, a compelling individual. Although Alice later described how 'at that time I stood in the place of the Mother who had just died', and spent her time caring for 'a very young, very callow, highly self-conscious & incompletely educated rebel Jewish youth',[91] Bomberg impressed her enormously. 'When she met David life really began for her', commented Alice's nephew John Mayes. 'What attracted her was his total integrity and independence, a man so sure of himself. He would refer to other artists as constipated, whereas he had flow and energy. She always spoke about him as if he were the Alpha and Omega. It was an adventure, an excitement, a sharing. David was the only man she really loved, and she was proud of having coped with a "toughie".'[92]

The early years of their relationship were undoubtedly a time of great happiness for both of them, and it was a tragedy when active service brought their intimacy to an end. For when Bomberg eventually returned from the war everything had altered. They no longer felt entirely at ease with each other, and over a decade was to pass before he began to recover the certitude which had stamped his pre-war work with its consistently high quality and singleness of purpose.

# CHAPTER FIVE  War and its Aftermath

Within a few months, the rapidly escalating conflict in Europe began to press even harder on artists who had already experienced great difficulty in selling their work. But Bomberg, with characteristic tenacity, was determined to continue painting if he possibly could. The advent of Alice seems to have helped him decide that Ormonde Terrace should be exchanged for the greater privacy of a studio, and he quickly found cheap accommodation in Robert Street, near the Cumberland Market. The move played a crucial role in sealing his intimacy with Alice. 'In the meantime, I had given up my room', she recalled, 'and so came the quiet day when we lit a fire on our own hearth and boiled the kettle on our own gas stove, and because it was war time, we dispensed with a marriage ceremony [and] went to bed happily in our own studio.'[1]

Because he could not afford the materials for a painting, Bomberg concentrated all his efforts at the beginning of 1915 on a large drawing (Plate 130). It marked a decisive shift away from the East End themes which had dominated so much of his previous work. For Bomberg, affected no doubt by newspaper reports and first-hand accounts of the experiences undergone by army recruits, developed a composition directly expressive of the country's new wartime mood. But the image he produced had nothing to do with the patriotic flag-waving and martial enthusiasm which fired the young men who offered their services to Kitchener and the King. Rather than portraying a group of courageous and confident soldiers training for the battlefield, he settled instead on a defiantly uncomfortable subject. Alice remembered that the drawing 'was to depict the new volunteers as they had first arrived at their new Billet, to find themselves with one bedstead between them, showing their attempts to find places for themselves'. It was an unusually downbeat theme, and Bomberg doubtless intended it as a sober corrective to all the propagandist posters celebrating the glorious progress of the troops towards the Front. Instead of showing khaki-clad heroes marching in smooth, irresistible unison, he caught them off-duty as they struggled to adjust themselves to an awkward and disturbing new routine.

In order to give *Billet* the maximum amount of dour conviction, he also reverted to drawing from life. Although it was a procedure he had seldom adopted since his Slade days, Alice described how 'I myself took all the postures, as David would have every posture verified by my ability to take and hold it. Hold the posture I did, until often I had to be lifted out of it and vigorously massaged to life again.' Bomberg clearly made the fullest use of Alice's availability as a model, not to mention her willingness to undergo gruelling physical exertions for the sake of his art. But the difference between *Billet* and the major pictures of 1914, none of which appears to have been based on drawing from life, can still be exaggerated. Even though Alice claimed many years later that *Billet* 'was to be entirely naturalistic, for he had done with Cubism "for the duration"',[2] her memories should not automatically be trusted. Bomberg may well have realized, like many of his contemporaries after him, that images of Britain at war demanded a greater degree of representation than he had allowed himself the previous year. He could also have been affected by the first stirrings of the discontent with abstract experimentation which caused him to alter course after the war. But *Billet* could in no sense be described as an

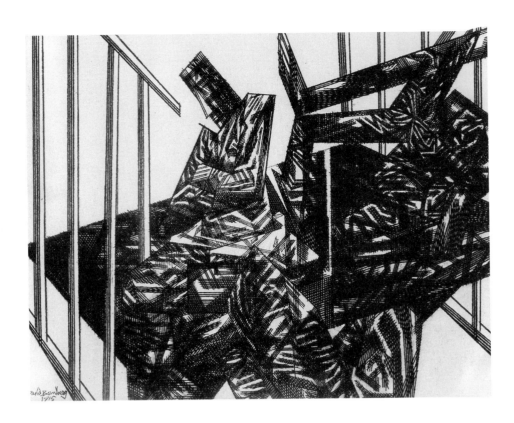

130. David Bomberg. *Billet*, 1915. Black ink, 39.5 × 51 cm. Victoria & Albert Museum, London.

131. David Bomberg. *Study for Billet*, 1915. Black chalk, 44 × 50.3 cm. Anthony d'Offay Gallery, London.

'entirely naturalistic' drawing which dispensed with the innovative language he had recently been exploring. It is based on the same rectangular platform employed in so many previous compositions, and a preliminary chalk sketch reveals that Bomberg began by simplifying the forms almost as drastically as he had done in *The Mud Bath* (Plate 131). Although the bed itself is clearly defined, and the principal figure can be seen without undue difficulty as Alice sitting on the mattress in a long dress, the other figures defy easy identification and recall the mechanistic forms who enlivened Bomberg's earlier work.

Even Plate 130, which employs a closely hatched style reminiscent of the 1913 *Jewish Theatre* (Plate 48), retains many ambiguities and formal complexities. The mass of figures jostling for space on and beside the bed is enmeshed in such a dense linear web that most of them cannot be distinguished one from another. Sometimes a leg or an arm bursts out of the tangled heap of bodies to assert its singular identity. But only one soldier can be discerned with any confidence, and even he merges with his companions as our eyes struggle to establish where the lower half of his figure can be found. His head and trunk alone remain free from the jostling limbs nearby. Bomberg gives his face a clenched weariness and an air of grim resignation as he slumps, shoulders hunched and arms tightly folded, on the uninviting mattress. This is a man exhausted and depressed by the harsh new surroundings he has encountered. He seems to be mourning his lost civilian freedom, and the cruel bars delineated with such clarity at either end of the bed imprison him like a criminal in a cell. Viewed with hindsight, *Billet* appears an uncannily prescient picture which warns that army life traps the soldier and renders him helpless. The harsh, jarring tangle of figures on the bed foreshadows the gruesome conditions they were soon to suffer in the cramped and degrading trenches. Bomberg's drawing is filled with his eerie anticipation of the far more devastating conflict to come, and the seated soldier can in this sense be seen as an elegiac presence burdened by a prophetic awareness of the fate awaiting them all.

No wonder *Billet* failed to sell when Bomberg exhibited it at the relatively conservative New English Art Club in the spring of 1915! Its vision of wartime conditions was too stark, and its intimations of tragedy too unsettling for most viewers to accept at this early stage in the conflict. Surprisingly enough, one of the few to understand it was his old teacher Tonks, who apparently 'admired' the drawing and recognized it 'as an expression of the confusion & muddled thought of the time, the vigorous gestures of the bewildered young soldiers crowded into sordid squalor while they were being "trained" to kill Germans, all weary after the orgasm of heroic enlistment'.[3] But if Bomberg had now regained the respect of his old

Slade professor, he still commanded admiration among his avant-garde contemporaries as well. Alice recalled that 'one of our first visitors to the studio in Robert Street was Wyndham Lewis, who spent many evenings trying to persuade David to allow him to have one of his drawings published in the new issue of "Blast".' Bomberg's attitude towards the Vorticists' magazine had mellowed a little since the previous spring, when he had firmly refused to allow any of his work to be reproduced in *Blast No. 1*. Now, mollified no doubt by Lewis's flattering persistence, his response was rather more positive. 'David was adamant that he should be "adequately represented"', wrote Alice, 'and demanded that five drawings be included in the publication – or none.'[4] Bomberg must have recognized that a work like *Billet* would not have looked at all anomalous in the pages of *Blast No. 2*, but his stipulation was unacceptable to its editor. Only one artist was allowed more than a couple of illustrations in the magazine, and Lewis reserved that privilege for himself.[5] So Bomberg never appeared in the Vorticists' periodical, and always insisted on remaining stubbornly independent from the movement.

All the same, Lewis's visits had persuaded Alice of his friendly intentions: 'I know from conversations I heard between [David] & Wyndham Lewis that they all of them "wished him well";'[6] and in the worsening economic climate of 1915 such gestures were as rare as they were welcome. So perhaps it is not surprising that Lewis's efforts bore fruit a few months later, when Bomberg finally agreed to be included in a special non-members section of the Vorticist Exhibition. Held at the Doré Galleries in June 1915, the survey concentrated in the main on the seven members of the Vorticist movement. But the additional room, containing 'Works by Those Invited to Show', enlisted the presence of rank outsiders like Duncan Grant and Nevinson. Bomberg presumably felt happy displaying his contributions with representatives of the rival Bloomsbury and Futurist camps, but none of his exhibits is now identifiable. The paintings were called *Decorative Experiment* and *Small Painting*, and equally non-representational titles were applied to the drawings as well. Bomberg called them *Design in White* and *Design in Colour*, names which suggest that he had decided to show the more abstract of his recent works. This supposition was reinforced by Rebecca West, who recalled that in 1915 Lewis took her 'to see Bomberg's white paintings, basically I think because he wanted to look at them himself. One of them was oblong, but they were all large and abstract.'[7]

Rebecca West's memories indicate that Bomberg had recently been pushing his involvement with near-abstraction to a new extreme. The tantalizingly brief comment made by a reviewer of the Vorticist Exhibition supports this hypothesis, recording that 'Mr Bomberg has a very pretty watercolour design of pseudo-calligraphic character.'[8] But he never excluded representational elements from his compositions entirely. Even the most 'abstract' of the watercolours which survive from this period retain vestiges of his preoccupation with the human figure. Bomberg never gave them titles, and it is understandable that one of them subsequently became known as *Abstract Composition* (Colour Plate 14). But the crisply outlined forms thrusting up energetically from the centre of *Abstract Composition* have not abandoned their representational role completely. Although they can no longer be identified either as machine components or as human limbs, both these possibilities are still inherent in their exclamatory movement. They possess much of the leaping, cranking vitality displayed by the mechanistic bodies in *The Mud Bath*, and suggest that Bomberg was willing for a while to take his pursuit of 'Pure Form' to a greater extreme. Another watercolour, now called *Abstract Design*, sheds even more of these lingering links with machine and human associations (Colour Plate 15). The line zig-zagging down towards the right corner has apparently detached itself from all figurative purposes, and the wild collision of forms which takes up so much of the remaining picture-surface likewise rebuts any attempt to saddle it with a clear representational meaning. But Bomberg never claimed that 'Pure Form' was synonymous with abstraction, and even *Abstract Design* arises out of his combative yet fiercely exuberant involvement with modern urban life.

Even so, the war was already beginning to change both the character of that life and Bomberg's own attitude towards it. On an economic level, he tried hard to gain further support for his work and found, perhaps inevitably, that former patrons had become distracted by a conflict which now obsessed the entire nation. 'David had written several letters to old friends of his', recalled Alice, 'telling how

132. David Bomberg. *Woman in a Bedroom*, 1915. Pencil and ink, 10.2 × 7.1 cm. Anthony d'Offay Gallery, London.

he was now fixed up in his own studio and was determined to carry on painting despite war conditions and in the meantime, he would be very glad to make a sale and very glad of a visitor.' But the response was scarcely encouraging. 'The one reply we received was from Sir Robert Waley Cohen, who said he would be pleased to come and see David's war-time work and meanwhile, he enclosed a cheque for twenty-five pounds for which he would choose a drawing later. David was a bit disappointed, but we put the cheque in the bank and hoped for the best.'[9]

Increasing financial privation was not the only way in which war affected Bomberg's outlook, however. He also found himself beginning to question the viability of the language he had developed in works as uncompromising as *Abstract Design*. His decisive move away from this experimental style occurred after the war, but the seeds of discontent can already be glimpsed in 1915. Drawing from life for *Billet* may have made him wonder whether it was wise to discard so much of the visible world, especially at a time when he was growing conscious of the need to depict wartime conditions in his art. At all events, Bomberg seems to have suffered a spasm of doubt around this time, for Alice recorded that 'David started another painting, but the urge was gone and after several attempts he painted it out and decided we would rely on the twenty-five pounds until we sold a picture.'[10] A small ink-drawing, one of the few works which can be securely assigned to 1915,[11] helps to explain the difficulties he experienced with the abandoned painting (Plate 132). It is a surprisingly straightforward study of a woman leaning on a brass bedstead, and looks back to the Camden Town preoccupations of Bomberg's early *Bedroom Picture* (Plate 29). Representational drawing was clearly becoming a serious issue once again, and he may now have felt torn by a conflict between 'Pure Form' and a more figurative approach.

Although the dilemma was to present itself in a far more acute form when he tackled his big war painting three years later, it is significant that Bomberg tussled with these preliminary doubts before he enlisted. The language he had evolved with such conspicuous brilliance and steadiness of purpose was already beginning to seem inadequate, and for the first time in years Bomberg found himself unable to paint. Apart from *Billet* and the paintings and watercolours he submitted to the Vorticist Exhibition, Bomberg seems to have completed very little work during the course of 1915. But that does not necessarily mean he felt downhearted. His love for Alice was at its height, and they led a convivial life together. 'As soon as it was known that David had established himself in a studio,' she related, 'we had plenty of visitors. Fellow students came from the Slade. Bobby Roberts came in every day and I had strict instructions from David to provide a meal for him at any time, "for he would surely need it". Zadkine looked in at the studio whenever he came from Paris and . . . we were very fond of making the trip to Mile End Road in search of cheap German shirts and chocolate cakes at Monicadams.' Better still, they discovered a new source of patronage. Among their neighbours were 'two maiden ladies who opened what they called "The Peasant Pottery Shop" in Theobalds Road, just round the corner', wrote Alice. 'These two ladies took a great liking to David and his work and bought several pictures.' Surprisingly enough, their purchases concentrated on the most experimental of Bomberg's 1914 works, like the superb squared-up study for *The Mud Bath* (Plate 102). These sales must have boosted his morale a great deal, and the ladies also 'took pity on our plight and invited us to a good dinner every Sunday, so as to ensure that we had "*one* good meal a week" . . . That Sunday meal kept us going every week and they had the joy of David's conversation on art, which they loved!'[12]

The money that Bomberg received for his pictures prompted him to organize a weekend trip to Paris for Alice and himself, partly as an unofficial honeymoon and partly as a means of discovering how the French avant-garde was responding to the war. They stayed at a 'most delightful' old house in the Rue des Petits Champs and, significantly enough, Bomberg first insisted on taking Alice to visit the Louvre nearby. Then they called on Nina Hamnett, who gave them Kisling's address. He greeted Bomberg 'as an old friend and soon a bottle and glasses were produced and we were drinking Cherry Brandy out of tumblers'. Kisling would have been able to tell Bomberg how the radical French painters were faring, and no doubt showed him some examples of their current work. Bomberg also had a chance to visit some galleries, but most of the weekend was given over to sight-seeing in Montmartre and Notre Dame. Alice's retrospective account of the weekend is

touchingly nostalgic, and happily records that 'I drank so much wine in Paris that I was giddy all the time and it was a lovely sensation.' The trip was such a success that Bomberg may well have begun to harbour thoughts of a possible marriage. But he keenly observed the work of the Parisian avant-garde as well. Towards the end of their stay, over tea in their room, Bomberg declared that 'he was satisfied with all he had seen in Paris and he decided that his work was all right.'[13] First-hand encounters with new paintings by Picasso, Braque, Léger and others surely convinced him that the war had not yet adversely affected the work of the artists he admired most.

But the euphoric mood engendered by Paris did not last long. On their return to London, Bomberg and Alice realized that their funds had almost run out. When Waley Cohen collected the drawing he had bought, he informed them of his ominous decision to stop buying pictures while the war continued. He even 'advised David to seek some more "essential work" where he would be replacing a man who had "joined up" and David, having such faith in Waley Cohen – from boyhood days – went to a workshop where cars were being polished and undertook the unskilled job of rubbing down the enamel on second-hand cars with pumice stone'. It was an arduous and extremely unpleasant task, leaving him with neither the time nor the energy to pursue his own work. Alice took a manual job as well, so 'the studio was only a place where we slept at nights and David was very discouraged, rubbing, as he said, "his nails to the quick" and no social life, because we were . . . too tired to entertain friends in the evening.' The prospect of continuing such a demoralizing existence eventually became unendurable, but there was only one alternative. 'Kitchener was calling for more men to replace those killed in the "great advance"', Alice remembered, 'and David began to think life in the army would be preferable.'[14]

The decision to enlist in the Royal Engineers was arrived at in November 1915. Like so many other young men of his generation, Bomberg probably felt that patriotic duty obliged him to fight for his country. Besides, his own work seemed to have reached a temporary impasse, and war service may almost have come as a release from the need immediately to confront his difficulties as a painter. Perhaps he even imagined that his way forward would become clearer after the war was over. The tragic death of Gaudier-Brzeska in June 1915, while fighting with the French army at Neuville-Saint-Vaast, appalled everyone who had known him and recognized his extraordinary potential. Bomberg was therefore already vividly aware of the risk he ran by enlisting, shaving off his beard and exchanging his ordinary clothes for a khaki uniform. But he could never have envisaged that the war would be as prolonged and destructive as it turned out to be. In 1915 hopes were still entertained for a swift, crushing victory against the Germans, and no civilian was able to guess what conditions at the Front were really like. Maybe Bomberg thought he would soon be returning when he left Alice to look after the 'sacrosanct'[15] studio and, before long, to find a job for herself at a printing works in the City.[16]

All the same, parting cannot have been easy. After billets in the North Country and then in South Wales, where 'he lived with coal miners and learned to respect hard work',[17] Bomberg was drafted briefly to Wimbledon Common. Alice therefore had a chance to visit him, and found that he wanted to get married at once. Although very little time was left before his company departed for France, Bomberg felt that Alice should prepare herself in the most elaborate way. His own beliefs were far from orthodox, but the prospect of a wedding brought his latent family loyalties to the surface. 'To satisfy his father, I must become of the Jewish faith', wrote Alice, 'so it was arranged that I should go thrice weekly to a Rabbi . . . and also I had to learn how to keep a Kosher household, which meant I must know all the rules which applied to serving meat and milk separately.'[18] It was a measure of Alice's devotion to Bomberg that she was prepared to undergo such a demanding initiation. But the whole notion appealed to the impulsive side of her temperament. 'I'm not surprised that Alice agreed to join the Jewish faith', commented John Mayes, 'because she threw herself into things and was very romantic.'[19] Alice found herself learning as well 'to repeat in Hebrew the various prayers of certain times of the day', but she does not seem to have resented the effort involved in taking another faith. 'With my quick mind I readily absorbed all this knowledge and had no difficulty in passing the exams', she recalled, adding that 'soon I was no longer a "shicksie", but a fit person to marry David (according to his father).'

Although Bomberg had by now become estranged from his father in many ways,

Abraham still appears to have exerted a powerful influence over the marriage preparations. On this matter his views accorded with his son's, for Bomberg even felt, 'in his thorough Jewish fashion', that he should seek out Alice's previous husband to inform him of the wedding 'and get his assurance that he had done with me and would make no claims on me'. So he travelled to the outer London suburb of Wood Green where Jack Richardson lived. According to Bomberg, 'Jack assured me quickly that his feelings for her were quite dead . . . but added: "One should be afraid to marry this woman, for she has deceived others and may deceive you." I replied that I would guard her as my most precious possession.' Alice recalled that this curious encounter affected Bomberg's volatile feelings so much that when he returned 'he took me in his arms and cried in his emotional Jewish way.'[20] But the following day, in March 1916, they were married.

The resourceful Alice managed to see a lot of her new husband while he was stationed at Wimbledon Common, so when his company finally set off for Folkestone she could not bear to let him go. At the last minute she hid under the seat in his train until the guards ejected her, and even then she defiantly followed him down to the coast. While the battalion remained at Folkestone she found a way of illicitly sharing his boarding-house billet. 'I reaped my reward for having followed him', she remembered, 'for we had three days of perfect bliss . . . we shared rations and . . . swam together several times a day for the weather was lovely – and so when the fatal day came when he sailed for Flanders . . . I went back to London a wiser and braver woman.'[21]

It is important to understand how close Bomberg and Alice were at this period, for her loss undoubtedly contributed to his sense of desolation at the Front. To be married and then, almost immediately, forced to part for a prolonged period is always a distressing experience. But Alice fulfilled an unusually maternal role in Bomberg's life, and he must have missed her protective presence in the degradation of the trenches. His letters home asked for malted milk tablets to help stave off hunger, and delousing powder to combat the incessant biting of lice. But they did not mention the most hellish aspects of the war: the remorseless destruction of human life, the nights spent crouched in shell holes sheltering from sporadic gunfire, and the older soldiers' tales 'of how women behaved when left alone in Blighty, tales of how women slept with other men, tales told to shock the younger men, well embroidered with lascivious details, tales which set David shivering with horror and suspicion'.[22]

Bomberg's mood progressively darkened, and he was unable to alleviate it by practising his art. Before he set off for the Front, painting and drawing had provided him with an outlet for the turbulent emotions which might otherwise have played havoc with his mind. But in the nightmare world of trench warfare he was incapable of finding solace in his work. The only images which survive from this time are barely decipherable scraps, like the mysterious sketch in blue crayon which bears on the reverse a staccato written expression of the terrors Bomberg was witnessing: 'Daily seen – six wiring-stakes driven in the ground – askew – some yards apart. . . . Demons dragging strangling wire! Earth and sky – each in each enfolded: hypnotised: sucked in the murky snare; stricken Dumb.'[23] Bomberg had to content himself with the writing of these terse notes, half prose and half poetry, which combined documentary observation and agonized protest in equal measure.

Some passages, which he subsequently incorporated in a long 'war poem' called *Winter Night*, gave a dramatic indication of the visual images he might have created at the Front: 'Assassins! Figurantes waiting in the wings! Hidden guns. And guns there are you cannot hear at all, – flashing in fast rotation, – fantastically. Dangling behind a grey glass screen; jerky marionettes, snow-clad. Dancing a comic jig on a straight edge, the battle ridge.'[24] It is easy to imagine how such a passage could have formed the basis of an arresting picture, using the jagged and simplified language of Bomberg's pre-war work to convey the violence and empty absurdity of a conflict which wasted so many lives in a military stalemate. On one occasion he did manage to draw some tiny sketches of barrage balloons (Plate 133),[25] but these hasty studies display none of the tortured feelings which Bomberg managed to express when he wrote about the same subject in a 'poem' called *Balloons*: 'Tommies, in derision, call them "sausages." Enemy balloons. Isolated, a curling string. Swollen, blown-out toads with piercing eyes – gloating in dripping lakes of boundless clouds, over desolated tracts of wasted ground.'

133. David Bomberg. *Study of Barrage Balloons, c. 1916–17*. Pencil and crayon, 12.5 × 12.2 cm. Anthony d'Offay Gallery, London.

134. David Bomberg. *Study for Memorial to T. E. Hulme*, *c.* 1917. Pencil and ink, 22.6 × 15.5 cm. Anthony d'Offay Gallery, London.

Even if Bomberg had been granted access to the materials and working space he needed for painting, his state of mind would probably not have allowed him to concentrate for long. The truth is that his morale deteriorated to a dangerously low point at the Front. In 1917 Bomberg's old friend Isaac Rosenberg, whose poetry reveals the anguish he was experiencing as a private in the King's Own Royal Lancaster Regiment, wrote with concern to Sydney Schiff that 'I have not seen or heard of Bomberg for ages but he was pretty bad 5 months ago.'[26] Rosenberg's anxiety was all too well-founded, for Bomberg at one stage experienced a wretchedness so complete that he was driven to make an extreme protest. Depressed not only by the deaths of his regimental comrades and one of his own brothers, but also by the loss of Hulme, the critic who had given him such valuable support in 1914, Bomberg reached a stage where he was no longer able to withstand the nightmare. The death of Hulme, who was blown to pieces by a large shell at Nieuport in 1917, 'caused widespread pain and sorrow'[27] among his friends, and Bomberg had as much cause as anyone to lament this tragic loss. He attempted to assuage his grief by planning a memorial to Hulme, which optimistically announced that he had died 'for Freedom and Honour' (Plate 134). But Bomberg remained despairing. Although he never again referred to the incident in later life,[28] he admitted to Alice in 1918 that the war's horrors had once completely overwhelmed him. She recorded that

He had – as he thought – to make a confession to me, and it had to be done at once, and then forgotten. He told me, as soon as he had the chance, that his foot was not accidentally wounded, but it was done deliberately – in other words, it was an S.I. (self-inflicted wound), for life in the trenches had had that effect on him and he was beyond caring about the rules of the war game. He had deliberately put the gun to his foot and pulled the trigger.

Luckily for Bomberg, some soldiers heard the shot and were able to bandage his wound without delay. He was sent to hospital, conscious no doubt of the official retribution which now hung over him. 'The Adjutant later came to see him and David told him why he had shot his foot', wrote Alice, 'and he had to listen to a long lecture on the crime he had committed, in depriving his Majesty of the services of a sworn member of his Forces.' Although the Adjutant's words sounded ominous, Bomberg was still in no mood to evade the consequences of his action. According to Alice, the Adjutant 'tried to get David to say that it was an accident, but David insisted that he had fired the shot deliberately, because he had found life too hard to bear – and must make some protest, whatever punishment it brought'. Bomberg's painful honesty must have impressed the Adjutant, for the penalty was not as severe as it might have been for such a precipitate gesture. 'The Adjutant listened to all David had to say and decided he was not for the "firing squad"', Alice wrote, 'but his pay was stopped for three weeks and he was put on light duties until his foot mended.'[29] The leniency of Bomberg's punishment was doubtless dictated by the army's awareness that, as Siegfried Sassoon pointed out in *Memoirs of an Infantry Officer*, 'self-inflicted wounds weren't uncommon on the Western Front, and brave men had put bullets through their own heads . . . especially when winter made trench warfare unendurable.'[30]

Inflicting a wound on himself, and then finding that the authorities adopted a sympathetic attitude towards his misdemeanour, helped Bomberg to withstand his subsequent life at the Front. Although he was 'given the post of Runner for his Unit, which meant going through the hottest part of the firing', Bomberg found that he 'had no fear now that he had made his protest'.[31] The terror of war was, to a certain extent at least, exorcised by the injury he had forced his own body to sustain. But the remainder of his active service was still a gruelling ordeal. However oblivious Bomberg now seemed to enemy fire, as he set up sound-ranging devices in No-Man's Land and made detailed sketches of army positions, his poems reveal that the incessant bombardment still launched a direct assault on his nervous system:

Guns in action! Spitting a tawny phlegm – firing swift as lightning: lightning's jagged tongue stinging the air.

Yelping oath, – shrieking, – piling curse on curse! Splashing the ground, the bark and foliaged trees, – whiteheat, – before the dark rebounds.

Striking a smarting blow defiantly: – cutting the night in half: – carrying all before. High velocity guns. Recoils – draws up in cold affected dignity, – mutters in undertone contemptuously, the cruel derisive word – the after-shock.[32]

Bomberg's writing, with its tersely unconventional punctuation and staccato attack, shows his awareness of comparable experiments in prose and poetry by Lewis, Rodker and Rosenberg. But the emotions expressed here constitute an intensely personal response to the war, and they show how conscious Bomberg remained of its remorseless destructive power. The machines which had so deeply affected his vision of modern urban life before the war were now turned into weapons of unprecedented power, and they displayed an appalling ability to massacre his fellow-soldiers in their thousands. His reaction to the suffering he witnessed is vividly conveyed in a swift, urgent study of figures crowding round a dead or dying soldier (Plate 135). Their agitated attempt to give help is chillingly contrasted with the inert body, its contours already stiffening into the rigidity of a corpse.

Bomberg's whole attitude towards the machine age was changed by his experience of pounding, callous bombardment at the Front, and at one stage he applied for a post in the drawing office in order to escape from the conflict. But soon after he started work there, 'he heard a brigadier talking with an officer and saying: "What is *he* doing?" "He's doing section mapping, sir." "What is his name?" "Bomberg, sir." And the brigadier said: "We can't have a man with a name like that doing map drawing." '[33] Anti-semitism, combined with an automatic suspicion of German-sounding names, ensured that Bomberg's period in the drawing office was short-lived.

He was returned with the 18th Kings Royal Rifles to the Front, where the seemingly endless toll of slaughtered lives reached a horrible climax for him with the death of Rosenberg. A devastating spell in the forward trenches during the winter of 1917 had severely undermined Rosenberg, who confessed to Edward Marsh in a passage cancelled by the censor that 'what is happening to me now is more tragic

135. David Bomberg. *Figures Helping a Wounded Soldier, c.* 1916–17. Ink, 12.5 × 17 cm. Collection of the artist's family.

C14. David Bomberg. *Abstract Composition*, *c.* 1914. Pencil and watercolour, 27.5 × 36.5 cm. Anthony d'Offay Gallery, London.

C15. David Bomberg. *Abstract Design*, *c.* 1914. Chalk and watercolour, 27.3 × 26 cm. Anthony d'Offay Gallery, London.

than the "passion play". Christ never endured what I endure. It is breaking me completely.'[34] He was killed soon afterwards, at a time when his poetry had arrived at an impressive and excoriating maturity. The news of his death would have made Bomberg abhor the wastefulness and insanity of war still more vehemently than before.

———

By the time Rosenberg was killed, however, Rifleman Bomberg had finally been permitted to withdraw from active service. The recently formed Canadian War Memorials Fund was commissioning a wide range of British artists to execute large-scale paintings of the conflict, and Bomberg lost no time in submitting his application. The Fund, founded in 1917 by Sir Max Aitken (later Lord Beaverbrook), aimed at assembling an ambitious visual record of Canada's contribution to the war. Aitken was prepared to pay handsomely for the huge canvases, and several of Bomberg's friends among the avant-garde secured commissions which enabled them to leave the fighting. But all of them – Etchells, Lewis, Nevinson, Roberts and Wadsworth – knew that the Canadian committee required images far removed from the experimental language of their pre-war work. The art critic P. G. Konody, who was the Fund's 'artistic adviser', had been unsympathetic to the Vorticists in 1914, and a firm desire for representational painting underlay the official claim that the Memorial's artists 'were selected in the most catholic spirit, to represent every school and group, from the most academic and traditional to the most revolutionary and advanced, so that the collection of large decorative paintings, which form the nucleus of the war memorials, should give a fair picture of the artistic conditions which prevailed at the most momentous epoch of the world's history'. Konody certainly showed an adventurous spirit by inviting rebels like Lewis and his allies to contribute, but he was guided by a clear awareness that 'in organizing the scheme, the Committee throughout endeavoured to do equal justice to the claims of history and art.'[35]

In other words, the demands of a documentary record loomed large in the committee's deliberations, and it was not prepared to consider abstractionist images. But Bomberg believed that the problem might still be surmountable. His commitment to a severely angular and simplified style had in any case begun to waver before he enlisted, and the crucible of war forced him to undergo a further reappraisal of his earlier attitudes. He already sensed, without having put his instincts to the test, that a return to a more representational language might be the best means of expressing his profoundly altered vision of the world. So the wary reply he received in December 1917, from the officer in charge of the Canadian War Records, may not have given Bomberg too many qualms. 'With reference to your communication re being transferred to the Canadians for the purpose of painting a picture of Passchendale [sic] for the Canadian War Memorials Fund', wrote the officer,

> I should be glad to know whether, providing you are given the necessary facilities and leave, you are prepared to paint this picture at your own risk to be submitted for the approval of the Committee. The reason for this request is that the Art Adviser informs us that he is not acquainted with your realistic work, and cubist work would be inadmissible for the purpose. If the picture, which would be 12 feet wide, is accepted you would be paid from £250 to 300.; in case of refusal you would be refunded for material.[36]

Like Lewis, Roberts and the other experimental painters who received similarly cautious replies from the officer, Bomberg accepted these guarded terms. But he encountered bureaucratic difficulties. 'The Canadian War Records Office made several applications to Whitehall to get me officially attached to their department to make the preliminary studies on the spot as an employed war artist', he recalled later, '. . . but our War Office would not consent on account of the speciality of my duties at the Front.'[37] But eventually, towards the end of the war, he started work on preparatory drawings for a painting to be called *Sappers at Work. Canadian Tunnelling Co. R.14, St Eloi*.[38] The records for the British side of the War Memorial Fund's operations are no longer extant,[39] so no details have survived to explain how Bomberg's subject was chosen. But the Canadians must have suggested that he tackle this theme, for they afterwards described how 'the Committee worked out a schedule of subjects embracing every sphere of Canadian war preparation and war activity . . . each one being entrusted to the artist whose past achievement pointed most clearly to his ability to do full justice to his task.'[40] Since Bomberg had spent part

of his army service as a sapper, he was probably deemed a suitable artist to record an exploit which occurred at the St Eloi Craters in the spring of 1916.

Mine warfare had by then become a crucial element in the siege tactics of the war. The Germans tunnelled underground, driving galleries beneath the British trenches and then blowing them up with mines. But these attacks were soon countered by far deeper tunnelling techniques which British sappers had devised, and their expertise was now instrumental in mounting a successful bid to capture the enemy-held salient at St Eloi. In his history of the *Canadian Expeditionary Force, 1914–1919*, Colonel G. W. L. Nicholson described this tunnelling operation as 'one of the most elaborate schemes in underground warfare yet undertaken by sappers of the Second Army'.[41] The focus of the assault was a large clay bank called The Mound used by the Germans as an observation post. Bomberg, who studied the tunnelling with great thoroughness, noted in his sketchbook that 'it was carried out under the greatest difficulties. The enemy were working their own sap alongside. Any excess of noise would be likely to draw the enemy's attention to our activity and result in them launching a torpedo through the earth works.'[42] But the British tunnellers had discovered how to sink their shafts as deep as ninety feet, driving down past the sand 'to reach hard packed strata through which they ran their galleries forward comparatively dry and almost undisturbed by the Germans, who lacked the skill and equipment to compete at these greater depths.'

Although the whole gruelling operation took eight months to tunnel, the sappers found themselves under the German positions in March 1916. Nicholson wrote that 'on a front of 600 yards six mines . . ., with charges ranging from 600 to 31,000 pounds of ammonal, were in readiness to initiate the British attack by blowing up The Mound and the enemy's front-line trenches.' General Plumer, who was in charge of the operation, decided that the 2nd Canadian Division should relieve the tired British 3rd Division after the assault had been carried out. And so, before dawn on 27 March,

> an opening salvo from 41 guns and howitzers up to 9.2 inches in calibre burst upon the objectives, and the six mines were sprung at intervals of a few seconds. The terrific explosions shook the earth 'like the sudden outburst of a volcano' and the colossal shower of yellow smoke and *debris* that leapt into the heavens could be seen from miles away. The eruption blotted out old landmarks and collapsed trenches on both sides like packs of cards. Two front line companies of the 18th Reserve Jäger Battalion were annihilated by the explosion of Mines 2, 3, 4 and 5 (Mine 3 turning what was left of The Mound into a gaping hole).[43]

Like most of the attacks carried out during this wretched war, the St Eloi initiative was implemented in appalling conditions. Its success did little to affect the overall stalemate paralysing the opposing forces, but the Fund decided that the Canadian contribution to the assault was still worth commemorating. The committee had declared that 'the fullest facilities should be given to every artist for gathering his material on the spot, and for absorbing the true atmosphere of the scene';[44] so Bomberg spent a considerable time preparing himself with drawings which, as Alice remembered, 'were made direct from Canadian soldiers and with authenticity as to uniforms and cap badges'.[45] One of these studies shows the care with which Bomberg scrutinized the belt around a man's waist and the sheath containing his weapon (Plate 136). These details suggest that a relatively representational image was aimed at from the outset, but an impressive oil-and-watercolour study reveals that he also toyed with the idea of a painting close in style to his pre-war work (Colour Plate 16). It is a superbly organized and energetic image, demonstrating that the subject of gesticulating figures within a confined space was fully in accordance with the compositions he had developed for *Ju-Jitsu* and *In the Hold*. The sturdy columns holding up the mining shaft are similar to the pillar in *The Mud Bath*, and the sappers' bending, twisting and stretching bodies are reduced to their most drastically simplified components.

Bomberg was quite capable of painting an epic canvas based on this compelling study, and it might well have been a worthy successor to his pre-war masterpieces. But he seems never to have painted a large version of this composition. No trace of such a picture can be found beneath either of the two subsequent *Sappers* paintings,[46] and Bomberg must have known that the committee would reject a 'geometrical' image outright. Besides, the whole direction of his post-war work demonstrates

136. David Bomberg. Detail from *Study for 'Sappers at Work': A Canadian Tunnelling Company* (First Version), *c*. 1918. Pencil, 40 × 26.3 cm. Collection of the artist's family.

a clear dissatisfaction with the style he developed in the pre-war period, and Bomberg may even have decided that this experimental oil-and-watercolour study failed to convey his true feelings about the subject. However admirable it was as a tense and crisply organized formal design, the figures lack humanity. They are indistinguishable not only from the shovels and levers in their hands, but also from the large machine containing a pulley. Later versions of the same subject reveal that this machine plays an important part in the composition, helping the sappers to carry out their tasks. But in Bomberg's oil-and-watercolour study, the significance of its wheel and girders is lost: the men are as mechanistic as the metal implement in their midst, and their bodies jerk like robots programmed to perform a job with the maximum amount of impersonal efficiency.

Like Léger, whose wartime study of two *Sappers* at work in a Verdun dug-out also reduces soldiers and machinery to geometrical segments,[47] (Plate 137), Bomberg underwent a decisive conversion after his return from the Front. Once the war had finished, Léger's art gradually moved away from the mechanistic abstraction of his pre-war work, and he explained later that his experiences in the trenches were responsible for a Damascan conversion:

> During those four war years I was abruptly thrust into a reality which was both blinding and new. When I left Paris my style was thoroughly abstract: period of pictorial liberation. Suddenly, and without any break, I found myself on a level with the whole of the French people; my new companions in the Engineer Corps were miners, navvies, workers in metal and wood. Among them I discovered the French people. At the same time I was dazzled by the breach of a 75-millimetre gun which was standing uncovered in the sunlight: the magic of light on white metal. This was enough to make me forget the abstract art of 1912–13. A complete revelation to me, both as a man and as a painter.

137. Fernand Léger. *Sappers*, 1916. Watercolour, 23 × 14.5 cm. Private collection.

138. David Bomberg. *Gunner Loading Shell*, *c*. 1918. Ink and wash, 12.5 × 17 cm. Collection of the artist's family.

Although Bomberg never recorded such an explicit statement to account for his own decision to abjure the pre-war style, his experience must have been similar to Léger's. Bomberg's sympathy for his fellow-soldiers is heroically evident in the *Sappers* painting he eventually produced. Moreover, a whole series of small, vivid and concise drawings, which show men loading shells into guns, soldiers patrolling underground tunnels and other scenes which he witnessed at the Front, survive from the 1918 period (Plates 138, 139, 140). They testify to his Léger-like desire to immerse himself in the weapons, uniforms, horses, equipment and claustrophobic surroundings of subterranean war. 'Once I had got my teeth into that sort of reality I never let go of objects again',[48] Léger explained, and his sentiments were clearly shared by Bomberg.

Léger was the greater and more singleminded artist of the two, and his post-war work never departed as drastically as Bomberg's did from the language he had developed in the 1911–14 period. But he did not have to contend with the demands of the Canadian committee, whose expectations finally drove Bomberg towards an idiom more representational than he would otherwise have espoused. In his

139 (right). David Bomberg. *Soldier Patrolling Tunnel*, *c*. 1918. Ink and wash, 17 × 12.5 cm. Collection of the artist's family.

140 (far right). David Bomberg. *War Scene*, *c*. 1918. Ink and wash, 17 × 12.5 cm. Collection of the artist's family.

C16 (facing). David Bomberg. *Study for 'Sappers at Work': A Canadian Tunnelling Company*, *c*. 1918. Oil and watercolour, 24 × 32 cm. Anthony d'Offay Gallery, London.

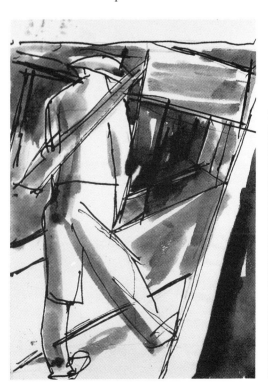

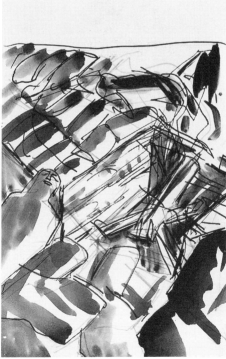

first large painting of *Sappers at Work* he did make a brave attempt to create an image which satisfied both the demands of the Fund and his own wish to develop a more humanist form of figurative art. A large pencil-and-ink study reveals how the picture changed from a horizontal to a vertical design, presumably in response to instructions from Canada (Plate 141). The committee intended to instal the panels in 'an architectural scheme which is to form a suitable and imposing framework for the pictures, so that they will present themselves as an impressive ensemble in orderly sequence'.[49] Ideas about this 'scheme' had obviously changed since 1917, when Bomberg was first invited to paint a picture 'which would be 12 feet wide'.[50] Now he was asked to produce a canvas ten feet high and eight feet wide, so he drew a line down his preparatory study cutting off an unwanted section on the right. Then, on another study very close to the composition of the first painting, he imposed a squared-up grid so fierce in its geometry that it dominates the figures beneath (Plate 142). The stridency of this grid, dividing the work into an even greater number of tiny segments than *In the Hold* had been, suggests that Bomberg wondered whether to shatter the painting into a multitude of angular particles. He was probably tempted to do so, for the result would have been dramatically expressive of the violent stress and tension undergone by men at war.

But he decided in the end that the grid should play no visible role in the painting. The committee would have found it completely unacceptable and besides, Bomberg himself no longer wanted to fragment the bodies of the sappers in such a dehumanized way. He explained afterwards that *Sappers at Work* was intended as 'a tribute to the heroic miners, comprised of Canadians in the main re-enforced [*sic*] by Yorkshire, Welch, and groups of Russian Canadian miners'.[51] So he wanted the painting to be a celebration of the unseen, and largely unsung, men who courageously burrowed deep underneath the earth for months on end to defeat the enemy. Bomberg's war-time period gave him a new-found admiration for the fortitude, camaraderie and resourcefulness of the ordinary soldier. He would have understood why Léger lauded 'the exuberance, the variety, the humour, the perfection of certain types of men with whom I found myself; their exact sense of useful realities and of their timely application in the middle of this life-and-death drama into which we had been plunged'.[52]

These were the qualities which Bomberg aimed at extolling in the new figurative style he developed for the first *Sappers at Work* canvas (Colour Plate 17). He started work on the painting soon after his discharge from the army just before Armistice Day.[53] The official war artist Muirhead Bone had 'handed him the commission for the large painting',[54] and Bomberg described how he 'returned to England so excited to get on with the Canadian Commission that I did not go out once to take part in the Armistice celebrations'.[55] While Alice joined the ecstatic crowds and 'climbed

141. David Bomberg. *Study for 'Sappers at Work': A Canadian Tunnelling Company* (First Version), *c.* 1918. Pencil and ink, 26.5 × 33 cm. Anthony d'Offay Gallery, London.

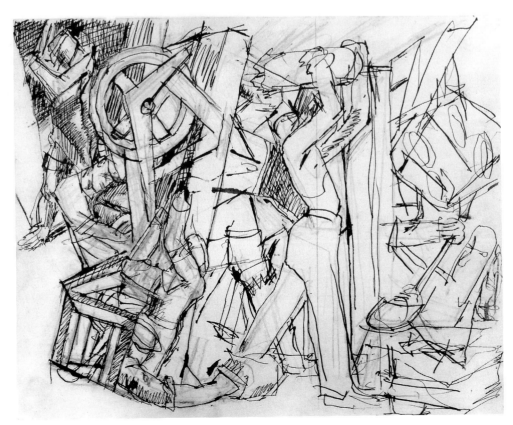

on the famous lions in Trafalgar Square and sang and sang',[56] Bomberg stayed at home and worked on the painting in an exalted mood. He recalled how 'in that spirit I painted the rejected panel. The aim was to extinguish the phase of war – I had had enough of that – and wanted the relief – and the sublimation of creating the forms of war not in the dank, death-smelling underground mine – like a coal pit – but in the open-air, bathed in sunlight.'[57]

Hence the extraordinarily dappled, patchwork quality of Colour Plate 17. The colours are just as surprising as the riotous orchestration of *In the Hold*, giving the man in the puce shirt who crouches on the left an unearthly green face and arms. The sapper occupying the foreground is cast in an even more unpredictable combination of purple, pale chocolate and mauve, while the beams of the tunnel are painted as shafts of dark and light blue. But the harsh, splintered geometry of *In the Hold*, where the labourers almost disintegrated in a hail of fragmented minutiae, has now been replaced by a warmer and more humanist vision. The contours are as wobbly as in a tapestry, and Bomberg clearly distinguishes between the machine and the figures surrounding it. Light no longer carves the forms into hard slabs, as it did in the great paintings of 1914. Instead, it seems to fall across the machine's huge wheel in a gentler way, and creates a wavering interplay between splashes of brightness and shadow on the sappers' bodies. Their figures are not, however, broken up by this restless flickering. They remain well-defined, flesh-and-blood creatures, far removed from the semi-automatons who filled the earlier oil-and-watercolour study with so much jagged energy (Colour Plate 16).

Bomberg here decisively rejected his impersonal and harshly simplified pre-war style. Each of these sappers is a distinct individual, and the large green bottom of the man who bends over with his shovel has a plumpness quite new in Bomberg's work. The handling of pigment is very different, too. Although applied quite thinly in most areas, it is looser and more freely brushed than the flat, dry paint of *The Mud Bath*. In the brown trousers worn by the man on the right, brushstrokes clearly define the folds and creases. The vigour and confidence of this new handling suggests that Bomberg enjoyed experimenting with a more loosely gestured approach. It gives the whole composition a feeling of festive vitality, as if the entire picture were intended to offer a full-throated paean of praise to the sappers' energy and dedication.

Even though the process of labour dominates the painting, and directs itself towards warlike ends, Bomberg no longer wants to dehumanize the people whom he depicts. Rather does he aim at correcting the mechanistic vision of his earlier art, insisting on the ordinary soldier's ability to counter the harshness of a combat where men realized how destructive the machine age could be. Collaborative action in full swing is seen here as positive and life-affirming. The sappers' hard, subterranean efforts, which must have been gruelling, dirty, dangerous and dimly-lit, is elevated into a heroic enterprise fit for commemoration in a massive painting. Muscular prowess is portrayed, but Bomberg refuses to make it ferociously aggressive. The communal character of their exertions is stressed instead, albeit in a crowded and jostling design which dramatizes the difficulty of working in a confined space. Indeed, a new mood of tenderness enters the painting on the left, where the crouching youth clasps his heavy sandbag in an unexpectedly heartfelt embrace.

The declaration of a more openly emotional and expressive voice in the first *Sappers* canvas heralds the direction Bomberg was to follow for the rest of his life. But the painting also suggests a new interest in El Greco, whose work was then becoming more and more widely admired. In 1919, when Bomberg completed this painting, the National Gallery acquired a Greco of *The Agony in the Garden of Gethsemane*[58] which excited a lot of attention after it was placed on view. In a 1922 lecture on *Modern Art*, Bomberg declared that El Greco's painting 'curiously coincides with the work of Paul Cézanne', and he singled out the National Gallery's *Agony in the Garden* as 'a picture with powerful pink, powerful purple, but what is most powerful in the picture is the design. No one but El Greco ever did such a thing as this. El Greco was an inventor, a mathematician. He looked on painting as an excuse to get curious patterns, to cut them up in various ways.'[59]

*Sappers at Work*, however, is more directly influenced by a far finer Greco painting already in the National Gallery's collection: *Christ Driving the Traders from the Temple* (Plate 143). Its dynamic and freely distorted treatment of the figures, revelling in *contrapposto* of the most exclamatory kind, surely affected Bomberg's approach to

142. David Bomberg. *Study for 'Sappers at Work': A Canadian Tunnelling Company* (First Version), *c.* 1918. Pencil and ink, 32 × 25.5 cm. Anthony d'Offay Gallery, London.

143. El Greco. Detail from *Christ Driving the Traders from the Temple*, *c.* 1600. Oil on canvas, 106.3 × 129.7 cm. National Gallery, London.

144. Michelangelo. Detail from *Christ Expelling the Money-Changers*, *c.* 1540–41. Black chalk, 17 × 27.1 cm. British Museum, London.

his composition. For the attitude adopted by the sapper pulling the rope of the machine is like a reversed version of Christ, and the cluster of stretching, bending and gesticulating traders on the left of Greco's canvas could have inspired several other poses in the *Sappers* picture. The expressionistic fervour of the Spanish master would also have appealed to Bomberg, who paid overt homage to Greco during a later stay in Toledo and subsequently gave his wife a large colour reproduction of *Christ Driving the Traders from the Temple* as a birthday present.[60] But that does not mean Bomberg's old admiration for Michelangelo had completely disappeared. Greco, in fact, adapted some of the motifs in his painting from Michelangelo, who made some arresting drawings of the same subject which Bomberg would have been able to study in the British Museum (Plate 144).[61] Moreover, Bomberg's decision to give the bottom of the green-trousered man such a prominent position may have been indebted to the equally ample bottom displayed by one of the damned figures in Michelangelo's *The Last Judgement*.

The cinquecento ancestry of the first *Sappers at Work* canvas passed undetected by Konody, the Canadian committee's adviser. Although Bomberg knew that its style was more audacious than any other painting produced for the Fund, he cannot have anticipated its hostile reception. The *Sappers* picture is not so very far removed in idiom from Roberts's contribution, *The First German Gas Attack at Ypres*, a ferocious and excoriating image already accepted by the committee (Plate 145). For all its startling colours and patchwork distortions, the *Sappers* canvas was still a figurative picture which included a considerable amount of representational detail in the sappers' uniforms. So Bomberg doubtless felt optimistic about the fate of the huge painting by the time he completed it, and the shock was all the greater when his hopes were cruelly confounded. 'At last David was notified of the date fixed for the "Mural" to be inspected by Konody', Alice recalled, 'and David took it to Burlington House in a taxi. I left as usual in the morning but some strange instinct caused me to ask my boss if I might leave early. I got home about 2 'o'clock to find David huddled in his chair by the fire – in tears.' The condemnation he had received was as demoralizing as it was unexpected. 'Konody had almost dissolved into tears himself when he saw what David had produced', wrote Alice.

> To quote his words, 'You submit to me the most wonderful drawings – yours is the last panel to be fixed before Government House can be opened, and you bring me this futurist abortion. What am I to say to my Committee?' And a great deal more to that effect, while he wrung his hands in annoyance, and stamped round and round the offending painting which had been laid out on the floor for his inspection. (Konody had a club foot and wore a built-up sole to his boot, which made him 'stamp' still more drastically).[62]

Because Bomberg had not yet recovered from the debilitating effect of his wartime experiences, he was in a vulnerable position. Moreover, he probably felt uncertain about the extent and advisability of the stylistic changes he wanted to make in his work. The demands of the Canadian commission must have obliged him to adopt a greater degree of representation than he would otherwise have desired at this stage, and most of the other English avant-garde painters felt constrained by Konody's strictures. Lewis, after completing his large canvas of *A Canadian Gun Pit*, even felt that Konody 'had succeeded in making me paint one of the dullest good pictures on earth',[63] but his contribution had at least been accepted by the Fund. Bomberg, by contrast, had produced a celebratory picture which he felt was 'bathed in sunlight',[64] only to find that his ambitious attempt to develop a non-academic figuration was rejected with scorn. He felt betrayed and so did Konody, who remembered almost a decade later how bitterly offended he had been by the first *Sappers* canvas. After declaring that Bomberg's pre-war 'extravagance of abstract invention laid him open to the suspicion of being a sensation-monger', Konody described how

> the suspicion was confirmed when, commissioned by the Canadian War Memorials to paint a subject peculiarly suited to his bent . . . in the face of serious warnings that this was no occasion for a display of 'Bombergism' and that a certain element of representational truth was a *sine qua non*, he weighed in with a huge canvas of patchwork in pretty, gay colours, in which the rigid lines of props and rafters, which gave him an ideal opportunity for geometrisation, were twisted into snake-

like writhing forms that conveyed no meaning. The picture was indignantly rejected.[65]

Konody's reference to a festive 'patchwork' of 'writhing forms' indicates that the Tate's version of *Sappers at Work* was indeed the painting he turned down. But he had no right to claim that the picture was devoid of meaning. His dismissal of the canvas seems grossly unfair, and Bomberg's tearful reaction shows how intense an effort he had made to arrive at an image acceptable both to the Fund and to his own imaginative priorities. It cannot have been an easy task, especially when he was struggling to arrive at an alternative language which took account of his response to the post-war world. So his despair is understandable, and he would have been well-advised to abandon all further attempts to satisfy Konody's insensitive demands.

Alice, however, thought otherwise. The sight of her husband

> aroused all the latent fire in me, and I went straight off to Burlington House and was lucky enough to find Konody there – still stamping . . . Then I went to work in my best method. I said that I understood he had disapproved of the painting David had submitted, which was a pity, as David had put much thought and endeavour into the work, but would he give David another chance, would he let him work on the painting still further to bring it up to his requirements?

Alice had made a perilous gamble, but it elicited sympathy.

> I must say that Konody heard me with courtesy, and it was finally agreed that David should start on a fresh canvas, which would be supplied to him with a fresh supply of colours, providing that I should take charge and make sure that no 'cubist abortions' should creep into the work. As a matter of fact Konody was only too pleased to agree to anything that would ensure him getting a reasonable work from Bomberg, and he was only too glad to make terms with a 'sensible woman'. So I went back to David with my tale and he agreed to paint another panel – more acceptable – and in a day or two the fresh canvas and colours were delivered and David started again.[66]

Why did Bomberg agree to such an inauspicious plan? He was unlikely to produce anything other than a compromised painting under these conditions, and Konody had already broken the Fund's solemn promise to ensure that 'each artist is given the fullest liberty to do whatever may best suit his temperament, so that the artistic quality of his work may not suffer from irksome restraint.'[67] Perhaps financial pressure played a part in persuading Bomberg to paint a revised version, for the Fund's eventual fee of £300 was as substantial as it was welcome.[68] Perhaps, too, his search for a more expressive figurative language helped to convince him that he might discover a more representational style which did not betray his singular vision. Nor should the legacy of his gruesome war experiences be underestimated, eroding the supreme confidence he had enjoyed in the 1913–14 period. When he returned from active service in 1918 Alice found 'a different man to the one who had kissed me goodbye at Folkestone',[69] and in this weakened condition he was undoubtedly more willing to take advice from a woman who had always played a strong maternal role in his life. Besides, Bomberg needed to be comforted, for Lilian Bomberg afterwards maintained that 'the committee's rejection of his first version came as an awful shock to David, a shattering personal blow, and he didn't really recover his earlier strength ever again.'[70]

Alice's arrangement with Konody seemed like a welcome solution, therefore, preventing him from lapsing into a state of mortifying depression. Since Konody recorded that the final canvas was finished 'in an incredibly short time',[71] Bomberg must have carried out his first drawing of the revised composition without delay (Plate 146). It is a tentative study, lacking in vigour and full of pen hatching which betrays the artist's anxiety. But it does show how he attempted to counter his more conventional treatment of the figures by making them smaller, and allowing the severe angularity of the foreground floor and roof-beams to assume far greater significance in the design. The diminution of the figures also enabled him to reinstate the right section, which he had previously discarded when the composition was changed from a horizontal to a vertical format. The largest of the new sappers in this section carries a massive girder on his shoulder, thereby reinforcing the part played by the geometry of the roof-beams.

145. William Roberts. *The First German Gas Attack at Ypres*, 1918. Oil on canvas, 305 × 365 cm. National Gallery of Canada, Ottawa.

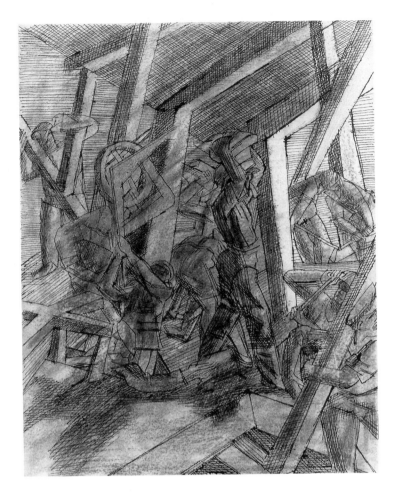

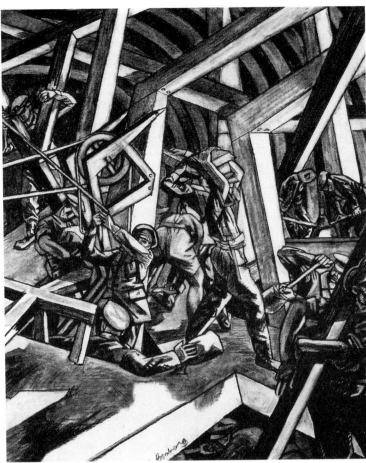

146. David Bomberg. *Study for 'Sappers at Work': A Canadian Tunnelling Company* (Second Version), 1918–19. Pen and wash, 39.5 × 32 cm. Tate Gallery, London.

147. David Bomberg. *Study for 'Sappers at Work': A Canadian Tunnelling Company* (Second Version), 1918–19. Charcoal, 67.3 × 55.9 cm. Imperial War Museum, London.

Bomberg was presumably encouraged by the stern structure of simplified diagonal shafts he had now inserted into his design. A second drawing displays a greater sureness as he firmly defines each figure's place, adds a taut network of cables to the pulley, and reveals a crouching sapper under the floor grimly shovelling in the darkness (Plate 147). Bomberg also contrasted the stiff interplay of pillars and beams with a sequence of rounded, arch-like bands which emphasize the claustrophobia of the tunnel. Since the rejection of the first painting had darkened his mood, the revised composition reflected this change by presenting a starker view of the sappers' activities and surroundings. The dappled celebration of labour presented in Bomberg's earlier canvas had vanished completely, to be replaced by a sombre and deeply shadowed alternative. This underground scene is more akin to the ominous setting of Wilfred Owen's *Strange Meeting*, where two former enemies encounter each other

> Down some profound dull tunnel, long since scooped
> Through granites which titanic wars had groined.[72]

This brooding sense of a sinister, awesome place is accentuated in the final painting Bomberg completed so swiftly during the summer of 1919 (Plate 148).[73] By far the most impressive part of the picture is its upper section, where the gaunt, sculptural shafts of the roof-beams occupy an even larger space than they were granted in the second preparatory drawing. The foreground platform on the left is scarcely less powerful, for Bomberg has allowed the mighty floor to assert its mass uninterrupted by anything other than a looming shadow which recalls the jagged, near-abstract forms of his pre-war work. But the handling of the figures is a disappointment. Although Bomberg has tried very hard to unify their bodies with the rest of the composition, they lack the vitality of the sappers in the previous painting. Each carefully defined pose now seems paralysed by a stillness which is the direct result of the naturalistic constraints now cramping Bomberg's instinctive exuberance. It is a diligent picture, cleverly organized and executed with formidable skill but lacking, finally, the passionate energy which characterizes all his finest works. The truth is that Bomberg excluded too much of his essential imaginative self from this coldly efficient canvas. Like the official catalogue description of the painting,

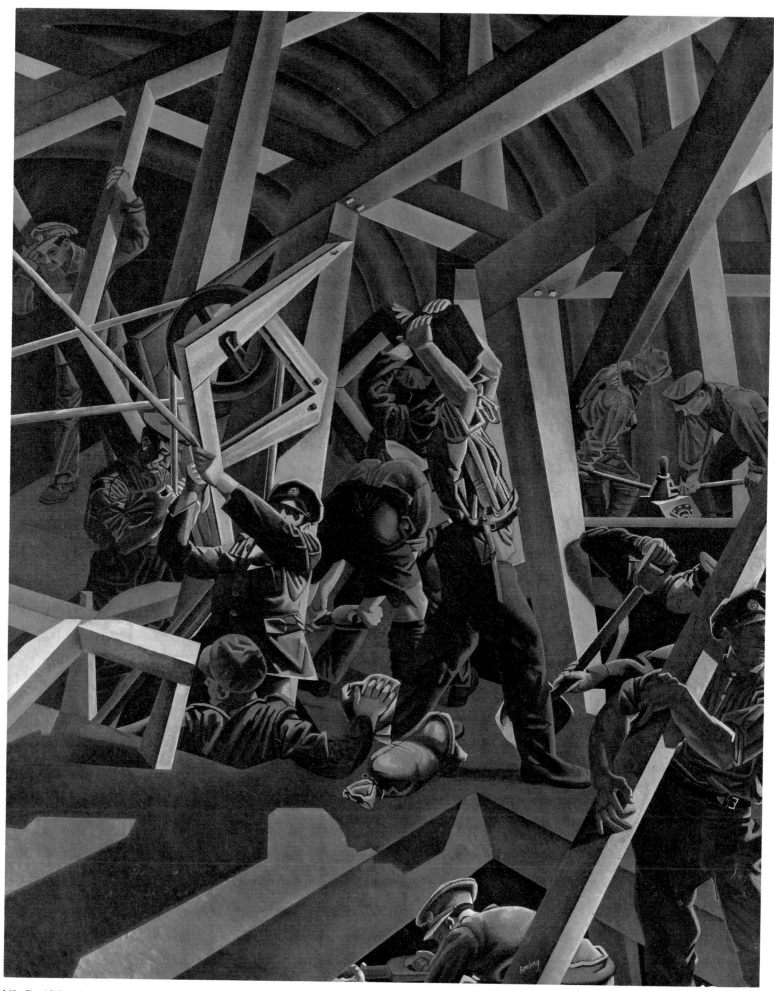

148. David Bomberg. *'Sappers at Work': A Canadian Tunnelling Company* (Second Version), 1919. Oil on canvas, 305 × 244 cm. National Gallery of Canada, Ottawa.

150 a. David Bomberg. *Working Proofs for the Russian Ballet lithographs*, 1914–19. Three prints, each 5.8 × 11.8 cm. Collection of the artist's family.

150 b (above right). David Bomberg. *Working Proofs for the Russian Ballet lithographs*, 1914–19. Three prints, each 10.2 × 9.8 cm. Collection of the artist's family.

149. David Bomberg. *Study for Russian Ballet lithograph*, 1914–19. Ink, watercolour and gouache, 5.9 × 11.4 cm. Collection of the artist's family.

which states that it 'represents a scene on a platform at the junction of a sap with men carrying boxes of explosive, timber, etc., and hauling up sand bags filled with earth excavated below',[74] Bomberg's image fails to express the resilient heroism which he had wanted his first version to convey. Cowed into submission by the humiliating defeat he had suffered at Konody's hands, he embraced an alien style incapable of transmitting his deepest response to the theme.

In an attempt, perhaps, to give the canvas a more personal character, he portrayed himself as the man carrying a beam in the lower right corner of the design.[75] But this gesture of solidarity with the labouring sappers did not save the painting from its deficiencies. The self-portrait which he included could equally well be seen as a reference to Bomberg's resentment at painting a second version, a task even more burdensome to him than the carrying of a heavy beam. Konody accepted the revised version, and claimed that the picture 'fully held its own with the works of the eminent artists who had been asked to contribute to this remarkable collection of war paintings'.[76] Moreover, the man who had 'handed' Bomberg the Canadian commission, Muirhead Bone, showed where his preference lay by presenting a study for the revised version to the Imperial War Museum in 1919 (Plate 147). But Bomberg himself cannot have been satisfied with the second version. He doubtless communicated his unease to Alice, for she later admitted her reservations about the advisability of compromising with the committee. 'He put much more detail into the new canvas', Alice wrote, 'and no "cubist abortions" crept in – I saw to that – but after all these years I still wonder if I did the right thing in speaking to Konody as I did – if it would not have been wiser to let David lose his chance of winning the three hundred pounds prize money – by withdrawing his work.'[77]

Just how many constraints this dutiful commission placed on Bomberg's individual vision can be gauged from a remarkable project he executed in his spare time. Still not wholly convinced that his pre-war style had nothing more to offer, he felt a strong urge to resume work on the dance theme which had produced such memorable images in 1914. The successive stages of the painfully protracted Canadian venture meant that he sometimes found himself at a loose end while the committee evaluated his proposals. 'But David set himself a task to fill in the waiting time', Alice wrote, describing how 'he did not feel like doing any actual drawings . . . So he turned out some old sketches which he decided to lithograph, for he had learned the method when serving his apprenticeship with Paul Fisher [*sic*]. He procured the necessary materials including zinc plates and he got very interested in the work, and in the end he made a small booklet, with appropriate wording, which he called "Russian Ballet."'[78]

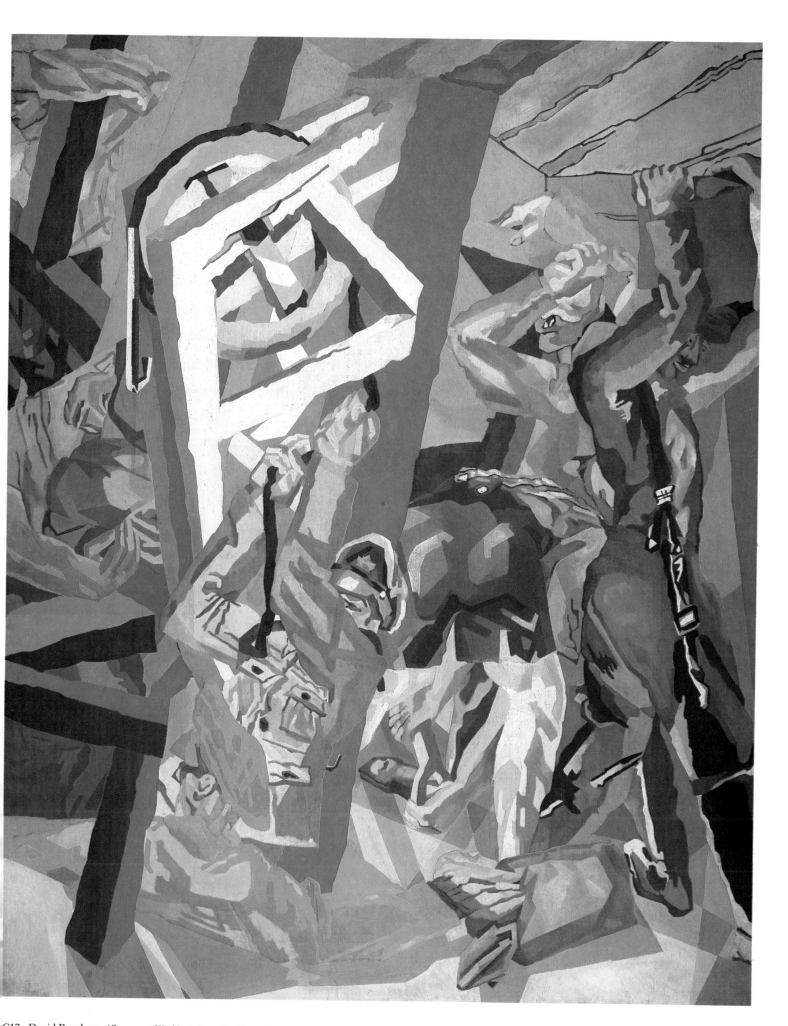

C17. David Bomberg. *'Sappers at Work': A Canadian Tunnelling Company (First Version)*, 1918–19. Oil on canvas, 304 × 244 cm. Tate Gallery, London.

C18. David Bomberg. *Russian Ballet lithograph*, 1914–19. Colour lithograph, 5.8 × 11.8 cm. Collection of the artist's family.

C19. David Bomberg. *Russian Ballet lithograph*, 1914–19. Colour lithograph, 10.2 × 9.8 cm. Collection of the artist's family.

C20. David Bomberg. *Russian Ballet lithograph*, 1914–19. Colour lithograph, 7.5 × 15.8 cm. Collection of the artist's family.

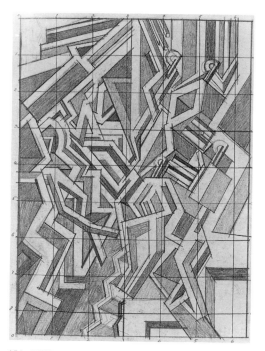

151. William Roberts. *Study for Theatre III*, c. 1915. Pencil, 22 × 16 cm. Private collection.

153. David Bomberg. *Russian Ballet lithograph*, 1914–19. Colour lithograph, 7.7 × 6.7 cm. Collection of the artist's family.

154. David Bomberg. *Russian Ballet lithograph*, 1914–19. Colour lithograph, 7.8 × 5.2 cm. Collection of the artist's family.

152. David Bomberg. *Russian Ballet lithograph*, 1914–19. Colour lithograph, 5 × 6.6 cm. Collection of the artist's family.

The sight of these small pre-war drawings, executed with all the young Bomberg's precocious certainty and verve, temporarily persuaded him that his old geometrical style might still be viable (Plate 149). He set to work on the proof stages with great confidence (Plates 150a,b), and the panache of the six final lithographs proves how exhilarated he felt to be free from the burdensome limits imposed by the Canadian painting. One of them, which arranges orange and umber limbs in an energetic frieze and further enlivens their movement by positioning them against diagonal bands of purple, can be related very directly to a dancing theme (Colour Plate 18). But others have a more oblique relationship with the Russian Ballet. Only after a while does it become clear that the composition of the large lithograph, showered with tiny black particles, can be seen as an aerial view of performers on stage (Colour Plate 19). Like Roberts's Vorticist *Theatre*, which looks down from a vantage high above and transforms the protagonists' bodies into simplified forms (Plate 151), Bomberg's image seems to have been inspired by an overhead position. The white vertical on the left is probably the edge of the stage, and the cluster of white segments at the top of the design could refer to the scenery. But the dancers themselves are handled with such angular severity that their bodies are impossible to identify. Bomberg concentrates here on essential movement alone, as well as establishing a tension between the scattered fragments and the solid shafts of brown, blue, ochre and orange which give the performers their corporeal substance.

The brief text which Bomberg wrote as an accompaniment to the lithographs proves that he aimed to catch a sequence of brilliant, dramatic segments rather than a comprehensive view:

Methodic discord startles . . .
Insistent snatchings drag fancy from space,
Fluttering white hands beat – compel. Reason concedes.
Impressions crowding collide with movement around us –
the curtain falls – the created illusion escapes.
The mind clamped fast captures only a fragment, for new illusion.[79]

Bomberg's three small lithographs are perhaps the most expressive demonstrations of this fleeting vision (Plates 152, 153, 154). They allow chinks of light to blaze out of the surrounding darkness with startling brilliance, or else push an abruptly chopped limb up against the surface of the design like a dancer's body thrusting brazenly at the spectator's face. But the most disturbing of the lithographs is the widest image, where ominously penumbral forms clash with each other and threaten to block out the fitful areas of light yellow (Colour Plate 20). Although this lithograph is faithful to the forceful sentiments of the text printed on the opposite page, where Bomberg writes about 'impressions crowding collide with movement round us',

it also conveys the subterranean mood of the *Sappers* composition. Even as he returned to the audacious extremism of his pre-war work, Bomberg could not prevent the brooding imagery of underground tunnels from seeping into his design.

The *Russian Ballet* lithographs seem, nevertheless, more like a rousing finale to the dance compositions of 1914 than a product of Bomberg's most enduring post-war preoccupations. After the Armistice he was unwilling to revive his former enthusiasm for Diaghilev, and Alice recalled that 'when I first suggested a visit to the Alhambra, David was rather against it – he didn't feel inclined to see "that old fashioned stuff". However, he consented to come with me "as an experiment".' Once they had reached their seats, Bomberg's scepticism was confounded. 'The Ballet I had particularly chosen was "La Boutique Fantastique"', wrote Alice, describing how, after the house-lights dimmed,

> it was dawn, and the curtains were being drawn, and the whole shop came to life – in mid-Victorian colouring – and then I heard David's particularly Jewish chuckle of acceptance and delight, and then I knew that Diaghilev and I had won. After that wonderful first night we went often to the Alhambra and saw all the Ballets that Diaghilev was putting on, but 'La Boutique' remained our favourite because of the . . . opening music . . . ending in the riotous March of the Toys in procession.[80]

But after Diaghilev's London season was over, Bomberg once more forsook the style he had momentarily resurrected for the *Russian Ballet* lithographs. A sheet of paper bearing two studies for the lithographs also contains, below them, a far more naturalistic drawing of a woman pulling off her clothes to reveal her breasts (Plate 155). No more succinct dramatization could be imagined of the tussle between conflicting styles in Bomberg's mind. The rival demands of abstraction and representation were hard to reconcile, and Bomberg was only able to execute the *Russian Ballet* booklet in such a radically simplified style by relying on studies he had made long before the war filled him with doubts about the direction his future work should take. After completing these eloquent and technically proficient lithographs, which show how Fischer's early training had stood him in good stead, Bomberg never again returned to the extremism of his pre-war style. The visible world would henceforth receive greater acknowledgement in his work, and his move towards a more representational approach was probably hastened by the humiliating fate of the booklet. Having printed all the copies himself, Alice 'helped to cut the covers and sew them on'.[81] Then they went off to the Alhambra and, as she recalled,

155. David Bomberg. *Studies for Russian Ballet lithographs and Woman Undressing*, 1914–19. Pencil and watercolour, 18.6 × 19 cm. Anthony d'Offay Gallery, London.

> in one of his madcap moods, he and a friend (and I) went among the people in the stalls pretending to be selling programmes at 2/6d a time. Of course Diagileff [*sic*] soon got wind of what was going on and naturally would have none of it, the buyers were reimbursed and the 'programmes' collected and together with David and friend and myself, were chased up into the ninepenny gallery where we belonged. David took his hundred unsold copies to Henderson's Bomb Shop in Charing Cross Road, where they were put out for sale and about ten were sold and then Henderson withdrew them as unsaleable.[82]

Such experiences were hardly calculated to encourage Bomberg, whose rejection by the Canadian committee had already shaken him so badly that he became a prey to fits of depression. In later life these disabling attacks sometimes became severe enough to prevent him from working, but in 1919 he refused to let either Konody's rebuttal or the paucity of buyers stop him embarking on an extended sequence of well over a hundred ink-drawings. Carried out in pen and wash on thin paper, these small studies confirm Bomberg's new-found determination to pursue a figurative style more rounded and humane than the angular harshness of his pre-war work. But they are far freer and more personal than the literal idiom he adopted for the final Canadian painting. Indeed, the drawings were executed as an impulsive reaction to the weeks he had spent repressing his individuality while the amended *Sappers* canvas was completed. Having sent off this dogged picture to the committee he could restrain his imagination no longer, and Alice recalled that 'almost before it was gone David was at work on a set of small drawings – encouraged by the quality of typing paper I was able to bring him from the office. One day I got home from the office and there wasn't anywhere to sit – chairs and tables and the throne even was [*sic*] covered with small drawings in

various stages, from finished works to wet sheets of paper waiting for the final application of gum arabic – which would produce a glazed finish.' Alice philosophically decided that, for the time being at least, there was no room for her in a flat festooned with drawings. 'After all, it was David's studio – dedicated to his work. So I went out and found myself a furnished room quite close and settled in there quite happily, and there I stayed for a month or six weeks.' It was, perhaps, the first overt sign of the strain in their relationship which would lead, a few years later, to irreversible discord. But this curious period of separation came to an end when 'David came to fetch me one evening. He said "the studio wanted tidying up" and also he "had run out of salt". So I went back and found the small drawings had all been placed in separate folders ready for inspection. He sold many of them to friends at a pound each and we said they kept us in bread and butter for many months.'[83]

Several drawings of men at work among pillars and beams recall the *Sappers* composition, and look like studies for the picture which Bomberg would ideally have liked to paint without the committee's constraints (Plate 159). But Bomberg never gave any of the drawings a *Sappers* title. He subsequently explained that the series was 'done in twelve parts, each part having twelve variations, each drawing was based on one of twelve patterns, the key to the whole'.[84] When he later made a list of the drawings, preserved in twelve numbered folios, Bomberg gave each folio a thematic title. They reveal the range of subjects dominating his imagination at the time: *The Visitor, Mother & Child, The Square Floor, Family Group, Ballerina, Bargees, Opera, The Staircase, Men & Women, The Table, Lock-up,* and *Ostlers* (Plate 156).[85] Within the variety of themes, one preoccupation remained constant: the human figure. But these drawings, economically defined by delicate pen contours and then vigorously brushed in with wash, give the figures such diverse activities to perform that their bodies assume many different forms. Sometimes, as in the *Mother & Child* series, the woman's maternal bulk dominates the composition (Plate 157). On other occasions, the tenderness of the parent could well belong to a notably affectionate father (Plate 158). Elsewhere, manual energy is stressed in the vigorous movements of the bargees (Plate 159), and an altogether more graceful rhythm enlivens the studies of ballerinas (Plate 160).

All the same, Bomberg rarely strays very far from one physical type: an amply proportioned body which is never afraid to indulge in gestures of the most exclamatory kind (Plate 161). The handling varies considerably, ranging from very linear and angular strokes of the pen which treat the design as a flat pattern, to studies where wash is relied on more heavily to model the limbs and give them a greater

157. David Bomberg. *Mother & Child*, 1919. Pen and ink wash, 28 × 20.8 cm. Private collection, London.

156. David Bomberg. *Ostlers*, 1919. Pen and ink wash, 20.3 × 25.4 cm. Collection of the artist's family.

159 (right). David Bomberg. *Bargees*, 1919. Pen and ink wash, 25.4 × 20.3 cm. Fischer Fine Art, London.

160 (far right). David Bomberg. *Ballerina*, 1919. Pen and ink wash, 26.5 × 20.3 cm. Private collection, London.

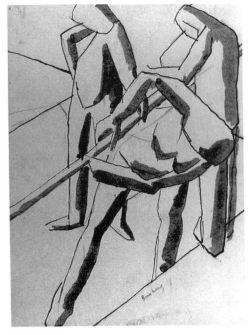

158. David Bomberg. *Family Group*, 1919. Pen and ink wash, 25.4 × 20.3 cm. Fischer Fine Art, London.

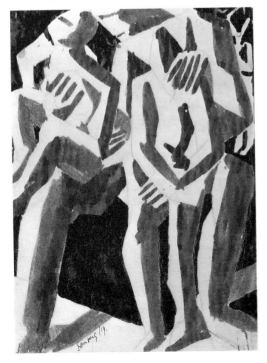

sense of volume (Plates 162, 163). But all the figures, regardless of how they are drawn, constantly assert a Bombergian sense of bulk. These studies are composed in an instinctively monumental way, and the gaunt settings they inhabit only accentuate their massive proportions. Although some of the locations refer directly to the stage – most notably in the *Opera* and *Ballerina* folios – the entire series is imbued with a strong theatrical character. Whether Bomberg depicts rough-hewn steps, or rooms where the walls tilt and sway at alarming angles, all the places have the bareness of a stark set-design by Edward Gordon Craig (Plate 164). The 'scenery' which Bomberg employs has a planar severity which recalls Craig at his most minimal, and the figures who people the drawings often look like performers acting out a strange, vehemently stylized drama. The men wearing hats who appear in some of the pictures seem to be malevolent presences, apparently bent on threatening or intimidation (Plate 165). Other drawings adhere to the same sinister mood, showing isolated figures languishing in distorted and claustrophobic interiors which suggest a kinship with George Grosz's harsher, more satirical vision of post-war urban life (Plate 166). Bomberg is never savage enough to qualify as an Expressionist, and the London he inhabited was far removed from the Berlin of the Weimar Republic. But a number of these drawings do seem oppressed by a sense of danger, as if their protagonists were trapped in an alien environment where shadowy intruders might at any moment consign them to a Kafkaesque hell.

The doom-laden feeling in some of the ink-wash series may well reflect Bomberg's dark suspicion that he had returned to peacetime England only to find himself persecuted by authorities who could not understand his work. Over the next few years these feelings of claustrophobia and alienation were to grow more acute; they had already been expressed in an elaborate 1918 ink drawing where a woman crouches in a desolate pose before a bleak fireside (Plate 167). Bomberg probably found his gloomiest fears echoed in the books which he began avidly to devour around this time. Alice recalled that he 'was reading a lot, and Russian novels principally. He read "Crime and Punishment" and "The Idiot" and Tolstoy's "War and Peace", and I noticed he was less interested in his drawings the more he read.'[86] Ultimately, though, Bomberg may have found in Tolstoy's novel the comfort he needed, for Siegfried Sassoon also read *War and Peace* towards the end of the war and decided that it was 'a grand and consoling book – a huge panorama of life and suffering humankind which makes the present troubles easier to endure and the loneliness of death a little thing'.[87]

Some of the drawings are summary and perfunctory enough to suggest that Bomberg executed them in a hurry before returning to his voracious reading programme. But other images in the series are carefully considered and impressive. The critic Frank Rutter liked them so much that he displayed 'more than a hundred'[88] of the drawings at his newly-opened Adelphi Gallery in the autumn of 1919. Strangely, in view of the prevailing antagonism towards abstraction, the few critics who

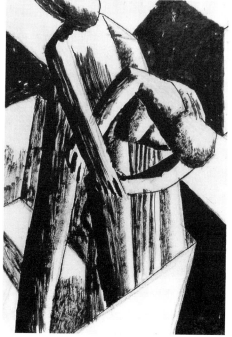

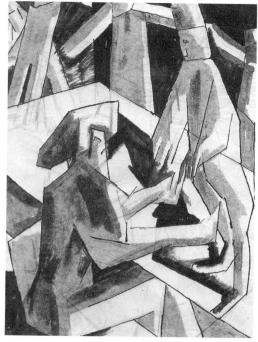

161 (far right). David Bomberg. *The Table*, 1919. Pen and ink wash, 26 × 20.3 cm. Private collection.

162. David Bomberg. *Men & Women*, 1919. Pen and ink wash, 25.4 × 20.3 cm. Collection of the artist's family.

163. David Bomberg. *Family Group*, 1919. Pen and ink wash, 26 × 19.7 cm. Fischer Fine Art, London.

164 (far right). David Bomberg. *Lock-up*, 1919. Pen and ink wash, 25.4 × 20.3 cm. Fischer Fine Art, London.

165. David Bomberg. *The Visitor*, 1919. Pen and ink wash, 25.4 × 20.3 cm. Collection of the artist's family.

166 (far right). David Bomberg. *Men & Women*, 1919. Pen and ink wash, 25.4 × 20.3 cm. Private collection.

reviewed the exhibition responded with greatest warmth to the most geometricized works on view. *Jewish World* singled out the 'series of drawings entitled "The Square Floor", which seem to possess an almost uncanny impressiveness'.[89] Another reviewer declared that 'the cubical shape has provided a genuine artistic inspiration to Mr Bomberg. By far the best of his drawings at the Adelphi Gallery are those in which cubical, or, at any rate, quadrangular shapes predominate by the accident of subject; such as the "Bargees" and "Staircase" series.'[90] Herbert Read, writing one of his first post-war pieces of art criticism, shared the admiration for the *Bargees* drawings and claimed that in several of them 'a high standard of formal beauty is attained'. But he also pointed out that the entire series had 'a distinct homogeneity', explaining how 'the *ideas* are always good. Perhaps the fact that Mr Bomberg has ideas is his most remarkable peculiarity. And the way he will explore all the possibilities of an idea in a series of drawings seems to indicate that his mind is of that objective, scientific sort that alone is capable of wonders. Mr Bomberg is possibly a great artist.'[91]

Praise from a critic as discerning and well-informed as the young Read must have pleased Bomberg a great deal. Since Read met Lewis and other avant-garde English artists at this time, he was probably introduced to Bomberg and had the chance to discuss the drawings with him. Bomberg's own comments on the ink-wash series certainly echo Read's belief that they explored formal variations with logical precision. For 'the problem' tackled by the drawings was, in Bomberg's view, 'to expand the possibilities of one combination of forms into as many variations to exhaustion of possibilities without altering the juxapositions, but slightly modifying and stressing the parts of the key'.[92] The pronounced schematic character of the drawings suggests that Bomberg used them to investigate formal problems which preoccupied him and required resolution. But to overemphasize the 'objective, scientific' aspect of the series would be a mistake. For the drawings also affirm, quite

167. David Bomberg. *Fireside*, 1918. Ink and pencil, 32 × 46.6 cm. Anthony d'Offay Gallery, London.

168. David Bomberg. *Self-Portrait*, 1919–20. Oil on board, 38.5 × 32.3 cm. Private collection.

169. David Bomberg. *Self-Portrait–Profile*, 1919–20. Oil on board, 38.5 × 32.3 cm. Anthony d'Offay Gallery, London.

unequivocally, Bomberg's post-war commitment to a more figurative style. Although the people whom he depicts in the drawings are simplified and often angular, they are far more recognizably human than the mechanistic figures who enlivened his pre-war work.

Executing the prolonged ink-wash series seems to have helped Bomberg convince himself that he could never return to the structural extremism of the 1914 period. So when he was approached once again by his old friend Robert van't Hoff, who by this time had become involved with the De Stijl group, Bomberg felt irrevocably estranged from the concerns of the European abstractionists. The two men had found common concerns when they first met in pre-war London, where van't Hoff designed Augustus John's Mallord Street house (Plate 71). But by now their differences had become impossible to ignore. Bomberg remembered that van't Hoff, who in 1914 'took his own estimations of the contribution I was making back to Holland', decided to 'visit England again in 1919. He asked me to collect together a pleiad of the advanced in Art and Literature, to unburden himself regarding a conflict in his mind relating to Architecture and the Visual Arts generally and their effect on the Social Structure of Society. The discourse went on throughout the night and ended in the morning hours on Wyndham Lewis's note that we had arrived at the blank page.' Van't Hoff's attempt to establish close connections between De Stijl and the 'pleiad' of experimental English artists had foundered. The differences between the two camps were irreconcileable and the meeting dispersed. But its failure did not stop van't Hoff from attempting to recruit Bomberg's services alone. Bomberg wrote that

> He asked me to return with him to Leyden and join the Group in developing the ideas they had come together for in 1917. The examples of the work he showed me that the Group stood for I was not impressed with. There was evidence that they were not sensing design as that which emanated from the sense of mass, but depended more for their appeal on juxtapositions of form that found their way to Leyden via the Cubists and Paul Klee and Kandinsky, but more elementarily and architecturally integrated. This I felt could only lead again to the Blank Page. I declined the Leyden invitation – I had found I could more surely develop on the lines of Cézanne's rediscovery that the world was round and there was

a way out through the sunlight – this I have followed and matured in ever since.[93]

Bomberg's refusal to align himself with De Stijl was a decisive act. It marked a definitive break with his pre-war work. Although the styles he explored over the next few years were often tentative in character and bewilderingly diverse, he never again returned to the kind of concerns which had once made his paintings so agreeable to the De Stijl group. The war had brought about a profound change in Bomberg's vision of the world, and the two small self-portraits he executed around this time investigate the possibilities of a surprisingly naturalistic idiom (Plates 168, 169). One of them, a stern profile view posed like a police photograph, suggests that his features had lost little of the jutting belligerence and determination which characterized the young Bomberg. But the other canvas reveals a less forceful and more wary individual. Dressed with a neatness he would have spurned in his Slade days, Bomberg now looks guarded and almost diffident. He seems to be asking himself where his future direction should lie, and during the 1920s the answer to that question astonished everyone who had known him as an uncompromising rebel dedicated to 'the *construction of Pure Form*'.

CHAPTER SIX  # Palestine: The Years of Transition

Bomberg was by no means alone in deciding to pursue a more conventional path. All over Europe painters who had once been leading exponents of avant-garde rebellion were now pausing, taking stock and wondering whether they should return to more traditional ways of seeing. The waste and despair of the war years bred among many artists an instinctive mistrust of militant extremism. There was a widespread longing for order, and the general move away from abstraction was evident when many of the former English insurgents exhibited in the 1919 London Group show. The critics generally welcomed the change, sharing the *New Statesman*'s view that 'it is a good exhibition, less flighty and more solid than usual, and it is interesting to note a definite tendency to return to so-called representational art'.[1] Not that Bomberg's contributions had yet departed too far from his earlier work. *The Observer* pointed out that he had 'retained from his erstwhile Cubism a sense of solid form which gives intense significance and character both to his treatment of the human figure and to his splendidly-designed "Barges"'.[2] The version of *Barges* displayed in the London Group was indeed a satisfying image (Colour Plate 21). Bomberg had succeeded in arriving at a balance between his former obsession with structural simplification and his new-found desire to incorporate more of the visible world in his art. The jagged, criss-cross pattern of the foliage on the canal bank is still reminiscent of his earlier work, and the barges' timber roofs are depicted with geometrical severity. But the schematic elements in the design now serve to elucidate a clearly identifiable scene, and even the block-like reflections cast by unseen trees are broken up by a few vertical brushstrokes applied with a new fluidity and freedom.

If Bomberg had exhibited his other version of the subject, *Barges on the Canal*, the full extent of his changed attitude would have astonished visitors to the London Group show (Plate 170). For this painting dispenses with the rigid organization and solidity of *Barges*, opting instead for a more naturalistic approach and a wild, loose handling which places greater emphasis on gestural marks. The trees which Bomberg excised from the other composition are included here, and their reflections fleck the surface of the water with excited, darting brushwork. Although it is a far less resolved and coherent painting than the London Group version, *Barges on the Canal* is more prophetic of the direction Bomberg was soon to take. It also conveys some of the nervous excitement he experienced when discovering the motif, quite by chance, on a warm Sunday afternoon in England. Previous writers have supposed that the barges pictures were only based on memories of army life in Flanders, when he rode out with messages and became 'so interested in watching the barges on the canal that he missed his balance and fell in'.[3] But the full genesis of the barges pictures is at once more complex and more intriguing. Bomberg's recollections of the tranquil Flanders scene, which must have afforded him welcome relief from the grim desolation of trench warfare, were augmented by a subsequent encounter with barges on a canal in the countryside near London. Alice recalled how, during the summer of 1919, 'David suggested that we take our bicycles out for a run, so we set off, but away from Hampstead Heath, as he thought it would be too crowded. We took another road and after pedalling for some time, perhaps an hour, I found myself riding up a fairly steep ascent and realised we were on a bridge and there was water below.' The resemblance between the scene Bomberg

170. David Bomberg. *Barges on the Canal*, 1919. Oil on canvas, 60.7 × 70.9 cm. Private collection.

171. David Bomberg. *Bargee Family*, *c.* 1919. Black chalk, 57.8 × 55.8 cm. Private collection.

172 (far right). David Bomberg. *Bargee Mother and Child*, 1920. Watercolour, 38.1 × 28 cm. Private collection.

saw here and the Flanders canal appears to have taken him by surprise, for Alice described how

> David literally fell off his bike, and while I dismounted quickly I grabbed his bike and took the two bicycles on to the kerb to get them away from other riders. Meanwhile I saw that he was hunting in his pockets and I knew he was getting pencil and paper and then I saw what he had seen as we mounted the bridge – four or five barges in line – tied up for the night, with willow trees throwing shadows from the other bank. I suppose we stood there for nearly one hour while he made his sketch and then we rode home, and he spent some time brooding over the drawing he had made on the back of an old envelope![4]

It was a highly significant moment in Bomberg's troubled development. The experience of drawing a landscape in the open air must have made him wonder if he should alter his entire *modus operandi*, henceforth devoting every ounce of energy to first-hand scrutiny of nature. The freely painted version of the barges composition proves that he dallied with the idea, and he certainly adopted this course of action after moving to Palestine four years later. But as the greater confidence of the more schematic barges painting proves clearly enough, in 1919 he was not yet ready to repeat his *en plein air* experiment. Bomberg needed time to absorb the full implications of a procedure so flatly opposed to his pre-war work; and besides, the English countryside did not appeal to him very strongly. Indeed, he was becoming ever more ill-at-ease with a nation that refused properly to understand and appreciate his art. Perhaps that is one of the reasons why bargees appear in so many drawings and paintings of this period (Plates 171, 172). They may have seemed to him like outsiders, who occupied as marginal a place in society as Bomberg now felt he

173. David Bomberg. *Down and Out*, *c.* 1919. Pen and wash, 17.3 × 12.2 cm. Collection of the artist's family.

174 (right). David Bomberg. *Huddled Figures*, *c.* 1919. Pen and ink wash, 20.3 × 31.8 cm. Private collection.

175. David Bomberg. *Woman and Machine*, 1920. Oil on canvas, 61 × 76.3 cm. Erich Sommer, London.

176. Edward Hopper. *Girl at Sewing Machine, c. 1921*. Oil on canvas, 47.8 × 45.3 cm. Thyssen-Bornemisza collection.

did. One little sketch from this period shows a shabby figure leaning drunkenly against a wall, and other drawings are peopled with itinerant street players or vagrants (Plates 173, 174). Bomberg may have felt a growing sympathy with the outcast. At the 1919 London Group show he also displayed, alongside *Barges*, a painting called *The Hunger Marcher* based on his pre-war friend Stewart Gray. The picture has been lost, but since *The Times* described it as a 'large figure'[5] Bomberg probably endowed the protesting marcher with an heroic significance.

The following year he continued to explore the theme of alienation. In *Woman and Machine*, exhibited at a mixed show of contemporary art in the Hampstead Art Gallery, the loneliness and drudgery of sweated labour is dourly conveyed (Plate 175). Its grim mood becomes even more marked when compared with Edward Hopper's roughly contemporaneous treatment of a similar theme (Plate 176). Hopper, who is unlikely to have been aware of Bomberg's work, depicts his *Girl at Sewing Machine* as a solitary and down-at-heel figure. But the picture is not as dark and brooding as Bomberg's canvas, where woman and machine appear locked together in a remorseless union.

Incessant labour for minimal rewards dominated his vision of most people's lives, and a morose painting entitled *Ghetto Theatre* proves that Bomberg's figures were unable to find real enjoyment even in their leisure hours (Plate 177). Exhibited at the 1920 London Group show, it marks a deliberate return to the East End Jewish subject-matter which inspired some of his finest pre-war work. But the mood has now changed as radically as the style. In earlier paintings like *Ju-Jitsu* and *The Mud Bath*, Bomberg depicted figures who were dehumanized and yet filled with muscular vitality. Their energy gave his work an extraordinary dynamism, implying that he wanted to celebrate the toughness and resilience of Whitechapel life. *Ghetto Theatre*, by contrast, is subdued. The people in the Pavilion Theatre's audience may be more 'human' than their counterparts in Bomberg's earlier work, but now they lack animation. Hunched and weary, they slump on the hard benches and seem incapable of responding to the play with any gusto. Seven years before, in *Jewish Theatre* (Plate 48), Bomberg had drawn an audience in the same auditorium reacting with great dramatic intensity to the performance on stage. Now, however, the spectators remain motionless and eerily becalmed. They seem hemmed in by their surroundings, and the railing which Bomberg has placed so prominently in front of them has the cruel force of bars in a prison cell. The figures exude a melancholy which surely reflected the artist's own feelings, as he contemplated his own frustrated position in a country which refused to provide the support he required. The White-

177. David Bomberg. *Ghetto Theatre*, 1920. Oil on canvas, 75.2 × 62.6 cm. Ben Uri Art Gallery, London.

chapel area, where he had once felt so completely at home, is seen in *Ghetto Theatre* as a place of narrow confinement. Having escaped from the boundaries of a life which so richly stimulated his early work, Bomberg could never bring himself to settle in the East End again.

No solace was to be found in the company of like-minded painters of Bomberg's generation. When a number of his old allies exhibited together in a show called *Group X*, held at the Mansard Gallery in March 1920, he was conspicuous by his absence. Although Lewis's introduction to the catalogue promised that the exhibition was free from any 'theory or dogma that would be liable to limit the development of any member',[6] Bomberg was as unwilling to join the group as he had been during the formation of the Vorticist movement. Artists like Roberts, Etchells and Wadsworth contributed to *Group X*, thereby temporarily reuniting most of the English painters who had shared Bomberg's earlier dedication to renewal. But he still could not bring himself to become closely associated with the domineering Lewis. The only post-war occasion when Bomberg did respond positively to an invitation from Lewis came in March 1921, when preparations were being made for the first issue of *The Tyro: A Review of the Arts of Painting, Sculpture and Design*. Lewis, its editor and chief contributor, called on Bomberg and 'asked for four Drawings to reproduce'. Presumably because the magazine did not set out to promote a new group, Bomberg selected his drawings and told Lewis 'he could use which he pleased'. As a result, *The Tyro*'s first instalment in April 1921 contained a powerful ink composition by Bomberg called *The Exit* (Plate 178). Reproduced above a pencil study by Roberts and opposite John Rodker's short story,[7] Bomberg's contribution was surrounded by work from old friends. But *The Exit*, which depicts a burdened man lurching out of a room even more cramped and claustrophobic than Bomberg's previous interiors, indicates that his sense of imprisonment was

179. David Bomberg. *English Woman*, 1920. Oil on canvas, 61 × 51 cm. Ben Uri Art Gallery, London.

growing ever more irksome. The association with *The Tyro* did not lead to any greater involvement with Lewis, either: Bomberg tersely recorded that his 'three remaining Drawings were never returned – from that date Lewis & I ceased to be friends'.[8]

A comparison between two barge paintings, both executed during this difficult period, reveals the increasing sense of tragedy in Bomberg's work. One, *English Woman*, made in 1920, is dominated by a bending but by no means servile figure who seems to be grasping the tiller with all her considerable strength (Plate 179).[9] Bomberg's handling of the paint is still relatively flat and undemonstrative, and the woman is an anonymous form whose bulk remains resolutely compact. A year later, by contrast, the larger canvas called *Bargee* expresses a more turbulent vision (Colour Plate 22). An elongated woman, bowed and despondent, stares down at the naked baby in her lap. She is hemmed in by massive beams which recall the structure of the *Sappers* pictures, but this time Bomberg appears to have painted the entire composition with a palette knife. The freely worked pigment is openly agitated, declaring his tumultuous emotions with a new directness and force. *Bargee* anticipates the heavily loaded surfaces and expressive frankness of his later work, but there is no sense of liberation. Rather than realizing that the style he had developed here showed him a way forward, Bomberg stressed confinement. Both woman and baby seem trapped by their surroundings, and the rasping orange floorboards have a vertiginous tilt which accentuates the feeling of unease.

Bomberg was not yet ready to pursue the implications of this commanding image. Instead, he decided for a while to take up chicken farming and moved with Alice to a house in the village of Beech, near Alton in Hampshire. Relieved to escape from the monotony of her secretarial job in London, Alice enjoyed the year they spent there. She looked after a motley range of chickens, rabbits, ducks and bees, saving money for poultry food by 'living on eggs and bread and wild raspberries'. But Bomberg could not settle down. 'The idea of living in the country had captured his imagination', Alice explained, 'but he did not know until we had left the studio how much he was going to miss London life. He unpacked his paints and canvases and easel and arranged everything ready to start work, but he could not start.' The truth was that Bomberg's urban upbringing left him ill-equipped to cope with such a sudden transition to rural life. 'When David was asked why he could not settle to paint in "his big room"', wrote Alice, 'he replied that "the country was too noisy" – this from a Londoner – he said he would no sooner settle when down came those damned ducks, quacking, quacking, quacking, and he would have to go out and see what was the matter.'[10] It is significant that one of the few works

178. David Bomberg. *The Exit*, 1919, Ink. Lost. Reproduced in *The Tyro*, April 1921.

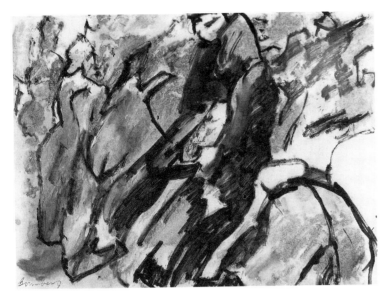

180. David Bomberg. *Design for 'Orwell' Electric Trucks & Lorries Advertisement*, 1921. Ink. Original lost. Print, 18.3 × 25.3 cm. Collection of the artist's family.

181 (above left). David Bomberg. *Vagrants*, 1920–22. Oil on paper, 32 × 42 cm. Collection of the artist's family.

182 (above right). David Bomberg. *The Circus*, 1920–22. Oil on paper, 31.8 × 40.6 cm. Fischer Fine Art, London.

183. David Bomberg. *The Island: Land and Sea*, 1920–22. Oil on paper, 31.3 × 40.2 cm. Joanna Drew, London.

definitely executed at Beech was a design for an 'Orwell' electric trucks and lorries advertisement (Plate 180).[11] A subdued and over-complicated image, its presentation of dockyard life compares poorly with the vitality of the pre-war studies which culminated in his great *In the Hold* canvas. The countryside had an inhibiting effect on his work, and the 'posters for the Railway'[12] which he also prepared at Beech were ultimately turned down by the Underground company.

In view of the inspiration which Bomberg was subsequently to derive from the countryside in Spain and Cyprus, the failure of the Beech experiment may seem strange. But he rarely found excitement in the English landscape at any stage of his career, and apart from an occasional tepid landscape study the only other works made during the Beech period seem to be derived from his imagination alone. Although they bear titles like *Vagrants*, *The Circus* and *The Tent*, these oil-on-paper studies are often difficult to read on a representational level (Plates 181, 182; Colour Plate 23). Compared with the very tight and literal image which Bomberg produced for the 'Orwell' advertisement, they are astonishingly loose and abstract, making many figurative references but insisting all the time on the artist's right to explore a more allusive and ambiguous world. He described the series simply as 'Sixty Imaginative Compositions' when they were exhibited a decade later,[13] and their collective title certainly implies a freedom from any overriding representational intention. In this respect, they demonstrate Bomberg's continuing need to assert the liberty he had first claimed for himself before the war, when so many of his images made a radical departure from the thing seen. They also return to East End themes like street players, the ghetto theatre and itinerant performers on Bethnal Green.[14]

In every other respect, however, the 'Imaginative Compositions' are quite distinct from the pre-war work. Although many of their titles affirm his continuing involvement with working-class subjects like miners, lightermen, stevedores and quarrymen, other images such as *The Island: Land and Sea* prove that he was moving away from an exclusive interest in the human figure and beginning to involve himself with landscape themes (Plate 183). Moreover, all the 'Imaginative Compositions' break away from the angular, geometrical draughtsmanship of his earlier period. Their forms are fluid, organic and broken, created by brushwork which investigates the expressive potential of marks placed with great assertion on the paper. Bomberg's unwillingness to exhibit them until long after their completion suggests that he did not immediately feel convinced of their importance. Moreover, Lilian Bomberg remembered David telling her that 'he did the "Imaginatives" in secret and never showed them to Alice, because she didn't approve of such "modern" works after the Canadian debacle.'[15] But they enabled him to move away from his earlier style and discover a new sensibility which only emerged fully at a later stage in his development.

For the time being he remained in a state of chronic indecision, about both the direction his work should pursue and the place which might prove most conducive

to the production of worthwhile art. Moving back to London after the failure of the chicken farming did not solve the problem at all. A spacious flat in Cleveland Gardens failed to cure Bomberg of his restlessness, and he wasted energy on vain experiments with portraiture and poster-work. After spending a lot of time painting 'a portrait of a wealthy Jewish poet', the sitter refused to accept it 'because David had made a *true* portrait instead of how the poet *thought* he looked'. In order to search for poster subjects, Alice remembered, Bomberg 'decided to join forces with another couple and to hire a punt and spend a fortnight together on the River Thames, hoping for scenes that would provide material for posters. But although we took plenty of charcoal, no scenes presented themselves and after a week, the other couple went home leaving us to pay for the punt.'[16]

Throughout his life Bomberg would expend a great deal of effort on similar ventures, all devised in order to furnish him with an income and all doomed to end in futility. Even when Ben Nicholson approached him with a generous and promising offer of support, the outcome was disastrous. Although Nicholson had studied briefly at the Slade just before Bomberg arrived there, the two men's work had little in common during the subsequent decade. But by 1922 Nicholson had begun to shake off his father's inhibiting influence and direct himself towards more independent possibilities. Since Bomberg was at that stage still one of the most adventurous painters in England, Nicholson was naturally well-acquainted with his exhibited paintings. Indeed, Nicholson later recalled that he found Bomberg's 'early work . . . v. interesting'.[17] For his part, Bomberg described how 'Nicholson gained my esteem as one artist for another's work', and he must have been gratified when Nicholson 'showed similar esteem for my work by buying such small works as he liked and could afford'.[18]

184. Ben Nicholson. *Cortivallo, Lugano*, 1921–c. 1923. Oil and pencil on canvas, 43 × 60 cm. David Nicholson.

Both artists might have benefited from developing a friendship with each other. They certainly shared an enthusiasm for contemporary French painting, and Nicholson would have approved of Bomberg's decision to conclude a 1922 lecture on *Modern Art* by declaring that 'there are three people now working that have inherited this wonderful vitality, Picasso, Derain [and] Matisse.'[19] Alice remembered that, soon after she settled in Cleveland Gardens with Bomberg, 'Ben Nicholson found us . . . and invited us to Lugano.' It was here that Nicholson painted his first fully convincing landscape, the limpid *Cortivallo, Lugano* (Plate 184),[20] and he seems to have hoped that Bomberg's presence might help him build on the discoveries he had made. Glad of the chance to escape from London again, Bomberg accepted Nicholson's invitation. 'I had saved some cash by then', Alice recalled, 'so I gave up my job and off we went – to the great fiasco.' Bomberg does not seem to have been prepared for the rigours of the Swiss climate. 'It was bitterly cold with snow, no fires or heating in the supposed "summer villa" and we were half starved on macaroni and cheese and such-like', Alice wrote. 'David hated being hauled out in the snow on painting expeditions, expected to play the maestro and teach them how to paint. Finally there was a show-down and they paid our fares home glad to get rid of us!'[21] Ultimately, of course, the refined and delicate style Nicholson developed in *Cortivallo, Lugano* had little in common with the fiery and gestural language Bomberg was now beginning to explore. But the abortive Swiss expedition, which only lasted a fortnight, at least introduced Bomberg to the whole notion of painting out-of-doors. Even if he loathed the snow which had such a purifying effect on Nicholson's palette, Bomberg was soon to realize that painting landscapes in the open air afforded him immense gratification.

185. David Bomberg. *Grief*, 1922. Oil on canvas, 91.5 × 73.7 cm. Leicestershire Museum and Art Gallery.

Back in London, his dissatisfaction turned to gloom. A strangely disturbed painting called *Grief* suggests that Bomberg, like many other soldiers who survived the war, was still suffering from the traumatic experience of death he had so often encountered in the trenches (Plate 185). When John Mayes met Bomberg for the first time in the 1940s, he explained that he was a pacifist who hated war 'because it destroys men'. Bomberg smiled and replied: 'Yes, I know what you mean, John. But war can also make men grow.'[22] Bomberg was probably referring to his own ability to recover from a self-inflicted wound and resume active service as a soldier, but the war also gave him a lasting insight into the meaning of human suffering. The painting of *Grief*, apparently occasioned by the death of a relative, universalizes the event by casting it in biblical terms. But the grimness of its mood is informed by Bomberg's memories of war as well, for he wrote some time after the Armistice that 'there are such sorrows on a battlefield that they that have never fought can

never realize – there are so many crushed ideals and hopelessness in a peace compact that they who rejoice were surely ignorant of, and if war brings sorrow and poverty to a peace like this and all wars for victory bring a peace such as this – what merit then is there in all of it?'[23] An intolerable sense of melancholy and frustration lies behind *Grief*. Bomberg may have proudly claimed to a collector in November 1922 that 'I am able in the medium of oil paint to force this monumentalism of design & subject',[24] but the execution of *Grief* did little to alleviate his feelings of restlessness and oppression.

Bomberg's plight was exacerbated by the knowledge that few collectors were prepared to purchase his work, and most critics still felt he remained too involved with his former radicalism. But he continued to command the admiration of other artists, for his Slade contemporary Paul Nash urged Edward Marsh to overcome his reservations and buy some Bombergs in 1922:

> I saw the Bombergs and liked them – I think they'll repay your generosity – I do not think, of course, it is a 'generous' act to buy contemporary work, but it becomes so when it's of a nature you don't greatly admire and when you have really ceased to collect! The Landscape would look twice as good framed, as its design needs keeping in bounds. The head is very original don't you think – a representative example of Bomberg's vision and peculiar technique.[25]

The artist Muirhead Bone, whom he had first met while working on the Canadian war commission painting, went further than Nash in offering Bomberg support. Even though Bone had little sympathy for the avant-garde cause with which Bomberg had once been so closely associated, he admired the proficiency of the final *Sappers* canvas. Suspecting that Bomberg had now arrived at a watershed in his development, Bone tried to sell a drawing for him and offered some avuncular advice. 'I'm still sure that you should face the trouble and difficulty of realism and not take refuge in short cuts!' Bone wrote in March 1922. 'Forgive my cheek in writing like that – I only mean we have all a tendency to put on a convenient uniform (which happens to be a kind of cubism today) instead of finding out what is personally at the bottom of our own souls and striving to give it shape. Forgive this!'[26]

However remote Bomberg's work may then have seemed from the topographical tradition espoused by Bone, this injunction probably struck home. Bomberg did need to search for a way of working which would do full justice to his post-war perception of the world. He respected Bone's frankness, and found his support invaluable at a time when the patronage of other collectors was dwindling. For Bone was generous as well as sympathetic. 'I am sorry you are going through such a hard time', he wrote in November 1922, enclosing £8 and confessing that his efforts to sell Bomberg's drawing had failed. 'I am afraid you have to face the fact that there is scarcely any buying public for work like yours and I don't know where it is going to come from', Bone continued.

> I had a good look at your picture at the London Group and frankly it seemed to me more a notion for a picture than a really successful representation of your ideas – at least that was my feeling about it. If your present style won't carry you farther than that I should go back to a franker naturalism if I were you and see how much of design & powerful simplified feeling you can get into *that*. You should attack an important thing and stick to it and bring it out with real finish (I don't say '*trade* finish' but the appropriate finish for the style) in the end. Your second picture for the Canadians is the only thing of yours which really sticks in my mind.[27]

Bone's preference for the final *Sappers* canvas now seems sadly wrong-headed, and Bomberg never pursued the style he had momentarily adopted in order to placate the Canadian War Memorial Fund. But his drastic change of direction in the Palestine pictures proves that Bone's advocacy of 'a franker naturalism' was pertinent. Many years later Bomberg's sister Kitty remembered him explaining that 'I took the Cubist work as far as I could', and in the early 1920s he wondered increasingly whether an impasse had been reached. He was also growing disenchanted with an art establishment which persisted in ignoring his best work. Although the Tate Gallery purchased two of his pictures in 1923, they were both small and oddly atypical images. Rather than buying his greatest youthful achievements – *In the*

C21 (facing above). David Bomberg. *Barges*, 1919. Oil on canvas, 59.7 × 77.5 cm. Tate Gallery, London.

C23 (facing below). David Bomberg. *The Tent*, 1920–22. Oil on paper, 35.2 × 50.2 cm. Tate Gallery, London.

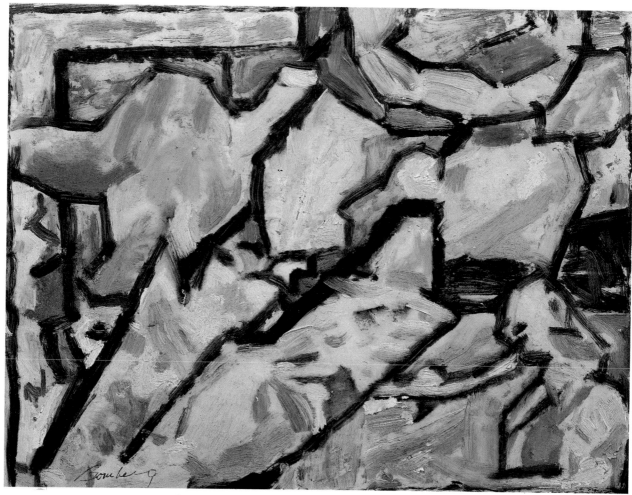

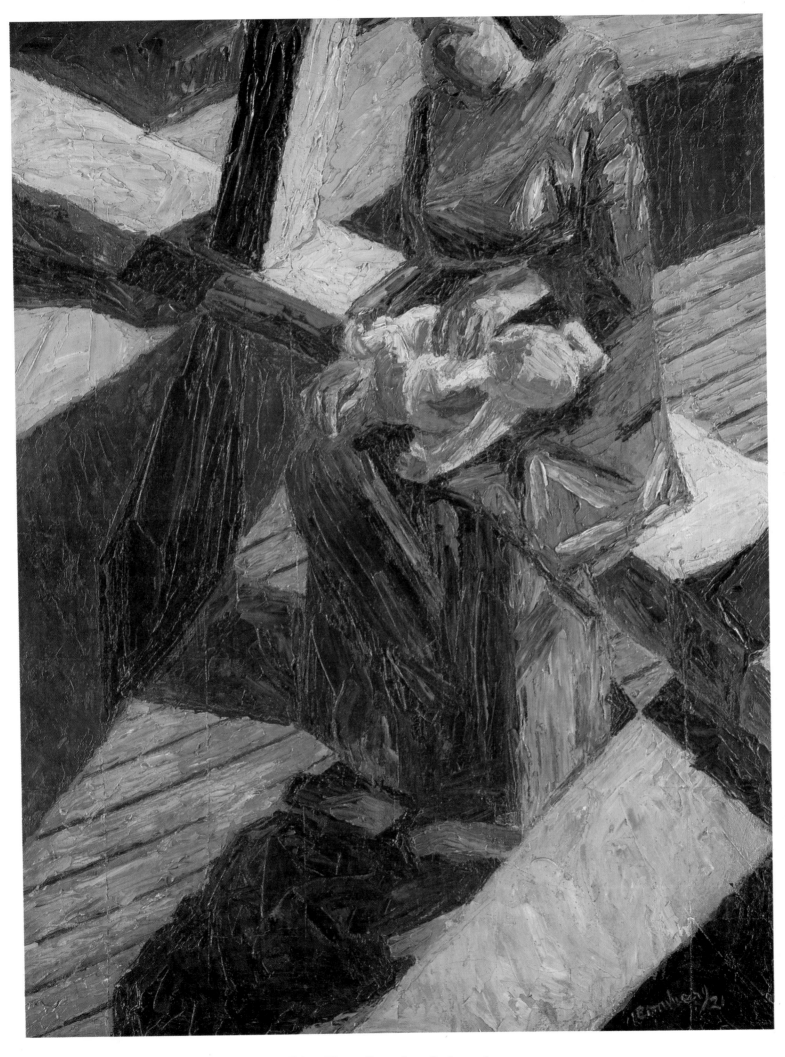

C22. David Bomberg. *Bargee*, 1921. Oil on canvas, 91.5 × 71.1 cm. Thyssen-Bornemisza collection.

*Hold* and *The Mud Bath* – the Tate acquired an unusual watercolour executed when Bomberg was in his first year at the Slade, and a dull sketch for the final *Sappers* painting (Colour Plate 1; Plate 146). Neither picture was at all representative of Bomberg's vital contribution to early English modernism, and he had good reason to conclude that his most important work remained completely misunderstood in his native land.

Realizing perhaps that a complete change of surroundings might help to resolve Bomberg's difficulties, Bone now proposed an intriguing idea.[28] He wondered if the recently-formed Zionist Organization, created by the British government after the Balfour Declaration had established support for a Jewish nation in 1917, might agree to employ Bomberg as its official artist in Palestine. Although not at all in agreement with the Zionist cause,[29] Bomberg must still have been fascinated by the prospect of visiting Jerusalem and recording his response to the environment he found there. As a Jewish artist who felt more and more estranged from the country of his birth, he was prepared to imagine that Palestine could make him feel at home. At all events, he had given his blessing to the proposal by November 1922, when he wrote to Captain Desmond Coke suggesting 'a visit to my studio' in order to view 'several oil paintings of curious subjects that I am anxious to show to people who I think they may interest. I am leaving England for Palistine [*sic*] at the end of this year for the purpose of making some records of the life there under reconstruction conditions, and am making the effort to secure the necessary funds for this project.'[30] But the year ended without any progress, and only in January 1923 was Bone able to report that 'I went yesterday to the Zionist Organization & saw Mr Leonard Stein about your project. We had a long talk together & I feel very hopeful about your getting the job.'[31]

Acting on a request which Stein made at that meeting, Bone also sent Bomberg a 'businesslike suggestion' about the terms of his employment in Palestine. This comprehensive memorandum declared the artist's willingness to work for the Zionist Organization, producing 'pictures and drawings ... the sole copyright of which will belong to the Z.O., reproductions of these works to be used by the Z.O. in any way they decide'. In return, Bomberg would receive money for his passage to Jerusalem, travelling expenses and a salary the equivalent of £400 a year in England. Then, having sent pictures home at regular intervals throughout the scheme's initial year, an exhibition of the work 'should be held in London and could be afterwards on tour throughout the country as well as in America'. The memorandum also suggested that shows might be staged 'in Zionist circles on a smaller footing, by the use of colour facsimiles'. It even reported that 'the Leicester Galleries in London have favourably considered the holding of such an exhibition in their well-known premises' – a plan which would eventually be implemented with a rather different collection of Bomberg's work five years later.

Bone did his best to persuade the Zionist Organization that Bomberg was an admirable candidate. 'Personally he is most likeable – clever, bright and sympathetic and not easily discouraged', declared the memorandum. 'I can vouch for his sobriety and personal straightforwardness. I consider the Z.O. could not make a more promising choice of an artist to serve them. His fresh and modern style of art will make the choice a strong recommendation in many quarters.' The memorandum was noticeably and no doubt wisely reluctant to specify the kind of images Bomberg might be best able to provide. Bone confined himself to describing them as 'original and vivid impressions of Palestine and the work of the Z.O. there, actually done on the spot'. But the memorandum did emphasize that illustrations of Bomberg's work, 'in newspapers and journals throughout the world', would be bound to 'stimulate interest and bring home to people what is being done'. Bone eagerly stressed the unique contribution which a painter could make to such an endeavour. 'Photographs, though valuable, are too much taken for granted nowadays', he argued, 'and one artist at least should be maintained by the Z.O. to lend more variety to their propaganda and to strike the minds of thoughtful imaginative people to whom photographs make little or no appeal. It is quite conceivable that such recruits to the Z.O. might prove the most valuable of all.'

These were large claims, and Bomberg's contemporaneous style was certainly not representational enough to be illustrated in magazines and newspapers where direct, easily comprehensible images would have been required. Moreover, his detachment from the Zionist cause made the whole notion of 'propaganda' painting

143

wildly implausible. But by giving his assent to the memorandum, he implicitly agreed with Bone's ringing declaration that 'an artist has the power of quickening life by showing its activities in a vivid, striking way and so displaying the spirit underlying it, and a good artist ought to be able to render this service to Zionism.'[32] At any rate, the document was duly dispatched on 24 January to Stein's office in Great Russell Street. But both Bomberg and Bone, who entertained great hopes of a favourable outcome, were dismayed by the reply they received a month later. Stein regretfully informed them that 'the Executive do not at present see their way to accept' the proposal, adding only that they did think Bomberg 'should be enabled to proceed to Palestine, as you desire'.[33]

Bone wrote to Bomberg without delay, admitting that 'I was exceedingly disappointed by the Zionist letter.' But with characteristic persistence, he refused to give up hope and promised that he would 'get into touch with Sir A. Mond'[34] – a man of great influence in Zionist circles. The counter-attack partially succeeded. At the end of March Stein was able to inform Bomberg that a new agreement had been reached with the Palestine Foundation fund, a body intimately connected with the Zionist Organization but enjoying a separate existence. The Fund had been established a few years earlier to help Jewish settlers build their houses, start irrigation schemes and bring in further immigrants. But it also felt able to subsidize Bomberg's journey in return for some of his Palestinian pictures. 'With regard to the drawings and paintings of Zionist reconstruction work which are to be placed at our disposal under an arrangement to be made with Mr Muirhead Bone', wrote Stein, 'I should explain that your passages are, strictly speaking, being paid for by the Keren Hayesod (Palestine Foundation Fund) and that any work which may become available under the terms of the agreement to be eventually made will therefore go to the Keren Hayesod.'[35]

It was a better offer than the proposal Stein had originally outlined, and Bomberg must have felt relieved that the venture did seem feasible after all. But since the annual salary suggested in the memorandum was still not forthcoming, he had no idea how funds might be procured once they arrived in Jerusalem. Bomberg's own slender financial resources might exhaust themselves all too rapidly, obliging him to return before he had fully absorbed his strange new surroundings and executed any substantial paintings. Once again the indefatigable and wonderfully loyal Bone decided to supply the necessary help. 'Bomberg has been to see me & we have talked over matters thoroughly', he wrote to Stein in April. 'It is of the utmost importance for him to get out there *now* & not linger on in London.' Bomberg was clearly desperate to undertake the journey and leave his unsatisfactory English life far behind, so Bone pleaded with Stein to 'add something in the way of little facilities from your Organization when he gets there'. In exchange, Bone promised he would 'personally undertake that Bomberg gives to the Keren Hayesod really fine work which will exhibit him credibly, & to the value of £50 in my professional opinion'.

With considerable generosity, Bone also sent Bomberg a cheque for £60, 'which is his estimate of the absolutely necessary money in addition to the little – the *very* little – he has'. The payment would ensure that Bomberg was able to start his journey 'in a fortnight', but Bone's limited resources did not enable him to give such a large sum outright. 'I cannot afford this sum & it rather cripples me but I feel it must be done', he told Stein, implying that Bomberg's need was unusually urgent. 'I have told him that I will *give* £15 of it as my share & that the remaining £45 I will hope to get back from any believers in Bomberg's ability who would like to help in a really good idea which will result in valuable pictures of Jewish life & Palestine achievement.' Bone remained confident that these images would be carried out in a style far removed from the works which Bomberg was currently exhibiting at the Whitechapel Art Gallery. They were in Bone's view 'a bit too much on the experimental side', but from now on 'it should be remembered that Bomberg is done with *that* & means in Palestine to do sober, serious, really "record" work!'[36]

Whether Bomberg himself intended at this stage to pursue such a singleminded direction remains doubtful. While recognizing a growing inner urge to return to the study of nature, he probably intended to make up his mind only after appraising Jerusalem and its environs at first hand. To arrive at a drastic decision about the future course of his art before the journey would have been far too arbitrary. He

could not predict how the experience of Palestine might really affect his way of seeing. Only by trial and error could Bomberg determine the extent of his ability or willingness to carry out the Zionist brief, and subsequent events proved that he reserved the right to reject its demands if they became irksome. Hence his anxiety to begin the journey as quickly as possible: Bomberg was determined to confront the reality of Jerusalem with his own eyes, and the sooner he settled there, the sooner he would be able to assess the viability or otherwise of the whole hazardous enterprise.

His final London exhibition, which had opened in March 1923 at the Mansard Gallery, certainly gave him no further incentive to remain in London. The show displayed 'a small collection of pen and wash drawings', and at least one 'coloured drawing' which the *Daily News* described as 'a humorous interpretation of a poached egg or a serious representation of a Mediterranean sunset'.[37] Only one reviewer rose above the predictable sarcasm of the popular press and noticed Bomberg's new vein of brooding disquiet. *The Times*'s critic wondered at 'these strange, rough-hewn, angular figures, with nothing expressed in them that could counteract the impression of strain'. He concluded that 'it looks as if Mr Bomberg had to "tear" his meaning "with rough strife Through the iron gates of life"; and, having torn it, held it prisoner once and for all.'[38]

In a brave attempt to help others view the exhibition as acutely as *The Times*'s reviewer had done, Bomberg announced that he would be present at the gallery every Tuesday and Wednesday afternoon 'to discuss the drawings with visitors'.[39] *The Daily Graphic* published a photograph of this unusual event (Plate 186), commenting that he had set 'an example which might be followed by cubists, futurists and distorticists generally. We could understand their pictures then – perhaps.'[40] Some of Bomberg's comments were reported by journalists intrigued by the novelty of this exercise, and they sounded as modest as they were sensible: '"I am not out for sensation," he said; "I am simply dependent on people getting the same interest from the arrangements and volumes of forms that I get."'[41] But the enterprising experiment which Bomberg conducted with his audience at the exhibition did not dissuade him from going ahead with the Palestine venture. Lilian Bomberg, who went along to the Mansard show, remembered that there were 'not many visitors, and they were laughing at the work because they didn't understand it. He was discouraged by the reception.'[42] It was time to leave England in search of a more congenial locale.

186. Photograph of Bomberg talking to visitors at his Mansard Gallery exhibition, 1923. Reproduced in the *Daily Graphic*, 9 March 1923.

## ARTIST EXPLAINS WHAT HIS PICTURES MEAN.

David Bomberg, the cubist, who is holding an exhibition at the Mansard Gallery explaining his theories to the visitors—an example which might be followed by cubists, futurists and distorticists generally. We could understand their pictures then—perhaps.

Having sold their studio furniture with surprising ease, Bomberg and his wife managed to start the trip to Palestine as early as April 1923. 'We found ourselves on a small ship of the Lloyd Triestino line, bound for Jaffa via Alexandria, together with a group of Jewish people who were bound for the "Promised Land" to work there on the land that had been taken from them so many years ago', recalled Alice. But any possibility that Bomberg would identify himself with his fellow-passengers, and thereby grow more sympathetic to the Zionist standpoint, was rapidly confounded. 'No sooner had we arrived on board than the Head Purser, seeing that we were English and of a different class to the others, told David that five pounds gratuity to the cook would provide us with special meals served in our cabin', Alice wrote, adding that 'this was immediately agreed to by David and we did have the most wonderful meals, including ice-cream, every day.'[43] After a brief stop at Alexandria, where the Bombergs drove along the waterfront in an open horse-drawn cart, the ship proceeded to Jaffa. There they took a bus to Jerusalem, where they found to their undoubted relief that an official reception was waiting for them in the person of Clifford Holliday, the Chief Architect and Town Planner of Jerusalem.[44]

Bomberg felt an initial sense of 'disappointment on arrival',[45] but Holliday was ideally qualified to show his visitors the distinctive character of their new surroundings. The previous year he had succeeded C. R. Ashbee in the special responsibility of planning the preservation and development of Jerusalem.[46] Holliday was engaged on restoring the historic areas of the city and ensuring that its architectural integrity was honoured by the additional buildings then being erected. His knowledge must have made him an ideal guide when, as Alice remembered, he 'took us up some steps on top of the Jaffa Gate and showed us the view all over the City of Jerusalem'. It was an overwhelming experience. 'You must remember', Bomberg told a friend many years later, 'I was a poor boy from the East End and I'd never seen the sunlight before.'[47] Its dazzling intensity was 'something quite unbelievable for me',[48] and Alice shared his astonishment. Although she 'felt frightened to see so many Arabs in their robes and kaffiyehs', she wrote afterwards that 'I can never forget our first day in Jerusalem. It was all so new and strange.'[49] Bomberg, who had never before been further afield than Switzerland, was surely a little awed by this sudden panoramic encounter with a city so different from anything he had imagined Jerusalem might be like. In a talk given some time later he admitted that his mind had been dominated by an 'Italian conception of Palestine . . . before visiting the Middle East',[50] and the reality conflicted with this fantasy to a bewildering degree. Instead of a Tuscan hill-town, defined in so many religious paintings of the Quattrocento, Bomberg found himself gazing at 'a Russian toy city, punctuated by its red roofs, jewelled with the gildings of the Mosque spire – set against hills – patterned with walls encircling the Christian holy places – the horizontal lines accentuated by the perpendicular forms [of] the minarets'.[51]

As his eyes travelled over this unexpected scene, Bomberg must have experienced the first stirrings of his prolonged obsession with Jerusalem's distinctive structure. He was soon to become so absorbed in scrutinizing its peculiar interplay of 'flat roofs, vaults, domes, street arches, abutments and buttresses'[52] that they were placed at the very centre of his art for the next five years. But at first the strangeness of this new environment, where the intense sunlight defined forms with an incisive and brittle clarity he had never encountered before, was difficult to absorb.

Perhaps that is why, when the Bombergs reported to Colonel Frederick Kisch the day after their arrival, they conveyed a sense of discomfort. Leonard Stein had asked Kisch, who was a member of the Zionist Executive in Jerusalem, to 'give him [Bomberg] all reasonable facilities for carrying out his intentions'.[53] After Kisch's first meeting with the Bombergs he wrote to Stein explaining that 'in consequence of their difficulties en route they arrived rather sore, but I think I have appeased them . . . I will, of course, do everything possible to make their stay in the country pleasant and useful.'[54] But Kisch did not like Bomberg. He confided to his private diary on the same day that 'I hope his work will make a better impression than he did',[55] and after entertaining Alice and David to lunch in his flat the following day he decided that Bomberg was 'inconceivably conceited, which drove both Van Vriesland [a Dutch lawyer and Zionist leader] and myself to an attitude of opposition. We are, I am sure, right in taking up the position that there are several other good

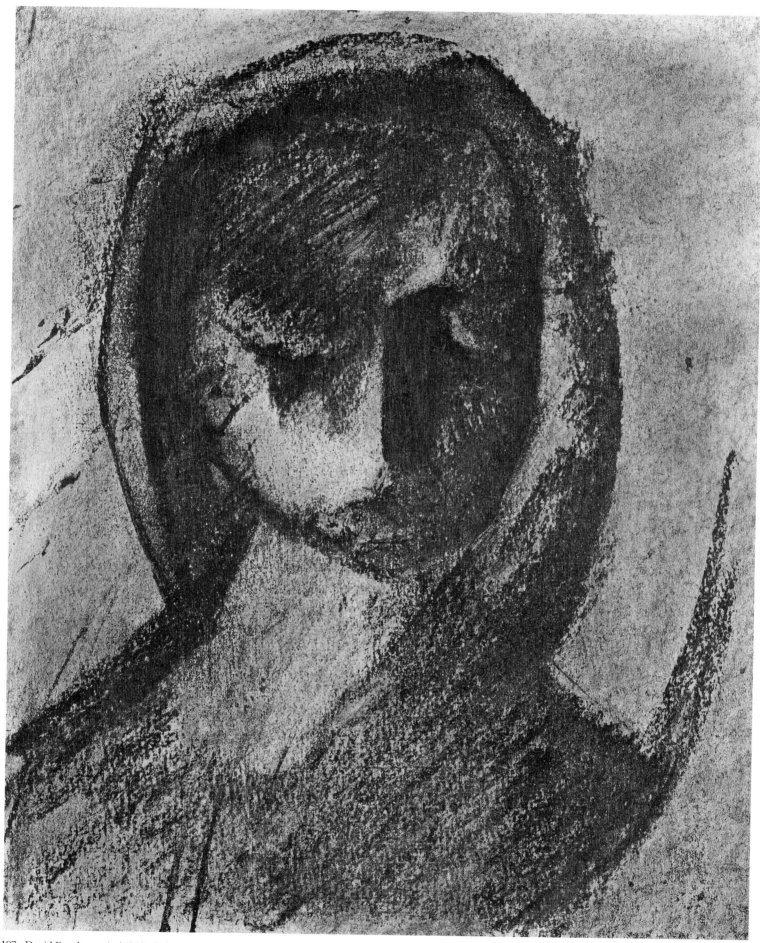

187. David Bomberg. *Arab Girl – Palestine*, 1923. Charcoal, 58.4 × 43.2 cm. Private collection, London.

Jewish artists who have already settled in this country and were striving to earn a living here and that we cannot put him in a favoured position.'[56] One of these artists was Abraham Melnikof, who executed the Roaring Lion monument at Tel-Hai a few years later. On 12 May Kisch wrote in his diary that he had arranged for Bomberg 'to meet the sculptor Melnikof who has just become President of the Jewish Artists Association here, and I also arranged later with Ben-Zvi for him and his wife to be able to get their meals at the Workers' Kitchen, as the hotel they are at is, they told me, far beyond their means. I foresee trouble over the Bombergs' finances before long.'[57]

Kisch was all too prophetic, but both he and the Anglo-Palestine Company Bank rejected Bomberg's application for a six-month loan.[58] Although their refusal came as a disappointment to the hard-pressed artist, he and Alice did have luck over accommodation. After staying in 'quiet rooms' at the Jewish Hotel, where they found 'a lunch laid with pickled cucumbers ready for us'[59] on the first day, they gradually adjusted to the noise and glare of Jerusalem outside. By 28 May Kisch was able to report on a '7 p.m. supper with the Bombergs who seem to be settling down happily. Melnikof has found them quarters in the Old City at a nominal rent and he is hoping to secure a studio in the Citadel.'[60] The quarters, according to Alice, consisted simply of 'a room built over the main street of the City where we could see from our window Arabs coming in and going out and village women bringing in their small stores of parsley (or bagdounis) and other garden stuffs'. But Bomberg needed somewhere with more space inside and an expansive view of his surroundings. 'The shop where we bought a primus stove and some cups and saucers knew we were looking for a place to live and we were introduced to a merchant who had half a house to let away up from the city – in the hills', Alice wrote. 'We went to look at it and the view showed the Walls of the Old City of Jerusalem as well as the fields that sloped and stretched over the Mount of Olives right away to Bethany and beyond to the Road to Jericho. Of course we moved in right away.'[61]

The panorama was so extensive and beautiful that it must have helped win Bomberg round to the unfamiliar idea of painting landscapes in the open air. Before he went to Jerusalem his art had been dominated above all by the human figure. Whether working in the hold of a ship moored at the East End docks, exercising their limbs in a Whitechapel bath or tunnelling below ground to undermine the German army's defences in France, these massive bodies had filled Bomberg's canvases with their energy and weight. But now, in Palestine, his earlier preoccupation disappeared. Apart from a handful of small drawings of Alice and some of the Arabs whom he encountered during his stay (Plate 187), most of his Jerusalem pictures are strikingly devoid of people. The lively little painting called *Outside The Damascus Gate, Jerusalem* is one of the very few city views to include figures, and even here they

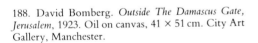

188. David Bomberg. *Outside The Damascus Gate, Jerusalem*, 1923. Oil on canvas, 41 × 51 cm. City Art Gallery, Manchester.

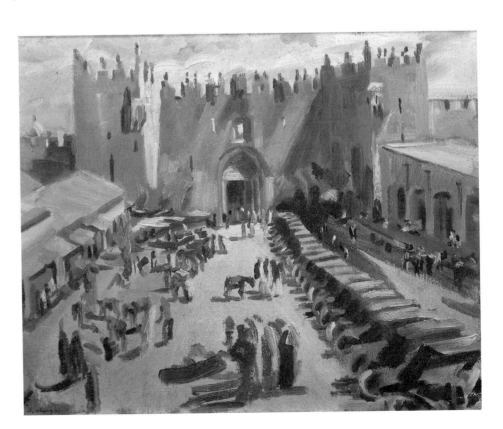

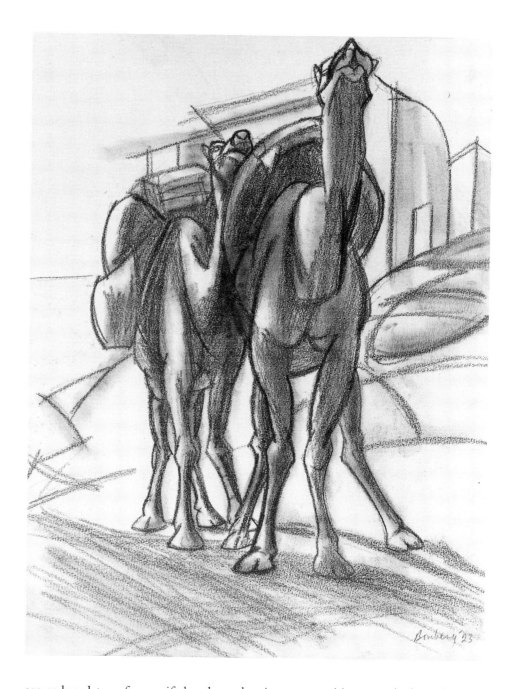

189. David Bomberg. *Camels*, 1923. Charcoal, 64.5 × 52 cm. Private collection, Bradford.

are reduced to a few swift brush-strokes in a composition overshadowed by the line of tourist-cars, the grain-sheds and the architecture of the gate itself (Plate 188). Bomberg later admitted that 'I was particularly interested in the cars, in their form relation to the sheds'. He undoubtedly relished the scene he had painted outside the Damascus Gate, explaining that 'when the grain season is in full swing this space is one of the most glorious scenes of light and colour – camels, camelmen, Bedouins, and grain-dealers all mixed in a wonderful display.'[62] Bomberg studied the camels in a superbly concise and humorous chalk drawing which contrasts their erect, haughty heads with their comically splayed legs (Plate 189). He also enjoyed brushing in a remarkably free and simplified watercolour of *The Melon Market*, where the huge piles of fruit are treated as an exuberant accumulation of swiftly defined circles glowing in the light. But in his subsequent pictures a growing obsession with structure ensured that Jerusalem is seen as a curiously deserted place, filled with buildings whose inhabitants are nowhere to be seen.

It was for him a crucial turning-point. Once landscape imagery took hold of Bomberg's imagination, humanity would never regain the position it had previously occupied in his work. Only Jerusalem and its hillsides promised to provide him with the stimulus he needed now. Working very quickly in the strong light cast by the moon, with his palette numbered by Alice to enable him to identify the colours,[63] he carried out several small studies which prove that his earlier preoccupation with structural simplification was carried over to this new scrutiny of nature.

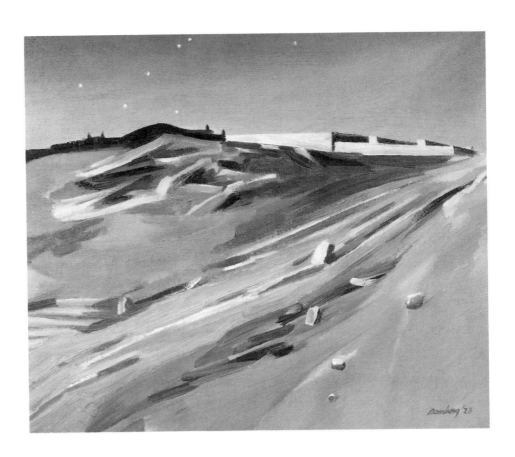

190. David Bomberg. *Jerusalem by Moonlight*, 1923. Oil on canvas, 37 × 44 cm. Edgar Astaire, London.

In *Jerusalem by Moonlight* (Plate 190), he deftly summarized the gaunt features of a terrain which looked like a lunar landscape in the eerie illumination. The moonlight encouraged him to discard inessentials; but the forms are no longer as schematic as they would once have been, and the ground is given a more supple, organic rhythm which responds to the dip and swell of the earth. Such a picture anticipates the character of the mature landscapes which Bomberg was to execute after his Palestine period, and shows how the stark rigour of his pre-war work still informs the more naturalistic style he developed at Jerusalem.

Even so, Bomberg now began to explore a language far more straightforward and topographical than anything he had attempted earlier. An important new supporter encouraged him to follow this path, too. Before Bomberg left London, his old friend and patron Edward Marsh gave him a letter of introduction to Sir Ronald Storrs, the Military Governor of Jerusalem,[64] who proved to be a far more congenial patron than the Keren Hayesod. Since his arrival there in 1917, Storrs had become passionately devoted to the preservation of a city left in a parlous and ramshackle condition by the Turks.

> I had been there but a few weeks when I was aware of a tendency to demolish the interesting and the beautiful, and to substitute for them the cheapest and most immediate commonness in design or material that could be procured. The fifty previous years of unchecked religious exploitation had already hidden or thrown out of scale most of the ancient northern and western walls, by the building hard against them of colossal and hideous convents and monasteries ... I found a positive pleasure in replying to a request for a concession to run trams to Bethlehem and the Mount of Olives, that the first rail section would be laid over the dead body of the Military Governor.

Storrs was determined to resist developments which wrecked the unique identity of the city, and he also wanted to restore the historic buildings threatened by demolition, vandalism and insensitive modernization. The foundations of his enlightened town-planning policy were laid in April 1918, when he issued a stern 'Public Notice' forbidding anyone to 'demolish, erect, alter or repair the structure of any building in or near Jerusalem without my permission in writing'. He quickly followed it with another notice banning the use of stucco and corrugated iron inside the old city. Storrs's appreciation of Jerusalem's architectural character was rooted firmly in his knowledge of its origins. He insisted that everything should remain true

150

to the rock on which the city was built: 'From that rock, cutting soft but drying hard, has for three thousand years been quarried the clear white stone, weathering blue-grey or amber-yellow with time, whose solid walls, barrel vaultings and pointed arches have preserved through the centuries a hallowed and immemorial tradition.'[65]

Storrs wanted this tradition to continue undisturbed, and he prohibited advertisements everywhere in the city apart from a couple of authorized hoardings in commercial quarters. But he also realized that Jerusalem should not merely be conserved in aspic, its picturesque attractions impeding necessary developments. The needs of the different communities living there had to be taken into account as well, and so Storrs founded the Pro-Jerusalem Society in order to assemble all the leading representatives of the population around one table and hear their views. The response was positive: many prominent merchants contributed generously to the Society's funds, and further money came from people all over the world who appreciated 'how greatly the future of Jerusalem depended upon its preservation as Jerusalem (and not an inferior Kieff, Manchester or Baltimore)'.[66]

Armed with these resources, Storrs and his Pro-Jerusalem colleagues achieved a great deal. They established a 'Dome of the Rock Potteries' to make replacements for the brilliant tiles which had fallen from the Dome itself. They commissioned street-name plaques 'in blue or green tiles glittering against the sober texture of [Jerusalem's] walls like chrysoprase and lapis lazuli'.[67] They also started an annual salon of the visual arts, as well as holding exhibitions of ancient Moslem art and modern Palestinian crafts in the great halls of the Tower of David. After a few years of intensive activity, Storrs was able proudly to record:

> we put back the fallen stones, the finials, the pinnacles and the battlements, and we restored and freed from numberless encroachments the mediaeval Ramparts, so that it was possible to 'Walk about Zion and go round about her: and tell the towers thereof: mark well her bulwarks, set up her houses.' Of the interest and variety of these three sacred miles I never grew weary.[68]

It is essential to understand the extraordinary devotion Storrs lavished on his beloved Jerusalem, for his patronage had a decisive influence on Bomberg's approach to painting in Palestine. Naturally enough, Storrs and the other government officials who purchased work from the newly-arrived painter wanted images capable of doing precise justice to the city's beauty. Since they had spent so much time ridding Jerusalem of its excrescences and revealing its authentic identity once again, Storrs and his circle wanted to find a painter who could define the splendour they had uncovered. Although Bomberg's earlier work seemed disconcertingly avant-garde, they must soon have realized that he was now in a state of transition. Storrs sympathized with him for failing to become excited by the Keren Hayesod work, and noticed with approval that Bomberg was far more instinctively attracted to painting views of Jerusalem in all its newly disclosed magnificence. Although Storrs acknowledged that Bomberg's 'Zionist sponsors were hardly receiving the sort of value they had reason to expect for their money', the Governor understood exactly why the task of depicting pioneer settlements fired him with far less zeal than the challenge of studying Jerusalem in all its mesmerizing aspects. 'I could not blame him for finding such subjects more easily convertible into terms of art than the facts of Jewish progress, enterprise and development', Storrs wrote, adding that Bomberg's views of the city 'were at least as likely to attract the world to Palestine as the mechanized sower going forth sowing, or groups of merry immigrants dancing round Old Testament maypoles.'[69]

The Keren Hayesod did not agree, so Bomberg decided that there was no point in pursuing the Zionist commission any further than his initial obligations demanded. The government circle appeared to be promising far more congenial patronage, and Bomberg's readiness to paint Jerusalem quickly found support. At first the government architect, Austen St B. Harrison, provided the most positive response. He occupied a house outside the city commanding an extensive view of the Church of the Dormition, the Temple area and Siloam. Bomberg lived just below him, and Harrison encountered him by accident in the most unusual circumstances. 'He was painting just outside my garden the night I first set eyes on him', Harrison wrote; 'I mistook him for a chimney until I saw him move.' Astonished to find a painter working in the moonlight, and doubtless impressed by the fluent and poetic little picture Bomberg produced of *Mount Zion with the Church of the Dormition:*

*Moonlight* (Plate 191), Harrison soon became a close friend. Sometimes he would visit Bomberg's studio, and 'many a profitable & enjoyable hour I spent there, talking interminably, or being shown his works new & old.' On other occasions the Bombergs would go to supper at his house and spend the evening in uninhibited conversation. 'We talked of everything', Harrison recalled, 'and as I was a detached person leading rather an eremitical existence no subject was taboo, not even Zionism, Jesus, Imperialists, Civil Servants, round which subjects most Christians & Jews skirted in those days. But above all we talked about art, though my knowledge of his art was limited. I learned so much from him; certainly much more than from anyone else in Palestine. He was so patient with ignorance & innocence.'[70]

In Jerusalem's provincial art-world, Bomberg's knowledge of contemporary developments in painting must have appeared impressive. The picture of *Siloam*, however, which Bomberg painted from Deir Abu Tor, near Harrison's home, was utterly removed in style and intention from the avant-garde work that he had made in his youth. It was also far more representational than the 1923 moonlit scene of *The Judean Hills*, where a diagonal oblong of light cutting through the gloom has the starkness of an abstract segment (Plate 192). Harrison, who bought *Siloam* at once, would have admired its technical skill and intricate grasp of architectural form (Plate 193). But to what extent did he actually influence Bomberg's decision to produce such a startlingly detailed and precise record of the scene? It is difficult to tell. Harrison would seem by his own account to have adopted the role of a humble pupil whenever Bomberg talked about art, but most of the government officials surely had little hesitation in expressing their preference for a relatively topographical mode of painting. They wanted an image which remained as faithful to the authentic structure of Jerusalem as they had themselves been when restoring the city to its original state. In a sense, Bomberg came to see his surroundings partially through their eyes, and persuaded himself that only the most painstaking approach to the motif could convey the full character of a place which had so recently been saved from imminent destruction. Men like Storrs and Harrison taught him a great deal about Jerusalem, and their almost religious veneration of the city doubtless affected Bomberg when he sat down in the blazing heat and light to scrutinize his environment with such dogged, patient care.

But there were other, more personal reasons why his work now took such an astonishingly orthodox course. Having arrived at a crisis in his involvement with

191. David Bomberg. *Mount Zion with the Church of the Dormition: Moonlight*, 1923. Oil on canvas, 40.6 × 51 cm. Ben Uri Art Gallery, London.

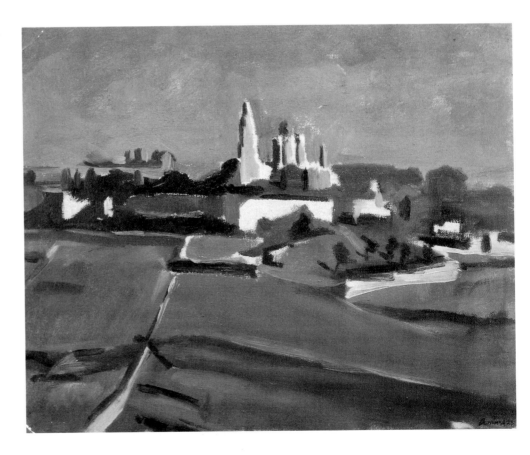

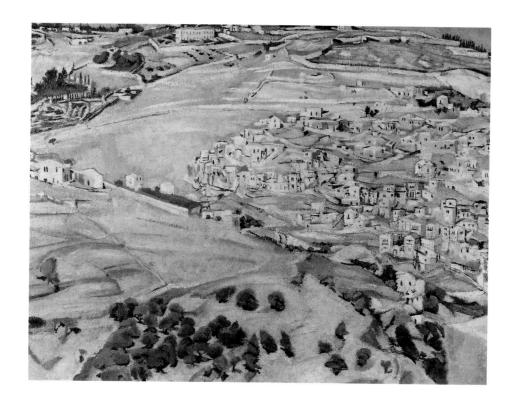

193. David Bomberg. *Siloam and the Mount of Olives*, 1923. Oil on canvas, 49 × 66 cm. Edgar Astaire, London.

modernism, he may well have felt impelled to return for a while to the most direct, representational working method he could devise. Since his pre-war art had led him towards a near-abstract language, which he felt was dangerously detached from earth-bound reality, was it not logical to study this world with a closeness and attention to detail that he had never attempted before? Only thus, Bomberg may have argued to himself, could he assess the advisability of a return to naturalism. Although the gap between his avant-garde paintings and these topographical landscapes may seem vast, they are both products of the same complex disposition. The temperament which lay behind his pre-war work is not, in the end, very far

192. David Bomberg. *The Judean Hills Between Jerusalem and Jericho: Moonlight*, 1923. Oil on canvas, 40 × 49.5 cm. Private collection, Bradford.

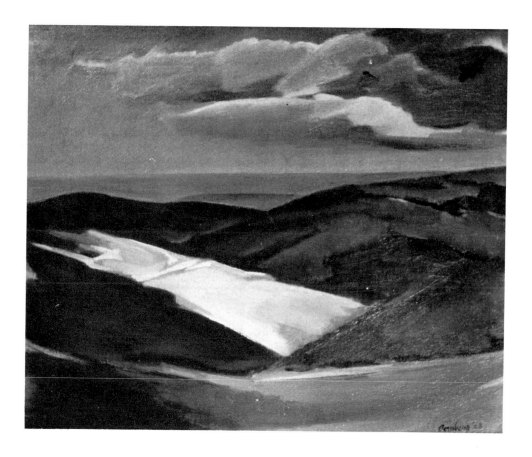

197. Thomas Seddon. *Jerusalem and the Valley of Jehoshaphat from the Hill of Evil Counsel*, 1854. Oil on canvas, 67.3 × 83.2 cm. Tate Gallery, London.

today is exactly as it was then.'[79] Seddon's obsession with microscopic incident was so excruciating that Richard and Samuel Redgrave accused him of producing nothing more than a coloured photograph. Aaron Scharf has established[80] that a photograph of the scene did in fact assist Seddon when he subsequently completed the painting at home in London, and it probably had a deleterious effect on the composition. Bomberg never employed such a device, and a comparison with Seddon's plodding canvas shows how much breadth and vitality *Mount of Olives* commanded without the camera's aid.

Storrs was very excited when he saw Bomberg's prodigious composition. Apart from the 'whimsically interesting' Rubin, the painters of Palestine had not until then impressed the Governor at all. He deplored their tendency to pursue a self-consciously nationalistic art, and wrote later:

> I can recall little beyond an unending series of Shulamits, Jeremiahs, Rabbis in Synagogues or refugees in the snow. 'Art' rugs were (most un-Mosaically) stencilled with portraits of Herzl or Solomon's Seal. This attitude, these exhibits, may have stimulated nationalistic expression but, especially as cultivated at the Bezalel Art Institution, they were the negation of art – often the death of craft.[81]

Bomberg's work came as a refreshing and salutary corrective to such images, and Storrs responded immediately to what he described as the 'powerfully cosmic stare'[82] informing a picture like *Mount of Olives*. Before purchasing it, he asked his colleague Ernest Richmond to examine the picture. Alice remembered that 'Richmond looked carefully at it and studied it well, and his verdict was that "It was flaunting technique." Sir Ronald was so delighted with this verdict that he called on us next day and told David he had decided to buy the picture. He gave us one hundred pounds for it.'[83]

Such a substantial sum must have convinced the Bombergs that they had a future in Palestine, at least for the time being. Storrs was so satisfied with the acquisition that he recommended his protégé's work to other members of his circle, and Bomberg sold several more Jerusalem canvases to appreciative government officials. By this time, he had distanced himself from the Jewish artists of Jerusalem. One of the finest, Joseph Zaritsky, recalled that Bomberg 'had no influence on local art. They didn't see what he did. When he needed money, he would arrange his paintings in his home and invite all the Mandate officers. And he would sell one, two, three pictures, and with that money he lived here. He was very, very friendly with the British. When I visited him I would see all the important Mandate people. They were at his house. They were all interested in art.'

But Zaritsky, who remembered that Bomberg was 'like a gypsy', enjoyed his company. Although Bomberg never exhibited his paintings with the Jewish artists of Jerusalem, he played a significant role in persuading the British officials to let Migdal David be used for exhibitions. Zaritsky was struck by the individuality even of Bomberg's most representational paintings: 'he painted from nature but it was very far from realism ... He came here and he was *here*. He saw the light here. He wasn't an impressionist, realist or naturalist. He was Bomberg. He was English.' The two men became acquainted and visited each other's houses. 'He was a man of strong temperament', Zaritsky recalled. 'When he walked it was difficult to keep up with him. If you met him in the street and you wanted to stop and talk, you couldn't do it. It was impossible to stop him. When he walked, he walked!' In many respects, Zaritsky found Bomberg defied classification, and therein perhaps lay some of his fascination. 'He didn't let it be shown that he was Jewish or not Jewish. He was Jewish, but he was British – British in his blood and in all his movements. It was very difficult to talk to him about his past – who and what he was. He wouldn't let you. Once when I pressed him, he said: "My father stole horses and my mother stole cows." He gave me to understand not to talk about that and not to take an interest in it.' But despite Bomberg's unwillingness to become closely involved with Zaritsky and the other Jewish artists, either on a professional or on a personal level, he remained in contact with them. Indeed, he persuaded Zaritsky to make his first trip to Paris – an experience the latter was to find invaluable.[84] He also appreciated the visits Bomberg made to his home in Jerusalem:

> At my house there were always artists and they talked, and he was among them, although he didn't know Hebrew. He would sit on the side. It was very hard

for him to understand what was being said. But it is wrong to think that he suffered from that. I don't know Yiddish and he didn't know Yiddish, but by a few words we were connected by Yiddish – what I remembered from my home he remembered too. It was very difficult but we both made an effort. By accident or not by accident, we became friends without a language.[85]

When the winter of 1923 arrived, the colder weather finally made working out-doors impossible. Bomberg's *modus operandi* was now wholly dependent on painting from the motif in the open air: no other strategy enabled him to carry out the tenacious observation of nature he desired. So he accepted some sensible advice to move to the warmer climate of Jericho, and there became absorbed in studying the same subject at different times of day (Plate 198). 'David painted the mud huts of Jericho', wrote Alice, 'first in the early misty morning light and in the blazing sunlight of the afternoon. In the morning I had to watch him or he would have gone on painting till the sun was high.'[86] Bomberg was so fascinated by registering the transformation undergone by Jericho in the light that he would have been content to stay there some while. The paintings he executed there show that he was already beginning to move away from the exacting scrutiny which had produced *Siloam* and *Mount of Olives*. The winter sunlight seemed to soften the forms of the huts, and his brushwork loosened a little in order to deal with the play of light on roofs, walls and makeshift roads.

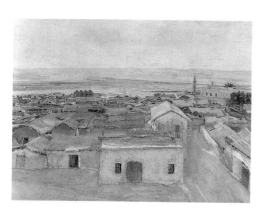

198. David Bomberg. *Jericho*, 1924. Oil on canvas, 50 × 66 cm. Private collection.

But the Jericho episode was cut short by an unexpected telephone call from Storrs, who proposed an immediate expedition to Petra where, he claimed, 'there were wonderful pictures waiting for David to paint.'[87] Bomberg's first reaction was to insist that he stay in Jericho for another week and finish his mud-hut canvases. Petra was to him no more than a mysterious name,[88] and some local Arabs increased his bafflement by telling him vaguely that 'it was a long way off on the Wadi Musa and that nobody lived there but a few Bedouins'. But after returning to Jerusalem he was given a detailed account of Petra's unique and haunting history by Storrs, and Bomberg's imagination was roused by the thought of undertaking such a lengthy and hazardous journey to discover an ancient ruined city carved out of the red rock. The suggestion that the pictures he brought back from Petra would bring him fame was not, he explained later, 'so much an incentive as the prospect of the adventure'.[89] Storrs offered to finance the entire project, thereby showing the extent of his faith in the work of a man who had never before enjoyed such munificent patronage. The offer surely meant a great deal to Bomberg, confirming his feeling that in Palestine he had found a support far more wholehearted than anything London provided. Gratified and moved by Storrs's generosity, he agreed to the plan at once. 'I was allowed to go too', Alice recalled, 'though Sir Ronald had at first objected, saying that David would have ten soldiers to look after him. But David's reply, which much amused Sir Ronald, was that his wife would do the work of ten soldiers.'[90]

The trip was, however, dangerous enough to make Storrs insist on supplying the Bombergs with a full military escort. An order survives from the 'Officer Commanding The Arab Legion' decreeing that 'one N.C.O. & 4 men of the Camel Corps must accompany this painter.' Their duties were manifold: not only escorting Bomberg and his wife to Petra on horseback but remaining there with them, pitching tents, making beds, fetching water and firewood, carrying post and guarding the camp. The fear of attack from robbers was a very real one, and the order emphasized that the soldiers should 'always detail one man to be with the Painter at the time he paints'.[91] The journey commenced on 12 April 1924, and after staying a night at Peake Pasha's residence in Amman the Bombergs moved on to Karak. Here they mounted horses and rode the rest of the way behind a caravan of camels carrying the baggage. 'The gaily decked dromedaries with their spirited riders who led the party made a dazzling spectacle in the morning sunlight', Bomberg wrote, clearly excited by the dreamlike landscapes through which the party proceeded. 'One of the most thrilling visions can be seen from the heights of Karak', he continued, recalling how 'the rift of the Dead Sea to our right and behind us' seemed to present 'to the eye a sort of mirage stretching into infinity. In colour, like fire and ashes.'[92]

Bomberg's expectations had therefore been raised to an extremely high pitch by the time he reached Petra. But when his party finally wound its way through the narrow rock passage and confronted the ruins themselves, he felt alarmingly

diminished by their towering grandeur. 'It literally crushed me', he confessed later, describing the 'immense sandstone facades of colossal proportions, one behind another, rising to a terrific height, closing us in. I felt like a tiny ant, labouring along the white river bed, with all the egotism knocked out of me.'[93] The prospect of painting such an awesome and totally unfamiliar spectacle must have seemed daunting at first, and Bomberg's exploration of the entire site over the next few days did little to allay his misgivings. 'In spite of being taken ... to various "Antiques", David could find nothing to paint',[94] Alice commented, and at this stage the future of the expedition seemed dubious.

The main trouble was that Bomberg could not imagine how these vast and mysterious architectural ruins, carved into the rock-face so many centuries before, could be represented in all their immensity on canvas. He was aware that artists like William James Müller, David Roberts and Edward Lear had visited Petra in the nineteenth century (Plate 199). Indeed, he wrote about them later, commenting that David Roberts's Petra drawings were 'unfortunately not completed on the spot, & I confess my impoliteness in suspecting a slightly curious resemblance in his rock formation to our own Peak Country. I suppose this is forgivable [sic] when they are backgrounds to such highly finished studies of Petra's architecture.' Bomberg considered that Lear's pictures were 'much more spirited ... pencil sketches faintly tinted'.[95] But he did not want to traduce the elemental power of this eerily preserved desert city by painting picturesque views of its most celebrated monuments. They would only seem belittled by such an approach, and yet Storrs sent him a letter at the end of April implying that a faithful, not to say literal representation of Petra's architecture should be the main aim. 'You will not have forgotten the accurate architectural aspect of your paintings', wrote Storrs, 'with especial reference to the view of the Temple of Isis at the exit of the Sik when the light best suits it by day and possibly by moonlight.'[96]

Such a brief might have seemed more acceptable if Bomberg's exploration of the city had convinced him of its attractions. But during his preliminary investigations he remained, according to his brother-in-law Jimmy Newmark, 'not one little bit aesthetically impressed. It all appeared to him rather theatrical.'[97] Even the colour of Petra, to which Dean Burgon had paid a celebrated tribute in his poem about 'a rose-red city "half as old as Time"'!', did not fulfil Bomberg's hopes. He remarked that

> Some travellers, after one hasty visit to Petra, have spoken of the generality of its colour as blood red, but the portions of sandstone rock which would truly merit the description of deep crimson, though abounding in great masses, is [sic] comparatively small and not sufficiently prominent to warrant Petra being spoken of as a 'rose red city'. Petra really is of a ruddy, earthenware pottery tint, seen as a whole, but showing the crimson on closer inspection.[98]

Bomberg's instincts as an artist encouraged him to make this 'closer inspection' the basis of his work at Petra, suggesting the gigantic scale of the whole city by filling his canvases with vast fragments of the rock-face. But Storrs's preference for accurate views required him to move back from the monuments, thereby running the risk of reducing them to toy-like proportions.

The problems involved in carrying out his commission in a manner which would satisfy both artist and patron were exacerbated by confrontations with the men appointed to look after him. 'Do not have more rows than necessary with the camel men', Storrs warned on 30 April, 'remembering that they are, so to speak, not broke to domestic service.'[99] But his advice did not prevent Bomberg from falling foul of the very men who were supposed to protect him from danger. Although Alice did not record her own feelings about these difficulties in a small diary she kept during the Petra expedition, some of the terse entries reveal the problems clearly enough. On 5 May she noted that 'Salaman missing from camp with camel', and the following day she described how 'Abdul Rachman refuse [sic] order to escort me, claiming that one man guard at camp is not sufficient. Snaps his fingers in our faces & spits.' Then, on 8 May, Alice's diary reported that 'order for bread refused, order for escort refused', and the next day she wrote about the 'trouble with Mustafa who ... threatens to shoot.'[100] The whole series of incidents came to a head when Bomberg realized, as he explained later, that

199. Edward Lear. *Petra*, 1858. Pencil, sepia ink and watercolour and bodycolour, 25.4 × 51.8 cm. Private collection.

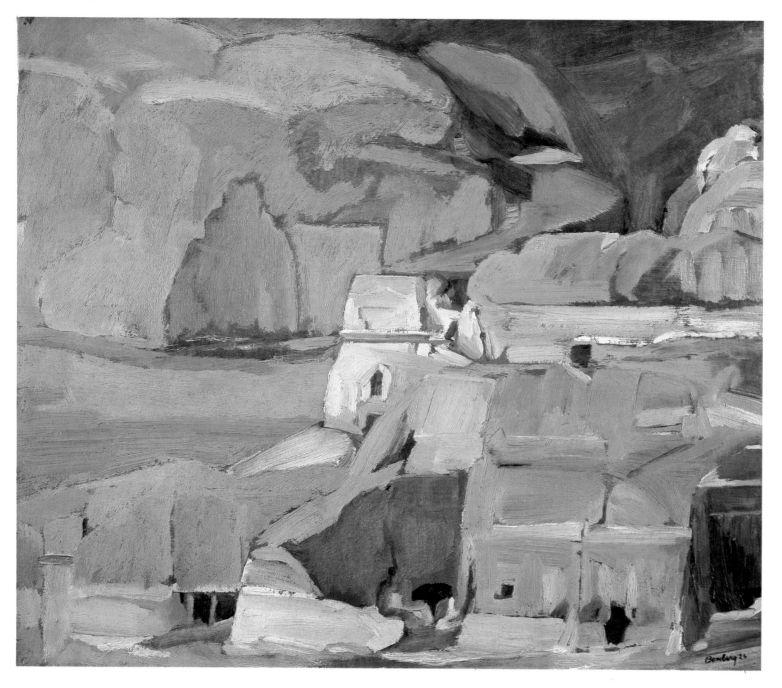

C24. David Bomberg. *Steps to a 'High Place' on al Khubha, Petra; early morning*, 1924. Oil on canvas, 44.5 × 53 cm. Private collection, Bradford.

my escort of fasting Arabs were ravenous and were scheming to get rid of me. They look upon Petra as nothing more than so much dead rock with nothing to eat on it for themselves or camels and regarded my bringing them to Petra ... as rather a bad joke which they were determined not to take in good part. I got them to lay a ring of stones round my tent and made them realise that under no circumstances were they to step over those stones. Nevertheless, one did in the dark after supper on the pretext that I was a robber in my own tent. It required all my nerve to persuade him to take the muzzle of his rifle out of my chest. It was real good fortune that I carried no arms, for I would have been tempted to use them and the fat would have been in the fire. After they got over cursing me, they vented their spite on the Government by using an old khaki tunic as the symbol, laying it on the ground, and performing a mad war dance ... Some days later I found them all gone; they just went off on their own and deserted me. In many respects I felt happier. At the same time, I was glad when the relief rode in some two weeks later, not Bedouins this time, but the black man from Mecca, who was much more dependable for my purpose.'[101]

It was not long before this accumulation of problems forced Bomberg to take a dramatic decision. Having spent so much time and effort travelling to Petra, he

159

now suddenly undertook the long trek back to Jerusalem 'to have a talk with Sir Ronald'.[102] Although the conclusions reached by the two men at their meeting were not recorded, they agreed that Bomberg should return to Petra for a six-month stay and execute a substantial body of work. Storrs must somehow have convinced his apprehensive friend that the outcome would be a success, and Bomberg did indeed manage to paint a considerable amount during that period. 'On our second arrival in Petra', wrote Alice, 'David settled down to work seriously determined not to be overcome by the vastness of the place.'[103]

But the most elaborate canvases he executed there suggest that he did not conquer his inhibitions and respond to the surroundings with enough imaginative vitality. Painting in the open air 'under bleached white linen tents', and working on several subjects 'at different times of the day, according to the lighting chosen',[104] he managed to produce a conscientious record of important sites. The large pictures were, however, burdened by Bomberg's dogged approach. His canvas of *The Rock Facade, North-East Wall, Petra*, which Alice described as 'the important painting that should pay for our journey',[105] is a disappointingly dour and laborious image (Plate 200). He spent six weeks on it, but the morning sun rising over the hills and illuminating the great rock did not animate Bomberg's attitude to the scene. Nor did he avoid the mistake of reducing Petra to almost petty proportions. Another large painting called *Site of the City*, depicting part of the rock wall jutting out onto the boulder-strewn plain (Plate 201), is handled with a little more *brio* than *The Rock Facade*; but the epic dimensions of the scene have dwindled so drastically that the

C25. David Bomberg. *Jerusalem, looking to Mount Scopus*, 1925. Oil on canvas, 56.2 × 75.5 cm. Tate Gallery, London.

201. David Bomberg. *Site of the City, Petra, Ras-al-Khaur and Desert beyond*, 1924. Oil on canvas, 50.8 × 66.1 cm. Lost.

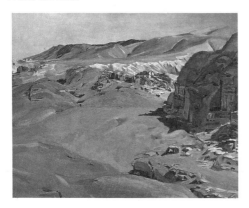

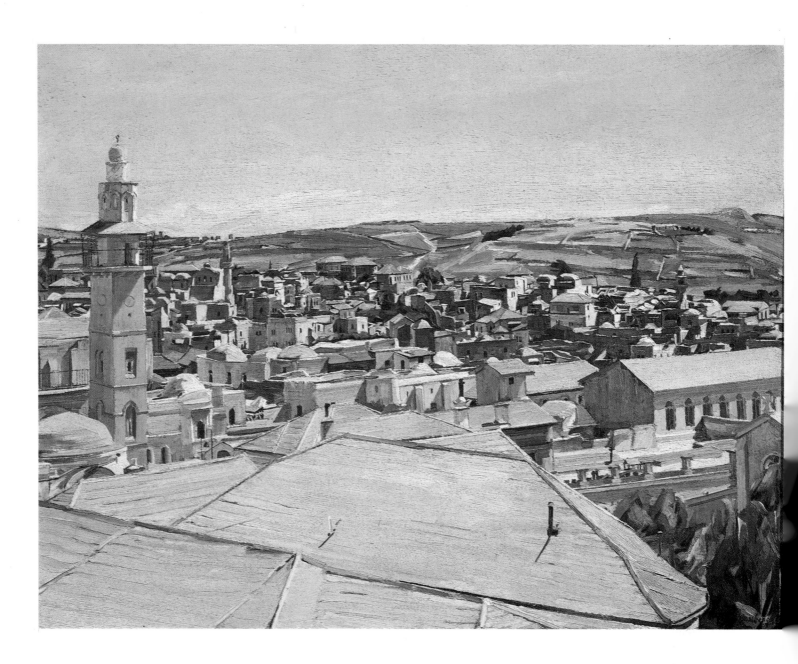

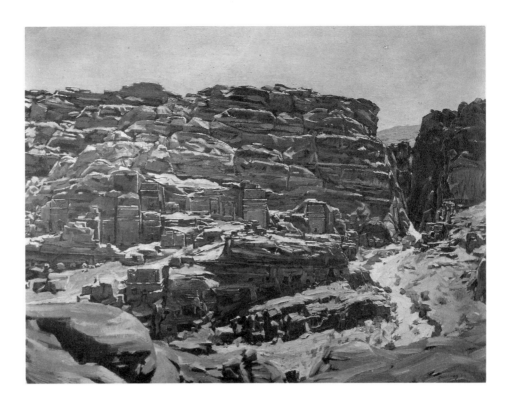

200. David Bomberg. *The Rock Facade, North-East Wall, Petra*, 1924. Oil on canvas, 58.4 × 76.2 cm. Private collection.

202. David Bomberg. *The Temple of Isis, Petra: Moonlight*, 1924. Oil on canvas, 58.4 × 50.8 cm. Private collection, Bradford.

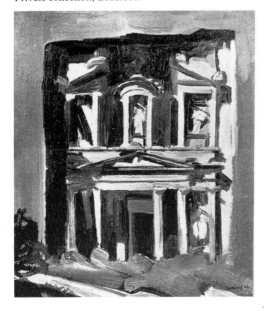

hapless Petra looks like a miniature model, incapable of conveying the vastness of this locale.

Only when he stopped trying to fulfil Storrs's expectations did Bomberg achieve happier results. He enjoyed clambering about on the rock itself, and found that these spontaneous expeditions brought him into more immediate contact with the spirit of Petra's ancient occupants. 'In treading the paths that the original inhabitants had cut laboriously in the rock surface, and in visiting the places of Sacrifice and ritual on the heights', he explained, ' I began to visualise their lives to such an extent that, with my circumscribed activity, I was actually living the life that they led.'[106] Such encounters gave him a far more intimate understanding of Petra's identity, and in a painting like *Steps to a 'High Place' on al Khubdha* his brushwork finally loosened up enough to transmit his most personal response (Colour Plate 24). Employing a more expressive handling, which declares every swoop, twist and thrust of his wrist as he drags the heavily loaded pigment across the canvas, Bomberg here conveys the tactile immediacy of his encounter with the rock-face. Throughout the rest of his life he set an increasing amount of store by the sense of touch, and in this relatively uninhibited study he makes us feel that we have placed our own hands on the surface of Petra's rough-hewn facade.

Bomberg also attained a more spontaneous and direct image when he followed Storrs's injunction to paint the Temple of Isis by moonlight. It was a dangerous project, and Alice described how he 'rounded up all the soldiers to guard us, whereat they made violent protests, intimating that we should be at the mercy of The Djinns'. In the end the guards 'only consented to come with us if they were fully armed, and they stood around David with guns at the ready'.[107] But their fearful faces seem to have increased Bomberg's anxiety rather than alleviating it, for he remembered his shocked reaction on discovering that 'rocks that were known to me from a distance in daylight from above, were now above me at close quarters, cut up by the strangest imaginable shadows, taking terrifying shapes. And at every step in stumbling along among the boulders in the moonlit river bed, I would go alternately hot and cold with fear at the tremendous forms that crept out of the darkness as if to terrify me and bar my way.'[108] The oil study which Bomberg painted of the moonlit Temple betrays no overt sign of the trepidation he experienced (Plate 202). But it does have a nervous, jagged urgency which suggests that he was in a hurry to pack up his materials and return to the safety of the huge tent which Emir Abdullah had loaned him as a home.[109]

Sometimes Bomberg found himself able to paint Petra's temples with equal vivacity in the daytime. A small painting of *The Urn Temple* is especially successful,

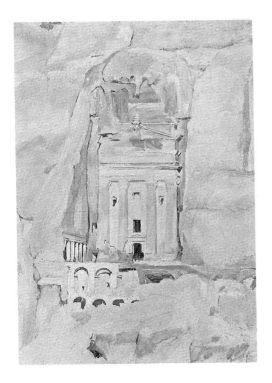

combining a precise account of the pink and white facade at the centre with a free, lyrical handling of the rocks around it (Plate 203). By selecting an hour of the day when the sun was most fierce, Bomberg found that the rock-face lost its dourness and became almost incandescent with light. *The Urn Temple* shows how tender and delicate a painter he could be, and how a little canvas did not hinder him from evoking the sense of immensity which eluded his largest Petra pictures.

Storrs was waiting to greet Bomberg in Jerusalem when he returned from his arduous expedition, with 'a largish donkey standing in the rear half of his Ford car'. The Governor wrote later that his protégé had brought back 'some excellent canvases'[110] from the trip, but even Storrs appears to have realized that the most elaborate Petra paintings were marred by excessive diligence and strain. After examining the big picture of *The Rock Facade* at his residence, he went round to the Bombergs' new lodgings above the Banco di Roma and told them that 'the picture David had painted specially for him "looked out of place on the walls of Government House." It was too sombre in spite of the morning sun coming over the hills, and lighting up the edges of the rocks, "and would David do one instead of the Old City of Jerusalem as it spread out before us from our roof." So David took it as a commission and started setting it out right away in charcoal.'[111]

The outcome, a painting of *The Holy City*, now destroyed, pleased Storrs so much that he accepted it straight away. Even though he had persuaded Bomberg to visit Petra and paint its monuments, Jerusalem remained the Governor's first love. He described it as 'a City of invincible and unutterable attraction', and took

203. David Bomberg. *The Urn Temple*, 1924. Oil on canvas, 40.6 × 30.5 cm. Mrs James de Rothschild.

204. David Bomberg. *The Muristan, Jerusalem*, 1925. Oil on canvas, 50 × 41 cm. Tel Aviv Museum, bequest of Brenda Z. Seligman, London.

205. David Rees. Photograph of the Muristan, Jerusalem, today.

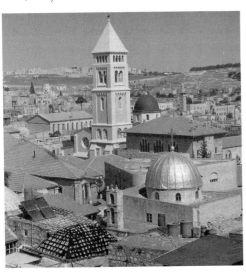

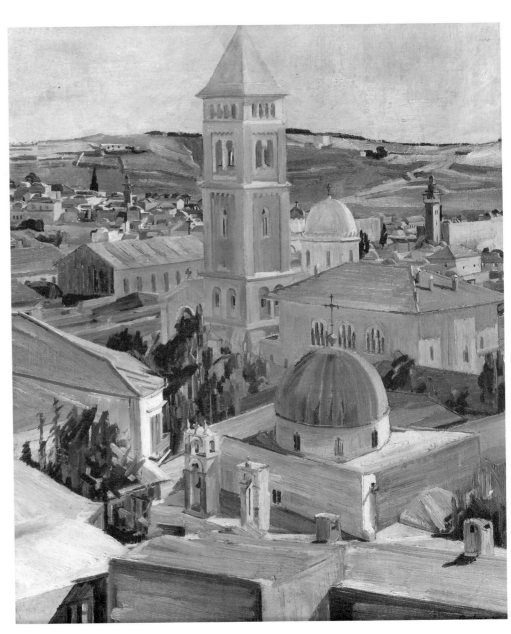

206. Photograph of Bomberg painting on the roof of the Banco di Roma, Jerusalem, 1925. Collection of the artist's family.

207. David Bomberg. *Pool of Hezekiah – Jerusalem*, 1925. Oil on canvas, 61 × 50.8 cm. Lost.

great pride in the knowledge that it was 'fast emerging from the primitive conditions in which we had found it'.[112] He therefore attached enormous importance to paintings capable of rendering the revived city with precision and crisp authority. Bomberg's style grew more topographical over the next year or so, and photographs of the sites he painted all prove how accurate his work had become (Plates 204, 205). Its tightness inevitably stifled the most vigorous and soaring side of his imagination. Painting from his rooftop vantage (Plate 206), he began to view Jerusalem as a strangely pristine city, free not only from people but from any sign of the dirt, decay and architectural impurity which Storrs was trying so hard to combat. Bomberg's pictures of 1925 show the environment in its ideal, untainted state, reflecting the Governor's belief that Jerusalem 'stands alone among the cities of the world'. These hard, dry and rather brittle views celebrate the Lazarus-like rebirth of the buildings which they depict with such accuracy. Writing of *The Holy City* and its predecessor, *Mount of Olives*, Storrs insisted that they conveyed passion as well as technical finesse: 'the two landscapes of and from Jerusalem which he did for me were the best presentments that I have ever seen of those immortal prospects: the light white summer dust parched and blinded: the stones cried out. They were Jerusalem.'[113] But compared with Bomberg's later and more outspoken work, his 1925 cityscapes appear oddly lacking in strong emotion, and the rooftop vantage that he employed only accentuates their air of detachment (Plate 207).

Other government officials shared Storrs's enthusiasm. In 1925 Sir Harry Luke, the Assistant Governor, purchased a blindingly bright view of *The Church of the Holy Sepulchre* rising above a huddle of hot orange rooftops, while the Attorney-General, Norman Bentwich, acquired an even more detailed prospect of *Jerusalem, looking to Mount Scopus* (Plate 208; Colour Plate 25). Bomberg's use of impasto in these skilful paintings prevented them from becoming too literal and lifeless. Despite their preoccupation with the minutiae of the city's architecture, which Bomberg defined in a highly proficient and sometimes almost illusionistic idiom, they are still informed by a feeling for underlying structure. His stark preliminary charcoal drawings of Jerusalem concentrate on a skeletal summary of basic forms (Plate 209), looking back to Bomberg's near-abstract phase and forward to the similarly bare studies he was to make of blitzed London buildings in the 1940s (Plate 323). This fundamental need for a pictorial order ensures that the 1925 paintings, even at their most detailed, are never merely picturesque. The art critic of *The Times* was quite right when he wrote that the Palestine paintings offered a corrective to conventional paintings of 'places generally treated from either the sentimental or the archeological point of view ... From its very freedom from associational bias, his renderings

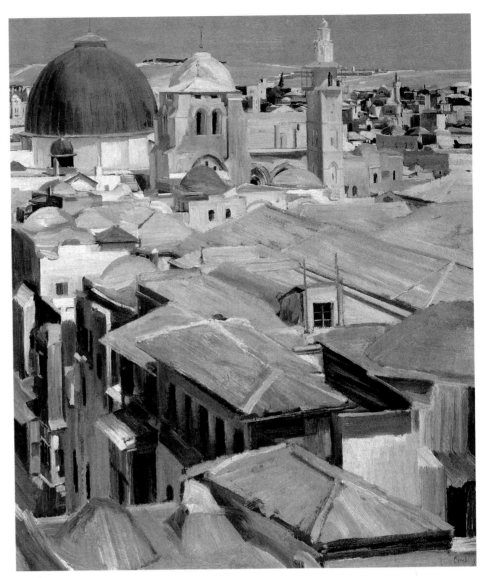

208 (right). David Bomberg. *Church of the Holy Sepulchre, Jerusalem*, 1925. Oil on canvas, 61 × 51 cm. Ivor Braka Ltd, London.

209. David Bomberg. *Study of Jerusalem*, c. 1925. Charcoal, 47 × 61 cm. Private collection.

of the place . . . are convincing – so far as the immediate visual aspect is concerned.'[114]

Only on one occasion did 'associational bias' begin to appear in Bomberg's Palestine work. In 1925 he 'spent many days'[115] painting interior views of the Armenian Church in Jerusalem. 'At the time it was extremely difficult to get a Jew into an Arab Christian church', explained Alan Rowlands, whose father purchased one of these paintings, 'and the church authorities refused permission for Bomberg to be allowed in. So his friends smuggled him in, and managed to get him into a good vantage point in a high gallery, where he would not be noticed.'[116] The richly decorative tiles, burnished chandelier and ornate High Altar which Bomberg could see from his secret perch inevitably brought about a change in his pictures (Plate 210). The crisp and factual character of the cityscapes gave way to a warmer, more religious emphasis.

Moreover, Bomberg witnessed the ceremony of the Washing of the Feet at the church, and it prompted him to reintroduce figures to his work. Although he had rarely allowed people to disrupt the eerie stillness of his Jerusalem street scenes, robed processions now make their way through his ecclesiastical interior and help to soften the severity of Bomberg's work. They are, admittedly, very subservient to their architectural surroundings in most of the Armenian Church series, but several broadly handled oil studies for the Washing of the Feet canvas give its protagonists unusual prominence (Plate 211). Indeed, one extraordinary oil sketch lets draped figures dominate the entire composition (Plate 212). Painted with conspicuous audacity on a sheet of thin paper, across which Bomberg has dragged the pigment and left it in broken patches, this mysterious picture makes its robed participants almost indecipherable. The encrusted handling is, however, directly expressive of the glowing ornamental splendour to be found in the church's ritualistic display.

The extreme recklessness of this oil study implies that Bomberg's temperament was still not completely satisfied with the very representational work he was carry-

211. David Bomberg. *Study for The Washing of the Feet*, 1925. Oil on board, 24.2 × 33 cm. Private collection.

210 (below right). David Bomberg. *The Washing of the Feet, Cathedral Church of St James, Jerusalem*, 1925. Oil on canvas, 75 × 60 cm. Private collection.

212. David Bomberg. *Armenian Church, Jerusalem*, 1925. Oil on paper, 50.8 × 40.7 cm. Colin St John Wilson, London.

ing out in Jerusalem. Most of the time he managed to suppress his wilder and more experimental urges, quietly painting city views for appreciative patrons. Two studies for a painting of *The South East Corner, Jerusalem* show how willing he was to reduce the scene to its barest essentials before embarking on the final detailed canvas (Plates 213, 214). But the finished painting (Plate 215) has a fluency of handling which demonstrates Bomberg's increasing urge to escape from the tightness of the 1925 cityscapes, and in a lyrical panorama of *The South East Corner and Mount Zion* his brushwork soars and glides with exhilarating ease among the light-bathed forms of the terrain he now knew so well (Plate 216). This analytic yet rapturous painting anticipates the more impulsive direction which he would pursue in later life.

But if Palestine granted him a necessary breathing-space, where he could pause, take stock and subject himself to the discipline of working direct from nature, it ultimately became restrictive. Nowhere did its limitations become more painfully apparent than in his paintings of the pioneer camps, which he at last began to execute in 1925. Bomberg had delayed fulfilling his commitment to the Keren Hayesod for a long time, even though he later recalled his 'anxiety to find the Pioneer Workers and start heroic pictures' based on first-hand study 'of the quarrying done by the communistic workers – their lives in huts at Ratisbon'.[117] The series of studies for a Palestine Restoration Fund poster, probably carried out before he set off on his Holy Land expedition, certainly suggest that he expected to depict large figures labouring in the countryside (Plate 217). But soon after going to the camps, his involvement seemed to evaporate. By May 1924 the Zionist Executive had become displeased by the direction his art had taken, and Colonel Kisch complained to Leonard Stein in London that 'Bomberg, in spite of his bombastic booming of how he was going to paint Jewish life in Palestine, has been devoting himself almost exclusively to Arab subjects, or subjects at least not typically Jewish.' Kisch went on to describe how Storr's munificence meant that 'Bomberg's prices have swollen simultaneously with his head', and that his views of Jerusalem included a prominent Christian monastery and the tower of the Anglican church. 'Of course,' Kisch concluded, 'an artist is free to paint what subjects appeal to him, but in such a case

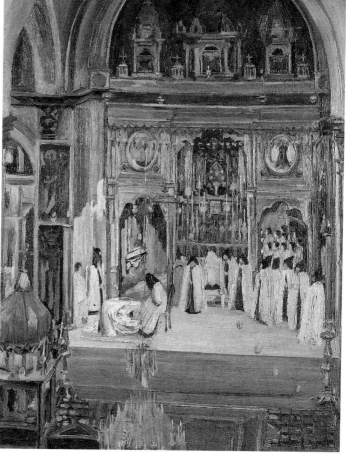

165

215 (right). *The South East Corner, Jerusalem*, 1926. Oil on canvas, 51 × 66 cm. Colin St John Wilson, London.

213 (below top). David Bomberg. *Study for The South East Corner, Jerusalem*, 1926. Charcoal on paper, 51 × 66 cm. Colin St John Wilson, London.

214 (below centre). David Bomberg. *Study for The South East Corner, Jerusalem*, 1926. Crayon, 51 × 66 cm. Colin St John Wilson, London.

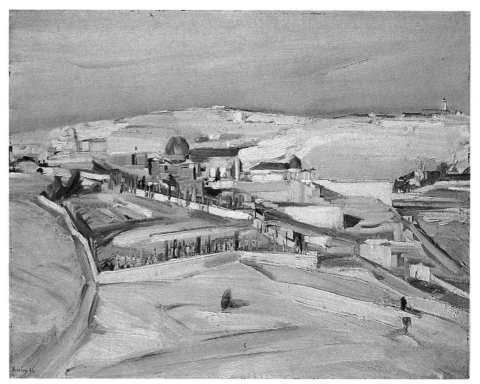

217. David Bomberg. *Palestine Restoration Fund Poster*, 1923. Watercolour on paper, 38.5 × 26 cm. Collection of the artist's family.

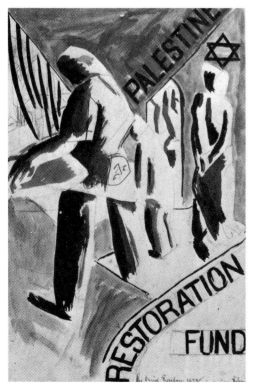

he should not obtain financial assistance on the grounds that his work is to be of propaganda value.'[118]

In 1925, however, Bomberg finally addressed himself to the task of painting the Zionist settlements. At the outset, he may have imagined that these pictures would indeed concentrate on the 'heroic' forms of the labourers, occupying spaces in the composition as prominent as those the sappers had earlier inhabited. But when Bomberg turned his attention to drawing in charcoal at the camps, he only executed one study dominated by the straining, thrusting bodies of quarry workers (Plate 218). The tension between their energetic limbs and the pole-structure around them might have led to a painting as impressive as his pre-war figure compositions. The drawing is, after all, rooted firmly in the tradition of *In the Hold* and other dynamic early figure-groups which celebrated the physical prowess of men at work. But the other Zionist drawings relegate the figures to surprisingly insignificant roles (Plate 219). Although they are seen shouldering timber and bending purposefully over the ground, these matchstick men are dwarfed by their rugged surroundings. Bomberg appears more interested in the gouged earth and hacked stones, handling their rough-hewn contours with a vitality which his human protagonists no longer embody. Perhaps the unpleasant memory of his compromise over the final *Sappers* canvas prompted him to recoil from the prospect of attempting another large figure composition. Perhaps too his growing interest in landscape made him realize that the Palestine terrain dominated the people it contained.

The sense of detachment became stronger still when he depicted the activities above ground. One little oil sketch of machinery and a horse is executed with considerable freedom and panache, proving that Bomberg had not lost his enthusiasm for swift paintings conceived on a small scale with broad, muscular strokes of the brush (Plate 220). But the larger and more elaborate canvases of the same subject isolate machines, huts and figures in landscapes which only emphasize dullness and monotony (Plate 221). Bomberg's handling of pigment grows listless, as if it was directly affected by the tedium he experienced at the camps. Far from looking 'heroic', the workers have now shrunk to miniscule proportions, and their puny efforts seem unlikely ever to transform the bleak surroundings into an environment fit for the Jewish nation of the future. Bomberg's honesty prevented him from concocting any spurious admiration for the scenes he witnessed. To his credit, he could not simulate excitement over a heroism which did not, in his final view, exist. He must have realized that the resolutely desolate paintings of 'Palestinian Development' would not please his sponsors, but no other course of action could be adopted.

His pioneer paintings have a lassitude and even a despondency which bear out Storrs's claim that 'Bomberg, though entirely Jewish, was strongly anti-Zionist.'[119] His sister Kitty later contested this view, declaring that 'while not a committed

166

216. David Bomberg. *The South East Corner and Mount Zion*, 1926. Oil on canvas, 57 × 74.5 cm. Mishkan Leomanut Museum of Art, Ein Harod.

Zionist, he was a firm supporter of the right of the Jewish people to resettle in their ancient homeland.'[120] But Colonel Kisch went so far as to complain in 1924 that 'Bomberg has no Jewish sentiments whatsoever.'[121] The remark was clearly exaggerated, a product of Kisch's own acute disappointment over Bomberg's failure to align himself with the Zionist cause and paint appropriate images of its followers' endeavours. But the pioneer paintings offer incontestable proof of Bomberg's refusal to regard the camps with any warmth. Nor was he alone in his disenchantment. Even Alice, who was an unequivocal Zionist supporter, admitted afterwards that the settlements did not lend themselves to the kind of optimistic and elevated images required by the Keren Hayesod. 'Although we stayed several days in Chalutzin camps', she wrote, 'David got no inspiration from them. They seemed to be untidy and shiftless and to lack a sense of order.'

Once he had fulfilled his obligations to the Zionists, Bomberg soon recovered the *élan* he had lost in the quarries. He visited the Greek Orthodox monastery of St George Hodjava on the Wadi Kelt in 1926, and the outspoken work he produced at this dramatic site reveals an urgency which his detailed paintings of Jerusalem and Petra had suppressed. No specific commission seems to have inspired the idea of staying there, so several of the paintings executed at the monastery are free from

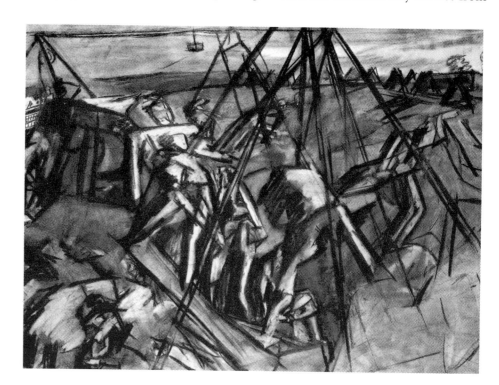

218. David Bomberg. *Quarrying: Jewish Pioneer Labour*, c. 1925. Black chalk, 52 × 72.5 cm. Ralph Shovel, London.

219. David Bomberg. *Quarrying: Zionist Development*, c. 1925. Charcoal and chalk, 51.5 × 72.4 cm. Fischer Fine Art, London.

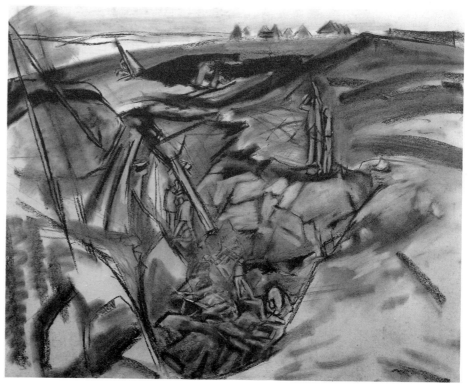

221. David Bomberg. *The Quarrymen: Palestine Development*, 1925. Oil on canvas, 51 × 66 cm. The Jewish Agency for Israel, Balfour House, London.

220. David Bomberg. *The Crushing Machine, c.* 1925. Oil on board, 30.9 × 39 cm. Private collection, London.

any sense of constraint (Plates 222, 223). Rapidly brushed onto paper, and varying in texture from thinly stained areas to passages of bold impasto, they show how ready Bomberg now felt to interpret the monastery and its craggy hillside with a new vitality. The isolation of this strange place, which Alice recalled was only 'kept going by two monks', appears to have helped Bomberg release his most vigorous instincts. He stayed there 'for nine weeks, taking the long walk to Jericho for supplies, for there was nothing around us but rocks and hills'.[122] Bomberg responded to this gaunt, remote location, and his studies of the monastery prove that he was unburdened by all thought of satisfying patrons' expectations in the monastery's silent fastness.

Soon afterwards, sensing perhaps that the Palestine venture ought soon to be terminated, Bomberg and Alice decided she should return to London with his paintings and arrange an exhibition. Two years earlier, Storrs had already investigated the possibility of such a show at the Leicester Galleries, and had told Bomberg of his confidence that 'if the Exhibition comes off it will arrest the public attention.'[123] But now, in the autumn of 1926, Alice found that the task of arousing interest in Bomberg's Palestine work was by no means as easy as Storrs had supposed. The correspondence between husband and wife – the one busily painting in Jerusalem, the other struggling to contact likely patrons and dealers in London – vividly records the problems they confronted while attempting to find a sympathetic response. Most of the London art world's leading members regarded Palestine as a somewhat obscure region, and the dramatic metamorphosis which Bomberg's style had undergone there caused widespread confusion.

At first Alice felt disheartened. 'If you were here & felt the deadness of everything', she wrote in September, 'you would feel glad to get anything to carry on with.'[124] A few weeks later she was able to report more cheerfully that 'Muirhead Bone saw the pictures today & is now prepared to go "on the warpath" & do his utmost to get them exhibited.'[125] But her high spirits proved short-lived. 'Don't anticipate too seriously leaving Palestine, London is abominable', she wrote after meeting the critic P. G. Konody, who had been responsible for obliging Bomberg to compromise himself over the Canadian war painting. Alice related that Konody

wants to know if you have for ever foresworn cubes & angles. I replied "How can I answer that" & he giggled & said "Goodbye." If it interests you I can say that this seems to be a general attitude towards your work. "So many styles, how is one to know the real Bomberg." Damn them. It would make you sick if I repeated all the twaddle people talk about your work.[126]

For his part, Bomberg remained cheerful, active and full of all too implausible plans. In October 1926 he told Alice about his hope of securing a commission

222 (facing above). David Bomberg. *The Monastery of St George, Wadi Kelt* (?), 1926. Oil on paper, 50.8 × 50.8 cm. Private collection.

223 (facing below). David Bomberg. *The Monastery of St George, Wadi Kelt* (?), 1926. Oil on paper, 48.5 × 51 cm. John Longstaff, London.

to execute an ambitious sequence of murals for the Library of the Jewish University. 'My thought is that if some one, Sir Robert Waley Cohen for instance, could take £2,000 from the Jewish War Memorial Fund & commission me to make the twenty Panels – (about a four years work)', he wrote, 'the Jewish War Memorial Fund ought to be interested in the scheme & perhaps set a subject that would be sympathetic with their aims.'[127]

It was a remarkably ambitious plan, implying that Bomberg had momentarily recovered his commitment to staying in Palestine if it was worth his while. At regular stages throughout his career he nurtured a desire to paint on an architectural scale, and the Library panels scheme might have enabled him to bring his transitional work of the 1920s to a memorable conclusion. After all, Stanley Spencer was at the same time preparing a comparable war memorial chapel at Burghclere, and the huge canvases that he painted for its walls constitute his greatest achievement. Bomberg could likewise have risen to the challenge of the Library decorations by bringing together the diverse strands of his current work in a grand synthesis. Living alone in Jerusalem, free from his increasingly strained relationship with Alice, filled him at first with energy and optimism. 'I am painting every day', he wrote happily in November 1926, explaining that 'tho' rains have come very early this year, the little room is a great success. I enjoy living there very much. It's the most beautiful Room I have ever had – the sun comes in first thing just as it pops over the Hills … No dear, I'm happy to stop in Palestine as long as I can get a living out of painting the stuff.'[128]

But this mood did not last long. In London, Bone was surprised by the problems he experienced in persuading his influential friends to support Bomberg's recent paintings, and he told Alice that the Palestine work 'is of such a different kind than what he used to do that it is almost like the work of a new man who has to gain a new circle'.[129] Alice discovered that Bone's report was corroborated when she received the views of the Contemporary Art Society, an important source of patronage for British artists. 'The members of the CAS who saw the Jerusalem pictures did not like your new phase of work', she wrote to Bomberg in December. 'The "red curtain" was the only possible choice because it appealed to them "as artists" & they look chiefly in a painting for strange & original treatment.'[130] Despite the prevailing conservatism of art in Britain during the 1920s, the most adventurous patrons found Bomberg's topographical style altogether too literal in its aims.

Over in Jerusalem, divorced entirely from the London art circles he had once known so well, Bomberg felt a growing sense of bewilderment when he read Alice's reports. 'It is all very curious and surprising that pictures no one would look at here are favourites in England', he commented, 'while those people were keen on here do not seem to get over in England.'[131] Crestfallen by the reactions from home, his spirits fell further when Sir Robert Waley Cohen refused to back his plan for the Library panels.[132] Worse still, financial straits forced him to take the desperate step of asking Alice to sacrifice important examples of his early work stored at Maples in London. 'The large war painting thing can be cut in four either there or here', he wrote, pointing out that 'it will make 4 canvases 3′ 8″ by 4′ 8″.' The picture he referred to was the important first version of his Canadian war painting, but good canvas was so expensive that he was prepared to slice it up.[133] Nor would he stop there in his efforts to save money. 'Bring back from Maples any thing you think I ought to paint over',[134] he added, grimly accepting the need to destroy his past achievements so that solvency could be maintained.

The worsening climate in Jerusalem did nothing to restore his buoyancy. Just before Christmas 1926 he told Alice that although 'we are getting much rain, & it is very cold & over cast most of the day', he was still working outdoors and 'putting in most of the time in Harrison's garden'. But his painting had to be continued despite the foulest weather, for he now conceded that 'I am out of funds.'[135] In these circumstances Bomberg decided to accept the Leicester Galleries' unsatisfactory offer of a show as far ahead as February 1928. Alice was also experiencing acute financial strain in London, and at the end of 1926 she found a job euphemistically described as 'under-manageress' in a small Mayfair hotel. Although she still had a little spare time to devote to Bomberg's affairs, her attitude hardened now that the exhibition had been finalized. Taking a decision which foreshadowed the break-up of their marriage, she told him that 'I am to be called "Mrs Mayes" for business purposes there. The manageress agrees with me that it is more suitable than Bomberg.

Will you be agreeable to address my letters "Mrs Mayes"?'[136]

This ominous request prompted Bomberg to send her an affectionate reply, but Alice was in no mood to be placated. He had never been an easy man to live with, prone all the time to wild swings from elation to despondency, and she no longer believed his promises. In February 1927 she coldly complained that his last letter was

> as 'idealistic' as your letters used to be from the dugouts in France. How can you kid me or yourself that you will work 'in my honor' [sic]. You work because you are possessed by the creative impulse & have chosen to put your energy into 'painting good pictures to earn more money to paint more pictures with' & because you can satisfy yourself that way & become deeply immersed & therefore are happy. My job is the means by which I can stay in England & look after your affairs without draining you of cash or running you into debt. Also there is continually in my mind the memory that my companionship for various reasons works you up to semi-insanity in which I partake.[137]

Bomberg must have known that Alice was, in essence, correct. Their marriage had been irreparably soured during the Palestine period, and his only real happiness now lay in work. But he eventually persuaded her to join him in one last attempt to live together, hoping no doubt that they might somehow regain the close relationship they had once enjoyed. After returning to Jerusalem Alice therefore spent the summer of 1927 in a field 'tormented with flies'[138] while Bomberg worked at her side, carrying out a £100 commission to paint the Hospital of the Order of the Knights of St John for its Warden, Dr Strathearn. Although this gruelling ordeal contributed to the dogged way in which Bomberg painted the hospital building, the broadly handled impasto in the foreground of the canvas looks forward to the free brushwork of Bomberg's later landscapes (Plate 224). He subsequently tried to soothe himself by obtaining permission from the Assistant Superintendant of Police 'to paint outside the Old City, Jerusalem during the nights and after midnights'.[139] Working in such conditions always encouraged him to paint more freely and escape from the topographical trap, but Bomberg's attachment to Jerusalem came to an end after a frightening incident towards the end of the year.

While he was painting from the roof-top of an old house near the Wailing Wall, Alice became exhausted by the extreme heat at home and fell asleep on her bed.

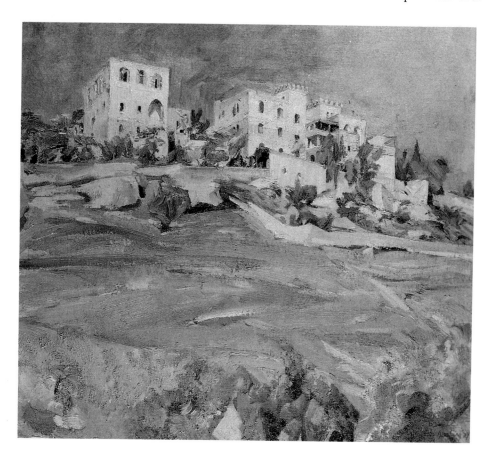

224. David Bomberg. *The Ophthalmic Hospital of the Order of St John*, 1927. Oil on canvas, 67.3 × 76.2 cm. Museum of the Order of St John, London.

'I was awakened by the door rattling furiously and I thought it was David trying to get in', she wrote, 'but I had no memory of locking the door, and it was the shaking of an earthquake.' Alarmed, she hurried out onto their flat roof and watched people thronging the streets in consternation. Since Bomberg was among them, walking quite slowly, she grew angry about his apparent lack of concern for her safety. 'Then I saw he was more interested in the action the earthquake was having on people in the crowded street, so I was angry no more, but glad he was safe. But the next day, when we walked past the old home where he had been working on the roof, we saw it was a heap of rubble and then he got the shock – that if he had not left when he did he would have been in that heap of rubble too.' It was a decisive revelation. 'He got the horror of it', Alice recalled, 'and said he would rather go through ten bombardments than . . . another earthquake. And so he got the idea that he must get away from Jerusalem as he could not paint any more among the ruins.'[140]

Other factors were involved in the decision as well. Storrs's recent departure for Cyprus must have helped to give Bomberg the feeling that an era had come to an end, and during the course of 1927 his dissatisfaction with the painstaking style he had developed in Jerusalem reached its climax. A painting of *Roof Tops, Jerusalem* reveals a strong desire to loosen his handling and cast off any details which threatened to detract from the image's formal dignity (Colour Plate 26). Referring to government patrons whose interest he now found irksome rather than encouraging, Bomberg wrote in March that 'the Bowmans are coming to see the snow picture with the possibility of buying it. But I hear they are expecting a worked out picture of detail whereas this is only complete in construction & tone. If I miss the sale on account of its "roughness", it will be because I did not want to put in such detail as would make it loose [*sic*] dignity.'[141] He decided at last that the quest for representational accuracy had led him into a cul-de-sac, and no government official was now going to prevent him from seeking an escape. The detailed views he had executed with such dogged care in Palestine seemed to Bomberg increasingly constricted, for even the most 'finished' of the later Jerusalem pictures reveal a distinct eagerness to broaden his brushmarks, thicken his impasto and experiment with more outspoken colours in order to model form. The foreground areas often have a vitality of handling which looks forward to his subsequent work, but even in the most minimally organized and limpid of his final cityscapes he still remained within the general conventions of the topographical view (Colour Plate 26). Bomberg could not yet break free, and mounting inner discontent made him less able to withstand criticism from other people, not least his wife. 'He was always saying to me of her that she was his most infallible critic', Austen Harrison remembered. 'But she was not tactful in choosing her time. It hurts a man badly, and does not keep him, to be deflated when he is exhausted by creative effort & has not, as it were, yet come back to earth.'[142]

All these different sources of strain conspired to persuade Bomberg that he had to leave Palestine, and the earthquake incident was only the culmination of his increasing sense of frustration. Leaving Alice behind, he set off for Paris in October 1927. Then, at the end of the year, he finally moved on to London. The Leicester Galleries exhibition was now imminent, and Bomberg succeeded in gathering together a substantial array of fifty-six paintings for display there. They represented nearly every aspect of his work in Palestine, from Storrs's highly finished *Mount of Olives* and *The Holy City* (Plate 195) to the Zionist quarry scenes, the moonlight views and even freely handled paintings like *Steps to a 'High Place' on al Khubdha, Petra; early morning* (Colour Plate 24). Only the boldest oil studies on paper were excluded. Storrs, writing from his official residence at Government House, Cyprus, contributed an enthusiastic preface to the catalogue. 'When I was in Jerusalem', he wrote, 'Bomberg was deprecated by some local talents, anaemic techniques and relaxed apprehensions as being exact and topographical. He is indeed both, and much more . . . there is revealed the grand style, in a scale as small as Dante's, the poignant atmosphere and the unforgettable distinction of the hills that stand about Jerusalem.'[143]

Although none of the exhibition's reviewers echoed Storrs's rather puzzling and inappropriate reference to Dante, they did share his admiration. Konody, writing in *The Observer*, expressed great relief that Bomberg had turned away from his earlier 'extravagance of abstract invention' and emerged as 'a matured artist, free

from affectation and eccentricity, with a style of his own, in which the experience gained from his youthful experiments in Cubism is sensibly applied to the structural emphasis of representational work based on close and penetrating observation of nature. This structural emphasis is the whole residue of his erstwhile obstinate wilfulness.'[144] Konody was delighted that the former delinquent had now decided to behave himself, and his review expressed nothing but praise for the Palestine pictures. The *Daily Telegraph*'s critic likewise viewed the Leicester Galleries show in terms of the Prodigal Son's return, declaring that Bomberg 'is no longer the exponent, or the victim, of the Cubist tradition, but has become much more of a pure pictorialist'.[145] Frank Rutter congratulated Bomberg in the *Sunday Times* for having 'derived good' from his youthful experiments: 'he has found something worth painting, and he has painted it not only with reverent fidelity and understanding, but also with artistic distinction.'[146]

In an otherwise approving review, *The Times* critic was perceptive enough to notice a clash in some of Bomberg's work between the rival claims of 'the architectural or structural emphasis associated with the name of Cézanne', and a 'gift for direct representation in broad terms of painting' which seemed to derive from Bomberg's early association with Sargent. It was an interesting critical attempt to define the two broad strains in the Palestine work, and *The Times* decided that 'to a certain extent the two tendencies conflict.'[147] But the *Jewish Chronicle*'s review prophesied the direction he would explore in later life by announcing that 'suddenly one realises that Bomberg is primarily a colourist, and that he has the makings of a very fine colourist indeed, and, moreover, that it is in his feeling for colour that he is most himself and of his race.'[148]

It was a remarkably accurate prediction. Even the most literal of the Palestine pictures bore witness to Bomberg's passion for discovering a wealth of minute colour variations within the overall dryness and lightness of his subjects. But none of his large topographical paintings explored colour with the gusto Kokoschka was to display a year later in his vigorous view of Jerusalem. Looking round the Leicester Galleries show, Bomberg confirmed his previous suspicions about the painstaking style he had evolved over the previous five years. 'What happened to the wild trumpeter?' asked one visitor to the show, comparing its contents unfavourably with Bomberg's earlier work.[149] The outsize energy, grandeur and boldness which had made his youthful pictures so exciting could not be found in the recent canvases. Although the critics were approving, old painter-friends whose opinions he valued most highly did not like the Leicester exhibition. 'Artists who had known the early work were disappointed by the reactionary nature of the Palestinian paintings', Lilian Bomberg recalled,[150] and this judgment was implicit in a letter he received in March 1928 from Rupert Lee, President of the London Group. Although Lee made a complimentary remark about the exhibition, he only wanted to display examples of Bomberg's earlier paintings in a retrospective survey of the London Group's history.[151] By this time the artist's own doubts had hardened into outright dissatisfaction, but he only wrote them down four years later in a letter to the Director of the Ferens Art Gallery in Hull. 'At the period I painted the Palestine pictures I was working and living in the midst of Colonial government social life', Bomberg explained, admitting that it 'was not conducive to the freer and more unrestricted expression which after all is the fundamental quality of an artist's work. I became aware of this after I left Palestine temporarily as I thought, but decided to break altogether when I realised its effect on me.'[152]

Bomberg's growing unhappiness with his work was exacerbated by the meagre sales at the Leicester Galleries show. Only seven paintings were purchased, and he discovered that framing expenses 'as well as other outgoings in connection with the show has [*sic*] left me in debt to the amount of £80.'[153] Worse still, he succeeded in alienating the gallery director who had just given him this major exhibition in a prominent London venue. Ernest Brown later revealed that he 'never wanted to have another exhibition with Bomberg, because he wanted to run the gallery for me.'[154] Bomberg's relations with galleries were never very cordial, and his subsequent career suffered from his inability to sustain a fruitful relationship with the kind of dealer who could have helped him most. Unhappiness with the Leicester Galleries venture prompted him to tell Storrs irritably in March 1928 that 'I do not like London',[155] but Palestine no longer offered a feasible alternative. In a fit of impatience Bomberg even declared privately that the Jerusalem period had led

him to commit the error of 'painting picture postcards for government officials'.[156] His anger was understandable, and he would never again allow the expectations of patrons to convince him that a topographical path was worth pursuing.

But the Palestine venture ought not to be dismissed so lightly. Bomberg failed to define his mature identity during this transitional period, and he sometimes executed disconcertingly dull and vapid images which are the weakest paintings he ever produced. Even so, he did at least establish in Jerusalem the foundations on which his later achievements were built. Palestine gave Bomberg an enduring love of landscape painting in the open air, and it also gave him a life-long partiality for the heat and brilliance of Mediterranean countries. More important still, throughout the rest of his life he rarely forsook the habit developed in Jerusalem of scrutinizing his subjects at first hand. However many daring liberties he subsequently took with the thing seen, Bomberg always remained rooted in his sensuous and tactile reactions to the material world. He had learned how to look during his years of intense, lonely observation in Palestine, and this arduous discipline stood him in good stead as he gradually discovered how to break free from topographical propriety, infusing the objective study of nature with his own passionately subjective response.

# CHAPTER SEVEN Spain, Britain and Russia

Despondent and bewildered after the Palestine exhibition, Bomberg stopped painting altogether for a while. The tepid response to another show he staged at his Knightsbridge studio in June 1928, where the unsold Petra and Jerusalem pictures found few buyers, intensified his sense of depression. Irrevocably estranged from his wife, and uncertain about the direction he should now pursue, the thirty-seven-year-old artist must have wondered if the onset of middle age would be accompanied by a deepening fear of failure. At this low point in his life, he might easily have succumbed to a period of inactivity as prolonged as his unproductive retreat to the Hampshire countryside eight years before. But now, just as his spirits began to falter, Bomberg was fortunate enough to renew his acquaintance with a remarkable individual. On a walk down Shaftesbury Avenue one day, he passed a woman in a striking cherry-red dress and black cape. Realizing that she seemed familiar, Bomberg retraced his steps, remembered her name, and triumphantly announced: 'That's Miss Holt.'[1] His eager interest annoyed her companion Jacob Mendelson, an art dealer who had married Lilian in 1923. But their relationship was already deteriorating beyond recall, and later in 1928 they divorced. So she was particularly glad to meet Bomberg again.

Lilian had first been introduced to him early in 1923, just before her ill-fated first marriage (Plate 225). Bomberg had called on Mendelson, hoping to sell him some work before leaving for Palestine. Mendelson took Bomberg's penniless state as a cue to lecture Lilian, who wanted to become a painter, on the insecurity of an artist's life. Many years later she recalled that 'Mendelson said to David: "You must dissuade Miss Holt from painting as an objective – tell her there's no money in it." And I said: "I'm not interested in money – I'm interested in painting." So David said: "If Miss Holt is interested in painting and she's not interested in money, then I'm interested in Miss Holt." '[2]

Despite her involvement with Mendelson, Lilian's curiosity was aroused. 'I took up David's invitation to visit his studio at Cleveland Gardens', she remembered.

> He looked at my work and advised me to go to the Slade. He wasn't happy. He said: 'I want to be your mentor – you don't want to be a friend of Mendelson.' But I said: 'You're married to Alice, and you're going to Palestine.' And he replied: 'If you'd be my friend, I won't go to Palestine.' So I said: 'I'm *fidèle* – I can't be your friend.' Mendelson was mesmerising at that stage in his life, and I was fascinated by him. Besides, I didn't think it was right to involve myself with a married man.[3]

But Lilian did meet Bomberg on several other occasions before he left for Palestine. At a fancy dress party, she danced with him before Mendelson grabbed her plaits and tried to take her away. Then, over a dinner at Bomberg's studio where Mendelson made an offer for some drawings, she found herself impressed by a picture of bathers displayed on an easel. It was the first time Lilian had seen Bomberg's work, and her interest in it was confirmed when she accepted his invitation to visit the Mansard Gallery show in March 1923 (Plate 186). 'We discussed his work for a total of three-and-a-half hours',[4] she recalled; but Bomberg had already committed himself firmly to the Palestine venture. He set off soon afterwards, and Lilian did not see

225. Photograph of Lilian Mendelson with her dog Raggles, 1924. Collection of the artist's family.

226. Photograph of Lilian Holt with her father and brother Jack, *c.* 1916. Collection of the artist's family.

C26 (facing above). David Bomberg. *Roof Tops, Jerusalem*, 1927. Oil on canvas, 67.5 × 86 cm. Private collection, Bradford.

227 (facing below). Photograph of Lilian Mendelson with her daughter Dinora, 1925. Collection of the artist's family.

228. Lilian Holt. *David Bomberg*, 1928. Charcoal, 38.1 × 27.9 cm. Reading Museum and Art Gallery.

him again for five long years.

By the time they met once more, in Shaftesbury Avenue, Lilian was feeling almost as bruised by life as Bomberg. When she agreed to marry Mendelson, Lilian had believed that he would keep his promise to help her paint and study the history of art. Although she had previously attended Putney Art School and evening classes at the Regent Street Polytechnic, Lilian had not yet been able to pursue painting on a sustained basis. Her father, a civil servant, wanted her to gain a secure job in the same profession as himself, but innate nervousness made her fail all the entrance exams (Plate 226). For much of her youth Lilian suffered from a chronic inferiority complex. Her mother died of alcoholism when Lilian was only seven; and at a very early age she had already reluctantly realized that her mother cared far more about her elder brother Jack. 'Mother was indifferent to me', she explained in retrospect, 'and I never remember her kissing me or having affection from her.' The perpetual drunkenness, which seems to have developed after a hysterectomy, also affected Lilian very deeply. 'I remember her going into pubs to drink when we were out shopping', Lilian said, describing how once her mother 'sat on a bench and was so drunk that she couldn't get up. So I ran home to get Jack and we helped her up and got her home. She lay down on the floor in front of the fire, and Jack bathed her with a bowl of water.' A deeply unhappy woman, perpetually suspecting her husband of infidelities both real and imagined, Lilian's mother spurned all her daughter's attempts to win love. 'I didn't think I was worthy of affection', Lilian remarked; 'I was very naive when I met Mendelson, and I thought he would bring me into the art world. But he only wanted to exploit me.'[5]

Instead of fulfilling her passionate desire to paint, Lilian found herself helping

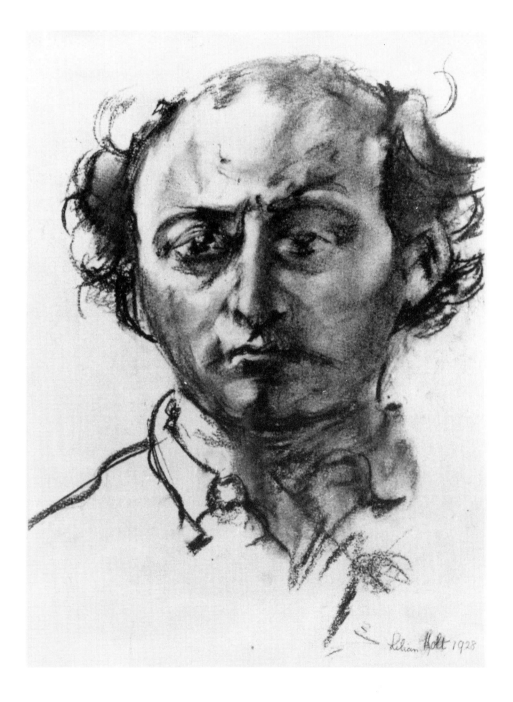

Mendelson with his burgeoning arts and antique business. She did meet artists like Epstein, Kramer and Sickert, whose works passed through Mendelson's hands, and she gratefully recalled that Sickert was very kind and understanding when he talked to her. Lilian also kept her interest in Bomberg alive during the Palestine years by hanging his *Barges* painting near her bed shortly before giving birth to her daughter Dinora in 1924 (Plate 227). But she soon began to resent Mendelson's refusal to acknowledge her ambition to be an artist, and their marriage quickly became a source of intense bitterness. In November 1928, soon after they were divorced, Lilian moved into a house at Fordwych Road in West Hampstead with Dinora and the devoted Sarah Elledge, who had previously been the housekeeper in Lilian's childhood home. Here Bomberg joined them, and as if to celebrate his arrival Lilian drew him in a spirited charcoal study which stresses his vulnerability even as it rejoices in his resilience (Plate 228). The drawing shows how assured a draughts-woman she must already have been before her life with Bomberg began. It also reveals her understanding of his complex temperament, at once imperiously wilful and a prey to depressive anxiety. Because of her own unhappy childhood and disastrous marriage, Lilian was able to perceive the injured side of Bomberg's character as well as his stubborn vitality.

At first, however, they both experienced difficulty in establishing a complete relationship. 'I was interested in him more as an artist than as a person', Lilian explained, recalling those early months in Fordwych Road.

My feelings for him grew through his mind and his work, and he was drawn

C27. David Bomberg. *Cathedral, Toledo*, 1929. Oil on canvas, 77.5 × 59.5 cm. Private collection, Bradford.

229. David Bomberg. *Kitty*, 1929. Charcoal, 62.9 × 47.6 cm. Tate Gallery, London.

to my mind. We were suited to each other on the spiritual level. It wasn't a sexual attraction. He realized that I was interested in painting and could help him through my personality. We recognised the total commitment to art in each other. The affection grew in the relationship by the time we'd been together a good while. We needed each other. I was emotionally wounded when I first met David – neither of us wanted to get married again after our first marriages. But the barriers broke down.

Having visited the Leicester exhibition and been disappointed by the 'reactionary nature' of the most topographical Palestine paintings, Lilian wanted to help convince him that he should escape from the tightness of the style developed in Jerusalem. But it was difficult for her to proffer advice without sounding presumptuous. 'I was a nonentity in the art world and he was a painter who had a reputation', she remembered. 'I felt shy about telling him how I thought about the very representational paintings, but I did it subtly, carefully criticizing the work he was doing.'[6]

Gradually, and at the outset rather unconvincingly, Bomberg started to paint on a regular basis again. He executed a few portraits of his relatives: his sister Kitty, to whom he was by now very close (Plate 229), his brother Mo and niece Queenie. Not for the last time in his career, Bomberg began to wonder whether he might earn his living as a portrait painter. But the truth was that he had not yet learned how to master portraiture, and the disappointingly uncertain attempts he made to paint his intimate friends would hardly have recommended him to other potential sitters. Even the canvas called *Lilian Painting David (Painting Lilian)*, which celebrates their shared devotion to art, is constricted by a tightness of handling which Bomberg only left behind in later years. He was, for the moment, far more confident executing a large and spectacular hand-painted shawl for Kitty, employing a decorative idiom which recalled earlier work like *The Mud Bath* rather than the representational style he now preferred (Plate 230). The shawl, which Bomberg actually nicknamed 'The Mud Bath',[7] looks like a freely handled homage to his pre-war masterpiece. It comes as a great surprise at a time when he appeared to have forsworn abstract experimentation altogether. Perhaps the making of a shawl, in Kitty's presence, encouraged him to meditate on the viability of an idiom which he had long since abandoned. But Bomberg never went back to the *Mud Bath* language in his oil

230. David Bomberg. *Shawl: The Mud Bath*, c. 1929–30. Hand-painted silk, 139.8 × 138.5 cm. Victoria & Albert Museum, London.

paintings, and Lilian tried to help him resolve the doubts he harboured as to the direction which his work should take. 'I nurtured him through the months', she recalled, 'telling him that I liked the more free pictures, like a painting of me and Elledge in the Fordwych Road garden. Gradually he gained confidence, but I had no time to paint while doing the housework and posing for David.' The resumption of painting did not make Bomberg any less restless, though. Despite the doubts he now harboured about much of the work executed during his Palestine period, he still felt a strong urge to escape England and go south once again. Kitty remembered Bomberg telling her that 'he didn't feel there was as much in England to give him inspiration as there was abroad.'[8]

The remarkably sustained quality of the paintings he made in Toledo proves that his instincts were correct. But Bomberg did not initiate the trip to Spain. Kitty suggested it, lending him some money for the purpose,[9] while the faithful Sir Ronald Storrs also provided some funds and wrote to the Duke of Alba, 'giving him your qualities and address'.[10] Bomberg's choice of destination may have been further influenced by another old friend, Muirhead Bone, who travelled extensively in Spain, executed a watercolour of Toledo in 1929 and held an exhibition at Colnaghi's the following year of seventy views ranging from the Alhambra to Segovia and Ronda.[11] Although Bone's very precise and detailed images were far removed from the work Bomberg was to carry out in Spain, he may well have been affected by Bone's enthusiasm for the country. Bomberg had certainly seen some of Bone's Spanish etchings before the Toledo trip,[12] but it was El Greco's vision of the city which really stimulated his imagination. 'Perhaps he felt with Toledo that he wanted to find out what excited El Greco so much', Kitty commented later, 'because he had a great admiration for Greco.'[13] His respect for the Spanish master had become apparent a decade before with the first version of the *Sappers* canvas (Colour Plate 17), and now he would be able to see many of El Greco's finest works in the city where he had lived. 'I saw a bit of landscape in an El Greco', Bomberg told a friend many years later, 'and that persuaded me to visit Toledo.'[14] Lilian felt upset about the trip: 'I was very angry, because he was leaving me and we'd been so close.'[15] But the separation was only temporary, and the work he produced during this extraordinary period fully bore out the wisdom of the venture.

Arriving in Toledo in September 1929, Bomberg rented a small house opposite the Alcazar near the top of the city. He lost little time in sending a letter home to 'Lil', outlining his initial impressions of the new surroundings.

> Having found an empty house in Toledo & promptly moved into it & bought a Second Hand Bed Stead & Spring & Earthenware Pots, I have set up House Keeping & shall call this my headquarters for the next few months. TOLEDO, is *not* Disapointing [*sic*] but not quite as wonderful as I thought it would be, but it is *Romantic*. More so even than Jerusalem with which it compares in several ways. Mainly in [that] there are some remarkable things in this town & a good prospect from my little Bit of a platform roof.[16]

The vantage enabled him to survey a surprising amount of this compact and astonishingly well-preserved city. He did not have to look far in order to discover buildings of superb quality, many of which appealed to his eye for great architecture. Perched on a hilltop providing natural fortification, Toledo had managed to avoid the fate of so many historic cities in England. It was intact, unspoiled and – most important of all – redolent of the period when El Greco was at his zenith. By using the word 'romantic' in his letter to Lilian, Bomberg referred above all to Toledo's potent ability to evoke a sense of the past.

After thoroughly acquainting himself with his stimulating environment, Bomberg followed the practice of painting outdoors from the motif in every instance. The *modus operandi* was therefore a continuation of the habit he had formed during his Palestine years, but the outcome was startlingly different. Most of the Petra and Jerusalem pictures had striven for an objective accuracy which excluded too much of Bomberg's own passionate response to the world. Only in a few paintings, like the unusually free oil studies on paper made at the Monastery of St George, Wadi Kelt, did he break away from this confining search for exactitude (Plate 222). At Toledo, by contrast, he felt able to replace topographical precision with an altogether more fiery and unfettered approach which established his mature identity as an artist for the very first time. The handling of pigment became more outspoken,

231. David Bomberg. *Toledo*, 1929. Charcoal and white gouache, 71 × 81.5 cm. Private collection, Bradford.

and Bomberg conveyed his impulsive involvement with the subject through openly urgent brushmarks which no longer had time to deal with painstaking minutiae. The only drawing he seems to have executed here was, significantly, a freely defined scene of the city at night (Plate 231). The forms of its buildings are delineated with great vitality in white gouache enlivened by streaks of yellow and orange, which stand out dramatically against a dark charcoal ground. The picture's sense of verve helps to explain why Bomberg dispensed with any other attempts at drawing and immersed himself in the pleasures of pigment.

At Toledo, working energetically and confidently enough to complete over twenty memorable canvases within a few months,[17] he finally arrived at the singular expressive vision which would be further developed and refined throughout his subsequent career. In a letter to Lilian, written towards the end of September, Bomberg pledged himself to pursue a more audacious approach to landscape painting. After admitting that 'I do not yet know whether I am doing any good', he insisted: 'I am quite sure of one thing & that is I do not want to repeat the Palestine style. & as long as I can find a broader manner of treating the infinite amount of detail I am contented. What Toledo lacks is colour. I mean gay colour. It is heavy . . . in purplish greys & blacks, & would become depressing but for the fact that I am trying to paint it.'[18] The activity of painting had become so engrossing that it gave Bomberg a feeling of purposefulness which offset the reservations he harboured about the subdued colours of Toledo in autumn.

The discovery of a personal vision did not encourage him to depart too wilfully from the views he elected to paint. *The Cathedral, Toledo*, one of the most elaborate canvases which Bomberg executed there, still adheres faithfully to the architecture of the city, and he rejoices in his ability to create a rigorous structural design out

181

232 (above). David Bomberg. *Cathedral, Toledo: Afternoon*, 1929. Oil on canvas, 66.1 × 50.8 cm. Lost.

233 (centre). David Bomberg. *Cathedral, Toledo: Evening*, 1929. Oil on canvas; 66.1 × 50.8 cm. Private collection, Bradford.

234 (right). David Bomberg. *The Cathedral, Toledo: Sunset*, 1929. Oil on canvas, 33 × 24.1 cm. Dr Barnet Stross.

of the crowded roofs, buttresses and towers (Colour Plate 27). But even as he took care to honour the character of the city in front of his eyes, Bomberg no longer felt bound by the ocular priorities which had dominated most of his Palestine paintings. He now wanted his art to bear the overt imprint of an intensely physical response. The succulent, heavily loaded marks pressed onto the foreground roofs are handled with a muscular directness which makes us acutely aware of the action of the artist's own hand, wrist and arm. As the pigment travels across the canvas, scoring a vehement diagonal here and asserting an equally strong vertical thrust there, the pattern of abrupt fragmentation becomes reminiscent of Bomberg's pre-war angularity. But the juicy impasto is far removed from the insistent flatness of the young Bomberg's pigment. Rather than pushing his art towards extreme simplification, he now attempted to grasp the full density and richness of the world he so greedily observed.

This new emphasis on gravity, weight and texture did not prevent him from trying to express the evanescence of scenes caught at particular times of day. *The Cathedral, Toledo* must have taken a considerable while to complete, and its harsh colour remains faithful to a time when the city baked in the steady, uninterrupted glare of the sun. But other views of the same building look as if they were painted quickly, to catch a fleeting quality of light. The three pictures which study the cathedral in the afternoon, evening and sunset progressively close in on the tower silhouetted against the darkening sky (Plates 232, 233, 234). As they move nearer,

235. David Bomberg. *Sunset, Toledo*, 1929. Oil on canvas, 58.4 × 76.2 cm. Leon Kossoff, London.

236. El Greco. Detail from *View and Plan of Toledo*, 1608–14. Oil on canvas, 132 × 228 cm. El Greco Museum, Toledo.

however, the building's substance wavers a little, blurs and then threatens to dissolve in the gathering dusk, while the roofs beneath fade into loosely applied strokes of deep purple. Nor did Bomberg stop there. A brooding panoramic view called *Sunset, Toledo* dares to catch the brief and dramatic moment when the city is enveloped in darkness, while the fading sun still manages to glow in the sky and fleck a few buildings with its fitful yet fierce light (Plate 235).

The broken, nervous brushstrokes which Bomberg evolved in Toledo are far more sensitive and eloquent than anything to be found in the Palestine canvases. Andrew Forge was right to observe of the Toledo paintings that 'an extraordinarily strong personal note enters his work at this point; one seems to feel oneself breathing the artist's breath in front of some of these pictures.'[19] But Bomberg was surely inspired in his search for this individuality by first-hand experience of El Greco's work. The darting and unpredictable handling he developed in Toledo owes a debt to the quicksilver brushstrokes found in El Greco; and Bomberg's new silver-grey tonality, fortified by rich maroon and sonorous green, likewise recalls the Spanish master's work. Bomberg was stimulated by the electric vitality of El Greco, whose extensive *View and Plan of Toledo* was on display at the city's Greco Museum (Plate 236). Lilian, who joined him briefly when money from her divorce settlement enabled her to travel, remembered that 'David had a photograph of this Greco painting which he showed me in Toledo and brought home.'[20] Her recollections are substantiated by a letter Bomberg wrote to her before she visited him, pointing out that 'El Greco has painted Toledo, a kind of imaginative aeroplane view of it. It is in the El Greco museum here, not a very good work but the masterpieces of El Greco are here in the Cathedral – among them some unfinished paintings of Saints.'[21] Despite his reservations about the *View and Plan of Toledo*, Bomberg responded positively to his friend Pedro Rico's suggestion that he paint a view of *Toledo and River Tajo* based on El Greco's painting (Colour Plate 28). 'David called it Pedro Rico's view', explained Lilian, 'and it's the same view that Greco painted.'[22] The resemblance between the two canvases should not be carried too far: El Greco included a map in his view and altered the buildings at will, whereas Bomberg remained more faithful to the conventions of a landscape view. He also placed a characteristic emphasis on the ravine plunging down from the city to the river, treating the forms of the vertiginous hillside with greater spontaneity than the buildings above. But towards the end of his life Bomberg described the painting as 'the El Greco view',[23] and *Toledo and River Tajo* can still be seen, essentially, as a homage paid to El Greco by a twentieth-century painter who felt liberated by the Spanish master's example. Well over a decade later Bomberg was still extolling El Greco's virtues, telling Josef Herman that 'from Greco, the great El Greco, from him you can learn that drawing and painting is one process and this is where the truth of life's structure comes in.'[24]

Some of Bomberg's most exhilarating Toledo pictures were executed on a modest scale, with great speed and concentration, on the outskirts of the city. In one canvas, *San Juan Toledo: Evening*, the brazenly glowing buildings are dominated by a juicy slash of dark green coursing across the sky (Colour Plate 29). But many of these

238. David Bomberg. *Outskirts of Toledo*, 1929. Oil on canvas, 22.8 × 33.1 cm. Josef Herman, London.

237. David Bomberg. *The River Tajo, Toledo*, 1929. Oil on canvas, 50.8 × 40.7 cm. Private collection, London.

240. Chaim Soutine. *Landscape at Ceret, c.* 1920–21. Oil on canvas, 55.9 × 83.8 cm. Tate Gallery, London.

239. David Bomberg. *Convent and Tower, San Miguel, Toledo*, 1929. Oil on canvas, 50.2 × 65.5 cm. Keith Critchlow, London.

small paintings, each of which might only have taken a couple of hours to complete,[25] follow the Tajo away from the city and make its zig-zag form affect the equally jerky rhythms of the hills around it (Plate 237). Another canvas, even smaller but more animated still, studies the *Outskirts of Toledo* with such highly-charged feeling that every inch of the composition is heaped with encrusted impasto (Plate 238). Although Bomberg retains a vestige of spatial recession in such pictures, he ensures that the distant hills have as substantial a presence as the foreground buildings. He makes us vividly conscious of the material identity and texture of heavily applied paint projecting from a flat surface, and *Outskirts of Toledo* anticipates the way in which Bomberg's later landscapes bring the spectator into a peculiarly intimate involvement with the weight and gravitational pull of the land. It is as if he were able to enliven the earth with his own impassioned apprehension of the scene. Buildings and landscape fuse into a single organism, which heaves and sways with Bomberg's powerful response to a scene not only scrutinized but seemingly touched and grasped as well.

Perhaps Bomberg was at his most voracious when he painted some small views of San Miguel, with the convent and tower leading to a range of hills beyond (Plate 239). Seen from above, like so many of his Toledo paintings, these canvases appear to have been completed in an especially exalted mood. The pigment is loaded onto the picture-surface with a rapturous abandon which could have become self-indulgent without the discipline Bomberg commanded. The brushmarks are swift, decisive and never flaccid. They have the crisp authority of a fresh response to the thing seen, and at the same time celebrate the soaring of Bomberg's spirit as he projects his own exuberant emotions into the landscape. One of these paintings, *San Miguel, Toledo* (Colour Plate 30), has a boiling energy and furious handling of pigment comparable with Soutine, whom Bomberg had met in 1913 and later described as 'a superb manipulator of oil paint and a great and individual stylist',[26] But it would be wrong to imply that Bomberg was emulating Soutine's far more distorted and dithyrambic Ceret landscapes rather than evolving his own vision (Plate 240). The Toledo series is quite distinct from anything Soutine ever painted, and the prospect of the countryside stretching away from the confinement of the city seems to release Bomberg's most ardent feelings. In a pocket-size view of *Hills, Toledo* he appears to survey the open country with the swooping agility of a bird in flight (Plate 241). Then, in the most poetic of the San Miguel series, he paints the *The White Mist* (Colour Plate 31). The creamy grey paint, flecked with dabs of crimson, washes over the ridges like an incoming tide. Even the towers in the foreground are lapped by this softly surging sea, and the whole canvas is alive with the swirling

241. David Bomberg. *Hills, Toledo*, 1929. Oil on canvas, 22.8 × 33.1 cm. Private collection, Bradford.

242. David Bomberg. *Toledo from the Alcazar*, 1929. Oil on canvas, 67.3 × 76.2 cm. Ota Adler.

rhythms of a beneficent substance which seems to soothe and silence everything in its path.

Bomberg was fully absorbed while painting at Toledo, and communicated his feelings with an uninhibited vivacity which had eluded him in Palestine. His pleasure is evident in a letter to Lilian:

> my adventures consist of a couple of tough Spaniards calling for me & taking me to a bull fight ten or twelve miles away. The village bull fights are always very interesting, more so than the important town fights. Yesterday afternoon I was taken to a village called Bargas for two events, a Bull fight at 4.30 & a Religious possession [*sic*] at 8, thousands of villagers joining the possession with candles. Of course I was made very drunk, but enjoyed the supper my Pals supplied – two Big fishes & salad out of one dish.

He also explored the nocturnal attractions on offer in the city itself, and told Lilian about them with an impish sense of humour. 'There are no special adventures to relate', he wrote, before revealing that 'I have visited every brothel in Toledo. They are very amusing indeed. Very few do anything – they are more of a night club where the fellows drink & dance with the Senorettas [*sic*].'[27] But these diversions, entertaining though they were, did not deflect him from the crucial business of painting ambitious pictures. When Lilian eventually arrived in Toledo, she found canvases like *Toledo from the Alcazar* combining intricacy and gusto in equally impressive measure (Plate 242). It seems difficult to believe that such a robustly handled picture could have been painted out-of-doors in the chill of winter: Lilian recalled 'climbing up to the top of the Alcazar tower with him, where he was painting the grand vistas of Toledo', and she realized that 'it was very, very cold with the wind whistling through the open walls.'

Bomberg does not appear to have made many friends in Toledo, apart from the 'tough Spaniards' who took him to the bull fight and a hard-drinking Socialist described by Lilian as 'a jolly character who ran with the bulls and was a member of the underground movement'. He certainly showed no interest in establishing contact with other painters. 'Contempory [*sic*] Spanish art does not exist in Spain – in fact it does not exist at all', he wrote. 'The good Spanish painters live & work in Paris – Spain (at Madrid) has a collection of modern Spanish effort [*sic*] but it is very inadequate – such men as ... Picasso are not represented, what they do show is very poor indeed, a kind of turn out of the local amateurs.' But he did

243. Diego Velázquez. *Dona Jeronima de la Fuente*, 1620. Oil on canvas, 160 × 110 cm. Prado, Madrid.

244. David Bomberg. *San Justo, Toledo*, 1929. Oil on canvas, 50.8 × 66 cm. Ferens Art Gallery, Hull.

come across at least one discerning aesthete in Toledo itself, and warmed to him with gratitude: 'The other day I was invited to the House of a distinguished art philospher, a remarkable house & a remarkable collection of Toledo antiques – The whole family appear to want to be friendly – & they speak English which is a comfort.'[28] His enjoyment of their company is evident, but Bomberg was too engrossed in his ceaseless round of painting expeditions to suffer from loneliness, and he had always been a rather solitary individual. 'David was very happy about working in Toledo', Lilian remembered. 'He was very satisfied with the city. He didn't have much to do with the Spanish people, nor indeed with anyone who lived in the countries where he worked. He never learned Spanish or any other foreign language. David didn't need people the way most of us do – he could go for days on end without seeing them.' This self-sufficiency enabled him to devote all his energies to an intimate exploration of Toledo itself, and the results of this infatuation with El Greco's city mark the return of Bomberg's fullest confidence as a painter.

But he did not immediately capitalize on this welcome event. After quarrelling with him, Lilian left Toledo and travelled on her own in southern Spain. Although she visited Ronda for the first time during this trip and fell in love with it, there was no question at this stage of settling there with Bomberg. So she returned briefly to Toledo, and made a bizarre attempt to help Bomberg act as a go-between in the purchase of a fine early Velázquez painting. It was a compelling portrait of the Franciscan nun Dona Jeronima de la Fuente, and the London National Gallery was interested in buying it from the Convent of Santa Isabel de Los Reyes in Toledo (Plate 243). 'David got permission to export it', Lilian recalled, 'but the nuns would only let the painting go if we passed the pesetas through the grill in their door as the painting came out. The National Gallery couldn't agree to this.'[29] Nor could Lilian agree to accompany Bomberg on further expeditions. So she went home to England while he travelled on to Morocco and the Greek islands, painting nothing en route. Lilian corresponded with him in the early months of 1930, telling him that 'I've just written a revolutionary article on Marriage & Divorce but I don't suppose I shall get it accepted.'[30] Later in the same month she noted that 'our Greco at the National Gallery is beautiful, but we can do with others – he is so intensely interesting in view of the trend of modern painting.'[31] But two months later she began to feel anxious about Bomberg, confessing that 'I worry quite a lot how on earth you are managing or going to manage with that little bit of cash . . . I wish Ramsay Macdonald would start a national scheme for artists so that they also could be assured of food & roof & decent return for labour expended.'[32] Similar anxieties may have prompted Bomberg to delay his return to England as long as possible, and they never left him throughout the rest of his life.

—

C28. David Bomberg. *Toledo and River Tajo*, 1929.
Oil on canvas, 58.4 × 76.2 cm. Oldham Art Gallery.

An attack of jaundice eventually obliged Bomberg to return to London, but at first Lilian refused to have him back. Their relationship was still suffering from the conflict they had experienced in Toledo, so he went to live with his brother Mo and only met Lilian every other day. 'Finally he begged me so much that I took him back', recalled Lilian, adding that 'he was getting well by then, and started to paint as soon as he came back.'[33] But the tension between Lilian and Bomberg remained, and he was further frustrated by his inability to persuade any London gallery to hold an exhibition of his Toledo work. The only airing Bomberg's Spanish pictures received in 1931 was at the newly-founded National Society of Painters, Sculptors, Engravers and Potters, where he displayed two of the Toledo paintings. They excited the perceptive reviewer for *Apollo*, who called *The Church of San Justo, Toledo: Morning* 'the most remarkable picture here, at all events among the land-scapes', and observed that 'the church itself is only an incident in what appears to be at the first glance only a mosaic of thick and "fat" impasto. This somewhat abstract appearance is, however, only due to the comparatively and necessarily small scale of what, in Nature, is a wide vista. The eye of the spectator becomes, as it scans the surface of the canvas with increasing wonder, gradually aware of an amazing orderliness of design and a convincing truth to Nature.'[34] The dealers' lack of interest in these splendid landscapes now seems as incomprehensible as it was wrong-headed (Plate 244). Their rejection made Bomberg even more aware of finan-cial insecurity, and the growing unemployment in the Depression years exacerbated his anxiety.

How was he to earn a living which would leave him enough time to work with the sustained conviction so evident in the Toledo canvases? Lilian later described how 'I determinedly fought against him becoming a teacher, because I thought he would be lost as an artist and devote too much energy to it.'[35] Accordingly, in June 1931 Bomberg tried once again to enquire into the possibilities of Palestinian

187

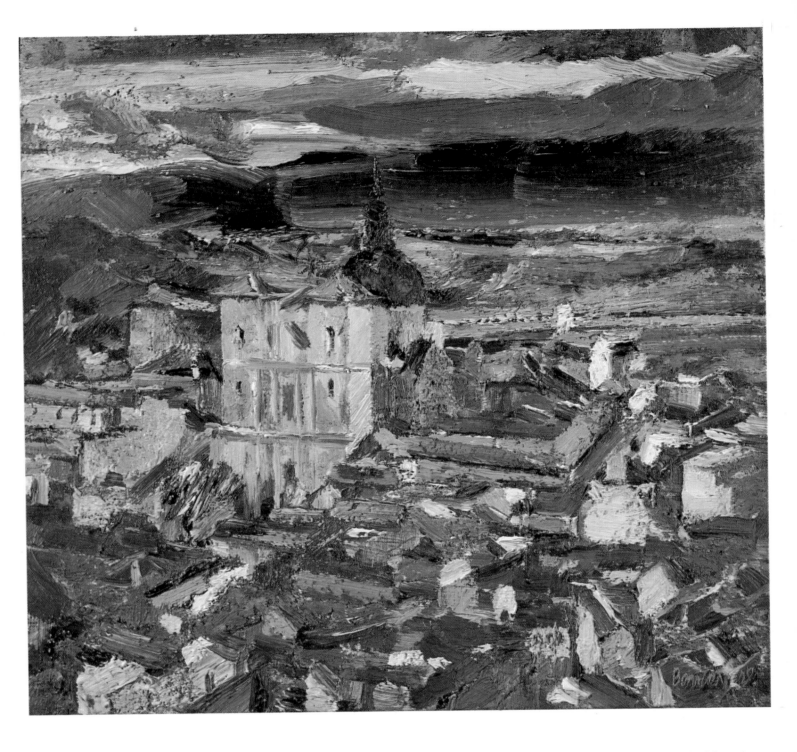

C29. David Bomberg. *San Juan, Toledo: Evening*, 1929. Oil on canvas, 38.5 × 43.5 cm. Private collection, Bradford.

patronage; but the Jewish Agency for Palestine turned down the proposal, although admitting that they were 'greatly interested in what you wrote, and can easily conceive that the right kind of artistic presentation of Palestine, and of our work in Palestine, would be of great value'.[36]

Bomberg therefore decided to resume his attempt to become a portrait painter, and during the latter half of 1931 he wrote to a surprising cross-section of assorted notables asking them if they would sit for him. In a letter to Campbell Dodgson, Keeper of the British Museum Print Room, he explained his plans.

As an experiment Miss Agnes Conway (Sir Martin's daughter) gave me a sitting to see if such a drawing would appeal to people to have. She decided that she liked what I had done of her – & also from a standpoint of saleability agreed that people would be getting good value for their money. I had fixed on a price of 5 gns. for such portrait studies & we now await our friends' verdict to see whether it will support our own as to its merit as a drawing on one hand & its success as a portrait on the other ... I did very little drawing of the kind when it is meant to be an end in itself after I went to Palestine in 1922 [*sic*]. But taking up the chalk again after holding the palette for so many years – & this, at the suggestion of Miss Conway – I was more pleased than not with

the result. Miss Conway was not quite sympathetic with the rough surface effect of my oil portraits which I had agreed to paint of people for 10 gns on a 20″ × 24″ canvas, & the drawing idea occurred to her as one of a wider appeal, & likely to get more commissions than the paintings. The paintings are completed in one sitting, say, of about 2 hours – The hours spent on the drawing are almost the same but I do two or three studies of different aspects before I decide on one particular one.[37]

The 'rough surface effect' criticized by Agnes Conway probably alienated many other potential sitters. The convention of the period rested on 'a smooth, glassy finish, and Bomberg's turbulent interpretation of his model's features must have disturbed people accustomed to the flattery of the professional portraitist. The Art Editor of *The Times* certainly thought that 'the series of portraits you offer'[38] were inappropriate. But Bomberg's proposals were also rejected by Edward Marsh, Jim Ede, H. J. Laski and John Gielgud, whose secretary explained that 'he is playing every night and rehearsing as well.'[39] R. B. Cunninghame Graham, who had recently written an enthusiastic foreword to the catalogue of Muirhead Bone's *Spain* exhibition, suggested that Bomberg approach Bernard Shaw: 'his rugged features give a painter greater opportunity for his art.' Graham also recommended H. G. Wells, explaining that 'of all men in the world he is the least of a snob, and I should think attached no importance at all to the fact of a painter not being fashionable or academic.'[40]

Nothing seems to have come of these promising suggestions, and Virginia Woolf replied that 'I . . . very much dislike sitting for my portrait, and have not done so for years.'[41] With her Bloomsbury affiliations, Woolf was highly unlikely to favour Bomberg's work anyway, but he entertained even more far-fetched ideas in his search for other sitters. He wrote to members of the aristocracy like the Duke of Beaufort and the Earl of Lonsdale, suggesting that he draw their portraits for reproduction in *The Field*. But none of them accepted the offer, and one noble

C30. David Bomberg. *San Miguel, Toledo*, 1929. Oil on canvas, 31.5 × 40 cm. Private collection, Bradford.

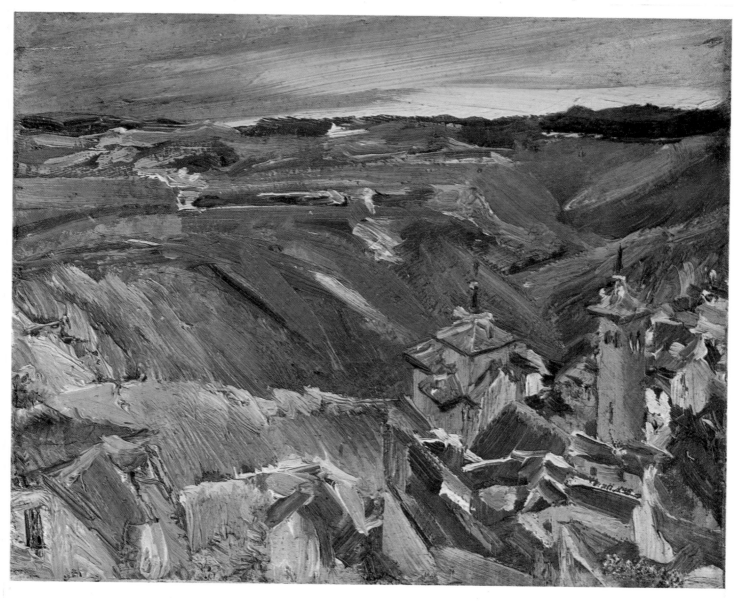

C31. David Bomberg. *The White Mist, San Miguel, Toledo*, 1929. Oil on canvas, 22.8 × 33.1 cm. Collection of the artist's family.

245. David Bomberg. *The Man from Marrakesh*, 1931. Oil on canvas, 54 × 44 cm. Private collection, Bradford.

lord drily pointed out that 'my portrait has been done for "The Field", and I cannot think that they would wish to have another one.'[42] The only positive response to *The Field* project came from John Dewar, who agreed to give Bomberg a sitting at Dewar House in the Haymarket.[43] But soon after he arrived for the appointment, on 26 October 1931, Bomberg showed how temperamentally incapable he was of playing the discreet portraitist's role. His brother John remembered that 'when Dewar closed the windows on the unemployment protest march going down the Haymarket, David put down his chalks and left immediately. There was either right or wrong, nothing in between. He'd never compromise.'[44]

The real trouble, however, was that Bomberg's rough-hewn style remained unsuited to the task of gratifying his sitters' expectations. Muirhead Bone, who deplored the economic stringency of the 1930s and declared that 'this passion for "doing without" will be the death of culture', helped by advising Bomberg to send some 'portrait drawings specimens'[45] to John Mabbott, a Fellow of St John's College, Oxford. Although Mabbott's reply was kind enough, he was powerless to help:

> Our college is pretty representative, I think. We have four fellows out of twelve or so who have some interest in modern works of art. We shall actually have to get a drawing done of one of our number soon – that was why I thought I might do something with your work – but they all insist on something 'safe' – (Muirhead Bone or Francis Dodd you know) and even the people who are sympathetic are inclined to agree that, for a portrait of a colleague, to be generally appreciated, any 'experimental' work should be avoided. I'm sorry this is so, because I like the determined directness of your pictures. But I feel myself that if I knew the subjects well, I should be distracted between the picture as a picture and as a portrait. I don't really see that we can help in Oxford.[46]

The prospects seemed negligible, and Bomberg had to content himself with painting self-portraits instead. One of them, executed with slashing brushstrokes which potential patrons would doubtless have found disconcerting, suggests that Bomberg

190

enjoyed an element of play-acting and self-dramatization when he looked in the mirror (Plate 245). He even called this painting *The Man from Marrakesh*, as if to acknowledge the fact that the scarf on his head gave him an exotic appearance. But he adopted a far more engaging persona when he drew himself in charcoal with a pipe (Plate 246), and in a drawing of Lilian he produced a masterly likeness which emphasized the gauntness of her strong, sculptural features (Plate 247).

She proved an invaluable companion when Bomberg managed to secure a modest commission from Shell-Mex for a poster design of a rural scene. Jack Beddington, the enterprising patron who ran Shell's publicity department, agreed in July 1931 to pay Bomberg 'twenty-five guineas for your experiments in connection with a landscape of the country near Manchester'.[47] The money enabled him to set off with Lilian on the first of their many painting expeditions together, camping in a tent and enduring 'continuous rain and cold' for several weeks before finding the right scene at Cavedale rocks in Castleton. Lilian recalled their delight at seeing 'a grand flood of sunlight shafting through, throwing the great forms into the shadow depth'. Bomberg decided at once that it should be painted, and he completed the canvas in one vigorous session. Afterwards, 'excited, tense, yet very restrained', he decided that the painting had done justice to the grandeur of the location. But it was the only picture executed during this arduous expedition, and Shell-Mex decided that it would be 'too subtle'[48] for reproduction as a poster.[49]

Compared with the large number of fully achieved paintings which Bomberg produced at Toledo, his meagre output on the Cavedale trip was disappointing indeed. Apart from a few exceptional moments later in his career, he did not respond to the English landscape with the excitement he felt in Mediterranean countries. Nor had Bomberg and Lilian succeeded in overcoming the element of explosive conflict in their relationship. It continued to erupt periodically, threatening at one stage to part them for ever when he met the artist Pearl Binder. As a committed

246. David Bomberg. *Man with Pipe: Self-Portrait*, 1931. Charcoal, 73.7 × 53.3 cm. Private collection, Bradford.

247. David Bomberg. *Woman (Lilian)*, 1931. Black chalk, 69 × 45 cm. Private collection, Bradford.

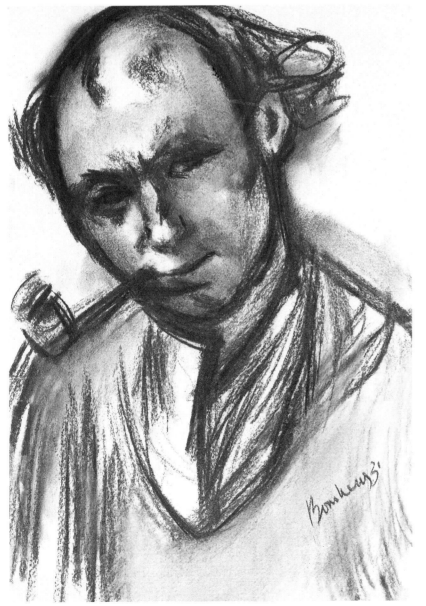

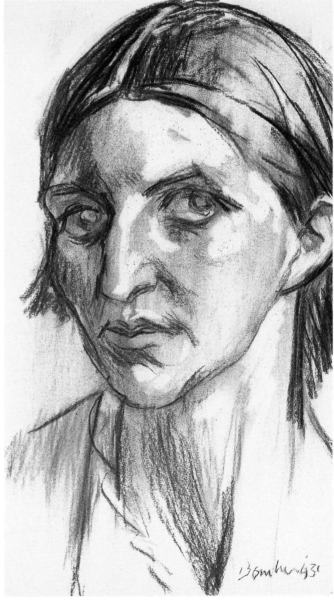

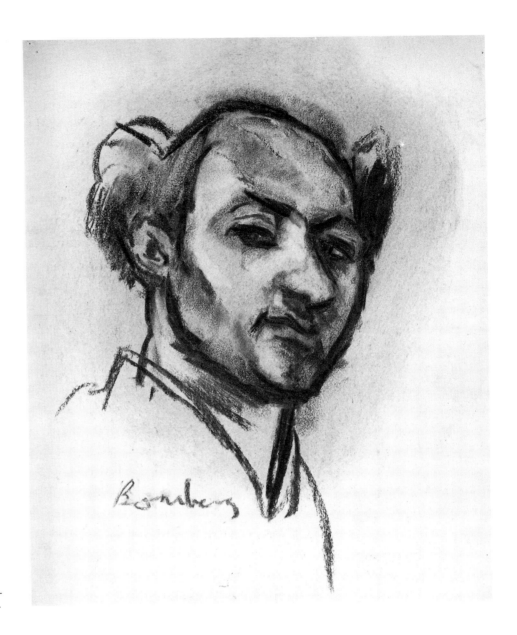

249. David Bomberg. *Self-Portrait*, *c.* 1932. Charcoal, 50.3 × 39.5 cm. Colin St John Wilson, London.

248. Publicity leaflet issued by Lilian Holt to launch her Kensington shop, n.d. Collection of the artist's family.

left-winger, she had decided in 1929 to live in Whitechapel and learn as much as possible about the lives of the working people there. Her art was socially motivated in a gentle yet overt way, and therefore very different from Bomberg's. But Lilian realized at once that he was strongly attracted to her. 'I went broke at Fordwych Road and had terrible scenes with David over Pearl', she remembered. 'So I moved to Peel Street off Church Row in Kensington and started a fruit and vegetable shop called "Lilian".' With the help of her brother Oliver, who lent her £9 to start the business, Lilian tried to establish herself as a shopkeeper and printed her own publicity material (Plate 248). 'I used to go to Covent Garden every morning', she recalled, 'and bring the fruit and vegetables home on a horse and cart driven by a rag-and-bone man.'

On the wall of her flat over the shop, where she lived with Dinora after selling Fordwych Road, Lilian hung a painting of herself by Bomberg called *The Red Hat* (Colour Plate 32). It is one of his most exuberant portraits, executed with a fiery aplomb which reveals the complexity of Bomberg's feelings towards Lilian at this difficult period. The brushstrokes seem to attack her features with disconcerting harshness. But they also revel in her vitality, and in the hat itself they explode in uninhibited swathes of scarlet and crimson. Quite understandably, Lilian cherished this vibrant and unfettered image. But she saw nothing of the man who had painted it until he decided to apologize for his behaviour by designing a sign for Lilian's shop. Pearl Binder painted vegetables on one side and Bomberg painted fruit and flowers on the other. 'But the sight of these two bohemian artists up a step-ladder in weird clothes outraged the whole street, which was very respectable', Lilian remarked, 'and so my trade was ruined – the local residents wouldn't go into such

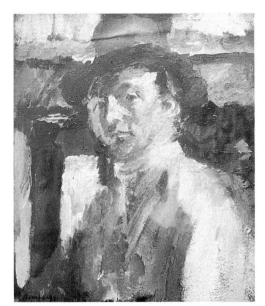

250. David Bomberg. *Self-Portrait*, 1931. Oil on canvas, 59.8 × 49.5 cm. Private collection.

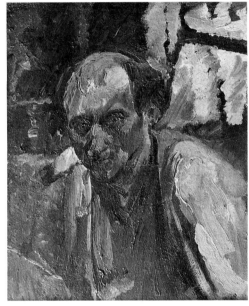

251. David Bomberg. *Self-Portrait*, 1932. Oil on board, 59.6 × 49.4 cm. Ulster Museum, Belfast.

252. Walter Richard Sickert. *The Servant of Abraham*, 1929. Oil on canvas, 61 × 50.8 cm. Tate Gallery, London.

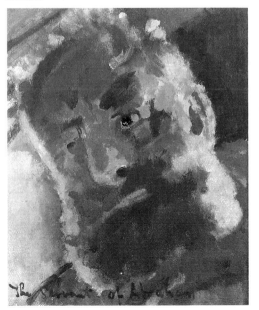

a strange shop. Then David, who had started coming to see me almost every day, said that I should come back to him. I had no other opportunity open to me. I still liked him as a person, and I wanted his friendship and his outlook on art.'[50]

The turbulence of Bomberg's emotional state during this troubled time is openly declared in a series of self-portraits. Lacking the resources to pay for models, he scrutinized his own features again and again in a full-sized mirror.[51] The finest of these drawings and paintings show a man engrossed, not so much in the examination of his external appearance, but in a profoundly questioning meditation on his inner self. A very powerful charcoal drawing depicts Bomberg staring sidelong at his reflection, as if determined to catch himself unawares (Plate 249). Although he looks tired and somewhat dishevelled, the energetic charcoal coursing round the main contours of his face signifies a formidable resilience. Bomberg was set on achieving, in both his drawing and his painting, a greater degree of expressive freedom than before. This charcoal self-portrait has all the largeness of form which he commanded in his pre-war work, and yet it is handled with a quite new breadth of touch. Using his finger as much as the charcoal stick, he rubs in the shadows on cheek, chin and forehead so robustly that the modelling takes on a tactile, sensuous immediacy. The artist is presented here in all his physical vigour, as a balding middle-aged man with a pugnacious frown whose living presence impresses itself forcibly upon us.

He adopted a more formal pose in a richly coloured *Self-Portrait* painted in 1931 (Plate 250). Its emphasis on umber, siena and deep ochre is almost Rembrandtesque in feeling, foreshadowing the open declaration of his debt to the Dutch master in the harrowing *Last Self-Portrait* painted thirty-five years later (Colour Plate 65). Here, though, the mood is restrained rather than tragic. Bomberg eyes himself rather warily, and remains content to hide in the shadows thrown across his face by the strong light exploding on his shoulder as a soft blaze of whiteness. Soon afterwards, he began to manipulate pigment with a similar fluency and freedom in a *Self-Portrait* tilts his features towards us (Plate 251). Bomberg was now prepared to dramatize his expression more openly than he had in the charcoal drawing. The paint is pushed over his face with such urgency and speed that he appears to accept a considerable element of risk. He wants to surprise himself, producing an image less recognizable but also less predictable than he might otherwise have done.

Sickert, whose work Bomberg had respected ever since he studied at the older man's classes, attained a comparable rawness and brusque vitality in late self-portraits like *The Servant of Abraham* (Plate 252). Bomberg probably saw this magisterial image when Sickert exhibited it, along with the equally commanding *Lazarus breaks his fast*, at the Savile Gallery in 1930. They may have helped him arrive at his resolve to paint more broadly, but Sickert's use of photographs in these self-portraits was anathema to Bomberg. He was now firmly committed to working from life, and in an eloquent *Portrait of the Artist* the brushwork becomes more openly agitated than anything Sickert ever wanted to achieve (Colour Plate 33). With his head tilted back as if recoiling from the image he saw in the mirror, Bomberg now reveals more of the spiritual turbulence which was to increase as the 1930s proceeded. The pigment is dragged, prodded and pushed onto the canvas with a muscularity which makes us vividly aware of the painter's manual gestures, and the sense of torment is accentuated by the equally feverish handling of the space surrounding his head.

But he did not reserve this revelation of disquiet for his own portraits alone. In 1932 he also executed a half-length painting of Lilian, and it makes no attempt to disguise her inner emotions (Colour Plate 34). 'It was his idea to paint me in the nude', she recalled; but rather than simply celebrating her physical beauty Bomberg may well have wanted to explore the vulnerability she felt without her customary clothes. Lilian explained that 'I posed with a black satin dressing-gown on my shoulders and arms, because I was very shy of standing in the nude. I wasn't used to it.' She did not withhold herself from the picture in any other respect, however, and later described how she responded to the challenge of posing for Bomberg. 'You must give out your whole being, the same as painting', she explained. 'I was giving my whole soul to him. David insisted on my being very still – the stillness was essential for the giving out. And you mustn't talk. Absolute concentration . . . there was total silence.'[52]

The intensity paid off. Although Lilian tried to hide her awkwardness beneath

the dressing-gown, Bomberg's free brushwork minimizes her garment's presence in the picture. Her pale body looks painfully exposed and isolated in the surrounding darkness. She turns away from her observer, like a woman unwilling to confront the male eyes scrutinizing her flesh. But at the same time she makes no attempt to hide the nervousness she feels. Indeed, there is a despondency in her expression which reflects the disappointments Lilian had already suffered in her relationship not only with Mendelson but with Bomberg himself. The turning of the head could in this sense be seen as a reflection of her unwillingness to commit herself unreservedly to a man whose fidelity had been called into question not long before. As well as this sense of unease, however, Bomberg's painting has a caressing and tender quality which discloses the true depth of his affection for Lilian. It is a compassionate image which shows great sympathy for a woman whom Bomberg may have felt responsible for wounding. Even though her gaze is averted, the picture still seems to be animated by the hope that she might soon feel ready to look at him directly again, discard her robe and restore the lost intimacy between them.

Around this time, the sale of a Jerusalem painting for forty guineas to Mrs Robert Solomons prompted Lilian to suggest that 'we could go to Scotland on the money.' Bomberg, who must by now have been anxious to return to landscape painting, agreed. The working partnership already established on the Cavedale expedition was revived, and Lilian accompanied him on even the most gruelling and hazardous parts of the Scottish journey. After calling in on her brother at Perth they made for Pitlochry and the Grampians, where wretched weather turned their camp-site into a sea of mud. 'While we were out one day, the farmer put a bedstead in the tent because he said we'd get rheumatism sleeping on the ground', recalled Lilian. But the Grampians did not satisfy Bomberg enough to make him settle for long, and after completing a few canvases they moved on to the Cairngorms. Once again the weather did its best to deter them: Lilian described how, one especially foul night, 'it was blowing down the Llarig Ghru Pass at ninety miles an hour and snowing, and we weren't able to sleep all night.' But in the morning, after the storm was over, 'we felt elated' and Bomberg was ready to start work the moment a painting proposed itself to him. 'David used to tie a string round a rock to steady the easel', Lilian remembered. 'He'd look around very quickly and start work with tremendous speed.'[53]

The canvases which survive from this expedition cannot, on the whole, be placed among Bomberg's most satisfactory works: they are often marred by signs of excessive haste, and an unwillingness or inability to produce a fully coherent image. But they also prove that he was struggling to find a more freely gestured approach to landscape painting, markedly broader than the Toledo canvases had been. Perhaps the most successful Scottish picture is a surprisingly unfettered view of *Brierloch – Glen Kinrich, Cairngorms*, where Bomberg retains the spontaneity and freshness of a small oil-sketch (Colour Plate 35). Painted with great rapidity, it catches the soft, pastel-like glow of a salmon-pink sky above deep blue mountains, adding broken strokes of gold, pink and green to the ground below in order to intensify the almost mystical sense of lyricism. In Scotland Bomberg began to feel his way towards the expansiveness which was to mature completely during the following decade; and as Lilian pointed out, the expedition also confirmed him in his belief that 'the artist can only depict those situations and experiences in which he has become intimately involved ... knowing every rustle of air, every scent of earth, every step of the way.'[54]

Bomberg's attempts to gain a closer relationship with the landscape, by exposing himself to the rigours of the climate and the considerable dangers of mountain climbing, left most of London's dealers and critics unimpressed. It is true that in 1932 the *Daily Mail* singled out his contributions to the National Society's annual exhibition, describing how this 'real master of pigmentary treatment ... seems to use his brush like a firebrand, producing on the canvas a conflagration of colours which are like an orgiastic display of fireworks managed by a bold but competent pyrotechnician'.[55] But he was still regarded as a puzzling outsider in the context of English painting, with its habitual emphasis on discretion and unemphatic handling. The *Daily Express* certainly presented him as a bizarre adventurer when it reproduced a photograph of Bomberg painting in his Hampstead garden, surrounded by canvases from the Scottish expedition and the tent he had used on the trip (Plate 253). 'ARTIST WHO LIVES DANGEROUSLY' ran the *Express* headline, while the caption

194

beneath breathlessly declared that Bomberg 'takes risks when he seeks his subjects. He established a tent studio on the chill, raw heights of the Scottish Cairngorms, where no one had ever lived before.'[56]

The *Express* published this photograph the day before Bomberg's new show opened at the Bloomsbury Gallery on 10 November 1932. But this *Exhibition of Sixty Imaginative Compositions, Spanish and Scottish Landscapes and other work* could hardly be described as the event Bomberg had been hoping for. The Bloomsbury Gallery, in a quiet street off Bedford Square, did not enjoy the prominence and status of the Leicester Galleries where his Palestine pictures had been displayed. Moreover, Bomberg had to agree to some unreasonable terms before he could exhibit there. The gallery's owner insisted on a financial guarantee, and Bomberg was once more forced to ask Muirhead Bone for his assistance. 'I have written to the Bloomsbury Gallery guaranteeing to pay them the £10.10 when & if it is necessary', Bone generously replied. 'I think they should be content with this. Perhaps you have good reasons for going to the Bloomsbury Gallery but I must say their terms seem to me pretty stiff. I never heard of an artist paying for his catalogue (I hope you make *that* as cheaply printed as possible!) And the Booking Fee is unusual also, is it not? I fear your business abilities must be sleeping!'[57]

The melancholy likelihood is that the Bloomsbury Gallery was the only place now willing to stage a Bomberg one-man show. It was a substantial event, with twelve Toledo canvases, a few Palestine pictures, thirteen Scottish landscapes and a number of recent portraits. The addition of sixty 'Imaginative Compositions', culled from the series Bomberg had painted in the early 1920s (Plates 181, 182, 183, Colour Plate 23), may have puzzled visitors: they were executed in a far more abstract idiom than the canvases on display. One of the few critics who bothered to review the show decided that 'aesthetically the "Imaginative Compositions" in gouache are probably the best works in the show.' But none was sold, and the same reviewer said of the Scottish landscapes that 'Mr Bomberg has not the lightness, the broad spacing and the bravura of – the name will out – Turner.'[58] Even this criticism was preferable to the lack of interest displayed by most reviewers. Angered by their refusal to discuss the show, and by the Bloomsbury Gallery's parsimonious attitude towards the cost of the exhibition, Bomberg now devoted more of his

253. Photograph of Bomberg in his Hampstead garden with paintings from the Scottish expedition, reproduced in the *Daily Express*, 9 November 1932.

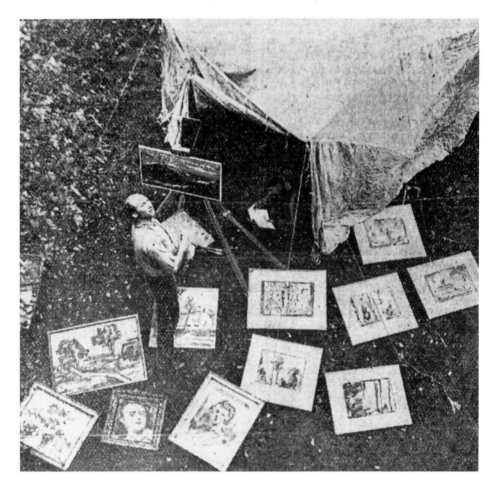

attention to the militant left–wing activities which burgeoned throughout Britain in the early 1930s.

———

His sister Kitty was instrumental in awakening him to the communist cause. Along with her husband Jimmy Newmark, who now believes that 'David was apolitical basically',[59] Kitty did her best to convert Bomberg to the movement (Plate 254):

> I tried to put before him the unassailable glory of Marx. I was a fervent Marxist, and at that time we were all interested in a new society. David was a humanitarian and always championed the underdog, and Jimmy stirred the embers. I spent twenty-four hours a day trying to bring about the glorious revolution, so I attempted to take David with the cause. A tremendous ferment was going on at this period, and David became interested. I didn't realize what he was trying to do as an avant-garde artist, and afterwards I regretted wasting his time with politics when I should have been discussing art. But David was so singleminded that he would go on with his art, inviting me to sit for him and then asking me to tell him about Marx and Engels. David had a growing awareness of a world he hadn't explored. At that time we felt that if you were an artist you shouldn't be concerned only with your ivory tower: there was an outside world.[60]

Bomberg did not join the socially committed Artists International Association when it was founded in 1933 by a group of artists including his friend Pearl Binder. But he was affected by the same political fervour which inspired the AIA's members to declare their support for 'the international unity of artists against Imperialist war on the Soviet Union, Fascism and Colonial oppression'.[61] Bomberg did hold similar views, and the sympathy with the oppressed which had driven him to paint a lost picture of *The Hunger Marcher* as early as 1919 was quickly reawakened by the gathering economic hardship and social unrest of the Depression years. Lilian, who recalled that 'David read all through *Das Kapital* at the time',[62] felt at first a greater reluctance than Bomberg to become a communist. But once she had made the decision to join the party, Lilian involved herself in its activities as willingly as Bomberg. For a while he was prepared to lend his talents as an artist to furthering the activist cause. 'Kitty and Jimmy were making propaganda every weekend and drew in David and me', said Lilian. 'The studio was full of banners painted for demonstrations. I became a member of the International Legal Defence of those imprisoned or arrested, and David painted a huge banner for the ILD in gold, black and red.'

254. Photograph of (left to right) Bomberg, Jimmy and Kitty Newmark at Merstham, 4 August 1931. Collection of the artist's family.

255. Photograph of unemployed demonstrators climbing Hyde Park gates, 27 October 1932.

The presence of such a banner could have a remarkably potent effect at a demonstration: Lilian recalled that it 'was the biggest thing there, although not many people turned up.'[63] But massive crowds assembled when the Hunger Marches, organized by the National Unemployed Worker's Movement, reached London (Plate 255). The biggest march arrived in October 1932, when ten thousand people gathered in Trafalgar Square calling for a march to Parliament to present a petition with a million signatures. Jimmy Newmark, who went on a hunger-march demonstration with Bomberg and Lilian in Trafalgar Square, described how 'the police charged unprovoked with their batons, hitting me so hard on the back that I felt the bruise for weeks afterwards. So David, who was an enormously powerful man, became incensed by this and tried pulling the stones away from the plinth outside Canada House to throw at the police!'[64] On another occasion, attending an anti-war demonstration in Trafalgar Square, Lilian, David and the Newmarks climbed on to the lion statues. 'The mounted police came in too close and Jimmy was pressing against me', Lilian recalled. 'David jumped down, and I saw him duck under the horses because the police were lashing out with their long canes. I was left on the plinth, but I pulled a fast one. "Give me a hand, there's a good chap", I told a policeman, and he was so surprised that he helped me down.'[65]

Before long Bomberg's new-found communist convictions led him, like so many other left-wing Englishmen, to believe that a trip to the Soviet Union would be in order. He asked the critic P. G. Konody to act as his referee when applying for permission to the Society for Cultural Relations Between the People of the British Commonwealth and the USSR, a body which counted E. M. Forster, Aldous Huxley, Maynard Keynes, Bertrand Russell and R. H. Tawney among its vice-presidents.[66] Konody duly obliged, and wrote a helpful letter to the Secretary of the SCR. 'I understand from Mr Bomberg, whom I have known as an artist for many years, that he is in communication with you about his proposed visit to the USSR for the purpose of holding exhibitions of his work at Leningrad, Moscow, and other centres', wrote Konody in January 1933. He went on warmly to commend Bomberg as 'an artist of rare distinction', and concluded that 'if Mr Bomberg could be the means of enabling us, in this country, to get acquainted with the artistic activity of Russia during recent years, any move in this direction would be heartily welcomed by all lovers of Art in England.'[67]

Soon after this letter was written Bomberg joined the SCR, and his support within the Society was considerably strengthened by the presence of John Rodker, who had Moscow connections and edited the Society's publication, *Soviet Life and Letters*. By the summer of 1933 the SCR's secretary Hilda Browning was able to write to Mr Amdur of VOKS in Moscow, announcing that Bomberg 'is coming to Moscow with the intention of finding out what he can about the Union of Revolutionary Writers and getting information to enable him to start a similar movement in this country'. But Bomberg was not solely nor ever primarily concerned with the state of contemporary Soviet literature. As Hilda Browning went on to explain, 'Mr Bomberg is acknowledged as a painter of great force and distinction, but he is dissatisfied with his opportunity of expression in London. He is considering the possibility of remaining in Moscow to express his ideas more fully than he can in any capitalist country and hopes that he may be of use in the Soviet Union.'[68]

The fact that Bomberg was prepared to think of settling in Moscow shows how little he really knew about the condition of the artist in the Soviet Union. He seems to have imagined that greater freedom and opportunity awaited him there, but the harsh truth was that the USSR's official policy on the arts had recently hardened into an oppressive and intolerant enforcement of Socialist Realism. Other British artists who visited Russia during this period, like Cliff Rowe and Bomberg's friend Pearl Binder, placed working-class life at the very centre of their art. They enjoyed considerable success in Moscow, where Rowe painted a 'very realistic night scene of "Hunger Marchers Entering Trafalgar Square"'[69] for a huge Red Army exhibition; and Binder was even honoured with a one-woman show at the Museum of Modern Western Art. But despite Bomberg's willingness to paint banners for demonstrations in London, his paintings of the early 1930s display no overt involvement with working-class life. So it was extremely unlikely that his art would find official favour in the Soviet Union, and the great hopes he entertained for his Moscow trip were bound to end in bitter disillusionment.

Even so, in Britain's worsening economic climate it was natural for artists to

wonder if the communist system might offer a better alternative. Since accurate information about the reality of Soviet life was hard to obtain, Bomberg's decision to find out for himself seemed sensible enough. 'We both discussed it', Lilian related, 'and I said: "You go to Russia and see what is what." We thought there might be a new deal for artists, and we wanted to find out whether the communist system was good for artists or not.'[70] Bomberg therefore travelled to Moscow in July 1933, and at first the expedition seemed to go well. John Rodker joined him, and the two men's preliminary impressions were so favourable that Bomberg asked Lilian to go over there as well. Writing from the Intourist Hotel New Moscow, in September 1933, he suggested that she 'think of the possibility of coming out here for 6 months, because a visit out here is a better education in working class politics than can be obtained in any other way.' (Plate 256).

Bomberg also told her that he felt hopeful about procuring support for his work from the Soviet authorities as an artist rather than as a visiting observer. 'An Art Critic here is trying to improve the terms of my contract with the art publishing house', Bomberg wrote. 'He is also arranging that I meet the party representative of art matters. I also saw today the director of the Tretakoff [sic] Gallery who said that he will try and get me an important commission to go south & paint Socialistic Construction.' Bomberg's previous failure to respond to similar subjects in Zionist Palestine should have been enough to warn him off such an idea, but for the moment he was determined to view the USSR with optimism. 'Part Share in a studio is also promised', he told Lilian, '& a room to be used as a studio & to live in.' During his stay he had discussed as well 'the matter of an art exhibition in London of the 15 years painting of Red Army & 15 years of Soviet Art, to be arranged in such a way that SCR cannot make a mess of it. If it is taken up I will get Konody to handle the matter together with Muirhead Bone. So there is more hope today for my staying on. If I do, then, perhaps, your coming out can be made inexpensive – as you would only need a one way ticket.'[71]

But Lilian never did join him in Russia, and the remaining few months of Bomberg's stay were clouded by a gathering sense of disappointment and outrage. He had been warned, by a Maxim Gorki pamphlet in his possession, that conditions in the USSR were far from perfect. 'In Moscow', Gorki wrote, '86% of the houses are one-storied, wooden structures. They have not been repaired for seventeen years and have been built in such a way that the streets of Moscow are unnaturally crooked and confusing. Your first impressions of our city will be disappointing, even distressing, an impression of a lack of culture.'[72] But Bomberg found that his readiness to make allowances for a country undergoing a massive upheaval was eventually replaced by a feeling of alarm. On a financial level, his life was made very difficult when thieves lifted the wallet from the inside pocket of his coat while he was straphanging on a tram. Then he began to suspect that such an incident might be the

256. Letterhead of Bomberg's letter to Lilian from Moscow, 11 September 1933. Collection of the artist's family.

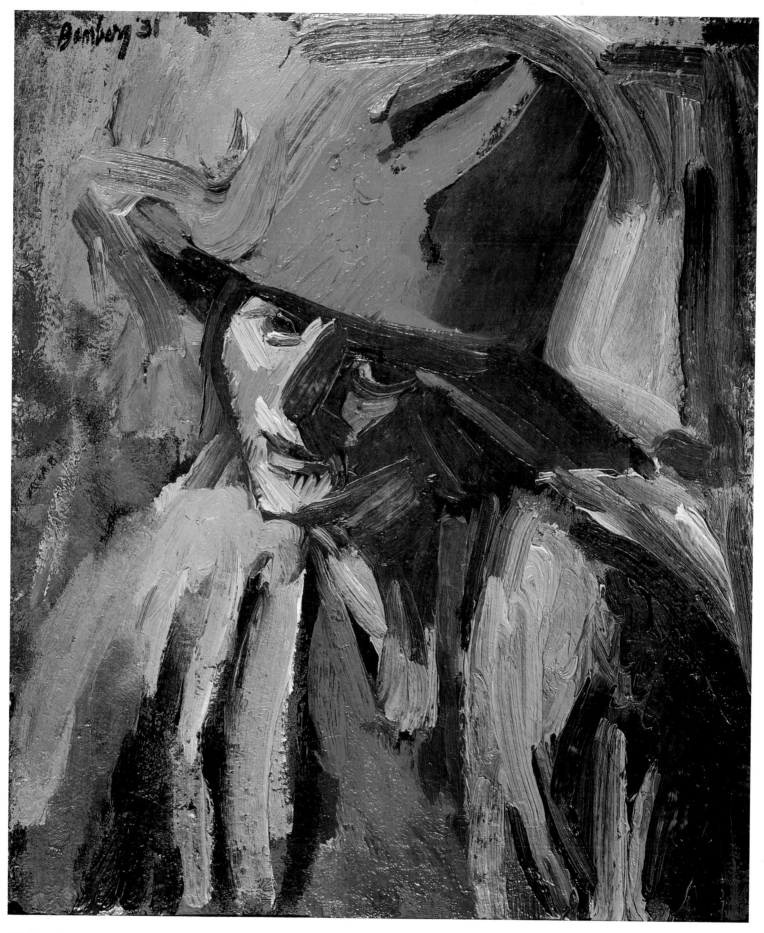

C32. David Bomberg. *The Red Hat*, 1931. Oil on canvas, 62 × 52 cm. Private collection, Bradford.

direct result of the hardship still being suffered by an alarming number of ordinary Soviet people. 'He visited an experiment on the "wild boys" who lived on the streets', Lilian remembered. The aim was 'to reintegrate them into society. A man from the same background was trying to retrieve them. They were attempting to make the boys engage in painting, drawing and other things, for rehabilitation. They were thieves and criminals, and David asked them whether, if they wanted a particular colour, would they steal it? And they said yes.' The only person they would refuse to rob was the man who ran the experiment, and Bomberg found their attitude alarming. It confirmed his growing concern about the prevalence of abject poverty in Russia, an affliction which rudely contradicted everything he had been told to expect there.

Similar disenchantment confronted him when he talked to painters and saw their work. 'He visited artists engaged on communal projects', Lilian recalled. 'One of them was painting a large mural of a naval subject, and told David he had to change it because the cultural committee said that Soviet sailors always smile. If he didn't make them smile, he'd lose his bread ticket.' Bomberg also came across artists whose work he respected, but they were shunned by the authorities and punished for retaining their integrity. 'He found the good artists were drawing on little bits of toilet paper', said Lilian; 'they couldn't get issued with proper materials because they were painting good pictures!'[73]

The cumulative effect of such encounters prompted Bomberg to change his mind completely about the state of art in the USSR. Kitty, who corresponded with him during the Soviet trip, succinctly declared later that 'he went there pro-Russian and came back anti-Russian.'[74] The development of Bomberg's thoughts about Soviet art can be traced in his writings on the subject during the 1930s. In one of the earliest passages, he appears to accept that in Russia 'abstraction cannot be entertained, because it will tend to obscure the class nature of the Struggle by concealing the Subject which must be brought out in sharpness – namely the working class against the Capitalist Class – the expropriation of the Expropriators.' But by the time Bomberg arrived at his definitive views on Soviet art, he had no hesitation in condemning its desperately poor quality. 'We find that where the painter departs from the actual life around and strives for Socialist Realism the paintings do not inspire in the way they are meant to', he complained; 'the conception is derivative in composition and technique and lacking in that full vision which is necessary to inspire conviction in those people who see it. The theory and tactics of the Revolution is [*sic*] one thing and the creation of a work of art another. They have little in common.'[75]

It was an eminently sane conclusion for Bomberg to reach. No good would have come from any attempt to tailor his art and thereby obtain Soviet patronage, for the authorities there were incapable of understanding his sturdily independent standpoint as a painter. Lilian described how, with a defiant sense of pride, he turned down Moscow's offer of 'the rate for fourth-class artists, saying: "I'm a first-class artist."' Significantly enough, he had abandoned all thoughts of Soviet patronage and exhibitions by the time he made one final application to Russia. 'I want to travel in the USSR and paint a number of landscapes in oil, sufficient . . . for a single one-man exhibition in London at one of the prominent London Galleries',[76] he wrote to Intourist in December 1933. But by then it was too late. Russia had lost its former attraction, and the plan, based on the supposition that Lilian would accompany him, was never implemented.

Bomberg settled in England once again, and Lilian remembered that 'he was shocked' at the conditions he had found in the Soviet Union: 'He asked an East End friend, who was a Communist and had encouraged him to visit Russia: "Why do they have waifs and strays in the streets?" And the friend said: "You shouldn't have seen them." David was disillusioned and I, who was a member of the CP, couldn't believe it was true. He took a month to convince me, and when I was convinced we both resigned from the CP together.'[77] Nor did Bomberg's sense of disenchantment with Russia ever lessen. A decade later, in conversation with Ludwig Meidner and Josef Herman, he looked back on his involvement with Communism and admitted that 'we, too, talked a lot about *the Revolution*! But look what happened to Soviet art. Spinster painting! That is what happened!'[78]

C33 (facing left). David Bomberg. *Portrait of the Artist*, 1932. Oil on canvas, 50.8 × 41.2 cm. Collection of the artist's family.

C34 (facing right). David Bomberg. *Lilian*, 1932. Oil on canvas, 76.2 × 55.9 cm. Tate Gallery, London.

C35 (facing below). David Bomberg. *Brierloch – Glen Kinrich, Cairngorms*, 1932. Oil on canvas, 51 × 67.5 cm. Private collection, Bradford.

CHAPTER EIGHT # The Discovery of Ronda and Escape to London

The shattering of Bomberg's faith in Communism did not mean that his concern for the plight of the poor and oppressed came to an end. Nor did his rejection of Russia imply that he became any more satisfied with the capitalist order after his return to London. But among the few collectors who did seem consistently interested in buying his work during the 1930s, he was particularly glad to regain contact with a trio of wealthy men in Bradford. Bomberg had originally been put in touch with them by Alfred Willey, a dealer who used to come to London on regular buying trips. Having been introduced to Bomberg by Horace Brodzky, Willey purchased a number of Toledo and Palestine pictures. The Bradford collectors liked them, and although they drove hard bargains, Willey was able to sell them an encouraging quantity of Bomberg's work.

Arthur Crossland and Asa Lingard, a wool-merchant and draper respectively, were probably the richest of the Bradford collectors. But the most remarkable collection was amassed by Wyndham T. Vint, a solicitor who eventually acquired a resounding total of over forty works by Bomberg alone.[1] He was a man of catholic taste, buying everything from Brangwyn, Sickert and Wyndham Lewis to Vlaminck and Soutine. His voracious appetite for pictures led to a final collection of around eight hundred works. 'He didn't like his job very much', explained Vint's son. 'He fell in love with the Louvre, and for many years served as chairman of the committee for the annual spring exhibition at Cartwright Hall.'[2] It was Bradford's local art gallery, and Lingard and Crossland also sat on the committee. All three collectors seem to have relied on Willey to bring them most of the pictures they purchased. 'They used to give him his fare to London and hope he'd come back', recalled Vint's son. 'He'd return with a batch and they'd pick two apiece.'[3] The great advantage of this procedure was that Willey acquired paintings at a price considerably lower than the Bradford collectors would have paid in the London galleries. But they were not simply interested in bargains. The quality of Vint's Bomberg collection testifies to his discernment as well, and he benefited from the advice of the respected Leeds artist Jacob Kramer, who was William Roberts's brother-in-law and had known Bomberg since his student days.[4] Although Willey always tried his best to persuade Bomberg to sell cheaply, his visits were welcome. 'Willey was very important in our lives', explained Lilian's daughter Dinora, 'because his arrival meant that we'd have a few pounds to spend for a change.'[5]

So Bomberg wrote to Willey immediately after his Soviet trip came to an end, and the response was encouraging. 'I was pleased to receive your interesting letter which will be shown to two or three likely to be interested', Willey wrote in December 1933. 'I also note that you have not yet commenced painting again, one wishes you had tried a shot at it, I for one would have liked to have seen if there was any development resulting from the communistic & revolutionary unrest that has been in your system the last 18 months. However, I have heard you were always a slow starter so one must leave it at that.'[6] No works seem to have survived from Bomberg's Soviet expedition, and after this fallow period he must have been anxious to start painting again. His thoughts naturally went back to the excitement of the Toledo visit, when so much had been achieved in a concentrated burst of activity. Remembering an engraving of Cuenca from his previous Spanish trip,

258. David Bomberg. *East Valley, Cuenca: Morning*, 1934. Oil on canvas, 57.1 × 71.2 cm. Private collection, Bradford.

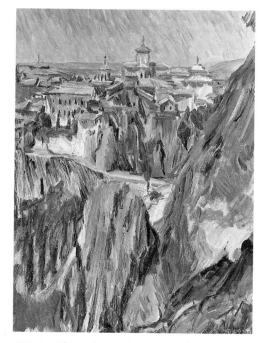

257. David Bomberg. *The Road to the city Cuenca*, 1934. Oil on canvas, 66.1 × 50.8 cm. Private collection, Bradford.

he and Lilian decided in the summer of 1934 to go there. 'He knew the landscape suited him, and life was very much cheaper in Spain', explained Lilian, who remembered that 'I sold *The Red Hat* (Colour Plate 32) to provide boarding-school fees for Dinora in England.'[7]

Cuenca, built on a high ridge of rock with rivers on each side, is a dramatic sight. Bomberg regained the old sense of excitement as he approached it, in a painting called *The Road to the city Cuenca*, where the brushmarks are applied like driving strokes of rain (Plate 257). Cuenca was an ancient settlement, and Bomberg honoured its sense of history by renting a house for the equivalent of 30p a week in the old part of the city near the cathedral. As in Toledo and Palestine, he painted outdoors as frequently as possible. From the end of his garden there was a precipitous descent to the valley below, and several Cuenca paintings dramatize the apparent vulnerability of the old buildings clustered on the edge of the ravine. Sometimes, as in *East Valley, Cuenca: Morning*, Bomberg's long, swooping brushstrokes concentrated on a relatively literal depiction of Cuenca and its primitive setting (Plate 258). But when he painted in the evening light, his response to buildings and landscape alike became looser and less inhibited. The dissolution of form as it faded in the gathering dusk against a sky flecked with orange, purple and crimson gave the superb *Sunset, Cuenca* a greater freedom and vitality than many of the large canvases that he executed there (Colour Plate 36). Several of them lack the sustained energy and exhilarated emotional commitment he had displayed in the Toledo pictures. The brushwork sometimes looks hasty rather than impassioned, and hectic handling then becomes a substitute for genuine engagement. Apart from the exalted *Sunset, Cuenca*, which can be counted among his finest landscapes of the 1930s, only a wild and almost feverish composition called *Cuenca from Mount Socorro* fully succeeds in realizing on a large scale the ambitions which he brought with him to the city (Plate 259). But Bomberg was experimenting with a far broader and more summarizing approach than he had dared to attempt in the Toledo canvases, and the results were bound to be uneven as he strove to achieve a way of painting which allowed for a franker declaration of his subjective reaction to the landscape.

In the smaller Cuenca paintings, Bomberg was able to cast aside his self-consciousness and arrive more frequently at the intensity of his earlier Spanish work. Unencumbered now by the urge to produce a representative view of the area, he roamed around the outskirts of the city and carried out some fiery little oil studies. Paintings like *Dusk in the Cuenca Hills* and *Mountains around Cuenca*, both of them executed very swiftly on board, catch the essential pulse of his most heartfelt response to

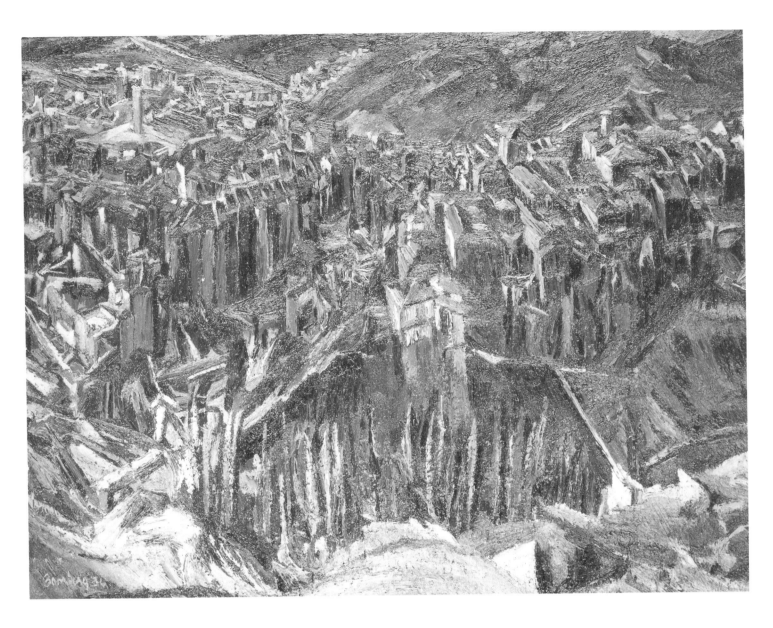

259. David Bomberg. *Cuenca from Mount Socorro*, 1934. Oil on canvas, 73.7 × 94 cm. Private collection.

the Spanish landscape (Plates 260, 261). The brushmarks gain in vigour and certitude as they trace the diagonal thrust of shadows flung across a ravine. Bomberg is at his most spontaneous and personal in these pictures. They convey an intimate sense of identification with the motif, and at the same time retain a firm grasp of the grandeur of the earth as it pulls and strains with an almost volcanic force.

This access of bracing energy and certitude was not confined to his treatment of the land. When Bomberg realized that turbulent weather was approaching, his attention shifted to the sky. In *Storm Fury, Cuenca*, the valley and hills appear almost insignificant compared with the massive disturbances above (Plate 262). The three dark forms gathered on the right of the sky take on a particularly threatening identity, as if Bomberg were tempted to see them as a trio of vengeful figures directing the storm. But the rest of the clouds are also agitated by the muscular stabbing and sweeping action of Bomberg's brush. They have a barely suppressed violence which reflects the artist's inner disquiet as much as the weather he observes, and in this respect they suggest that Constable's cloud studies may have helped Bomberg to use the study of natural forces as a means of expressing his emotional condition. For the turbulence in a Constable sky reflects the strength of the artist's feelings even as it testifies to his penetrating scrutiny of cloud formations. The two elements of the painting cannot be distinguished from each other, and *Storm Fury, Cuenca* anticipates the finest of Bomberg's later works by achieving a similar fusion.

Life was rudimentary in Cuenca. The house was so old that Lilian found a hole gouged out of the wall on the upper floor to let the inhabitants spy on their enemies 'coming up the street'. She kept chickens at the top of the house, where there was a view over the Jucar Valley. They did not enter into the life of the town; but

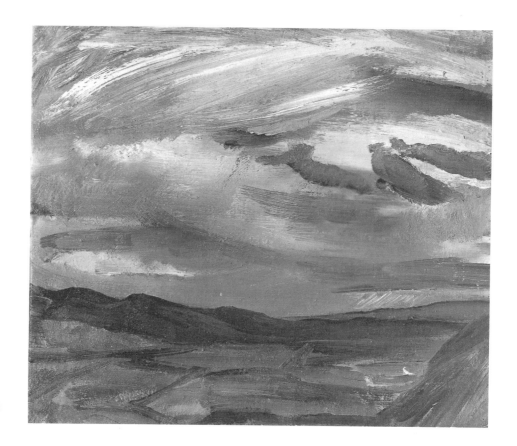

262. David Bomberg. *Storm Fury, Cuenca*, 1934. Oil on canvas, 51.5 × 61.7 cm. Private collection, France.

260. David Bomberg. *Dusk in the Cuenca Hills*, 1934. Oil on board, 31.7 × 40.6 cm. Private collection.

261. David Bomberg. *Mountains around Cuenca*, 1934. Oil on board, 31.7 × 40.6 cm. Private collection.

a photograph survives of an excursion in June 1934 to a place outside Cuenca, where they enjoyed a convivial picnic with a group of wine-quaffing young Spaniards (Plate 263). Posing in a bucolic tableau which has the character of a theatrical set-piece, or even an indirect tribute to Velázquez's great painting *Los Borrachos*, Bomberg looks unusually relaxed. His whole pose exudes a bibulous *bonhomie* which suggests that he savoured the company of Cuenca people on the rare occasions when he was not scouring the countryside for locations to paint. Neither he nor Lilian became part of the community there, however. 'They were all very poor', she recalled, 'and I used to tell the women to read books on birth-control and not have such big families. When I got severe morning sickness, I didn't know I was pregnant – I thought it was fish poisoning. Then I told David I was pregnant, and he said: "We've got chickens, so why not babies?" But having lectured the local people on not having so many children, I thought it was probably best to leave Cuenca!'[8]

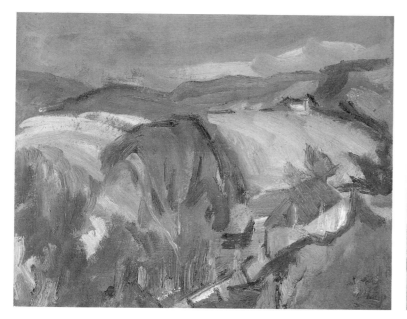

263. Photograph of David (centre) and Lilian Bomberg on a picnic with Spanish friends near Cuenca, June 1934. Collection of the artist's family.

266. Photograph of David and Lilian Bomberg at Cuenca, 1934. Collection of the artist's family.

Before their final departure, an expedition was mounted to meet Dinora's boat at Santander. Her experiences at boarding school in north London had proved harrowing, and so she was reunited with her family in Spain. Waiting for the boat to arrive might have proved irritating to Bomberg, but the countryside there inspired him to paint some of his most direct and lyrical landscapes. Working once again on small pieces of board, a format which so often brought out the best in him, Bomberg managed at nearby Santillana to dispense with inessentials and unite land and sky with the barest of means. In *The Pastures of Santillana* his brushmarks take on a more outspoken life of their own as they course over the terrain. But *Santillana, Northern Spain* is even more remarkable, defining with the minimum of means the elusive identity of a featureless plain and the wispy clouds blowing lightly above it (Plate 264).

The same sense of simplicity and completeness characterizes an equally small study of *Mist: Mountains and Sea, Santander*, where the broad strokes of pigment sweeping across the water give way, above the distant land-mass, to an exuberant display of mark-making in the generous expanse of sky (Plate 265). Here Bomberg's brush declares its presence more openly, perhaps, than ever before in his work. It twists, glides and terminates in little flourishes which convey an irrepressible *élan* without descending into self-indulgence. However much he wanted to give his handling greater eloquence, Bomberg never allowed it to sever all vital connections with nature and become an activity pursued for its own sake.

The paintings executed at Santander and Santillana prove that Bomberg was in a mood to enlarge the expressiveness of his work. But after returning briefly to Cuenca with Lilian and Dinora, he was obliged to confront the problem of his rapidly diminishing finances. The thought of returning to England in order to earn a living darkened the pleasure he had so far derived from his second Spanish trip, and he stared sombrely at the camera when posing for a photograph with Lilian (Plate 266). Where could money be obtained if, as he hoped, the expedition were continued in another congenial Spanish location? The answer lay with Alfred Willey and his trio of wealthy clients in Bradford, who had already proved such enthusiastic collectors of the Toledo and Palestine paintings. Bomberg first wrote to Willey from Cuenca in June 1934, and at the end of the month he received a friendly

reply hoping that 'you have found your form & are really doing some fine work. I think you should as Spain seems to suit your temperament judging from the Toledo I bought from you.' Willey affirmed that 'your Bradford friends are very interested in what comes from the palate [*sic*] of Bomberg while in Spain. I should like you to write Mr Vint (*make it interesting*) he would be very pleased to hear from you.'[9]

Bomberg probably followed Willey's advice, but in the event the other two Bradford collectors turned out to be the providers of the much-needed money. In November 1934 Willey wrote to Bomberg again, thanking him for photographs of the Cuenca pictures and commenting rather warily that 'your painting and subjects seem to me very much like your Toledo & other previous Spanish pictures.' Nevertheless, Willey remained optimistic about Bomberg's future progress. 'Re your desire to go further south & work there', he wrote, 'I think it is a good idea seeing you are in Spain, and with that object in view I have managed to raise a loan of £50/–/– for you.' Willey's letter concluded with a page written by one of the Bradford collectors, Arthur Crossland, who explained that he was sending '£25 from Mr Lingard & £25 from myself'. He added, with doubtless characteristic caution, that the money would take the form of a cheque – 'I dare not send English notes to you as there is a lot of pilfering in Spain.'[10] By the end of the year the money had arrived, thereby helping Bomberg to contemplate spending the next six months painting without undue financial distraction. It was a positive act of patronage on the part of both Crossland and Lingard, even though they would be the first to benefit from the fruits of Bomberg's continuing efforts. 'I shall expect to see some brilliant work after your long rest', wrote Willey in December 1934; 'you certainly are in the most romantic country & probably one of the most picturesque in Europe according to Mr Lingard who has visited Spain . . . quite a few times.' Then Willey presumed to offer Bomberg some advice. 'I will give you a tip, I think I could dispose of a few pencil and chalk drawings *not too sketchy* as my customers seem to prefer fairly *finished work*, however, I leave that to your own judgement, as I do not guarantee sales.'[11]

During the Palestine period, such remarks from a prospective buyer might have tempted Bomberg to adopt a more representational and 'finished' approach. But there is no evidence that Willey's 'tip' influenced the character of the work which Bomberg proceeded to execute once he had settled in Ronda at the end of 1934. Lilian remembered this ancient town from her previous visit and suggested that they move down there. She liked the idea that Ronda was 'near enough to Gibraltar for the baby to be born on British soil',[12] and she also hoped Bomberg would find abundant inspiration in a location dramatic enough to bring out the most forceful and impulsive side of his temperament. Her hopes were amply fulfilled. Bomberg responded very directly to a place he later described as 'the most interesting of the towns of Southern Spain'. He was particularly impressed by its command of 'an extraordinary view of the amphitheatre of mountains by which it is surrounded',

264. David Bomberg. *Santillana, Northern Spain*, 1934. Oil on board, 31.2 × 40 cm. Private collection.

265 (right). David Bomberg. *Mist: Mountains and Sea, Santander*, 1934. Oil on board, 31.7 × 40.6 cm. Private collection, London.

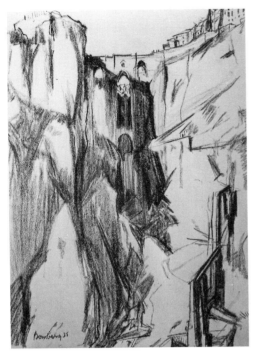

268. David Bomberg. *Bridge and Gorge, Ronda*, 1935. Charcoal. Dimensions and whereabouts unknown.

267. Leslie Marr. Photograph of Ronda, with the bridge spanning the ravine, *c.* 1959. Mr and Mrs Leslie Marr, Scotland.

269. David Bomberg. *Ronda*, 1935. Charcoal. Dimensions and whereabouts unknown.

and drew special attention to 'the gorge – a stupendous rent 250–300 ft wide & 400 ft deep'.[13]

This ravine, splitting in the most spectacular manner the great plateau of rock on which the town itself rests, gives Ronda a wonderfully dramatic identity (Plate 267). Viewed from a distance, where it seems to run like an immense fissure through the otherwise impregnable fortress rising up from the surrounding land, the chasm is arresting enough. But to come across it unawares while walking through the centre of the town is an even more awesome experience. No visible warning is given as visitors approach the bridge. Only when they begin to cross does the sheer plunge to the bottom of the gorge far below suddenly become apparent. The first unexpected look over the bridge makes viewers aware both of the dizzying emptiness beneath them and of the geological violence which must have created such a titanic rupture in the first place. For the hollows of the rock on one side appear to fit into those on the other, suggesting that the breach was originally made by 'a seismic formation either through an earthquake or some other form of movement'.[14] The river Guadalevin, which runs through the gorge, could not, therefore, have carved the rock through its movement. But the longer visitors gaze down into this astonishing abyss, the more conscious they become that its dimensions are being relentlessly extended all the time. One of Ronda's historians has pointed out that 'the depth of the gorge has been made greater and will continue to become deeper due to the erosion from the water of the river.'[15]

Understandably enough, Bomberg derived enormous stimulus from this compelling new locale. Only a few of the drawings he produced there, like a charcoal study of the bridge spanning the chasm, were as 'finished' as Willey would presumably have liked (Plate 268). And even this study becomes progressively more free as Bomberg leaves the top of the gorge far behind, blocking in the ominous shadows cast by the massive boulders. This drawing was probably executed at the beginning of his stay in Ronda, while he was still acquainting himself with the character of the rough-hewn citadel. His admiration for the monumental structure of the bridge, which was designed by an Aragonese architect in the eighteenth century and took over forty years to build, is already apparent. The sheer grandeur of his surroundings may have intimidated Bomberg at first, but other drawings show how imperiously he managed to shake off any lingering hesitation and leave the minutiae of external appearances behind him. The forms of the Ronda rock-face soon become more summary and bare, recalling in their simplified masses the most minimal of his pre-war drawings. In one looming study Bomberg's charcoal reduces the town itself to a small row of buildings teetering perilously on the plateau's edge (Plate 269).

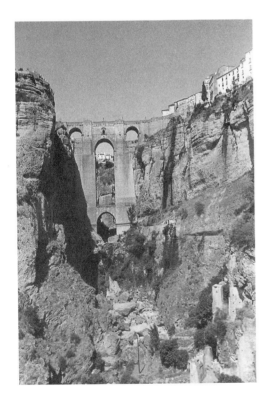

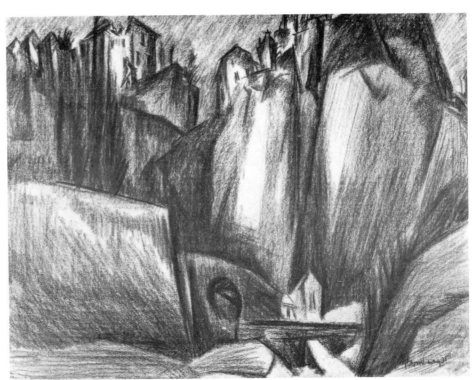

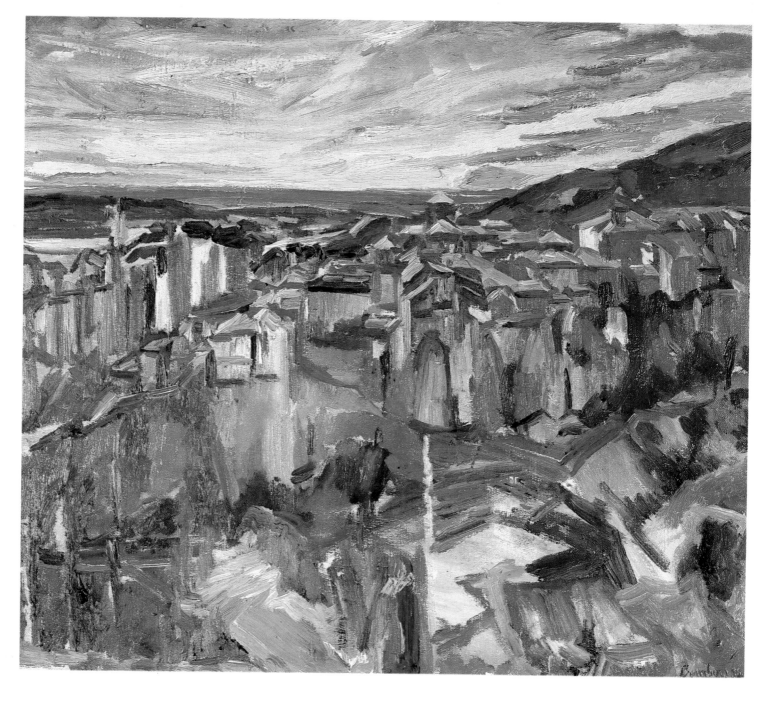

C36. David Bomberg. *Sunset, Cuenca*, 1934. Oil on canvas, 66.5 × 77.5 cm. Private collection, Bradford.

This impressive drawing, which anticipates the studies he was to make of the same rock twenty years afterwards (Plate 366), shows how alive Bomberg was to the precipitous nature of the town. The strains in his own personality led him to suffer from bouts of intense depression in later life, when his spirits would suddenly plummet to depths as gloomy as the lowest recesses of the gorge itself. So it is scarcely surprising that Bomberg's Ronda paintings often thrive on the tension between the defensive fastness of the buildings and their proximity to the fissure running through their midst. Sometimes he saw Ronda as a paradigm of strength, an invulnerable structure carved out of the austere rocky bluff which supports it (Plate 270). On other occasions he stressed its volcanic aspect, revealing how the dizzy plunge of the rift which divides the old part of Ronda from the new town undermines its fortress-like character (Colour Plate 37). But in the most complex of his pictures, Ronda's resolute sturdiness is welded so vigorously to the threat of impermanence that we can no longer be sure where stability ends and vertigo begins. Both extremes are locked in a prodigious balance, as if resolving – for the moment, at least – a similar conflict within Bomberg's own attitude to life (Plate 271).

He invested his Ronda pictures with a far greater charge of structural rigour and emotional energy than any previous British artist had done. In 1834 David Roberts

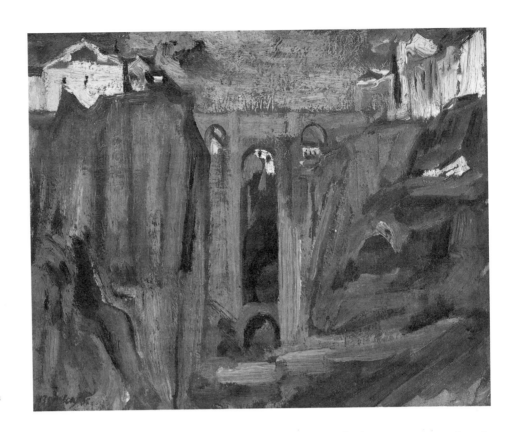

270. David Bomberg. *Ronda Bridge*, 1935. Oil on panel, 31 × 41 cm. Fischer Fine Art, London.

presented it as a grand but essentially placid structure, laid out on a central rock with no signs of the central bridge to disturb the appreciative gaze of the figures posing so decoratively in the foreground (Plate 272). Almost eighty years later, just before the First World War, William Strang executed an etching of the *Plaza Mayor, Ronda* which presents the town as a quiet, picturesque backwater unlikely ever to be disturbed by the convulsive vitality stressed by Bomberg (Plate 273).[16] Even Paul Nash, who made a watercolour entitled *Moorish Ruin, Ronda* only a year before Bomberg settled there, produced a quiescent image of the site (Plate 274). Although Nash gives his freestanding lump of overgrown masonry a strain of Surrea-

271. David Bomberg. *Ronda, Andulusia: The City above Tajo*, 1935. Oil on canvas, 67 × 76 cm. Fischer Fine Art, London.

272. David Roberts. *Ronda*, 1834. Watercolour, 23.5 × 33 cm. Tate Gallery, London.

273. William Strang. *Plaza Mayor, Ronda*, 1913. Etching, 25.4 × 34.3 cm. Glasgow Art Gallery and Museum.

274. Paul Nash. *Moorish Ruin, Ronda*, 1934. Pencil and watercolour, 25.4 × 17.8 cm. Graves Art Gallery, Sheffield.

list mystery, as he meditates on the vicissitudes undergone by Ronda during its long and complex history, his watercolour is still notable for its reticence.

Compared with these diverse yet calm interpretations, Bomberg's vision of Ronda was tumultuous indeed. He saw the town not from the vantage of a detached observer, simply employing it as a springboard for a pleasant exercise in nostalgic reverie, but from the standpoint of a profoundly engaged imagination which viewed Ronda as a living force. Instead of distancing himself and regarding it as nothing more than a theatrical backdrop, he ensured that many of his Ronda paintings lead us towards the rocks and press our eyes hard against them. In the powerful and thunderous *Sunset, Ronda, Andalucia* a richly coloured evening light emblazons the thin strip of sky straggling across the top of the composition (Colour Plate 38). But down below, most of the canvas is occupied by a brooding, darkly shadowed cliff-face. Only after adjusting to the gloom can we detect the thrust and counter-thrust of its rugged crags and clefts, all of which appear to be animated by an eruptive awareness of the rock's inherent dynamism.

Not all Bomberg's Ronda pictures were permeated by this volcanic strain. A large drawing which pushes us up against the formidable rock, leaving even less room for the sky above, is softer in feeling and gains warmth from his vigorous finger-rubbing of the charcoal (Plate 275). Unlike the Toledo period, when Bomberg concentrated almost entirely on painting, the stay at Ronda prompted him to resume drawing on an ambitious scale and produce images as substantial in their way as his works on canvas. By this time Bomberg always regarded his landscape drawings as independent works rather than studies for paintings. Lilian, who recalled that 'he would have very good handmade paper and pin it up on board', explained that Bomberg never used a sketch-pad because he 'didn't need to sketch – he had an enormous capacity to size up what he wanted and do it quickly'.[17] According to Lilian, most of the Ronda paintings were executed in little more than a couple of hours' intensive work, and she believed that even the two versions of his most elaborate Ronda canvas were probably completed in the same week.[18]

Painted on 'a mountain ledge three miles from Ronda across the valley',[19] this confident and carefully organized design is Bomberg's most panoramic view of the town (Colour Plate 39). It also presents the rock-face as a more stable structure than the turbulent alternatives he painted on other canvases. Lit by a brazen afternoon sun which strikes the cliff so forcibly that every segment glows with heat, this majestic *Ronda* celebrates the full imposing magnificence of a scene which clearly enthralled Bomberg. His response was as ardent as the burning range of yellow, orange and ochre which threatens to engulf the house at the base of the rock in a mass of scalding foliage. The terrain behind is hardly less heated. Bomberg's brush charts the dips and swellings of the land as it leads up to the great cliff-face, and his mark-making transmits the very pulse of his excitement. Some passages assume a zig-zag identity which recalls the stark scaffolding of his pre-war work, but now they arise directly from a passionate apprehension of nature. Their darting movements shoot through the landscape like a series of nervous tremors, suggesting that even in this magisterial and seemingly unshakeable image, the heat boiling beneath the earth's crust might one day burst through and overwhelm Ronda in an inferno of boiling lava. No wonder the artist himself once referred to the canvas as *Red Ronda*.[20]

Bomberg's paintings of the town and its setting gain much of their force from his ability to suggest deep-seated tensions even as he asserts order with a sense of imposing finality. Although a canvas like *Moorish Ronda, Andalucia* is modest in size, its austere construction and unusually subdued range of black, grey, umber and pale green implies an edifice of daunting dimensions (Colour Plate 40). His imagination was ignited by Ronda, and his awareness of its darker side did not arise solely from a contemplation of the sites he painted. For the Bombergs were always acutely conscious of their position as outsiders in a city where any strangers or foreigners were automatically regarded with suspicion. Lilian remembered that it was a 'primitive Catholic community and we were like Martians. Our colourful clothes contrasted with their dark garments. Apart from Tristram Rainey, a painter who passed through, no other artists were there. We didn't make friends with the Spanish. David had no gift for languages and spoke only in English.' The most distressing outcome of this social isolation was that 'stoning by children happened quite a lot', especially when Bomberg and Lilian set out on their regular journeys

276. David Bomberg. *Dark Street, Ronda*, 1935. Oil on canvas, 77 × 59 cm. Private collection, Bradford.

to a painting site. Such experiences may well have helped to ensure that some of the Ronda paintings are more embattled in mood than his earlier Spanish canvases. Time and again they explore the town at the end of the day, when shadows threaten to turn both the buildings and the rocky bluff into a sombre, menacing silhouette. In a remarkably simplified painting called *Dark Street, Ronda*, Bomberg invites us to explore the brooding recesses of an ancient quarter where sinister presences might lurk in the deep purple road stretching towards a mysterious distance (Plate 276).

Bomberg became so fascinated by the town after dark that he made a habit of painting at night. Working from the first-floor balcony of his house at 9 San Juan de Letran, in the old part of Ronda, he set up his easel to paint a nocturnal religious procession as it wound through the streets below him. As a result, three paintings of *The Procession of 'La Virgen de la Paz'* were executed, and the unusual degree of freedom displayed in their handling arose from Bomberg's extraordinary decision to dispense with conventional sources of light. 'He painted them one after the other, very quickly, while the procession was on', Lilian remembered. 'Dinora and I got candles, but David didn't want them and he worked in the dark with only the lights from the procession itself. We all had to be very silent while David painted.'[21] The flickering illumination provided by the passing torches must have been fitful, and most painters would never have contemplated such an unpredictable procedure. But Bomberg, who had already worked beneath the moon at Jerusalem (Plates 191, 192), was adventurous enough to experiment with this erratic source of light. At least one of the canvases he produced is a surprisingly eloquent interpretation of the event, with boldly handled brushstrokes summarizing the ghostly figures who file past facades treated in an equally simplified manner (Plate 277). Bomberg would have been familiar with Pissarro's painting of *Paris, The Boulevard Montmartre at Night*, acquired by the National Gallery in 1925 (Plate 278). But he strives for a more radical dissolution of form than Pissarro, and *The Procession of 'La Virgen de la Paz'* anticipates in its bold declaration of impasted pigment the looser approach which Bomberg developed later in his career. The comparison with Pissarro also reveals how fascinated Bomberg became by the eeriness of the scene. The Impressionist's Parisian boulevard is a lyrical celebration of the city at night, whereas the excitability of the phantoms who fill Bomberg's canvas with their frenetic movement conveys the disconcerting impact of this strange, centuries-old ritual as it holds Ronda in its thrall.

The six months he spent in the town amounted to a productive period. Some of the paintings executed there look coarse, over-hasty and unresolved, but they were the inevitable price Bomberg paid for pursuing an audacious path and working at speed. Lilian, who explained that 'at Ronda he painted day after day, without much of a pause', described how Bomberg refused even at the beginning of a picture

275. David Bomberg. *Ronda*, 1935. Charcoal, 46.5 × 60 cm. Private collection, London.

C37 (facing above). David Bomberg. *The Moor's Bridge, Ronda*, 1935. Oil on canvas, 51 × 66 cm. Fischer Fine Art, London.

C39 (facing below). David Bomberg. *Ronda*, 1935. Oil on canvas, 73.7 × 91.5 cm. Private collection, France.

277. David Bomberg. *The Procession of La Virgen de la Paz*, 1935. Oil on canvas, 61 × 50.8 cm. Lady Dacre, Cambridge.

278. Camille Pissarro. Detail of *Paris, The Boulevard Montmartre at Night*, 1897. Oil on canvas, 53.3 × 64.8 cm. National Gallery, London.

279. Photograph of Bomberg with Dinora holding the baby Diana, Ronda, 1935. Collection of the artist's family.

to draw its outline. 'He wouldn't make linear marks – he worked direct in the paint', she recalled. 'He would work all over, as a unity. And he'd always know when to stop. He was intuitive. If he wasn't satisfied he'd paint it out and then paint again: he wouldn't come home until he had something to bring home. In the evening, back at the house, he would look at the work he'd done that day.'[22] It was an arduous and singleminded way of life, and Bomberg must have sensed that the increasingly broad and uninhibited handling of the Ronda canvases marked the onset of a new period in his development. When he wrote to Alfred Willey in the spring of 1935 describing his progress there, the reply from Bradford expressed curiosity about the direction Bomberg was now taking. 'I shall be interested to see this new phase of your work you mention in the letter', wrote Willey, 'as personally I don't think your Cuenca work is any advance on your Toledo period, neither do my clients, anyway you should be the best judge and I am sure you have enough creative ability in you to show that neither Toledo or [*sic*] Cuenca is your summit.'[23]

Uneven though they were, the Ronda paintings proved at their best that Bomberg had indeed been able to 'advance' on his Cuenca work. But he only managed to achieve this development in the teeth of continuing hardship. Although Willey promised in his letter to send some more money from the Bradford collectors – most notably from Arthur Crossland, who had purchased the large painting of *Cuenca from Mount Socorro* (Plate 259) – the Bomberg family still had to battle against ever-present hunger and rudimentary living conditions which threatened the safe delivery of Lilian's baby. Lack of funds obliged her to abandon the plan to give birth in a Gibraltar hospital, and towards the end of May she realized that the baby was about to be born in their ramshackle house. She later remembered that the local midwife, Ignacia Diaz, was extremely old, and when the baby was due,

> David leant out of the window and spoke to the nightwatchman, asking him to go to the midwife. He came back with a message that she wasn't well and couldn't come out on this cold night. I didn't know what to do. So I said to myself: 'I can't have the baby', and held it back. Then the house-help in the morning suggested another midwife. She came at midday, and turned out to be about sixty. David was very worried and frightened all the way through. The baby was born purple and black because she was tangled up with the umbilical cord – nearly dead through lack of oxygen.[24]

But little Diana survived and Dinora, then aged eleven, was delighted to have a baby sister (Plate 279). As for Bomberg, his reaction was joyfully expressed in a letter to John Rodker. 'It is good news I have to write', he began, announcing the birth. 'The baby will be two weeks old next Wednesday, both mother and child are robust and we are all happy the confinement has been such a success,

in face of the difficulties that surrounded us at the beginning.' Bomberg had never fathered a child before, and there must have been times when he wondered if he would ever be able to. Now Diana had arrived, his pleasure was boundless. 'The baby we got is the loveliest thing one could wish for', he told Rodker. 'I note Lilian's eyes in my sort of head and Lilian's hands. Diana crosses its little feet just in the way I cross my big ones, she behaves more like a baby of six months, her expression in repose is serene – except of course when she is being bathed. Then she halloos [?] just as I do when I am cross' (Plate 280).

280. Photograph of Bomberg with the baby Diana, Ronda, 1935. Collection of the artist's family.

281. Photograph of Bomberg with Dinora and the baby Diana carried on the donkey, Ronda, 1935. Collection of the artist's family.

Bomberg ended this uncharacteristically personal letter by informing Rodker that 'we will be leaving Ronda at the end of June for some warmer spot', because 'we have had weeks of cold and rain.'[25] But apart from the vagaries of the Ronda climate, Bomberg's departure was hastened by his inability to pay the rent. A photograph survives of Bomberg and Dinora with a donkey, and baby Diana sitting in the panier protected by an umbrella (Plate 281). Bomberg looks happy enough smiling for the camera, but Dinora's thin arms show how lacking in food they really were: she remembers going to pick wild berries in an attempt to fill herself up. 'Then David and I had a row about having a baby with no money', recalled Lilian, 'and I threatened to pack up and leave. So he picked up the baby clothes and threw them out of the window. David was hysterical: money problems always drove him mad. Dinora only had one summer dress – a green one which gradually became white as I added more bits on.'[26] But despite their outspoken disagreements, Lilian and Bomberg were by now enjoying an enormously close relationship. He relied very heavily on her help looking after him, assisting with his equipment on painting expeditions and providing him with incessant understanding and encouragement. Lilian was sustained above all by her profound admiration for his work, and a desire to nurture its creator. 'Looking back, I think David was with me like a child with its mother', she reflected afterwards, adding: 'That was satisfying to me.'[27]

After sending the Ronda works back to England, the Bombergs travelled north towards the Asturian Mountains. In July 1935 they walked up the valley of La Hermida to the tiny settlement of Linares, and Bomberg soon found himself astounded by the rugged beauty of this isolated region. He wrote later:

> There is a winding road into these mountains from Santander which was meant to bring life & prosperity to the mountain villages. It glides away across the plains – it climbs the mountains as it winds through the passes, running along the precipitous ledges, up awesome gorges & over the mountain tops, onwards to the villages to a life so far removed from that of the plains some 50 miles away. But commerce did not take this road – it could not follow so adventurous a path into the mountains – it built for itself a longer & less hazardous way – & left the older, higher road to the solitude of the heights, the peasants, & their cattle. When I searched the Picos de Europa for an entry to paint its wonder, how glad was I of this road, for it climbs in one place the outer heights of the Picos & runs through a clustering village, steeped at times in rain clouds, at times shimmering in the sun. Here I persuaded the mountain peasant to share his rare spacious farmhouse with my self & small family.[28]

To everyone's delight, the farmhouse rent also provided them with an adjoining stable and donkeys. But it was a difficult time. On painting expeditions, Lilian had to go down the winding path from the farmhouse with a donkey carrying provisions, equipment and the baby. So Bomberg sometimes went off to work by himself, and once spent a couple of weeks on a lone expedition 'to climb the Naranco de Bulnes – the highest point in the Peaks'. He declared afterwards that 'although I have painted in many strange & inaccessible places, one of the most memorable weeks of my painting life' occurred during this trip. But the journey was so gruelling that it nearly killed the donkey, and yielded nothing in terms of finished paintings. Conditions in the highest areas of the region, where Bomberg thought he would gain his greatest inspiration, were so extraordinarily primitive that they frustrated his desire to concentrate on a sustained period of work. He recorded later that

> Though it is generally known that Spain was fifty years behind Europe, it is not known even by the Spanish that these villages were many hundreds of years behind Spain – They seem to have retained the costumes, customs & forms of

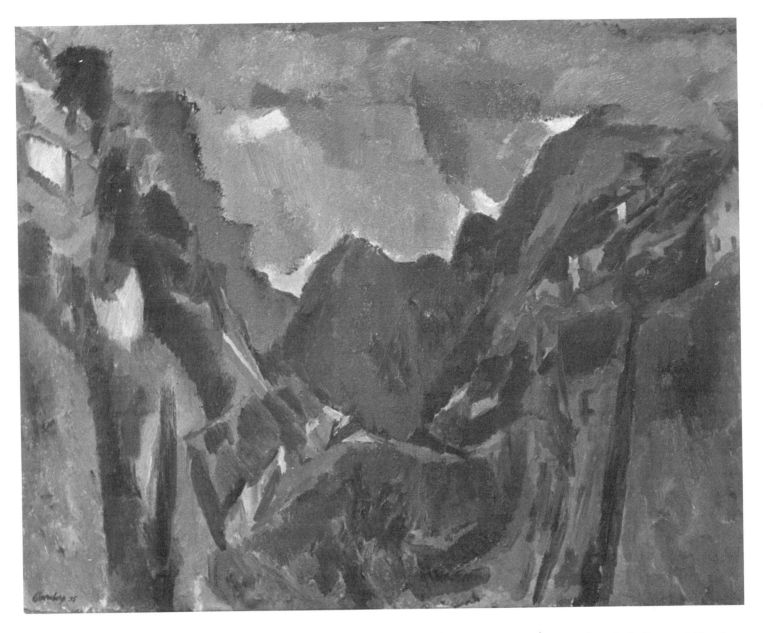

282. David Bomberg. *Storm over Peñarrubia*, 1935. Oil on canvas, 76.2 × 96.6 cm. Harry Barr, London.

production from the earliest medieval times. Here the Black Gowned Shepherdesses, their heads swathed in bands of black cloth, shear their sheep, spin the wool with the most primitive implements known & knit the thick traditional woollen sock to keep out the soaking moisture of the Pastures, which are more often lost in the rain clouds than seen against the clear skies.[29]

During the four months Bomberg spent in the Asturian Mountains, he had plenty of opportunity to study these turbulent climatic conditions. In *Storm over Peñarrubia* the advent of thunderous weather was caught on a large-scale canvas, and executed with a greater verve and economy than his earlier Spanish paintings had achieved (Plate 282). The cloud-heavy sky is in a state of flux, and its movement also animates the broken forms of mountains where the dampness of newly fallen rain still seems to glisten. But even though Bomberg is studying a momentary phenomenon, wielding his brush with a spontaneity which accentuates the transience of the storm, he gives the image considerable substance and monumentality as well. For all their vitality, the tumbling clouds are lodged securely within a composition of immense craggy grandeur.

He was just as alert to the splendours of the mountain range when the storm disappeared and the full brilliance of Spanish light reasserted itself. Painting from the balcony of the farmhouse he had rented,[30] he conveyed the heat and stillness of the scene in another large painting called *Sunlight in the Mountains, Asturias* (Plate 283). Bomberg's handling here takes on an encrusted thickness which emphasizes the tranquillity and primordial solidity of the landscape. The tree on the right of the painting appears to sag in a listless curve for want of wind, and the foreground house has almost become merged with the shimmering vegetation on the hillside

216

beyond. A sensuous heat-haze hangs heavily over the entire picture, reflecting Bomberg's own contentment as he surrendered to the pleasure of being alive on a fine day in Linares. The view from his balcony was capable of inducing an exalted mood in him, and he expressed some of this delight in a retrospective description which celebrated the act of looking 'across the valley to the grand panorama of the central peaks with its little villages set like jewels in the mountain pastures.'[31]

The biggest of all his Spanish paintings was even more remarkable. Fusing the dynamism of *Storm over Peñarrubia* with the stability of *Sunlight in the Mountains*, Bomberg managed to define both the brooding turbulence and the light-filled splendour of the *Valley of La Hermida, Picos de Europa, Asturias* (Colour Plate 41).[32] He painted it 'from the side of the mountain on which Linares was situated',[33] gazing down at the dizzying immensity of the ravine as its steep sides plummeted to the valley floor far below. Bomberg's brushmarks give full vent to his awareness of the threatening aspect of the mountains on the left, covered in a disconcerting purple and maroon gloom. But this shadowy area is dramatically enlivened by great shafts of pink and orange sunlight, thrusting down from the hill-top like lances piercing the dark. They shoot towards the opposite hillside and ignite it in a flaring mass of loosely applied pigment, brushed in with greater softness than their counterparts on the other side of the valley. The brightness of this huge golden mountain is so refulgent that it seems to shine back onto the opposite wall, where a flurry of light, broadly applied strokes are scattered over the penumbral slopes. The whole canvas, from the base of the valley to the distant, cloud-covered peaks and clouds rendered in the richest impasto of all, is alive with Bomberg's marvelling apprehen-

283. David Bomberg. *Sunlight in the Mountains, Asturias*, 1935. Oil on canvas, 72.4 × 91.5 cm. Howard H. Manning.

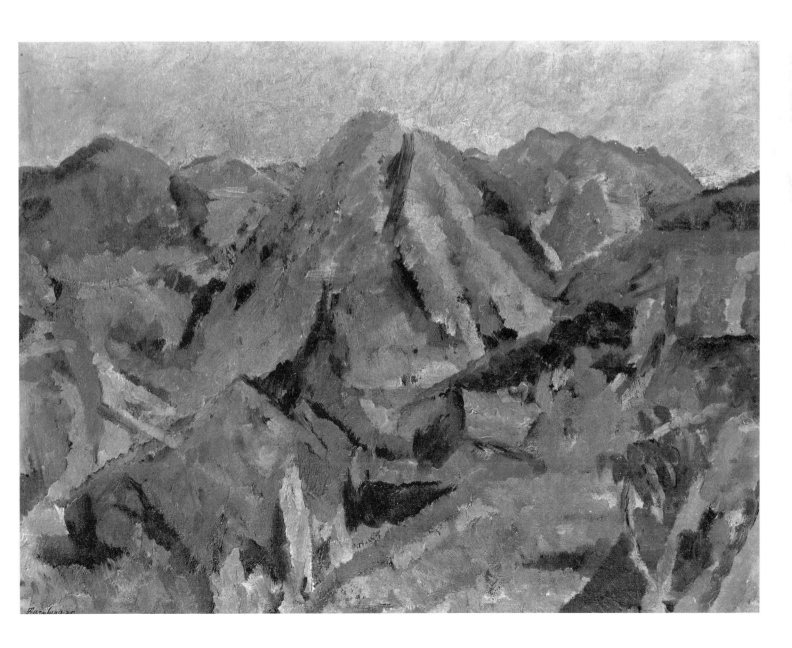

sion of a landscape ideally suited to his ardent temperament. It is the outright master-piece of his second period in Spain.

Bomberg worked brilliantly in the Asturias, bringing his expedition to a memorable climax. His sensibility seemed to be fully liberating itself after years of struggle, uncertainty and inhibition, and Lilian recalled that 'we were hoping the work would be a continuous progression towards freedom during this period.' But just at the moment when full confidence had at last been attained, Spain's political turmoil intervened. 'On the way up we'd already been aware of civil unrest', remembered Lilian, describing how the walls of the Town Hall at Oviedo had been punctured by newly fired machine-gun bullets. By the end of October 1935 they reluctantly acknowledged that the internal dissension in the country was worsening, and that a full-scale civil war was about to overwhelm everybody. 'At Linares we began to be fearful that people might loot us – they thought our equipment showed that we were rich', Lilian related. 'One day Dinora came back and said the other children were crying because their parents knew the revolution was coming and they were trying to arm themselves. So we were frightened of being attacked, and decided to move out quickly.'[34]

Within forty-eight hours of hearing Dinora's story, Bomberg and his family had packed up and left their mountain farmhouse. They made the move just in time. Arriving at Santander for the voyage home, they obtained berths on a small cargo boat which only carried about twenty passengers. It turned out to be the last boat leaving for England before the Civil War broke out. Dinora described how, on this bitterly cold November day,

> a very overwrought young English teacher stood on the quayside insisting that 'I must stay – I've got to stay.' David and Lilian tried to bring her to the boat, but she wouldn't come. When we got on board, anxious about our own safety and the Spanish people we had left behind in the Asturias, our fears increased when we realized the crew were all German. Aware of the growing anti-semitism in that country, Lilian said: 'I hope they don't harm David.' She became even more worried when David was put in a separate cabin. Lilian and the baby Diana were sent with me to another berth. It was all very rudimentary, and as soon as we left port a severe storm blew up. It got worse in the Bay of Biscay, so Lilian tied Diana to her bunk to secure her. We were seasick continuously for two days and two nights, too ill to leave our cabin and find out how David was being treated. But the boat finally reached calmer waters as we approached England, and although David had also been terribly ill we found out that the crew had looked after him magnificently.[35]

------

The sporadic and uneven character of Bomberg's work over the next few years suggests that the sudden interruption of his painting at Linares was a considerable blow. It broke the momentum he had established in Spain, and forced him to return to a country where he felt increasingly ill-at-ease. Back in London Bomberg experienced great difficulty in regaining the sureness and vitality which had distinguished his work during the Asturias period, and he followed the calamitous events in Spain with growing horror. Some months after his return he wrote an unpublished memoir of the expedition, commencing it with a heartfelt passage devoted to the plight of the Spanish people. 'Whoever has lived in the Picos de Europa, Asturias, will comprehend the magnitude of the suffering in store for all those who have sought refuge in these mountain fastnesses', he wrote.

> Even in times of peace the frugality & meagreness of life among the peasantry on these heights, born & bred here as they are in a tradition of hardship, is only just bearable. With the flight to these mountains of the *12,000* inhabitants of the recently bombed & destroyed village of *CANGAS de ONIS* – the last point before the ascent at Cavadanaga – together with the inrush of the retreating refugees from the surrounding country to the three other points of entry to the Central Peaks, commences a story of suffering almost incomprehensible to the people of this country.[36]

Although Bomberg felt profoundly grateful that he had evacuated his own family just in time, the tragedy of the Spanish Civil War haunted him still. So must the thought that he would, in more propitious times, have been able to prolong his

Spanish period and continue working in a country which offered him a stimulus London could not provide.

Immediately after his return, the perennial problem of financial support began once more to exert its pressure. After establishing himself and his family at a terraced house in Cavendish Road, a quiet area of north-west London, he tried hard to resolve the question facing so many adventurous painters in this decade of Depression: was it at all possible to earn a living without devoting the greater part of your energy to a job which had nothing to do with art? During the course of 1936 Bomberg despatched a fusillade of letters to people and institutions he hoped might help. The response was uniformly discouraging. Charles Holden, who had previously commissioned Epstein, Moore, Gill and other sculptors to make carvings for his buildings, declined Bomberg's offer to provide a 'mural decoration' for the new London University Senate House building.[37] Soon afterwards he wrote a letter to the Publicity Manager of the LMS Railway Company proposing to paint pictures of 'the ancient monuments of Britain' for the decoration of the Company's trains and waiting rooms. Reproductions of the paintings could replace 'those photographs exhibited in the Railway Company wall panels', and Bomberg argued that 'a good colour reproduction of a fine spirited oil painting would do much to dispel that travel gloom some of us feel in making that weekly or monthly journey to the North.'[38] His ambitious suggestion was not accepted, and a similar fate befell a letter to the Cunard White Star Company proposing 'a group of decorative panels' for 'the sister ship to the "Queen Mary".' Bomberg offered to concentrate either on the national monuments 'most outstanding in historic interest & beauty', or on 'subjects of a closer & more intimate social nature dealing with the life of present-day Gt. Britain'.[39] But the response was again negative, and he had to content himself with a one-man show at the Cooling Galleries in June 1936.

This exhibition, *Recent Paintings of Spain by David Bomberg*, contained a comprehensive display of his work from Cuenca, Ronda and the Asturias. The most appreciative review came from the *Jewish Chronicle*'s critic, who rightly warned that 'those who want souvenir landscapes are likely to be disappointed, for Bomberg has an individual vision. Most of his landscapes convey the impression one gets with half-closed eyes. At a first glance they are confused; gradually, as when one gets used to dazzling sunlight, they take form and at last their essentials are planted in the mind.'[40] After experiencing initial disorientation, the critic had spent enough time with these paintings to discover their fundamental coherence. But few other reviewers were prepared to make that commitment, let alone publish their reactions in newspapers or magazines. The only other supportive review came from the *Manchester Guardian*, claiming that Bomberg 'is an artist whose works cannot fail to interest anyone who is open to receive an individual inspiration and to realise the aims and ideals expressed in often revolutionary terms.'[41] Bomberg must have been heartened by such open-minded sympathy, but the brutal fact remained that not a single picture was sold at the Cooling exhibition.[42] It was, as he told his old friend Sir Ronald Storrs, 'a "flop"',[43] and the gallery's astounded owner told Lilian that 'he'd never had an exhibition which didn't sell anything before.'[44]

Bomberg was able to draw some consolation from the interest shown by Kenneth Clark, the young Director of the National Gallery, who thanked him for the invitation to visit his studio by replying that 'I remember your work perfectly, especially the war picture you painted for the Canadian gallery, and I should much like to see what you have been doing in the last few years.'[45] Bomberg would also have been cheered by the news that he occupied a prominent place in the large exhibition of Wyndham T. Vint's collection, held at the Bradford City Art Gallery in July 1936. The *Yorkshire Post* reported that 'the most favoured artist in this collection, if we go by numbers, is David Bomberg, who has as many as twelve places.'[46] Other artists occasionally sent him messages of friendship: Winifred Nicholson, remembering no doubt their Lugano expedition fourteen years before, invited him to a party celebrating the opening of her summer exhibition at the Leicester Galleries and added that 'I'd like to see you so much again.'[47] Nevertheless, Bomberg could hardly be blamed for feeling despondent about the Cooling exhibition's humiliating lack of success. Although he knew that a significant development had occurred in his work during the recent Spanish expedition, no one seemed prepared to pay anything more than lip-service to that achievement. No wonder he yearned to leave England again, wondering in July whether it might be possible to organize 'a party

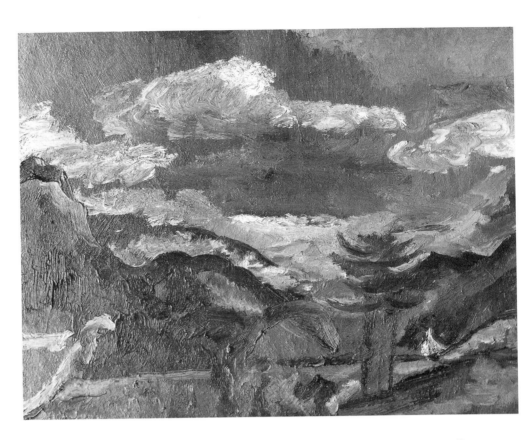

284. David Bomberg. *The Valley of Beddgelert, North Wales*, 1936. Oil on canvas, 50.8 × 67.3 cm. Art Gallery of South Australia, Adelaide.

of Painters in a visit to Burma, spending a fortnight at each Port en route'.[48] But Bomberg could not possibly meet the £100 cost of a return ticket, and he must have longed to accompany his large *Ronda* canvas when the British Council included it in a touring exhibition of *Contemporary British Painting* culminating at the National Gallery of Canada (Colour Plate 39).

The only trip he could afford was a month in North Wales with Lilian during the summer of 1936, staying in the mountainous country around the little village of Beddgelert. 'He enjoyed it from the painting point of view, but rain prevented him from working much', recalled Lilian, describing how appalling weather forced them to abandon their dilapidated cottage and move into a tent. Without blankets or sleeping-bags, they 'huddled together' and 'slept on bracken under the ground-sheet. Physically it was gruesome.'[49] So the expedition yielded disappointingly little, apart from a lyrical canvas of *The Valley of Beddgelert* (Plate 284). Although it lacks the fiery attack and headlong confidence of the best Spanish paintings, this modest picture has a freshness of response and handling which marks it out from his other Welsh landscapes. Despite the cloud-laden sky, Bomberg gives the image a tenderness and delicacy rare in his work of this period. One reviewer singled it out as 'a lovely painting' from an exhibition Bomberg held with Horace Brodzky and Marguerite Hamerschlag at Foyles Art Gallery in January 1937. The same writer had the opportunity to talk about the painting with Bomberg at the show, and reported that the artist himself 'called it, as Rossetti did a sonnet, "A Moment's Monument".' It was painted, he told me, after he had been in camp in the valley for five days of ceaseless rain and mist. Then suddenly the sun broke through, and his joy found expression in the little touches of pink and yellow that are interwoven in the clouds.'[50]

By the time the Foyles exhibition was open, Bomberg had been re-elected to the London Group after more than a decade of lapsed membership.[51] He threw himself into the Group's activities with a vigour sharpened by his growing anxiety about the menace posed by Fascism both in Spain and elsewhere in Europe. Although he still shied away from expressing any overt political concerns in his work, Bomberg was prepared to recommend the adoption of a hard anti-Fascist policy by the London Group's members. At their annual general meeting he proposed that they 'be prohibited from exhibiting with reactionary groups; that the London Group . . . consolidate with the AIA and Surrealist Groups in their support of Anti-Fascism in politics and art; that funds be granted for Spanish Medical Aid; and that Honorary Membership in the London Group . . . be extended to certain left-wing poets and writers'.[52]

220

Although these radical suggestions were turned down by the meeting, Bomberg was certainly not alone in his increasing determination to condemn the Fascist threat. In his case, hatred of Fascism had been accentuated by the appalling tragedy of Spain, where the cities and people he admired so much were embroiled in a desperate internecine struggle. But his feelings were shared by a wide range of British artists, writers and intellectuals, many of whom committed themselves to fight in the Spanish Civil War. Bomberg, by now in his late forties, stopped short of returning to Spain as a soldier. Most of the English volunteers were young men, and his new responsibilities as the father of a baby girl must also have helped him to decide against any active participation in the conflict. When the London Group's 1937 exhibition was held, however, the *Evening Standard* reported that Bomberg displayed 'a Spanish picture which is an interesting document of the war. It shows a mountain which is swarming with thousands of refugees from the bombing of Cangas de Onis. The name of the mountain is not disclosed in the title of the picture for fear of giving information to the enemy as to the paths – only four in number – which lead there.'[53] The picture has since been lost, but it must have been startlingly at variance with most of Bomberg's contemporaneous work. Figures are usually conspicuous by their absence from his landscapes, so his sudden readiness to cover

C38. David Bomberg. *Sunset, Ronda, Andalucia*, 1935. Oil on canvas, 66.7 × 76.2 cm. Fischer Fine Art, London.

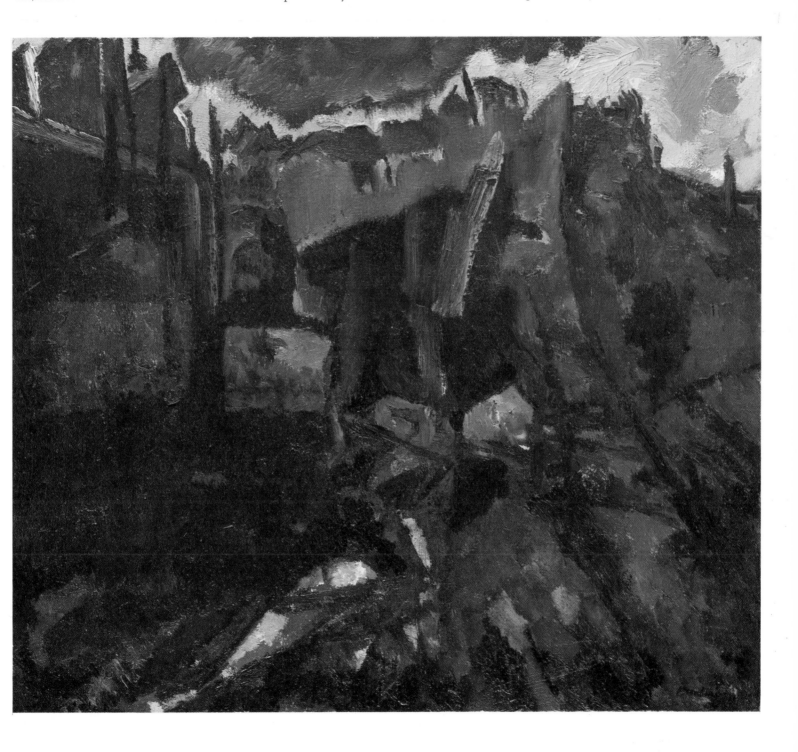

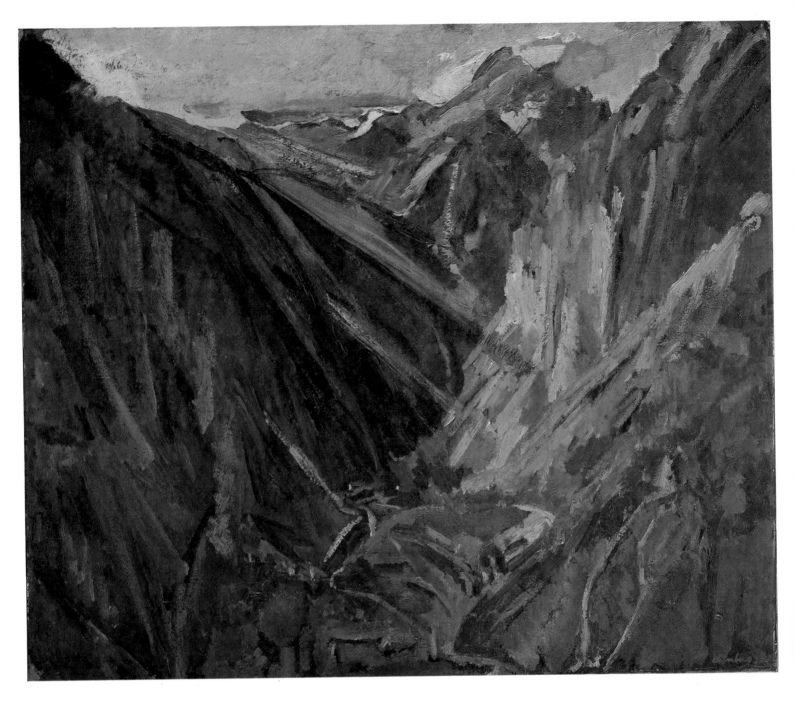

C41. David Bomberg. *Valley of La Hermida, Picos de Europa, Asturias*, 1935. Oil on canvas, 91 × 107.1 cm. Sheffield City Art Galleries.

C40 (facing above). David Bomberg. *Moorish Ronda, Andalucia*, 1935. Oil on canvas, 66 × 61 cm. Ivor Braka Ltd, London.

C42 (facing left). David Bomberg. *Self-Portrait*, 1937. Oil on board, 61 × 50.8 cm. Colin St John Wilson, London.

C43 (facing right). David Bomberg. *Self-Portrait*, *c.* 1937. Oil on canvas, 75.5 × 55 cm. Scottish National Gallery of Modern Art, Edinburgh.

a mountainside with fleeing crowds shows how deeply concerned he must have felt about their plight. The undefiled countryside which Bomberg had painted with such eloquence in the Asturias had now been disrupted by a fearful conflict, and his decision to depict this event anticipates the urgent interest he was to take in war art when Fascism threatened to invade his own country at the end of the decade.

Apart from worrying about the turmoil in Spain, Bomberg also became increasingly involved with the pressing question of how the visual arts in Britain could best be supported by state patronage. Intrigued by the financial aid which the American government offered its artists, he wrote to Kenneth Clark at the National Gallery proposing that a similar scheme should be initiated by the English government. Clark replied in February 1937, wholeheartedly agreeing that 'there should be something in England equivalent to the United States Federal Art Scheme.' Indeed, he went on to reveal that 'when I was in Washington last time, I was so much impressed by this that I got all the particulars of the American Scheme with a view to submitting it to the Government here.' But Clark did not sound at all positive about the prospect of action. 'I am afraid there is not much hope of anyone taking an interest in it', he went on. 'After all, far more influential people than I have tried for years to get the Government to support a national theatre or a national opera without any success, and I imagine that both these would have more appeal than a Federal scheme for artists.' Clark did not offer any more grounds

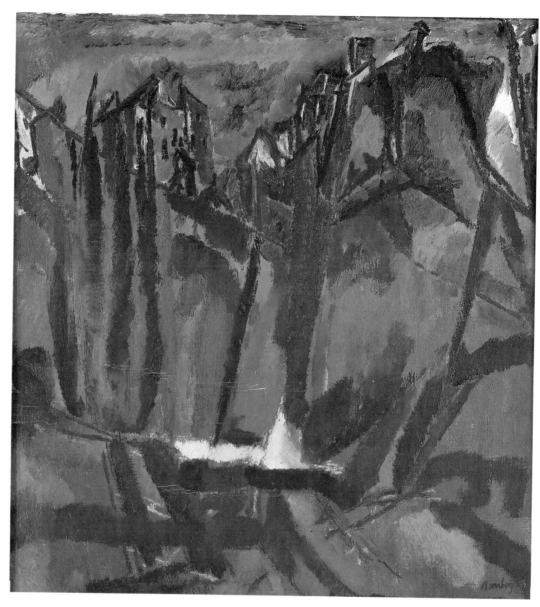

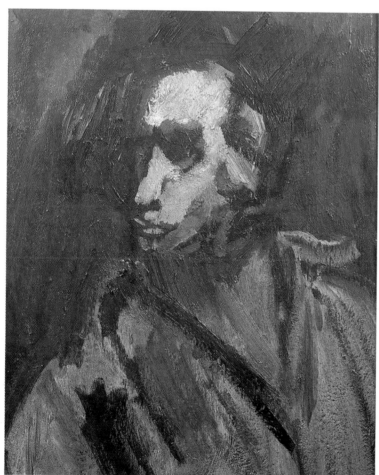

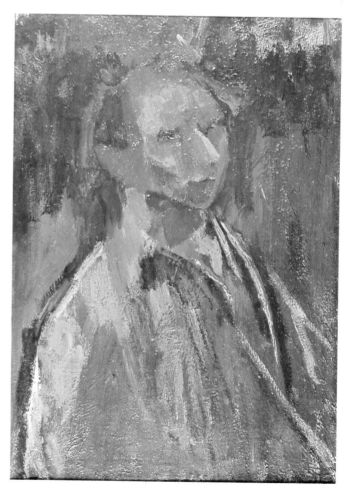

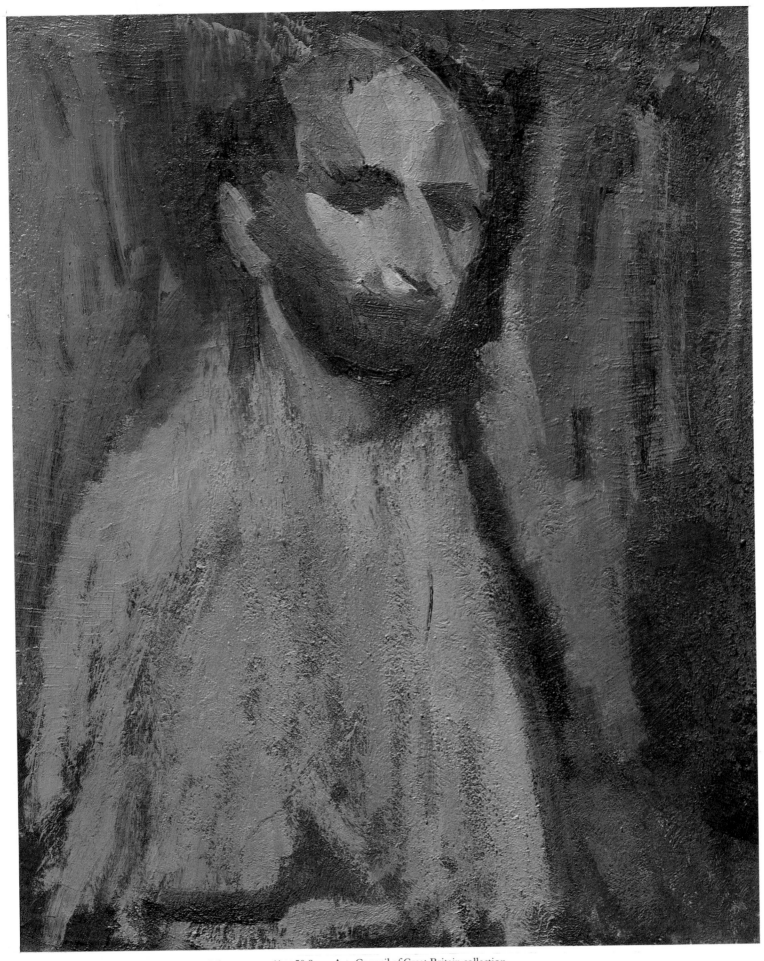

C44. David Bomberg. *Self-Portrait*, 1937. Oil on canvas, 61 × 50.8 cm. Arts Council of Great Britain collection.

for optimism when he approached 'the other question raised in your letter'. For Bomberg had also asked him whether anything could be done about the meagre representation of living artists in the Tate Gallery's collection. 'The Tate does not come under my control and I have very little influence there', Clark explained; 'but what influence I have has always been used in favour of buying the work of living English painters instead of the hugely expensive works of the great French painters who flourished 50 years ago. So far my efforts have been almost entirely unsuccessful.[54]

Bomberg now decided that it was up to him to challenge the Tate directly, and with the help of Sir Evan Charteris he persuaded the Trustees to consider four of his recent paintings – three Spanish landscapes and a portrait called *Head of a Man*.[55] Bomberg told Charteris that they 'were the four best works I had & were in the opinion of several artists as good as the best work being done in contemporary British Painting'.[56] The assessment was no more than the truth, but at the Trustees' board meeting in July 1937 all the paintings were rejected. The decision confirmed Bomberg's darkest views about an institution which had only ever acquired two of his minor works: an early watercolour of *Sleeping Men*, made during his Slade years, and a drawing for the Canadian painting (Colour Plate 1, Plate 146). Moreover, both these pictures had been purchased as long ago as 1923. During the fourteen years since then the Tate had declined to buy a substantial painting by Bomberg, and no polite words of regret could compensate for this reprehensible neglect. 'As far as your remark regarding the refusal of recognition and support is concerned', wrote the Tate Director's assistant on 29 July, 'I am afraid that is a personal feeling which is shared by hundreds of artists in this country. It is a matter in which personal feelings are apt to assume an importance which is not really justified by fact.'[57] But Bomberg could hardly be blamed for reacting angrily to the unavoidable 'fact' that some contemporary British artists were represented with extraordinary comprehensiveness in the Tate's collection. His old friend Muirhead Bone, for example, whose work now seems far less impressive than Bomberg's, had as many as twenty-seven pictures in the Tate. No wonder Bomberg felt puzzled and aggrieved by the Gallery's refusal to acquire even one of his major paintings! After the Trustees had informed him of their decision, he told Charteris that it was 'very regretable [*sic*] news & means that as far as my endeavour and achievement as a British painter is concerned I cannot get any support from the Tate Gallery of British Art.'[58]

It was a dispiriting conclusion for a middle-aged artist to reach, and Bomberg painted little during the course of 1937. One canvas of *Thames Barges* renewed his interest in a subject he had not painted since the early days of *In the Hold*, and its dark yet warmly lyrical vision of the river at sunset can be counted among his most successful pictures of London (Plate 285). On the whole, however, he returned to portraits of himself and his close relatives. Lilian, who recalled later

285. David Bomberg. *Thames Barges*, 1937. Oil on canvas, 50.8 × 61 cm. Private collection, London.

286. David Bomberg. *Portrait of Lilian*, 1937. Oil on canvas, 61 × 50.8 cm. Fischer Fine Art, London.

287. David Bomberg. *The Baby Diana*, 1937. Oil on canvas, 50.2 × 40.3 cm. Tate Gallery, London.

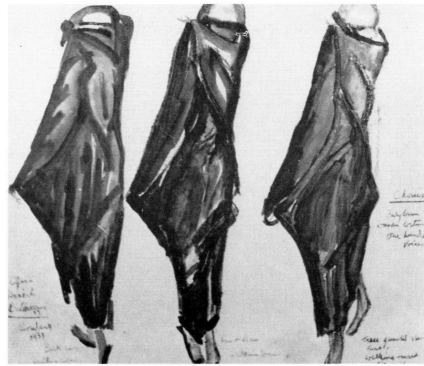

289. David Bomberg. *Design for 'Belshazzar': Baby-lonian Nobleman*, 1937. Charcoal and watercolour, 50.8 × 40.7 cm. Collection of the artist's family.

290. David Bomberg. *Design for 'Belshazzar': Baby-lonian Woman*, 1937. Watercolour, 47.7 × 55.9 cm. Collection of the artist's family.

that the 1937 self-portraits were all painted at home in Lymington Road, explained how the political events of the time lowered Bomberg's spirits. 'David was depressed day after day reading *The Times*', she remembered, 'so I suggested that he paint himself in the back room which had a skylight.'[59] The outcome was a series of self-portraits frankly exploring the turbulence of Bomberg's emotions. The most outspoken is an eerily disturbed double image (Colour Plate 42). As if attempting to catch his face in the slipstream of its movement from one position to another, Bomberg amalgamates two views in a single head. Staring sombrely both to the left and the right, these pale and disquieting faces seem haunted by their fragmentary condition; indeed, they may well seek to express some deep-seated division that Bomberg sensed within himself. The other self-portraits painted at this time appear burdened by suffering. One of them presents him as a tired and ageing figure, with his face quietly lit and the rest merging into the shadows where Bomberg manipulates his pigment with notable austerity (Colour Plate 43). Then, in another self-portrait, his face takes on an ascetic severity while the body beneath sheds much of its bulk and threatens to dissolve in a haze of ethereal pigment (Colour Plate 44). This is a portrait of the artist as a wraith, troubled by intimations of his own mortality.

When he turned to portraits of his wife and family, Bomberg's tragic mood lifted. The *Portrait of Lilian* is animated by much of his old vitality, and the sculptural strength of her aquiline features is softened by the sensuous brushmarks which play across her face (Plate 286). A small portrait of *The Baby Diana* is even more tender, defining her sleeping features with a sparseness and delicacy which proves that Bom-berg was capable of understatement when the subject demanded it (Plate 287). The baby seems cossetted not simply by the blankets[60] which enfold her but also by the soft strokes of pigment, caressing her face and tiny outflung hand with their protective love. Bomberg's handling was flexible enough to adapt itself to the particu-lar challenge presented by each sitter he tackled, and when he turned to drawing Dinora a more robust quality enlivened the outcome (Plate 288). She was now a spirited adolescent, capable of posing for her stepfather with a towel wrapped round her wet hair. Bomberg's charcoal is at its most emphatic as he sets down the contours of a face which seems to observe him with ambivalence, half affectionate and half defiantly independent.

In November 1937 Bomberg accepted a welcome invitation to 'design the scenery and costumes'[61] for a production of Handel's *Belshazzar* by the London Co-operative Societies' Joint Education Committee. Mr Tongue, the secretary, told him that 'my committee have asked me to convey to you their appreciation of your interest in

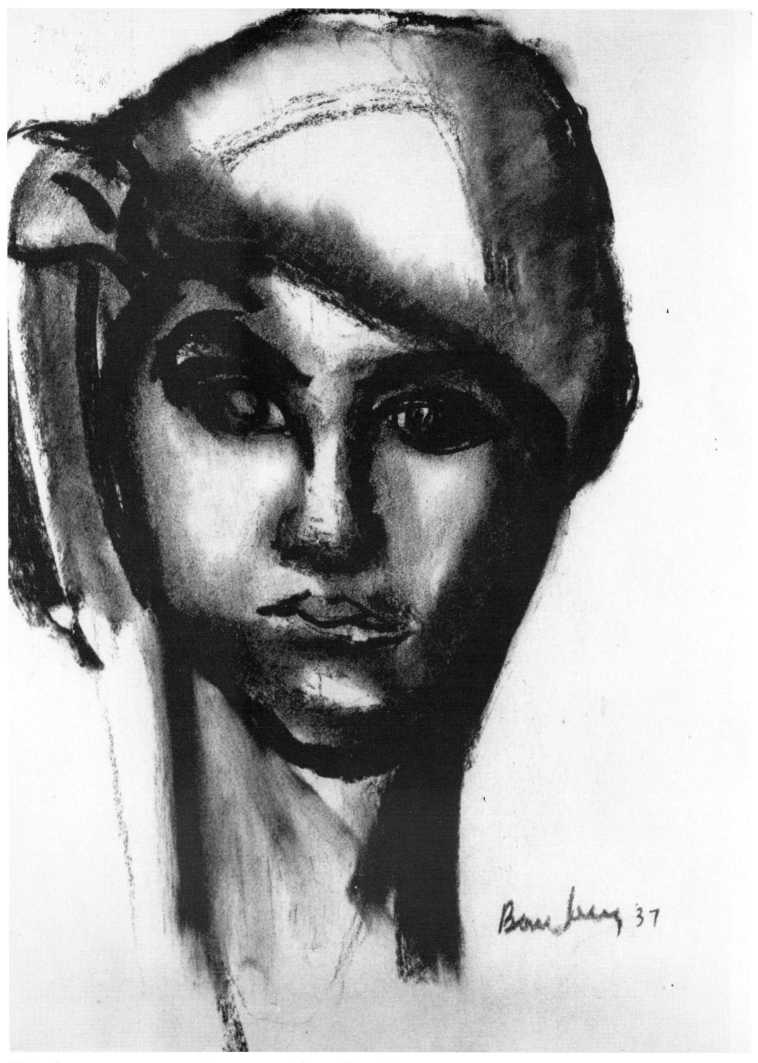

288. David Bomberg. *Dinora*, 1937. Charcoal, 43.2 × 33.1 cm. Collection of the artist's family.

this production',[62] and Bomberg responded by building a model of the stage to help him visualize exactly how the scenery might be designed. Recovering some of the excitement he had found in pre-war days at the Pavilion Theatre in Whitechapel, the scene of his early *Jewish Theatre* drawings (Plates 48, 49), he also set to work on some watercolours of costumes. The performers' poses were as exclamatory as they had been in his youthful figure compositions, and Bomberg brushed in their draperies with a boldness and zest which reveals how much he enjoyed working for the stage (Plates 289, 290). Unfortunately, however, his involvement with the project was terminated before the end of the year. 'Though I could cooperate with the musician, producer & stage manager, & they with me', he told Wyndham Vint, 'the Cooperative Wholesale Society could not cooperate. They were prepared to pay "Trade Union" rates of pay to everyone concerned, but not to the artists & designers.'[63]

Once again Bomberg felt that he was not receiving the treatment he deserved. Whenever he suspected that his abilities as an artist were being slighted, all his accumulated feelings of resentment about the neglect he had suffered rose to the surface of his mind. He may at first have entertained hopes of a more supportive response from Kenneth Clark, who used a considerable amount of his private wealth to purchase contemporary British art. Clark agreed to consider a selection of Bomberg's work, but his final verdict fell far short of the enthusiasm Bomberg would have liked to elicit. 'It was good of you to send me round your drawings to choose from, and I have selected one of them', Clark wrote in December 1937.

> I am taking the others back to the National Gallery where you can call for them at your convenience. I was glad to have been able to help you at a critical moment. I find that in my position the support of painters raises a very difficult problem which I can only solve in one way – by putting aside a fixed sum of money for the purpose every year and by making up my mind to spend it only on those painters whose work I really like. Although I recognise that your work has many qualities, it does not appeal to me very strongly and I would not be acting sincerely if I were to buy it.[64]

After receiving Clark's friendly but severely qualified patronage, Bomberg was doubtless cheered to hear about a far more positive response from another collector the following month. John Rowlands, who assembled a substantial collection of Bomberg's paintings, wrote to thank him for an invitation to a forthcoming National Society exhibition. 'I hope the Public will like the pictures at the Show as much as we do in our home', Rowlands wrote. 'The Ronda [Colour Plate 39] is a constant joy to the family – they find the Thames barges a bit more difficult but are getting there gradually & as it hangs in my den they only get privileged views. I hope to see you soon – are you doing any work these days?'[65]

The answer, sadly, was that Bomberg had almost stopped painting altogether. After he completed a brooding view of *Wapping*, which expressed his darkening mood clearly enough and appears significantly more dour than the *Thames Barges* painted a year earlier, Bomberg seems to have abandoned any attempt to continue his work. Worsening financial troubles, combined with more frequent depressive attacks, discouraged him so much that he produced virtually nothing between 1938 and 1941. Chronic hardship forced the family to leave their accommodation at Lymington Road, where Bomberg had painted some summary views over the rooftops of north London in 1937 (Plate 291). The family became temporarily vagrant, relying on the kindness of old friends to house them. Bomberg kept devising schemes which might provide him with patronage, and in March 1938 asked the Education Department of the London County Council whether it would 'commission pictures for school purposes'.[66] But the Education Officer replied that 'the pictures supplied to schools are selected from the colour reproductions available from the various publishers',[67] and he rejected the proposal. A few weeks later Bomberg even wrote to the War Office applying 'for enrolment in a suitable branch of His Majesty's Forces',[68] only to receive a non-committal response informing him of the existence of 'the Field Survey Association, the object of which is to keep in touch with past members of the sound-ranging and flash-spotting organization which came into being during the late war'.[69]

Bomberg had no desire to join an Old Boys' Club of ex-soldiers, and as his prospects of employment dwindled he gratefully accepted John Rodker's loan of

291. David Bomberg. *Three Chimneys*, 1937. Oil on canvas, 51.4 × 45.7 cm. Fischer Fine Art, London.

an Essex cottage. The whole family moved there in October 1938, but the dampness of their new home soon resulted in illness and despondency. Within a month Lilian and the children had left Bomberg and returned to London. Staying on there for a while, he made notes in the isolated surroundings for another ambitious plan to provide artists with the patronage they needed. On 9 November, two days before the twentieth anniversary of the Armistice, he proposed a scheme coloured by his memories of the Great War. 'It it because we are near Armistice day – that I am being sentimental or is there foundation to this idea?' he wrote.

> I am not only thinking of British Legion Clubs & recreation Halls – but the possibilities of commissions & funds from the great industrial & social public services of this country – the four Railway Companies . . . the Post Office – Education – L.C.C. [and] the Borough Councils all over the country. They might support a fund for commemorating through artists (painters & sculptors & etchers & draughtsmen) the sacrifice made by the Body of Man Power of this Country & Colonies & Dominions overseas during the great War.'

He even suggested that 'this project should be a life work of we Artists who came out of it all and able to carry it through. The nature of the subject-matter . . . would be a memorial to peace & friendship & good will to all mankind.'[70]

The untrammelled scope of Bomberg's plans poignantly contrasts with his total inability to paint during this difficult period. But the advent of another world war was eventually to provide a way out of his deadlock, spurring him to make from his experience of destruction a whole sequence of images which can be counted among his finest later achievements. They also prove, by prophesying a catastrophe more than two years before it finally occurred, that an artist's work can sometimes possess the most unnerving and salutary power to warn.

# CHAPTER NINE  Bomb Store and Blitz

By the time 1939 arrived, the gap between Bomberg's spiralling ambitions and the afflictions of daily life had grown so great that it seems to have induced in him a state of acute creative paralysis. The sole consolation was that the entire family, early in the year, found accommodation at Greville Place in St John's Wood. But the advent of war only a few months later made their financial prospects look even grimmer than before. Who would be prepared to buy paintings at a time of desperate national emergency? Artists who had already suffered great hardship during a decade of slump now confronted the possibility of still more numbing neglect, and in October Bomberg sent a letter to *The Times* protesting against the government's failure to utilize the power of art during the struggle ahead:

> In a war fought for freedom and progressive culture, the artist surely has a vital role to play. The government should call in the artists to inspire the people, to express their ideals and hopes, and create a record of their heroic effort for future generations. The spiritual and cultural need that art alone can satisfy is greater now than in peace time. By relegating art to oblivion we are not only creating distress among the individual artists, who are now almost entirely deprived of private patronage and . . . left stranded without any means of support, but we are thereby depriving the nation of part of its richest inheritance.

Spurred on by the urgency of his argument, Bomberg concluded by outlining the practical steps which he believed should be implemented at once.

> The Ministry of Labour has already received particulars of thousands of artists volunteering for national service through their respective societies. A committee of artists should be appointed to evolve a plan of work on which these artists can be employed, and a fund allocated by the government for this work. Such a plan . . . would of necessity include the reproduction and distribution of work throughout the country and the armed forces, and in many cases its sale to the civilian population. Such work will activise the printing and allied trades. No time should be lost in arranging for a meeting between the representatives of artists, colour printers and allied industries and members of the government to solve this urgent problem of national life.[1]

It was a compelling proposal, but Kenneth Clark had already begun to establish a scheme which paralleled Bomberg's ideas and seemed likely to enjoy official approval. Meirion and Susie Harries have described how, on 29 August 1939, Clark 'approached the MoI [Ministry of Information] with the suggestion that it appoint a committee to advise on the employment of artists to record the war',[2] and towards the end of November the War Artists' Advisory Committee met for the first time under Clark's chairmanship. It was to pursue a programme of patronage which produced images as memorable as Nash's elegiac *Totes Meer*, Moore's brooding *Underground Shelter* drawings and Spencer's dynamic *Shipbuilding on the Clyde* series, but the committee's emphasis on the need 'to record the war at home and abroad' also meant that it avoided artists whose concerns or abilities were felt to lie outside such a documentary brief. Although Bomberg might have privately wondered whether he would be considered too 'extreme' for such purposes, the presence on

the committee of his long-standing supporter Muirhead Bone probably led him to expect that he would be appointed as a war artist. Bomberg's own writings had argued in favour of just such a public role for some time, and so when he heard a radio announcement one evening about the government's 'commissioning of artists to do war pictures', his reaction was instantaneous. The very next day, on 16 December 1939, he wrote to the committee's secretary asking him 'to be good enough to place my name before the Committee as one interested in the project & available to undertake such work'. He also pointed out that his approach to such a task would be fortified by 'experience of a similar project on which I was employed as an artist after demobilisation 1918–19', and his letter enclosed a testimonial from P. G. Konody referring to the 'admired' quality of his Canadian *Sappers* painting of 1919 (Plate 148).[3]

But Bomberg had been conspicuous by his absence from the list of war artists commissioned by the British government during the First World War, and he now found himself summarily rejected once again. Although the War Artists' Advisory Committee lavished patronage on many artists whose work was inferior to Bomberg's, it refused to engage his services and provide him with the support he so urgently required. The humiliation must have been hard to bear. A commission would surely have enabled him to shake off the obstructions which had prevented him from painting for the past two years. He needed the stimulus of such a challenge, and the committee could well have been responsible for generating a sustained flowering of Bomberg's art throughout the war; but its members were not even prepared to ask him for an exploratory drawing which would have established his fitness for the task. So he was obliged to apply again in July 1940, explaining that 'I should very much like to do some war paintings to fit in with the scheme, and if I do not keep on applying it may appear that I am not trying hard enough to get a task to do. Which is not the case.'[4]

The intensity of Bomberg's desire was expressed directly enough, but the committee again turned him down. Clark had already admitted, in a 1937 letter, that his admiration for Bomberg's work was limited,[5] and so Bomberg may simply have fallen foul of Clark's aesthetic preferences. As chairman of a committee which supported a wide range of artists, however, Clark must have been prepared to lay his personal prejudices aside if he thought that a painter would produce images of value to the nation. Moreover, Meirion and Susie Harries have pointed out that when Clark formed the committee, 'he was anxious that its members should represent the widest possible spectrum of taste',[6] and he was certainly prepared to support on a munificent scale artists like Eric Kennington whose work cannot have appealed to him personally. Why, then, did Bomberg suffer such a cruel rejection? One answer may be that Clark counted him among those artists of stature whose work simply did not meet the demands of the committee brief. As Clark explained in *The Studio*,

> The War Artists collection cannot be completely representative of modern English art because it cannot include those pure painters who are interested solely in putting down their feelings about shapes and colours, and not in facts, drama, and human emotions generally. For this reason it contains no work by such distinguished painters as Matthew Smith, Frances Hodgkins, Ethel Walker, Ivon Hitchens, Ben Nicholson and Victor Pasmore. It would be a pleasure to see the names of these fine painters among those of the War Artists, but it is very doubtful if they would do as good work on war subjects as they are continuing to do on the subjects which they have made their own.[7]

Although Clark omitted to mention Bomberg by name, and may not have considered him as 'distinguished' as Smith, Hodgkins, Walker and the rest, he could perhaps have classed Bomberg among those artists 'who are interested solely in putting down their feelings about shapes and colours'. It would be hard to apply these words to Bomberg's landscapes or figure paintings; and his subsequent work in the bomb store proved that his art, even at its most seemingly 'abstract', was inspired by a passionate awareness of war's capacity for destruction. But for the time being he was condemned to endure the committee's repeated rejections, and apply instead for jobs in 'the Camouflage Establishment'[8] and the National Buildings Record where he hoped John Summerson would commission him to execute 'paintings and drawings of architecture'.[9] Bomberg received negative replies on all sides, and fared no better when he wrote to Clark in March 1941 asking – with pathetic

modesty – 'if there is any use for a person with my qualifications in the Ministry of Information'.[10] By the end of the year these perpetual rejections had made Bomberg so desperate that he started applying for wildly unsuitable jobs at firms like Smith's Motor Accessories Works in Cricklewood,[11] only to receive the same depressing replies. He even wrote to the Ministry of Supply, asking whether he could execute some publicity design for Russia, but met with the discouraging response he had encountered so many times before.[12] His despondent state of mind was further aggravated when he realized how inferior some of the war artists' work really was. 'I was working at the Ministry of Supply', recalled Lilian, 'and I went to the lunchtime concerts at the National Gallery and saw the war commissions on exhibition, including Eric Kennington who was given so many pictures to do. So I came home and said it was unjust that David wasn't given a commission.'[13] Bomberg had no alternative but to agree, and all his accumulated feelings of resentment about the committee's attitude gained an obsessive dominance over his mind. He simply could not understand why its members continued to turn him down, especially when he was so eager to place the subject of war at the very centre of his current work.

Accordingly, in February 1942, he decided to write a long letter to the committee revealing the full extent of his anger, frustration and bewilderment. Realizing no doubt that he no longer had anything to lose by expressing his frankest feelings, Bomberg launched an uninhibited attack which claimed that

> since I have not yet been recognised as one of the artists to be employed on the recommendation of the Artists Advisory Committee, the Ministry of Labour together with the Assistance Board have no alternative but to terminate payment of benefit & render me destitute, unless you can state from your knowledge of me & my work that I am genuinely seeking employment, & to state in your letter to me (which I shall have to show to the Board) the reason why the Artists Advisory Committee have not included me among the artists selected to create paintings & drawings for War records.

Bomberg wanted the committee's members to feel guilty about their handling of his application, and make them realize just how much misery they were making him experience. So he concluded his letter by warning that 'if I am forced out of my profession into either destitution or acceptance of dilutee labour (when there are thousands of skilled & unskilled men signing as unemployed at the labour exchange daily) the responsibility for this must rest with the Artists Advisory Committee in general & my professional Colleagues on that Committee in particular.'[14] It was a tough and vehement outcry, directed especially at fellow artists like Muirhead Bone whose support Bomberg had imagined would prove forthcoming. The committee's Secretary, E. M. O'Rourke Dickey, sent the letter to Clark two days later, explaining in a note that 'the plain fact is that Bomberg is annoyed because he finds that he must make munitions in order to gain a livelihood and is venting his spleen on the Artists' Advisory Committee.'[15]

Whether Bone or Clark himself decided to relent, and let Bomberg tackle a commission at last, is not known. But his letter does appear to have struck home and persuaded the committee that he deserved at least a modicum of support, for Dickey wrote to him on 23 February announcing that 'you should be commissioned to make a painting of an underground bomb store for a fee of 25 guineas.'[16] At the same time Bomberg received a further letter from the Ministry of Information offering him 'third class travelling expenses, and, should you have to work away from your home, maintenance allowance at a flat rate of £1 a day for each absence of 24 hours, and a day allowance of 6/8d for an absence from home of more than 10 hours.' The Ministry's letter went on to emphasize the crucial importance of security precautions, informing Bomberg that 'it will be necessary to submit all your preliminary sketches and studies, as well as the finished work, for censorship. This will be done by us, and it is, of course, desirable that we should have your painting as soon as conveniently possible after it has been completed. I must caution you not to show any of these works, even to your friends, before they have been submitted by us to the censor.'[17]

No explanation was offered to Bomberg about the reason why a bomb store had been chosen as his subject. But during the First World War Muirhead Bone himself had executed a drawing called *The Hall of the Million Shells* which signified

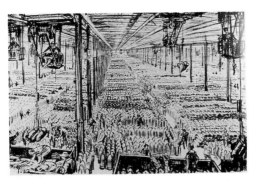

292. Muirhead Bone. *The Hall of the Million Shells*, 1917. Charcoal and wash, 36.4 × 53.3 cm. Imperial War Museum, London.

clearly enough that the shell shortages of 1915 were by then over (Plate 292). The immense receding perspective he employed in this interior was likened by P. G. Konody to the mile-long banqueting hall in D. W. Griffiths' *Intolerance*.[18] So Bomberg was presumably expected to produce an equally awesome image of Britain's bombing power in 1942. It was a small commission compared with the largesse extended to many other favoured war artists, but the subject of men working in subterranean surroundings suited an artist who had made studies of sappers during the Great War (Plates 141, 142, Colour Plate 17). He must have hoped that it would be the start of a continuing and fruitful relationship with the committee. Bomberg was therefore quick to follow Dickey's instructions to 'get in touch direct with Group Captain Lord Willoughby de Broke, M.C., A.F.C., Air Ministry, Whitehall, S.W.1., who will make the necessary arrangements.'[19] Just over a month later the Ministry informed Bomberg that he would be drawing 'interior subjects in an underground bomb store . . . at a depot in the neighbourhood of Burton-on-Trent'. He was also instructed, in the same letter, that 'during the course of your stay, estimated to be 14 days, your sketches will have to remain at the depot each night. They will be carefully looked after and available to you each morning.'[20]

A permit enabling Bomberg to enter the bomb store arrived on 3 April, and five days later he took the train from St Pancras to Burton-on-Trent. There he telephoned the Adjutant who sent a car to pick him up and take him to RAF Fauld at Tutbury, the strange, sinister place where the bombs were stacked. By an extraordinary coincidence, Lilian was in charge of bomb-store information at the Ministry of Supply and realized that he was being sent to an important one. As she related,

> David had been instructed not to tell anyone the secret site but I knew when he was given the ticket to Burton-on-Trent that it was the bomb store I had a file on. We didn't say anything to each other, though! He was treated as an officer and left to his own devices. He took paints and canvases and greaseproof paper with him, paper he normally used to wrap pictures in. But he was determined to make full use of the weeks he had. I was nervous for him, because I knew he was unsure on his feet and I visualized him clambering among the bombs which might roll around and explode.[21]

Later in the war, Lilian's fears about the dangers of the bomb store would turn out to be horribly well-founded; but the caverns which confronted Bomberg when he went down into the depot were structurally secure, at least. Acquired by the Air Ministry in 1937, the long-disused gypsum mines underneath the wooded escarpment of the Stonepit Hills were well-suited to ammunition storage. The Fauld mines were ninety feet below the surface, and large enough to hold as many as ten thousand tons of high-explosive bombs. Moreover, further expansion could be achieved with only a modest amount of conversion. At an early stage in the site's development a railway track was constructed in the subterranean store as well, branching into a network of roads, shunts and loops which serviced all the areas where the bombs were housed. By the time Bomberg arrived at the location, this intricate system of underground lines was about to be extended still further. The development of the war had brought mounting pressures to hold even greater tonnages in the store, and a decision had recently been taken to open up more unused sections of the mine. An additional ten thousand tons of bombs could thereby be accommodated.

Despite the obvious dangers involved, Bomberg seems to have explored this unsettling locale without any trepidation at all. The uncanny strangeness of the store, where the atmosphere of an ancient cave blended very uneasily with the technology of modern transport and weaponry, is conveyed by four photographs sent to Bomberg later in the year by Central Press Photos of Fleet Street. They had all been taken in January 1942, and one photograph showed the 'miniature railway' transporting carriages loaded with bombs into the mine's cave-like entrance. The driver's workaday attitude conveys little hint of the care with which he had to guide his cargo towards its destination (Plate 293). But the other three photographs show just how unnerving the bombs appeared once they had been assembled in their subterranean shelter. Men were expected to assemble and stack the five-hundred-pound and thousand-pound bombs, and their bodies stretch in strange diagonal poses as they roll their deadly charges along makeshift rows of planks (Plate 294). To civilian eyes it all looks alarmingly perilous, but some of the men smile as they push the bombs towards their resting-place and examine them to make sure that

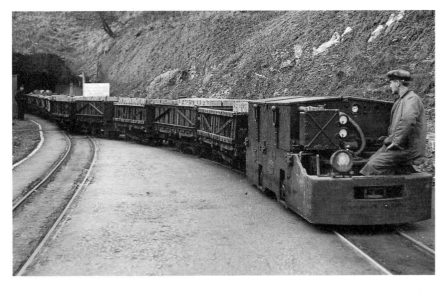

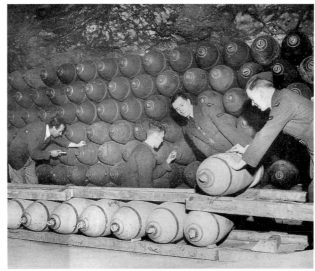

293. Photograph of a train transporting bombs on the 'miniature railway' to the bomb-store entrance, January 1942. Central Press Photos, London.

294. Photograph of men stacking 500 lb bombs in the bomb store, January 1942. Central Press Photos, London.

295. Photograph of men examining and stacking 500 lb bombs in the bomb store, January 1942. Central Press Photos, London.

296 (right). Photograph of rows of 1,000 lb bombs stacked in the bomb store, January 1942. Central Press Photos, London.

they are all in proper working order (Plate 295). The workers quietly and methodically carry out their appointed duties, and the bombs themselves take on a curiously comic aspect when the photographer selects an angle which presents them in the foreground as a cluster of enormous Surrealist breasts (Plate 296).

The amount of large oil-on-paper studies inspired by the bomb-store theme testifies vividly enough to Bomberg's excitement. After four long years of inactivity and unbearable constriction, his full abilities as a painter were released at last. Judging by the spontaneity and vigour of the images, he worked with the furious speed of a man who feared he would not have time to set down everything his imagination demanded. The bombs and figures inhabiting their macabre shelter crowded in on Bomberg, impelling him to use sheet after sheet of greaseproof paper after his small supply of canvases ran out. Far from feeling at all inhibited by his official brief, and striving to supply a faithful documentary record of the store, he had no hesitation in giving rein to his most untrammelled emotional response. Bomberg's ardent desire to become a war artist had been pent up for so long that, when the opportunity at last arrived, it allowed him to express his feelings with outstanding eloquence (Plate 297).

The *Bomb Store* paintings reveal that these feelings were as complex as they were powerful. Bomberg's hatred of Fascism naturally encouraged him to view the galleries of the disused mine as a redoubtable arsenal, filled with the weapons which would play a crucial role in Hitler's eventual defeat. But there is nothing propagandist about the way he depicted this massive stock-pile of ammunition. Rather than simply

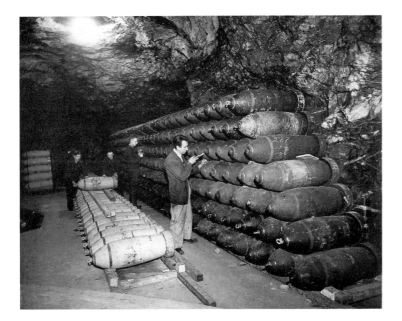

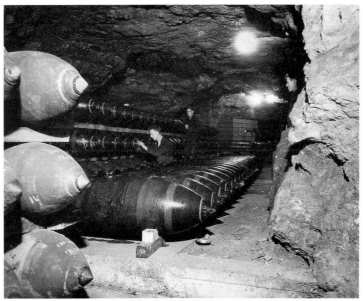

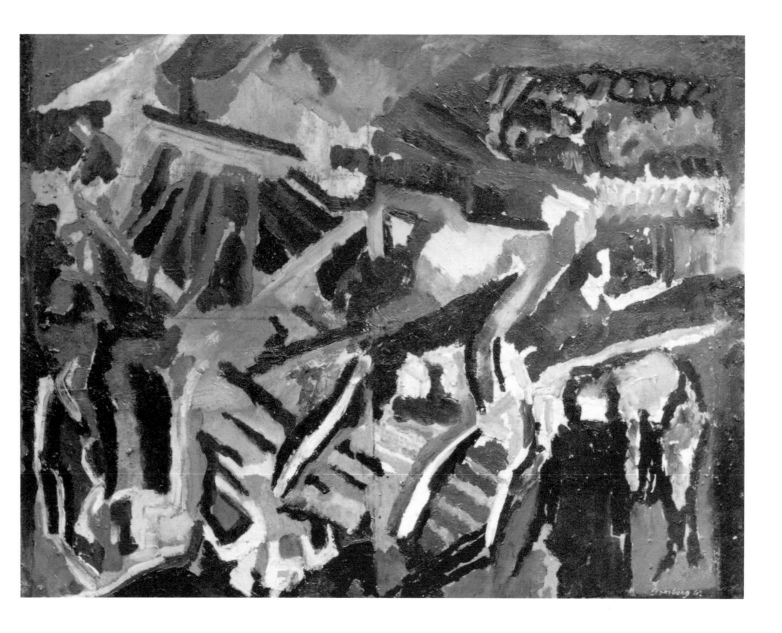

297. David Bomberg. *Bomb Store*, 1942. Oil on canvas, 76 × 91.5 cm. Raymond Danowski.

300. Giovanni Battista Piranesi. *Carceri XIV: Prison with system of interlocking arches and staircases*, c. 1743–4. Etching. British Museum, London.

301 (below right). David Bomberg. *Study after Piranesi's Carceri*, c. 1942. Charcoal, 12.7 × 16.6 cm. Collection of the artist's family.

rejoicing in the sleek rows of fat bombs, as they gleamed in the reflected glare of the spotlights shining down from the shelter roofs, Bomberg allowed his perception to be affected by his own knowledge of what military destruction on the grand scale really meant. The subterranean subject he was given here inevitably awoke memories of the tunnelling sappers he had painted during the previous world war (Plate 298), and his experiences in the trenches were gruesome enough to have imprinted themselves permanently on his mind. The death of so many comrades haunted some of the drawings he made at the Front (Plate 135). He never forgot

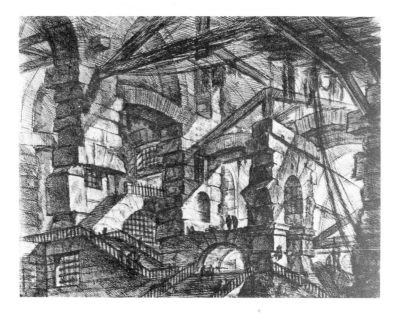

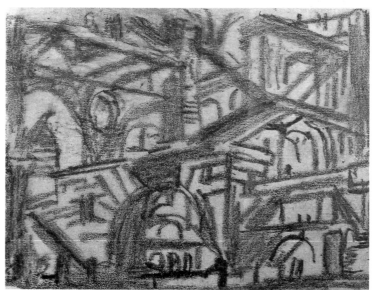

that harrowing period, least of all during his visit to the bomb store. Bomberg realised, far more than most of the young artists employed by the War Artists Committee, that machine-age conflict was a devastating experience for everyone involved in the heat of the inferno. He had witnessed unimaginable carnage in the battlefields of France, and he must also have appreciated that the technology of war was now vastly more sophisticated and deadly. Nowhere more so than in aerial bombardment, which subsequently inflicted appalling destruction on German cities as the Allied counter-offensive intensified. The bombs stacked with such deceptive calmness in the Burton-on-Trent store were an integral part of Churchill's determination to demoralize the enemy's heartland by subjecting it to a cataclysmic assault from the air. In this respect, Bomberg could not have been sent to a more chillingly pertinent area of the country. Behind the ordered and workaday scenes to be witnessed at the bomb store lay a capacity for titanic violence which played a large part in undermining Germany's resistance.

Only an artist of Bomberg's insight could have understood and, more important still, conveyed the full significance of the scenes he so avidly scrutinized in the mine. For he does not attempt to celebrate the nationalistic might of the armaments on display. Instead, he presents the store as a dark, eerie chamber permeated by intimations of the human tragedy that these bombs would inflict when they were unleashed on historic cities and on the helpless citizens who became the victims of remorseless night raids (Plate 299). A few years later, when Bomberg began teaching, he kept a volume of Piranesi's great *Carceri* etchings in the class for students to consult if they wished,[22] and some small drawings after Piranesi have survived among his papers (Plates 300, 301). Admiration for the *Carceri* images underlies his exploration of the mysterious, theatening and awesome spaces in the bomb store, too. They led him to create caverns as contradictory and disturbing as Piranesi's interiors, which arouse expectations only in order cruelly to frustrate them as our

298. David Bomberg. *Bomb Store*, 1942. Oil on paper, 136.5 × 77 cm. Collection of the artist's family.

299. David Bomberg. *Bomb Store*, 1942. Oil on paper, 91.4 × 63.5 cm. Private collection.

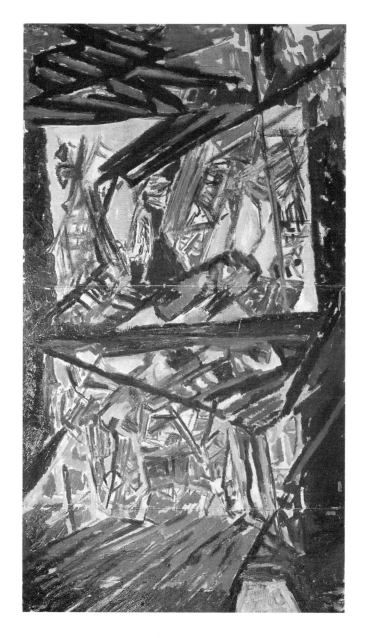

eyes travel over the interstices of the shadowy structures in plate after plate of the *Carceri* sequence. Bomberg would have respected Piranesi for questioning 'the entire Renaissance system of pictorial space . . . with a degree of daring unparalleled before Cubism', as John Wilton-Ely has pointed out.[23] But the *Bomb Store* paintings make that space even more ambiguous and perplexing, fusing the mine, the workers and the bombs they handled in images so densely impacted that we are sometimes unable to identify them with complete confidence (Colour Plate 45).

In picture after picture the underground arenas are presented as strange, haunting and distinctly ominous places, charged with Bomberg's troubled awareness of the menacing cargo they contain (Plates 302, 303, Colour Plate 46). The energetic activity of men's limbs scythes restlessly through compositions dominated by the tall pillars supporting the store's roof, and by the jagged forms of the bombs themselves stacked in piles or racks. Bomberg adopted a degree of abstraction he had not employed since his early years as an artist, a development probably quickened by his recollections of the initial studies he executed for the *Sappers* canvas in the First World War period (Colour Plate 16). But now his handling of pigment was far removed from the hard-edge severity he had favoured a quarter of a century before. Bomberg's succulent, loose brushmarks swoop, dart and swerve among the architectonic forms of the mine and the munitions housed within it, enlivening their gaunt geometry with fiery scarlets, yellows and pinks. These anarchic colours race in and out of the brooding umber and khaki shadows, sometimes appearing so incandescent that they threaten to ignite the bombs in a premature holocaust. Bomberg wanted to convey the full destructive potential of the slumbering missiles he surveyed, and his oil studies have an impassioned abandon which still assaults our nerve-ends today.

Compared with many of the works commissioned so plentifully from other war artists, who often produced anodyne images testifying only to their own lassitude or detachment, Bomberg's paintings are alive with a sinister, raging wildness. Even the much-admired young painter Graham Sutherland could not match the potency of Bomberg's vision, when he was asked to tackle a similar subject in 1944. The WAAC sent him over to France in order to depict the sites of the recently destroyed flying-bomb depots at St Leu d'Esserent. Widespread suffering and alarm had been

302. David Bomberg. *Bomb Store*, 1942. Oil on paper, 76.5 × 57.5 cm. Douglas Woolf, London.

303. David Bomberg. *Bomb Store*, 1942. Oil on paper, 76 × 57.5 cm. Douglas Woolf, London.

305. David Bomberg. *Bomb Store*, 1942. Oil on paper, 61 × 83 cm. Private collection, London.

304. Graham Sutherland. *A Flying-Bomb Depot*, 1944. Gouache, 29.3 × 46.6 cm. Imperial War Museum, London.

caused when the German V-bombs first landed on London. But the gouaches Sutherland made there are curiously tepid, as if the cumulative nightmare of war had drained him of the capacity to respond with adequate conviction. The images which he produced merely resembled stage scenery (Plate 304). Withered trees on the skyline look like perfunctory quotations from Paul Nash's Great War paintings rather than a first-hand response to the desolation Sutherland confronted. Although he recalled that 'a lot of Germans had been killed inside the caves and there was a terrible sweet smell of death in them',[24] disappointingly little of that experience is transmitted by Sutherland's depot pictures.

Bomberg's oil studies, on the other hand, do justice to the terrible reality of their subject. Even though the bomb store did not confront him with combat or corpses, he knew enough about war to transform one painting of the disused mine into a scene uncannily reminiscent of the blasted landscape he had surveyed during his service in the trenches (Plate 305). Alongside the fiery vitality of his handling and the poignant, unpredictable beauty of the colours he employs, this painting possesses an elegiac strain which suggests that Bomberg was already prepared to mourn the loss of all the lives subsequently sacrificed during the raids on Dresden and elsewhere. The bomb-store setting is here fused with his newly stirred memories of the devastated Great War landscape to produce an evocation of battle's aftermath, a wasteland of shattered fragments and melancholy, flickering light.

The energy and inventiveness of the *Bomb Store* series prove, however, that Bomberg was fortified rather than depressed by his fortnight in the mine. The commission had stimulated him into working once more at the top of his form, producing images which can now be ranked among the most impressive of his later paintings. So although Bomberg must have worked with gruelling intensity each day at the store, he was exhilarated by the challenge and enjoyed convivial evenings at the Mess as well. Having been told that he could sign for drinks instead of paying cash for them, he concluded that they were free and was shocked at the end of his stay to find himself confronted by a large bill which he was unable to settle.[25] But the incident could not detract from the immense satisfaction Bomberg had gained at the mine. He returned to London eager to report on his experiences, in the hope of obtaining further commissions which might enable him to maintain the momentum he had already established. The advent of spring would, he hoped, usher in a new period of concentrated work. Having demonstrated how well he could operate under these testing conditions, Bomberg believed that the committee's support would be forthcoming when he informed them of his progress and displayed the results of his unremitting efforts on their behalf.

'The Visit was a thrilling one', he told Dickey on 28 April, in a letter which tumbled over itself in an attempt to convey the full exuberance of Bomberg's feelings.

The subject is rich in possibilities – where I succeeded in doing the subject & myself justice in Drawings on the spot, which are complete – the Paintings on the spot, owing to the difficulties of lighting – had to be left incomplete – and on the completing of these Paintings with the help of the Drawings I have been engaged since my return on the 22nd of April & as soon as they are ready all I have done on the spot together with what is being worked on in the studio – will be submitted according to the rules you have given me – & meanwhile the rule of keeping the work from being seen by anyone is being strictly carried out.

Later in the same letter, Bomberg decided to reveal the ambition he had begun to nurture while working at the bomb store. Remembering the monumental scale of the paintings he had been commissioned to paint at the end of the First World War (Plate 148), he declared:

> the subject is worthy of a great Memorial Panel – a memorial to the heroism of that kind of labour. There are some aspects scattered over various sections that could be brought together under one roof so that the painting became representative of the whole activity. And this was at the back of my mind during the making of the Studies on the spot. If after I have submitted the work I have done – & your Committee can see its way to commission this Memorial Panel, I will be very happy to use my experience of the subject to paint it.[26]

Bomberg's letter makes clear that he saw the proposed large painting essentially as a figure composition, concentrating on the energy of the men at work in the store. It would therefore revive his earlier ambition to create massive paintings animated above all by the dynamism of human limbs – an ambition which had been supplanted almost entirely over the past twenty years by his preoccupation with landscapes. Most of the surviving *Bomb Store* pictures either show an uninhabited setting or relegate the figures to a subordinate position within the design, so Bomberg had not yet arrived at the image he described in his letter to Dickey. Since the 'Commissioned Painting' he sent to the committee in fulfilment of his original brief is now impossible to identify with complete certainty, we do not know whether it contained prominent figures. But the picture which accords most closely with the size of the 'Commissioned Painting'[27] conveys scarcely a hint of figures, and the audacious bareness of its style could not have recommended it to the committee (Colour Plate 47). An austere image, restricted to a subdued range of pale grey, dull orange, blue, ochre and white, it has an unequivocally desolate air. Although bombs are depicted in the foreground, securely lodged in rows, the rest of the composition looks disquieting and oddly forlorn. Strange shadowy figures, attenuated and almost ghostly, can be detected emerging from the central darkness of the mine, but they seem to wander through a ruined locale. The entire painting evokes the aftermath of a disastrous explosion rather than the security of an arsenal, and Bomberg's frank admission of the forebodings aroused in his mind by the bomb store would never have met with the committee's approval.

They rejected the 'Commissioned Painting' out of hand, privately commenting that they thought it was 'of inferior quality'.[28] But Bomberg had also sent two small paintings and four drawings along with the main picture, explaining that they were 'available for purchase',[29] and the committee decided 'to accept in fulfilment of your commission three drawings'.[30] Surprisingly enough, one of these drawings was very close to the image which may have been the 'Commissioned Painting' (Plate 306). But it was, significantly, more specific about the scene. Bomberg's charcoal defines the racks of bombs, the figures, the railway track and the tunnel leading to the cave. There can be no doubt that the drawing conveys more information, and in this respect satisfied the official brief more than the painting had done. Even so, it lacks the brooding power of another selected drawing, which dispenses with detail and concentrates on the funereal blackness of a mine seemingly unalleviated by the bright spotlights visible in the photographs (Plate 307). It is an extraordinarily bleak and uncompromising image, filled with Bomberg's darkest presentiments about the outcome of war. The store resembles a tomb built for the corpses of all those who would be destroyed by the bombs. As for the third drawing selected by the committee,[31] it is dominated by the bombs themselves (Plate 308). They nestle in their racks like elongated eggs waiting to be dropped and broken.

306. David Bomberg. *Bomb Store*, 1942. Charcoal, 53.5 × 66 cm. Imperial War Museum, London.

C45 (top). David Bomberg. *Bomb Store*, 1942. Oil on paper, 65 × 100 cm. Collection of the artist's family.

C46 (right). David Bomberg. *Bomb Store*, 1942. Oil on paper, 76.5 × 57.8 cm. Douglas Woolf, London.

C47. David Bomberg. *Underground Bomb Store*, 1942. Oil on paper, 80.6 × 108 cm. Fischer Fine Art, London.

307 (right). David Bomberg. *Bomb Store*, 1942. Charcoal, 79.4 × 69.2 cm. RAF Museum, London.

308. David Bomberg. *An Underground Bomb Store (2)*, 1942. Charcoal. Dimensions and whereabouts unknown.

C48 (facing above). David Bomberg. *Bomb Store: Study for Memorial Panel*, 1942. Oil on paper, 117 × 151.2 cm. Collection of the artist's family.

C49 (facing below). David Bomberg. *Bomb Store: Study for Memorial Panel*, 1942. Oil on paper, 118 × 149 cm. Collection of the artist's family.

But this composition makes no more attempt than the other accepted drawings to place working figures at the forefront of the design.

Bomberg had yet to arrive at the major figure composition which he regarded as the culminating image of the *Bomb Store* series, but he hoped the committee would buy him the time and materials to carry it out. 'I have used only part of the material gathered during the facility visit', he told Dickey on 5 June.

> I am interested in the subject & given the financial support I believe I could do credit to it – I have in view a panel 10 × 12 feet constructed on imaginative groupings expressing the purpose of the whole rather than simple sections – The theme would be action that goes with an urgent issue. I could do this or any other work the committee are pleased to give me. The main thing is to keep going now I have started, & produce good work.[32]

Bomberg was absolutely right in supposing that he should continue to explore the rich vein of imagery he had discovered at the bomb store, and if the committee had allowed him to implement his plans they would surely have resulted in one of the greatest paintings to come out of the Second World War. But his proposal was turned down. Too many of the paintings and drawings he had already submitted were outspoken, extreme and disturbing images which flouted the committee's requirements. Bomberg was not prepared to supply a sanitized vision of war, and he was punished for his temerity.

In retrospect, the committee's verdict seems short-sighted. But at least Bomberg was spared the agony he had experienced over his First World War painting, when he finally adopted an alien style in order to supply an image acceptable to official taste (Plate 148). Perhaps that is why he was so determined, this time, to follow the imperatives of his own imagination rather than tailoring his individual style to suit the committee's brief. Although compromise of that kind might have won him further support, Bomberg knew from previous experience that it would be fatal to betray himself for the sake of bureaucratic approbation. Better by far to remain true to his highest creative priorities and accept the consequences.

He paid a very high price for his integrity. While the committee continued to shower patronage on its favourites, including some intolerably dull painters, Bomberg never received another penny. He seems to have struggled on for some time, preparing brilliant and substantial studies for the big canvas which he so desperately wanted to paint. But by the time his renewed application for assistance was again turned down in September 1942,[33] he had probably decided to abandon hope. Even his old ally Bone showed far less sympathy than he had in the past, telling Bomberg in the same month that 'I'm afraid your Bomb store work was unfortunate. As I was away at the time I have not seen the results yet but the Committee seemed disappointed with them.' Without realizing that he was helping to prevent Bomberg

from painting a potential masterpiece, Bone even had the gall to remark that 'a tough 51-year-old man like yourself should be able to get employment of some sort in these days!'[34]

If Bone and the other members of the committee had been able to examine the rest of Bomberg's *Bomb Store* paintings, and appraise them with eyes unclouded by governmental considerations, they might have realized that it was unforgiveable to reject his pleas for support. But the full extent of Bomberg's achievement with this series only became apparent forty years after he completed the paintings, for he folded up most of the large sheets of paper and stored them in drawers where they lay undisturbed until long after his death. Now that they have at last been pieced together and restored, however, we can appreciate just how magnificent Bomberg's proposed 'Memorial' painting might have been.

The key image is a huge composition, painted on several segments of paper which have been carefully reassembled to comprise the largest picture he had painted since the First World War (Colour Plate 48). By no means as vast as the 'Panel' he envisaged, and entirely lacking the figures who were to have dominated the final composition, it still affords a grand and tantalizing idea of what Bomberg intended to achieve. The pigment is manipulated with even greater fluency and freedom than before, splashed on with such verve that it dribbles down in several places as freely as an action painting. Bomberg's vigorous and uninhibited handling gives everything in this immense subterranean interior a disconcerting life of its own. Although a large part of the design is occupied by a heap of bombs, they are far from static. Animated by brushwork which has been applied at white heat, their circular forms appear to be on the point of revolving and whirring like a cluster of catherine wheels about to discharge colour and energy into the space around them. Nor is the analogy with fireworks at all far-fetched. The whole painting is charged with Bomberg's perception of the bombs as volatile and terrifyingly powerful agents of destruction. They seem to be impelled by an urge to dislodge themselves from their racks and roll off towards their self-appointed destinations.

At the moment they are still relatively contained, and held within one distinct area of the store. But they could break loose, and the dark clumps of upright bombs ranged like an informal pallisade beyond would not prevent them from escaping. Indeed, the upright bombs look distinctly vulnerable and unsteady, surrounded as they are by a cavern which already appears on the point of erupting in a mighty conflagration. The fiery scarlets and oranges licking around the foreground of the picture are about to reach the bombs. And the apocalyptic outcome is anticipated in the distance, where a double stretch of railway track is partially enveloped in a flaring, flame-like rush of pink and yellow. This incandescent burst is countered, for the time being at least, by the midnight-blue gloom on the other side of the painting's upper section. But sooner or later this balance of power could easily be disrupted, the fieriness spread and the entire cavern be destroyed in an explosion of colossal magnitude.

It was not an image which a cautious wartime committee would ever have wanted to support. The whole point of a bomb store lay, after all, in its capacity to stockpile armaments capable of annihilating the enemy, not blowing up in storage. Even so, Bomberg was not being merely fanciful by creating a vision of imminent devastation. For his painting gives a far more truthful account of the terrifying reality of bombs, and the reason why they are made, than a factual picture of the underground cave ever could. He shows, in one composite picture, both the quiescence of stored bombs and the force they are capable of unleashing. Bomberg knew, as well as the committee, that an explosion was unlikely in the mine he had visited. But his aim was not to predict an accident. Rather does his painting insist that we should not contemplate bombs without also taking into account the fearful consequences of their use. Bomberg's first-hand experience of war had given him a lasting awareness of the lethal power commanded by twentieth-century armaments, and he also realized that it was impossible to view the future bombing of German cities as an event completely divorced from the store in Burton-on-Trent. His painting seems to be insisting, with persuasive forcefulness, that the wilful extermination of human lives is a tragedy which involves us all.

How close would this remarkable painting have been to the 'Memorial Panel' he never executed? The available evidence indicates that Bomberg planned to superimpose a group of labouring figures on the image he had already created, so that

their limbs would enliven the design with an even greater dynamism than it already possessed. A large but unfinished oil-on-paper composition certainly begins to carry out this aim, and the fierce colours employed in the background area suggest that he considered working towards a more dramatic image in the final picture (Colour Plate 49). The exploratory nature of this figure study cannot, however, be taken as a reliable guide to the elaborate painting which he envisaged. Bomberg clearly abandoned it before he was able to arrive at a fully coherent solution, and we are left with a powerful yet tantalizingly incomplete notion of the painting he might have gone on to execute. The committee's refusal to offer the requisite encouragement and financial assistance prevented him from reaping the full benefit from the plethora of intense and absorbing studies he had made of the bomb-store theme. Bomberg must have known that an exceptionally fruitful and promising period of activity was now being terminated by the committee's short-sightedness, and he found this repudiation hard to bear.

The WAAC's decision appears even more unfortunate when we consider that it commissioned two pictures of *A Bomb Store* and *A Wellington Bombing-Up* from Cuthbert Orde (Plate 309). They are lacklustre exercises, dutifully showing the bombs being taken out of store, loaded on trolleys and then placed in readiness on a Vickers Wellington bomber. None of the energy and danger involved in the operation is conveyed by Orde's routine paintings, and yet they were chosen for the booklet illustrating WAAC pictures of the RAF in 1942, along with a caption explaining that the bomber was 'about to set out on one of the many raids which have been so successfully conducted by this type of machine'.[35] Bomberg knew what these bland words actually meant in terms of the inferno created by a bombing raid, and he could never have contented himself with the reassuring images which Orde was complacent enough to provide.

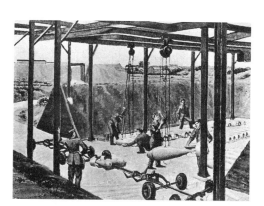

309. Cuthbert Orde. *A Bomb Store, c.* 1940. Oil on canvas, 71.2 × 91.5 cm. RAF Museum, London.

His understandable chagrin was exacerbated by a growing awareness, as the months went by, that the three drawings accepted by the committee had not been included in the regular exhibitions of current war art. Eventually, in March 1943, he wrote to the committee pointing out that the drawings 'have been at your framers & have not yet been on public exhibition – If I am in error on this point I will be glad if you correct me, but so far each time myself or my friends have been to see the War Artists exhibition at the National Gallery I have noticed the omission & they have remarked upon it.' Forcing himself to keep his temper and maintain a level-headed tone, he then asked the committee for an explanation:

> If you can give me a reason why the drawings are kept at the framers & not shown to the public, it might be more satisfying than waiting to no purpose for their showing – I might ask you then to allow me to borrow them to exhibit at some public Gallery. I do not wish to protest about the committee's treatment of my work, but I take the view that if drawings are acquired for public exhibition & they are not shown, at least some explanation could be made to the artist why they cannot be shown.

Towards the end of the letter, however, Bomberg found he was unable to contain his mortified emotions any longer. Having held them on a tight rein for several months since the committee's last rejection, he could not help pointing out how proud he felt of the *Bomb Store* images. 'Without prejudice to the committee's decision, I wish to say that these three Drawings are examples of my work done in a good creative mood, & that they do me credit', Bomberg wrote.

> The present position of these works give [*sic*] me the impression that I am out of favour for any of the commissions that are being distributed often in duplicate, triplicate & quadruplicate etc., etc., & the rapidity with which they are publicly shown astounds me. I would much appreciate enlightenment on whether my work will be shown or not, whether I am in or out of favour & whether I may expect another commission – or whether I am considered by this committee as not a suitable artist for the encouragement of a commission.[36]

Bomberg had succeeded in speaking his mind, but he need not have bothered. So far as the committee was concerned his work did not deserve any further support, and the reply he received was dismissive. 'It is hoped that one or more of the drawings will shortly be on exhibition', wrote the WAAC's secretary, deigning to add that 'on the other points you raised, as to your standing with the committee,

310. Photograph of the bomb-store site after the explosion, November 1944. Private collection.

and the likelihood of further commissions, the committee did not express any opinion.'[37] Its members clearly wanted to wash their hands of all further involvement with Bomberg, and this curt message brought any lingering thoughts of a further war artist's commission to a bleak end. He resumed the cheerless task of searching for employment elsewhere, and it has been calculated that between 1939 and 1944 Bomberg applied unsuccessfully for over three hundred teaching posts.

The extraordinary prescience of the *Bomb Store* pictures was, however, borne out on a devastating scale by the subsequent tragedy in the depot itself. Full details of the disaster were hushed up at the time, and neither Bomberg nor Lilian ever seems to have heard about it.[38] But the fact remains that the blazing destruction predicted in so many of his paintings of the mine actually overcame the bomb store less than three years after Bomberg visited it. Around eleven o'clock in the morning, on 27 November 1944, the underground site was blown apart in the largest explosion ever to have occurred in Britain. The accidental detonation of a single bomb led, within seconds, to the concerted blasting of 3,500 tons of high-explosive bombs. Sixty-eight people were killed and twenty-two injured in this terrifying holocaust. One farm was destroyed so completely that not a trace of it remained. Others were extensively damaged, two hundred cattle were killed, and the villages of Hanbury and Tutbury sustained such grievous damage that they both suffered a total breakdown in public services. The roar of the explosion could be heard as far south as London and as far north as the River Humber. In Geneva and Rome the earth tremor was recorded as an earthquake.

When the explosion occurred it seemed to eye-witnesses as though a cataclysm had overtaken the world. James Major, whose farm is situated near the site of the store, described how his father 'was loading cattle into a lorry to go to auction

at the time of the blast: 'The buildings rocked like an earthquake and the ground felt as if one was standing in a small rowing boat on a choppy sea; so much so that it was incredible to think that the buildings would ever return to their original place.' Only when the shaken Mr Major stepped outside his lorry did he begin to realize what had happened. 'He could see, less than half a mile from the house, the enormous mushroom of black smoke, fire and earth being blasted into the sky. The sight was fantastic; boulders, trees, gates and earth could be seen on its [*sic*] way up.' Over a million tons of earth were flung miles in the air during the explosion, and the five hundred acres surrounding the blast were devastated by falling debris. As James Major recorded,

> The effect afterwards was like a battlefield, for each large boulder of rock which fell from miles above caused a crater ... When father went to see the [main] crater in the afternoon, he went to the edge of what appeared to be a bottomless pit which still had black smoke curling from the bottom. The area was like an open-cast coal-mine and everywhere was covered with a thick layer of very fine powder. That night it rained very heavily and turned the area into a sea of mud and sludge. The thousands of craters filled with water, and travelling, even on foot, was very difficult, as one sank in the soft mud up to one's thighs. What made matters worse was the explosion had burst a reservoir which contained 6,000,000 gallons of water, in fact it was this water which killed Mr and Mrs Goodwin who were just leaving their farm. They were found five weeks later, buried under five feet of sludge, brought down the small valley by the burst reservoir.[39]

Photographs of the scene after the explosion reveal a shocking and desolate panorama (Plate 310). Stripped, blackened trees seem barely able to sustain themselves in the gouged terrain. If Bomberg had visited this wasteland he would inevitably have been reminded of his experiences in the First World War, where trench battles were fought out in a similarly ravaged and mud-choked landscape. He might have shuddered at the realization that the bombs which caused such horrible devastation once surrounded him on every side at the store. But he could also have counted himself lucky that he had not been sent to RAF Fauld in November 1944, when the mounting intensity of the allied offensive meant that the depot was placed under a near-intolerable strain. The monthly total of issues and receipts approached 20,000 tons, and there was a regular requirement for a hundred bombs per day. Extra labour was hurriedly recruited from the nearby prisoner-of-war camp to cope with the mounting demand. Italian soldiers, who had no more than a rudimentary knowledge of the hazards involved in handling explosives, were pressed into service at the mine. Only thirty years after the tragedy did the Air Ministry finally release detailed evidence about the explosion's likely cause, and report that negligence had been discovered on the part of those responsible for maintaining safe working conditions.[40]

Although much has been done at Fauld since that appalling event to reinstate the landscape, the crater still remains (Plate 311). 'Even to this day I find the sight of the main crater breathtaking', commented James Major, 'for it is $\frac{3}{4}$ mile in circumference and 100 yards deep.'[41] Grassed over and extensively planted, it still inflicts on the countryside a wound which will probably never be healed. It stands as a dramatic testimony not only to the eruption of November 1944, but also to the uncannily prophetic quality of the images which Bomberg had painted two years earlier. Even though he had no desire to anticipate such a calamity, the fact remains that his vision of the bomb store was permeated by an apprehensive and vivid awareness of imminent destruction. The WAAC disapproved of Bomberg's perceptions, preferring to regard RAF Fauld as a secure arsenal manned by wholly dependable personnel. But an artist of his insight could never rest content with an official, cosmetic view of war. Bombs, to Bomberg, meant only one thing, and not for a moment was he taken in by the deceptively quiescent appearance of the thousand-pounders resting in their neat stacks. His *Bomb Store* paintings imply, with magnificent and troubled eloquence, that we should never view the accumulation of mass-destructive armaments with complacency. Today, when the lethal capacity of such weapons has multiplied to an extent quite unimaginable in the 1940s, and artists are no longer allowed to penetrate the silos where nuclear missiles silently await their signal, Bomberg's clear-sighted warning seems more pertinent than ever before.

311. Photograph of the bomb-store crater as it is today. Private collection.

312 (right). David Bomberg. *Flowers in a vase*, 1943. Oil on canvas, 106.8 × 79.5 cm. Cecily Bomberg, London.

313. David Bomberg. *Flowers in a vase*, 1943. Oil on canvas, 108 × 80 cm. Private collection.

Once Bomberg acknowledged that his dreams of further war commissions would never be fulfilled, he lapsed into despondency again and became a prey to fits of depression which entirely prevented him from painting. His sister-in-law Olive, who stayed with him for a while during the war years, recalled his habit of swinging from moods of delightful friendliness to unalleviated desolation. 'He gave me an insight into human values, life in general', she said, describing how 'it opened up a completely new sphere for me. He had a great, deep insight into life – into people.' But Olive also remembered that 'I always felt with David that he spoke as the day was: one day the whole family would be full of talent, the next none.' She explained how suddenly his mood could change. One moment, apparently, 'David would be all right, and then a black cloud would descend and nothing could be done.'[42] Only Lilian was capable of lifting him out of these debilitating spiritual troughs, and during the summer of 1943 she succeeded in devising a way of stimulating his urge to paint.

By this time the Bombergs were living in Queens Gate Mews, and she recalled that

> I was in the habit of passing a lady who sold flowers outside Gloucester Road tube station. I thought that if I spent a little housekeeping money on a bunch that I picked, David might be induced to start painting them. I took a bunch home, arranged them in a vase on the living-room table and left them there. After two or three days I suggested to him that he paint them. He put up objections that he had nowhere to paint, but I said: 'The top light is coming through the little place where they used to lower the horses' hay down to the stables below.'

This part of their mews had been boarded over, but Lilian soon managed to turn it into a studio with the help of some curtains hung on the wall. One of them served as a background for the flowers, which Bomberg now began to study with avidity. 'The flowers I first brought home were a mixed bunch – delphiniums, lavender mist and various flowers that were in season', Lilian explained. But once

Bomberg became enthusiastic about them as a subject for paintings, 'he used to go every day early to Covent Garden to buy the flowers himself. He only painted flowers, and very much enjoyed doing it. He always arranged them himself, in the same vase, against the same curtain. He wasn't interested in flower arrangement – he'd just put them in and paint them.'[43]

The impulsive directness with which Bomberg set up his flower groups also informs his handling of the paintings themselves (Plates 312, 313). Although he had executed a few flower canvases six years before, and had treated them with an unusual amount of freedom, they are less headlong than the far greater number of paintings carried out during this burst of activity in Queens Gate Mews. Dispensing with drawings and working only in oils, he manipulated his brushes with a fluidity and abandon which testify to his new-found infatuation with the subject. In canvas after canvas the stalks and leaves launch themselves out of the vase with ebullience, burgeoning into blooms so exuberant that they often seem to scatter colour like star-bursts in the sky (Plate 314). But there is little sense of empty air in these images. Bomberg fills his compositions with an efflorescence of petals and foliage, which threatens to choke the picture-space entirely. Compared with Ivon Hitchens's *Flower Group* (Plate 315), executed in the same year with a similar vivacity of gesture, Bomberg's paintings have no room for anything other than the flowers they contain. Hitchens, who admired Bomberg[44] and was one of the few British painters to rival his freedom of handling at this period, allows his flowers to curve and waver as they leave their container. He also mingles them with references to furniture, views through the window, and other paintings in the room. His *Flower Group* is relaxed, lyrical and hedonistic, whereas most of Bomberg's flower paintings are essentially eruptive (Colour Plate 50). They thrust their way up from the circular

315. Ivon Hitchens. *Flower Group*, 1943. Oil on canvas, 104.2 × 69.9 cm. Sheffield City Art Galleries.

314. David Bomberg. *Flowers*, 1943. Oil on canvas, 91.5 × 71 cm. Bristol City Art Gallery.

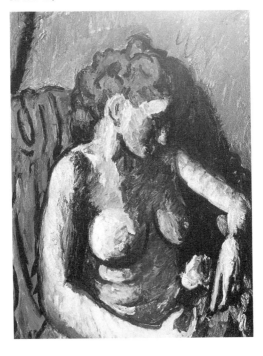

317. Matthew Smith. *Nude with a Rose*, 1944. Oil on canvas, 101.6 × 76.2 cm. Private collection.

316. David Bomberg. *Nude*, 1943. Oil on canvas, 91.4 × 71.1 cm. Tate Gallery, London.

aperture like the shafts of a mighty bomb-burst, and threaten to break the boundaries of the picture-frame with their explosive force.

Even as Bomberg celebrates the exultant vitality of flowers in full bloom, therefore, he also invests them with a darker intimation of destruction. Nor was it surprising that an artist who endured the hazards of blitz-torn London should reflect them in his work. The savage bombing of the city, coupled with Bomberg's inevitable consciousness of the war fought elsewhere in the world, are reflected in these ostensibly straightforward paintings. Although Bomberg never participated in active service during these years, he taught drawing to the anti-aircraft gun crews in Hyde Park and served his turn as a fire-watcher for the Kensington area. These experiences would have sharpened his awareness of war's devastation, as well as reawakening memories of the fearful slaughter that he had witnessed during the Great War. Nevinson, who also confronted the terrible reality of conflict in the trenches, once painted an *Explosion* which fills the canvas with its deadly force. A similar image seems to lie behind Bomberg's *Flowers*, but it takes on a greater poignancy here. For however hard he tries to concentrate on the affirmative exuberance of freshly-cut Covent Garden blooms, Bomberg cannot prevent himself from introducing overtones of war as well. Although he rejoices in the flowers' colour and potency, Bomberg is powerless to protect them from the destructive forces which threatened every aspect of London life in the early 1940s.

How conscious was he of the tragic dimension lurking within these paintings? It is impossible to tell, but when Bomberg met Josef Herman around this time he did not hesitate to shed light on the state of mind which produced the flower canvases. Herman, newly arrived in London and suffering from feelings of despair, found Bomberg's company inspiring. Recalling in particular a lively afternoon spent in his studio with Bomberg and Ludwig Meidner, he described them as 'two painters

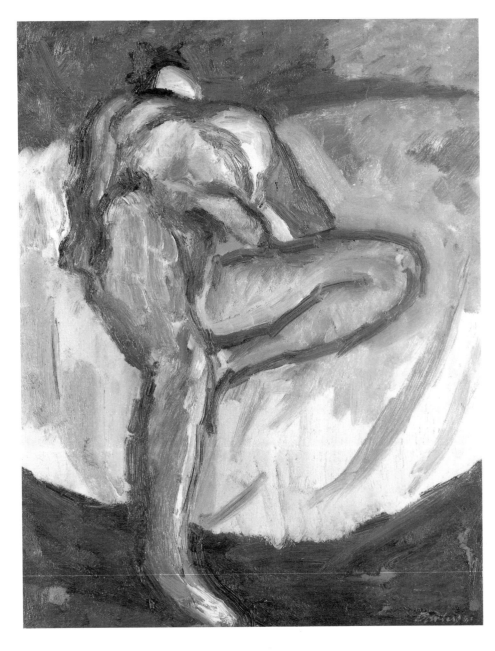

318. Walter Richard Sickert. *The Camden Town Affair*, 1909. Oil on canvas, 61 × 40.5 cm. Private collection.

319. David Bomberg. *The Baby Juliet*, 1943. Oil on canvas, 38.2 × 29.3 cm. Collection of the artist's family.

who knew where they were going, war or no war; it was therefore refreshing to listen to their excited outpourings.' Herman found himself caught between these unusually forceful individuals, for 'David had a temperament not much quieter than that of Meidner.' At one point in the conversation, Bomberg took issue with Meidner's insistence that 'the essence of the art to come is in painting big-city life.' Bomberg explained that he liked to paint mountains, and added: 'Even flowers can be painted so as to remind us of all the terror in the human breast! Painting reaches its artistic momentum on its own terms no matter what subject one paints!' By the time their meeting came to an end, Herman remembered, 'it was late afternoon . . . and the sirens sounded the warning of approaching German planes.'[45] Listening to the grim and menacing sound, no one in the room could have failed to realize that 'the terror in the human breast' was an ever-present part of blitz-ridden existence.

Nor did the disturbing implications of Bomberg's flower paintings escape notice when he included some of them in an exhibition at the Leger Galleries in November 1943. The show consisted mainly of his 'Imaginative Compositions', still unsold twenty years after he painted them (Plates 181, 182, 183, Colour Plate 23). But they did not attract much admiration from either reviewers or collectors. One critic drew attention to 'two of his flower pieces', and declared that 'these are veritable *explosions* in oil colours; No. 25 goes off with an almost audible bang.' But he added that 'I don't think they should, although I admit that very occasionally, and under special conditions of light and background, that sort of thing comes very near happening in *nature*.'[46] Bomberg's vision was too disconcerting for the critics to accept without severe qualms. In a war-torn world his turbulence was regarded as a threat, and people seeking reassurance or solace in art rejected him.

If Bomberg had ever exhibited the *Nude* he painted in 1943, they would probably have responded with equal disapproval (Plate 316). For this canvas, inspired by a girl called Anne who was working on a farm and agreed to pose in his studio,[47] makes little attempt to provide an erotic vision of the female body. The openly declared broken brushwork, especially on the girl's right leg, is tactile enough to signify the act of touching. But there is nothing straightforwardly delectable about this image. Compared with the sensual nudes of Matthew Smith, whose handling sometimes seems related to Bomberg's (Plate 317), she is a disconcerting presence. Flung back on the bed so that her face is no longer visible, this anonymous body looks marooned and awkward. No nude could be more alone, and Bomberg has surely used her to project his own desolating sense of isolation. She is also a war nude, in the sense that a prescience of mortality pervades the painting. Indeed, her pose recalls the sprawling woman in Sickert's *The Camden Town Affair*, a painting of the murdered prostitute Emily Dimmock and made at the time when Bomberg studied under Sickert at the Westminster School (Plate 318).

This uncompromising *Nude* was not shown to anyone outside Bomberg's immediate family circle, and he never painted another female body with such directness. But he did execute a small oil study of Dinora's daughter Juliet where the heavily loaded pigment seems to caress and enfold the young face (Plate 319). In the latter months of 1943 he devoted a considerable amount of his time to expressing his appreciation of the Soviet Union's decision to fight Hitler. The two representatives sent to London by the USSR to back Mrs Churchill's Aid to Russia Fund visited Bomberg's exhibition, and he also showed them his paintings in the 1943 London Group show. 'They liked my fierce flower picture', Bomberg reported to a friend, 'so on the spot I presented it to the Soviet Union. It was accepted & so at the close of the London Group . . . the formal presentation will take place at the Soviet Embassy.'[48] In all good faith, Bomberg intended the painting to be the foundation of a collection of gifts by other British artists 'to help rebuild the . . . dispersed collections in the Soviet Union & and the enemy-occupied Allied Countries'.[49] He even sat on the stage of 'a big theatre'[50] in London as a member of the reception committee held in honour of the two Russian representatives, and his old friend Joseph Leftwich made a speech welcoming them to London. But then Bomberg's generosity was thrown back in his face. Lilian described how 'I went to the Russian embassy and asked them whether they'd accept' the flower painting, 'and they said no. If it had been by Churchill, yes, but David no!'[51]

In view of the Soviet Union's notorious disapproval of modern western art,

C50.  David Bomberg. *Flowers*, 1943. Oil on canvas, 91.4 × 71.8 cm. Tate Gallery, London.

C51. David Bomberg. *Evening in the City of London*, 1944. Oil on canvas, 69.8 × 90.8 cm. The Museum of London.

this response was scarcely surprising. But Bomberg continued to suffer from humiliating neglect in his own country as well. Only temporary and part-time jobs came his way, teaching for a while at the LCC Institute in Clapham, and the Katherine Low Settlement at Battersea. 'I was always against him teaching because it exhausted his energy and diluted his art', Lilian explained, 'but he couldn't get any other source of income during the war.'[52] Nor did he find himself acknowledged by the art establishment in prestige exhibitions. When the Central Institute of Art and Design organized from its headquarters at the National Gallery a major survey of contemporary British art, to be staged in America, Bomberg was excluded from the list. He wrote to the Institute's Secretary, T. A. Fennemore, to confirm this dismaying news, and the reply admitted that 'you were not invited to send to America. There was a Selection Committee who combed through something like 5,000 names of artists and finally selected about 100 painters, 20 or so sculptors, and some engravers. This, according to their judgement, was the best selection they could make, and I am sorry you feel hurt about it.'[53] Bomberg's reaction was at once terse and caustic. 'You make me laugh', he wrote to Fennemore. 'It's not a question of hurt – it is of merit. If you don't think I come within the first hundred – I do.'[54]

During the course of 1944, however, Bomberg did become intrigued by the idea of depicting the blitzed London cityscape. He made a gaunt and brooding charcoal drawing of his neighbourhood at Queens Gate Mews in the moonlight, where the high walls seem to have been blackened by the smoke of falling bombs (Plate 320).

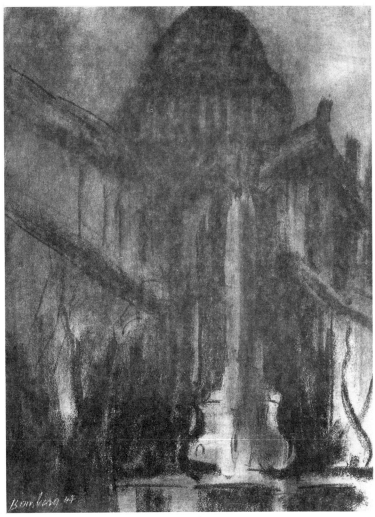

320. David Bomberg. *Queens Gate Mews, Kensington: Moonlight*, 1944. Charcoal, 61 × 48.3 cm. Collection of the artist's family.

322 (right). David Bomberg. *St Paul's Cathedral*, 1944. Charcoal, 58.5 × 44.5 cm. Collection of the artist's family.

321. Bill Brandt. *St Paul's Cathedral in the moonlight*, 1940s. Marlborough Fine Art, London.

But he was more attracted to the image of St Paul's, still miraculously intact despite the severe bombing suffered by the surrounding area of the city. By this time Wren's cathedral had become for many artists, photographers, writers and film-makers a symbol of Britain's continuing will to resist the worst which Hitler could inflict on the country; the knowledge that St Paul's was a prime target for the Nazi bombers made its survival even more astounding. Bill Brandt, for example, meditated on its indomitable silhouette in a study of the moonlit building surrounded by rubble (Plate 321). Bomberg was as impressed as anyone by the symbolic importance that St Paul's had assumed, and Lilian remembered that they both visited the cathedral 'first thing in the morning after bombing in the night'. As a firewatcher himself, he was particularly interested in the heroic activities of the 'group of voluntary firewatchers in the upper part of the gallery putting out the firebombs'. He made several close-up drawings, sometimes stressing the scorched solidity of the building and on other occasions presenting it as a strangely wraith-like presence emerging from a mist (Plate 322).

But by far the most memorable image of the cathedral was drawn from a distance, where St Paul's could be seen in the context of the battered city around it. 'He got permission to climb to the top of a church, in Cheapside I think, and painted St Paul's from its east side', Lilian recalled, adding that 'it was done in one go, but he did the drawing for it first.' It was the only church Bomberg got permission to enter, presumably because strict safety regulations forbade easy access to buildings regarded as prime targets for enemy attacks. 'There was always an element of danger', Lilian confirmed, because 'we didn't know when the raids were taking place. David went out in spite of this. He did worry about it, and it interfered with his drawing.'[55]

Little sign of tentativeness mars the drawing which Bomberg executed from his vantage-point in the church, however (Plate 323). Benefiting once again from the structural discipline he had acquired in his pre-1914 period, he emphasizes the cubic starkness of the buildings below him. Their contours are scored onto the paper

with a charcoal sooty enough to have been seized, still smouldering, from the burnt-out wreckage of a bomb-site. Bomberg sees the cityscape as a sequence of eerily deserted containers, no more than a skeleton of the metropolis that he knew before Hitler's raids pummelled the area so grievously. The advent of evening spreads shadows across these uninhabited spaces, intensifying their gutted desolation. But church towers still punctuate the charred ruins, and Bomberg ensures that the distant cathedral rises with proud, substantial conviction on the horizon. David Piper, who described this remarkable drawing as 'the finest picture' of London in wartime, pointed out that 'the impression is almost, perhaps optimistically, serene.'[56] Bomberg's drawing strikes a subtle balance between melancholy and fortitude, and it is charged with far more emotion than the skilful yet cold study of *St Bride's and the City after the Fire* made by Muirhead Bone as an official war artist's commission (Plate 324). Bone's picture is a technical *tour de force*, certainly, but sadly lacking in the intensity of feeling which informs Bomberg's drawing.

Looking at *Evening in the City of London*, and the canvas he painted of the same view (Colour Plate 51), makes us regret that Bomberg was not enabled to study such subjects with more time and materials at his disposal. Kenneth Clark may have declared that St Paul's had never 'looked more beautiful rising out of this sort of Pompeii in the foreground',[57] but he encouraged Duncan Grant to depict it rather than Bomberg. As a result, the painted version of *Evening in the City of London* remains the only canvas Bomberg executed of the blitzed cityscape. Set at a slightly later time of day than his bare and economical drawing, the picture envelops its buildings in a colour-haze which threatens to rob them of their substance. Bomberg evokes heat as well as the failing light of dusk, and manages to suggest that these sorely battered buildings are still glowing from the embers of the fires which assailed them. All the same, St Paul's dominates the skyline as a triumphantly intact silhouette rising up to the topmost edge of the painting, and the smoky splendour of Bomberg's colours gives the image a redemptive quality which seems to sustain the wounded city spreading around Wren's defiant dome. Lacking the encouragement to develop this haunting vision in further images of the wartime city, Bomberg had to settle instead for showing his painting at the London Group's 1944 exhibition. 'The Private View L.G. went off quite well', he wrote to Lilian in October, adding that 'as usual the effort was made to put my paintings anywhere but on the walls, but they are good & look good – Compliments from the London Group members are not profuse – but Ivon Hitchens came up to tell me it was

324. Muirhead Bone. *St Bride's and the City after the Fire, 29th December 1940*, 1941. Chalk and pen, 197.9 × 111.5 cm. Imperial War Museum, London.

323. David Bomberg. *Evening in the City of London*, 1944. Charcoal, 46.4 × 59 cm. Ashmolean Museum, Oxford.

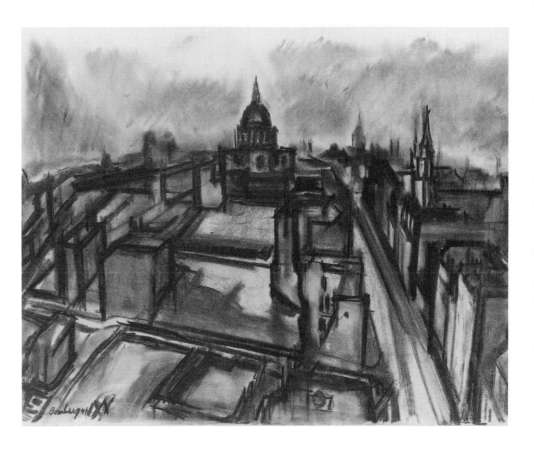

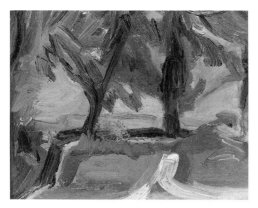

325. David Bomberg. *Trees near Talgwyn Farm,* 1944. Oil on board, 31.5 × 40 cm. Mary Hale.

326. David Bomberg. *St Paul's and River,* 1945. Charcoal, 50.8 × 63.8 cm. Tate Gallery, London.

327. David Bomberg. *London River – after Blitz,* Charcoal, 51 × 63 cm. Private collection.

the only painters painting of bombed London he had seen & one or two members indicated likewise.'[58]

Bomberg was not exclusively preoccupied with images of blitzed London at this period: in the summer of 1944 he managed to make a camping expedition with the family to Anglesey, where a few paintings executed at Talgwyn Farm showed that he had not lost his impulsive emotional reaction to the landscape (Plate 325). But the urban scene again fired his imagination when he returned to London, and at one stage John Rodker, who owned the Imago Press, responded positively to Bomberg's suggestion that a book of the blitz drawings should be published. The freedom with which Bomberg handled charcoal proved a stumbling-block to the enterprise, however. Lilian recalled that 'David showed his drawings to Jimmy [Rodker], who said: "Can you make them more like a panorama? Otherwise they won't be suitable for the public." '[59] During his Jerusalem period Bomberg had bowed to the demand for a more topographical approach, and he was determined never to make the same mistake again. A drawing like *St Paul's and River*, outstanding though it is in terms of his blitz scenes, would never have satisfied the book collectors who liked to buy publications containing urban views (Plate 326). The reductive forms, which so decisively convey Bomberg's grasp of the ravaged city he surveyed, were far too stark to win approval from people hungry for identifiable panoramas and accurate information about damaged or destroyed historic buildings. *St Paul's and River* does not even offer a reliable account of what Bomberg saw from a fixed vantage. Although some aspects of the view suggest that it was made from St Bride's, the square church drawn in front of St Paul's would not have been visible from this site. So the answer seems to be that Bomberg, caring more about his own expressive motivation than topographical propriety, created in this drawing a composite of different views which altered building positions and the angle of curvature of the Thames at will.[60]

Nevertheless, Bomberg continued for a while to persuade himself that such highly personal drawings could somehow be made compatible with the project which Rodker had outlined. In October 1945 he wrote to the Ministry of Works seeking 'permission to view from "Big Ben" the aspect of the City and the River. I am working on a series of drawings that will form when co-ordinated a panorama of London – to be reproduced and published in London. If the aspect provides the material I need I will ask your permission to make a number of drawings.'[61] A month later he was also allowed to 'photograph/sketch' from the Golden Gallery of St Paul's, but surviving drawings like the damp and misty *London River – after Blitz* betray no sign of striving for the accuracy which a camera could supply (Plate 327). At one stage Bomberg appears to have concluded that he needed expert advice on wide-angle lenses, and went to Kodak House in Kingsway to discuss the problem with members of the Research Laboratory staff.[62] Soon afterwards, in December 1945, he received a long and detailed letter from one of the laboratory team, describ-

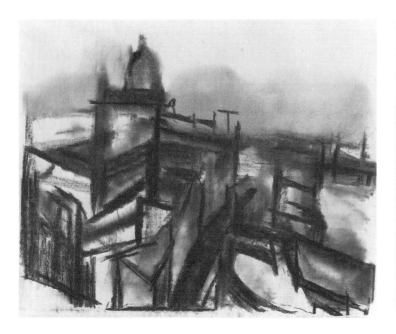

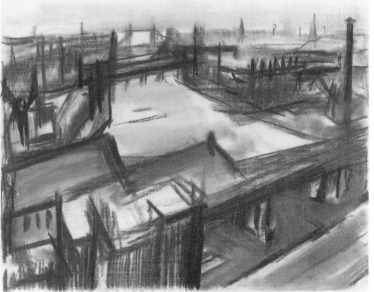

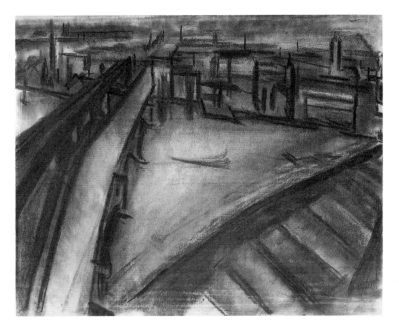 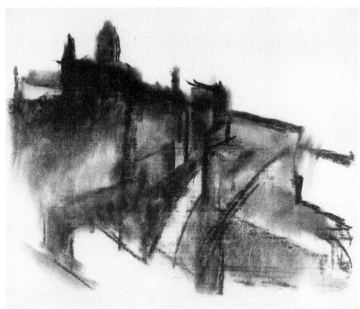

328. David Bomberg. *London River (Blackfriars Bridge)*, 1946. Charcoal, 50.2 × 62.8 cm. Fischer Fine Art, London.

329. David Bomberg. *St Paul's and River Thames*, 1946. Charcoal, 50.8 × 62.2 cm. Colin St John Wilson, London.

330. William Coldstream. *St Giles Cripplegate, c.* 1946–7. Oil on canvas, 78.7 × 91.4 cm. Arts Council of Great Britain collection.

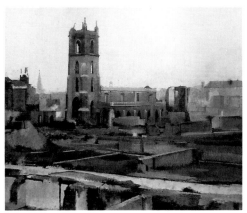

ing all the technical possibilities then available. The letter even suggested that 'you try using a pin-hole as a lens. Although the pictures will not be as sharp the perspective will be at least as good as a lens will give, and the pin-hole is cheaper than any wide angle lens. Anybody could make one – which is more than can be said of lenses!' But no evidence has survived to prove that Bomberg ever acted on this advice, and the Kodak letter concluded that he would be unwise to set too much store by the camera's prowess:

> It seems to me that the management of the perspective, in the sense which you indicated to us, is only possible by the ingenuity and inspiration of a painter. It is possible that a wide-angle camera would help, at those times when the subject was not at hand, in providing a means of considering the subject, provided that it was viewed under proper conditions i.e. at the correct distance. But this question is still one of art, and not capable, in our opinion, of solution by the mechanics of photography.[63]

The Kodak letter could have helped Bomberg arrive at his decision to abandon the Rodker project. The vigorous and summary study of *London River (Blackfriars Bridge)*, made in 1946, is certainly not striving to supply the kind of view which would have lent itself to publication in book form (Plate 328). Admittedly, *St Paul's and River Thames*, one of the last in the blitzed London series, includes a horizon curvature which suggests he was still contemplating a panorama where the perspective would be consistent through 360 degrees (Plate 329). But by now Bomberg's style has become even further removed from the approach that Rodker deemed appropriate for the book. This drawing's notable lack of architectural detail contrasts absolutely with the diligent precision displayed in William Coldstream's *St Giles Cripplegate*, a painting of the war-damaged city executed not long afterwards (Plate 330). For Bomberg ensures that the harsh scaffolding of contours, with which he had once delineated London's painfully exposed skeleton, now gives way to a more ethereal vision. In *St Paul's and River Thames* the cathedral and its surroundings appear to be overtaken by a twilight haze, indicating that the gaunt reality of bomb-devastated streets is swiftly fading into an elegiac and redemptive dream.

# CHAPTER TEN  Teaching and Travelling

At long last, after years of rejected applications and short-term assignments, Bomberg was able to secure a more substantial position as a teacher. Towards the end of the war the Bartlett School of Architecture allowed him to take over a drawing class with the help of a warm recommendation from Sir Charles Reilly. Although he had no previous experience of teaching architectural students, Bomberg's work convinced Reilly that the Bartlett would benefit from the artist's presence. Ever since the Palestine period he had displayed a particular interest in the structure of buildings, either dominating the composition with their stark geometry or contrasting with the altogether more unruly and organic forms of the landscape around them. Bomberg renewed this involvement with architecture when he began drawing the city in the blitz period, and he showed a selection of these powerful studies to Reilly (Plate 331). At all events, Reilly had no hesitation in giving Bomberg's work an enthusiastic endorsement in December 1944:

> I have been looking at Mr David Bomberg's drawings of great masses of buildings, and feel he has something valuable to convey to the young architectural student. He has extraordinary powers of giving a sense of mass and it is on its mass and volume a modern building so much relies. He could help therefore the young architect, who so often today has to rely on time-making [*sic*] models to express himself quickly and effectively. If I had charge of a school still I should like Mr Bomberg to take a sketching class for me, feeling he would help the student

331. David Bomberg. *Round Church, Middle Temple*, 1944. Charcoal, 47.7 × 62.2 cm. Fischer Fine Art, London.

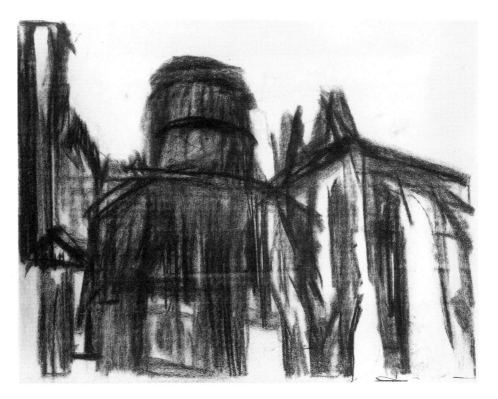

332. Raymond Myerscough-Walker. *Senate House, London University – view from Malet Street*, 1936. Pen and watercolour, 53.5 × 75 cm. Messrs Adams, Holden & Pearson, London.

333. David Bomberg. *Interior, St Paul's*, 1945. Charcoal, 50.8 × 38.2 cm. Roy Oxlade, Sittingbourne.

to get at the meaning of the mass composition of the building rather than of their detail, and that is what is wanted.[1]

As a friend and admirer of Charles Holden, to whom Bomberg had written eight years before offering to paint a 'mural decoration'[2] for London University's new Senate House building, Reilly was predisposed to admire the starkness of these blitz drawings. Their gaunt, rough-hewn economy had little in common with the highly finished and scrupulously detailed perspective drawings which architects favoured when they presented their proposed buildings. Even Holden, whose work had a simplification and bare severity which Bomberg could respect, employed a perspectivist as meticulous as Raymond Myerscough-Walker when the Senate House design was exhibited at the Royal Academy (Plate 332).[3] But both he and Reilly acknowledged the importance of an austere emphasis on 'mass and volume', and the Bartlett was prepared to enlist Bomberg's services in the autumn of 1945 for Saturday drawing expeditions to the Victoria & Albert Museum, Westminster Abbey and St Paul's Cathedral, where he drew some distilled and almost mystical studies of the domed interior (Plate 333).

Despite the Bartlett's refusal to consider his requests for further classes during the week as well, Bomberg greatly impressed some of the students whom he taught. Richard Michelmore, an uncertain seventeen-year-old, never forgot the first lesson he learned from Bomberg in the gallery where the Victoria & Albert Museum displayed its sculpture casts. The class was told to draw the Siena Pulpit and Michelangelo's *David*, just as Bomberg himself had done as a young student in 1907 when Sargent befriended him. But Bomberg was now a mature artist with decades of drawing experience behind him, and he was determined that his class should avoid making literal, academic copies which failed to penetrate the superficial appearance of the motif. Michelmore remembers Bomberg insisting that 'there is no fixed way in which a line goes, but there is a relationship between lines. There is then an order peculiar to one's own vision of a thing, an order which underlies the image.'

Bomberg had no time for the kind of teaching which satisfied itself with a conscientious account of externals alone. From the outset, he wanted students to grapple with the preoccupations explored in his own drawings, and he was not afraid to ask them to strive for a profoundly personal response which dispensed with conventional form-language in favour of a radical alternative. His class, inevitably, was astonished by the demands he made. 'To an architecture student his refusal to accept perspective was revolutionary in itself', recalled Michelmore, who described how Bomberg 'was always requiring a wider and wider view to stop us fiddling about with detail, and this too ties up with this basic philosophy'. Once he had overcome his amazement at discovering such an audacious teacher, Michelmore found Bomberg's outlook immensely stimulating. 'This approach gives enormous freedom', Michelmore explained. 'No holds are barred, the end justifies the means, whereas in all the training I had experienced the means justified the end. Distortion was irrelevant; colour was part of drawing, good colour arose naturally out of good drawing; good drawing was delineation of forms in relation.'[4]

However enthralling such an approach may have been to students like Michelmore, it was bound to upset and antagonize the more orthodox members of Bomberg's classes. He had already encountered some hostility during a temporary spell at Dagenham School of Art earlier in 1945. His insistence that individual exploration came before technical concerns angered other staff-members and led one of his students, Dorothy Mead, to lodge a formal protest against his approach. But Mead and another student, Edna Mann, were both subsequently won over by Bomberg and became devoted to his challenging example. After a few months at Dagenham he seems to have realized that teaching could be a creative exploration rather than simply a means of earning a livelihood, and that students were showing clear signs of appreciating his efforts. For Bomberg, such a positive response must have been intensely gratifying. After years of wretched neglect, when he felt that no one outside his immediate family and friends understood or appreciated his standpoint as an artist, the emergent generation now seemed to be responding to his teaching. Although he believed that 'art cannot be taught', Bomberg did consider that 'it is stimulated in contact with Art & Artists & happens – it is like life – conception Birth & this is a mystery – but no less a mystery than Art.'[5]

Indeed, a 'Syllabus' dated 22 May 1937 has survived among his papers to prove that he was even then contemplating a 'Series of Lectures on Drawing & Painting'.

They were probably never delivered, but one section of the 'Syllabus' discloses that he was already prepared to tackle the question of 'How Drawing can be Taught'. Here Bomberg declares that 'the principle of the teaching should be to point out – if such be the case – the inadequate representation of the forms; not to alter the artist's drawing, but to encourage the artist to feel more deeply or more generously about it, and the most effective way of demonstrating this is through the medium of the Teacher's own draughtsmanship.'[6] Bomberg was clearly prepared to recognize the special value of the artist-teacher, inspiring through his example. Although he stresses elsewhere in the document that 'it is best to let the Artists find a method for themselves' rather than adopt an unsympathetic mode imposed by a teacher, the urge to impart advice remains strong throughout the 'Syllabus'. At one point he defines drawing in terms which directly anticipate the teaching he was to practise during the post-war period. 'The most satisfactory definition of Drawing I have found is the one that defines Drawing as the representation of form', he wrote, adding: 'not the representation of appearances of Form, but more the representation of all our feeling about a form'.[7]

Bomberg's rejection of traditional teaching procedures, coupled with his ability to convince students that everything he said carried with it the commitment of a practising artist with hard-won achievement behind him, ensured that he offered a refreshing alternative to the predictability of ordinary art-school instruction. Positive response from students heartened Bomberg enormously, and as early as the summer of 1945 a collector of his pictures remarked on the difference it had brought about. 'I was very pleased to notice a great change in your views on life', wrote Arthur Stambois, 'and can never remember seeing you look so pleased with life as you did the other night – it seems that teaching has brought your peace of mind and satisfaction to your spirit.' Stambois even ventured the opinion that 'you will shortly reach your true zenith which lies in your power to pass on your very fine knowledge, to the initiated and also the unsophisticated – as David I think that will be your truer vocation.'[8]

However much Bomberg may have resented this last comment, he could hardly deny that teaching now seemed to be providing him with an absorbing new outlet for energies which had so often been thwarted in the past. But where could he find a more permanent post? The answer came quite unexpectedly, and somewhat haphazardly, in August 1945. Earlier in the year Bomberg had been turned down after interviewing for a job teaching life drawing and painting at the Borough Polytechnic, where Roger Fry had decorated a students' dining-room with several other English Post-Impressionists in 1911.[9] The excitement generated by that experimental period had long since cooled by the time Bomberg applied for a post at the Borough: all the dining-room decorations were dismantled in 1931, and along with them went any lingering sense that the Polytechnic was in the vanguard of contemporary British art. All the same, Bomberg wanted a job keenly enough to take heart from a letter he received after the interview from Mr Patrick, the Head of the Borough's Art Department. 'I assure you I was very pleased to meet you and if at a future time can offer any teaching it will be pleasure', wrote Patrick, adding that 'you left one of your photographs – I will take care of it until you call.'[10] This postscript may have given Bomberg the chance he needed to establish a firmer relationship with the Borough, for at the end of August 1945 Patrick wrote again, explaining that 'I may be able to fix you up for a day each week, that is morning and afternoon. We are starting day classes for American personnel in Commercial Art to commence on 1st October.'[11]

Although only a modest offer, it enabled Bomberg to establish at the Borough one of the most significant and consistently adventurous classes in post-war British art education. For the time being he continued with other teaching commitments as well, obtaining permission in October 1945 from Professor Richardson of University College 'to conduct parties of students to sketch London buildings'.[12] Bomberg also applied, the following month, for the Chair of Fine Art at Durham University, declaring in his lengthy letter that 'I have become convinced that after 30 years of intense painting I can bring all the knowledge gained thereby together with all I have learned from my eminent teachers, to helping the younger generation of students and artists.' He was inevitably rejected by Durham, but the intensity of one particular passage in his application gives an insight into the depth of commitment Bomberg would give his students at the Borough:

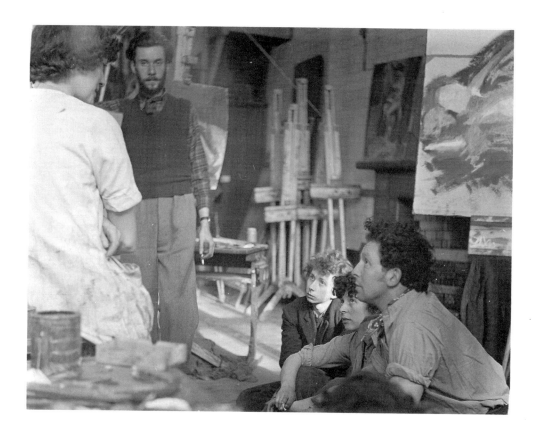

334. Photograph of (left to right) Dinora Mendelson, Leslie Marr, Dennis Creffield, Dorothy Mead and Cliff Holden at the Borough Polytechnic, *c.* 1948. Collection of the artist's family.

Anyone with a mind at all is able to see at what a low standard is the achievement of the study of Art in the country, both inside the Universities and out – the war is responsible for this. A great driving force is more necessary now than ever before to get the studentship on to a high cultural level, as much for its own sake as to arrest that factor of mediocrity apparent both in the Art Study and in the teaching thereof.[13]

From now on Bomberg dedicated himself at the Borough to act as a spearhead of this 'great driving force'. He was able to convince his students that his teaching was animated by an unusual amount of passionate conviction, too. Cliff Holden, who became for a while one of Bomberg's most ardent students, realized when he first encountered his future teacher that here was a man worthy of the most unequivocal admiration. Holden came across Bomberg in an evening class on drawing at the City Literary Institute. 'There he was, patiently expounding his basic principles to middle-aged ladies', Holden recalled. It was a bizarre occasion, but Bomberg impressed him at once. 'I'd been disillusioned with the curriculum of modern art schools, and dissatisfied with being taught by eclectic teachers', Holden explained; 'I mean by men who attempt the impossible task of interpreting the practice of others while involved in that merry-go-round of teacher training teacher who will in turn produce teachers; I had been consciously searching for a master.'[14]

Bomberg was clearly the figurehead he wanted to find. Along with Edna Mann and Dorothy Mead, whose enthusiasm for Bomberg's teaching had first been aroused at Dagenham School of Art, Holden started attending the Borough classes. The very existence of the class was in itself something of a miracle. 'It is possible that Bomberg's Borough classes would not have flourished at all, had it not been for the rather peculiar circumstances which schools and colleges were in at the end of the war', explained Roy Oxlade, 'when Art departments were starting up again and looking for students at a time when there was still a large number of potential students away in the services. In this atmosphere Bomberg's first students acted somewhat as recruiting officers, enlisting likely people from all parts of London, and in this respect, Cliff Holden saw himself as a natural leader, having what he now describes as "a Messianic feeling about Bomberg".'[15] Before long, Holden, Mann and Mead were joined by other young students, including Gustav and Max Metzger, Dennis Creffield, Dorothy Missen, David Scott, Ian Gordon, Don Bradman and Cecil Bailey.

Members of Bomberg's family came too. Lilian, whose own work as an artist had remained dormant since she drew an eloquent portrait of Bomberg during their earliest days together (Plate 228), attended the classes as a mature artist rather than a pupil. Bomberg, realizing that 'she had always been frustrated in this part of her life',[16] persuaded her to join. He may well have been trying to thank Lilian for selflessly nurturing his art over the previous two decades, when her desire to paint was entirely subsumed in a determined attempt to keep him working. Now, at the Borough, she started painting again with a vigour which was to characterize her art for the next quarter of a century.[17] Dinora also came to the classes, and for the only time in her life she felt 'at one with David – he treated me as an artist.' She introduced other young students like Leslie Marr, Peter Richmond, Allan Stokes, Len Missen and Peter Lasko, later to become Director of the Courtauld Institute (Plate 334). Within weeks of joining Bomberg at the Borough, most of them realized that they were fortunate enough to be in the presence of a very remarkable teacher – a man described by Frank Auerbach, who began attending in 1947, as 'probably the most original, stubborn, radical intelligence that was to be found in art schools'.[18]

Dennis Creffield's memories of the Borough are just as warm as Auerbach's, and likewise stress Bomberg's opposition to prevailing art-school values. His teaching was, according to Creffield,

> a curious situation – classes within an art school but not of it – no diplomas or exams. You paid – or didn't – a small fee, simply to work with him. It was to all intents a private school. Of course the authorities didn't care for this ... The schools taught a debased academicism, and were repressive to innovation. So his classes were a beacon to people of spirit – they found there purposive seriousness and encouragement. He was also ill at the time, and it's been suggested that he felt that he might not have much time left for painting. True or not, that was the spirit in which he taught – giving everything that he knew and loved – holding nothing back – to a degree that can have been rarely paralleled.[19]

It would be wrong to imagine that Bomberg approached his classes in a rigid or even a totally consistent way. He had an empirical attitude, essentially, and was always prepared to take his cue from the requirements of the particular personalities he encountered. This responsiveness to individual needs constituted one of Bomberg's central strengths as a teacher, and helps to explain why he elicited such intense admiration from so many of his students. Cliff Holden, who has written an excellent account of Bomberg's approach to the Borough classes, laid special emphasis on his flexibility and openmindedness:

> Like Léger and André Lhote, Bomberg taught his practice, but unlike them he did not teach a method and he hadn't any complete aesthetic system. His methods were dogmatic and contradictory. It was a sort of battle between a trinity of teacher, student and model, a fight which could not take place away from the materials. In this fight he was anything but restrictive. If the student was painting in a perpetual gloom he would be shown means of lightening his palette, if he was tentative he would be encouraged to become more engaged with the materials and throw it on in shovelfuls, to walk on it, or attack it with the knife – any means of making the mark was permissible. If the paint was getting thick so that the student couldn't see the wood for the trees he would be asked to use coloured papers. If he was using thick lines which impeded the flowering of the form he could then experiment with small dots of colour. But if the student were facile, using an aesthetic line, then Bomberg would give him a great lump of charcoal and cite Modigliani and John as examples of men who would tie the tool to the big toe to escape the domination of a facile hand. On the other hand he didn't allow any student to completely abandon himself to the line, to the paint, the texture, the sensuality of the brush; and he had no respect for the brute force of the blowlamp, the bicycle, or any other medium which savoured of trickery.[20]

The fact remains, however, that Holden was delighted to regard Bomberg as 'my master',[21] and a surprising number of the Borough students produced work which bore an unmistakeable resemblance to their teacher's own art. In other words, Bomberg exerted a formidable hold over many of the young men and women

who studied with him. A number of them were soon to form an official group exhibiting under his guidance, and they found inspiration in Bomberg's summary dismissal of the approach to draughtsmanship taught in British art schools. He once referred to it as 'corruption in the name of Drawing – the "Hand and eye" disease',[22] and insisted on developing a radical antidote which refused to rely on a predictable, mimetic account of the thing seen. 'When the door has been closed on the completion of an academic rendering, no matter how rendered to the resemblance of the anatomic stress and strain, it is still only saying the things you already know', he once wrote; 'it may be excellent in its representation of the form of Man in its finest, it can be a highly skilled rendering, contain and show care – it is still a lifeless drawing in the light of modern art.'[23]

Bomberg was certainly not opposed to the traditional art-school practice of drawing from a model: all activity at the Borough revolved around the students' scrutiny of a posed figure, and he declared that 'the exercise of drawing from the life brings out the individuality of the [artist] in the man.'[24] But he was adamantly against any dutiful recording of the external facts presented by the model, relying on stereotyped conventions to produce a clever and yet unimaginative study. Bomberg wanted his students to cast aside all the academic props that they might be tempted to employ, and embark instead on a voyage of authentic discovery. In the draughtsmanship he valued most deeply, 'the hand works at high tension and organizes as it simplifies, reducing to bare essentials, stripping all irrelevant matter obstructing the rapidly forming organization which reveals the design. This is the drawing.'[25] His refusal to depend on ready-made formulae and hackneyed perceptions demanded a great deal of the students who responded to his call. Rather than steadily acquiring the ability to produce an acceptable drawing from life, they were challenged by a startlingly different imperative. For Bomberg claimed, in effect, that there was no point in accumulating technical expertise if it prevented artists from conveying their own imaginative insights. That is why he insisted that 'Art cannot be taught – but Draughtsmanship can be taught to those who have a Natural Gift.'[26] Although he had no desire to furnish students at the Borough with a slick, superficial method of reproducing the familiar face of reality, Bomberg did believe that they should be encouraged to break through this surface and conduct a more intuitive and poetic exploration of nature.

The lack of emphasis on craftsmanship and illustrational accuracy led many other art schools to dismiss the teaching at the Borough, and to advise their students firmly against any contaminating adherence to Bomberg's heretical views. 'I can remember while I was a student of Bomberg's being warned at my own art school, Bromley College of Art, that I was trying to run before I could walk',[27] testified Roy Oxlade, one of the later pupils at the Borough. British art education was in a generally parochial state after the Second World War. Many influential heads of departments still could not bring themselves to acknowledge the cardinal achievements of Picasso and Matisse, and so Bomberg's impatience with life-room propriety sounded like a dangerously subversive attitude to the British art-school establishment. 'Bomberg himself talked constantly of the mood', Holden remembered; 'he always said, "try to remember the mood"; it was only by remembering the mood of the creative act that one could be certain of working well, and progressing from one vital image to another. It had to be an almost ecstatic drunken state, in which we project ourselves into reality, into things, rather like an actor becoming identified with the character he is playing. It was in a concern with mass that we strove to find the unique character of the mass and the meaning in the reality.'[28]

Bomberg himself, coining his most memorable and eagerly debated phrase, declared that 'our search is towards the spirit in the mass.'[29] His words left their mark, too. Creffield recalled that at the Borough 'the key words were "structure" and "the spirit in the mass".' He remained quite clear about their meaning, explaining that ' "the spirit in the mass" is that animating principle found in all nature – its living vibrant being – not simply the sheer brute physicality of the object. "Structure" did not mean anatomical structure or geometrical reduction – it was the unique image – or metaphor – in which the experience of "the spirit in the mass" found embodiment.'[30] Bomberg himself remained unwilling to elaborate on the precise meaning of this potent phrase, preferring instead to leave it standing alone as a pronouncement with a distinct poetic resonance of its own. 'Many people have asked us for a further definition', he wrote in 1949, insisting that 'words cannot

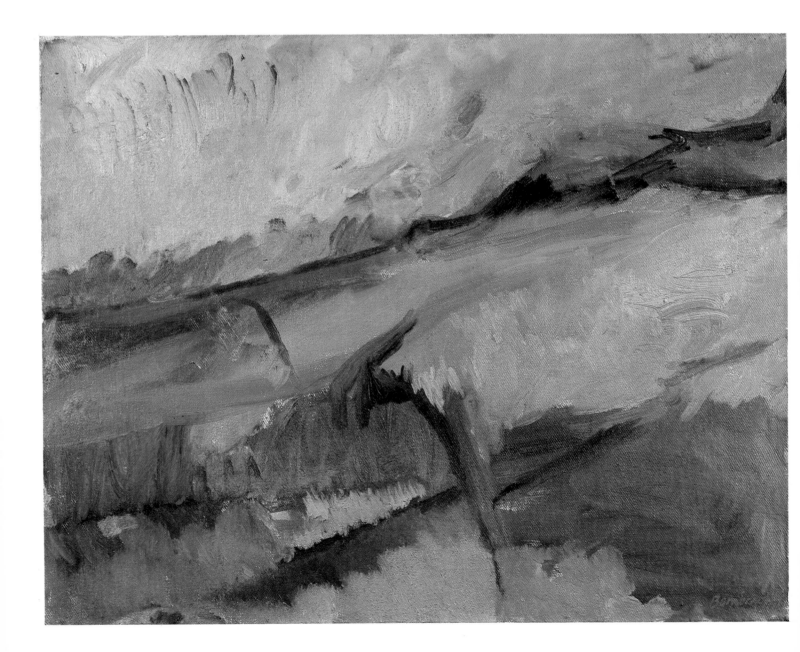

give it; the answer lies in the content of the painting.'[31] It was a reasonable assertion for any artist to make: why, after all, try to explain something in words when the ultimate aim is a visual image? But as his largely unpublished writings demonstrate, Bomberg could not resist the urge to provide a verbal analysis of his aims and beliefs on many other occasions. The truth is that he felt unable to make up his mind about the value of writing about art, decrying the whole notion and at the same time attempting to set down his own views on the matter in sentences whose awkward and unorthodox construction often mirrors the ambivalence he experienced. In one passage he moves with extraordinary rapidity from a wholesale condemnation of verbal definitions to an attempt at providing a dictum of his own:

> The futility of pronouncements from the so many, together with the human ego & desire to encompass a magical phenomenon is to state in words what is the meaning of, or what is art, has served to confuse & confine something that in essence lives but is not life, beauty & truth which is near but is not God – something that is boundless & infinite – a magnitude beyond measure – something unidentifiable & yet has Form but which is not synonymous with nor can exist as form only.[32]

Bomberg's belief that the essence of art remained 'unidentifiable' did not lead him to condone woolliness, in either his own or his students' work. 'The spirit in the mass' may have sounded like a grand, generalized statement, but he never intended it as a justification of slackly organized images. On the contrary: he was always preoccupied with formal discipline, insisting that 'I watch with interest the structure of a painting – what it depicts comes next – but I will not consider the second if the first is unsatisfying.'[33] The coherence of art was of paramount importance to Bomberg, for he believed that artists should convey a state of heightened awareness through the tactile intensity of their drawings and paintings. This conviction, which can be traced back as far as his early interest in Berenson's writings on the Florentine Renaissance,[34] underlies all Bomberg's mature reflections on art. He wanted to revitalize humanity's relationship with nature by discarding conventionalized ways of seeing and replacing them with a more direct, fresh and vivid apprehension of the world of forms.

This view has evident connections with the opening words of Bomberg's militant credo in the catalogue of his very first one-man show: 'I APPEAL to a *Sense of Form*'.[35] But a crucial change had overcome Bomberg's beliefs during the decades since he published his 1914 statement, and it centred on his attitude towards the machine age. Before the First World War, he accepted the inevitability of mechanized civilization and was content to let its hard, clean energy pervade his work. 'I look upon *Nature*, while I live in a *steel city*', he announced in 1914, implicitly acknowledging that his vision of the world had been shaped by the industrialized, urban surroundings he inhabited. But the protracted horror of the Great War made Bomberg realize how great a threat mechanical inventions could pose to humanity when they were used for destructive ends. This revelation coincided with his feeling that extreme geometric abstraction was a cul-de-sac, and for the rest of his life Bomberg dedicated himself to developing an alternative rooted in his avid response to the natural world. He decided finally that 'we are resolutely committed to the structure of the organic character of mass'[36] – an explicit rebuttal of his youthful involvement with machine-age forms. Indeed, Bomberg now thought that the artist's prime task lay in providing a sturdy corrective to the relentless advance of the technological society. 'We have no need to dwell on the material magnificence of man's achievement', he wrote, 'but with the approach of the scientific mechanization and the submerging of individuals we have urgent need of the affirmation of his spiritual significance and his individuality.'[37]

Precisely because Bomberg had passed through an initial phase of optimism about the machine age, succeeded by an equally heartfelt period of disillusion and even despair, he attached an almost crusading importance to his mature conviction that art should now counteract the dehumanization of modern life. This belief has, if anything, grown in pertinence since Bomberg propounded it during his Borough years, and it gives an additional sense of urgency to his search for 'the spirit in the mass'. Art, he fervently insisted, offered humanity nothing less than salvation from the damning consequences of a mechanized existence. Rather than remaining alienated from nature, Bomberg wanted to regain first-hand contact with

C52 (facing above). David Bomberg. *Sunset, Bideford Bay, North Devon*, 1946. Oil on canvas, 61.2 × 76.3 cm. Laing Art Gallery, Newcastle-upon-Tyne.

C53 (facing below). David Bomberg. *Trendrine, Cornwall*, 1947. Oil on canvas, 84 × 109 cm. Arts Council of Great Britain collection.

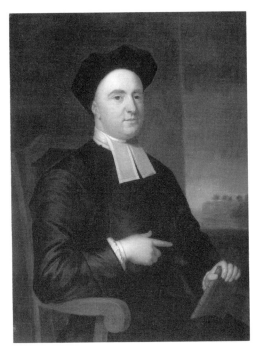

335. John Smibert. *George Berkeley, Bishop of Cloyne*, 1730. Oil on canvas, 101.6 × 74.9 cm. National Portrait Gallery, London.

a world which threatened to become cold, inert and nullified in the work of artists who shut themselves away from natural laws and rhythms. Hence his particular emphasis on discovering 'the spirit in the mass', for he explained that 'Mass is nothing unless it is the poetry in mankind in contemplation [of] Nature.'[38]

Since he took such a missionary view of the artist, who ought to tear down the veil preventing people from confronting reality on its own terms, Bomberg did not want the work produced at the Borough to be at all equivocal in its meaning. Hence the amount of stress he always laid on clarity of structure. 'Among the discernible factors, *immediately* discernible for endurance, is definition', he wrote, '– be the inspiration of the artist vague, the forms nevertheless that are to convey and define the human element of thought and feeling, whether in abstract or in natural form, must be clear.'[39] The role of art, as Bomberg now defined it, was far too important to be confounded by unnecessary obscurity. That is one of the principal reasons why he stressed his indebtedness to the philosophical writings of Bishop Berkeley (Plate 335), whose work had first been drawn to his attention by Professor Brown when the young Bomberg went to be interviewed for a place at the Slade. 'We spoke about the Bishop of Cloyne',[40] Bomberg recalled later, and Brown probably mentioned Berkeley in the context of an essay on 'The Principles of Teaching Drawing at the Slade School' by John Fothergill. It was published in *The Slade*, a 1907 collection of work by Slade students, and Bomberg would have found there an enthusiastic endorsement of Berkeley's thought. For Fothergill believed that the only way to comprehend the true solidity of things was to supplement sight with the sense of touch. He revealed in a footnote to the essay that his attention had been 'called to Bishop Berkeley's "New Sense of Vision" (1709), wherein he was brought to discover the same fact for the purpose of exposing some of the doctrines of geometry'.[41] As we have already noted when examining Bomberg's period at the Slade, he was probably influenced by Fothergill's theories about drawing. Bomberg even revealed in a retrospective memoir that during his student years 'we were directed to the Study of the theory of Vision of Bishop Berkeley.'[42] But the full significance of Berkeley's *Essay Towards a New Theory of Vision* only became apparent to Bomberg in later life, long after he had turned away from his early style.

In the 1937 'Syllabus' Bomberg already pointed out the importance of 'Bishop Berkeley on theory of Optics – proving that impression by sight is two-dimensional – that the sense of Touch and associations of Touch produce on sight the illusion of the third dimension'.[43] But after the Second World War Berkeley assumed the status of a mentor in Bomberg's teaching and writing. He must have renewed his acquaintance with the Bishop's essay, which argues that we place special reliance on the sense of touch to give form and body to the visual information we receive. Sight alone merely records patches of colour, although Berkeley is understandably anxious to point out that 'we cannot, without great pains, cleverly separate and disentangle in our thought the proper objects of sight from those of touch which are connected with them. This, indeed, to a complete degree, seems scarce possible to be performed.'[44] Bomberg, who felt that the cultivation of tactile values was crucial in helping him to disengage from ordinary perception and discover a more intuitive way of grasping reality, naturally warmed to Berkeley's emphasis on touch. It coincided with his own conviction that 'in sensing the magnitude & scope of mass & finding the purposeful entities to contain it in the flat surface (this is the mystery) is cultivated its rehabilitation.'[45]

Bomberg held that the discovery of these 'entities' had nothing to do with abstraction, and here again he must have been aware of Berkeley's similar views. For the author of *Essay Towards a New Theory of Vision* maintained that abstract ideas are based on direct experience of particular aspects of reality. But this emphasis on immediately sensed perception did not prevent either Berkeley or Bomberg from finding intimations of God in the natural world. Both men were convinced that gravitational forces – to which Bomberg attached special importance in his art – attested to 'our conception of God the Creator'.[46] That is why Bomberg was quite willing, in his most explicit published tribute to Berkeley's influence, to admit that religious belief informed his conception of art. 'We gladly make known our acknowledgement to the source at the mountain peak, George Berkeley Bishop of Cloyne', he wrote in 1953, explaining why 'we truly claim to be friends and appraisers for we knew the secrets of George Berkeley's philosophy of the

metaphysic of mind and matter lay in its divinity, and we could not follow in its footsteps unless we ourselves were of that.'[47]

By the time Bomberg wrote those words, he was speaking on behalf of a group who had attended the Borough for some years and exhibited together. In 1945, when the classes began in the white-tiled life room at the top of the Polytechnic building, this feeling of solidarity had yet to develop. But Bomberg's students did not take long to realize that he was an unusually intense man, sincere in his conviction that the artist could save the world from the threat posed by incessant technological advance (Plate 336). Bomberg held the highest ambitions for art, and his willingness to do so inspired students who had heard other teachers propose far more mundane interpretations of the artist's role. He was convinced, now, that geometrical abstraction ran the danger of terminating in sterility. The only way to avoid such a pitfall was to become attuned once again to the fundamental rhythms of nature. In a lyrical passage, Bomberg called attention to the overriding importance of 'the seasons, the winds, Tides & Ocean Swell – we may be Realists Mystics or Romantics or all three – But it is with these reasons when we are impelled to Draw to Paint or Sculpt that we approach the mass to unite in harmony Spirit & Matter.'[48] As this exalted statement indicates, Bomberg expected an unusually rapt concentration from his students in order that they should attain this heightened state of feeling. The Borough's clinical room, with its hired model, was hardly the most conducive place for them to become involved with organic and dynamic forms of life. But Cliff Holden described how Bomberg was able to bring the classes to a pitch of absorption by stressing, in particular, the 'continuous and active' role of light:

In working from the model he always encouraged the students to work in a variety of lights; it didn't matter if the sun came into the room, and often we worked on into the dusk and even when it was dark. In this way we gained

336. Photograph of Bomberg at the Borough Polytechnic, 1947–8. Collection of the artist's family.

complete understanding of the form. We used light to reveal those changes in the related directions of the form, which are the only factors which differentiate one form from another and give each its peculiar character. We worked towards what Bomberg called 'the spirit in the mass'.[49]

———

After a while Bomberg felt the need to undertake a painting expedition. The Borough had become so demanding of his best energies that he was neglecting his own work. Besides, the radical reappraisal of humanity's relationship with nature, which lay at the centre of his teaching, could not be achieved if artists restricted themselves exclusively to a life-class context. It was vital to escape from the metropolis, and lack of funds probably dictated the choice of a trip to north Devon rather than the Mediterranean countries which Bomberg preferred. Lilian was responsible for settling on the precise location: 'I had a recollection of staying in Instow when I was young and riding there on horseback.'[50]

When they arrived there in 1946, she found Instow itself disappointingly altered: 'it was all fish and chips.' But they enjoyed crossing over the water to Appledore on the opposite shore, and after their tent had been pitched in a field 'high up on a hill near Instow', their spirits rose still further. 'I took to camping like a duck to water', Lilian explained; 'I must have gipsy blood, I dance like a gipsy and gipsies have always recognized that.'[51] Bomberg discovered that the view over Bideford Bay stimulated him to paint his first landscapes for almost a decade. He stayed there for two or three weeks, and the paintings completed there prove that Bomberg was able to recover much of his old feeling for working out-of-doors.

Although the English landscape had never before excited him as powerfully as Spain, *Sunset, Bideford Bay, North Devon* is indeed an impassioned image (Colour Plate 52). The view from the upper reaches of Instow commands an epic sweep of water, and Bomberg conveys its panoramic immensity by dragging his generously loaded brush across the lower reaches of the composition with great vigour and certitude. But the sky, occupying the largest portion of the picture-surface, contains

337. David Bomberg. *Bideford, Devon – the meeting of the Tor and the Tay*, 1946. Oil on canvas, 58.4 × 76.2 cm. National Gallery of Victoria, Melbourne, Felton Bequest.

338. David Bomberg. *Barnstaple Bay, Devon*, 1947. Oil on canvas, 51 × 66 cm. Pamela Sylvester, London.

339. David Bomberg. *Flowers*, 1946. Oil on canvas, 92.9 × 71.2 cm. Herbert L. Lucas, Los Angeles.

the most dramatic passages. Treating it like an arena where his most tumultuous emotions could fuse with the overcast and blustery dynamism of nature, Bomberg animates the clouds with marks energetic enough to evoke the west country climate at its most volatile. Although the day is dying, the vitality of his brushstrokes and the sonorous richness of his colours ensure that *Sunset, Bideford Bay* is not a gloomy image.

There is, nevertheless, an emphasis on overcast weather and even storminess in the Instow paintings. The sunlight bursting like an incandescent explosion on the waters of *Bideford, Devon* fails to disperse the ominous gathering clouds (Plate 337). They dwarf the vulnerable boat sailing alone on a sea that could soon grow rough and hazardous, and only for the moment does a relatively placid passage seem assured. Bomberg was interested in the image of a lonely vessel. It appears again in *Barnstaple Bay, Devon*, this time punctuating the scene (Plate 338), and Lilian recalled that Tennyson's *Crossing the Bar* had particular meaning for them during the Instow expedition. She associated it with this locale, asserting that 'David would have known the poem',[52] and it is certainly true that the brooding isolation of these paintings accords well with Tennyson's poignant yet stoical mood:

> Sunset and evening star,
>> And one clear call for me!
> And may there be no moaning of the bar,
>> When I put out to sea,
>
> But such a tide as moving seems asleep,
>> Too full for sound and foam,
> When that which drew from out the boundless deep
>> Turns again home.[53]

Apart from a less successful attempt to paint Exmoor,[54] and a few flower paintings which constitute an exuberant coda to the series he executed three years before (Plate 339), Bomberg painted little in 1946. As his commitment to teaching grew, so he seemed incapable of recapturing the sense of sustained creative purpose which had prompted the prolonged sequence of *Bomb Store* pictures. Bryan Robertson had recently written an enthusiastic article on his work in *The Studio*, declaring that 'he has already achieved greatness by his sincerity, craftsmanship, and intensity of expression',[55] but this rare manifestation of critical support did not help Bomberg overcome his tendency to stop painting for lengthy periods of the year.

Part of the problem lay in the very success of the Borough classes. Although they did not attract a great number of students, some of the men and women who

attended became so involved with his teaching that they now began to discuss the possibility of forming a group named after the institution they were attending. Dorothy Mead, who became one of its initial members, later recorded that 'the Borough Group started in 1946', and she explained that it was formed 'to further the aims of David Bomberg and to establish his students as professional painters'.[56] At first, Bomberg preferred to see himself only as teacher and adviser, letting Cliff Holden assume the role of President and refusing to include his own work in the Group's first exhibition. But Holden emphasized its fundamental indebtedness to Bomberg's example by explaining afterwards that 'all of us were dedicated people, who had consciously, not accidentally, sought out Bomberg as the only hope of salvation in British painting at the time.'[57]

The exhibition was held, 'after many refusals',[58] in June 1947 at the Archer Gallery – a little-known venue in Westbourne Grove set well apart from the main exhibition centres of London. The catalogue was entitled *Exhibition of Paintings by The Borough Group*, but the subtitle added a provocative note by stating that the exhibits included 'Some Rejects From The London Group's Current Show'. Precisely who had been turned down by the London Group committee was not stated, but the artists listed in the Borough catalogue were Lilian Bomberg, Cliff Holden (who had the largest number of exhibits), Christine Kamienieska, Edna Mann, Dorothy Mead and Peter Richmond. Although Allan Stokes was also included in the catalogue, Mead later pointed out that 'he was never at any time a member of the group.'[59] An unsigned essay on the Group's 'Approach to Painting' in the catalogue sought to establish common aims, however. Dissociating itself from other contemporary British painters who had 'departed from the pale shadows of the so-called academic tradition', the statement maintained that the Borough Group was

experimenting with an idiom which we feel is capable of capturing the deeper and more profound aspects of life. The language in which we are endeavouring to express ourselves is understood only by a very small number of people, and the purpose of this exhibition is to broaden that understanding. We know that this work is anathema in the eyes of contemporary tonal painters because it does not approximate to the refined surface quality of their own paintings. And in its naked structure we are certain our work would be rejected from [*sic*] any exhibition in England.[60]

It was a defiant and embattled declaration, lacking in specific precepts but already voicing the conviction that the Group had been 'founded on the belief that there is in nature a truth and a realism which the usual contemporary approach to painting is unable to convey'.[61] If any critics did manage to make the journey to Westbourne Grove, however, they failed to mention it in their reviews. The Borough Group's first exhibition passed unnoticed by the art columns, and this lack of response must have disappointed the hopes of painters who, according to the catalogue foreword, trusted 'that our work may not only serve to bring to the knowledge of people the wealth and richness of life, but also make them conscious that this depth is in themselves'. How could the Borough Group's members transmit this awareness if their exhibition remained unvisited and ignored by the critics? It was a question never to be satisfactorily answered in the brief span of their existence, but the catalogue did implicitly acknowledge that they needed time to attain maturity. 'The endeavour in all our work is to express ourselves clearly and sincerely', declared the foreword, 'and if we fail it is not because our principles and objects are wrong but that we ourselves require more and more experience.'[62]

Bomberg did his utmost to help them develop their youthful abilities, and all the students were encouraged by the sense of indomitable optimism he exuded at his classes. Dennis Creffield recalled that

in spite of neglect he never once, while I knew him, spoke a bitter word about his treatment. The nearest he came was to quote – 'the labourer is worthy of his hire.' His emphasis was always on the positive. He held that creativity is the most important human activity – and he made you feel proud to be an artist. Proud, that is, to be engaged in an important work, and so to be an associate of all those generations of artists who had gone before. Proud, but not egotistical. He believed profoundly in individuality but regarded it as our birthright. No need to strain for it, and falsely to contrive a precocious originality. The individual,

340. David Bomberg. *Trendrine in Sun, Cornwall,* 1947. Oil on canvas, 59 × 77 cm. Manchester City Art Gallery.

given a sound foundation (good draughtsmanship), matured as inevitably and as slowly as a plant. That is why he believed in teaching – why he thought it necessary.

As far as Creffield was concerned, Bomberg did not seek to impose his own vision on any members of his class.

He never taught a style of drawing but tried to help the students to aim in the right direction – to develop – a moral disposition – the artist as a man. He would quote Tonks – 'a bad drawing is a lie' – and he continually emphasized the importance of integrity. Contrary to common opinion, there was nothing of expressionism in his teaching. Charcoal and oil paint were used because of their well-tried plastic, tactile and sensuous qualities. He himself used them boldly and richly but he never ploughed his paintings – and he never taught us to – enough is enough. The school of thick paint which is often attributed to him does not derive from his teaching but is the personal characteristic of certain artists who attended his class – or who have been taught by them. His classes were orthodox in form – no coloured lights or moving models – no contrived excitement. The student had to learn to conjure his own magic.[63]

So did Bomberg, and the outcome of the Devon trip prompted him to set off in 1947 on the most successful painting expedition he ever undertook in Britain. Eager no doubt to continue the exploration of the west country commenced the previous year at Instow, he travelled this time to Cornwall. The six-week trip took place in August and September, and Bomberg was accompanied not only by Lilian but also by Diana, Dinora, her daughter Juliet, and Leslie Marr. This extensive family gathering pitched an ample tent on the Trendrine farm near Zennor, one of the most primitive and untouched stretches of land in the whole of Cornwall. Its wildness appealed to the man who had savoured the ancient integrity of Toledo and other Spanish sites; but the region around Zennor possesses nothing as spectacular as the vertiginous cliff-face at Ronda. Its beauty is less assertive, yet equally compelling, and it prompted Bomberg to paint his finest British landscapes.

The first canvas, according to Lilian's recollection, was the ecstatic *Trendrine in Sun, Cornwall* (Plate 340). It is executed with an audacity which might initially suggest that Bomberg was taking unprecedented liberties with his subject. Impulsive strokes of hot orange brandish their own identity as they swoop down from either side of the composition, engaging the viewer at once in a pictorial drama which testifies to Bomberg's heightened state of awareness. The marks which he so rapturously applies seem at first to be transporters of his feeling, metaphors for a deep-seated desire to run his fingers over the land and grasp it in the most tactile sense. But

further examination of the painting discloses that it also succeeds in remaining faithful to a particular locale, where two surging hills descend to meet each other and then direct the eye through a ravine towards the blue of the sea beyond. Lilian remembered that the painting was 'done on the camping site leading down to the opening of the bay',[64] and the image shows how ardently Bomberg wanted to project himself into the landscape rather than remain at a remove from nature.

This desire to become immersed in the scene, so that he acted as a participant and not a detached observer, is even more evident in a larger canvas called *Trendrine, Cornwall* (Colour Plate 53). Instead of looking down to the sea, Bomberg this time walked to the field in front of the camp-site and set up his easel looking inland towards the hills behind his tent.[65] Once again the painting brings us up against the rising land in an intensely physical way. Not for him the studious reticence of the artist who prefers to maintain a distance from the motif: this exalted canvas transmits the sensation of feeling his way up a steep slope towards a horizon where

341. David Bomberg. *Sea, Sunshine and Rain*, 1947. Oil on canvas, 66.1 × 96.6 cm. Private collection, Australia.

342. David Bomberg. *Tregor and Tregoff, Cornwall*, 1947. Oil on canvas, 87 × 107.3 cm. Tate Gallery, London.

the sun erupts in a flurry of crimson, puce and pale yellow. The brushwork is more loosely applied than in *Trendrine in Sun*, less concerned with charting the structure of a ravine and more intent on caressing the land's surface with straggling yet fiercely applied brushmarks. Trendrine is seen here as an almost Mediterranean site, aflame with colours not normally associated with the English landscape. But Bomberg preferred Turner to Constable, and the Zennor area sometimes enjoys a summer more exotic than the rest of the country. Although Lilian described the climate as 'just sunny, not very hot', she did remember that 'the sunset was spectacular'. Bomberg had favoured this time of day before, in Devon as well as Spain, and at Trendrine it prompted him to indulge in an incandescent palette.

Bomberg's Cornish trip was a particularly fruitful one, unmarred by the misfortunes which interrupted so many of his expeditions. The surroundings were beneficent rather than obstructive, and when he ran out of tobacco Lilian found that they were able to pick substances from nearby trees, crumble and then smoke them.[66] The weather broke for a while, but even then Bomberg was able to capitalize on the disturbance by setting off with a canvas to execute a painting called *Sea, Sunshine and Rain* (Plate 341). As its Turneresque title implies, this superb picture brings together the struggling forces of a volatile Cornish day and amalgamates them in a single tumultuous image. Clouds and mist drive across the earth, casting sombre shadows as they pass. Bomberg's slashing brushstrokes act out in their movement the lancing of rain, but they also reveal that the sun is striving to pierce the storm. Light already succeeds in irradiating the sky with shafts of orange and an occasional hint of blue, suggesting that the turbulence might soon give way to a more serene alternative. For the moment, though, the two opposing elements are held in energetic balance by a painter able to give this temporary conflict a permanence which still retains the vitality of the event he witnessed.

Bomberg's spirits were fortified on this memorable expedition by the activities of his family. Lilian often painted near him, impervious to the weather. Recalling the day when *Sea, Sunshine and Rain* was executed, she described how 'it was raining while we were painting, and wind and rain were slashing. We didn't mind that: we've often painted in stormy conditions. It enters into the painting.'[67] Bomberg's grand-daughter Juliet was also painting at Trendrine with the aid of colours he had laid out for her 'on a little piece of glass'.[68] Bomberg admired children's art, finding in it a freshness of response and a boldness which he wanted his own work to embody. In his 1937 'Syllabus' he had declared that 'the cave paintings in the Altamira Cavern . . . are examples of a type of draughtsmanship that has never been excelled by any race of mankind throughout the ages', and he went on to point out that 'the drawings of the immature in human experience, such as children between 3 and 7 years of age . . . have in many respects points of similarity with drawings done by cave dwellers in the infancy of the human race.'[69] Juliet's painting of *The Windmill*, completed that day at Trendrine, would therefore have given him special pleasure, and Bomberg was similarly gratified when Diana painted a series of works while he completed another surging landscape called *Tregor and Tregoff* (Plate 342).

It is a measure of Bomberg's isolation in the British art world that he never contacted the remarkable colony of painters and sculptors at nearby St Ives. Ben Nicholson, who was living in the town with Barbara Hepworth, had invited him on a Swiss painting expedition a quarter of a century before (Plate 184). But the trip was unsuccessful, and the two men had in subsequent years pursued very different directions. The image of Cornwall defined by Nicholson's work is restrained, pacific and delicate. His painting of *Mousehole*, executed in the same year as Bomberg's visit, draws on the inspiration both of Cubism and of the St Ives 'primitive' painter Alfred Wallis (Plate 343). Its bleached reticence and exquisite calculation stand in total contrast even to the quietest of Bomberg's Cornish canvases. Although he allows *Evening, Cornwall* to be dominated by an unusually generous amount of placid sea (Plate 344), it is still a more expansive and epic image than the discreet *Mousehole*. Nicholson emphasizes domesticity by placing a still life in the foreground and contrasting its compact rigidity with the more organic forms of the hillside beyond. But the countryside is seen as a tame, reassuring place which enfolds us in a protective embrace, whereas Bomberg's Cornwall exposes the viewer to a more outspoken range of elements. In this respect, his vision is closer to Kokoschka, who spent nine months in Cornwall at the beginning of the Second World War and painted a view of Polperro as exclamatory and agitated as the inscription on

343. Ben Nicholson. *Mousehole, November 11 1947*, 1947. Oil on canvas mounted on wood, 46.5 × 58.5 cm. British Council collection.

344. David Bomberg. *Evening, Cornwall*, 1947. Oil on canvas, 68.7 × 106.1 cm. Herbert Art Gallery, Coventry.

345. Oskar Kokoschka. *Polperro II*, 1939. Oil on canvas, 60.6 × 86.4 cm. Tate Gallery, London.

the back of the canvas: 'An artist's signature/remains. – but leaders/of states bloom & fall./All?/Why? –/How an artist lives!/gives!'[70] (Plate 345).

In the final analysis, though, even Kokoschka's hectic interpretation of Cornwall is very different from the landscapes Bomberg executed at Trendrine. They stand on their own, a unique synthesis of his need to study nature and at the same time infuse it with the actuality of his own living body – a breathing, touching, embracing presence which animates his paintings wherever we look. Bomberg's Cornish work parallels the Abstract Expressionists' emphasis on bodily rhythms and gesture, especially in the work of Pollock and de Kooning. Although Bomberg would not have been aware of contemporaneous developments in American avant-garde painting, landscapes like *Trendrine in Sun, Cornwall* demonstrate that he made his own distinctive contribution to a gestural language which radical painters developed in both Europe and America during the post-war years (Plate 340). If Bomberg had received more encouragement to develop the insights he discovered in Cornwall, he might have been able to pursue his work with greater vigour and consistency in the final decade of his life. But he could not even find a dealer who was prepared to give him a one-man show, and so his painting came to a halt once more after he returned to London in the autumn of 1947.

His absorption in teaching at the Bartlett and above all the Borough was partly to blame for distracting him from his own work. But at least Bomberg had found at the Borough a cluster of young painters who admired both his teaching and his work, regarding him as the one artist in England they would most like to emulate. Their heartfelt enthusiasm and dedication were immensely encouraging, and he soon felt impelled to reconsider his earlier decision not to exhibit with them in their group shows. In December 1947 several of the painters who had participated in the first Borough Group survey – Holden, Mann, Mead and Richmond – contributed to an exhibition at the Everyman Cinema in Hampstead. But it was not, this time, an official Borough Group event, and the addition of Leslie Marr and Dinora created dissension among the other participants. Lilian, who had exhibited in the first Borough Group show and also displayed her work at the Everyman, found herself in an uncomfortable position. So did Bomberg, torn between loyalty towards his

own family and a sincere regard for his other pupils at the Borough. When Holden resigned from the Borough Group's presidency, Bomberg realized that he should now attempt to heal the wounds by establishing the group with a written constitution and becoming the new President himself.

His intervention was successful. At a meeting in January 1948 a formal list of the Group's members was drawn up. Apart from Lilian and Dinora, they encompassed Holden, Mann, Marr, Mead, Len and Dorothy Missen and Richmond. They were all happy to stay together now that Bomberg had at last assumed leadership, and within a month Marr invited the Group to show its work on a permanent basis at The Bookworm, his bookshop in Newport Court. It was a welcome opportunity, especially since Bomberg's presidency did not prevent him from displaying two of his paintings in the London Group during the summer. But the Borough Group soon felt the need to organize a proper show in a professional context, so in June 1948 its *Second Annual Exhibition* was held at the Archer Gallery.

This time the catalogue contained no statement, but Bomberg issued a circular to the press announcing his readiness to be interviewed in the Gallery at certain times. He also declared that, 'having found the Academic approach to Art is sterile we have formed a group welcoming the uninitiated, believing they may have something to contribute to the progress of painting as a form of human expression. Our aim is to nurse promise to maturity & fulfilment.'[71] If the critics took up Bomberg's invitation to meet him in the Gallery – an idea he had attempted to implement at some of his shows in the past (Plate 186) – none of them bothered to report their encounters except Oswell Blakeston of *Art and Artists*. Bomberg talked to him not only about the personal satisfaction afforded by art but also about its wider purpose:

> art helps a man to fulfil himself – to fulfil the potentialities of expression which the life force gives him. It is the example the artist gives of fulfilling himself in his work that is of social use to others; for the man who solves his personal problems thereby involuntarily helps everyone else. It is wrong to think of Cézanne painting with the primary intention of contributing to the social good; but because he gave an example of fulfilment, Cézanne has tremendous social importance.

Bomberg's experience as a teacher had doubtless prompted him to consider art's usefulness, in the largest sense of the word rather than as a utilitarian activity, and he went on to affirm that 'there will always be need for art. In the past frustrations have been banished from the community by magic – by the caveman's drawings; today the modern painter's abstraction may be a way of overcoming the communal frustration of a world whose appearance has grown evil with war and corruption.'[72]

Bomberg's refusal to set any narrow and arbitrary confines on the role that art could perform in modern society was one of the reasons why students found him such an inspirational teacher. He really did see painting as an affirmative force, capable of restoring humanity to a more sane and harmonious relationship with the natural world. At the end of his interview with Blakeston he maintained that 'tomorrow, even in Utopia, existence must continue to be itself a limiting factor, needing artistic creation to show that its limits can be transcended.'[73] His convictions were probably fortified by the knowledge that art provided him with a means of countering the frustrations he so often experienced in daily life: through painting Bomberg could momentarily overcome the setbacks and depressions he suffered, and enter a more heightened and rewarding level of awareness. Proof of the exalted rapport he could achieve when making a landscape was offered in the Borough exhibition, too. *Tredega and Tredog* and *Sunset, Bideford Bay, Devon* were both included (the latter at the extraordinarily high price of £250), and the *Manchester Guardian*'s critic praised their 'monumental solidity and repose'. The same reviewer also singled out Holden's 'big, ambitious painting of the battered buildings of Lambeth, a version of the London scene which is rough and heavy but powerful and interesting as well'.[74] The other members of the Group were not discussed, but the *Kensington Post* reported that the exhibition as a whole succeeded in provoking a range of powerful reactions from its visitors: 'a number walk out, shaking their heads sadly, after only a few minutes. Some laugh, others become angry – but many stay, impressed and interested in this revolutionary form of art.'[75]

Although critical response to the Borough show was still sparse, the Group had

346. Photograph of part of the Borough Group's contribution to the first LCC open-air art exhibition, held at Embankment Gardens, London, July 1948. Collection of the artist's family.

347. Photograph of (left to right) Lilian, Bomberg, Diana, Dinora and her daughter Juliet in a train *en route* to Cyprus, July 1948. Collection of the artist's family.

at least begun to establish itself. The decision to participate in the London County Council's free-for-all exhibition of paintings at Embankment Gardens in July proved, too, that the Group believed in reaching towards the widest possible public (Plate 346). All ten members, attracted by the idea that the open-air event would be visited by 'very many thousands of the public, who do not normally visit Art Exhibitions',[76] displayed their work there. It was a courageous act, for the Group could not have known what else might be presented in such an open-ended jamboree. But Bomberg had no objection to showing in the company of amateurs. He liked the idea of contributing to 'London's greatest free show', and Creffield admiringly recalled Bomberg's willingness to turn up at the Gardens 'at six o'clock every morning – to get space! And then during the day he would, literally, accost passers-by, to talk to them about the work.'[77]

The BBC interviewed Lilian and Holden on the *In Town Tonight* programme, thereby enabling the Group 'to explain its aims and ways of working'.[78] And Bomberg professed himself happy with the Borough's participation in an event which occurred well outside the narrow boundaries of the gallery world. He enjoyed encountering the public and discussing viewers' reactions to his work, explaining to a reporter that 'a good feeling was maintained throughout between the public and ourselves, which, in view of the controversial character of our paintings, was no small achievement.'[79] But he was saddened by the refusal of other artists comparable in stature with himself to participate in the show. Writing to the *New Statesman* in his capacity as President of the Group, he pointed out that

> though the majority of professionally known artists could not see their way to support the exhibition, a few, though not the greatly known, came with their best, and materially helped to indicate the sincerity of true artists ... Unhappily no adequate provision for the protection of our paintings in bad weather was provided: also the 'first come, first served' idea involved us and the others in a form of trench warfare. But artists who live for their art and not for their reputations only should have taken that opportunity and not been put off by the conditions. We should have been happy to share our tarpaulins with other artists of renown and distinction had they come out to join us.[80]

The only artists who did prove willing to share Bomberg's aspirations were the Borough Group members, and one of them now enabled him to undertake the most rewarding of his post-war painting expeditions. Leslie Marr, who had recently married Dinora, was generous enough to ask Bomberg where he wanted to go on his next trip. Cyprus was at the forefront of Bomberg's mind, for he had recently met a partner of Austen St. B. Harrison at the private view of the Borough Group exhibition. Harrison, who had been government architect in Jerusalem and a patron of Bomberg when the artist lived there, was now in partnership with Hubbard and Brown. They opened a branch at Lapithos in Cyprus, and when Hubbard came to the Borough show he warmly recommended 'Cyprus, the jewel of the East' as a splendid subject for Bomberg to tackle. He also suggested the name of a monastery which would provide suitable accommodation and so, with Marr's financial support, the entire Bomberg family set off for Cyprus with an immense amount of painting equipment in July 1948 (Plate 347).

Bomberg's elaborate luggage was enlarged, this time, by the abundant supplies of paint and canvas which Marr's funds provided. Accompanied by Lilian, Dinora, Diana, Juliet and Marr himself, he travelled overland to Italy, stopping at Paris, Florence and Rome on the way. 'I wanted David to see the Sistine Chapel', explained Lilian, 'and he liked it – it was wonderful.'[81] Bomberg's youthful enthusiasm for Michelangelo was thereby rekindled, but the expedition soon boarded a Greek ship for the last stage of the journey. During the voyage an unpleasant incident revealed that Bomberg's disapproval of Zionism had, if anything, hardened since his Palestine period a quarter of a century before. The ship, according to Lilian, was 'a nasty cargo boat flying the Panama flag', and at Genoa,

> a couple of hundred young Jewish immigrants on their way to Israel from the German camps came aboard. They were hysterically excited, singing Jewish national songs as the boat got near to Palestine. Having made the captain run up the Jewish flag, they wanted David to salute it. He wouldn't. So they went up to him, threateningly, and said: 'You bloody English Jew, why don't you come

over and join us?' David replied: 'I don't want to. If there's any flag I'll salute, it would be the Union Jack.' I got between them and David, and told them: 'You're behaving like German Fascists.'[82]

Tempers were restored as the journey neared its destination, but Bomberg's expedition suffered an ominous setback immediately Cyprus was reached. Contrary to expectations, Harrison was unable to meet them. Instead, he sent a young man to guide them to the monastery, and when they arrived a Greek priest ushered them into two squalid little cells. To stay there was clearly impossible and so, after leaving their luggage at the monastery, the family trudged off through the darkness along the coast to a Turkish holiday camp. Here they were entertained with exemplary friendliness. The following day they found a furnished house in Lapithos and settled there, after Bomberg and Marr had been forced to break down a door at the monastery in order to retrieve their luggage from the hostile priests. The Cyprus sojourn had started on a decidedly unpropitious note, and their discomfort intensified when they discovered that Lapithos itself had 'a warlike atmosphere'. Political tensions on the island often erupted, making the Bombergs feel besieged. 'We had to close the window shutters whenever we stayed in the Lapithos house', recalled Lilian, explaining that no paintings were made there because it was 'not interesting enough – only a main street'.[83]

So Lapithos was used simply as a base for treks to other, more inspiring parts of the island. And despite the intense sun, producing a climate hotter and drier than anything Lilian had experienced in Spain, Cyprus stimulated Bomberg to paint some of his very finest landscapes. He was particularly excited by the ruined castle of St Hilarion which, as Lilian observed, 'seemed to be growing out of the rocks'.[84] Bomberg was invariably attracted to ancient fortifications lodged in hard, precipitous settings: the cliff-like locale of the Monastery of St George, Wadi Kelt, had prompted some of his most arresting Palestine paintings (Plate 222), and the town of Ronda appeared to be an almost integral part of the vertiginous outcrop on which it rested. Perhaps Bomberg favoured such places because, at a subconscious level, he drew comfort from the sight of ancient buildings which had managed to survive the vicissitudes of time. Even though he may not consciously have realized it, a parallel could well be drawn between these crumbling yet resilient structures and his own capacity to withstand all the setbacks and disappointments of life. The castle at St Hilarion was in a more dilapidated state than any building he had painted before. But Bomberg himself was now approaching sixty, and had endured many frustrations and depressive moods since his Palestine and Spanish periods. He was, in a sense, as battered as the ruins on the St Hilarion rocks, and yet they still rose stubbornly into the air above him when he surveyed them from the lower slopes.

Small wonder, then, that Bomberg was able to paint several sublime images of this motif. The most triumphant is an exceptionally large canvas called *Castle Ruins, St Hilarion*, where the scalded tangle of vegetation and scrub sweeping up to the fortress seems on the point of igniting in the intense heat (Colour Plate 54). Bomberg's palette had never been more tropical in its insistent use of brilliant ochre, scarlet, yellow and rose madder. Laid on with impetuous stabs of the brush and finger, which declare his urgency with great forcefulness, the strokes surge towards the castle walls in an almost delirious rush. Although the fortress itself is considerably darker, it sways and tilts according to the rhythms which pulse through the landscape below. Too solid to be in any danger of collapse, it has nevertheless been transformed from an inert mass of stone into a structure charged with the energy running through the rest of the scene. Bomberg emphasizes the unity between castle and nature by allowing them to merge into each other. It is not entirely clear where the jostling cluster of trees and foliage on the right of the canvas ends and the fortress walls begin. They are both caught up in the same dithyrambic movement, reflecting the pulse of Bomberg's exuberance as he set down his full-hearted response to a landscape which stimulated him so fruitfully.

Not all the St Hilarion paintings share this fieriness. A resplendent small canvas of a sunset is more serene in mood (Colour Plate 55); while the mark-making in *Rock Fortress, Cyprus* achieves a limpidity and lightness rare in the work of a painter who so often built up his canvases with encrusted layers of pigment (Colour Plate 56). This lyrical painting is more abstract than *Castle Ruins, St Hilarion*, and less anxious to build a monumental structure. Bomberg was here concerned about releas-

348. David Bomberg. *Moorish Wall, Cyprus*, 1948.
Oil on canvas, 71 × 91.5 cm. Nottingham Castle
Museum.

ing. the flow of feeling which animates wall, sky and land with unusually loose,
fluent brushwork. It is one of Bomberg's loveliest landscapes, proving that the
St Hilarion setting could inspire in him tenderness as well as ardency.

*Moorish Wall, Cyprus*, on the other hand, shows that the castle and its surroundings
also provoked a more impulsive order of feeling (Plate 348). The outer wall, where
the Bomberg family camped during their two-week stay at St Hilarion, curves
into the picture, its crumbling ramparts white against the mountain rearing up
beyond. As this wall travels into the landscape, it accentuates the division between
sunshine and shadow which gives this canvas its drama. For Bomberg has taken
an extraordinary pictorial risk, contrasting the richness of the light–filled slope with
the almost alarming gloom in the ravine on the right. Moreover, he heightens the
extreme disparity between them by filling the diagonal area of darkness with violent,
zig-zagging brushstrokes which flatly oppose the more caressing marks on the
brighter side of the mountain. This wild variation in handling could easily have
torn the image apart, and it remains perhaps the most eruptive of all his pictures.
But because the entire painting is alive with a consistent intensity of response, Bom-
berg manages to weld these diverse elements into a hard-won unity without lessening
its capacity to startle and even perplex the unwary viewer.

Apart from isolated pictures like the glowing *Trees and Sun, Cyprus* (Colour Plate
57), which was executed on the way back to Lapithos from a fruitless expedition
to some nearby copper mines, most of the other Cyprus canvases were painted
at the Monastery of Ayios Chrisostomos. Lilian recalled that it was 'quite a long
way from Lapithos, and we had to get permission from the archbishop to stay
there'. But the coolness of the monastery must have been a relief after the heat
of St Hilarion, where 'it was so parched that we couldn't get any water: it was
almost like a desert.'[85] Although the family suffered from illness, poor accommoda-
tion and inadequate food at the monastery, it was set in a landscape which once
again fired Bomberg with the urge to paint well. Taking as his focus the erect
form of a thousand-year-old cypress tree, he executed a radically simplified view
of the monastic buildings enfolded by hills and lit by a sky more overcast than
the refulgent blue of St Hilarion (Colour Plate 58). The prominent, sharp-pointed
vertical of the black cypress could have given the picture an air of mourning, but
Bomberg ensures that the hill behind blazes with a red warm enough to kindle
affirmative emotions. The most stark and reductive of all the Cyprus landscapes,
this powerful picture is at the same time the most festive in its colour.

Other paintings executed at the monastery do not pursue the ruthless structural

349. David Bomberg. *Mountain Road, Near Platres, Cyprus*, 1948. Oil on canvas, 50.8 × 61 cm. Sandelson collection, London.

simplification employed here, so Bomberg may well have recoiled from the rather skeletal image he had produced. A smaller painting centred again on the same cypress, this time curving in response to wind which stirs everything else in the landscape as well, reverts to a more broken and impasted handling. The same richness of texture distinguishes *Mountain Road, Near Platres, Cyprus*, which is characterized by a great diversity of handling (Plate 349). Bomberg's marks encompass the round, prodding dabs on the right, where the pigment almost seems to have been pressed onto the canvas by an importunate thumb, and the altogether more sweeping and turbulent strokes in the cloud-heavy sky. At times gathered into tight, frenzied little clusters, and then breaking free to assert a more fluid identity, the handling in this picture shows how eloquent and resourceful Bomberg could be when he let his fingers and brushes enjoy the maximum amount of gestural licence. The frankness with which he displayed a wide repertoire of marks on the picture-surface is one of Bomberg's most potent legacies to a younger generation of British painters.

The high level of achievement in the Cyprus paintings should have encouraged Bomberg to work more frequently after the trip had finished. But, as so often before, the return to London ushered in a long period of inactivity. For the next four years, when he might have been producing work as outstanding as the Cyprus canvases, Bomberg did not paint at all. Teaching, coupled with the organizational demands of the Borough Group, again claimed so much of his energy that Creffield believes the nurturing of students 'became, at that time, *his Work*'.[86] For Bomberg gave to teaching all the commitment and insight that he had previously devoted to his own art. And he had no hesitation in extending help to students far beyond the limits of the Borough classes. If someone needed his assistance, he granted it with great generosity and blithely regardless of the time spent on talking, advising, encouraging, and sharing his hard-won experience. Bomberg should, ideally, have been firm enough to insist that a certain proportion of each week be assigned to painting alone. But he attached such overwhelming importance to the responsibilities of teaching that his own work was set aside, and the sacrifice grew as he immersed himself more and more deeply in his students' lives. 'He used to come round to my studio and spend endless hours talking', Peter Richmond recalled.

> I'd never met anybody who took painting with that kind of seriousness. He thought it could change the world, and his conviction took a lot of time to get used to. You were either with him or against him. He said: 'You've got enough talent to paint all the time, not do all these odd jobs.' He even wrote to my father saying that I should be a painter. Bomberg invited him, a prim civil servant, to talk about my future. When we got there, Bomberg was sitting up in bed with dressing-gown and beret, and we talked to him for hours. My father sat there very correctly, but Bomberg persuaded him that I should be a painter.[87]

The paradox was, of course, that the more Bomberg urged the younger generation to take up the brush, the more he neglected the call of painting himself. And whenever he did take a rest from his consuming interest in teaching, a far more inordinate distraction succeeded in wresting him still further from his easel. Through the generosity of Leslie Marr, a splendid house in Rosslyn Hill, Hampstead, was purchased for Bomberg and Lilian in 1948. They planned, rather implausibly, to live in a few rooms and run the rest as a hotel. But neither of them was temperamentally suited to such a scheme. After a great deal of money had been lavished on expensive period furnishings, and even old master paintings purchased at auction for the purpose, their funds soon ran out. Instead of getting on with his own work, Bomberg spent his time tinkering with a faulty heating system, decorating the rooms in exquisite style, repairing the fabric and worrying over the complex finances of the whole doomed enterprise. Even a plan to convert the stables into studios came to nothing in the end. 'It wasn't the right life for either of us', Lilian admitted, 'and for several years I was the only one painting. David couldn't paint because there wasn't the right atmosphere for him to work. He was very reliant on that atmosphere, and couldn't operate otherwise.'

Bomberg must have realized that he was expending far too much effort on futile home improvements rather than pursuing his own ambitions as an artist, and the steadily accumulating guilt and frustration must have been hard to bear. The only solace was his teaching, for many of the students continued to give him their loyalty and regard him as a master. 'Working with the Borough Group gave him a sense

of being wanted', explained Lilian, recounting how 'one day he said to me when we were walking home from the Borough: "The young will provide me with recognition." '[88] Perhaps that is why, at the Borough Group's third and final annual exhibition at the Arcade Gallery in March 1949, he showed as many as ten pictures spanning all the principal periods of his career, from a 1913 *Acrobats* drawing to a recent canvas called *Medieval Ruins, Cyprus*. It must have looked like an attempt to alert visitors to the remarkable range of Bomberg's work, but a proper retrospective was the only way he could have revealed the full extent of his achievement. At the Borough show his pictures were displayed with forty-eight other exhibits by the Group's members, who now included Dennis Creffield. Looking back on the venture over three decades later, Creffield was even more impressed than he had been at the time by Bomberg's willingness to participate in the Borough show at all: 'I am increasingly amazed and respectful of his humility in showing his work in company with a group of comparative beginners. I cannot imagine another artist of his age and stature doing so – only Blake or Van Gogh perhaps? It shows his total commitment to his teaching, to his students and to his idea of art – his value of art was greater than the concern for his own reputation.'[89]

The Borough show was a substantial event, and since the exhibition was held in Bond Street rather than Westbourne Grove it attracted a greater amount of critical attention. In the catalogue preface Bomberg tried to summarize their beliefs, declaring that 'we have said that our search is towards the spirit in the mass. Many people have asked us for a further definition. Words cannot give it; the answer lies in the content of the painting. That is our purpose.

> Our interest lies more in the mass than in the parts;
> More in movement than in the static;
> More in the plastic than in the decorative.

Identical objects no longer yield the same experience. Our awareness is both of sensation and direction.'[90] One reviewer seized on this concise and somewhat enigmatic credo, declaring that 'in the event, the "mass" tends to become mess, the "movement" hurry, and the "plastic" a too fragmentary plasticity. To search for "the spirit in the mass" is a fine aim but it cannot be achieved by banging at the gates with such fevered impatience.' Even so, the writer concluded by admitting that Bomberg himself 'does from his fuller experience at times make moving incursions into the citadel';[91] and the *Art News and Review* maintained that

a good Bomberg has a genuine intensity. His group numbers about ten and their style is remarkably integrated with their leader's. The uniformity of the exhibition is quite remarkable. They all use the same summary and rapid brush and aim at a rich texture. Even Peter Richmond's big abstract composition is painted in the same way as the landscapes, flowers and figures. The general level of execution is high; besides those mentioned the works of Lilian Bomberg, Dinora Mendelson and Leslie Marr stand out. But there is a tendency towards opaque and dirty colour; if the group as a whole could clean their palettes and let in more light its reputation would be enhanced.[92]

The only leading critic to mention the show was Wyndham Lewis, now pursuing an active post-war role as the Art Critic of *The Listener*. He had not met Bomberg since the early 1920s, and his review implies that he arrived at the show before the exhibits had been properly hung. His reaction was expressed as a series of questions: 'What happened to Bomberg after 1920? Was he one of the lost generation that really got lost? Or has he an aversion to exhibition? He ought to be one of the half-dozen most prominent artists in England. When I got there, the gallery had no one in it: it was nothing but a chaos of pictures only half on the walls. Anything with which that fine artist, Bomberg, has to do you cannot afford to neglect.' That was the extent of Lewis's notice, apart from a remark later in the same column that 'the "Borough Group", from the glimpse I had of them, are rip-roaring flaming romantics.'[93] But the admiration he expressed for Bomberg's work was enough to make the latter get in touch with Lewis, thanking him for the review and even suggesting that Lewis might 'go further' and write a book about Bomberg's entire career. Not surprisingly, this proposal was never implemented, and the two men failed to renew a relationship which had been fraught with tension even when they knew each other well in the 1914 period.

C54 (facing above). David Bomberg. *Castle Ruins, St Hilarion, Cyprus*, 1948. Oil on canvas, 99.2 × 127.1 cm. Walker Art Gallery, Liverpool.

C56 (facing below). David Bomberg. *Rock Fortress, Cyprus*, 1948. Oil on canvas, 72.5 × 92.5 cm. Edgar Astaire, London.

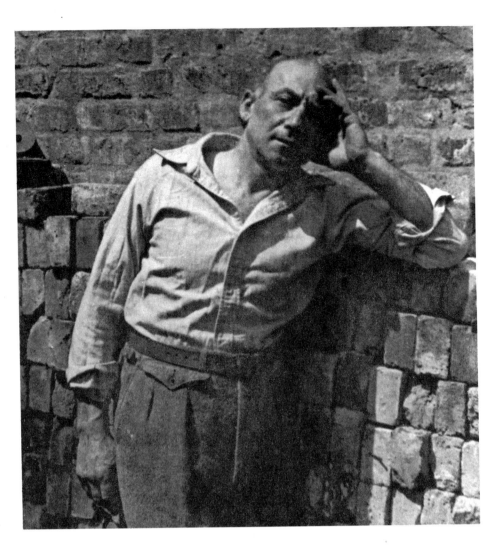

350. Photograph of Bomberg at Rosslyn Hill, London, *c.* 1949. Collection of the artist's family.

The Borough Group's spirits rose when an invitation was received from the undergraduates of Brasenose College, Oxford, to exhibit in their Junior Common Room. Holden, who described this unusual initiative as 'original, healthy, and encouraging to artists', reported that the paintings were displayed 'for the duration of the summer term with a view to purchase. Pictures were chosen for suitability of proportion – one from each of the eleven members of the group – and for the most part prices were adjusted to be within the reach of the college. The whole aspect has a unity and harmony rarely achieved by a mixed show.'[94] But the Group had become completely dissatisfied with the exhibiting conditions at the LCC's second open-air show in the Embankment Gardens. While continuing to acknowledge 'the importance of bringing art before the public who do not, normally, visit exhibitions of painting', the Borough's members decided that they could no longer accept the 'first come, first served' conception. In a letter to the *Kensington News*, they pointed out that 'while being admirable in dispensing with the usual selection committees, dealers' preferences, and conditions, this conception in practice means an ignominious scramble for positions at dawn, quite an unnecessary effort to protect works in inclement weather, and a colossal effort in removing and storing the works at nightfall.' Realizing that serious artists could not in all honesty be expected to suffer such inconveniences, the Group's members announced that they would not contribute to the 1949 show. They predicted that 'the public will have placed before them the work of a few artists of talent, and a whole panorama of pavement art and trash . . . a grand opportunity of cultural education is being dissipated in favour of a jollification of the park.'[95]

Although all the members of the Group signed this letter, they could not arrive at unanimous agreement about anything else. As the year came to an end, the tensions which had existed since the Group's inception worsened to an intolerable extent. The regular meetings degenerated into battlegrounds which made a mockery of any attempt to foster a cohesive purpose. Some members of the Group continued to oppose Bomberg's family: 'they regarded me as an also-ran', Lilian recalled,

'and I was angry that they treated Dinora with scorn.'[96] Both mother and daughter grew to dread the meetings, and there was even a suspicion of plans to divest Bomberg of the presidency. No wonder he looked rather beleaguered and careworn when his photograph was taken at Rosslyn Hill around this time (Plate 350).

It was inevitable, as well as merciful, that the Group finally disbanded early in 1950. Although the members all realized that they had failed to fulfil the large hopes harboured at the Group's inauguration, and had never acquired the reputation or influence they desired, Bomberg's work as a teacher did not terminate. Soon after the dissolution of the Group his classes at the Borough were reduced, but he continued to exert a powerful influence over students who found him far more stimulating than the teachers they encountered elsewhere. As Creffield pointed out:

> He was a teacher of the type of the perennial radical, the fundamentalist who reminds us of our obligation to aspire to quality and excellence. He was critical of contemporary art (any art) where he found it facile and empty. But he was in no way a reactionary – he had complete confidence in the present. As he wrote late in life – 'The strength that gave the cave dwellers the means to express the spirit of their life is in us to express ours.'[97]

The young Frank Auerbach, who first joined Bomberg's classes in 1947, arrived at the Borough after attending art classes at the Hampstead Garden Suburb Institute. He was waiting to take up a place at St Martin's School of Art later in the year, and the Borough was 'the only school that would take me'.[98] Although Auerbach had been educated at a school where 'art was taught by people who were totally

C55. David Bomberg. *Sunset, Mount Hilarion, Cyprus*, 1948. Oil on canvas, 51.5 × 61.5 cm. Colin St John Wilson, London.

unqualified, and I was fairly innocent when I came to London',[99] he was in no mood to be impressed by a teacher.

> The thing that I knew was that one's teachers were going to be silly fools and that one was going to rebel against them. I went to Bomberg's class where he said to me, 'Oh so you think I'm a silly old idiot don't you?', or something like that, and I said in my ... arrogance, 'Yes I do.' He was delighted and I didn't realise that I had met with probably the most original, stubborn, radical intelligence that was to be found in art schools. It wasn't his phrases that made sense to me, because my relationship to teaching was one of rejection and rebellion. I mean, by itself and whether I was consciously aware of it or not, the status of the disciple seemed to me to be a totally futile one ... it was his practical instruction rather than his maxims which registered.

Auerbach, who subsequently became one of the most impressive painters in Britain, was fortunate indeed to enter the Borough at a crucial stage in his development and find a teacher who encouraged him to take risks. 'There was a radical atmosphere in those classes', he recalled. 'There was a feeling that in the rest of the art schools something presentable had to be presented, but in those classes there was an atmosphere of research and of radicalism which was extremely stimulating.'[100]

As a result, Auerbach ended up studying at Bomberg's classes 'for longer than anyone else. I entered the class in January 1947 and stayed until it closed. I never joined any of the groups; I was there before members of the family ..., and I was there after the members of the Group had left. I was sixteen when I came. I was a very immature and I am sure cocky and callous student, but I was there for a very long time.'[101] Only a teacher of unusual gifts could have sustained Auerbach's loyalty for such an extended period, and he remained in no doubt of Bomberg's outstanding qualities. 'He was enormously courageous and enormously serious in a way that very few painters are', Auerbach commented.

> He had no gift at all for prevarication or for fitting in. He had a deep instinct as to how a painting should go. The link is tenuous, but his art teaching was not like verbal teaching, there was an element in it of something like teaching ballet: certain things are transmitted that don't have to be fully articulated, and there was a line stretching back from Bomberg to Sickert to Degas to Ingres to David which had a deeper understanding of how drawings are made. It left some of its traces on what he had to say. His pedagogic method seems to me now not to have had to do with teaching people how to paint pictures or how to be artists, but to do with trying to instil a sense of the quality of form. He never talked about subject (subject seems to me central to the whole business of painting); he didn't talk about certain things which I think he took for granted, which had to do with rendering the specifics of a scene, because it was so deeply in him that he never felt it necessary to articulate it.[102]

Auerbach was particularly impressed by Bomberg's absolute refusal to allow his students to settle for a preconceived or superficial approach when they worked from the model posed in the Borough class:

> What happened was that people would draw, and as soon as they seemed to be drawing in a way that was bitty or affected or mannered, or using a cliché learnt from art, he would refer people back to the model and say to them: 'Look, there are these grand possibilities about this disposition of masses which you are betraying.' I am putting this in my own way, of course, in a partial way. He would suggest a total destruction of what the students were doing, and they would destroy it and go on. Probably at some point of destruction, at some point where they were not in the least aware of having done a picture, he might stop suddenly and say: 'There is some quality in this form.' There would be these pieces of paper and these paintings which I think had very little of the sense of achievement, of the responsible achievement by the artist, but which bore within them a hint of something very grand and noble and profound in painting. They would carry in them somehow a language, hints of a language, of a greater depth and of a greater freedom and of a greater courage than most of the achieved art that was being created in other places in England.[103]

C57 (facing above). David Bomberg. *Trees and Sun, Cyprus*, 1948. Oil on canvas, 63.5 × 76 cm. Ivor Braka Ltd, London.

C58 (facing below). David Bomberg. *Monastery of Ay Chrisostomos, Cyprus*, 1948. Oil on canvas, 91.5 × 91.5 cm. Private collection, London.

Auerbach found Bomberg's classes a continuing source of inspiration at a time when he was struggling to define his own emergent identity as an artist, to resolve the conflict between the Borough approach and the 'far less abandoned way' which he explored both at St Martin's and, subsequently, at the Royal College of Art. 'I had a number of teachers who meant quite a lot to me and from whom I learnt a lot', he explained, 'but I think that on the whole in my time as a student Bomberg was far more important to me than anybody else.'[104] He found in Bomberg's teaching not 'a technique or an approach' but rather a defiant refusal to remain content with limited ambitions in art. 'Bomberg had, I thought, a sense of the grand standards of painting and wouldn't tolerate any fiddling around on the foothills', Auerbach recalled, describing how students at the Borough were taught not to tolerate

some trivial success which might lead people away from grasping the form on the level on which the form is grasped in the great works of art of the world. It was those standards and his impatience with anything less that I found stimulating; and his total lack of self-preservation both for himself, which is hard, and also for other people, his students, which is even harder. I mean, he wasn't interested in whether they would pass exams or whether they would have a painting to present at the end of the evening. He simply wanted them to be working at a most serious level.[105]

In 1950 Auerbach encouraged Leon Kossoff, another of the Borough's most distinguished pupils, to attend these remarkable classes. The previous year he had likewise enlisted at St Martin's School of Art, and his teachers there did not want him to fall under Bomberg's heretical influence. But Kossoff, who was then twenty-four, wanted to go. 'I'd been aware of Bomberg as a mysterious presence for some years', he related; 'I'd seen some of his paintings and been very moved by them.' Although Kossoff went along to the Borough in some trepidation, the classes proved a revelation:

The life room at St Martins, at that time, was very rigid and inhibiting, and I remember a feeling of relief and excitement when I first entered Bomberg's class. People were working in a way I'd only previously dared work when on my own. The atmosphere was intense and everyone was involved in an energetic manner. Bomberg was an intent teacher, showing respect for each individual student's work; and though he was objective and concerned when talking about the emerging drawing, he always kept something of himself in reserve. I admired this. Once I watched him draw over a student's drawing. I saw the flow of form, I saw the likeness to the sitter appear. It seemed an encounter with what was already there and I'll never forget it. Though his deep experience of life somehow guided me, I did not have a personal relationship with him. I hardly knew him as a man. His teaching time was coming to an end, life had been difficult and, at that time, he was rather frail and on a knife-edge.

It is a measure of Bomberg's stature as a teacher that he was able, despite this vulnerability, to provide Kossoff with an experience at once affirmative and profoundly liberating. 'Although I had painted most of my life', Kossoff explained, 'it was through my contact with Bomberg that I felt I might actually function as a painter. Coming to Bomberg's class was like coming home.'[106]

CHAPTER ELEVEN **The Final Years**

Although the finest of Bomberg's Cyprus paintings suggest that he might in other circumstances have gone on to enjoy a continuously fruitful old age, the last phase of his life was dogged by illness, depression, professional neglect and an inability to sustain full momentum in his own painting. While often telling his students to 'keep the paint moving, even if it is only for six hours a week',[1] he followed this sensible advice only intermittently during the 1950s. Far too few canvases were completed, and the finest images that Bomberg produced when he did manage to take up his brush and charcoal are a tantalizing indication of what he might have achieved had he not been afflicted by barren periods. If his own temperament had enabled him to work at full stretch throughout this final phase, he would surely have created a plentiful amount of top-flight paintings to crown his career as an artist. But if painters stop work for years at a stretch they are bound to experience difficulty in wielding the brush again, and Bomberg was no exception. The long period when he stopped work altogether, from the autumn of 1948 to the winter of 1952, had a devastating effect on his subsequent productivity. From then until his death in 1957 Bomberg's spells of painting became sadly sporadic, and his most memorable late pictures were only produced in momentary defiance of moods which prevented him from working at all.

His predicament was exacerbated by the humiliating treatment meted out to him by the art establishment. Two particularly crushing demonstrations of official disapproval occurred in 1951, when the Festival of Britain's organizers commissioned a diverse range of both senior and young artists to produce work for the spectacular celebrations on the South Bank. Bomberg would have been delighted to receive an invitation: the whole notion of a people's festival accorded with his belief in the importance of widening the audience for art, and the chance to paint on a monumental scale might well have rekindled the energies which had been so cruelly thwarted at the time of the *Bomb Store* project almost a decade before. But he was omitted from the list of favoured artists, and in the same year an equally devastating snub was delivered by Herbert Read. Although Bomberg's work had been known to Read ever since he praised it in 1919,[2] the influential critic excluded it from his widely-read Pelican book on *Contemporary British Art* in 1951. The seventy-two painters and sculptors in the book encompassed minor figures like Bateson Mason, Leonard Applebee, H. E. Du Plessis and Vivian Pitchforth, so there was really no excuse for Bomberg's omission. But Read, who by this time exerted enormous power in the decision-making circles of the British art world, ignored him with a coldness which was echoed by major institutions as well.

Before Lilian and the family were permitted to donate one of his wartime flower paintings to the Tate Gallery in 1952 (Colour Plate 50), the national collection of modern art contained only two small examples of Bomberg's art – a Slade watercolour and a drawing of sappers at work, both purchased as long ago as 1923 (Colour Plate 1, Plate 146). Although the Tate is now proud to possess a large group of Bomberg's work, including several major canvases, it never bought anything from the artist himself, apart from those two early works on paper. He had good reason to feel that his entire career was overlooked, often in favour of artists far less significant than himself. No wonder his anger against the indifference of the London

art world sometimes erupted with spectacular force when he came across wealthy dealers who did nothing to support contemporary artists. Peter Richmond, who maintained that Bomberg 'had an old prophet's virulence about him', described a visit to Wildenstein's gallery where Bomberg said: '"Why don't you take this second-rate rubbish off the walls, Mr Wildenstein? I've got some good young painters you should show." He became so vehement that Wildenstein nearly called the police and threw him out.'[3]

Bomberg continued to exhibit at the London Group's exhibitions, but his presence was either ignored or censured by most critics. The references made to his contributions by the reviewers tended to be as dismissive as the *Yorkshire Observer*, whose correspondent complained that 'two large compositions from Cyprus by David Bomberg are, I feel, ruined by coarse handling and an effort to apply pure strong colour at any cost.'[4] Virtually the sole support came from John Berger, who declared in his *New Statesman* review of the November 1951 London Group exhibition that 'perhaps the most outstanding painting is a ravine landscape by David Bomberg. Bomberg's apparently careless and passionate use of paint has weight and guts to it, one is thrilled by a brush mark as a juicy slash of paint and as a precise statement of the angle of declivity of a gully, seen through atmosphere.'[5] Berger's perceptive evaluation of the dual role performed by Bomberg's brushwork, boldly declaring the material identity of pigment even as it remained faithful to the reality of an observed scene, was not supported by other critics. Their notable lack of enthusiasm helps to account for the fact that Bomberg's classes at the Borough had been reduced, by 1951, to Wednesday and Friday evenings only. The other art colleges were so hostile to his teaching that he retained his post at the Polytechnic with difficulty, and few former members of the Borough Group now attended his classes.

He was able, nevertheless, to command the loyalty of a new group of students, who worked at the Borough with the same avid concentration as their predecessors. Apart from Auerbach and Kossoff, the regular attenders were Cecil Bailey, Anthony Hatwell, Gustav Metzger, Richard Michelmore, Garth Scott and Roy Oxlade, the last of whom had been very impressed by an exhibition called *4 Contemporary Painters* held in 1951 at Parson's Gallery by former members of the Borough Group: Creffield, Holden, Mead and Richmond. Acting on Creffield's suggestion, Oxlade enrolled at Bomberg's classes and found them a liberating experience in comparison with the teaching he endured at Bromley College of Art. 'It was a generally accepted rule at Bromley while I was a student there, that any expression of individuality, what was called the students' "own work", should be done in their own time, that is, outside the art school', explained Oxlade; 'the most serious declaration of change . . . was made by any student who stood up to draw at an easel upon imperial size paper, who required room to walk back and forth from his work, and who risked becoming caricatured as a Bombergian.'[6] Oxlade felt stifled by such a repressive atmosphere, and he realized that Bromley was not alone in its myopic attitude towards the most vital developments in twentieth-century art. 'There was a complacent and insular disregard for the modern movement as a whole', he maintained, describing how 'most English art schools were cosily insulated from a revolution which had begun fifty years earlier.'[7]

Bomberg's classes offered a compelling alternative to this lamentable timidity and provincialism. Oxlade was as gratified as the other students to discover a genuinely stimulating teacher, who had first-hand knowledge of the modern movement and refused to let anyone at the Borough remain content with safe, lazy images. 'It was training in judgement which formed the basis of Bomberg's teaching, and which made it a collaborative activity and not mere instruction,' Oxlade pointed out.

> It cannot be stressed too strongly that the emphasis upon *invention* made Bomberg's classes essentially radical in contrast to other contemporary art school practice. His students intuitively and in varying degrees recognised the truth of Bomberg's belief that English tonal painting and the School of Paris were both blind alleys, and that the main direction led . . . from Cézanne towards a proper understanding of structured form. They therefore began with the assumption, conscious or unconscious, that form, that is solidity, is of primary importance in drawing, and I know of no occasion when there was a need for Bomberg to argue the validity of this. Form seeking provided a common working base.

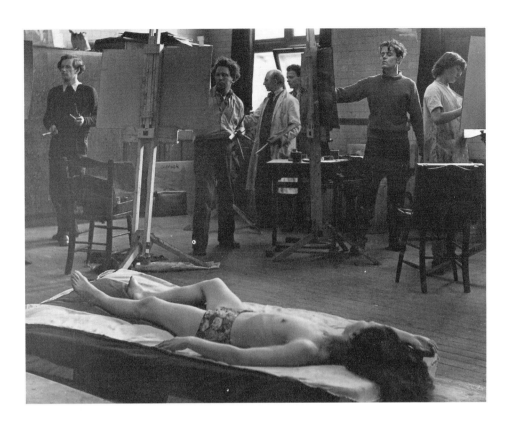

351. Photograph of Bomberg (centre) with his students at the Borough, n.d. Collection of the artist's family.

The singleminded pursuit of form entailed a rigorous avoidance of illustrational or literary approaches. It also meant dispensing with superficial decoration, and developing instead what Oxlade described as an 'elemental mark-making language'. Whether they employed charcoal, chalk or oils, students in Bomberg's classes always preferred 'large pieces of paper' and worked standing up, 'using the natural sweep of the arm as an extension of the whole body'.[8] It was an intensely physical and indeed dynamic activity, for Oxlade remembered how students 'took up an attitude of attentive response to their drawings ... One foot usually in front of the other, the non-drawing arm held out a bit for balance, they seemed to launch themselves bodily into the work, attentive to every shift of relationship between model and drawing mark which was emerging as a synthesised structure on the paper or painting'[9] (Plate 351). There are, of course, connections between this approach to drawing and the freedom of painterly gesture developing elsewhere in Europe and America at this period. But it remains crucial to emphasize the importance Bomberg attached to the definition of a particular subject, which prevented the rhythm of his handling from ignoring its point of departure in the thing seen. Rather than permitting the growth of mark-making for its own sake, he always insisted on anchoring everything at the Borough in a close scrutiny of a model who was expected to hold the same pose, apart from the normal rest-intervals, for the entire evening. As Creffield recalled, Bomberg 'preferred twenty drawings from the same position to twenty different positions'.

Bomberg had no intention of letting the model adopt attitudes which expressed little more than bovine solidity. He went to unusual lengths to discover unconventional poses which would stimulate his students, encouraging them to find the dynamism latent even in a static human body. Oxlade stressed that

the pose was important, and Bomberg took a great deal of trouble to find one which was expressive of movement or tension. He would speak quietly to the model and explain what he was looking for. Then perhaps, if the model were sitting, he would ask her to get up and move around, only to stop her just as she was half-way between sitting and standing, to explain that she was now in a perfect pose. With the model who elected not to understand, and who got out of the crippling position as soon as possible, he might go on to other possibilities before coming to a truce with something a little less painful. In this way it became clear to those drawing, as well as to the model, that it was the stress and implied movement in the forms, which was to be the subject of the drawing. Needless to say, many models remained mystified, particularly when the results,

to them, seemed to be totally unconnected with what the students had been looking at.[10]

The spirit of exploration in Bomberg's classes, triggered by the unorthodox poses and then pursued further as each student defined an individual path, accounts for the total absorption which his students experienced at the Borough. 'There was always a heightened sense of performance', explained Oxlade, 'produced not only by the time factor – the pose would last for two hours only – but above all by the student's awareness that he was engaged in a struggle. He was not there merely to make a study, a record of visual data, but to *discover* a synthesis between four basic forces, the model, himself, the work and Bomberg. There was no hint of artificial theatricality and everything was urgent and workmanlike.'[11]

The overall mood of the classes may well have changed since the early years at the Borough, about which Cliff Holden wrote so well in his essay on Bomberg as teacher.[12] Oxlade admitted that the students still 'worked fast; they ignored all details of form; they improvised freely and imaginatively from the forms to avoid distortion; and they worked towards finding a synthesis of structure which had individual character.'[13] But he was also at pains to point out that rapidity and summary simplification were not, so far as he was concerned, dependent on the mood described by Holden:

> It is, I think, somewhat misleading for Holden to say that the kind of involvement we have been talking about 'had to be an almost drunken ecstatic state'. For the mood to be effective it must be vital with no diminution of mental faculties. Also we must not forget, there is the presence of the artist as objective spectator, that part of the artist's consciousness whose voice he holds off indefinitely, for how long he does not know, but which at some point he must admit to say, 'Stop! You may have something here.'[14]

Bomberg certainly did not encourage the attainment of an 'ecstatic drunken state' by acting in an excitable way himself at the Borough. Far from it: patience, attentiveness and sobriety were the outstanding attributes of his conduct in the classes, and the radicalism he taught was never accompanied by superficially 'unconventional' behaviour. 'The mechanics of the class were quite orthodox', Oxlade recalled.

> Bomberg set up the pose, and the students chose a place and started to work. Then after everyone had got started, Bomberg went round giving advice and encouragement. A lot of his teaching was done by talking and gesture, which he did very quietly and individually. In place of the usual teacher's demonstration on drawing showing the student how to get it right, Bomberg showed an interest in reality from the student's point of view. But he was not prepared to sanction indiscriminate attempts at unstructured personal vision, and did in fact, on occasions make a diagram on the side of a student's work. He did this once in my own case during a life class. He looked at my drawing and then at the model, and after doing this several times more, he drew in pencil, very lightly, two dome shapes one above the other and said 'the dome of St Paul's is like this and not like this.' A number of things emerge here. First of all he was telling me that my drawing was not enough like the subject. But since he was not showing me how to do it, it is important to recognize that he was telling me that it was not enough like the subject in the terms *I* had elected to use. Also he was not prepared to illustrate what he meant by referring to the model because that would have pre-empted what I might do subsequently. It is clear that generalities would not do. Bomberg believed one must be specific, but specific according to one's own idea.[15]

Sometimes, however, Bomberg was prepared to go further than drawing diagrams on the margin of his students' work. He did, as Leon Kossoff never forgot,[16] draw directly over a student's study on occasions, and a photograph survives of Bomberg with brush in hand apparently at work on someone else's painting of the recumbent model (Plate 336). It must have been a student's picture, for Bomberg never did his own work during the Borough classes. But he was prepared to execute collaborative paintings at certain moments. Two of them, a *Messiah* and a double-sided *Reclining Nude*, were carefully preserved by Richard Michelmore, who worked on them so closely with his teacher that he could not finally disentangle his own contribution from Bomberg's (Plate 352). Although such images are rare, Dennis Creffield main-

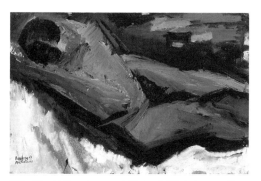

352. David Bomberg and Richard Michelmore. *Reclining Nude (recto)*, 1953. Oil on board, 61 × 92.4 cm. Tate Gallery, London.

tained that intervention played an important part in the teaching process at the Borough:

> He not only talked – he showed. He would – with your permission – work on your painting. This generally occurred when he saw that the painting was becoming confused through contradictory ideas. He had a wonderful ability to see what you were trying to do – and he would help you to clarify it – collaborating with your paint – to find a definition. This was most important. Frequently, towards the end of a class he would say – 'just a few minutes more – find your definitions'. He was teaching us to put our money down. Sometimes, if our images became too generalised, he would work carefully at defining (say) an eye. In this way reminding us that although 'the whole is more than the sum of the parts' – the parts are not to be disregarded. That the key to the structure may reside in the definition of a finger – or even an eyelash.[17]

So far as Oxlade was concerned, such an intervention on the teacher's part had an inhibiting effect, and did not encourage the student to complete the image after Bomberg had stopped work on it. 'I had gone on altering and re-drawing with charcoal and white conte crayon, and had arrived at a scrubbed out area of tone, ready to re-draw yet again, when Bomberg intervened', Oxlade remembered. 'And after gaining my permission, he drew steadily for about ten or fifteen minutes, before arriving at a defined statement of the figure. At which point, he handed me back the charcoal and said, "Now make it your own." I could think of no way of doing this, without completely changing Bomberg's drawing, which would have amounted to starting again; instead, I kept it.'[18]

Oxlade's reaction is understandable enough. After all, if Bomberg's own contribution to the drawing was so 'defined', there was little point in anyone else presuming to spoil the image he had already achieved on the paper. But he never aimed as a teacher arrogantly to impose his vision on the students. 'What I think I must stress', Oxlade wrote, 'is that the "idea" which Bomberg was trying to identify and encourage the students, first to recognize, then develop, and finally define, was the student's own idea, from his own specific point of view *within* an accepted "manner Style pure form", which as Bomberg saw it, was that "joint belief", summed up in "approach to mass". And in this way, there was a mutual dependence between master and students.'[19] Within that dependence, Bomberg did his best to help the students make confident and sound decisions about the direction their work should pursue. 'He believed that the development of an artist is concomitant with the development of his critique', Creffield explained. 'So we were taught to evaluate our work – to learn from it. To this end he would often ask us to leave a painting, because he could see a quality in it which he knew we would lose if we continued. Preciousness and timidity were fatal – the artist must have the daring of a gambler. But an alert recognition, and acceptance, of what had been discovered – given – was at the heart of good judgement.'[20]

By this time, however, Bomberg's career as a teacher was coming to an end. The eventual termination of his classes at the Borough was inevitable, for he would brook no compromise with the art-education establishment. His singleminded independence antagonized many other teachers, and he made no attempt to placate them by making his approach more acceptable in their eyes. 'With Bomberg's teaching there did not seem to be room for half measures', Oxlade pointed out; 'you were either for it or against it. People were rarely dispassionate in their response to Bomberg.'[21] His relationship with the other teachers at the Borough, never cordial or understanding, now deteriorated beyond recall. Bomberg did not resist the attempts to oust him as determinedly as he might have done, for he remained ambivalent in his attitude towards the activity over which he presided in his classes. 'Bomberg himself always referred to his "approach", with its implication of something empirical, experimental, because he . . . had doubts about the advisability, even the possibility of teaching art at all', Oxlade recalled. 'This created fundamental difficulties within any institution which employed Bomberg, and where the general direction of studies was outside his control. He had no belief in the normally accepted ways of teaching art, and what is more important, he totally rejected the Art Schools' objectives of the time.'[22] As a result, the classes he conducted had become 'a small but very lively cell of reaction to the widespread belief in academic draughtsmanship', and it was inevitable that he would suffer a *putsch* sooner or later. In retrospect,

the wonder is that he lasted so long at the Borough. 'The requirements of the National Diploma in Design and Bomberg's teaching were totally incompatible', Oxlade emphasized, 'which meant that within the Art School structure of the time his influence was subversive. Furthermore, the special relationship which his teaching demanded meant that he could not "share" students with other teachers whose methods were unsympathetic to his.'[23]

No one was surprised, therefore, when Bomberg finally found himself without any post at the Borough in 1953. It may even have been something of a relief to him, for his departure from teaching marked a watershed in his life. The hopelessly extravagant and ill-judged attempt to run a hotel at 'Torrington', the grandiose house at Rosslyn Hill where he and Lilian had lived since 1948, also came to an end around the same time. Few of the elegant and lavishly decorated rooms in this 'Hotel Extraordinaire' had ever been inhabited by the well-heeled guests whom they had once been expected to attract. One couple, according to Peter Richmond, gained the friendship of the Bombergs and 'persuaded them to go away one weekend for a rest. When David and Lilian returned, they discovered that the couple had stripped the house of its most valuable contents and vanished.'[24]

The Bombergs eventually discovered that the whole unlikely venture was costing them an alarming amount of money, and could not possibly be sustained as a viable source of income for their retirement. The finale came in an appropriately farcical manner. 'I got fed up with the life at "Torrington"', Lilian remembered. 'I called Leslie Marr up and said: "I can't go on, I feel like a carthorse, the weight is too much for me."' In order to make her feelings unequivocally clear, she staged a climactic protest. 'I threw the crockery at David in the kitchen, to end it all',[25] she explained, and the sight of the expensive 'blue and white china' being hurled

353. David Bomberg. *Portrait of Dinora*, 1952. Oil on canvas, 91.4 × 71.1 cm. Fischer Fine Art, London.

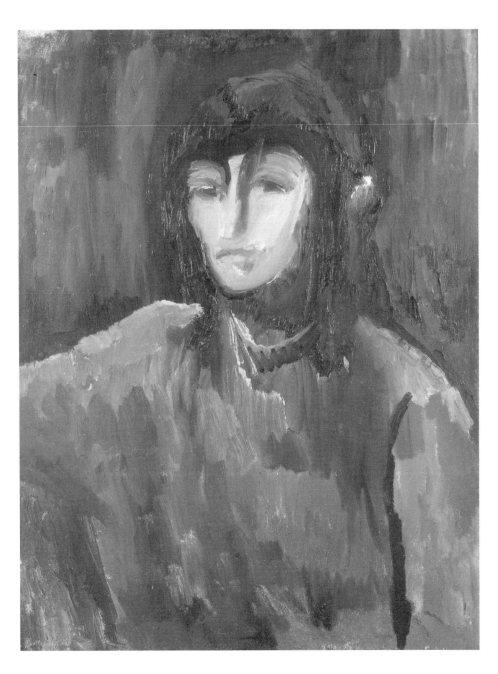

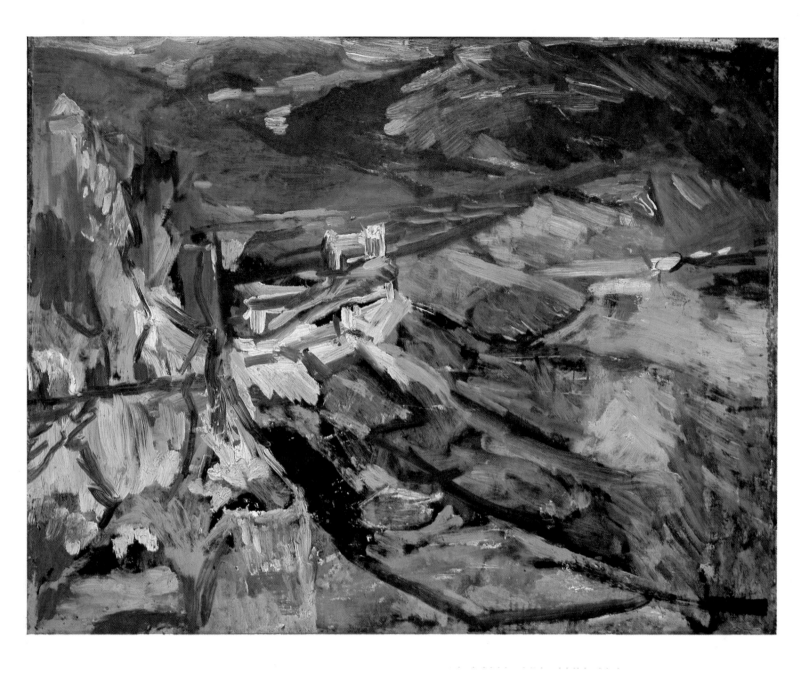

C59. David Bomberg. *Ronda, towards El Barrio, San Francisco*, 1954. Oil on board, 71 × 91.5 cm. Mr and Mrs Leslie Marr, Scotland.

through the air had an unnerving effect on Bomberg. Dinora's daughter Juliet never forgot seeing 'David running round the kitchen to get out of the way', while Juliet herself was obliged to duck under the kitchen table to avoid the missiles crashing all around her.[26]

The substantial amount of money which Marr had so generously given them to initiate the 'Torrington' project was now lost, so Dinora invited the Bombergs to come and stay with her in Steeles Road. It was an intensely difficult period, and Bomberg's understandable feeling of insecurity might easily have engendered a depression which made him unable to paint. But Dinora succeeded in bringing his long period of creative paralysis to an end. In the winter of 1952 she offered to sit for her portrait, and to her delight Bomberg agreed. After several years of complete inactivity as a painter, he must have wondered whether the session arranged with Dinora in Marr's Hampstead studio would turn out to be an unbearable ordeal. But in the event, Bomberg's decision to take up his brushes once again engendered in him a sense of exuberance. Dinora recalled that he worked with extraordinary rapidity, painting three portraits in a few hours. The last and finest of them proved that Bomberg was now on the way to recovering his old form, for Dinora emerges from this canvas as a commanding and almost hieratic presence (Plate 353). Although her purple pullover has been handled with a characteristic Bombergian richness, the face is pale and austere. No facile smile enlivens her features, their severity accentuated by the helmet-like frame of dark hair. With narrowed eyes and a down-turned mouth, she appears to be veiling her wistfulness with a stoical reserve. It

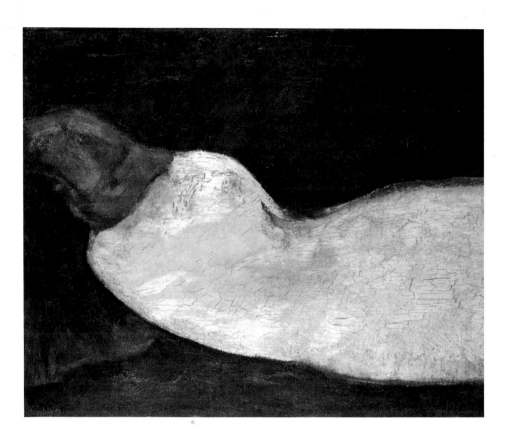

354. David Bomberg. *Mother of Venus*, 1953. Oil on canvas, 71.5 × 91.5 cm. Private collection, New York.

is one of Bomberg's most reticent and gentle portraits, but this blanched young woman displays an incipient melancholy which implies her willingness to sympathize with Bomberg's predicament. Although she had never enjoyed an easy relationship with her stepfather, the portrait commemorates a moment of understanding. Bomberg seems to acknowledge, through this grave and poised image, that Dinora was capable of absorbing some of the spiritual desolation which afflicted him at this time.

He had good reason to feel troubled, too. For Lilian had become increasingly resentful of his close friendship with a former student at the Borough. 'David liked the adoration from him', Lilian explained, describing how Bomberg for a while 'lived through the younger one, and it reminded him of his own youth'. She grew so angry about their rapport that, in the spring of 1953, she 'moved out of the house into a tent in the garden at Steeles Road. It was interfering with the plan to retire to Spain and paint there. That's when he painted the *Mother of Venus* [Plate 354]. I don't know the meaning of it, except that I was the mother of Dinora and Diana who were both beautiful. I recognised it as a figure turning away from David, and I had literally turned my back on him, shunning him.'[27]

It remains one of Bomberg's strangest paintings, in style quite unlike anything else he executed. The hot yellow nude, lying on a deep brown ground shot through with pink and crimson, has a parched air. The cracking of the pigment on her body – probably caused by an unusual amount of overpainting as Bomberg struggled to arrive at the image he wanted – accentuates the sense of arid heat. The woman who so decisively turns herself away from the artist induces in him a feeling of desolation, like a man in a desert suffering from the unalleviated assault of the sun. The pose of the nude is reminiscent of *The Rokeby Venus*, which Bomberg had admired for many years in the National Gallery. But unlike Velázquez, he displays little sensual involvement with this implacable woman, and no beckoning mirror is included in the background to give the spectator a glimpse of her face among the shadows.

This devastating divide between man and wife did not, mercifully, last very long. A local priest, who was a good family friend, finally talked to them both, and advised Lilian to return to him. So the rift, which had lasted for several agonizing weeks, was healed. The anxiety it had caused on both sides did not, of course, disappear at once. Another melancholy canvas painted around the same time is called *Antigone*, and Lilian always thought it reflected 'the suffering of myself during that period: the figure on the right is doubled up in anguish'[28] (Plate 355). But

355. David Bomberg. *Antigone*, 1953. Oil on canvas, 71.1 × 91.4 cm. Private collection.

356 (right). David Bomberg. *Spires and Towers, Notre Dame de Paris*, 1953. Charcoal, 63.5 × 52 cm. Fischer Fine Art, London.

357. David Bomberg. *Chartres Cathedral – Side Facade*, 1953. Charcoal, 51 × 63 cm. Private collection.

soon afterwards a new spirit of optimism was generated by their decision to undertake an expedition together, drawing the great cathedrals of France with the same enthusiasm which had previously impelled Bomberg to study St Paul's and Westminster Abbey. The trip was made 'during the Easter holidays' in 1953. They made their first stop at Paris to draw Notre Dame's noble spires and towers (Plate 356). At the same time Bomberg paid the last of many calls on Kisling, with whom he had been friendly since first visiting Paris in the heady days of 1913. Later they travelled on to Avalon and Vezelay, making architectural studies in charcoal because the short trip only allowed them to execute drawings. Chartres was, perhaps, the most inspiring subject they found. Lilian remembered how at one point they both occupied the same stone ledge overlooking the cathedral, 'and drew different aspects of it, sitting apart'.[29] Bomberg enjoyed the work, studying not only the entire mass of the building from a distance but also more intricate close-up views, where the stern geometry of buttresses was enlivened but not overwhelmed by a greater degree of architectural detail (Plate 357).

Soon after their return from this brief but encouraging expedition, which proved that Bomberg had recovered the will to work in a sustained and positive manner, moves were made to establish another group based on the close understanding he enjoyed with his students. The fact that the Borough Group had ended in such disarray and mutual recrimination did not prevent him from hoping that another group would fare better. Nor had he been disheartened by the unpleasant implications of an exhibition held the previous year by four former students: Creffield, Holden, Mead and Richmond. The show, given the non-committal title *Fyra Engelsman* (*Four Englishmen*), was held at the Gummesons Konstgalleri, Stockholm, between April and May 1952. And the catalogue foreword, written by the Swedish painter Torsten Renquist, made clear that all the participants subscribed to an approach pioneered at the Borough. But Renquist also implied that Bomberg was something of a spent force as a painter, especially in comparison with the contributors to the Swedish exhibition. Although the painters themselves may not have been aware of the foreword's meaning, they incurred Bomberg's wrath when he read it in translated form. Both Creffield and Richmond were subsequently reconciled with their old teacher, but he never forgave Holden for the foreword's suggestion that the participants in the Stockholm show were 'the sole remaining inheritors of the approach to mass' taught by Bomberg. He told Holden that it was, in fact, 'being practised quite richly and effectively by a number of young gifted personalities'.[30]

Bomberg's satisfaction with the progress of these students meant that he was

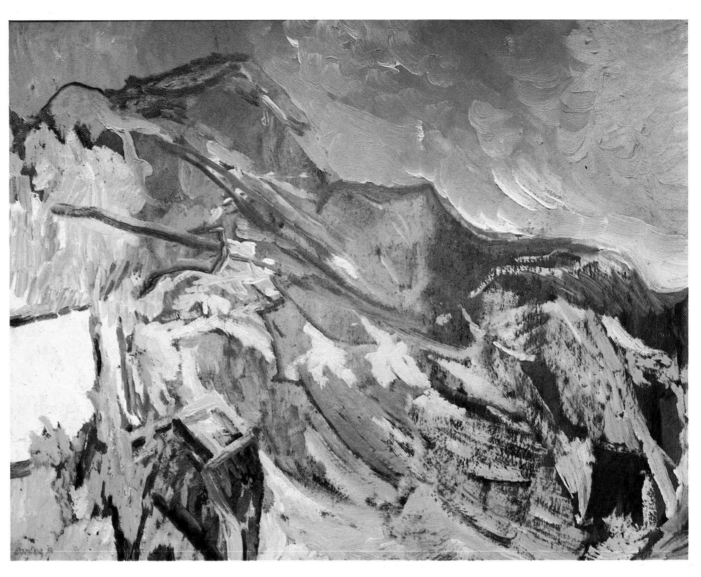

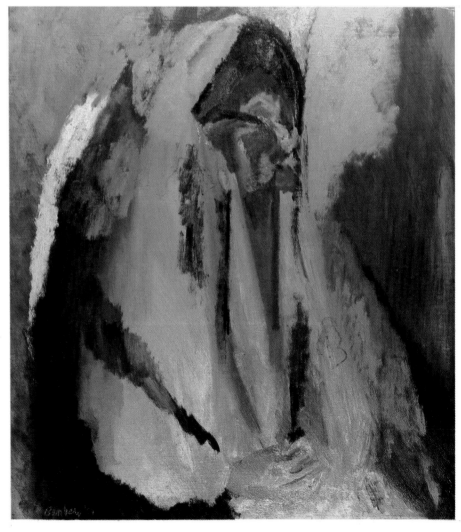

now prepared to look favourably on the idea of starting yet another group. The catalyst seems to have been an exhibition planned for the Berkeley Galleries in November 1953. At first, preparations for the show were initiated without any formal discussions about the possibility of founding a group. The initial entry in the minutes of the meetings held by the Borough Bottega Group state only that 'at the last classes of David Bomberg at the Borough Polytechnic, it was suggested that students exhibiting at the show arranged for November 1953 should meet to discuss arrangements. Frank Auerbach declined the invitation.'[31] The gathering was held at Dinora's house in Steeles Road, and she attended it along with Bomberg, Lilian, Bailey, Hatwell, Kossoff, Metzger, Michelmore, Oxlade and Scott. When the notion of a group was mentioned, 'a long argument followed',[32] and Kossoff made clear that he did not want to exhibit on that basis. But it was agreed that the show should be called *Borough '53*, while Bomberg demonstrated his commitment by consenting to write the catalogue introduction.

Accordingly, the same gathering reassembled in July for the second meeting, with the exception of Kossoff and the addition of Marr, who agreed to exhibit but refused to join the group because he was acutely 'disillusioned by the bitter feelings which broke up the Borough Group'.[33] All the others were happy to become members, however, and they also assented to the three-point declaration of the group's aims:

1 To organize the display of members' works
2 To revitalize art
3 To increase the serious practice of art by inviting unknown or well-known artists to exhibit.[34]

After a certain amount of argument, the newly-formed group postponed a final decision about the name they should adopt. Some members, Oxlade among them, felt that the word 'Borough' should be dropped because of its links with the earlier group. But at the next meeting Bomberg maintained 'that eight years' work and associations lay in the name Borough, as well as prestige'.[35] He was deeply attached to it, and at the following meeting proposed with Lilian that the title Borough Bottega be chosen.[36] His reasons were made more clear in the foreword for the November 1953 exhibition, where he argued that the title signified both his own teaching and the Renaissance precedent he admired most. Casting his mind back almost half a century to his own first teacher, at the City and Guilds evening classes, Bomberg declared that 'to Walter Bayes I owe his conception of an Italian Bottega and my earliest initiation.' But Bomberg also emphasized that 'the Borough Bottega denotes the spirit in the mass', and he underlined his consistent hostility to the Royal Academy by explaining that the '15th Century Italian Bottega' was a 'work-shop where the apprenticeship proved better than the system of academic training that followed in the 17th Century'.[37]

In other words, Bomberg was clearly attached to the prospect of continuing the spirit of the Borough teaching, even though his classes had finished. It was a difficult aim to implement without the communal enthusiasm he had inspired in the Borough itself, but the group pressed ahead with its plans while freely conceding that 'the idea of an unlimited span of years in decay like the Academies was unattractive.'[38] Judging by the extraordinary number of meetings held during the summer of 1953, devoted to lengthy and often bitterly contested debates about the constitution, the Borough Bottega was in danger of exhausting its energies before the first exhibition had even been staged. The disputes took their toll on Bomberg, for his health had by now become a cause for concern and could easily be undermined by excessive worries. Michelmore, the group's secretary, noted in the minutes that Bomberg was 'feeling the strain, the previous meeting far too worthless and niggling. He looks tired and unwell. Atmosphere rather strained ... Terribly slow progress, again with a great deal of quibbling over words, the turn of a phrase, the placing of clauses, even the fundamental idea of a group. Members suggested resignation.'[39] Although Bomberg must often have wondered whether it was worth enduring all these interminable disputes, he was probably encouraged by Metzger's insistence that the new group should hold exhibitions of Bomberg's work, supply information about him, and throw its weight behind furthering 'the understanding and recognition of Bomberg's achievement'.[40] These proposals must have heartened a man who had been neglected for so long, and

C60 (facing above). David Bomberg. *Rising Wind, Ronda*, 1954. Oil on canvas, 69.3 × 87.7 cm. W. H. Crawford, Hexham.

C61 (facing below). David Bomberg. *Soliloquy, Noonday Sun, Ronda*, 1954. Oil on canvas, 89 × 79 cm. Colin St John Wilson, London.

they were generally approved. But by the time the group's constitution was finally drawn up and signed on 20 August 1953,[41] both Oxlade and David Scott had decided not to stay in the Bottega. Even Metzger, who had been closely involved with Bomberg during the period when preliminary meetings were held, resigned from the group near the end of the year.[42]

So it was something of a wonder that the exhibition which Metzger had been so instrumental in planning did finally open at the Berkeley Galleries on 16 November 1953. It bore the elaborate title *Drawings and Paintings by The Borough Bottega and L. Marr and D. Scott*, in full acknowledgement of the fact that two guest exhibitors were permitted to show their work alongside the group's members. Bomberg himself was as sparing with his contributions as he had been in the Borough Group shows, displaying four paintings along with two drawings of Vezelay and St Paul's. He thereby ensured that attention would not be too forcefully distracted from the twenty-one exhibits by the other members of the Bottega. Although Hatwell showed sculpture as well as a drawing, the rest of the display was taken up by oils, water-colours and charcoal studies. Some of them shared Bomberg's preoccupation with Gothic cathedrals, and his name was linked with Michelmore's as the joint creators of a painting called *Messiah*. But the subject-matter tackled by the other contributors ranged from Lilian's *Mother of the Poet* and Dinora's *Levanto, Italy* to Bailey's *The Bather* and Metzger's *Clown*. No arbitrary limits were set on the themes and motifs which the Borough Bottega's members could explore.

All the same, Bomberg's foreword to the catalogue did not hesitate to refer to the exhibitors as a collective 'we', and he appeared to speak for all of them when acknowledging a primary debt to 'the source at the mountain peak, George Berkeley Bishop of Cloyne and to Paul Cézanne, father of the revolution in painting'. Summarizing the fundamental tenets of the teaching he had carried out during the Borough years, Bomberg paid tribute to Berkeley's 'theory of vision' and the help it had given the group in 'the contemplation of the meaning of drawing and how it is related to the interpretation of form, to the study of its structure'. But he went on to emphasize that 'this prepared the base for the understanding of the significance of Cézanne's contribution to painting.' In Bomberg's view, Cézanne 'taught us how to invent'. But he also warmed to the fact that 'Cézanne often wished to communicate what was being revealed to him', and Bomberg openly declared that 'the fundamental creativeness of all true artists, great or small, has been not only in making good works themselves but in inspiring others to follow them.' Bomberg attached great importance to the capacity of artists to teach the true meaning of what they themselves had learned, 'for to understand is to avoid the weakness that permeates the blood stream.' He abhorred British art-education's inadequacies precisely because poor teaching meant that 'vigour and vibrant vitalities go unnurtured'. As a result, the overall level of contemporary art was in Bomberg's view distressingly low. 'Why British painting shares with all other countries a decline', he wrote, 'is because it is so facile with its own virtuosity trying to imitate the virtues of others . . . structure has become less important.'

Bomberg had no doubts about where the prime loyalties of himself and his fellow-members really lay. 'We are resolutely committed to the structure of the organic character of mass', he insisted. 'We have no concern at all with the decorative properties of attractive superficialities. We do not admit of wilful distortion which is another superficial appearance on the horrific side of the attractive. We conceive of art as the incomprehensible density of cosmic forces compressed into a small space, therefore any of the manifestations to the contrary will not find a habitation with us.' The advent of post-war reconstruction on a massive scale throughout Britain may well have reinforced Bomberg's dissatisfaction with the machine age, and made him even more determined to reassert the crucial importance of what humanity 'thinks and feels'. For he pointed out that 'with the approach of the scientific mechanization and the submerging of individuals we have urgent need of the affirmation of [humanity's] spiritual significance and . . . individuality.'

This passionate belief rested at the centre of his aims as an artist. He was increasingly alarmed by the realization that 'man and nature as we conceive the content is going out of art and in its place creeps in the substitutes as content.' Bomberg wanted to correct the imbalance, restoring to contemporary painting the centrality of humanity's relationship with nature. After all, these concerns had inspired the first surviving manifestations of visual art, and he saw no reason why they should be ousted

in the second half of the twentieth century. 'The strength that gave the cave-dwellers the means to express the spirit of their life is in us to express ours', he wrote, going on to stress his conviction that 'the permanent values' would never be ousted by 'the transitories' of modern life:

> In the movement of man from extreme to extreme, nature finds an equilibrium, adjusts the balance, fulfils her design. Whether the paintings or sculptures of the future are carried out in ferro-concrete, plastic, steel, wire, hydrogen, cosmic rays or helium, and oil paint, stone, bronze, superseded as anachronisms, it is reality that man is yet subject to gravitational forces and still dependent on sustenance from nature and a spiritual consciousness, an individual with individual characteristics to remain so for aeons of time.[43]

It was an eloquent statement of the beliefs which had impelled Bomberg to make the paintings and drawings of his later decades, when his reaction against the '*steel city*' and the mechanized destruction of war led him to pursue an art radically different from the work produced in his youth. But the overriding involvement with 'structure' ensured that there was still a constant preoccupation running through his entire oeuvre, from youth to age; and another link with his early years as an artist was emphasized when Michael Bullock reviewed the Borough Bottega exhibition. For Bullock had just published a translation of Wilhelm Worringer's classic *Abstraction and Empathy*, which had exerted a profound influence on Bomberg's champion T. E. Hulme after it first appeared in 1908.[44] Through Hulme, the young Bomberg must have become aware of Worringer's insistence – radical for its time – that the stylistic characteristics of art arise not from a lack of technical ability but from a different level of spiritual need; certainly, Bomberg's continuing admiration for the 'cave-dwellers' whose art expressed 'the spirit of their life' was evident in his foreword to the exhibition's catalogue. Bullock's sympathetic review was the only extensive notice that the show received. He rightly pointed out that 'this grouping round a teacher is a phenomenon which is, I believe, really quite exceptional in these days when every painter, however young and inexperienced, is anxious to give the impression that he sprang to life like Minerva, fully armed.' Bullock welcomed the Bottega's 'willingness, indeed eagerness, to acknowledge their debt to their common teacher and inspirer'. He decided that their refreshing modesty, 'far from producing uniformity . . . has led to a sincere and unforced originality by which the visitor to the Berkeley Galleries cannot fail to be struck'.[45]

Another voice of encouragement was heard in America, when Lewis Mumford replied to a letter Bomberg had sent him along with a copy of the Berkeley exhibition catalogue. 'I was stimulated by the foreword to your exhibition', Mumford wrote, 'and I am honored by your confidence.'[46] But most of the London critics were not 'stimulated' enough to write reviews of any kind. The few who did confined themselves to notices as brief as John Berger's, which simply reported that 'in a folio there are some magnificent charcoal drawings of Chartres and Vezelay by David Bomberg. The drawings of some of his students are also of a high standard.'[47] More than that he did not say, and the Borough Bottega's members were obliged to conclude that their show had received even less attention from the press than the Borough Group exhibitions ever did. A second exhibition, sponsored by the British Council and mounted with exceptional speed in January 1954 at Black Hall in Oxford, was unaccompanied by a catalogue and passed almost without notice. So it was hardly surprising that Bomberg and Lilian decided there was little point in prolonging their life in England. Spain had continued to beckon both of them ever since they were forced to leave in 1935, and now its attractions proved impossible to resist. It had, after all, inspired Bomberg to paint his finest landscapes of the 1930s, and the memory of a masterpiece like *Valley of La Hermida, Picos de Europa, Asturias* (Colour Plate 41) would have tempted Bomberg to imagine that he might once again find his best form in the Spanish countryside. In February 1954, therefore, he left the snow and fog of London and travelled with Lilian back to their beloved Ronda.

———

Their flight from the indifference and frustrations of England did not mean that Bomberg had abandoned all thought of continuing as a teacher. Ever since 1952 he had been planning to establish a school of painting and drawing in Spain, and in that year he had sent out a typed copy of a proposal to a wide and somewhat

bizarre range of possible supporters, including the Gulbenkian Foundation, the Mexican ambassador, the Rockefeller Foundation, a firm of sherry shippers, the United Nations Office of Refugees and the Spanish Foreign Ministry. At this stage Bomberg imagined that the school might move around 'the most temperate parts of Spain', and he was even prepared to 'visualise the possibility of an encampment on the outskirts of a city with working equipment in one or two large caravans'.[48] The response, predictably, had been negative, but he was undeterred. In the summer of 1953 he wrote to Siegfried Giedion, author of *Space, Time and Architecture*, describing the 'approach to mass' and boldly maintaining that 'all would agree how the world would be saved by it'.[49] Later in the year Bomberg wrote to Walter Gropius as well, enclosing a copy of an *Approach to the Teaching of Daughtsmanship* and reporting that other copies had been sent to all the 'heads of the Departments of Fine Art in the Universities'.[50] It was naive of Bomberg to expect that Gropius, who had retired from his position as Head of Architecture at Harvard, would be able to help an artist whom he had never heard of before, and Gropius's reply suggested that, 'if you apply to other people, be sure to add some illustrations of your work, which in our fields will always be so much more eloquent than words.'[51]

But Bomberg still refused to be dismayed by the lack of positive response. Indeed, by the time he decided on returning to Spain the teaching plans had been finalized. He and Lilian intended to establish at Ronda a school which would offer 'a summer and winter course annually in Spain for students of all countries in painting, sculpture and architecture and others in the profession of the visual arts'.[52] This, at any rate, was the bold announcement which they printed in a 1954 brochure issued to attract students to the school (Plate 358). Its link with Bomberg's old teaching endeavours was proudly declared at the top of the brochure, where it was described as 'Borough Bottega de Londres en Ronda Andalucia Spain', and in the section outlining the school's aims Bomberg revealed that it would continue to uphold the precepts he had always advanced in the Borough classes. The school wanted, he claimed, 'to free the Practice of Art, from the precepts and limitations involved in the academic inheritance from the seventeenth century onwards, and members of the course will be encouraged to comprehend and interpret their individual assessment of Mass in the representation of form, whether in Landscape, Architecture, or working from Life in the various aspects of Drawing and Painting'. The brochure did its best to entice prospective subscribers by describing Ronda's 'natural grandeur and Architectural Form of unique character'. It also promised painting expeditions 'by mule, donkey, road or rail at moderate additional transport charge'. Should any students want to share the Bombergs' love of open-air life, the brochure announced that 'arrangements have been made for Members of the course to live and work under canvas . . . a special facility granted to the Borough Bottega in Ronda.'[53]

It all sounded promising enough. If students attended the school in sufficient numbers, Bomberg and Lilian would be able to support themselves financially in Ronda by running the kind of classes he had enjoyed so much during the Borough's heyday. The surroundings were delectable, too. 'The Villa Paz was part of an old palace, crumbling but beautiful', Lilian remembered, and the terrace commanded stupendous panoramic views from the edge of the Ronda cliff-face across the valley below to the distant mountains. Situated in the middle of the old quarter, within reach of awesome countryside which had remained essentially unchanged for many centuries, the Villa could have become a splendid centre for a school devoted to furthering Bomberg's belief that humanity was 'still dependent on sustenance from nature'.[54] Peter Richmond certainly went out to Ronda with high expectations, wanting 'to renew contact' with his old teacher. 'Bomberg said: "Why don't you become my assistant at the school?"', Richmond recalled. 'I agreed, but my first job was to help him move *out* of the Villa Paz.'[55]

Only one student had enrolled by the time trouble began with the owners of the Villa, who had originally been happy to grant Bomberg the tenancy. 'They were the main reason for the failure of the school', Lilian maintained, describing them as 'two old *señoritas* who had fallen on hard times. They sent their niece to get us out after we'd only been there a few months, and all our letterheads had been printed with this address. They made life hell for us. I went to see the Mayor at the Town Hall, and he said they couldn't get us out. We paid our rent regularly, but we were forced out because they refused to stop rain coming in through the roof. We were both very upset.'[56] Bomberg and Lilian, who abandoned the fight

358. Brochure for the School at Villa Paz, Ronda, 1954. Collection of the artist's family.

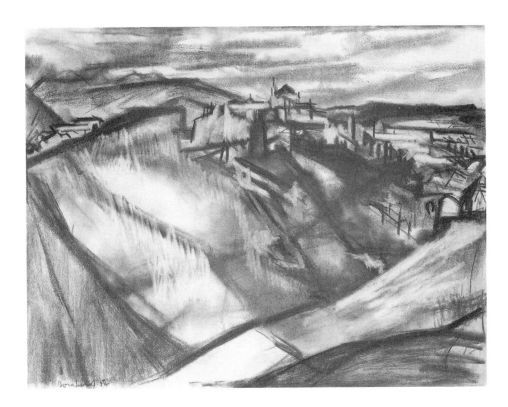

360. David Bomberg. *Ronda*, 1954. Charcoal, 47.6 × 61 cm. Cecil Higgins Art Gallery, Bedford.

359. Photograph of David and Lilian Bomberg in the Old Bull Ring, Ronda, 1954–5. Collection of the artist's family.

only when all the electricity and water had been cut off, discovered that the Villa's owners had decided to rent it to wealthier Spanish tenants for the summer.

The farcical termination of the school did, however, engender a late flowering of Bomberg's drawing and painting. Just as he must have hoped, the return to the Spanish landscape rekindled the old intensity of response which he had first experienced in Toledo a quarter of a century before. Then, at a crucial turning-point in his career, Spain had helped him to move beyond the unsatisfactory style of his Palestine years, casting off his inhibitions so that the more direct and expressive language of Bomberg's maturity could be developed. Now, in 1954, Spain inspired him again. The failure of the Villa Paz enterprise was fortuitous in this respect, for his inability to teach gave him more time to resume his impassioned relationship with the locality around him. Lilian may even have been relieved that the school had collapsed, for Richmond remembered that she was 'very bitter about Bomberg giving his life-blood to teaching'.[57] Leaving the Villa meant that they were forced temporarily to 'move into the attic of a house a quarter of a mile away,'[58] but it gave Bomberg and Lilian more time together to explore Ronda on their donkeys looking for possible sites where paintings and drawings could once more be produced (Plate 359).

The mark-making in an impressive charcoal study called *Ronda* is more supple than before, and takes on a life of its own in the forceful zig-zags darting like summer lightning over the hillsides on the left of the composition (Plate 360). But these declarations of Bomberg's highly tactile reaction to the landscape never detach themselves from the observed scene. They arise out of his involvement with a very particular terrain, and it is represented with a greater density than before. Using his fingers as much as the charcoal stick, Bomberg achieves a richness of texture which depends very heavily on his ability to juxtapose dramatic extremes of light and shadow. Areas where the paper has been left free to register refulgent whiteness give way to passages of almost velvet blackness, and these contrasts are heightened by the buckling dynamism which Bomberg discovers in the structure of the land.

He conveyed this sense of geological stress and movement even more directly when drawing *La Inglesia Espiritu Santo and El Barrio San Francisco, Ronda* (Plate 361). The earth here seems to shift and break with a near-volcanic strength, as if the surface of the land might at any moment crack open and lead to an outright eruption. Some of Bomberg's marks accentuate this feeling of disturbance as he slashes them across the paper like a sequence of vehement, up-and-down brush-strokes. But in the more distant parts of the landscape a softer touch is evident. Bomberg's awareness of the earth's fissures and strains is matched by his tender

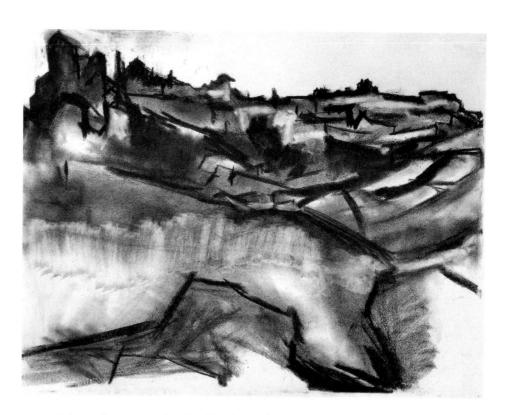

361. David Bomberg. *La Inglesia Espiritu Santo and El Barrio San Francisco, Ronda*, 1954. Charcoal, 48.2 × 61 cm. Private collection.

appreciation of a country he cherished, and both responses coexist in this eloquent drawing.

Ultimately, though, it is dominated by powerful black contours which discipline even the loosest and most unruly areas. Only in his paintings did Bomberg allow himself to pursue a greater dissolution of form, especially in a wildly handled canvas called *Ronda, towards El Barrio, San Francisco* (Colour Plate 59). The black linear scaffolding which dominates his drawings can still be found, but its tautness has given way to a less assertive structure. The lines are thinner and more straggling here. Nor are they permitted to extend themselves into every corner of the composition. In several places their progress is interrupted by patches of agitated paint, which appear to invade the landscape like swathes of mist and obscure the body of the land beneath. This pigment emphasizes the picture-plane as well, countering the illusion of distance and asserting the physical reality of brushmarks in their own right. The outcome is paradoxical, celebrating the robust vitality of Bomberg's handling of pigment even as it threatens to rob the landscape of the solidity still so evident in his drawings.

Bomberg seems to have become preoccupied by the incipient dissolution of mass in this final phase of his painting career. Another outstanding 1954 canvas, *Rising Wind, Ronda*, uses the threat of a storm to set land and sky alike into tumultuous motion (Colour Plate 60). The paint appears to take on the action of the wind itself, hitting the hillside with exclamatory force. This onrush of pigment, driving and swirling with a muscular momentum which reflects Bomberg's own exhilarated anticipation of the approaching tempest, threatens to overwhelm the rockface in a flurry of freewheeling brushmarks. Attacked from below by the whirling impact of dust and wind-tossed vegetation, and from above by gathering clouds which press heavily upon it, the range of hills looks beleaguered indeed. But its uppermost peak, which bears an unmistakeable resemblance to the Provencal mountain painted so often by Bomberg's mentor Cézanne, succeeds in standing firm. Although its contour is partially obscured by the invading clouds, the peak remains visible and indeed resilient in the face of the turbulence all around.

The conflict enacted in *Rising Wind, Ronda* between permanence and evanescence, order and tumult, solidity and decomposition, was not confined to landscapes alone. It also entered the figure paintings which Bomberg now began executing. In the previous decade most of his energies had been devoted to subjects where the human presence was hard to find: people are notably absent from the Cornwall and Cyprus landscapes, the flower paintings and many of the bomb store compositions. But now Bomberg began a whole sequence of single-figure pictures based on a posed model. One reason for this may have been physical – painting outdoors in hot weather was an arduous activity, and his deteriorating health militated against it.

Some of the Ronda landscapes executed in 1954 are disappointingly weak and ragged, suggesting that infirmity prevented Bomberg from sustaining the high level of achievement reached in *Rising Wind, Ronda*. He acknowledged the problem himself, admitting in a letter to Hatwell that 'when a person is getting old and no longer able to bring the physical strength and stamina to maintain the hold on a work on which the reputation has been made, another kind of work must take its place that is done with less struggle and greater tactile enjoyment.'[59] Figure paintings, which could be executed indoors and at a more contemplative pace, must therefore have seemed an ideal vehicle for a man constrained by age and illness.

The first picture Bomberg painted from a model in 1954 appears to have been *Soliloquy, Noonday Sun, Ronda* (Colour Plate 61). But the sitter was employed as a springboard for his imagination rather than as the basis of a portrait. Lilian remembered that Concita, the model for this painting, was 'a housewife in her thirties' who 'lived next door but one to the Villa Paz'.[60] The woman in the final canvas seems elderly, however, and Bomberg used Concita to meditate on his own state of mind as a sixty-four-year-old artist who had become increasingly aware of physical frailty. Although the title *Soliloquy* was only given to the painting a year later, just before it was sent off to an exhibition in London,[61] Bomberg did indeed paint it at the hottest time of the day.[62] The figure appears to be enduring the full force of the sun, and partially shields herself from it by retreating into the folds of a hooded robe. Her dark-skinned face looks weather-beaten and gaunt, as if long accustomed to withstanding the intense heat. Closing her eyes to avoid the glare, she is absorbed in her own thoughts. The blazing colours with which Bomberg irradiates this canvas prevent it from taking on an excessively introspective character: the woman's sombreness is stoical rather than melancholy. All the same, her robe does appear to be melting in the heat and dazzle generated by the brilliant whites, yellows and mustards. Corporeal substance is giving way to a more disembodied state which surely reflected Bomberg's growing preoccupation with the transience of life. This lonely figure, embroiled in a meditative vigil, seems ready to divest herself of palpable substance and fade into the noonday light.

Although the loss of the Villa Paz was a melancholy event, Bomberg was cheered by the news of a modest survey of his career at the Heffer Gallery in Cambridge. The exhibition, which opened in May 1954, was divided in two halves. Bomberg's thirty-seven paintings and drawings, ranging from the 1915 *Billet* to the paintings completed just before his recent departure for Spain, occupied one half of the gallery. The other half was given over to the Borough Bottega, which now consisted of Lilian, Dinora, Bailey, Hatwell and Michelmore. But Creffield, Oxlade and Scott also participated as guests with several works each, and they were all conscious of the event's importance in Bomberg's life. As the catalogue foreword explained, it amounted to 'Bomberg's First Retrospective Exhibition'.[63] Not surprisingly, Oxlade later recalled that it was, 'for those who were interested, a revelation'. But he also pointed out that 'apart from the local press, it attracted no critical comment.'[64] So the only wide-ranging survey of Bomberg's work staged in his lifetime was confined to a local Cambridge audience, and another cruel irony was that the artist himself never saw the exhibition.

Ousted from the building where they had hoped to establish a school, Bomberg and Lilian now cast around desperately for alternative accommodation where he could continue the attempt to teach. They found it at La Casa de la Virgen de la Cabeza, an isolated and 'rather derelict' house situated well outside Ronda on a hillside facing the town (Plate 362). 'The Cabeza belonged to a rich family', Lilian remembered, 'and they suggested that it was a likely place: they only used it as a summer residence. It was at the end of a ridge, very hard to reach, and we had to get there by donkey along a bad track. It was very rudimentary – the nearest water was twenty minutes' rough journey down the hill.'[65]

They attempted to continue the school in this unlikely setting, for the Cabeza affords a staggeringly beautiful view of Ronda perched on its mighty rock. But only two or three students appeared, including a Canadian woman, and Bomberg was soon obliged to accept the fact that he would never again be able to teach a substantial group of committed students. The school idea was finally abandoned altogether. 'It was very sad', commented Lilian, 'because we had tried so hard'.[66] The only link Bomberg now had with his Borough students was provided by Peter Richmond and his wife Nora, who had obtained a house elsewhere in the district

362. Leslie Marr. Photograph of La Casa de la Virgen de la Cabeza, 1959. Mr and Mrs Leslie Marr.

363. Dinora Davies-Rees. Photograph of David and Lilian Bomberg at La Casa de la Virgen de la Cabeza, with Ronda beyond, 1956. Collection of the artist's family.

and stayed to paint. The presence of the Richmonds ensured that Bomberg was not entirely frustrated in his desire to teach. The art historian and critic Charles Spencer, who had written an article on Bomberg's work in 1954, came to the Cabeza and accompanied the 'prematurely frail' painter on an expedition to the Richmonds. 'He advised me that we would visit the young man', Spencer recalled, 'and that I should take an interest in his work ... Bomberg rode on the donkey, which Lilian led down the mountain track – a somewhat Biblical group. No sooner had we arrived and viewed Richmond's work than Bomberg started a long critique, which literally meant I never got a word in.'[67] (Plate 363).

Bomberg's urge to talk about art with like-minded painters led him to become astonishingly loquacious whenever the opportunity for such a discussion arose. Richmond himself cherished these moments, and during Bomberg's final years 'we spent much time alone talking and working side by side.' It was for Richmond an invaluable experience, and he subsequently looked back on that period with a sense of gratitude. 'Bomberg had a profound belief in the integrity of the individual: that if the individual would be true to the vision he was given, he was an irresistible force in the world', Richmond wrote. 'Against the tyranny of systems, the tyranny of ideas, the tyranny of hopes and fears, he set his faith in the power of individual vision, realised through individual energy in individual work, to free man from tyranny without and within. For David Bomberg this capacity within the individual depended essentially on the practice of virtue. He did not believe that a bad man could paint.'

Richmond also came to appreciate how much Bomberg valued his nationality and the standards which he believed his country upheld:

He had an enormous respect for the British democratic tradition built on the inalienable right of freedom of conscience, and his ways and his words often resembled the moral earnestness of our 17th-century founding fathers. These words of Milton could well have been Bomberg's: 'For doubtless that indeed according to art is most eloquent, which turns and approaches nearest to nature, from whence it came; and they express nature best, who in their lives least wander from her safe leading, which may be called regenerate reason. So that how he should be truly eloquent who is not withal a good man, I see not.' When I was his student I thought Bomberg's morality odd and archaic. I thought that as long as one painted with energy and conviction one's behaviour in other ways was incidental and irrelevant to one's work as a painter. Bomberg taught that integrity of vision depended on the total integrity of the individual, and I'm sure that he was right. Painting is a symbolic act, and his integrity alone ensures that the painter himself is committed to the symbolism enacted in his own work and thereby able to become a man of destiny beyond the seeming accidents of everyday.[68]

When Bomberg was not talking and painting with the Richmonds or Lilian, the extreme isolation of the life he led at the Cabeza drove the ailing artist in on himself. Continuing the series of figure paintings commenced at the Villa Paz, he invested them with an increasing strain of introspection. They became embodiments of his own self-absorbed mood, rather than portraits of other people. The starting-point

C62. David Bomberg. *Vigilante*, 1955. Oil on canvas, 72 × 60 cm. Tate Gallery, London.

C63. David Bomberg. *'Hear O Israel'*, 1955. Oil on canvas, 91.5 × 71 cm. Cecily Bomberg, London.

364. David Bomberg. *Talmudist*, 1953. Oil on canvas, 76.2 × 63.6 cm. Colin St John Wilson, London.

365. El Greco. *Christ Carrying the Cross*, 1590–95. Oil on canvas, 108 × 88.3 cm. Prado, Madrid.

for *Vigilante* was a highly individual Spanish woman whom Lilian discovered during her customary search in Ronda 'for possible interesting models' (Colour Plate 62). She persuaded her to sit for Bomberg, and afterwards described her as 'a very old Gypsy, named Eduarda, elegant, refined, and very dignified, somewhat remote, with gaunt, weather-beaten features, and a kind of masculinity, yet very gentle. She had traversed the mountains on foot, most of her life, selling her wares from village to village, and David's painting of her came out this way.'[69]

Something of Eduarda's resilience is undoubtedly conveyed in *Vigilante*,[70] for the figure has a vizored air as if accustomed to protecting herself against the harshness of a nomadic existence. But by placing these strange black bars in front of her face, Bomberg also robs her of the specific personality which she would otherwise have revealed. As the painting's title suggests, he wanted this figure to express the spirit of watchfulness, and the outcome discloses just as much about himself as about Eduarda. The failure of his school plans, combined with deteriorating health and the loneliness of life in Spain, led him to adopt a wary attitude to the world. A growing awareness of vulnerability, coupled with anxiety about an uncertain future, prompted him to develop a more defensive outlook. The figure in *Vigilante* appears to be under siege, and the broken autumnal colours signify that corporeal dissolution is imminent.

But Bomberg was determined to survive as long as possible. In a superb painting called '*Hear O Israel*' he demonstrated that a sense of disintegration could still be offset by an obstinate vitality (Colour Plate 63). Relying this time on himself as a model,[71] he created a robed presence whose identity is almost as hidden as the helmet-face in *Vigilante*. But now the taut watchfulness has given way to a feeling of unguarded withdrawal. Bomberg appears to be sunk in thought, and the folds of his hood gather round his face so heavily that they threaten to cover it altogether. These voluminous robes thereby become a metaphor for Bomberg's desire to hide himself away in a private meditation on his own plight. But they also give him a hieratic quality, indicating that he may be contemplating the links between his own predicament and that of the Jewish people. The ringing title, '*Hear O Israel*', certainly suggests that Bomberg is echoing the Jews' ancient plea to be saved by God, and the figure closes its arms round a copy of the *torah*. It is as if his ruminations on the difficulty of life had awakened memories of his childhood: the *mezuzah* installed on the side of the door in the Bomberg family home at Tenter Buildings had contained the scrolls of the *torah*, and his consciousness of Mosaic law now impelled him to refer to it in '*Hear O Israel*'.

In this respect, the painting develops a specific concern with Bomberg's Jewish origins which first became overt two years before, when he painted the blanched and shadowy *Talmudist* in London (Plate 364). This earlier canvas was likewise based on the artist's own face, and its melancholy introspection had been triggered by his temporary estrangement from Lilian. After remembering that he was at work on *Talmudist* when their reconciliation occurred, she stressed that 'he didn't read the *Talmud*.' But Bomberg was 'conscious of his race'[72] – an awareness ultimately reflected in his request to have a Jewish burial – and this aspect of his vision found its most moving expression in '*Hear O Israel*'. It is to a certain extent a despairing image. Bomberg's brother John, who bought the painting soon after its completion, believed that he was here 'crying out to God and Judaism in general: "look at my plight, look how I've carried the cross like Christ all my life, look at me, look at the state I'm in."'[73] There are indeed strange echoes in this canvas of a *Christ carrying the Cross* by Bomberg's hero El Greco (Plate 365), but the differences between the two pictures are far more significant than their similarities. Greco's Christ may be burdened by an intolerably heavy piece of timber, but he holds his head free from his robes and looks up steadfastly towards the heavens. Bomberg's figure enjoys no such reassurance. His face is bowed. He hides away from the world as if ashamed of his plight and unable to hold out any hope of comfort from above. Absorbed in his own dilemma, he clings to the *torah* and tries as best he can to endure the torment afflicting his mind.

In the end, though, '*Hear O Israel*' derives its unusual power from the ambiguous action of Bomberg's brushmarks. Some of them seem to rain down on the figure with relentless force, threatening to submerge him in their assault. But others appear to be flaring upwards, most notably in the great golden rush of pigment ascending from his right sleeve until it reaches the topmost limits of the canvas. The brilliance

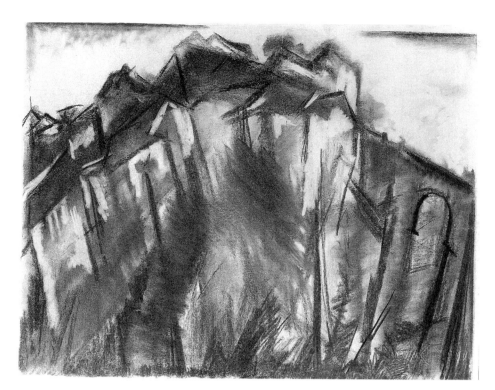

366. David Bomberg. *Ronda, Houses and Bridge*, 1955. Charcoal, 45.7 × 61 cm. Anthony d'Offay Gallery, London.

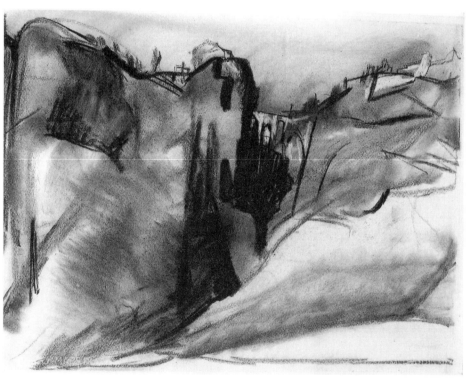

367. David Bomberg. *Ronda Bridge, The Tajo, c.* 1956. Charcoal, 48.5 × 62.5 cm. Mr and Mrs John Kay.

of these strokes counteracts the subdued and mournful colours employed elsewhere, and illuminates the painting with a transfiguring radiance which implies a refusal on Bomberg's part to let despair overwhelm him completely. 'David was a great fighter',[74] his brother John emphasized, and in '*Hear O Israel*' an instinctive vitality helps the figure to combat encroaching darkness.

This memorable painting was sent, along with *Vigilante* and several other canvases by both Bomberg and Lilian, to the fourth and final Borough Bottega exhibition held in March 1955 at Walker's galleries in New Bond Street. Over fifty works were included, by 'invited guests' like Marr and Oxlade as well as the group's members, and Bomberg was represented in strength by late paintings as fine as *Rising Wind, Ronda* (Colour Plate 60). A newspaper strike exacerbated the customary lack of critical response, but John Berger did treat the show as an important event. He singled out Bomberg's contribution, declaring with absolute justice that 'he

is an important and a very mature painter who should have a retrospective exhibition at the Tate. The emotion, manner and content of his pictures are completely integrated.'[75]

The Tate, however, signally failed to consider such a notion, and it did not even bolster its meagre representation of Bomberg's work by purchasing a painting from the show. Walker's Galleries hardly seemed over-anxious to give visitors an adequate chance to see the exhibition, either. It ran for less than a fortnight, and the foreword in the catalogue reiterated Bomberg's previous prefaces without augmenting them or articulating his arguments with the forcefulness he had previously been able to express. Although Michael Bullock opened the exhibition, and thereby confirmed the support he had provided before, the Borough Bottega lacked friends who might have been able to buy work and offer it a more extensive showing. Bomberg's animating presence was sorely missed, too. He stayed in Spain while Lilian brought the work over on her own, and without him the group languished. Berger praised its members for 'reacting against fashionable elegance, and seriously trying to deal with the constant problem of how to communicate what an artist finds in the normal facts of space, mass, weight, distance, movement and so forth'.[76] But the Borough Bottega never met or exhibited again after the Walker's Galleries show finished.

For a while, Bomberg was able to concentrate on drawing his surroundings with a commanding grasp of structure and an ever-deepening insight into the range of subjects which Ronda and its landscape afforded. Sometimes he closed in on the houses clustered round the bridge. One drawing builds them up into a formidable mass of masonry which seems to grow out of the cliff beneath, so that rocks and houses fuse into an unassailable structure reminiscent of Bomberg's early Cubist designs. But then, tackling a different view of the same motif, he gave the whole scene a far more vertiginous and unsteady urgency (Plate 366). The houses here seem about to career down the slope or even fall off the cliff's edge into the ravine, while the bridge tilts at such a drunken angle that it appears to be in danger of collapse. Only the decisive, marshalling strength of Bomberg's line, dominating the more unruly passages of rubbed charcoal playing around the centre of the drawing, asserts stability by giving the design a mighty pyramidal power.

On other occasions, Bomberg preferred to view Ronda at a distance, including it only as a tiny straggle of buildings perched on massive rocks which stretch into gaunt, uninhabited terrain beyond. One drawing, *Ronda Bridge, The Tajo* (Plate 367), is not so very far removed from a charcoal study executed in 1935 of the same mighty plateau (Plate 269). A comparison between these two drawings reveals that Bomberg was able in the mid-1950s to recapture the energy with which he had defined the site twenty years before. But now, in his old age, there is a greater breadth, a bolder willingness to discard inessentials, and a more subtle understanding of the organic rhythms running through the land he so avidly explored. In this and other drawings of the period, Bomberg relegates the buildings to an even more subordinate position and allows these rhythms to dominate the image. The landscape now appears to be set in motion by the life undulating through it. Both earth and rock heave and sway, animated as much by Bomberg's passionate empathy as by its own geological stresses. Writing with great understanding about these late land-

368. David Bomberg. *Trees, Ronda Valley*, 1956. Charcoal, 45 × 60 cm. Bernard Jacobson, London.

369. David Bomberg. *Ronda Evening*, 1956. Charcoal, 45.1 × 60.1 cm. Scottish National Gallery of Modern Art, Edinburgh.

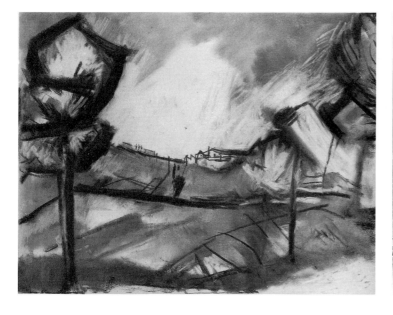

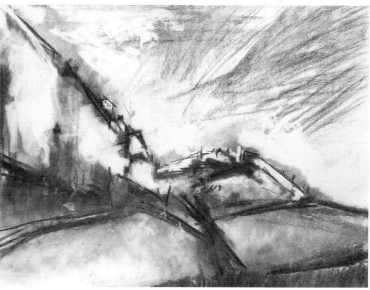

scapes, David Sylvester once observed that 'it is as if the contact were so close and so sustained that the painter had gone beyond being in the landscape and become the landscape. Looking at his picture I scarcely know if I am facing the scene or facing outwards from it.'[77]

Not all these late drawings depict a land unalleviated by vegetation. One study juxtaposes the starkness of the distant Ronda rock with richly foliated trees (Plate 368). Filling the foreground with their density and bulk, they offer shelter to anyone oppressed by the hard, empty countryside beyond. But even here Bomberg has parcelled up the trees' contours into spare, angular segments which reveal a continuing debt to Cézanne and affirm a preference for austerity. He felt truly at home in landscape at its most naked, and in *Ronda Evening* he returns to a harsh panorama where the thickly scored charcoal divides the ground into blocks of severe form while the approaching night is announced with agitated lines scything through the sky (Plate 369). Bomberg loved the elemental grandeur of this landscape, where he could pursue his search for a bare primordial essence unhampered by incidentals which might have diverted him from the matter in hand.

But a diversion of the most terrible kind was about to wrench him away from this fruitful involvement, ensuring that he wasted much of his final year engaged in a destructive obsession with the past. In July 1956 the Tate Gallery opened an exhibition called *Wyndham Lewis and Vorticism*. It should, ideally, have been restricted to Lewis alone, for most of the space was occupied by a straightforward retrospective survey of his career. But the final section of the show was devoted to 'Other Vorticists', and it gave a grievously distorted view of their achievements. Painters as substantial as William Roberts and Edward Wadsworth were represented by minor examples of their work, many executed after the Vorticist period had terminated. Other artists, like Frank Dobson and McKnight Kauffer, were included even though they had never been associated with the movement in any formal sense. But the worst victim was Bomberg, who found himself allotted one work only: a *Jewish Theatre* drawing executed while he was still at the Slade and untypical of the most audacious work he had executed during the 1914 period (Plate 48). The entire section should never have been tacked on to the Lewis retrospective, for it looked suspiciously like an attempt to pretend that these so-called 'Other Vorticists' were no more than insignificant acolytes humbly indebted to Lewis's superior genius. The extraordinary level of achievement Bomberg attained at that time seemed to have been completely erased from the Tate Gallery's distorted view of history.

While the exhibition continued at Millbank, Bomberg remained ignorant of the whole scandalous affair. But in September 1956, when the show moved on to Manchester, he received a letter from Roberts calling attention to the injustice. 'If you can spare a moment to take your attention off the Rock of Gibraltar', Roberts wrote, 'I am sure you will be interested in what Sir John Rothenstein and Wyndham Lewis are trying to do with the rock of your reputation as a leading English Cubist in 1914. I enclose the Tate catalogue and the Arts Council's.'[78] Roberts also sent two pamphlets he had already published to protest about the affair (Plate 370).[79] He was understandably incensed, and continued to issue robust broadsides about the event for years afterwards. Hoping no doubt that Bomberg would assist this polemical attack by writing a letter or pamphlet of his own, Roberts made sure that the ignominy of the Tate show was presented with appalling clarity in the package he sent to Ronda.

At first Bomberg tried to laugh off the entire problem. Peter Richmond remembered him declaring that '"Bobby Roberts is obsessed with the past. He ought to come out here and sit in the sun at Ronda."' But then his mood began to shift. 'Lilian said he should answer the letter', Richmond recalled, 'and so he sat down and wrote and wrote. Then he talked about it, incessantly and urgently, as if he wanted things to be recorded. He became totally obsessed, he wouldn't go out and didn't have enough to eat. He thought he'd found out a certain number of things that mattered, and it depressed him enormously that the world was so slow in acknowledging them. That made him bitter.'[80]

The effect on Bomberg was traumatic and, ultimately, disastrous. To be traduced in such a shameless manner confirmed all his gravest fears about the art establishment's apparent determination to minimize and scorn his achievement. Far from finding himself honoured at the Tate by the retrospective which was undoubtedly his due, he now realized with renewed force that England regarded him as an artist

"CONVERSATION PIECE"

JOHN    *We must include some " Other Vorticists " to give an indication of the effect of your " Impact " upon your contemporaries.*

MICHAEL    *They will look rather like a lot of sprats a whale has caught.*

WYNDHAM    *Gentlemen, Vorticism, in fact, was what, I, personally, did, and said, at a certain period.*

370. William Roberts. *Conversation Piece* from *Cometism and Vorticism. A Tate Gallery Catalogue Revised*, a pamphlet he published in 1956. The three figures in the drawing are (left to right) Sir John Rothenstein, Michael Ayrton and Wyndham Lewis.

310

of very little account. If the Tate had bothered to contact him, he would have been able to show them a carefully preserved collection of early works which established him beyond doubt as an outstanding painter. Bomberg himself still owned major canvases like *In the Hold* and *The Mud Bath*, but no one had seen them since they were put into store many years ago. The inclusion of one drawing in the Tate show was hardly calculated to arouse interest in his other works of the period, and Bomberg was also mortified to find himself described as a Vorticist. At the time he had always resisted Lewis's attempts to enrol him as a member of the movement; but now, it seemed, Lewis was going to have his way at last.

In reality, Lewis had nothing to do with the 'Other Vorticists' section. Nearly blind, and suffering from the illness which would bring about his death within a year, he was in no condition to mastermind the selection of the show. That task fell to the Tate, and Sir John Rothenstein confirmed that 'we assembled the exhibition with minimum recourse to Lewis himself.'[81] Many years later, when he read about Bomberg's reaction to the show, Rothenstein admitted that he had been responsible for adding its final section. 'The inclusion of his fellow Vorticists had not commended itself to Lewis', Rothenstein explained; 'he had nothing whatever to do with the selection of their exhibits. But if the Bomberg we selected – I cannot, after so many years remember what it looked like – did not worthily represent him, then the fault is mine.' Rothenstein went on to suggest that 'the pamphlets sent to Bomberg by Roberts, who interpreted the Tate's tribute to Lewis as an attempt "to minimize the standing of Lewis's former associates", were primarily responsible for the isolated Bomberg's acute distress.' But Rothenstein also emphasized his own sincere regret that the exhibition had wounded Bomberg so deeply: 'The cause for my own distress is simple: a primary responsibility of the Tate – or of any gallery of contemporary art – is to do all it can to ensure the satisfaction of the artists represented in its collection and exhibitions, so to cause them distress is accordingly distressing. To read about having done so to one for whom I had particular admiration, and at a time of his multiple affliction, is particularly so.'[82]

It is curious that Rothenstein, who could have done so much to alleviate Bomberg's neglect while he was Director of the Tate, failed to demonstrate this 'particular admiration' at the time. Bomberg must have asked himself, while brooding over his fate in Spain, why Rothenstein had never purchased his work for the national collection. The artist would likewise have wondered why he had been excluded from Rothenstein's multi-volume series on *Modern English Painters*. Only thirty years later did Rothenstein finally include Bomberg in a revised edition of the series,[83] and by then it was far too late to comfort the distraught man who had expended his much-needed energies in Ronda looking back and protesting about the indifference he suffered for so long.

Not that anyone outside Bomberg's immediate family was made aware of his mental turmoil. Unlike Roberts, who ensured that his broadsides were published and distributed, Bomberg never sent the letters he composed to *The Times*. But the vast mass of writing which survives from this period proves that he could not stop himself drafting countless versions of these letters. They began as an attempt to rebut Rothenstein's distortion of history, and invariably developed into lengthy attempts to provide an alternative account of his own career. The vehemence with which some of these writings denounce Rothenstein and the Tate reveals just how mortified and angry Bomberg felt. Moreover, the repetitions they contain are the work of a man unable to prevent himself returning, with obsessive frequency, to the same grievance. On some pages the quality of his grammar and handwriting alike degenerates to such an alarming extent that Bomberg's agonized state of mind is made painfully clear.

Until this period Bomberg had succeeded, despite recurrent bouts of severe depression, in maintaining a fundamental sense of stoicism about the indifference he suffered. Three years before he had mentioned his neglect in a letter to Siegfried Giedion, and added that 'I do not wish to convey the impression of being an aggrieved person – on the contrary is the case. I am happy in my own fulfilment.'[84] Peter Richmond confirmed this self-description by maintaining that in Ronda Bomberg was 'by and large an optimistic person: he was always trying to cheer people up'.[85] But the Tate affair changed all that. It triggered off his need to give vent to a sense of injustice which had been accumulating for decades, and once he started writing the grievance spiralled out of control. For weeks on end he could think

of little else. It dominated his mind with relentless force, and Charles Spencer realized that Bomberg had now become 'paranoiac about his fate'.[86] It was a terrible period, and Lilian found to her dismay that she was incapable of helping him break out of his gloom. She knew that painting would be the most effective therapy, as it had always been before. But all her attempts to coax him into working proved futile. 'In the end', she remembered, 'I threatened to go out on my own if he wouldn't paint, and I stayed out all night in the moonlight. When I got back in the morning, David said: "Don't you ever do that again. I was very worried." But he didn't start work again – he was very, very depressed at this time, and lost all inspiration and desire to paint.'[87]

This state of creative paralysis was so severe that it left a mark on the last paintings Bomberg ever executed. After recovering from the worst effects of the Tate *débâcle*, he finally turned his thoughts towards working outdoors again. 'Lilian tried to raise his spirits by organising working trips to the valley below Ronda', recalled Spencer, 'in the belief that the structure of the landscape would inspire him. These treks required elaborate organising. Bomberg was now physically and mentally exhausted, and his equipment needing carrying up and down.'[88] One of these gruelling expeditions yielded the last landscape he ever painted. Lilian, who executed a spirited canvas called *The Tajo, Ronda* at the same time,[89] described how they both set up their easels in the valley of the River Tajo about a mile from the rock face.[90] They arrived there 'after a donkey trip with the Richmonds, during which the donkeys got stuck in the mud and we had to unload the equipment, the canvases and paint-boxes.'[91] Eventually the site was reached, and while Lilian tackled her vigorous picture some distance away, Bomberg painted his beloved Ronda for the last time.

The outcome, *Tajo and Rocks*, has an almost visionary exaltation (Colour Plate 64). As if sensing that it might be his final opportunity to celebrate a location he had painted so often, Bomberg invested the rock-face with an unprecedented chromatic richness. Never before had he deployed such a resplendent range of crimson, ultramarine, pink, white and gold. Although they are still rooted in the landscape Bomberg surveyed, these sumptuous colours take on a greater life of their own as well. It is difficult, now, to identify the scene with any certainty. Freed from the defining contours on which Bomberg's earlier paintings so often relied, the loosely handled pigment declares itself as an expressive force more openly than ever. Bomberg emphasized the unity between air and land by flecking the sky with crimson, and carrying its intense blue into the rocks below. He also ensured that the land does not appear a great deal more solid than the sky. They are both woven together in texture by the same prodding, stabbing, broken brushmarks, and the rockface is divested of the substance it possessed in earlier paintings by the colour-haze spreading across its surface. The former hardness of Ronda's plateau appears to be softening and almost melting, as if Bomberg were suggesting that even the most palpable terrain could dissolve in a web of light. Conscious perhaps that he might be bidding farewell to landscape painting in this canvas, the sixty-six-year-old artist was already allowing his subject to take on the indistinct and fugitive quality of a dream.

This sense of transience is even more poignantly conveyed in his *Last Self-Portrait* (Colour Plate 65). Probably the final canvas he painted, it makes no attempt to provide a literal likeness. Lilian testified that Bomberg 'didn't use a mirror' for this picture, and his head is partially obscured by the 'blue and pink silk scarf' which he had often worn since its early appearance in his 1932 *Portrait of the Artist* (Colour Plate 33). Bomberg's figure is further covered by 'the white coat he usually wore while painting', and its looseness shows how emaciated his body had become. 'He was very thin towards the end', recalled Lilian, describing how 'the trousers hung off him.' Bomberg must have been conscious of his own physical disintegration, and he certainly filled this painting with a tragic awareness of impending mortality. 'I see it as a prophetic picture', Lilian confessed; 'he knew that this was the last portrait and that he was going to die.'[92]

Evanescence receives its most haunting expression in Bomberg's treatment of his own features. They seem in danger of effacement, by brushmarks which brusquely reject a factual account of physiognomy and opt instead for a more harrowing order of feeling. The pigment in this face obliterates as much as it elucidates. It batters the features almost beyond recognition, and at the same time uses near-illegibility

to arrive at an authentic image of Bomberg's state of mind. For he presents himself here as a man of sorrows, acquainted with a grief so lacerating that it twists and wrenches his head to the point of total destruction. The face resembles a ruin because Bomberg felt that his life was threatened with total collapse, and he wanted the painting to convey this appalling sense of disintegration with the utmost directness. The painting he produced has none of the carefully assumed dignity which characterizes so many other artists' self-portraits. It is recklessly confessional, exposing Bomberg's distress with the urgency of a man who has no time left for bogus equanimity. Doubtless realizing that he would never again have the chance to express his innermost feelings on canvas, he cast reticence aside and bared the full, painful extent of his despair.

But the *Last Self-Portrait* is not, in the end, a depressing image. Although Bomberg has transformed his white painting coat into a shroud, thereby implying that he is prepared for imminent death, the garment is at the same time suffused with light. It shines from his body, transfiguring the broken man with a radiance which counteracts the desolation so evident in his face. This extraordinary outpouring of light fills the canvas with an affirmative blaze of pink, yellow, crimson, violet and white, and it is reinforced by the pyramidal strength of Bomberg's figure rising up from its firm foundations at the base of the design. The frontal directness of his stance, as he gazes outwards at a world which seemed to have relegated him to the ranks of the dispossessed, signifies an underlying determination. He still grasps palette and brushes, too, like a man so proud of his lifelong commitment to painting that it ultimately overrides the bitterness of neglect.

The inclusion of the artist's implements echoes their presence in the great Rembrandt self-portrait at Kenwood House, a painting Bomberg must have known well (Plate 371). He 'loved Rembrandt',[93] and the structure of his body's bulk also suggests that a memory of the Kenwood canvas surfaced in Bomberg's mind while he was painting this final testament. He would certainly have approved of the frankness with which Rembrandt admitted a profound level of introspection into his late self-portraits, for the *Last Self-Portrait* hides nothing in its determination to attain unflinching honesty. But a comparison between these two pictures, both executed by men in their sixties nearing the very end of their lives, ultimately serves to emphasize the wildness and utter vulnerability of Bomberg's painting. It lacks the absolute finality of the Kenwood Rembrandt, which possesses the imperturbable poise of an artist working with supreme confidence at the peak of his abilities. Bomberg's self-portrait, by contrast, is executed by a man whose health is failing. The frailty of the image testifies to the fact that he has barely managed to paint it at all, and therein lies its particular power. The tenuous, searching quality of

371. Rembrandt van Rijn. *Self-Portrait*, *c.* 1661–2. Oil on canvas, 114.3 × 95.2 cm. The Iveagh Bequest, Kenwood House, London.

372. David Bomberg. *The Valley, Ronda: Moonlight*, 1956–7. Charcoal, 45 × 59.5 cm. Collection of the artist's family.

373. David Bomberg. *Evening from La Casa de la Virgen de la Cabeza*, 1956–7. Charcoal, 45.7 × 60.3 cm. British Museum, London.

the picture movingly exposes Bomberg's own predicament, as he prophesies and confronts his inevitable dissolution in a painting which only just succeeds in retaining its hold on the living form. Wavering on the edge of extinction, and yet stubborn enough to find a consoling resilience in the near-disembodied image he has created here, Bomberg could hardly have brought his career as a painter to a more memorable close. The *Last Self-Portrait* shares the feeling of distillation attained by many artists in their final years when, as Henry Moore once pointed out, they come 'to know that, in a work of art, the expression of the spirit of the person – the expression of the artist's outlook on life – is what matters more than a finished or a beautiful or a perfect work of art'.[94]

Bomberg now only had the strength left to execute drawings, and during this final period he created in charcoal some outstanding landscapes which summarized his long involvement with the countryside around Ronda. One of them concentrates, not unexpectedly, on a vision of darkness. *The Valley, Ronda: moonlight* reverts to his old habit of studying the landscape at night, and only the palest of lights washes over the surface of a terrain where nothing is visible apart from the earth's primordial bareness (Plate 372). But most of the last drawings were made in the evening, when traces of the sun still broke through the pervasive shadows. In *Evening from the Casa de la Virgen de la Cabeza* the great expanse of land, framed by a few foreground branches delineated with terse economy, is enlivened only by a fitful flicker of sunset above the distant hills (Plate 373). The beautiful *Evening Light, Ronda*, however, allows the entire panorama to be animated by a far more spectacular burst of radiance, which breaks up the mountainous mass below it and thrusts dramatically across the terrain in great shafts of illumination (Plate 374). The whole drawing is alive with Bomberg's fascinated awareness of the landscape as an arena, where the conflicting forces of day and night struggle for supremacy. Here, although dusk is rapidly approaching, the sun still manages to break up the gathering shadows and punctuate the scene with darting, playful ripples of light. More, perhaps, than in any other drawing he made, the 'spirit in the mass' is immanent wherever we look in this exalted and almost visionary image.

In *La Casa de la Virgen de la Cabeza*, which Lilian described as 'the culmination of the set of last drawings', [95] the onset of night is even more powerfully withheld (Plate 375). The refulgence which permeates the upper portion of the sky, and gives the ground beneath an extraordinary luminosity as well, seems to possess the same transfiguring power as the light in the *Last Self-Portrait*. It is a beneficent force, capable of ousting the darkness which so often threatened to overcome Bomberg during the final months of his life.

314

It was little short of a miracle that Bomberg succeeded in producing these drawings at all. For he was still struggling with the painful, self-imposed task of setting down on paper an interminable and rambling refutation of the Tate Gallery's recent exhibition. 'To get what I have so far written', he explained in a letter to Lilian, 'has involved me in reliving the years from my early entry as a student – & living back although it has done me good makes it more of a shock to return to the daily routine.'[96] But the 'shock' that he undoubtedly experienced far outweighed any cathartic value which his obsessive autobiographical outpourings might have possessed. By the time Bomberg wrote this letter to Lilian, in April 1957, she had been obliged to leave the Cabeza. Worn out not only by Bomberg's continuing anger and depression, but also by feuds between neighbouring share-croppers and the Cabeza's Grandee owner, she finally admitted that a rest was needed. 'It was Bomberg's suggestion that Lilian go back to London', recalled Richmond, remarking that, quite apart from the other sources of aggravation, 'the severity of the climate made her get very run down at Ronda.'[97]

At first, she only planned a trip to the coast. Once she arrived there, however, her enfeebled condition had become all too clear. 'I am taking the boat tomorrow for England', she wrote to Bomberg in March. 'I am afraid I need a complete rest – and attend to various matters. Also plan some other place to live and work. Ronda – the Cabeza is a sickening unnecessary hardship . . . I would have perhaps done better to take plane £16 on the 19th from Gib. This way it takes longer and costs more all round but I needed to rest on the boat and think before I meet the family.' Lilian realized well enough that Bomberg ought to leave the remoteness of the Cabeza as well, and her letter pleaded with him to overcome his unwillingness

374. David Bomberg. *Evening Light, Ronda*, 1956. Charcoal, 45.8 × 61 cm. Collection of the artist's family.

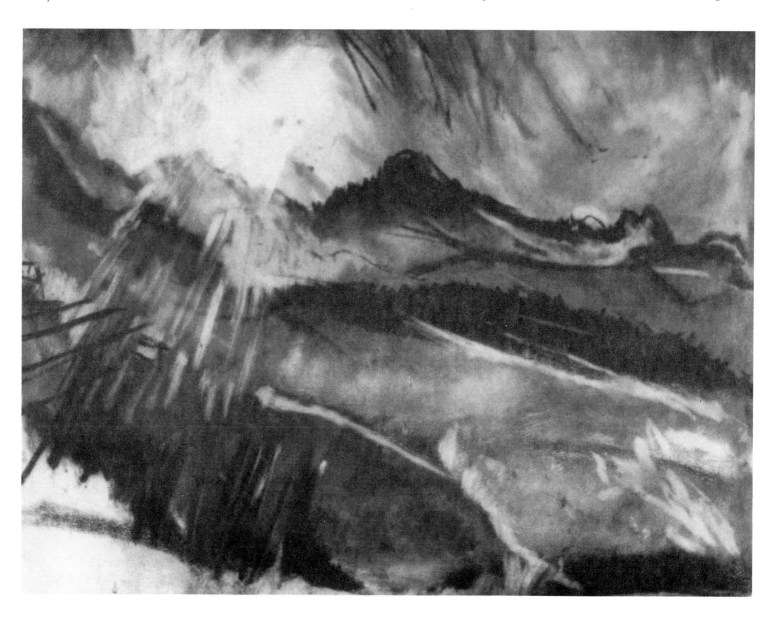

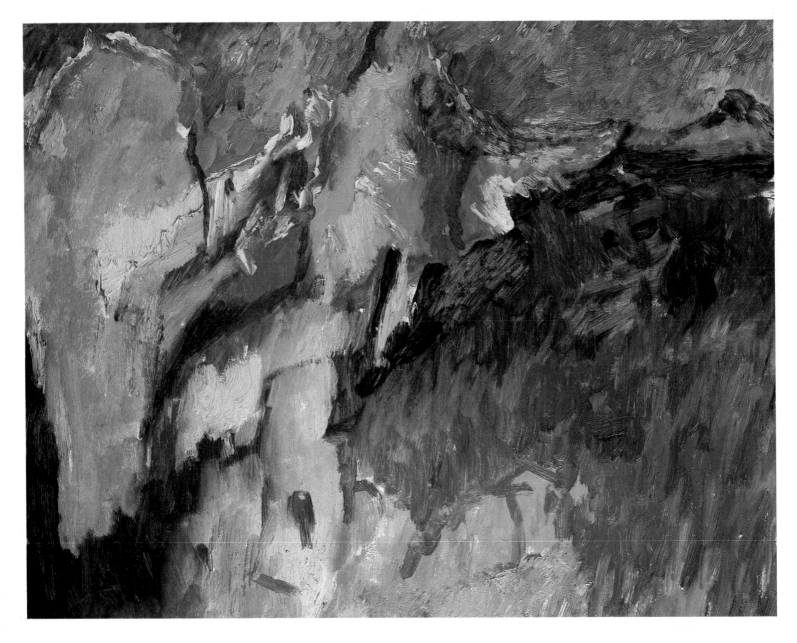

C64. David Bomberg. *Tajo and Rocks, Ronda*, 1956. Oil on canvas, 71 × 91.5 cm. Colin St John Wilson, London.

and consider a move. 'I know you are also at the end of your tether', she wrote, 'but even with the animals parked out I doubt if you would go – however try to think of doing this. Meantime I will try to sell some furniture and get funds for a move. Once away from the place one realizes the stupidity of hanging on there.'

For the time being, all she could do was send her husband some money and trust that he changed his mind soon. 'I am enclosing 300 pts, hope you get it safely', her letter continued, asking him to 'drop a letter also to enclose authority for me to release any items of furniture required either for sale or to prepare for eventual return. If you can park the animals and lock up also take the trip to England. I will send the fare from the account. If there is any job or person you wish me to see, tell me this also.' Although Lilian did not feel at all happy about leaving Bomberg behind, she felt impelled to seek comfort and rest. 'I am sorry not to return as soon as planned', she wrote, 'but there is no alternative as far as my health and future is concerned. I am more than tired.' After adding some details about how much to pay 'the Josefa crowd' for the shopping and washing, and stressing that 'only the money will keep them quiet and non-molesting', she advised him 'to get out and eat in the air'.[98] More than that Lilian could not do, and after she reached London in an acute state of physical and mental exhaustion Dinora looked after her.

She soon recovered, and at first the news from Spain encouraged her to believe that Bomberg's health was likewise improving. 'Worry little about me', he wrote to her in April, relating how Peter Richmond thought 'I was looking well more

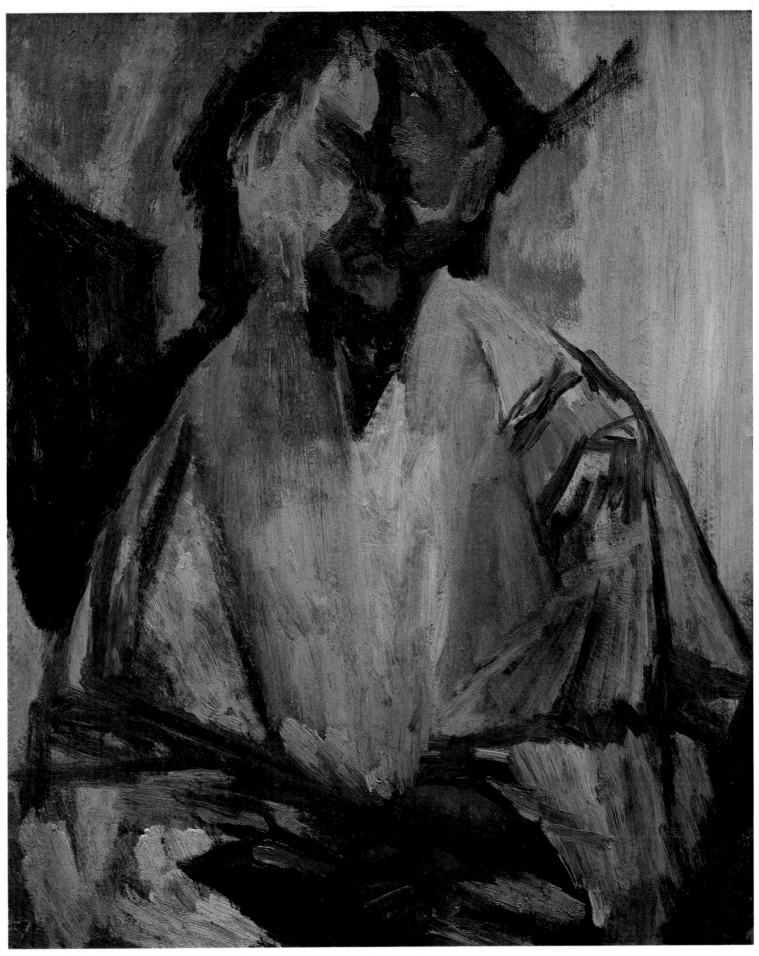

C65.  David Bomberg. *Last Self-Portrait*, 1956. Oil on canvas, 76 × 63.5 cm. Colin St John Wilson, London.

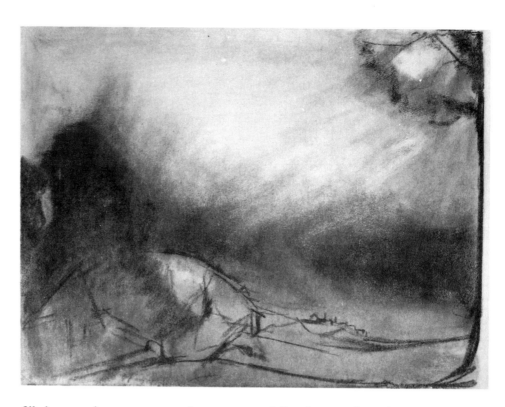

375. David Bomberg. *La Casa de la Virgen de la Cabeza: Night*, 1956–7. Charcoal, 49.1 × 61 cm. Collection of the artist's family.

filled out and years younger in appearance.' But he may have been deliberately exaggerating his recovery in order to reassure Lilian, whom he now realized had been suffering from overwork, malnutrition and anxiety 'that was eating away the nervous system'. So after thanking her for sending him some money, he insisted that 'I cannot see there is anything to worry – about – if I wanted to come to England for a rest – I would have to feel I needed it – but I do not in the least feel in that way yet – I think it is best to rest up than to disorganise myself just now.'[99]

But the truth was that Bomberg had become incapable of resting himself properly. His quarrel with the Tate Gallery, which had so far been confined to innumerable drafts of letters he never sent, now extended itself in the direction of the London Group. Bomberg had been a founding member of the Group in 1914, and exhibited there regularly for many years. Now, however, his continuing state of exasperation prompted him to cable his resignation to the Group's President Claude Rogers, who responded by informing Bomberg that he had been unanimously elected an Honorary Member. The gesture did little to mollify Bomberg's massive sense of grievance. He even refused a proposal made by Helen Lessore to mount 'a really big exhibition of your own work, a retrospective one',[100] at the Beaux Arts Gallery in London. Only a full-scale survey mounted by a public institution would now satisfy Bomberg, who knew that his life's work was too large and complex to be adequately represented in a dealer's gallery. The disastrous inclusion of *Jewish Theatre* in the Tate's Wyndham Lewis exhibition had convinced him, once and for all, that a retrospective of comparable size was required to reveal his achievements adequately.

He was to be proved right; but the final tragedy of Bomberg's career was that he never lived to see such an exhibition himself. In May the illness which had been undermining his strength for so long finally became intolerable. 'He was becoming weak, with terribly inflated stomachs', recalled Peter Richmond. 'I took him down to Gibraltar on the train, and by the time I got him to Algeciras Bomberg was unconscious. For a time the guards wouldn't let us through because his passport was out of date. They told us to go back to Seville.' Eventually Richmond managed to get Bomberg to the hospital in Gibraltar, where 'they took eighteen pints of fluid out of him. I thought he was a dead man. But he recovered for a while, and they tried to make him well enough to go to England.'[101] By this time Lilian had joined him. Bomberg's condition served to convince her that he should never be allowed to return to his old life at the Cabeza. So she travelled back to Ronda herself, 'to pack up the home and the paintings, sell the horses, find a home for the baby donkey, and a little dog "Chippy-Ting-Lee" . . . and to get all our goods,

paintings and equipment etc, to Gibraltar ready for shipment to England with ourselves, David and I.'[102]

At the hospital, although terribly fatigued, Bomberg kept Lilian informed about his condition in a letter which turned out to be the last he ever wrote to her. Maintaining that he had 'gone on all right while you were away', Bomberg went on to tell her that 'if it was necessary to stay on there for another week still would I not be lonely. This means I find enough to do. I walk without any assistance 240 yards four times a day after meals from the balcony terrace. I am out there 10 hours a day – sometimes the cook forgets herself and sends up a heavy meal which I eat but get the worse of – I shall speak to her today – she will get someone to collect the kosher meat today. I read mostly the New Testament Matthew Mark and Luke John . . . The Doctor is pleased with me and each day now is a day nearer the boat.'[103]

Bomberg wrote this letter on 2 August, and later that month he embarked with Lilian on his final journey. After a gruelling four-day trip, during which he suffered convulsions, they arrived on 17 August at Southampton where an ambulance was waiting with his sister Kitty and her husband Jimmy. Lilian recalled later that Bomberg 'complained to the doctors on arrival of the inadequate, rough treatment he had received on the boat from the doctor and his assistant nurse. In fact, he said: "They have killed me."' Bomberg's fears were confirmed by Lilian, who described how 'I learned in conversation with the nurse on the boat that when the convulsions took place, she had given David a double dose of cascara that morning, which seems an incredible thing to give a patient in his condition.' Lilian was so alarmed that she decided to complain as strongly as possible: 'I spoke fully to the Matron at St Thomas's Hospital and also reported it to the head office of the P & O Line in Cockspur Street'. But she realized there was little point in bothering with complaints when nothing now seemed able to prevent her husband from dying.

The end came only two days after Bomberg's arrival at St Thomas's, and Lilian must have wondered whether the journey to England had been medically advisable. But 'after David died the Matron said, possibly to console me: "Perhaps the journey helped to hasten his collapse, but he wouldn't have lasted long anyway and maybe he has been spared more suffering."'[104] Although the cause of death was officially registered as cirrhosis of the liver, Bomberg's awareness that his work was either forgotten or belittled by the London art establishment had clearly aggravated the illness. And the crowning irony was that the move to accord him proper recognition began the following day. *The Times*, which had scarcely acknowledged his existence while he was alive, published a substantial obituary praising his 'independence of vision',[105] and within a year the Arts Council mounted a retrospective exhibition which led at last to a widespread recognition of his true achievement. For Bomberg himself, however, it came too late.

# Afterword

The Arts Council's survey, which opened in the autumn of 1958, contained seventy-two of Bomberg's finest paintings, watercolours and drawings.[1] For many visitors it came as a revelation, and Andrew Forge's perceptive introduction to the catalogue laid particular emphasis on the Toledo and Cyprus paintings – the latter of which he asserted should 'be compared with the best of his contemporaries in Europe'.[2] But much was omitted from the exhibition. *The Mud Bath* and *In the Hold*, both of which had been in storage since they were displayed in 1914, were missing from the early section. Nor were any examples of his *Bomb Store* work included in the later rooms. So the show only offered a fragmentary view of his career, and Bomberg's art had to wait until 1967 for the Tate Gallery to reveal a more comprehensive picture in an exhibition containing over a hundred works.[3] By that time, however, several English critics had long been convinced of his true stature. David Sylvester, one of Bomberg's sturdiest and most eloquent champions, had already claimed in 1964 that 'there are two reasons for believing that David Bomberg was the finest English painter of this century: his early work and his late work.'[4] While John Berger, who had been acute enough to support Bomberg's work since the early 1950s, declared in a review of William Lipke's pioneering book on the artist that he was 'the most important British painter of our time.'[5]

After 1967 Bomberg's position became steadily more secure, although the attention given to particular phases of his career has varied enormously. In the 1970s his early work gained special respect, coinciding with a general quickening of interest in the whole pre-First World War period. Then, splendidly aided by an exhibition at the Whitechapel Art Gallery in 1979, the later work once again became the focus of admiration.[6] The show was very well timed, heralding the dramatic resurgence of enthusiasm for figurative painting during the 1980s. Two of Bomberg's former students at the Borough, Frank Auerbach and Leon Kossoff, are now rightly ranked among the most outstanding artists at work in Britain today, and Bomberg's own position as a venerated source of inspiration for contemporary painting was recognized by his inclusion in the 1986 Hayward Annual.[7] His late work has never seemed more eloquent than it does today, when so many young artists are once again fired by the expressive possibilities which he developed during his final years.

But the art of Bomberg's middle period is also undergoing a revaluation. Both the Spanish canvases of the mid-1930s and the *Bomb Store* paintings can now be counted among his most remarkable achievements, while our post-modernist climate even enables us to examine the Palestine period more sympathetically than before. In 1983 the Israel Museum mounted a comprehensive exhibition of the work he produced in Jerusalem, Petra and other locations,[8] proving that Bomberg's problematic Palestine sojourn did initiate his belief in the prime importance of humanity's relationship with nature.

His later conviction that art could counteract the impersonality of modern life has, if anything, grown in pertinence since Bomberg first advocated it. Now more than ever, we share his concern about the alarming consequences of technological advance in a world vulnerable above all to the threat of nuclear apocalypse. Seen in this context, Bomberg's evolution as an artist takes on a special poignancy and fascination today. Having been so magnificently stimulated by the machine age

in his youth, and then experienced its horrific consequences during the Great War, he was well-placed to develop an art that warned of the dangers of destruction and offered a heartening corrective to dehumanization.

Bomberg travelled a long distance, both physically and metaphorically, to arrive at such a defiant conclusion. The journey he undertook during this age of momentous upheaval was turbulent, uneven and strewn with pitfalls, not all of which he managed to avoid. But this book has been written in the belief that the work which Bomberg created on the way is of enduring value to anyone interested in the twentieth-century condition and the art it has engendered. Precisely because he was courageous enough to confront the central issues of his time, and assert an affirmative vision in the teeth of all the condescension he was obliged to endure, Bomberg can now be seen as one of the most rewarding and prescient painters Britain has produced in the modern era.

# Notes

## Introduction

1 The exhibition, consisting of his 'Imaginative Compositions', was held at the Leger Gallery in November 1943.
2 The two acquisitions were *Sleeping Men* (1911) and *Study for 'Sappers at Work': A Canadian Tunnelling Company* (Second Version) (1918–19).
3 In the meantime, the artist's wife and family had presented a 1943 painting of *Flowers* to the Tate Gallery in 1952.
4 The exhibit was *Jewish Theatre* (1913), now in the collection of Leeds City Art Galleries.
5 Alice Mayes, *The Young Bomberg, 1914–1925* (unpublished memoir, 1972), Tate Gallery Archives pp. 21–2.
6 David Bomberg, Foreword to the catalogue of *Works by David Bomberg*, an exhibition held at the Chenil Gallery, London, July 1914.
7 'A Jewish Futurist', interview with David Bomberg in *Jewish Chronicle* (8 May 1914).
8 Alice Bomberg to David Bomberg, 3 November 1926, collection of the artist's family.
9 Muirhead Bone to Alice Bomberg, 11 December 1926, collection of the artist's family.
10 David Bomberg to Vincent Galloway, 6 December 1932, collection of the Ferens Art Gallery, Hull.
11 David Bomberg, Preface to the catalogue of the *Third Annual Exhibition of the Borough Group*, held at the Archer Gallery, London, March 1949.
12 Frank Auerbach, interview with Catherine Lampert in the catalogue of *Frank Auerbach*, an exhibition held at the Hayward Gallery, London, May–July 1978, p. 20.
13 David Bomberg, Foreword to the catalogue of *Exhibition of Drawings and Paintings by the Borough Bottega and L. Marr and D. Scott*, held at the Berkeley Galleries, London, November–December 1953.
14 David Bomberg, unpublished writings, *c.* 1956, collection of the artist's family.

## Chapter One

1 The Bomberg family's address at the time of David's birth is recorded in his birth certificate.
2 The author is grateful to Patrick Baird, Acting Librarian of the Local Studies Department at the City of Birmingham Reference Library, for providing maps of the area. Florence Street now consists mostly of warehouses.
3 *Borough of Birmingham Report of the Artizans' Dwellings Committee 1884* (Birmingham 1884), p. 50.
4 John Bomberg, interview with the author, 6

February 1981.
5 David Bomberg, unpublished memoir, *c.* 1956, addressed 'to the Editor. The Times', collection of the artist's family.
6 Recorded on the birth certificate of Louis Bomberg, who was born at 9 Buckle Street, Whitechapel.
7 This description of Abraham's occupation is recorded in Bomberg's birth certificate.
8 *Borough of Birmingham Report, op. cit.*, p. 51.
9 May C. Staveley, *The Housing Problem in Birmingham* (Birmingham 1903), pp. 8–9.
10 *Borough of Birmingham Report, op. cit.*, p. 50.
11 The address recorded in the certificate is 80 Saltmead Road, Grange, Cardiff.
12 Lloyd P. Gartner, *The Jewish Immigrant in England 1870–1914* (London 1960), p. 46.
13 Kitty Newmark, interview with the author, 20 November 1980.
14 David Bomberg, unpublished memoir, *op. cit.*
15 Charles Booth, *Life and Labour of the People of London* (London 1896), p. 30.
16 Raymond Williams, *The Country and the City* (London 1976), p. 266.
17 Joseph Leftwich, interview with the author, 15 September 1980.
18 Kitty Newmark, interview with the author. She remembered that the Tower 'gave us a sense of history'.
19 John Bomberg, interview with the author.
20 Kitty Newmark, interview with the author.
21 John Bomberg, interview with the author.
22 Kitty Newmark, interview with the author.
23 David Bomberg, unpublished memoir, *op. cit.*
24 John Bomberg, interview with the author.
25 Kitty Newmark, interview with the author.
26 John Bomberg, interview with the author.
27 *Ibid.*
28 Kitty Newmark, interview with the author.
29 Quoted by Vivian D. Lipman, 'The Anglo-Jewish Background', an essay in the catalogue of *The Immigrant Generations: Jewish Artists in Britain 1900–1945*, an exhibition held at the Jewish Museum, New York, May–September 1983, p. 18.
30 See Joseph Cohen, *Journey to the Trenches. The Life of Isaac Rosenberg 1890–1918* (London 1975), pp. 16–17.
31 William Lipke, in *David Bomberg: A Critical Study of his Life and Work* (London 1967, p. 25), refers to it as the Castle Street School, but the Record Keeper for the Director-General of the Greater London Record Office informed the author (letter of 16 February 1981) that 'I would feel fairly certain that the school in question would have been Old Castle Street School, Whitechapel, which was in Old Castle Street, off Wentworth Street.'
32 John Bomberg, interview with the author.
33 Charles Spencer, 'Anglo-Jewish Artists: The

Migrant Generations', essay in the *Immigrant Generations* catalogue, *op. cit.*, p. 25.
34 The author is grateful to A. R. Neate, Record Keeper for the Director-General at the Greater London Record Office, for providing so much helpful information about Bomberg's school, its staff and syllabus.
35 John Bomberg, interview with the author.
36 *Ibid.*
37 Lilian Bomberg, in an interview with the author on 10 October 1980, remembered the drawing with great admiration and described it as 'a very exact copy of a half-length Holbein man in ink, perhaps 30 by 20 inches in size'. It was owned by Bomberg's brother Mo and destroyed in the Blitz. John Bomberg believed that Bomberg made the drawing while he was still at school.
38 Kitty Newmark, interview with the author. Lilian Bomberg recognized Holbein's John Godsalve portrait immediately the author showed her a reproduction of it.
39 The charcoal portrait is wrongly identified as Kitty in Lipke's *David Bomberg, op. cit.*, where it is reproduced as Plate 1. Rachel was especially interested in poetry, and died prematurely in 1917.
40 Kitty Newmark, interview with the author.
41 John Bomberg, interview with the author.
42 *Ibid.*
43 Lilian Bomberg, interview with the author, 29 September 1980. Lilian was recalling a story which Bomberg had told her about his early life.
44 John Bomberg, interview with the author.
45 Kitty Newmark, interview with the author.
46 John Bomberg, interview with the author.
47 Kitty Newmark, interview with the author.
48 David Bomberg, unpublished writings, *c.* 1956, collection of the artist's family.
49 See Michael Parkin's Introduction to the catalogue of *Walter Bayes 1869–1956*, an exhibition held at Michael Parkin Fine Art, March–April 1978.
50 *The Times*, 23 January 1956.
51 Quoted by Lipke, *David Bomberg, op. cit.*, p. 27.
52 Kitty Newmark, interview with the author.
53 The Russian Ballet colour lithographs which Bomberg executed in 1919 have a technical assurance which owes a great deal to Bomberg's early apprenticeship with Fischer.
54 David Bomberg, unpublished writings, *c.* 1956, collection of the artist's family.
55 Bomberg refers to Sargent's sitter as 'The Earl of Wymess [*sic*]', and adds that the portrait is now in the Tate Gallery. But he must be referring to the Earl of Wemyss portrait still in the Wemyss family's own collection. Although the painting was subscribed for by the Earl's friends to celebrate his ninetieth birthday in 1908,

56 Richard Ormond ascribes it to 1909 in his *John Singer Sargent* (London 1970), p. 254.

56 David Bomberg, unpublished writings, *c.* 1956, collection of the artist's family.

57 The two Sargent drawings are bound in an album of studies for *Israel and the Law*, and according to Miriam Stewart of the Fogg Museum, 'other drawings in the album, for example those between pages 90 and 99, could also be studies of Bomberg, but it is difficult to distinguish his arms and legs from those of other male models!' (letter to the author, 30 November 1983).

58 David Bomberg, unpublished writings, *c.* 1956, collection of the artist's family.

59 See Chapter Six, note 127.

60 In 1904 Rothenstein and Alfred Wolmark studied worshippers and Talmud groups at the Machzike Hadath Synagogue.

61 The first Jewish artist to be appointed was Zoffany, a founder-member of the Royal Academy.

62 David Bomberg, unpublished writings, *c.* 1956, collection of the artist's family.

63 *Ibid.*

64 *Ibid.* Bomberg wrote that 'we spoke about the Bishop of Cloyne.'

65 William Roberts, *Early Years*, memoir dated September 1977 (published posthumously, London 1982), p. 11. Lilian Bomberg had never heard her husband mention his modelling for Thomas. *Lycidas* is dated 1902–8.

66 *Ibid.*, pp. 10–11.

67 In 1912, attempting to subsidize himself while studying at the Slade, Bomberg entered a national poster competition for a design called 'Shakespeare's England' and won an award. He also tried unsuccessfully to design a poster for Shell-Mex in the 1930s (see Chapter Seven).

68 David Bomberg, unpublished writings, 1953–4, collection of the artist's family.

69 *Ibid.*

70 Wendy Baron, Introduction to the catalogue of the *Sickert* exhibition held by the Arts Council at several regional galleries, 1977–8, p. 6.

71 The exhibition opened at the City Art Gallery in Brighton in June 1910.

72 David Bomberg, unpublished writings, *c.* 1956, collection of the artist's family.

73 *The Times*, for example, declared that the exhibition 'begins all over again – and stops where a child would stop . . . it is the rejection of all that civilisation has done, the good with the bad.'

74 Eric Gill to William Rothenstein, 5 December 1910, *Letters of Eric Gill*, ed. Walter Shewring (London 1947), p. 35.

75 W. R. Sickert, 'The Post-Impressionists', *Fortnightly Review* (January 1911).

76 Roger Fry, 'Retrospect', *Vision and Design* (London 1920, Pelican edn 1961), p. 227.

77 Desmond MacCarthy, 'The Post-Impressionists', introduction to the exhibition catalogue of *Manet and the Post-Impressionists*, Grafton Galleries, London 1910.

78 *Ibid.*

79 Gauguin's *The Seaweed Harvesters* was not included in the *Manet and the Post-Impressionists* exhibition.

80 Desmond MacCarthy, 'The Post-Impressionists', *op. cit.*

81 *Ibid.*

82 Desmond MacCarthy, 'The Art-Quake of 1910', *The Listener* (1 February 1945).

83 Joseph Leftwich, interview with the author, 15 September 1980.

84 *Ibid.*

85 *Ibid.*

86 Joseph Leftwich, entry for 3 March 1911 in his unpublished diary, a copy of which is preserved in Tower Hamlets Library, London.

87 Joseph Leftwich, entry for 6 March 1911, *op. cit.*: 'He [Rosenberg] tells us he is painting a picture to send to the Royal Academy, a self-portrait in his wonderful hat, with his coat collar turned up.'

88 See Jean Liddiard, *Isaac Rosenberg: The Half Used Life* (London 1975), p. 73.

89 Rutter's *Revolution in Art* was published in 1910. It was dedicated to 'the rebels of either sex all the world over who in any way are fighting for freedom of any kind'.

90 Joseph Leftwich, entry for 4 August 1911 in his diary, *op. cit.*

91 Joseph Cohen, *Journey to the Trenches. The Life of Isaac Rosenberg, op. cit.*, p. 51.

92 Sonia Cohen Joslen's memories were recorded by Joseph Cohen, *op. cit.*, pp. 81–3. Rosenberg published the complete poem in *Night and Day*.

93 Joseph Leftwich, interview with the author, 15 September 1980.

94 William Lipke, in *David Bomberg* (*op. cit.*, p. 34), states that 'Bomberg enrolled in the Slade School of Fine Art in January 1911.' But the Senior Executive Officer of University College, London, stated in a letter to the author (10 January 1984) that 'Bomberg's registration papers show his date of registration as 11 April 1911.'

# Chapter Two

1 See Andrew Forge, *The Slade 1871–1960* (London n.d.), pp. 16–29, for a valuable account of Slade teaching during this period.

2 Fred Brown, 'Wander Years', *Artwork* (autumn 1930).

3 Adrian Allinson, *Painter's Pilgrimage. An Autobiography*, unpublished. The author is grateful to Miss Mollie Mitchell-Smith for permission to read this manuscript.

4 David Bomberg, unpublished memoir, *c.* 1956, collection of the artist's family.

5 In later life the two men briefly resumed their friendship and exchanged letters.

6 John Fothergill, 'Drawing', *Encyclopaedia Britannica* (London 1910–11), pp. 552–6. The article is signed 'J.R.Fo' at the end.

7 Andrew Forge, *The Slade, op. cit.*, p. 23.

8 Diana Cooper, *The Rainbow Comes and Goes* (London 1958, Penguin edn 1961), p. 81.

9 Both William Roberts (*Early Years, op. cit.*, p. 11) and Clare Winsten (interview with the author, 10 November 1980) recalled that Bomberg posed at the Slade before he became a student there.

10 William Roberts, *Early Years, op. cit.*, p. 13.

11 John Fothergill, 'Drawing', *op. cit.*, p. 555.

12 Ecclesiastes xii: 5.

13 Keith Bell, in his catalogue entry for this drawing (*Stanley Spencer RA* (London 1980), p. 41) states that 'the landscape in the background is a view looking south from the corner of Carter's shed by Lambert's stables, Cookham. The tree and the chain fence have been added.'

14 Cliff Holden, 'David Bomberg: an artist as teacher', *Studio International* (March 1967).

15 See Ronald Alley's catalogue of the *William Roberts ARA* exhibition (Arts Council 1965), p. 22.

16 Clare Winsten, interview with the author, 10 November 1980. At the time Mrs Winsten's name was Clara Birnberg.

17 David Bomberg, unpublished writings, n.d., collection of the artist's family.

18 Stanley Spencer to Sydney Spencer, 1911, quoted by Richard Carline, 'Stanley Spencer: his personality and mode of life', in *Stanley Spencer RA, op. cit.*, p. 11.

19 Alice Mayes, 'The Young Bomberg 1914–1925' (unpublished memoir, 1972) Tate Gallery Archives, pp. 11–12.

20 Kitty Newmark to the author, 4 November 1983. She also believed that the painting could not have been executed after 1912, and recalled that 'it was from that bed I was put on a stretcher & taken to the fever hospital, David being at the foot of the bed.'

21 Because Hulme's description of the painting tallies so well with *Bedroom Picture*, exhibited as no. 46 in Bomberg's one-man show at the Chenil Gallery, this title seems preferable to *At the Window*, the name it subsequently acquired in the Vint collection.

22 *The New Age*, 9 July 1914.

23 William Roberts, *Early Years, op. cit.*, p. 14.

24 Adrian Allinson, *Painter's Pilgrimage, op. cit.*

25 Darsie Japp to John Woodeson, quoted by Woodeson in *Mark Gertler. Biography of a Painter 1891–1939* (London 1972), p. 51.

26 Joseph Cohen, *Journey to the Trenches, op. cit.*, p. 63.

27 Jean Liddiard, *Isaac Rosenberg: The Half Used Life, op. cit.*, p. 77.

28 Sarah Roberts, interview with the author, 15 November 1982.

29 See entries 48 and 49 in the catalogue of the *Harold Gilman 1876–1919* exhibition (Arts Council 1981), where all three paintings are said to have been executed in the 1913–14 period.

30 Wyndham Lewis, 'The Improvement of Life', *Blast No. 1*, ed. Wyndham Lewis (London 1914), p. 146.

31 *Blast No. 2*, ed. Wyndham Lewis (London 1915), p. 92.

32 *Reflection* was listed as no. 79 in the catalogue of the Friday Club exhibition held at the Alpine Club Gallery, January–February 1913. No other surviving Bomberg picture of the period fits this unusual title. In later life, he entitled it *Lyons Café* in lists of his own work.

33 Isaac Rosenberg to Alice Wright, 15 July 1912, *Collected Works/Writings*, p. 329. Rosenberg says in the same letter that he is starting the picture, so Bomberg was presumably working on *Island of Joy* around this time.

34 Joseph Cohen, *Journey to the Trenches, op. cit.*, p. 73.

35 *Ibid.*, p. 74.

36 *Ibid.*, p. 72.

37 This painting was included in the 1967 Tate Gallery exhibition *David Bomberg 1890–1957* as *Primeval Decoration* (no. 3). But his first wife Alice Mayes identified it as *Island of Joy* in a letter (15 January 1972) to one of the compilers of *The Tate Gallery 1970–72* (London 1972), p. 87. She also confirmed that it was painted in response to the Slade's summer competition. Further evidence was supplied by Bomberg himself when he wrote to Harry Manheim on 10 May 1943 describing this painting as 'a figure composition – the subject "Joy"'.

38 Kandinsky also exhibited two other paintings in the 1910 AAA Salon, one of which was *Improvisation Number Six*. Kandinsky did not exhibit at the AAA again until 1913.

39 Roger Fry, Introduction to the catalogue of the *Second Post-Impressionist Exhibition*, held at the Grafton Galleries, London, October 1912–January 1913.

40 Clive Bell, 'The English Group', *ibid.*

41 Paul Nash, *Outline. An Autobiography and Other Writings*, with a preface by Herbert Read (London 1949), pp. 92–3.

42 Joseph Hone, *The Life of Henry Tonks* (London 1939), p. 103.

43 William Roberts, *A Press View at the Tate Gallery* (London 1956), unpaginated.

44 From a recollection of George Charlton, artist and teacher at the Slade, recorded by William Lipke, *David Bomberg, op. cit.*, p. 34.

45 Jean Liddiard, *Isaac Rosenberg, op. cit.*, p. 87.

46 Isaac Rosenberg to Ruth Löwy, *c.* 1912, quoted by Liddiard, *ibid.*, p. 87.

47 Mark Gertler to William Rothenstein, quoted by Woodeson in *Mark Gertler, op. cit.*, p. 60.

48 Clare Winsten, interview with the author, 10 November 1980.

49 The death certificate states that she died on 2 October 1912.

50 John Bomberg, interview with the author, 6 February 1981.

51 Kitty Newmark, interview with the author, 20 November 1980.

52 John Bomberg, interview with the author.

53 *Ibid.*

54 In this memoir Bomberg states that the drawing was executed in 1909, but in an index of his works compiled between 1953 and 1954, he listed 'Richard Feveral – Drawing' as 1912. The latter date seems far more convincing, and it may well have been a Slade set subject.

55 Roberts's '*Feveral*' illustration was listed as no. 483 in the Whitechapel Art Gallery's exhibition of *Twentieth Century Art. A Review of Modern Movements*, May–June 1914.

56 David Bomberg, unpublished writings, *c.* 1956–7, collection of the artist's family.

57 Kitty Newmark, interview with the author.

58 Although this drawing is dated 1913, it seems possible that Bomberg executed the other versions of *Family Bereavement* in the final months of 1912, following his mother's death.

59 Augustus John to John Quinn, 29 December 1913, quoted by Michael Holroyd in *Augustus John: A Biography* (revised Penguin edition, Harmondsworth 1976), p. 438.

60 See the chapter on the Cave of the Golden Calf in Richard Cork, *Art Beyond the Gallery in Early 20th Century England* (New Haven and London 1985).

61 *Ibid.*, p. 108.

62 David Bomberg, unpublished writings, *c.* 1956–7, collection of the artist's family.

63 George Charlton believed that Spencer's *Calf* drawing was probably a Slade Sketch Club subject, but Keith Bell has pointed out that Spencer's list contains no reference to the Calf story (*Stanley Spencer RA, op. cit.*, p. 40). Although Bell assigns the drawing to 1911, it may well have been executed the following year.

64 Bomberg simply called the painting *Ezekiel* when he displayed it in the February–March 1914 Friday Club exhibition (no. 19) and in the Whitechapel Art Gallery's *Twentieth Century Art* exhibition of May–June 1914 (no. 255). But later, in a letter to Harry Manheim (10 May 1943), he did at least reveal that 'the subject is "The Dream of Ezekiel".'

65 Although Bomberg never discussed the Biblical origin of the painting with her, Lilian Bomberg felt that the vision of the valley of dried bones was the most likely passage in Ezekiel. This hypothesis is also accepted by Joan Comay, *The World's Greatest Story. The Epic of the Jewish People in Biblical Times* (London 1978), where *Vision of Ezekiel* is reproduced on pp. 270–71.

66 Ezekiel 37: 1–5, 7–10.

67 Phillips commented in the *Daily Telegraph* in May 1914, when *Ezekiel* was displayed at the Whitechapel Art Gallery's *Twentieth Century Art* exhibition.

68 The word 'Decoration' was inscribed on the back of the canvas (along with Bomberg's home address at Tenter Buildings) before it was relined. Alice Mayes recalled that when Bomberg was asked to what genre this type of painting belonged, he replied: 'Pure Decoration' (Denis Richardson to compiler of entry on *Vision of Ezekiel* in *The Tate Gallery 1970–72* (London 1972), in a letter dated 20 January 1972).

69 Kitty Newmark, interview with the author.

70 Susan Compton, *Chagall* (London 1985), p. 195.

71 Ezekiel 37: 11–14.

72 Wyndham Lewis, 'Room III (The Cubist Room)', preface to the catalogue of *Exhibition by the Camden Town Group and Others*, Public Art Galleries, Brighton, December 1913–January 1914, p. 12. Although *Vision of Ezekiel* was not included in the catalogue, Lewis's description certainly accords with it. Bomberg later recalled Lewis's unsuccessful attempt to prevent the painting from being shown at Brighton (see Chapter Three, note 19).

73 Wyndham Lewis, 'A Review of Contemporary Art', *Blast No. 2* (London 1915), p. 41.

74 In *Rude Assignment. A Narrative of my Career Up-to-Date* (London 1950, p. 119), Lewis recalled that 'fronting the stairs that led upwards where the ladies were learning to be Michelangelos, hung a big painting of Moses and the Brazen Serpent.'

75 Although *Creation* is the only painting by Lewis listed in the 1912 AAA catalogue, the picture he exhibited was beyond all reasonable doubt *Kermesse*. See Richard Cork, *Vorticism and Abstract Art in the First Machine Age,* Volume 1, *Origins and Development* (London 1975, note 47 on p. 301) for a full examination of the reasons why it is identifiable as *Kermesse.*

76 Frank Rutter, *Art in My Time* (London 1933), p. 143.

77 *Paintings and Sculptures. The Renowned Collection of Modern and Ultra-Modern Art, Formed by the Late John Quinn. Including Many Examples Purchased By Him Directly From the Artists,* sale catalogue (New York 1927), lot no. 382.

78 For an extended discussion of *Kermesse* and its Breton origins, see Richard Cork, *Art Beyond the Gallery, op. cit.*, pp. 87–92.

79 Roger Fry, *The Nation* (20 July 1912).

80 David Bomberg, unpublished writings, *c.* 1957, collection of the artist's family.

81 Bomberg's 1913 Friday Club exhibits were: *Boy's Head* (no. 57), *Reflection* (no. 79) and *Job and His Comforters* (no. 115).

82 *The Observer,* 11 February 1912.

83 See Judith Collins, *The Omega Workshops* (London 1983), p. 85, for a detailed discussion of Fry's move from the Friday Club to the Grafton Group.

84 *Head of a Poet* is now lost, but the illustrated book of *John Quinn 1870–1925: Collection of Paintings, Water Colors, Drawings & Sculpture* (New York 1926) reproduced the drawing on p. 136 and gave its title, date and dimensions on p. 16.

85 Kitty Newmark, interview with the author.

86 At least two other versions of the *Racehorses* subject survive, including an oil painting on board, 36.8 × 54.7 cm.

87 Desmond MacCarthy (with notes from Roger Fry), introduction to the catalogue of the *Manet and the Post-Impressionists* exhibition, Grafton Galleries, London, November 1910–January 1911.

88 John Rodker, 'The New Movement in Art', *Dial Monthly* (May 1914).

89 *Jewish Chronicle* (15 May 1914). The comment was made about Bomberg's watercolour version of *Racehorses*, when it was exhibited as no. 252 in the Whitechapel Art Gallery's *Twentieth Century Art* exhibition, May–June 1914.

90 Roberts's version of the same subject suggests that the Slade asked them to tackle it. Bomberg exhibited a picture called *Study for Ulysses in the Courts of Alcinous* as no. 44 in his one-man show at the Chenil Gallery in July 1914.

91 David Bomberg, unpublished writings, 11 April 1957, collection of the artist's family.

92 David Bomberg, unpublished writings, 1953–4, collection of the artist's family.

93 The Modigliani *Head* was listed as no. 287 in the Whitechapel exhibition and lent by Edward Roworth. It subsequently entered the Tate Gallery's collection via the Victoria & Albert Museum.

94 According to *Jewish World* (18 March 1914), Bomberg executed *Ju-Jitsu* while he was still at the Slade.

95 The catalogue of the *David Bomberg 1890–1957* exhibition at the Tate Gallery, March–April 1967, p. 23, made this assumption, and so did my catalogue for the *Vorticism and its Allies* exhibition at the Hayward Gallery (March–June 1974, p. 37).

96 Joseph Leftwich, interview with the author, 15 September 1980.

97 See Ezra Pound, *Gaudier-Brzeska. A Memoir* (London 1916), pp. 45–6.

98 Henri Gaudier-Brzeska to Sophie Brzeska, 3 December 1912, University of Essex Library.

99 T. E. Hulme, 'Modern Art. IV. – Mr David Bomberg's Show', *The New Age* (9 July 1914).

100 *Japanese Play* was listed as no. 74 in the March 1914 London Group exhibition, and as no. 253 in the May–June 1914 Whitechapel *Twentieth Century Art* exhibition. But *Study for Ju-Jitsu* was listed as *Ju-Jitsu* when shown as no. 6 in Bomberg's Chenil Gallery one-man show of July 1914.

101 Pound's poem was published in *Blast No. 2, op. cit.*, p. 19. The word 'contes' printed in the final line of the *Blast* version is here corrected to 'contest'.

102 Clare Winsten, interview with the author, 10 November 1980.

## Chapter Three

1 Annie Wynick Papers, Joseph Cohen, *Journey to the Trenches, op. cit.*, p. 93.

2 *Allotment Grounds* and *Wind and Water* were listed as nos. 40 and 47 in the catalogue of Bomberg's one-man show at the Chenil Gallery, July 1914.

3 David Bomberg, unpublished writings, *c.* 1957, collection of the artist's family.

4 Bomberg's picture was the lost *Winter Afternoon*, listed as no. 4 in the NEAC catalogue.

5 The three pictures included in the 'drawings and watercolours' section were *Plague* (no. 118), *The Nurse Euryclea* (no. 142) and *Interval* (no. 215). None of them appears to have survived.

6 Frank Rutter, Foreword to the catalogue of the *Post-Impressionist and Futurist Exhibition*, Doré Galleries, London, October 1913.

7 Christopher Nevinson, *Paint and Prejudice* (London 1937), p. 57.

8 Wyndham Lewis to Mrs Percy Harris, November 1913, *The Letters of Wyndham Lewis,* ed. W. K. Rose (London 1963), p. 53.

9 David Bomberg, unpublished writings, *c.* 1957, collection of the artist's family.

10 *Ibid.*

11 William Roberts, *Early Years, op. cit.*, p. 18.

12 Sarah Roberts, interview with the author, 15 November 1982.

13 John Currie to Edward Marsh, quoted by John Woodeson, *Mark Gertler, op. cit.*, note 122.

14 Vanessa Bell to Roger Fry, 26 December 1913, Tate Gallery Archives.

15 William Roberts, *Early Years, op. cit.*, p. 18.

16 J. B. Manson, 'Introduction. Rooms I–II', in the catalogue of *Exhibition by the Camden Town Group and Others*, Public Art Galleries, Brighton, December 1913–January 1914, p. 8.

17 Bomberg's six exhibits were *Wind and water* (no. 153), *Study in oil paint* (no. 157), *Primeval Decoration* (no. 173), *Chalk study* (no. 184), *Drawing for 'Primeval Decoration'* (no. 186) and *Summer night* (no. 195).

18 The highest price attached to works by the other Cubist Room artists was £30, for Lewis's *Group* (no. 171).

19 David Bomberg, unpublished writings, 14 April 1957, collection of the artist's family.

20 Lilian Bomberg, interview with the author, May 1970.

21 Lewis's comments presumably refer to *Vision of Ezekiel*, even though he subsequently tried to prevent its inclusion in the show.

22 'A Jewish Futurist. Chat with Mr David Bomberg', *Jewish Chronicle* (8 May 1914).

23 Wyndham Lewis, 'Room III (The Cubist Room)', in the catalogue of *Exhibition by the Camden Town Group and Others*, *op. cit.*, pp. 9–12.

24 *Procession* may be identifiable as the *Mourners* which Bomberg exhibited at his 1914 Chenil Gallery exhibition (no. 3).

25 I called this drawing *Composition* in the catalogue of *Vorticism and its Allies* (*op. cit.*, no. 30), but it should more appropriately be given the same title as the ink version.

26 Augustus John to John Quinn, 13 May 1913, quoted by Michael Holroyd, *Augustus John*, *op. cit.*, p. 511.

27 David Bomberg to Siegfried Giedion, 27 July 1953, collection of the artist's family.

28 Augustus John, *Horizon* (August 1943).

29 Augustus John to John Hope-Johnstone, *c.* 1914, quoted by Michael Holroyd, *op. cit.*, p. 513. John later became dissatisfied with the house and dismissed it in 1916 as 'this damned Dutch shanty'.

30 T. E. Hulme, 'Modern Art and its Philosophy', delivered as a lecture to the Quest Society on 22 January 1914 and later published in *Speculations. Essays on Humanism and the Philosophy of Art*, ed. Herbert Read (London 1924, new edition 1960), p. 105.

31 David Bomberg, Foreword to the catalogue of his one-man show at the Chenil Gallery, July 1914.

32 It was entitled *Ezekiel* and listed as no. 19 in the catalogue.

33 *The Athenaeum* (21 February 1914).

34 Augustus John to John Quinn, 26 January 1914, quoted by Michael Holroyd, *op. cit.*, p. 438.

35 Mark Gertler to Edward Marsh, *c.* 1913, quoted by John Woodeson, *op. cit.*, p. 399. The two Bomberg drawings which Gertler mentioned by their titles were *The Nurse Euryclea* and *The Plague*.

36 *The Observer* (8 March 1914).

37 *Acrobats* was listed as no. 47 in the London Group catalogue, and *Ju-Jitsu* was called *Japanese Play* (no. 74). The other three exhibits were *Men and Lads Scheme A* (no. 48), *Men and Lads Scheme B* (no. 49) and *In the Hold* (no. 67).

38 *Jewish Chronicle* (15 May 1914).

39 *On Board Ship* was listed as no. 60 in the London Group catalogue, and *The Arrival* was no. 39.

40 *Blast No. 1*, *op. cit.*, p. 23. This passage was published in *Blast* as a vertical column, and did not include some of the punctuation added here to aid legibility.

41 Joseph Leftwich, unpublished diary, *op. cit.*, 9 August 1911. Further diary entries in the same month record other stages in the strike and the meetings held to debate its implications.

42 Linda Nochlin, *Realism* (Harmondsworth 1971), p. 127.

43 Joseph Leftwich, interview with the author, 15 September 1980.

44 Charles Booth, *Life and Labour of the People of London* (London 1896), p. 33.

45 'A Jewish Futurist. Chat with Mr David Bomberg', *Jewish Chronicle* (8 May 1914).

46 *Ibid.*

47 Linda Nochlin, *Realism*, *op. cit.*, p. 127.

48 Umberto Boccioni to Nino Barbantini, quoted by Joshua C. Taylor, *Futurism* (New York 1961), p. 35.

49 Marianne W. Martin, *Futurist Art and Theory 1909–1915* (Oxford 1968), p. 87.

50 Quoted by John Woodeson in *Mark Gertler*, *op. cit.*, p. 7.

51 *Jewish Chronicle* (8 May 1914).

52 *Ibid.*

53 Clive Bell, *Art* (London 1914), p. 207.

54 *Daily Telegraph* (10 March 1914).

55 *Daily News and Leader* (6 March 1914).

56 William Roberts, *A Press View at the Tate Gallery*, *op. cit.*, unpaginated.

57 *Daily Telegraph* (10 March 1914).

58 *The Athenaeum* (14 March 1914).

59 *The Nation* (14 March 1914).

60 T. E. Hulme, 'Modern Art. III. – The London Group', *The New Age* (26 March 1914).

61 'A Jewish Futurist', *op. cit.*

62 'Modern Art. III', *op. cit.*

63 Jean Liddiard, *Isaac Rosenberg*, *op. cit.*, p. 103.

64 D. L. Murray, quoted by Alun R. Jones, *The Life and Opinions of T. E. Hulme* (London 1960), p. 92.

65 Christopher Nevinson, *Paint and Prejudice*, *op. cit.*, p. 63.

66 Wyndham Lewis, *Blasting and Bombardiering* (London 1937), p. 39.

67 Hulme's article was entitled 'Mr Epstein and the Critics'.

68 T. E. Hulme, 'Modern Art and Its Philosophy', *Speculations*, *op. cit.*, pp. 73–109.

69 *Ibid.*

70 *Pall Mall Gazette* (25 June 1914).

71 'Modern Art. III', *op. cit.*

72 In *The New Age* (2 April 1914), Hulme explained that 'perhaps the only quality they [the drawings] possess in common is that they are all abstract in character. The series includes everyone in England who is doing interesting work of this character.'

73 *Ibid.*

74 The poem, called 'Chinnereth', was published in *The New Age* on 16 April 1914.

75 David Bomberg to Siegfried Giedion, 27 July 1953.

76 *Jewish Chronicle* (15 May 1914).

77 *Jewish Chronicle* (8 May 1914).

78 See Chapter Two, note 93.

79 *Jewish Chronicle* (8 May 1914).

80 Ezra Pound, 'Vorticism', *Fortnightly Review* (1 September 1914).

81 Ezra Pound, 'Wyndham Lewis', *The Egoist* (15 June 1914).

82 *Jewish Chronicle* (8 May 1914).

83 *Jewish Chronicle* (15 May 1914). The critic signed his review with the initials 'L.K.'

84 Isaac Rosenberg, lecture on modern art delivered in Cape Town, *Collected Works of Isaac Rosenberg*, *op. cit.*, p. 253.

85 David Bomberg, unpublished writings, *c.* 1957, collection of the artist's family.

86 Kate Lechmere, interview with the author, November 1969.

87 *Ibid.*

88 Sonia Cohen Joslen, interview with the author, December 1971.

89 Frederick Etchells, interview with the author, 2 June 1970.

90 The manifesto was published in *The Observer* on 7 June 1914, and subsequently in *The Times* and the *Daily Mail*.

91 *The Observer* (14 June 1914).

92 Lilian Bomberg, interview with the author, May 1970.

93 *Blast No. 1* bears the date '20 June' on the title-page, but it actually appeared on 2 July.

94 It should be pointed out that Roberts later claimed: 'I, in fact, personally signed nothing. The first knowledge I had of a Vorticist Manifesto's existence was when Lewis, one fine Sunday morning in the summer of 1914, knocked at my door and placed in my hands this chubby, rosy, problem-child *Blast*' (*Cometism and Vorticism. A Tate Gallery Catalogue Revised* (London 1956), unpaginated).

## Chapter Four

1 T. E. Hulme recorded (*The New Age*, 9 July 1914) that a number of 'early drawings' had been included in the show.

2 *Bedroom Picture* was listed as no. 46, and given the second highest price in the exhibition (£30). Hulme's review (*ibid.*) identifies it as the painting discussed near the beginning of the second chapter of this book (see note 21, Chapter two).

3 David Bomberg, unpublished writings, *c.* 1957, collection of the artist's family.

4 David Bomberg, Foreword to the catalogue of *Works by David Bomberg*, Chenil Gallery, July 1914.

5 Clive Bell's *Art* was written in 1912–13 and published in February 1914.

6 Clive Bell, *Art* (London 1914), p. 8.

7 *In the Hold*, which is larger than *The Mud Bath*, was not included in the Chenil Gallery exhibition.

8 *Daily Chronicle* (25 June 1914).

9 Alice Mayes to the author, 17 July 1973.

10 A. B. Levy, *East End Story* (London n.d.; *c.* 1951), p. 26.

11 John Bomberg, interview with the author, 6 February 1981.

12 James Newmark, interview with the author, 20 November 1980.

13 Louis Behr to the author, 13 April 1981, and notes given to D. T. Elliott, Chief Librarian of Tower Hamlets Central Library, 16 March 1981.

14 Reported by Alice Mayes's son Denis Richardson in a letter to the author, 23 September 1973.

15 Lilian Bomberg, interview with the author, May 1970.

16 Borough Librarian of Tower Hamlets to the Tate Gallery, 19 June 1969, *The Tate Gallery. Acquisitions 1968–69* (London 1969), p. 6.

17 Louis Behr to the author, 23 March 1981. Behr explained in the same letter that, 'being in age category classified in the early '70s, I have combined retentive impressions, in association with information from sources of more senior aged friends.'

18 Joseph Leftwich, interview with the author, 15 September 1980.

19 David Bomberg, Foreword to the catalogue of *Works by David Bomberg*, *op. cit.*

20 *Ibid.*

21 *Bathing Scene* was exhibited as *Study for the Mud Bath* in the Arts Council's *David Bomberg 1890–1957* exhibition, held at the Tate Gallery, March–April 1967 (no. 4).

22 Borough Librarian of Tower Hamlets to the Tate Gallery, *op. cit.*

23 The three studies were *Study for mud bath* (no. 11), *Mud bathers* (no. 15) and *Drawing for a painting* (no. 23), which Hulme's review of the show called 'the first drawing' for *The Mud Bath* (*The New Age* (9 July 1914)).

24 The study only came to light in Lilian Bomberg's collection in 1975, after the *Vorticism and Its Allies* exhibition and the completion of my book on *Vorticism*, *op. cit.*

25 John Bomberg, interview with the author, 6 February 1981.

26 This drawing was listed as *Acrobats* (no. 21) in the Arts Council's *David Bomberg* exhibition catalogue, *op. cit.* Subsequently, I assumed it was a study for *In the Hold* in my *Vorticism*, *op. cit.*, pp. 195–7.

27 *Jewish Chronicle* (8 May 1914).

28 *The New Age* (9 July 1914).

29 *Evening Standard* (1 July 1914).

30 *The New Age* (9 July 1914). *The Song of Songs* was listed as no. 33 in the Chenil exhibition catalogue, although Hulme mistakenly referred to it as no. 23.

31 T. E. Hulme, 'Modern Art and Its Philosophy', *Speculations*, *op. cit.*, p. 97.

32 *The New Age* (26 March 1914).

33 *The New Age* (11 February 1915).

34 Jacob Epstein, Foreword to Hulme's *Speculations*, *op. cit.*, pp. vii–viii.

35 Jacob Epstein, *Let There Be Sculpture* (London

1940), p. 70.

36 David Bomberg to William Roberts, unsent draft, *c.* 1957, collection of the artist's family.

37 Wyndham Lewis, *Blasting and Bombardiering* (London 1937), p. 39.

38 *The Sketch* (29 October 1913).

39 *Jewish Chronicle* (8 May 1914).

40 *The Nation* (18 January 1913).

41 Edward Wadsworth to *The Nation* (15 February 1913).

42 David Bomberg, Foreword to the Chenil catalogue, *op. cit.*

43 *Jewish Chronicle* (8 May 1914).

44 Alice Mayes, 'The Young Bomberg 1914–1925', unpublished memoir, *op. cit.*, pp. 2–3.

45 *Blast No. 2, op. cit.*, p. 77.

46 Quoted by John Woodeson in *Mark Gertler, op. cit.*, p. 125.

47 *Pall Mall Gazette* (25 June 1914).

48 Augustus John to John Quinn, 24 June 1914, quoted by Michael Holroyd, *op cit.*, p. 438.

49 Ben Nicholson to the author, 12 August 1972.

50 David Bomberg, unpublished writings, *c.* 1957, collection of the artist's family.

51 Sonia Cohen Joslen, interview with the author, December 1971.

52 David Bomberg, 'The Bomberg Papers', ed. D. Wright and P. Swift, *X, A Quarterly Review* (June 1960), p. 109.

53 *Reading from Torah* was listed as no. 5 in the Chenil Gallery catalogue, and the drawing to which Hulme referred was no. 23, *Drawing for a painting.*

54 *Zin* was listed in the Chenil catalogue as no. 20, and not, as Hulme maintained, no. 26.

55 *The New Age* (9 July 1914).

56 David Bomberg to Alun R. Jones, 23 December 1953, quoted by Jones in *The Life and Opinions of T. E. Hulme* (London 1960), p. 116.

57 David Bomberg, unpublished memoir, *c.* 1957, collection of the artist's family.

58 William Roberts, *Memories of the War to End War 1914–18* (London n.d., *c.* 1974), p. 1.

59 Jacob Epstein, *Let There Be Sculpture, op. cit.*, p. 118.

60 Augustus John to Evan Morgan, December 1914, quoted by Holroyd, *op. cit.*, p. 546.

61 Alice Mayes, 'The Young Bomberg', *op. cit.*, p. 1.

62 Jacob Epstein, *Let There Be Sculpture, op. cit.*, p. 119.

63 Augustus John to Evan Morgan, December 1914, *op. cit.*

64 William Roberts, *Abstract & Cubist Paintings & Drawings* (London n.d., *c.* 1957), p. 8.

65 Lilian Bomberg related Helen Rowe's memories to the author.

66 Sonia Cohen Joslen, interview with the author, December 1971.

67 Joseph Cohen, *Journey to the Trenches, op. cit.*, p. 91.

68 Joseph Cohen (*ibid.*, p. 114) states that *Poems by John Rodker* was published in April 1914. The British Library's copy is stamped with the acquisition date '14 October 1914'.

69 John Rodker, *Poems by John Rodker* (London 1914), p. 24.

70 John Rodker, *Collected Poems 1912–1925* (Paris 1930), where *Dancer*'s date of composition is stated to be 1915.

71 *The Little Review* (October 1918).

72 See the exhibition catalogue for *Frantisek Kupka 1871–1957. A Retrospective*, Guggenheim Museum, New York, 1975, p. 311.

73 Alice Mayes, 'The Young Bomberg', *op. cit.*, p. 10.

74 *The Archer* was published in St Petersburg and it probably obtained Lewis's *Portrait of an Englishwoman* from a reproduction in *Blast No. 1.*

75 Frank Rutter, *Some Contemporary Artists* (London 1922), p. 127.

76 *Blast No. 2, op. cit.*, p. 86.

77 *Ibid.*

78 Wyndham Lewis, *Blast No. 2, op. cit.*, p. 77.

79 Denis Richardson to the author, 10 March 1981.

80 John Mayes, interview with the author, 12 March 1981.

81 Denis Richardson to the author, 10 March 1981.

82 *Ibid.*

83 *Ibid.*

84 John Mayes, interview with the author, 12 March 1981.

85 Alice Mayes, 'The Young Bomberg', *op. cit.*, p. 2.

86 Denis Richardson to the author, 10 March 1981.

87 Alice Mayes, 'The Young Bomberg', *op. cit.*, p. 2.

88 Joseph Leftwich, interview with the author, 15 September 1980.

89 Kitty Newmark, interview with the author, 20 November 1980.

90 Alice Mayes, 'The Young Bomberg', *op. cit.*, p. 2.

91 Alice Mayes to Lilian Bomberg, 18 August 1958.

92 John Mayes, interview with the author, 12 March 1981.

# Chapter Five

1 Alice Mayes, 'The Young Bomberg', *op. cit.*, p. 3.

2 *Ibid.*, p. 4.

3 Alice Mayes to Lilian Bomberg, 18 August 1958.

4 Alice Mayes, 'The Young Bomberg', *op. cit.*, p. 10.

5 Lewis had two illustrations in the magazine as well as a large drawing on the cover, signed very prominently in capital letters. Several other contributors – Gaudier, Kramer, Nevinson and Shakespear – were only represented by one illustration each.

6 Alice Mayes to Lilian Bomberg, 18 August 1958.

7 Rebecca West, interview with the author, 8 February 1971.

8 *The Athenaeum* (19 June 1915).

9 Alice Mayes, 'The Young Bomberg', *op. cit.*, p. 5.

10 *Ibid.*

11 On the back of the drawing is a bill with the inscription '1915 Jan. 21. To removal of goods to Robert St.' written in ink.

12 Alice Mayes, 'The Young Bomberg', *op. cit.*, pp. 5–6. Elsewhere Alice adds that the ladies were 'Miss Philby and Miss Hayland'.

13 *Ibid.*, pp. 7, 8, 9.

14 *Ibid.*, p. 11.

15 *Ibid.*, p. 13. According to Alice, Bomberg insisted that she stay in London to protect the studio until he returned.

16 Alice's uncle worked for the firm, and she secured a job in the book-binding department at a pound a week.

17 Alice Mayes, 'The Young Bomberg', *op. cit.*, p. 14.

18 *Ibid.*, p. 15.

19 John Mayes, interview with the author, 12 March 1981.

20 Alice Mayes, 'The Young Bomberg', *op. cit.*, pp. 15–16.

21 *Ibid.*, p. 17.

22 *Ibid.*, p. 21. Alice adds that they were 'tales which I had to suffer from when he came home and he accused me of similar goings-on'.

23 This passage is inscribed on the back of an undated study in the collection of Anthony d'Offay.

24 *Winter Night* is dated September 1918, but it draws on passages written earlier in the war (ms in the collection of the artist's family).

25 On the back of the paper containing these sketches is a passage of writing, difficult to decipher, which concludes: 'Out of the depths of the rising mists other worlds'.

26 Isaac Rosenberg to Sydney Schiff, late 1917, quoted by Jean Liddiard, *op. cit.*, p. 239.

27 Jacob Epstein, *Let There Be Sculpture, op. cit.*, p. 76.

28 Lilian Bomberg told the author that Bomberg had never mentioned the self-inflicted wound incident to her.

29 Alice Mayes, 'The Young Bomberg', *op. cit.*, pp. 21–2.

30 Siegfried Sassoon, *The Complete Memoirs of George Sherston* (London 1940 edition), p. 421.

31 Alice Mayes, 'The Young Bomberg', *op. cit.*, p. 22.

32 David Bomberg, *Winter Night, op. cit.*

33 Lilian Bomberg, interview with the author, 4 November 1980.

34 Isaac Rosenberg to Edward Marsh, 26 January 1918, quoted by Joseph Cohen, *op. cit.*, p. 3.

35 'The Canadian War Memorials', unsigned Introduction to the catalogue of the *Canadian War Memorials Paintings Exhibition – 1920 – New Series. The Last Phase* (Toronto and Montreal 1920).

36 Harold Watkins to David Bomberg, 29 December 1917, collection of the artist's family.

37 David Bomberg, unpublished writings, 11 April 1957, collection of the artist's family.

38 This title, which differs from the shorter title used in recent years, is taken from the catalogue of the *Canadian War Memorials* exhibition, *op. cit.*, where Bomberg's painting is listed as no. 17.

39 Maria Tippett to the author, 27 February 1980.

40 Unsigned introduction to the *Canadian War Memorials* exhibition, *op. cit.*

41 Col. G. W. L. Nicholson, *Canadian Expeditionary Force, 1914–1919* (Ottawa 1962), p. 137.

42 David Bomberg, notes accompanying a sketch of a sapper, *c.* 1918, collection of the artist's family.

43 Col. G. W. L. Nicholson, *op. cit.*, pp. 137, 138, 139.

44 *The Canadian War Memorials Fund. Its History and Objects*, pamphlet reprinted from *Canada in Khaki* no. 2 (Public Archives, Ottawa).

45 Alice Mayes, 'The Young Bomberg', *op. cit.*, p. 25.

46 The Conservation Dept. of the Tate Gallery kindly responded to the author's enquiry by examining its version of *Sappers at Work*, and reported that 'there is no evidence of another general composition underlying the visible one' (Roy A. Perry to the author, 2 March 1981). Similarly, a National Gallery of Canada curator explained that 'there are no X-rays of our painting, but I have examined it together with a member of our conservation department, going over it with raking and infra-red lights, and we are unable to see any indication of another composition beneath the present one' (Catherine Johnston to the author, 6 February 1981).

47 According to Douglas Cooper and Gary Tinterow (*The Essential Cubism: Braque, Picasso & their friends, 1907–1920* (London 1983), p. 228), this drawing was 'made sometime during the large counter-offensive mounted by the French at Verdun against the German army' in autumn 1916.

48 Translated by Douglas Cooper, *Fernand Léger et le nouvel espace* (London and Paris 1949), pp. vii, 74–5.

49 Unsigned introduction to the *Canadian War Memorials, op. cit.*

50 Harold Watkins to David Bomberg, *op. cit.*

51 David Bomberg, unpublished memoir, *c.* 1957, collection of the artist's family.

52 Translated by Douglas Cooper, *op. cit.*

53 Barbara Wilson, the military specialist of the Public Archives in Ottawa, kindly provided the

author with details of Bomberg's employment by the Fund. The records of the Canadian Expeditionary Force 'contain little material relating to the operation of the Canadian War Memorials Fund', but a letter to the Adjutant-General at Argyll House does record that Sapper Bomberg's name was proposed on 19 November 1918: 'It would appear that the man during leave from France, began painting a picture for the War Records . . . The matter of an application to the War Office for the man's services for a period of six months, for work at the War Records, is referred for consideration, please.' On 22 November the Adjutant-General replied that 'it is approved that services of this soldier be applied for, for a period not exceeding six months.'

54 Alice Mayes to William Lipke, 27 June 1965.
55 David Bomberg, unpublished memoir, 11 April 1957, collection of the artist's family.
56 Alice Mayes, 'The Young Bomberg', op. cit., p. 25.
57 David Bomberg, unpublished memoir, 11 April 1957, collection of the artist's family.
58 The painting is now ascribed to the studio of El Greco, and is probably a workshop repetition of the original in the museum at Toledo, Ohio.
59 David Bomberg, 'Modern Art', transcript of a lecture dated 4 March 1922, possibly delivered at the Whitechapel Art Gallery as 'The Modern Feeling in Painting'.
60 The reproduction is inscribed: 'To Lilian with very best wishes for a happy healthy & prosperous year & many years & for this a happy birthday. From your loving husband & friend in all joys and what there is. Love & Kisses from David. 26 July 1953.'
61 The British Museum owns three of Michelangelo's studies for the Expulsion of the Money-Changers from the Temple, all of which were acquired in 1860.
62 Alice Mayes, 'The Young Bomberg', op. cit., pp. 27–8.
63 Wyndham Lewis to Herbert Read, 17 December 1918, Letters, op. cit., p. 102.
64 David Bomberg, unpublished memoir, 11 April 1957, collection of the artist's family.
65 The Observer (12 February 1928).
66 Alice Mayes, 'The Young Bomberg', op. cit., pp. 28–9.
67 The Canadian War Memorials Fund. Its History and Objects, op. cit.
68 In a letter to Bomberg, dated 25 March 1920, Harold Watkins wrote: 'Enclosed find cheque for £75 being final payment of the £300 due to you for the painting Sappers at Work.'
69 Alice Mayes, 'The Young Bomberg', op. cit., p. 19.
70 Lilian Bomberg, interview with the author, May 1970.
71 The Observer (12 February 1928).
72 The Collected Poems of Wilfred Owen, ed. with an introduction and notes by C. Day Lewis (London 1963), p. 35.
73 On 31 May 1919 S. P. Griffin, the Lieutenant Acting Officer in charge of Canadian War Records, wrote two letters asking for an extension of Bomberg's employment: 'The period of his loan to this office has now expired and it is understood from Sapper Bomberg that he will be unable to complete this picture in less than six weeks but he hopes that at the end of that time he will be quite finished.' Judging by a note scribbled on the bottom of this letter, the request was granted. (Owned by the Public Archives in Ottawa.)
74 Entry no. 17 in the catalogue of the Canadian War Memorials Paintings Exhibition, op. cit.
75 Lilian Bomberg, in an interview with the author on 4 November 1980, revealed that Bomberg had told her he was the figure on the far right of the foreground. The face certainly bears a strong resemblance to Bomberg's features.

76 The Observer (12 February 1928).
77 Alice Mayes, 'The Young Bomberg', op. cit., p. 29.
78 Ibid., p. 26.
79 The Russian Ballet was published by The Bomb Shop, Hendersons, 66 Charing Cross Road, London, in 1919.
80 Alice Mayes, 'The Young Bomberg', op. cit., p. 27.
81 Ibid., p. 26.
82 Alice Mayes to Lilian Bomberg, 27 September 1965, collection of the artist's family.
83 Alice Mayes, 'The Young Bomberg', op. cit., p. 30.
84 David Bomberg, undated memoir quoted by William Lipke, David Bomberg, op. cit., p. 48.
85 These are the titles of folios nos. 1–12 in a typed list called 'Works by David Bomberg. Drawings in Folios'. 106 drawings are listed here, but they do not include the entire series. As Alice recalled, some of the drawings were sold soon after Bomberg completed them.
86 Alice Mayes, 'The Young Bomberg', op. cit., p. 32.
87 Siegfried Sassoon, The Complete Memoirs of George Sherston, op. cit., p. 597.
88 Arts Gazette (13 September 1919).
89 Jewish World (15 October 1919).
90 Colour (October 1919).
91 Arts Gazette, op. cit.
92 David Bomberg, unpublished memoir quoted by Lipke, op. cit., p. 48.
93 David Bomberg to Siegfried Giedion, 27 July 1953, collection of the artist's family.

# Chapter Six

1 New Statesman (22 November 1919).
2 The Observer (2 November 1919).
3 Alice Mayes to Lilian Bomberg, quoted by William Lipke, op. cit., p. 47.
4 Alice Mayes, 'The Young Bomberg', op. cit., p. 31.
5 The Times (4 November 1919).
6 Wyndham Lewis, Foreword to the catalogue of the Group X exhibition, Heal's Mansard Gallery, London, March 1920.
7 Roberts's drawing, Dancers, was a study for one of his painted panels in the Restaurant de la Tour Eiffel, Percy Street (collection Glasgow City Art Gallery). Rodker's contribution was entitled 'Mr Segando in the Fifth Cataclysm'.
8 David Bomberg, unpublished memoir dated 11 April 1957, collection of the artist's family.
9 This painting may be identifiable as the Bending Woman which, according to The Athenaeum (6 August 1920) was exhibited in an Exhibition of Contemporary Art at the Hampstead Art Gallery, August–September 1920.
10 Alice Mayes, 'The Young Bomberg', op. cit., pp. 33, 35.
11 The only surviving copy of this advertisement is inscribed on the reverse: 'Sent From the Artist, David Bomberg, Kings Hill, Beech, Alton, Hants.'
12 Alice Mayes, 'The Young Bomberg', op. cit., p. 33. On p. 40 Alice records that Bomberg executed at least two studies of the Tower of London 'for Underground posterworks'. One of them is now owned by Manchester City Art Gallery.
13 The exhibition was held at the Bloomsbury Gallery in November 1932. Bomberg displayed the 'Imaginative Compositions' again at the Leger Gallery in 1943.
14 The most reliable guide to the multifarious themes of the 'Imaginative Compositions' is contained in the 1943 Leger Gallery catalogue, where they are listed thus: The Bargee's Family, 'Fiesta', Mother, Child and Figures, The Labourers, The Visitors, Mother and Daughter,

Fishing Folk, The Island; Land and Sea, The Tent and Figures, The Picadors, The Circus, Miners, Dredgers, Fishermen pulling in Nets, The Lightermen, 'The Players.' Stage Scene, Miners and seams of Rock, Miners, The Dance, The Quarrymen, 'The Players.' Circus, Open Air. Figures and structure, Interior. 'Friends Meeting', The Jolly Stevedores, Interior. Couch and Figures, Figures and Rocks, Watermen, Carnival, The Nomads, The Bargees, Vagrants, The Fishers, Family Foregathering, The Quarryman, The Tent. Father, Son and Family, Dredgers, Three Figures, Family Tent. The other three exhibits listed in the Leger catalogue were all called Flowers, and far higher prices were attached to them. They were almost certainly examples of his 1943 flower paintings, and nothing to do with the 'Imaginative Compositions'.
15 Lilian Bomberg, interview with the author, 28 January 1981.
16 Alice Mayes, 'The Young Bomberg', op. cit., pp. 41, 42.
17 Ben Nicholson to the author, 12 August 1972.
18 David Bomberg, unpublished writings, c. 1957, collection of the artist's family.
19 David Bomberg, lecture on 'Modern Art' dated 4 March 1922 and probably delivered at the Whitechapel Art Gallery.
20 Charles Harrison considered that Cortivallo, Lugano was painted in 1921 ('Notes on Ben Nicholson's Development and Commentary on Selected Works', in the catalogue of Ben Nicholson, an exhibition held at the Tate Gallery, June–July 1969, p. 10). But Jeremy Lewison believes that the painting was not completed before 1923 (in the catalogue of Ben Nicholson: the years of experiment 1919–39, an exhibition held at Kettle's Yard Gallery, Cambridge, July–August 1983, p. 55).
21 Alice Mayes to Lilian Bomberg, 9 December 1958, collection of the artist's family.
22 John Mayes, interview with the author, 12 March 1981.
23 David Bomberg, unpublished notes written after the Armistice, collection of the artist's family.
24 David Bomberg to Desmond Coke, 28 November 1922, collection of Lyndon Brook.
25 Paul Nash to 'Eddie' Marsh, 19 June 1922, courtesy of the Nash Trust.
26 Muirhead Bone to David Bomberg, 24 March 1922, collection of the artist's family.
27 Muirhead Bone to David Bomberg, 17 November 1922, collection of the artist's family.
28 Alice Mayes ('The Young Bomberg', p. 43) states that Bone 'had the idea' for the Palestine project.
29 In Orientations (London 1937, p. 495), Sir Ronald Storrs states that 'Bomberg, though entirely Jewish, was strongly anti-Zionist.' Storrs was, however, writing many years after the event, and before Bomberg's disappointing experience with the Keren Hayesod in Jerusalem he may have been less hostile to Zionism.
30 David Bomberg to Desmond Coke, 22 November 1922, collection of Lyndon Brook.
31 Muirhead Bone to David Bomberg, 18 January 1923, collection of the artist's family.
32 Muirhead Bone, 'Memorandum on the Suggested Employment of an Artist by the Zionist Organisation in Palestine', sent to the ZO with a letter dated 24 January 1923.
33 Leonard Stein to David Bomberg, 23 February 1923, collection of the artist's family.
34 Muirhead Bone to David Bomberg, 27 February 1923, collection of the artist's family.
35 Leonard Stein to David Bomberg, 28 March 1923, collection of the artist's family.
36 Muirhead Bone to Leonard Stein, 4 April 1923.
37 Daily News (7 March 1923). No catalogue was issued for the exhibition.

38 *The Times* (2 March 1923).

39 *Ibid.*

40 *Daily Graphic* (9 March 1923).

41 *Daily News* (7 March 1923).

42 Lilian Bomberg, interview with the author, 29 September 1980.

43 Alice Mayes, 'The Young Bomberg', *op. cit.*, pp. 43–4.

44 In 'The Young Bomberg', *op. cit.*, Alice Mayes mistakenly calls him 'Halliday'.

45 David Bomberg, unpublished notes for a talk on 'Palestine, as seen through the eyes of an artist', n.d., collection of the artist's family.

46 See Sir Ronald Storrs, *Orientations*, *op. cit.*, pp. 365–6, for an account of Ashbee's involvement with Jerusalem.

47 Peter Richmond, interview with the author, 6 August 1985.

48 Nora Richmond, interview with the author, 6 August 1985.

49 Alice Mayes, 'The Young Bomberg', *op. cit.*, p. 45.

50 David Bomberg, notes for a talk on Palestine, *op. cit.*

51 From an unpublished manuscript entitled 'Kitty's Requirements', n.d., which appears to be notes for a retrospective lecture or essay on Palestine by Bomberg (collection of the artist's family).

52 Storrs, *Orientations*, *op. cit.*, p. 514.

53 Leonard Stein to Colonel Kisch, 5 April 1923, Central Zionist Archives, Jerusalem.

54 Colonel Kisch to Leonard Stein, 11 May 1923, Central Zionist Archives, Jerusalem.

55 Frederick Kisch, Diary, 11 May 1923, p. 122. Central Zionist Archives, Jerusalem.

56 *Ibid.*, 12 May 1923, p. 123.

57 *Ibid.*

58 See Stephanie Rachum, 'David Bomberg: Views from the Jewish-Zionist Side', in the exhibition catalogue of *David Bomberg in Palestine 1923–1927*, held at the Israel Museum, Jerusalem, autumn 1983, p. 22.

59 Alice Mayes, 'The Young Bomberg', *op. cit.*, p. 45.

60 Frederick Kisch, Diary, 28 May 1923, p. 137. Central Zionist Archives, Jerusalem.

61 Alice Mayes, *ibid.*

62 David Bomberg, note on *Outside The Damascus Gate, Jerusalem* written for the *Manchester Guardian*, 16 March 1928, where Bomberg confirms that the picture was painted in 1923.

63 John Mayes, interview with the author, 12 March 1981.

64 Marsh warned Bomberg that he would not be able to deliver the letter to Storrs immediately after arriving in Jerusalem, for 'I am sorry to say I have just got a letter from Storrs in which he tells me that he is on the point of leaving Palestine for England – so I write to warn you that you won't find him there. This is a pity as I am sure he would have taken a personal interest in your plans.' But Storrs duly received the letter after his return, and Marsh's introduction proved immensely useful. (See 'An Honest Patron. A Tribute to Sir Edward Marsh', the catalogue of an exhibition held at the Bluecoat Gallery, Liverpool, 1976, pp. 18–20.)

65 Sir Ronald Storrs, *Orientations*, *op. cit.*, p. 363.

66 *Ibid.*, p. 364.

67 *Ibid.*, p. 369.

68 *Ibid.*, p. 366.

69 *Ibid.*, p. 495.

70 Austen St B. Harrison to Lilian Bomberg, 16 October 1960, collection of the artist's family.

71 Lawrence Gowing, Introduction to the exhibition catalogue *Painting from Nature* (Arts Council of Great Britain, 1981), p. 4.

72 On the back of the surviving photograph of *Mount of Olives* Bomberg wrote that its dimensions were 28 × 36 inches.

73 Austen St B. Harrison described *Siloam* as 'a study' for *Mount of Olives* (letter to Lilian Bomberg, 16 October 1960, collection of the artist's family).

74 Alice Mayes ('The Young Bomberg', *op. cit.*, p. 45) recorded that *Mount of Olives* 'was painted from our front garden'.

75 *Mount of Olives* was destroyed when Sir Ronald Storrs's residence in Cyprus was burned down in 1930.

76 P. G. Konody, *The Observer* (12 February 1928).

77 *Daily Mail* (14 February 1928).

78 See Allen Staley, *The Pre-Raphaelite Landscape* (Oxford 1973), pp. 100–3.

79 David Bomberg to S. C. Kaines Smith, 30 August 1928, collection of Birmingham City Art Gallery.

80 Aaron Scharf, *Art and Photography* (revised edition Harmondsworth 1974), pp. 103–4.

81 Sir Ronald Storrs, *Orientations*, *op. cit.*, pp. 495–6.

82 *Ibid.*, p. 495.

83 Alice Mayes, 'The Young Bomberg', *op. cit.*, pp. 46–7.

84 See Stephanie Rachum, 'David Bomberg: Views from the Jewish-Zionist Side', *op. cit.*, p. 25 (note 27).

85 Joseph Zaritsky, interview with Mordechai Omer and Stephanie Rachum, 15 April 1983, quoted by Rachum, *op. cit.*, pp. 23–4.

86 Alice Mayes, 'The Young Bomberg', *op. cit.*, p. 47.

87 *Ibid.*

88 In a memoir now entitled 'The Petra Essay' (n.d.), originally intended as a lecture, Bomberg admitted that 'I had heard nothing about Petra before'.

89 *Ibid.*

90 Alice Mayes, 'The Young Bomberg', *op. cit.*, p. 48.

91 Order from Amir Lewa, officer commanding the Arab Legion, 10 April 1924, collection of the artist's family.

92 David Bomberg, 'The Petra Essay', *op. cit.*

93 'Petra. Duologue between Mr David Bomberg and Mrs Steuart Erskine', unpublished script of proposed talk for BBC Radio, 1928, pp. 4–5 (collection of the artist's family).

94 Alice Mayes, 'The Young Bomberg', *op. cit.*, p. 51.

95 David Bomberg to S. C. Kaines Smith, 30 August 1928, collection of Birmingham City Art Gallery.

96 Sir Ronald Storrs to David Bomberg, 30 April 1924, collection of the artist's family.

97 J. Newmark, 'The Rose-red City of Petra', *The Studio* (August 1932), p. 104. Newmark told the author (interview, 20 November 1980) that this article was based on extensive conversations with Bomberg.

98 'Petra. Duologue', *op. cit.*, p. 5.

99 Sir Ronald Storrs to David Bomberg, 30 April 1924, collection of the artist's family.

100 Alice Bomberg, Diary of Petra expedition, 5, 6, 8, 9 May 1924, collection of the artist's family.

101 David Bomberg, 'The Petra Essay', *op. cit.*

102 Alice Mayes, 'The Young Bomberg', *op. cit.*, p. 51.

103 *Ibid.*, p. 52.

104 'Petra. Duologue', *op. cit.*, p. 8.

105 Alice Mayes, 'The Young Bomberg', *op. cit.*, p. 52.

106 'Petra. Duologue', *op. cit.*, p. 6.

107 Alice Mayes, 'The Young Bomberg', *op. cit.*, pp. 52–3.

108 'Petra. Duologue', *op. cit.*, p. 8.

109 See Alice Mayes, 'The Young Bomberg', *op. cit.*, pp. 51–2.

110 Sir Ronald Storrs, *Orientations*, *op. cit.*, p. 495.

111 Alice Mayes, 'The Young Bomberg', *op. cit.*, p. 55.

112 Sir Ronald Storrs, *Orientations*, *op. cit.*, p. 463.

113 *Ibid.*, p. 495.

114 *The Times* (14 February 1928).

115 Alice Mayes, 'The Young Bomberg', *op. cit.*, p. 56.

116 Alan Rowlands to Dinora Davies-Rees, 11 May 1983.

117 David Bomberg, notes for a talk on Palestine, *op. cit.*

118 Colonel Kisch to Leonard Stein, 20 May 1924, Central Zionist Archives, Jerusalem.

119 Sir Ronald Storrs, *Orientations*, *op. cit.*, p. 495.

120 Kitty Newmark to Stephanie Rachum, 25 January 1983.

121 Frederick Kisch to Leonard Stein, 30 May 1924, Central Zionist Archives, Jerusalem.

122 Alice Mayes, 'The Young Bomberg', *op. cit.*, pp. 46, 57.

123 Sir Ronald Storrs to David Bomberg, 26 August 1924, collection of the artist's family.

124 Alice Bomberg to David Bomberg, 7 September 1926, collection of the artist's family.

125 Alice Bomberg to David Bomberg, 27 October 1926, collection of the artist's family.

126 Alice Bomberg to David Bomberg, 3 November 1926, collection of the artist's family.

127 David Bomberg to Alice Bomberg, 21 October 1926, collection of the artist's family.

128 David Bomberg to Alice Bomberg, 12 November 1926, collection of the artist's family.

129 Muirhead Bone to Alice Bomberg, 11 December 1926, collection of the artist's family.

130 Alice Bomberg to David Bomberg, 15 December 1926, collection of the artist's family.

131 David Bomberg to Alice Bomberg, 15(?) December 1926, collection of the artist's family.

132 Alice Waley Cohen wrote to Alice Bomberg (13 December 1926), explaining that 'my husband regrets very much, however, that as the Jewish War Memorial Fd. is for religious education only it could not possibly be used for this' (collection of the artist's family).

133 Fortunately, the big war painting was not cut up and now belongs to the Tate Gallery. Other pictures may, however, have been sacrificed.

134 David Bomberg to Alice Bomberg, 16 December 1926, collection of the artist's family.

135 David Bomberg to Alice Bomberg, 23 December 1926, collection of the artist's family.

136 Alice Bomberg to David Bomberg, 28 December 1926, collection of the artist's family.

137 Alice Bomberg to David Bomberg, 8 February 1927, collection of the artist's family.

138 Alice Mayes, 'The Young Bomberg', *op. cit.*, p. 59.

139 Message from Assistant Superintendent of Police, 'Q' Division, Jerusalem, to 'All Inspectors of Police and other ranks', 17 July 1927, collection of the artist's family.

140 Alice Mayes, 'The Young Bomberg', *op. cit.*, p. 60.

141 David Bomberg to Alice Bomberg, 6 March 1927, collection of the artist's family.

142 Austen St B. Harrison to Lilian Bomberg, 16 October 1960, collection of the artist's family.

143 Sir Ronald Storrs, 'David Bomberg', preface to the exhibition catalogue of *Paintings of Palestine and Petra by David Bomberg*, the Leicester Galleries, London, February 1928, p. 6.

144 P. G. Konody, *The Observer* (12 February 1928).

145 R. R. Tatlock, *Daily Telegraph* (14 February 1928).

146 Frank Rutter, *Sunday Times* (19 February 1928).

147 *The Times* (14 February 1928).

148 *Jewish Chronicle* (16 March 1928).
149 Lilian Bomberg, interview with the author, 29 September 1980.
150 Lilian Bomberg, interview with the author, 10 October 1980.
151 Rupert Lee to David Bomberg, 5 March 1928, collection of the artist's family.
152 David Bomberg to Vincent Galloway, 6 December 1932, collection of the Ferens Art Gallery, Hull.
153 David Bomberg to Sir Ronald Storrs, 14 March 1928, collection of the artist's family.
154 Ernest Brown made this remark to Frank Auerbach, who recalled it in a conversation with the author, 18 October 1985.
155 David Bomberg to Sir Ronald Storrs, 14 March 1928, collection of the artist's family.
156 Lilian Bomberg, interview with the author, 29 September 1980.

## Chapter Seven

1 Lilian Bomberg, interview with the author, 10 October 1980.
2 Lilian Bomberg, interview with the author, 12 September 1980.
3 *Ibid.*
4 Lilian Bomberg, interview with the author, 29 September 1980.
5 Lilian Bomberg, interview with the author, 16 December 1980.
6 Lilian Bomberg, interview with the author, 10 October 1980.
7 Kitty Newmark to the author, 3 May 1986. In response to the author's query about the date of the shawl, which looks as if it was executed earlier, Mrs Newmark wrote: 'It was made at Fordwych Road (N.W.6) in my presence. The date, I think, was 1929, but it could conceivably have been done in the early part of the 'Thirties (I do not think later than 1935) ... I think I wore the scarf [*sic*] in a portrait David did of me. I saw it years ago, but cannot remember where. Or perhaps David scrubbed it out eventually. 1919 is not the date ... When David was at Fordwych Road he made several much smaller scarves for Lilian & myself – (perhaps floral in design). Anyway long since worn out!'
8 Kitty Newmark, interview with the author, 20 November 1980.
9 Lilian Bomberg, interview with the author, 10 October 1980.
10 Sir Ronald Storrs to David Bomberg, 23 October 1929, collection of the artist's family.
11 The exhibition was called *Spain, Drawings by Muirhead Bone*, and it was held at Colnaghi's between October and November 1930. A marked catalogue is preserved among Bomberg's papers.
12 Lilian Bomberg, interview with the author, 10 October 1980.
13 Kitty Newmark, interview with the author, 20 November 1980.
14 Peter Richmond, interview with the author, 6 August 1985.
15 Lilian Bomberg, interview with the author, 10 October 1980.
16 David Bomberg to Lilian Mendelson, 7 September 1929, collection of the artist's family.
17 Most of the surviving Toledo paintings bear the date '29, so they must have been executed between September and December of that year.
18 David Bomberg to Lilian Mendelson, 23 September 1929, collection of the artist's family.
19 Andrew Forge, Introduction to the exhibition catalogue of *David Bomberg 1890–1957*, held at the Arts Council Gallery, London, 1958.
20 Lilian Bomberg, interview with the author, 14 October 1980.
21 David Bomberg to Lilian Mendelson, 23 September 1929, collection of the artist's family.
22 Lilian Bomberg, interview with the author, 14 October 1980.
23 David Bomberg, unpublished writings, *c.* 1957, collection of the artist's family.
24 Josef Herman, 'The Years in Wales, 1944–1953/5 (II)', *The Scottish Art Review*, vol. XIII, no. 4 (1972), pp. 11–12.
25 Lilian Bomberg, interview with the author, 14 October 1980.
26 David Bomberg, unpublished writings, 11 April 1957.
27 David Bomberg to Lilian Mendelson, 23 September 1929.
28 *Ibid.*
29 Lilian Bomberg, interview with the author, 14 October 1980.
30 Lilian Mendelson to David Bomberg, 4 January 1930, collection of the artist's family.
31 Lilian Mendelson to David Bomberg, 15 January 1930, collection of the artist's family.
32 Lilian Mendelson to David Bomberg, 15 March 1930, collection of the artist's family.
33 Lilian Bomberg, interview with the author, 14 October 1980.
34 *Apollo* (July 1931).
35 Lilian Bomberg, interview with the author, 10 October 1980.
36 S. Brodsky to David Bomberg, 15 June 1931, collection of the artist's family.
37 David Bomberg to Campbell Dodgson, 12 July 1931, collection of the artist's family.
38 The Art Editor of *The Times* to David Bomberg, 15 July 1931, collection of the artist's family.
39 John Perry to David Bomberg, 8 April 1931, collection of the artist's family.
40 R. B. Cunninghame Graham to David Bomberg, 10 July 1931, collection of the artist's family.
41 Virginia Woolf to David Bomberg, 2 May 1931, collection of the artist's family.
42 'Desborough' to David Bomberg, 19 October 1931, collection of the artist's family.
43 Thomas Crenan (Dewar's secretary) to David Bomberg, 22 October 1931, collection of the artist's family.
44 John Bomberg, interview with the author, 6 February 1981.
45 Muirhead Bone to David Bomberg, 8 December 1931, collection of the artist's family.
46 John Mabbott to David Bomberg, 18 December 1931, collection of the artist's family.
47 Jack Beddington to David Bomberg, 23 July 1931, collection of the artist's family.
48 Lilian Bomberg, memoir of the Cavedale trip quoted by William Lipke, *op. cit.*, pp. 73–4.
49 In a letter to David Bomberg from Jack Beddington, 10 September 1931, a cheque for £35. 10s. 0d. was enclosed 'for the poster design of Cave Dale Castleton and expenses in connection therewith'.
50 Lilian Bomberg, interview with the author, 17 November 1980.
51 Lilian Bomberg, interview with the author, 20 October 1980.
52 Lilian Bomberg, interview with the author, 14 October 1980.
53 Lilian Bomberg, interview with the author, 20 October 1980.
54 Lilian Bomberg, memoir of the Scottish expedition, quoted by Lipke, *op. cit.*, p. 24.
55 *Daily Mail* (February 1932).
56 *Daily Express* (9 November 1932).
57 Muirhead Bone to David Bomberg, 26 October 1932, collection of the artist's family.
58 *Jewish Chronicle* (18 November 1932).
59 James Newmark, interview with the author, 20 November 1980.
60 Kitty Newmark, interview with the author, 20 November 1980.
61 The AIA was founded as 'The Artists International', and the other original members were Cliff Rowe, Misha Black, James Boswell, James Lucas and James Fitton.
62 Lilian Bomberg, interview with the author, 4 November 1980.
63 Lilian Bomberg, interview with the author, 29 September 1980.
64 James Newmark, interview with the author, 20 November 1980.
65 Lilian Bomberg, interview with the author, 29 September 1980.
66 The President of the SCR was Lascelles Abercrombie.
67 P. G. Konody to the Secretary of the SCR, 2 January 1933, collection of the artist's family.
68 Hilda Browning to Mr Amdur, 29 June 1933, collection of the artist's family.
69 Cliff Rowe, interview quoted by Lynda Morris and Robert Radford, *The Story of the AIA. Artists International Association 1933–1953* (Museum of Modern Art, Oxford 1983), p. 8.
70 Lilian Bomberg, interview with the author, 24 November 1980.
71 David Bomberg to Lilian Mendelson, 11 September 1933, collection of the artist's family.
72 Maxim Gorki, *To Foreign Workers* (Moscow 1931), p. 4.
73 Lilian Bomberg, interview with the author, 24 November 1980.
74 Kitty Newmark, interview with the author, 20 November 1980.
75 David Bomberg, from writings on 'Art and Society: 1934–1938', collection of the artist's family.
76 David Bomberg to Intourist, 4 December 1933.
77 Lilian Bomberg, interview with the author, 24 November 1980.
78 Josef Herman, *Related Twilights: Notes from an Artist's Diary* (London 1975), p. 82.

## Chapter Eight

1 Vint's Bomberg collection includes nineteen Palestine pictures, seven Toledo views, several portraits, three Cuenca landscapes, a major Ronda painting, a Scottish landscape and a number of important drawings.
2 Ronald Vint, interview with the author, 10 January 1984.
3 *Ibid.*
4 Bomberg and Kramer drew each other's portraits in 1914, and Bomberg's drawing of Kramer is in the collection of William Roberts's widow Sarah, Kramer's sister.
5 Dinora Davies-Rees, interview with the author, 10 January 1984.
6 Alfred Willey to David Bomberg, 26 December 1933, collection of the artist's family.
7 Lilian Bomberg, interview with the author, 24 November 1980.
8 *Ibid.*
9 Alfred Willey to David Bomberg, 30 June 1934.
10 Alfred Willey and Arthur Crossland to David Bomberg, 21 November 1934, collection of the artist's family.
11 Alfred Willey to David Bomberg, 19 December 1934, collection of the artist's family.
12 Lilian Bomberg, interview with the author, 8 December 1980.
13 David Bomberg, 'The Artist's Note Accompanying the Picture', dated 16 July 1936, sent with *Ronda* to the Canadian National Exhibition.
14 José Paez Carrascosa, *Ronda*, translated by Grace Rogers (Ronda, n.d.), p. 9.
15 *Ibid.*
16 Strang's *Plaza Mayor, Ronda* was one of 'Seven Spanish Etchings' published in portfolios by J. Maclehose and Sons, and T & R Annan, Glasgow, in 1913 (see entry no. 81 in the catalogue of the *William Strang RA 1859–1921* exhibition,

held at the Graves Art Gallery, Sheffield, December 1980–January 1981).

17 Lilian Bomberg, interview with the author, 8 December 1980.

18 *Ibid*. The smaller of the two *Ronda* canvases is almost identical to the version reproduced here.

19 David Bomberg, 'The Artist's Note Accompanying the Picture', *op. cit.*

20 David Bomberg, list of works drawn up *c.* 1953–4, collection of the artist's family.

21 Lilian Bomberg, interview with the author, 8 December 1980.

22 *Ibid*.

23 Alfred Willey to David Bomberg, 18 April 1935, collection of the artist's family.

24 Lilian Bomberg, interview with the author, 16 December 1980.

25 David Bomberg to John Rodker, 27 May 1935, collection of the artist's family.

26 Lilian Bomberg, interview with the author, 16 December 1980.

27 *Ibid*.

28 David Bomberg, unpublished memoir of his second Spanish period, *c.* 1936, collection of the artist's family.

29 *Ibid*.

30 Lilian Bomberg, interview with the author, 16 December 1980.

31 David Bomberg, unpublished memoir, *c.* 1936, *op. cit.*

32 A smaller painting of the same valley, concentrating on the floor and excluding the upper reaches, is in the collection of Lady Alexandra Dacre.

33 Lilian Bomberg, interview with the author, 16 December 1980.

34 *Ibid*.

35 Dinora Davies-Rees, interview with the author, 26 February 1986.

36 David Bomberg, unpublished memoir, *c.* 1936, *op. cit.*

37 Charles Holden to David Bomberg, 8 April 1936.

38 David Bomberg to the Manager, Publicity Department, LMS Railway Company Ltd., 10 August 1936.

39 David Bomberg to Sir Thomas Brocklebank, Cunard White Star Company, 13 August 1936.

40 *Jewish Chronicle* (26 June 1936).

41 *Manchester Guardian* (26 June 1936).

42 Archibald Ziegler, in a letter to the *Jewish Chronicle* (25 December 1936), complained that 'not one single painting was purchased' from Bomberg's Cooling exhibition. Lilian Bomberg confirmed this in an interview with the author, 22 January 1981.

43 Sir Ronald Storrs, who opened the Cooling exhibition, replied on 27 June 1936 to a letter from Bomberg: 'I am extremely sorry your exhibition is a "flop" and I only wish I had been able to help you more.'

44 Lilian Bomberg, interview with the author, 22 January 1981.

45 Kenneth Clark to David Bomberg, 28 April 1936, collection of the artist's family.

46 *Yorkshire Post* (4 July 1936).

47 Winifred Nicholson to David Bomberg, note written on an invitation to the private view of her Leicester Galleries exhibition, held on 24 June 1936 (collection of the artist's family).

48 An employee of the Passenger Department of Bibby Bros., who ran the Bibby Line, wrote to Bomberg on 25 July 1936 thanking him for his proposal regarding the Burma trip.

49 Lilian Bomberg, interview with the author, 22 January 1981.

50 *Birmingham Post* (9 January 1937).

51 Bomberg's re-election to the London Group was confirmed in a letter written to him on 4 December 1936.

52 Recorded in the 'Minutes of the Annual General Meeting of the London Group', 12 February 1937, p. 2.

53 *Evening Standard* (26 October 1937). The painting was entitled *Mountain Village: Picos de Europa, Asturias.*

54 Kenneth Clark to David Bomberg, 20 February 1937, collection of the artist's family.

55 According to a letter Bomberg wrote to R. C. Ironside, assistant to the Tate Gallery's Director (14 July 1937), the three Spanish landscapes were *Gathering Storm, Peñarrubia, Asturias, Sierra de Ronda, Andalucia*, and *Belfry and Convent, Ronda Spain, Evening.*

56 David Bomberg to Sir Evan Charteris (draft), 23 July 1937, collection of the artist's family.

57 David Fincham to David Bomberg, 29 July 1937, collection of the artist's family.

58 David Bomberg to Sir Evan Charteris, *op. cit.*

59 Lilian Bomberg, interview with the author, 22 January 1981.

60 Lilian Bomberg told the author (interview, 28 January 1981) that '*The Baby Diana* was painted when she was lying in her cot.'

61 E. R. Tongue to David Bomberg, 29 November 1937, collection of the artist's family. Mr Tongue, the secretary of the committee, offered a fee of £25 and noted that the opera was due to be performed the following May.

62 *Ibid*.

63 David Bomberg to Wyndham Vint, n.d., *c.* December 1937, collection of the artist's family.

64 Kenneth Clark to David Bomberg, 1 December 1937, collection of the artist's family.

65 John Rowlands to David Bomberg, 27 January 1938, collection of the artist's family.

66 E. M. Rich (LCC Education Officer) to David Bomberg, 29 March 1938, collection of the artist's family.

67 *Ibid*.

68 A. C. Short (Major, Geographical Section of the War Office) to David Bomberg, 3 May 1938, collection of the artist's family.

69 *Ibid*.

70 David Bomberg, proposal dated 9 November 1938, collection of the artist's family.

# Chapter Nine

1 David Bomberg to the Editor of *The Times* (not published), 20 October 1939, collection of the artist's family.

2 Meirion and Susie Harries, *The War Artists. British Official War Art of the Twentieth Century* (London 1983), p. 159.

3 David Bomberg to E. M. O'Rourke Dickey, 16 December 1939, Imperial War Museum Archives. Konody's letter was dated 26 November 1922.

4 David Bomberg to E. M. O'Rourke Dickey, 8 July 1940, Imperial War Museum Archives.

5 Kenneth Clark to David Bomberg, 1 December 1937, collection of the artist's family.

6 Meirion and Susie Harries, *The War Artists, op. cit.*, p. 160.

7 Kenneth Clark, 'War Artists at the National Gallery', *The Studio* (January 1942).

8 The Under-Secretary of State at the Home Office, in a letter dated 3 February 1941, turned down Bomberg's application for a camouflage establishment job.

9 John Summerson, then Deputy Director of the National Buildings Record, told Bomberg in a letter dated 18 February 1941 that 'the commissioning of paintings and drawings of architecture is outside our scope.'

10 David Bomberg to Kenneth Clark, 19 March 1941, Imperial War Museum Archives.

11 H. W. Lewis, Labour Superintendent of Smith's, turned down Bomberg's application in a reply dated 7 November 1941.

12 Recorded in the WAAC's minutes for 19 November 1941 (see Alan Ross, *Colours of War: War Art 1939–45* (London 1983), p. 32).

13 Lilian Bomberg, interview with the author, 22 January 1981.

14 David Bomberg to E. M. O'Rourke Dickey, 12 February 1942, Imperial War Museum Archives.

15 E. M. O'Rourke Dickey to Kenneth Clark, 14 February 1942, Imperial War Museum Archives.

16 E. M. O'Rourke Dickey to David Bomberg, 23 February 1942, Imperial War Museum Archives.

17 The Director General of the MoI to David Bomberg, 23 February 1942, collection of the artist's family.

18 See Meirion and Susie Harries, *The War Artists, op. cit.*, p. 290, note 49.

19 E. M. O'Rourke Dickey to David Bomberg, 23 February 1942, collection of the artist's family.

20 S. H. Robinson to David Bomberg, 31 March 1942, collection of the artist's family.

21 Lilian Bomberg, interview with the author, 22 January 1981.

22 Frank Auerbach conveyed this information to the author.

23 John Wilton-Ely, notes on the *Carceri* at p. 72 in the catalogue of *Piranesi*, an exhibition held by the Arts Council, London, 1978.

24 Quoted by Alan Ross, *Colours of War, op. cit.*, p. 46.

25 Bomberg recalled this incident in conversation several years later with Leslie Marr.

26 David Bomberg to E. M. O'Rourke Dickey, 28 April 1942, Imperial War Museum Archives.

27 In a letter to Dickey dated 5 June 1942, Bomberg described the 'Commissioned Painting' as a canvas measuring $32 \times 42$ inches. The picture which accords most closely with these dimensions measures $31\frac{3}{4} \times 42\frac{1}{2}$ inches, but it is painted on paper rather than canvas.

28 Memo from E. M. O'Rourke Dickey to the committee, 12 June 1942, Imperial War Museum Archives.

29 David Bomberg to E. M. O'Rourke Dickey, 5 June 1942, Imperial War Museum Archives.

30 E. M. O'Rourke Dickey to David Bomberg, 11 June 1942, collection of the artist's family.

31 This drawing is now lost and survives only as a photograph in the collection of the artist's family. It is probably identifiable as drawing no. 7 in the list Bomberg presented to Dickey in a letter on 5 June 1942, explaining that it depicted the 'sector known as Upstep Loop D.2' which contained 'stacked 500 pounds bombs' (Imperial War Museum Archives).

32 David Bomberg to E. M. O'Rourke Dickey, 5 June 1942, Imperial War Museum Archives.

33 The Secretary of the WAAC, A. Palmer, wrote to Bomberg on 7 September 1942 acknowledging his 'request for a further commission' and informing him that 'no recommendation was made'.

34 Muirhead Bone to David Bomberg, 17 September 1942, collection of the artist's family.

35 *War Pictures by British Artists No. 3: RAF*, with an introduction by H. E. Bates (Oxford 1942), p. 60.

36 David Bomberg to the Secretary of the WAAC, 11 March 1943, Imperial War Museum Archives.

37 Secretary of the WAAC to David Bomberg, 26 March 1943, collection of the artist's family.

38 Lilian Bomberg never mentioned the bomb-store explosion either to the author or to her family, and Dinora Davies-Rees thinks it most unlikely that Bomberg was aware of it.

39 James Major, 'Britain's Biggest Bang! RAF Fauld, Tutbury, Staffs', *Harper Adams Magazine* (n.d.), pp. 87, 89.

40 Even now, however, crucial questions remain unanswered and the possibility of sabotage has never been wholly ruled out.

41 James Major, *op. cit.*, p. 89.
42 Olive Bomberg, interview with the author, 6 February 1981.
43 Lilian Bomberg, interview with the author, 28 January 1981.
44 See Andrew Causey, 'Ivon Hitchens', in the catalogue of *Ivon Hitchens: A Retrospective Exhibition*, Royal Academy, London, March–April 1979, p. 17.
45 Josef Herman, *Related Twilights: Notes from an Artist's Diary* (London 1975), pp. 80, 82, 84.
46 *Apollo* (December 1943).
47 Lilian Bomberg, interview with the author, 28 January 1981.
48 David Bomberg to Nat Carne, 19 November 1943, collection of the artist's family.
49 *Ibid.*
50 Joseph Leftwich, interview with the author, 15 September 1980.
51 Lilian Bomberg, interview with the author, 29 September 1980.
52 Lilian Bomberg, interview with the author, 28 January 1981.
53 T. A. Fennemore to David Bomberg, 22 May 1944, collection of the artist's family.
54 David Bomberg to T. A. Fennemore, 23 May 1944, collection of the artist's family.
55 Lilian Bomberg, interview with the author, 11 February 1981.
56 David Piper, *Artists' London* (London 1982), p. 150.
57 Kenneth Clark to Duncan Grant, 7 July 1941, Imperial War Museum Archives.
58 David Bomberg to Lilian Bomberg, 13 October 1944, collection of the artist's family.
59 Lilian Bomberg, interview with the author, 11 February 1981.
60 See *The Tate Gallery Report 1974–76: Illustrated Catalogue of Acquisitions* (London 1978), pp. 60–61, where the compiler of the entry on *St Paul's and the River* examines the drawing's possible vantage-points in great detail and concludes that it was probably 'a composite study rather than an accurate record of a particular site'.
61 David Bomberg to the Ministry of Works, 8 October 1945, collection of the artist's family.
62 The meeting was held on 23 November 1945, and the two Kodak employees present were Mr Bennett-Smith and E. W. H. Selwyn.
63 E. W. H. Selwyn to David Bomberg, 4 December 1945, collection of the artist's family.

# Chapter Ten

1 Charles Reilly to 'Haynes', 2 December 1944, collection of the artist's family.
2 See note 37, Chapter Eight.
3 Myerscough-Walker's drawing was entitled *London University – Nocturne* (no. 1451) when exhibited at the Royal Academy in 1936.
4 Richard Michelmore to William Lipke, quoted in *David Bomberg*, *op. cit.*, pp. 88–9.
5 David Bomberg, unpublished writings, n.d., collection of the artist's family.
6 David Bomberg, 'Syllabus. Series of Lectures on Drawing & Painting', 22 May 1937, p. 4, collection of the artist's family.
7 *Ibid.*, p. 3.
8 Arthur Stambois to David Bomberg, 15 July 1945, collection of the artist's family.
9 Apart from Fry himself, the other artists involved in the dining-room project were Duncan Grant, Frederick Etchells, Bernard Adeney, MacDonald Gill and Albert Rothenstein. The remains of their decorations are now in the Tate Gallery collection.
10 R. Patrick to David Bomberg, 18 July 1945, collection of the artist's family.
11 R. Patrick to David Bomberg, 28 August 1945, collection of the artist's family.
12 Clerk to the School of Architecture, University College, London, to David Bomberg, 15 October 1945, collection of the artist's family.
13 David Bomberg to the Vice-Chancellor of Durham University, 26 November 1945, collection of the artist's family.
14 Cliff Holden, 'David Bomberg: an artist as teacher', *Studio International* (March 1967).
15 Quoted by Roy Oxlade, 'Bomberg and The Borough: An Approach to Drawing' (unpublished MA thesis for the Royal College of Art, London 1976), p. 185.
16 Lilian Bomberg, 'Biographical Notes' in the catalogue of *Lilian Holt Paintings & Drawings*, an exhibition held at the Ben Uri Gallery, London, May–June 1980.
17 See the author's Introduction to *Lilian Holt*, *ibid.*
18 Frank Auerbach, interview with Catherine Lampert in the catalogue of *Frank Auerbach*, an exhibition held at the Hayward Gallery, London, May–July 1978, p. 20.
19 Dennis Creffield to the author, 11 April 1985.
20 Cliff Holden, 'David Bomberg: an artist as teacher', *op. cit.*
21 *Ibid.*
22 David Bomberg, unpublished writings, n.d., collection of the artist's family.
23 David Bomberg, 'The Bomberg Papers', ed. David Wright and Patrick Swift, *X, A Quarterly Review*, volume 1, no. 3 (June 1960).
24 *Ibid.*
25 *Ibid.*
26 David Bomberg, unpublished writings, n.d., collection of the artist's family.
27 Roy Oxlade, 'Bomberg and The Borough', *op. cit.*, p. 25.
28 Cliff Holden, 'David Bomberg: an artist as teacher', *op. cit.*
29 David Bomberg, Preface to the catalogue of the *Third Annual Exhibition of the Borough Group*, held at the Archer Gallery, London, March 1949.
30 Dennis Creffield to the author, 11 April 1985.
31 See note 29.
32 David Bomberg, unpublished writings, n.d., collection of the artist's family.
33 *Ibid.*
34 Bomberg recalled discussing Berenson and the Florentine Renaissance at his interview with Fred Brown for a place at the Slade (see Chapter One, notes 62–4).
35 David Bomberg, Foreword to the catalogue of *Works by David Bomberg*, an exhibition held at the Chenil Gallery, London, July 1914.
36 David Bomberg, Foreword to the catalogue of *Exhibition of Drawings and Paintings by The Borough Bottega and L. Marr and D. Scott*, held at the Berkeley Galleries, London, November–December 1953.
37 *Ibid.*
38 David Bomberg, unpublished writings, n.d., collection of the artist's family.
39 David Bomberg, 'The Bomberg Papers', *op. cit.*
40 David Bomberg, unpublished writings, n.d., collection of the artist's family.
41 John Fothergill, 'The Principles of Teaching Drawing at the Slade School', in *The Slade* (London 1907).
42 David Bomberg, unpublished writings, n.d., collection of the artist's family.
43 David Bomberg, 'Syllabus', 22 May 1937, *op. cit.*
44 George Berkeley, *Essay Towards a New Theory of Vision* (Dublin 1709), CLIX.
45 David Bomberg, unpublished writings, n.d., collection of the artist's family.
46 *Ibid.*
47 See note 29.
48 David Bomberg, unpublished writings, n.d., collection of the artist's family.
49 Cliff Holden, 'David Bomberg: an artist as teacher', *op. cit.*
50 Lilian Bomberg, interview with the author, 11 February 1981.
51 *Ibid.*
52 *Ibid.*
53 Alfred Lord Tennyson, *Crossing the Bar*, *The Works of Alfred Lord Tennyson* (London 1902), p. 894.
54 *Exmoor, Devon* was listed as no. 55 in the catalogue of *David Bomberg: The Later Years*, an exhibition held at the Whitechapel Art Gallery, London, September–October 1979.
55 Bryan Robertson, 'David Bomberg', *The Studio* (January 1946).
56 Dorothy Mead, 'The Borough Group', unpublished memoir, n.d., sent to Lilian Bomberg, collection of the artist's family.
57 Cliff Holden, 'David Bomberg', *op. cit.*
58 Dorothy Mead, 'The Borough Group', *op. cit.*
59 *Ibid.* Mead maintained that 'Allan Stokes was included with one work in the first Archer show owing to a mistake of Dr Morris', the Director of the Archer Gallery.
60 'Approach to Painting', published in the catalogue of the *Exhibition of Painting by The Borough Group* held at the Archer Gallery, London, 2–28 June 1947.
61 *Ibid.*
62 *Ibid.*
63 Dennis Creffield to the author, 11 April 1985.
64 Lilian Bomberg, interview with the author, 11 February 1981.
65 *Ibid.*
66 *Ibid.*
67 *Ibid.*
68 William Lipke, *David Bomberg*, *op. cit.*, p. 92.
69 David Bomberg, 'Syllabus', 22 May 1937, *op. cit.*
70 Recorded by Ronald Alley, *Tate Gallery: the foreign paintings, drawings and sculpture* (London 1959), p. 113.
71 David Bomberg, draft of a press circular, n.d., collection of the artist's family.
72 David Bomberg, interviewed by Oswell Blakeston, *Art and Artists* (16 July 1948).
73 *Ibid.*
74 *Manchester Guardian* (9 June 1948). Holden listed the painting as *South West of Lambeth* (no. 10) in the exhibition catalogue.
75 *Kensington Post* (12 June 1948).
76 *Kensington News* (18 March 1949).
77 Dennis Creffield to the author, 11 April 1985.
78 *Kensington News* (18 March 1949).
79 *Ibid.*
80 David Bomberg to the editor of the *New Statesman*, 10 July 1948.
81 Lilian Bomberg, interview with the author, 18 February 1981.
82 Lilian Bomberg, interview with the author, 4 November 1980.
83 Lilian Bomberg, interview with the author, 18 February 1981.
84 *Ibid.*
85 *Ibid.*
86 Dennis Creffield to the author, 11 April 1985.
87 Peter Richmond, interview with the author, 6 August 1985.
88 Lilian Bomberg, interview with the author, 18 February 1981.
89 Dennis Creffield to the author, 11 April 1985.
90 See note 29.
91 *What's On* (11 March 1949).
92 *Art News and Review* (March 1949).
93 Wyndham Lewis, 'Round the London Galleries', *The Listener* (10 March 1949).
94 Cliff Holden, letter to the Editor, *Manchester Guardian* (12 May 1949).
95 David Bomberg and the other members of the Borough Group, letter to the Editor, *Kensington News* (6 May 1949).
96 Lilian Bomberg, interview with the author, 18 February 1981.
97 Dennis Creffield to the author, 11 April 1985.

98 Frank Auerbach, interview with the author, summer 1983.
99 *Ibid.*
100 Frank Auerbach, interview with Catherine Lampert, *op. cit.*
101 Frank Auerbach, interview with the author, summer 1983.
102 *Ibid.*
103 *Ibid.*
104 *Ibid.*
105 Frank Auerbach, interview with the author, broadcast on BBC Radio 3, 18 November 1985.
106 Leon Kossoff, interview with the author, 16 January 1981.

## Chapter Eleven

1 Recorded by Roy Oxlade, 'Bomberg and The Borough', *op. cit.*, p. 143.
2 Herbert Read, 'Bomberg', *Arts Gazette* (13 September 1919).
3 Peter Richmond, interview with the author, 6 August 1985.
4 *Yorkshire Observer* (9 January 1950).
5 *New Statesman* (24 November 1951).
6 Roy Oxlade, 'Bomberg and The Borough', *op. cit.*, pp. 159, 160.
7 *Ibid.*, p. 161.
8 *Ibid.*, p. 230.
9 *Ibid.*, p. 231.
10 *Ibid.*, p. 227.
11 *Ibid.*, pp. 227–8.
12 See Chapter Ten, especially note 14.
13 Roy Oxlade, 'Bomberg and The Borough', *op. cit.*, p. 236.
14 *Ibid.*, pp. 240–41.
15 *Ibid.*, p. 234.
16 Leon Kossoff, interview with the author, 16 January 1981.
17 Dennis Creffield to the author, 11 April 1985.
18 Roy Oxlade, 'Bomberg and The Borough', *op. cit.*, p. 233.
19 *Ibid.*, pp. 233–4.
20 Dennis Creffield to the author, 11 April 1985.
21 Roy Oxlade, *op. cit.*, p. 169.
22 *Ibid.*, p. 167.
23 *Ibid.*, pp. 173, 170.
24 Peter Richmond, interview with the author, 6 August 1985.
25 Lilian Bomberg, interview with the author, 18 February 1981.
26 Juliet Lamont, interview with the author, 18 February 1981.
27 Lilian Bomberg, interview with the author, 18 February 1981.
28 *Ibid.*
29 *Ibid.*
30 David Bomberg to Cliff Holden, 30 April 1953, collection of the artist's family.
31 Minutes, Meeting 1, Borough Bottega Group, June 1953 (written by Richard Michelmore).
32 *Ibid.*
33 Leslie Marr, quoted by William Lipke, *David Bomberg*, *op. cit.*, p. 99.
34 Minutes, Meeting 2, Borough Bottega Group, 1 July 1953.
35 Minutes, Meeting 3, Borough Bottega Group, 10 July 1953.
36 Minutes, Meeting 4, Borough Bottega Group, 17 July 1953.
37 David Bomberg, Foreword to the catalogue of *Drawings and Paintings by The Borough Bottega and L. Marr and D. Scott*, an exhibition held at the Berkeley Galleries, London, November–December 1953.
38 Minutes, Meeting 5, Borough Bottega Group, 21 July 1953.
39 Minutes, Meeting 9, Borough Bottega Group, 11 August 1953.

40 Minutes, Meeting 5, *op. cit.*
41 Minutes, Meeting 12, Borough Bottega Group, 20 August 1953.
42 Metzger's resignation is recorded in the Borough Bottega Group Minutes book in December 1953.
43 See note 37.
44 Hulme heard Worringer lecture on art at the Berlin Aesthetic Congress of 1911, and afterwards acknowledged that Hulme's central distinction between 'vital' and 'geometric' art was 'practically an abstract of Worringer's views' (T. E. Hulme, *Speculations*, *op. cit.*, p. 82).
45 *Plan for Freedom and Progress* (monthly journal of The Progressive League, January 1954).
46 Lewis Mumford to David Bomberg, 3 December 1953, collection of the artist's family.
47 *New Statesman*, 5 December 1953.
48 David Bomberg, 'Project for the Setting up of a School in Spain for the study of Mass in Architecture and its Rendering in the various Aspects of Drawing and Painting', 1952, collection of the artist's family.
49 David Bomberg to Siegfried Giedion, 27 July 1953, collection of the artist's family.
50 David Bomberg to Walter Gropius, 17 November 1953, collection of the artist's family.
51 Walter Gropius to David Bomberg, 4 December 1953, collection of the artist's family.
52 Villa Paz brochure, signed by 'David Bomberg and Members and Council of the Borough Bottega', Ronda, June 1954, collection of the artist's family.
53 *Ibid.*
54 See note 37.
55 Peter Richmond, interview with the author, 6 August 1985.
56 Lilian Bomberg, interview with the author, 13 March 1981.
57 Peter Richmond, interview with the author, 6 August 1985.
58 *Ibid.*
59 David Bomberg to Anthony Hatwell, 8 October 1954.
60 Lilian Bomberg, interview with the author, 13 March 1981.
61 See the entry for *Vigilante* in *The Tate Gallery Acquisitions 1968–69* (London 1969), p. 6.
62 Lilian Bomberg, interview with the author, 13 March 1981.
63 Note by 'Members of Borough Bottega' in the catalogue of *David Bomberg paintings and drawings 1915–1953. The Borough Bottega paintings and drawings by members*, an exhibition held at the Heffer Gallery, Cambridge, May–June 1954.
64 Roy Oxlade, 'Bomberg and The Borough', *op. cit.*, p. 260.
65 Lilian Bomberg, interview with the author, 13 March 1981.
66 *Ibid.*
67 Charles Spencer, 'Bomberg Comes Home', *Art Monthly* (November 1979).
68 Peter Richmond, 'David Bomberg', unpublished ms dated October 1979.
69 Lilian Bomberg to the Tate Gallery, 7 May 1969, quoted in *The Tate Gallery Acquisitions 1968–69*, *op. cit.*, p. 6.
70 Another version of the painting, entitled *The Vigilante*, is now owned by the Scottish National Gallery of Modern Art, Edinburgh. It is reproduced in colour in the catalogue of *David Bomberg 1890–1957. A Tribute to Lilian Bomberg*, an exhibition held at Fischer Fine Art, London, March–April 1985, p. 43.
71 In her letter to the Tate Gallery (see note 69), Lilian Bomberg confirmed that 'David was himself the model for both "Hear O Israel" (if you knew his hands, you would recognise them in his work) and "The Franciscan" '.

72 Lilian Bomberg, interview with the author, 18 February 1981.
73 John Bomberg, interview with the author, 6 February 1981.
74 *Ibid.*
75 *New Statesman* (March 1955).
76 *Ibid.*
77 David Sylvester, 'The Discovering of a Structure', essay in the catalogue of *David Bomberg 1890–1957*, an exhibition held at the Tate Gallery, London, March–April 1967, p. 10.
78 William Roberts to David Bomberg, September 1956, collection of the artist's family.
79 The pamphlets were *The Resurrection of Vorticism and the Apotheosis of Wyndham Lewis at the Tate* (London 1956), and *Cometism and Vorticism. A Tate Gallery Catalogue Revised* (London 1956).
80 Peter Richmond, interview with the author, 6 August 1985.
81 Sir John Rothenstein, *Time's Thievish Progress. Autobiography III* (London 1970), p. 41, where Rothenstein also explains that the idea of having a Vorticist section 'had not at all commended itself to Lewis himself'.
82 Sir John Rothenstein, *Modern English Painters*, volume two, *Nash to Bawden* (London 1984), pp. 92–3.
83 See note 82.
84 David Bomberg to Siegfried Giedion (draft), 27 July 1953, collection of the artist's family.
85 Peter Richmond, interview with the author, 6 August 1985.
86 Charles Spencer, 'Bomberg Comes Home', *op. cit.*
87 Lilian Bomberg, interview with the author, 13 March 1981.
88 Charles Spencer, 'Bomberg Comes Home', *op. cit.*
89 Lilian Bomberg's *The Tajo, Ronda* is now in the Tate Gallery's collection, catalogued under her maiden name, Holt.
90 See *The Tate Gallery 1980–82. Illustrated Catalogue of Acquisitions* (London 1984), p. 142.
91 Lilian Bomberg, interview with the author, 13 March 1981.
92 *Ibid.*
93 Peter Richmond, interview with the author, 6 August 1985.
94 *Henry Moore on Sculpture*, edited by Philip James (London 1966), p. 183.
95 Lilian Bomberg, interview with the author, 13 March 1981.
96 David Bomberg to Lilian Bomberg, 10 April 1957, collection of the artist's family.
97 Peter Richmond, interview with the author, 6 August 1985.
98 Lilian Bomberg to David Bomberg, 16 March 1957, collection of the artist's family.
99 See note 96.
100 Helen Lessore to David Bomberg, 23 March 1957, collection of the artist's family.
101 Peter Richmond, interview with the author, 6 August 1985.
102 Lilian Bomberg, 'Notes Relating to David's last letter to me from the civil hospital in Gibraltar, August 1957', collection of the artist's family.
103 David Bomberg to Lilian Bomberg, 2 August 1957, collection of the artist's family.
104 Lilian Bomberg, interview with the author, 13 March 1981.
105 *The Times* (20 August 1957).

## Afterword

1 The exhibition, selected by Joanna Drew and entitled *David Bomberg 1890–1957. An Exhibition of Paintings and Drawings*, was held at the Arts Council Gallery, London.

2 Andrew Forge, Introduction to the catalogue of *David Bomberg 1890–1957. An Exhibition of Paintings and Drawings*, ibid., p. 6.

3 The exhibition, organized by the Arts Council, was entitled *David Bomberg 1890–1957* and held at the Tate Gallery in March and April 1967. It subsequently toured to Hull, Manchester, Bristol and Nottingham.

4 David Sylvester, 'The Discovering of a Structure', introduction to the catalogue of *David Bomberg 1890–1957*, an exhibition held at Marlborough New London Gallery, March 1964, p. 2.

5 John Berger, 'Life of Bomberg', *Studio International* (July/August 1967).

6 The exhibition, entitled *David Bomberg. The Later Years*, was held at the Whitechapel Art Gallery, September–October 1979.

7 The Hayward Annual, entitled *Falls The Shadow, Recent British and European Art*, was held at the Hayward Gallery, London, April–June 1986. Selected by Barry Barker and Jon Thompson, it contained three Bomberg paintings: *Soliloquy, Noonday Sun, Ronda* (1954), *Portrait of the Artist* (1932) and *'Hear O Israel'* (1955). The last two were not listed in the catalogue, which only contained references to the works illustrated in it.

8 The exhibition, held at the Israel Museum, Jerusalem, in the autumn of 1983, was entitled *David Bomberg in Palestine 1923–27*.

# Bibliography

Magazines, catalogues and pamphlets are included in this bibliography, and previously unpublished material is grouped in a separate section at the end. Newspaper articles are not listed.

Alley, Ronald. *Tate Gallery: the foreign paintings, drawings and sculpture* (London 1959).
—— Introduction and notes to the catalogue of *William Roberts ARA, Retrospective Exhibition*, held at the Tate Gallery, London, November–December 1965.
—— 'David Bomberg's "In the Hold", 1913–14', *Burlington Magazine*, vol. cx (1968).
Auerbach, Frank. Interview with Catherine Lampert in the catalogue of *Frank Auerbach*, an exhibition held at the Hayward Gallery, London, May–July 1978.
Baron, Wendy. *Sickert* (London 1973).
—— Introduction to the catalogue of the *Sickert* exhibition held by the Arts Council at various regional British galleries, 1977–8.
—— *The Camden Town Group* (London 1979).
Bates, H. E. Introduction to *War Pictures by British Artists No. 3: RAF* (Oxford 1942).
Bell, Clive. 'The English Group', introduction to the catalogue of the *Second Post-Impressionist Exhibition*, held at the Grafton Galleries, London, October 1912–January 1913.
—— *Art* (London 1914).
—— 'Contemporary Art in England', *Burlington Magazine* (July 1917).
—— 'Wilcoxism', *The Athenaeum* (5 March 1920), reprinted in *Since Cézanne* (London 1922).
Bell, Keith. Catalogue for *Stanley Spencer RA*, an exhibition held at the Royal Academy, London, September–December 1980.
Berger, John. 'David Bomberg', in *Permanent Red. Essays in Seeing* (London 1960).
—— 'Life of Bomberg', *Studio International* (July/August 1967).
Berkeley, George. *Essay Towards a New Theory of Vision* (Dublin 1709).
Bomberg, David. Interview with the *Jewish Chronicle* (8 May 1914).
—— Foreword to the catalogue of *Works by David Bomberg*, an exhibition held at the Chenil Gallery, London, July 1914.
—— *Russian Ballet*. Text and six colour lithographs (London, The Bomb Shop, 1919).
—— 'Approach to Painting', introduction to the catalogue of *First Borough Group Exhibition*, held at The Archer Gallery, London, June 1947.
—— Letter to the Editor, *New Statesman* (10 July 1948).
—— Interview with Oswell Blakeston, *Art and Artists* (16 July 1948).
—— Preface to the catalogue of the *Third Annual Exhibition of the Borough Group*, held at The Archer Gallery, March 1949.
—— Foreword to the catalogue of *Exhibition of Drawings and Paintings by the Borough Bottega and L. Marr and D. Scott*, held at the Berkeley Galleries, London, November–December 1953.
—— 'The Bomberg Papers', ed. D. Wright and P. Swift, *X, A Quarterly Review* (June 1960).
Bomberg, David 'and Members and Council of the Borough Bottega'. *Villa Paz Brochure* (Ronda 1954).
Booth, Charles. *Life and Labour of the People of London* (London 1896).

*Borough of Birmingham Report of the Artizans' Dwellings Committee 1884* (Birmingham 1884).
Bottomley, Gordon and Denys Harding (eds). *The Collected Works of Isaac Rosenberg*, Foreword by Siegfried Sassoon (London 1937).
—— *The Collected Poems of Isaac Rosenberg*, Foreword by Siegfried Sassoon (London 1949).
Bowness, Alan. Introduction to the catalogue of *Post-Impressionism*, an exhibition held at the Royal Academy, London, November 1979–March 1980.
Brown, David. Introduction to the catalogue of *We Are Making a New World. Artists in the 1914–18 War*, an exhibition held at the Scottish National Gallery of Modern Art, Edinburgh, October–November 1974.
Brown, Fred. 'Wander Years', *Artwork* (autumn 1930).
Brown, Oliver. *Exhibition. The Memoirs of Oliver Brown* (London 1968).
Browse, Lillian. *Sickert* (London 1960).
Buckle, Richard. *Jacob Epstein, Sculptor* (London 1963).
Bullock, Michael. 'The Borough Bottega', *Plan* (January 1954).
*Canadian War Memorials Paintings Exhibition – 1920 – New Series. The Last Phase*. Catalogue (Toronto and Montreal 1920).
*The Canadian War Memorials Fund. Its History and Objects*. Pamphlet reprinted from *Canada in Khaki no. 2* (Public Archives, Ottawa).
Carrascosa, Jose Paez. *Ronda*. Translated by Grace Rogers (Ronda n.d.).
Carrington, Noel (ed.). *Mark Gertler. Selected Letters* (London 1965).
Causey, Andrew. 'The Two Worlds of David Bomberg', *Illustrated London News* (18 March 1967).
—— 'Ivon Hitchens', essay in the catalogue of *Ivon Hitchens: A Retrospective Exhibition*, held at the Royal Academy, London, March–April 1979.
—— *Paul Nash* (Oxford, 1980).
—— 'Stanley Spencer and the art of his time', essay in the catalogue of *Stanley Spencer RA*, an exhibition held at the Royal Academy, London, September–December 1980.
—— 'Harold Gilman: An Englishman and Post-Impressionism', essay in the catalogue of *Harold Gilman 1876–1919*, an exhibition held at the Royal Academy, London, 1981.
Chamot, Mary, Dennis Farr and Martin Butlin. *The Tate Gallery. The Modern British Paintings, Drawings and Sculpture*, volume I: A–L (London 1964).
Charlton, George. 'The Slade', *The Studio* (October 1946).
Clark, Kenneth. 'War Artists at the National Gallery', *The Studio* (January 1942).
—— Foreword to the catalogue of *The War Artists*, an exhibition held at the New Metropole Art Centre, Folkestone, 1964.
—— *The Other Half. A Self-Portrait* (London 1977).
Cohen, Joseph. *Journey to the Trenches. The Life of Isaac Rosenberg 1890–1918* (London 1975).

Cole, Roger. *Burning to Speak. The Life and Art of Henri Gaudier-Brzeska* (London 1978).

Collins, Judith. *The Omega Workshops* (London 1983).

Comay, Joan. *The World's Greatest Story. The Epic of the Jewish People in Biblical Times* (London 1978).

Compton, Michael (ed.). *Towards a New Art: Essays on the Background to Abstract Art 1910–20* (London 1980). With contributions from Lucy Adelman, Stephen Bann, Jane Beckett, Michael Compton, Susan Compton, John Gage, Christopher Green, Charles Harrison, Norbert Lynton, Sara Selwood and Peter Vergo.

Compton, Susan. *Chagall* (London 1985).

Compton, Susan (ed.). *British Art in the Twentieth Century. The Modern Movement and After*, catalogue of an exhibition held at the Royal Academy, London, January–April 1987. With essays by Dawn Ades, Andrew Causey, Richard Cork, Frederick Gore, Charles Harrison, Robert Rosenblum and Caroline Tisdall.

Conway, Martin. *A Concise Catalogue of Paintings, Drawings and Sculpture of the First World War, 1914–1918* (London 1963).

Cooper, Diana. *The Rainbow Comes and Goes* (London 1958).

Cooper, Douglas (trans.). *Fernand Léger et le nouvel espace* (London and Paris 1949).

—— *The Courtauld Collection: A Catalogue and Introduction* (London 1954).

—— *The Cubist Epoch* (London 1971).

Cooper, Douglas and Gary Tinterow. *The Essential Cubism: Braque, Picasso & their friends 1907–1920*, catalogue of an exhibition held at the Tate Gallery, London, April–July 1983.

Coote, Sir Colin. Introduction to the catalogue of *British artists of the second world war*, an exhibition held at the Arts Council Gallery, Cambridge and other galleries between February and November 1965.

Cork, Richard. Introduction to the catalogue of *Paintings and Drawings by David Bomberg (1890–1957) and Lilian Holt*, an exhibition held at Reading Museum and Art Gallery, June–July 1971.

—— Introduction to the catalogue of *Lilian Holt Paintings & Drawings*, an exhibition held at the Woodstock Gallery, London, June–July 1971.

—— Introduction to the catalogue of *Jacob Epstein. The Rock Drill Period*, an exhibition held at the Anthony d'Offay Gallery, London, October–November 1973.

—— Introduction and notes for the catalogue of *Vorticism and its Allies*, an exhibition held at the Hayward Gallery, London, March–June 1974.

—— *Vorticism and Abstract Art in the First Machine Age*, volume 1, *Origins and Development* (London 1975).

—— *Vorticism and Abstract Art in the First Machine Age*, volume 2, *Synthesis and Decline* (London 1976).

—— 'Vorticism: An Introduction', essay in the catalogue of *Vorticism and Abstract Art in the First Machine Age*, an exhibition held at Davis & Long Company, New York, April 1977.

—— Introduction to the catalogue of *Lilian Holt Paintings and Drawings*, an exhibition held at the Ben Uri Gallery, London, May–June 1980.

—— Introduction to the catalogue of *David Bomberg 1890–1957*, an exhibition held at the Gillian Jason Gallery, London, March–April 1983.

—— 'Bomberg in Palestine: The Years of Transition', essay in the catalogue of *David Bomberg in Palestine 1923–27*, an exhibition held at the Israel Museum, Jerusalem, autumn 1983.

—— 'A Tribute to Lilian Bomberg', in the catalogue of *David Bomberg: A Tribute to Lilian Bomberg*, an exhibition held at Fischer Fine Art Ltd., London, March–April 1985. With other tributes by Joanna Drew, Cavan O'Brien, Nicholas Serota and David Sylvester.

—— *Art Beyond the Gallery in Early 20th Century England* (New Haven and London 1985).

—— Entry on David Bomberg in the catalogue of *Futurismo & Futurismi*, an exhibition held at the Palazzo Grassi, Venice, April–October 1986.

—— 'Bomberg and the Bomb Store', *The Burlington Magazine* (July 1986).

—— Introduction to the catalogue of *David Bomberg 1890–1957*, an exhibition held at Rex Irwin, Sydney, Australia, June–July 1986.

—— 'Machine Age, Apocalypse and Pastoral', 'Vorticism, Bomberg

and the First World War' and 'Late Bomberg', essays in the catalogue of *British Art in the Twentieth Century*, an exhibition held at the Royal Academy, London, January–April 1987.

Cournos, John. 'The Death of Vorticism', *Little Review* (June 1919).

Deghy, Guy and Keith Waterhouse. *Café Royal. Ninety Years of Bohemia* (London 1955).

Denvir, Bernard. Introduction to the catalogue of the *Jacob Kramer* exhibition, held at the Parkin Gallery, London, March–April 1973.

d'Offay, Anthony. Introduction to the catalogue of *Abstract Art in England 1913–1915*, an exhibition held at the d'Offay Couper Gallery, London, November–December 1969.

—— Introduction to the catalogue of the *Alfred Wolmark Exhibition*, held at the Fine Art Society, London, October–November 1970.

—— 'David and Lilian Bomberg', introduction to the catalogue of *David Bomberg 1890–1957. Works from the collection of Lilian Bomberg*, an exhibition held at the Anthony d'Offay Gallery, London, February–April 1981.

Drew, Joanna. Catalogue of *David Bomberg 1890–1957*, an exhibition held at the Tate Gallery, London, March–April 1967.

Dunlop, Ian. *The Shock of the New* (London 1972).

Earp, T. W. Introduction to the catalogue of *Edward Wadsworth 1889–1949. A Memorial Exhibition*, held at the Tate Gallery, London, February–March 1951.

Emmons, Robert. *The Life and Opinions of Walter Richard Sickert* (London 1941).

Epstein, Jacob. *Let There Be Sculpture* (London 1940).

Farr, Dennis. *English Art 1870–1940* (Oxford 1979).

Farrington, Jane. *Wyndham Lewis* (London 1980). With contributions from Sir John Rothenstein, Richard Cork and Omar Pound.

Forge, Andrew. Introduction to the catalogue of *David Bomberg 1890–1957, An Exhibition of Paintings and Drawings*, held at the Arts Council Gallery, London, autumn 1958.

—— *The Slade, 1871–1960* (London n.d.).

—— 'Bomberg's "The Mud Bath"', *The Listener* (11 November 1965). Partially reprinted in the catalogue of *David Bomberg 1890–1957*, an exhibition held at the Tate Gallery, London, March–April 1967.

Fothergill, John. *The Slade. A Collection of Drawings and Some Pictures Done by Past and Present Students of the London Slade School of Art, 1893–1907* (London 1907).

—— 'Drawing', *Encyclopaedia Britannica*, volume VIII (London 1910–11).

Francia, Peter de. *Fernand Léger* (New Haven and London 1983).

Freeman, Julian. *Jewish Artists in an English Context, 1900–1920*, pamphlet accompanying an exhibition held at Brighton Polytechnic Gallery, April 1986.

Fry, Roger. 'The Grafton Gallery, I', *The Nation* (19 November 1910).

—— 'The Post-Impressionists', *The Nation* (3 December 1910).

—— 'A Postscript on Post-Impressionism', *The Nation* (24 December 1910).

—— 'Post-Impressionism', *The Fortnightly Review* (1 May 1911).

—— 'The Allied Artists at the Albert Hall', *The Nation* (20 July 1912).

—— Introduction to the catalogue of the *Second Post-Impressionist Exhibition. British, French and Russian Artists*, held at the Grafton Galleries, London, October 1912–January 1913.

—— 'Two Views of the London Group', *The Nation* (14 March 1914).

—— *Vision and Design* (London 1920).

Fuller, Peter. 'David Bomberg', in *Beyond the Crisis in Art* (London 1980).

*Exhibition of Works by the Italian Futurist Painters*. Catalogue of the exhibition held at the Sackville Gallery, London, March 1912.

*Exhibition of Works by the Italian Futurist Painters and Sculptors*. Catalogue of an exhibition held at the Doré Galleries, London, April 1914.

Gartner, Lloyd P. *The Jewish Immigrant in England 1870–1914* (London 1960).

Gaudier-Brzeska, Henri. 'Vortex. Gaudier-Brzeska', *Blast No. 1* (20 June 1914).

—— 'Vortex Gaudier-Brzeska (Written from the Trenches)', *Blast No. 2* (July 1915).

Gibson, Robin. Introduction to the catalogue of *William Roberts 1895–1980. An Artist and His Family*, an exhibition held at the National Portrait Gallery, London, July–October 1984.

Glazebrook, Mark. Introduction and notes to the catalogue of *Edward*

*Wadsworth 1889–1949. Paintings, Drawings and Prints*, an exhibition held at Colnaghi's, London, July–August 1974.

Golding, John. *Cubism. A History and an Analysis 1907–1914* (London and New York 1959).

Gore, Frederick. 'Spencer Gore: a Memoir by his Son', introduction to the catalogue of *Spencer Frederick Gore 1878–1914*, an exhibition held at the Anthony d'Offay Gallery, London, March–May 1974.

Gorki, Maxim. *To Foreign Workers* (Moscow 1931).

Gowing, Lawrence. Introduction to the catalogue of *Painting from Nature*, an exhibition held at the Fitzwilliam Museum, Cambridge, and the Royal Academy, London, 1980–81.

Green, Christopher. *Léger and the Avant-Garde* (New Haven and London 1976).

Grose, Irving. Introduction to the catalogue of *Jewish Artists of Great Britain 1845–1945*, an exhibition held at the Belgrave Gallery, London, March–April 1978.

Gross, John. 'The Bomberg Approach', *Sunday Times Colour Magazine* (22 March 1964).

Hamilton, George Heard. *Painting and Sculpture in Europe, 1880–1940* (London 1967).

Handley-Read, Charles. *The Art of Wyndham Lewis* (London 1951).

Harries, Meirion and Susie. *The War Artists. British Official War Art of the Twentieth Century* (London 1983).

Harrison, Charles. Catalogue of *Ben Nicholson*, an exhibition held at the Tate Gallery, London, June–July 1969.

—— *English Art and Modernism 1900–1939* (London 1981).

Hassall, Christopher. *Edward Marsh. Patron of the Arts. A Biography* (London 1959).

Herman, Josef. 'The Years in Wales, 1944–1953/5 (II)', *The Scottish Art Review*, vol. XIII, no. 4 (1972).

—— *Related Twilights: Notes from an Artist's Diary* (London 1975).

Holden, Cliff. 'David Bomberg: an artist as teacher', *Studio International* (March 1967).

Holroyd, Michael. *Augustus John. A Biography* (revised one-volume Penguin edn, Harmondsworth, 1976).

Holt, Lilian. Interview with Sue Arrowsmith, *Art Monthly* (March 1981).

Hone, Joseph. *The Life of Henry Tonks* (London 1939).

Hulme, T. E. 'The New Philosophy', *The New Age* (1 July 1909).

—— 'Mr Epstein and the Critics', *The New Age* (25 December 1913).

—— 'Modern Art. I. – The Grafton Group (at the Alpine Club)', *The New Age* (15 January 1914).

—— 'Modern Art. II. – A Preface Note and Neo-Realism', *The New Age* (12 February 1914).

—— 'Modern Art. III. – The London Group', *The New Age* (26 March 1914).

—— 'Contemporary Drawings', *The New Age* (2 April 1914).

—— 'Contemporary Drawings', *The New Age* (16 April 1914).

—— 'Contemporary Drawings', *The New Age* (30 April 1914).

—— 'Modern Art. IV. – Mr David Bomberg's Show', *The New Age* (9 July 1914).

—— Diary from the Trenches, 30 December 1914–19 April 1915. Published in *Further Speculations*.

—— *Speculations. Essays on Humanism and the Philosophy of Art*, edited by Herbert Read, with a Frontispiece and Foreword by Jacob Epstein (includes 'Modern Art and its Philosophy') (London 1924, new edition 1960).

—— *Further Speculations*, edited by Sam Hynes (Minneapolis 1955).

Hulten, Pontus. 'Futurism and Futurisms', essay in the catalogue of *Futurismo & Futurismi*, an exhibition held at the Palazzo Grassi, Venice, April–October 1986.

Humphreys, Richard. Introduction to *Pound's Artists. Ezra Pound and the Visual Arts in London, Paris and Italy* (London 1985). With other essays by Richard Humphreys, John Alexander and Peter Robinson.

James, Philip. Introduction to the catalogue of *Epstein*, an exhibition held at the Tate Gallery, London, September–November 1952.

John, Augustus. *Chiaroscuro. Fragments of an Autobiography: First Series* (London 1954).

—— *Finishing Touches*, edited and introduced by Daniel George (London 1964).

Jones, Alun R. *The Life and Opinions of T. E. Hulme* (London 1960).

Jonker, Gert. 'Robert van't Hoff revisited', *BOUW* (21 February 1981).

Kaines Smith, S. C. Foreword to the catalogue of *An Exhibition of Paintings and Drawings of Palestine and Petra by David Bomberg*, held at the Ruskin Gallery, Birmingham, February 1929.

Kampf, Avram. Essay in the catalogue of *Jewish Experience in the Art of the Twentieth Century*, an exhibition held at the Jewish Museum, New York, October 1975–January 1976.

Kandinsky, Wassily. *The Art of Spiritual Harmony*, first English translation by M. T. H. Sadleir (London 1914).

Konody, P. G. *Art and War: Canadian War Memorials* (London n.d.).

*Landscape in Britain 1850–1950*. Catalogue of an exhibition held at the Hayward Gallery, London, February–April 1983, with essays by Donald Davie, Ian Jeffrey and Frances Spalding.

Laughton, Bruce. Introduction to the catalogue of *The Slade, 1871–1971*, an exhibition held at the Royal Academy, London, November–December 1971.

Lechmere, Kate. 'Recollections of Vorticism', interview with Della Denman, *Apollo* (January 1971).

Lemaire, Gérard-Georges (ed.). *Wyndham Lewis Et Le Vorticisme* (Paris 1982). With contributions from Richard Cork, T. S. Eliot, Hugh Kenner, Gérard-Georges Lemaire, Wyndham Lewis, Marshall McLuhan, Ezra Pound, Edouard Roditi and Rebecca West.

Levin, Salmond S. (ed.). *A Century of Anglo-Jewish Life 1870–1970* (London 1970).

Levy, A. B. *East End Story* (London n.d., *c.* 1951).

Lewis, Wyndham. 'Room III (The Cubist Room)', preface to the catalogue of the *Exhibition by the Camden Town Group and Others*, Brighton Public Art Galleries, December 1913–January 1914.

—— 'The Improvement of Life', 'Long Live the Vortex!', 'Manifesto', 'Enemy of the Stars', 'Vortices and Notes', 'Frederick Spencer Gore', *Blast No. 1* (London 1914).

—— 'Kill John Bull with Art', *The Outlook* (18 July 1914).

—— Note in the catalogue of *The First Exhibition of the Vorticist Group, opening 10th June 1915 at the Doré Galleries, London*.

—— 'Editorial', 'War Notes', 'Artists and the War', 'The Exploitation of Blood', 'The Six Hundred, Verestchagin and Uccello', 'Marinetti's Occupation', 'A Review of Contemporary Art', 'The Art of the Great Race', 'Five Art Notes', 'Vortex "Be Thyself"', 'The Crowd-Master', *Blast No. 2* (London 1915).

—— *Tarr* (London 1918).

—— *Blasting and Bombardiering* (London 1937).

—— *Wyndham Lewis the Artist, from 'Blast' to Burlington House* (London 1939).

—— 'Round the London Galleries', *The Listener* (10 March 1949).

—— *Rude Assignment: A Narrative of My Career Up-to-Date* (London 1950).

—— Introduction to the catalogue of *Wyndham Lewis and Vorticism*, an exhibition held at the Tate Gallery, London, July–August 1956.

—— *Wyndham Lewis on Art. Collected writings 1913–1956*, ed. Walter Michel and C. J. Fox (London 1969).

Lewison, Jeremy. Catalogue of *Ben Nicholson: the years of experiment, 1919–39*, an exhibition held at Kettle's Yard, Cambridge, July–August 1983.

—— (ed.) *Henri Gaudier-Brzeska, Sculptor*, catalogue of an exhibition held at Kettle's Yard Gallery, Cambridge, October–November 1983. With essays by Serge Faucherau, Sarah Shalgosky, Rod Brookes, Jane Beckett and Jeremy Lewison.

Liddiard, Jean. *Isaac Rosenberg: The Half Used Life* (London 1975).

Lilly, Marjorie. *Sickert. The Painter and His Circle* (London 1971).

Lipke, William C. 'Vorticism and the Modern Movement', *The Arts Review* (21 August–4 September 1965).

—— 'Futurism and the development of Vorticism', *Studio International* (April 1967).

—— *David Bomberg. A Critical Study of his Life and Work*, with an appendix devoted to a selection of Bomberg's unpublished writings (London 1967).

—— 'Structure in textures of colour', essay in the catalogue of *David Bomberg 1890–1957. Paintings and Drawings*, an exhibition held at the Tate Gallery, London, March–April 1967.

—— 'The New Constructive Geometric Art in London, 1910–1915', in *The Avant-Garde*, ed. Thomas B. Hess and John Ashbery, *Art News Annual*, XXXIV (New York 1968).

—— 'The Omega Workshops and Vorticism', *Apollo* (March 1970).

Lipke, William C. and Bernard Rozran. 'Ezra Pound and Vorticism:

A Polite Blast', *Wisconsin Studies in Contemporary Literature* (summer 1966).

Lipman, Vivian D., 'England', in *Jewish Art and Civilisation*, ed. G. Wigodor (New York 1972).

—— 'The Anglo-Jewish Background', in the catalogue of *The Immigrant Generations: Jewish Artists in Britain 1900–1945*, an exhibition held at The Jewish Museum, New York, 1983.

Lynton, Norbert. *The Story of Modern Art* (London 1980).

MacCarthy, Desmond. 'The Post-Impressionists', unsigned introduction to the catalogue of *Manet and the Post-Impressionists*, an exhibition held at the Grafton Galleries, London, 1910–11.

—— 'The Art-Quake of 1910', *The Listener* (1 February 1945).

MacCarthy, Fiona. 'Roger Fry and the Omega Idea', essay in the catalogue of *The Omega Workshops 1913–19*, an exhibition held at the Crafts Council, London, January–March 1984.

Major, James. 'Britain's Biggest Bang! RAF Fauld, Tutbury, Staffs', *Harper Adams Magazine* (n.d.).

Manson, J. B. 'Introduction. Rooms I–II', in the catalogue of an *Exhibition by the Camden Town Group and Others*, held at the Public Art Galleries, Brighton, December 1913–January 1914.

Martin, Marianne W. *Futurist Art and Theory 1909–1915* (Oxford 1968).

Martin, Wallace. *The New Age Under Orage* (Manchester 1967).

Materer, Timothy (ed.). *Pound/Lewis. The Letters of Ezra Pound and Wyndham Lewis* (London 1985).

Meyers, Jeffrey. *The Enemy. A Biography of Wyndham Lewis* (London 1980).

—— *Wyndham Lewis: A Revaluation. New Essays* (London 1980).

Michel, Walter. 'Vorticism and the Early Wyndham Lewis', *Apollo* (January 1963).

—— *Wyndham Lewis Paintings and Drawings*, with an introductory essay by Hugh Kenner (London 1971).

Morphet, Richard. *British Painting 1910–1945* (London 1967).

—— 'Late Sickert, Then and Now', essay in the catalogue of *Late Sickert Paintings 1927–1942*, an exhibition held at the Hayward Gallery, London, November 1981–January 1982. With other contributions by Frank Auerbach, Wendy Baron, Helen Lessore and Denton Welch.

Morris, Lynda (ed.). *Henry Tonks and the 'Art of Pure Drawing'*, catalogue of an exhibition held at the Norwich School of Art Gallery, Norwich, 1985.

Morris, Lynda and Robert Radford. *The Story of the AIA. Artists International Association 1933–1953*, catalogue of an exhibition held at the Museum of Modern Art, Oxford, 1983.

Nash, Paul. *Outline. An Autobiography and Other Writings*, with a preface by Herbert Read (London 1949).

Neve, Christopher. 'The Divided View. David Bomberg in Ronda, Andalucia', *Country Life* (23 May 1985).

Nevinson, C. R. W. 'Post-Impressionism and Cubism', *Pall Mall Gazette* (7 March 1914).

—— 'Futurism', *The New Weekly* (20 June 1914).

—— 'The Vorticists and the Futurists', *The Observer* (12 July 1914).

—— Preface to the catalogue of *Exhibition of Pictures of War* (Leicester Galleries, London, March 1918).

—— *Paint and Prejudice* (London 1937).

Newmark, J. 'The Rose-red City of Petra', *The Studio* (August 1932).

Nicholson, Colonel G. W. L. *Canadian Expeditionary Force, 1914–1919* (Ottawa 1962).

Nochlin, Linda. *Realism* (Harmondsworth 1971).

Olson, Stanley. *John Singer Sargent: His Portrait* (London 1986).

*The Omega Workshops*, catalogue of the exhibition of *Furniture, Textiles and Pottery made at the Omega Workshops, 1913–1918*, Arts Council, London, May 1946.

Ormond, Richard. *John Singer Sargent* (London 1970).

Overy, Paul. Essay on *Vorticism* in *Concepts of Modern Art* (London 1974).

Oxlade, Roy. *David Bomberg 1890–1957*, RCA Papers No. 3 (London 1977). (See also Unpublished Material.)

—— 'A Rejection of "Bomberg Comes Home"', *Art Monthly* (December 1979) (see Spencer, Charles).

Paige, D. D. (ed.). *The Letters of Ezra Pound, 1907–1941* (London 1951).

Palmer, J. Wood. Introduction to the exhibition catalogue of *Henri Gaudier-Brzeska, 1891–1915*, Arts Council, London, 1956.

Parkin, Michael. Introduction to the catalogue of *Walter Bayes 1869–1956*, an exhibition held at Michael Parkin Fine Art, London, March–April 1978.

Pevsner, Nikolaus. 'Omega', *The Architectural Review* (August 1941).

Pickvance, Ronald. Introduction and notes to the exhibition catalogue of *Sickert 1860–1942. Paintings and drawings*, Arts Council, London, 1964.

Piper, David. *Artists' London* (London 1982).

Pound, Ezra. 'Exhibition at the Goupil Gallery', *The Egoist* (16 March 1914).

—— 'Vorticism', *The Fortnightly Review* (1 September 1914).

—— 'Affirmations II. Vorticism', *The New Age* (14 January 1914).

—— 'Wyndham Lewis', *The Egoist* (15 June 1914).

—— *Gaudier-Brzeska. A Memoir* (London 1916).

—— 'The Death of Vorticism', *The Little Review* (February–March 1919).

—— 'This Hulme Business', *Townsman* (January 1939).

Powell, L. B. *Jacob Epstein* (London 1932).

Preston, W. E. Foreword to the *Catalogue of an Exhibition of Oil Paintings Loaned by Wyndham T. Vint, Esq.*, held at Cartwright Memorial Hall, Bradford, July 1936.

*John Quinn 1870–1925. Collection of Paintings, Water Colors, Drawings & Sculpture.* Foreword by Forbes Watson (New York 1926).

*Paintings and Sculptures. The Renowned Collection of Modern and Ultra-Modern Art, Formed by the Late John Quinn. Including Many Examples Purchased By Him Directly From the Artists.* Sale catalogue (New York 1927).

Rachum, Stephanie. 'David Bomberg: Views from the Jewish-Zionist Side', essay in the catalogue of *David Bomberg in Palestine 1923–1927*, an exhibition held at the Israel Museum, Jerusalem, autumn 1983.

Read, Herbert. 'Bomberg', *Arts Gazette* (13 September 1919).

Read, Herbert et al. *Jacob Kramer. A Memorial Volume* (Leeds 1969).

Reid, B. L. *The Man from New York. John Quinn and His Friends* (Oxford 1968).

Roberts, Michael. *T. E. Hulme* (London 1938).

Roberts, William. 'Portrait of the Artist', *Art News and Review* (5 November 1949).

—— *The Resurrection of Vorticism and the Apotheosis of Wyndham Lewis at the Tate*, pamphlet (London 1956).

—— *Cometism and Vorticism. A Tate Gallery Catalogue Revised*, pamphlet (London 1956).

—— *A Press View at the Tate Gallery*, pamphlet (London 1956).

—— 'Wyndham Lewis, the Vorticist', *The Listener* (21 March 1957).

—— *A Reply to My Biographer Sir John Rothenstein*, pamphlet (London 1957).

—— *Abstract & Cubist Paintings & Drawings* (London n.d., c. 1957).

—— *Vorticism and the Politics of Belles-Lettres-ism* (London 1958).

—— *The Vortex Pamphlets 1956–1958* (London 1958).

—— *Paintings 1917–1958* (London 1960).

—— *8 Cubist Designs* (London 1969).

—— *Fame or Defame. A Reply to Barrie Sturt-Penrose* (London 1971).

—— *Memories of the War to End War 1914–18* (London n.d., c. 1974).

—— *In Defence of English Cubists*, pamphlet (London 1974).

—— 'Postscript' (to the *English Cubists* pamphlet), leaflet (London 1974).

—— *Paintings and Drawings by William Roberts R.A.* (London 1976).

—— *Early Years* (London 1982).

*William Roberts RA Drawings and Watercolours 1915–1968.* Catalogue of an exhibition held at the d'Offay Couper Gallery, London, September–October 1969.

*William Roberts RA A Retrospective Exhibition.* Catalogue of an exhibition held at the Hamet Gallery, London, February–March 1971.

*William Roberts, RA 1895–1980. A Retrospective Exhibition.* Catalogue of an exhibition held at the Maclean Gallery, London, September–October 1980.

*William Roberts 1895–1980. Drawings and watercolours.* Catalogue of an exhibition held at the Anthony d'Offay Gallery, London, n.d.

Robertson, Bryan. 'David Bomberg', *The Studio* (January 1946).

Roditi, Edouard. 'The Jewish Artists in the Modern World', in *Jewish Art: An Illustrated History*, ed. Cecil Roth (Greenwich, Conn. 1971).

Rodker, John. 'The New Movement in Art', *Dial Monthly* (May 1914).

—— *Poems* (privately printed, London 1914).

—— *The Future of Futurism* (London 1926).

—— *Collected Poems 1912–1925* (Paris 1930).

Rose, W. K. (ed.). *The Letters of Wyndham Lewis* (London 1963).

Rosenberg, Isaac. *Night and Day* (London 1912).

—— *Youth* (London 1915).

—— *Moses, A Play* (London 1916).

Rosenblum, Robert. *Cubism and Twentieth-Century Art* (New York 1976).

Ross, Alan. *Colours of War: War Art 1939–45* (London 1983).

Roth, Cecil. *The Jewish Contribution to Civilisation* (London 1938).

Rothenstein, John. *British Artists and the War* (London 1931).

—— Introduction to the exhibition catalogue of *Epstein*, Arts Council, London, 1961.

—— *British Art Since 1900. An Anthology* (London 1962).

—— *Time's Thievish Progress. Autobiography III* (London 1970).

—— *Modern English Painters. Volume Two. Nash to Bawden* (London 1984).

Rumney, Ralph. 'Kill John Bull with Art! What went wrong?', *Studio International* (December 1969).

Russell, John. 'London', *Art News* (May 1967).

Rutter, Frank. *Revolution in Art* (London 1910).

—— Foreword to the catalogue of the *Post-Impressionist and Futurist Exhibition*, held at the Doré Galleries, London, October 1913.

—— *Some Contemporary Artists* (London 1922).

—— *Evolution in Modern Art: A Study of Modern Painting, 1870–1925* (London 1926).

—— *Since I Was Twenty-Five* (London 1927).

—— *Art in My Time* (London 1933).

Sassoon, Siegfried. *The Complete Memoirs of George Sherston* (London 1940 edition).

Scharf, Aaron. *Art and Photography* (Harmondsworth 1974).

Secretain, Roger. *Un Sculpteur 'Maudit': Gaudier-Brzeska 1891–1915* (Paris 1979).

Severini, Gino. Preface to the catalogue of *The Futurist Painter Severini Exhibits His Latest Works*, Marlborough Gallery, London, April 1913.

Shewring, Walter (ed.). *Letters of Eric Gill* (London 1947).

Shone, Richard. Introduction to the catalogue of *An Honest Patron, A Tribute To Sir Edward Marsh*, an exhibition held at the Bluecoat Gallery, Liverpool, 1976. With a 'Memoir' by John Nash.

—— *Bloomsbury Portraits* (London 1976).

—— *The Century of Change. British painting since 1900* (London 1977).

—— 'Spencer Frederick Gore', introduction to an exhibition of the same name held at the Anthony d'Offay Gallery, London, February–March 1983.

Sickert, Walter. 'The Post-Impressionists', *Fortnightly Review* (January 1911).

—— *A Free House! Or, The Artist as Craftsman (Being the Writings of Walter Richard Sickert)*, ed. Osbert Sitwell (London 1947).

Silber, Evelyn, *The Sculpture of Epstein. With a Complete Catalogue* (Oxford 1986).

Soby, James Thrall, *Contemporary Painters* (New York 1948).

Sonntag, Jacob (ed.). *Ben Uri, 1915–1965: Fifty Years Achievement in the Arts*, a commemorative volume for the Ben Uri Art Society (London 1966). With essays by Leo Koenig ('Jews and the Visual Arts'), Joseph Leftwich ('Jewish London Fifty Years Ago') and Charles Spencer ('Jewish Art Since 1915 – Fifty Glorious Years').

Spalding, Frances. *Roger Fry, Art and Life* (London 1980).

—— 'Mark Gertler – the early years', essay in the catalogue of *Mark Gertler – the early and the late years*, an exhibition held at the Ben Uri Art Gallery, London, March–May 1982. With other contributions from Noel Carrington and Richard Shone.

—— *Vanessa Bell* (London 1983).

—— Introduction to the catalogue of *Jacob Kramer Reassessed*, an exhibition held at the Ben Uri Art Gallery, London, May–July 1984. With other contributions from Jacob Kramer, W. T. Oliver, Sarah Roberts and Joshua Walsh.

—— *British Art Since 1900* (London 1986).

Spate, Virginia. *Orphism* (Oxford 1979).

Spencer, Charles. Introduction to the catalogue of *Jewish Artists in England 1656–1956*, a tercentenary exhibition held at the Whitechapel Art Gallery, London, November–December 1956.

—— 'David Bomberg 1890–1957', *The Studio* (October 1958).

—— Essay in the catalogue of *Jewish Art: Paintings and Sculpture of Twentieth Century Jewish Artists of the French and British Schools*

(foreword by Alasdair A. Auld), exhibition held at Glasgow Art Gallery and Museum, September–October 1979.

—— 'Bomberg Comes Home', *Art Monthly* (November 1979) (see also Oxlade, Roy).

—— 'Anglo-Jewish Artists: The Migrant Generations', essay in the catalogue of *The Immigrant Generations: Jewish Artists in Britain 1900–1945*, an exhibition held at The Jewish Museum, New York, 1983.

Spurling, John. Introduction to the catalogue of *David Bomberg. The Later Years*, an exhibition held at the Whitechapel Art Gallery, London, September–October 1979.

Staley, Allen. *The Pre-Raphaelite Landscape* (Oxford 1973).

Staveley, May C. *The Housing Problem in Birmingham* (Birmingham 1903).

Stock, Noel. *The Life of Ezra Pound* (London 1969).

Storrs, Sir Ronald. 'David Bomberg', preface to the catalogue of *Paintings of Palestine and Petra by David Bomberg*, an exhibition held at the Leicester Galleries, London, February 1928.

—— *Orientations* (London 1937).

Sutton, Denys (ed.). *Letters of Roger Fry*, two volumes (London 1972).

Sylvester, David. 'Round the London Art Galleries', *The Listener* (18 September 1958).

—— 'Bomberg and Whistler', *New Statesman* (17 September 1960).

—— Introduction to the catalogue of *David Bomberg 1890–1957*, an exhibition held at Marlborough Fine Art, London, March 1964.

—— 'The Discovering of a Structure', essay in the catalogue of *David Bomberg 1890–1957*, an exhibition held at the Tate Gallery, London, March–April 1967.

—— 'Selected Criticism', essay in the catalogue of *Bomberg. Paintings, Drawings, Watercolours and Lithographs*, an exhibition held at Fischer Fine Art, London, March–April 1973.

Tarratt, Margaret. '"Puce Monster". The two issues of Blast, their effects as Vorticist propaganda and how the rebellious image faded', *Studio International* (April 1967).

*The Tate Gallery Report 1964–65* (London 1966).

*The Tate Gallery Report 1966–67* (London 1967).

*The Tate Gallery Acquisitions 1968–69* (London 1969).

*The Tate Gallery Report 1968–70* (London 1970).

*The Tate Gallery Report 1970–72* (London 1972).

*The Tate Gallery Report 1972–74* (London 1975).

*The Tate Gallery 1974–76* (London 1978).

*The Tate Gallery 1976–78* (London 1979).

*The Tate Gallery 1980–82* (London 1983).

*The Tate Gallery 1982–84* (London 1984).

Taylor, Basil. 'Blasted and Blessed', *The Listener* (15 February 1970).

Taylor, Joshua C. *Futurism* (New York 1961).

Tonks, Henry. 'Wander Years', *Artwork* (winter 1929).

*Twentieth Century Art. A Review of Modern Movements*, catalogue of an exhibition at the Whitechapel Art Gallery, London, May–June 1914.

Vengerova, Zinaida. 'English Futurists', *The Archer* (1915).

Vergo, Peter. Introduction to the catalogue of *Abstraction: Towards a New Art. Painting 1910–20*, an exhibition held at the Tate Gallery, London, February–April 1980.

Wagner, Geoffrey. 'Wyndham Lewis and the Vorticist Aesthetic', *Journal of Aesthetics and Art Criticism* (September 1954).

—— *Wyndham Lewis. A Portrait of the Artist as the Enemy* (London 1957).

Watney, Simon. *English Post-Impressionism* (London 1980).

Wees, William C. *Vorticism and the English Avant-Garde* (Toronto and Manchester 1972).

White, Gabriel. Introduction to the catalogue of *Sickert Paintings and Drawings*, an exhibition held at the Tate Gallery, London, May–June 1960.

Whittet, G. S. Introduction to the catalogue of *Horace Brodzky (1885–1969)*, an exhibition held at the Fieldborne Galleries, London, September 1973.

Wilenski, R. H. *The Modern Movement in Art* (London 1926).

Williams, Raymond. *The Country and the City* (London 1976).

Wilson, Simon. 'Jacob Epstein: pioneer of modern sculpture – the early years', essay in the catalogue of *Epstein Centenary 1980*, an exhibition held at the Ben Uri Art Gallery, London, November–December 1980.

Wodehouse, R. F. *A Check List of the War Collections of World War*

*I, 1914–1918 and World War II, 1939–1945* (National Gallery of Canada, Ottawa n.d.).

—— 'The Canadian War Memorials Collection at Ottawa', *Studio International* (December 1968).

Woodeson, John. Introduction and notes for the catalogue of *Spencer Gore, 1878–1914*, an exhibition held at Colchester, Oxford and Sheffield, March–June 1970.

—— Introduction and notes for the catalogue of *Mark Gertler 1891–1939*, an exhibition held at Colchester, London, Oxford and Sheffield, March–June 1971.

—— *Mark Gertler. Biography of a Painter 1891–1939* (London 1972).

Woolf, Virginia. *Roger Fry. A Biography* (London 1940).

Worringer, Wilhelm. *Abstraction and Empathy*, translated by Michael Bullock (London 1953).

Zilczer, Judith. *'The Noble Buyer'. John Quinn, Patron of the Avant-Garde* (Washington 1978).

## Unpublished Material

Allinson, Adrian. 'Painter's Pilgrimage. An Autobiography', manuscript in the collection of Miss M. Mitchell-Smith, London.

Auerbach, Frank. Interview with Richard Cork for Leonie Cohn, 1983, tape cassette owned by Leonie Cohn, London.

—— Interview with Richard Cork for BBC Radio 3, 18 November 1985.

Behr, Louis. Letters to Richard Cork, collection of the author.

Bomberg, Alice. Letters to David Bomberg and Diary of the Petra expedition, collection of the artist's family.

Bomberg, David. Letters, poems, theoretical writings, lists of work and memoirs, collection of the artist's family.

—— Letters to Desmond Coke, collection of Lyndon Brook.

—— Letter to S. C. Kaines Smith, curator of Birmingham City Art Gallery, collection of Birmingham City Art Gallery.

—— Letter to W. H. Berry, Curator of Oldham Art Gallery, collection of Oldham Art Gallery.

—— Letters to Vincent Galloway, Director of the Ferens Art Gallery, collection of the Ferens Art Gallery, Hull.

—— Letters to E. M. O'Rourke Dickey, Secretary of the War Artists' Advisory Committee, collection of the Imperial War Museum Archives.

Bomberg, Lilian. Letters to David Bomberg, collection of the artist's family.

Creffield, Dennis. Letter to Richard Cork, collection of the author.

Kisch, Frederick. Diary, collection of Central Zionist Archives, Jerusalem.

Kossoff, Leon. Letter to Richard Cork, collection of the author.

Lechmere, Kate. 'Wyndham Lewis from 1912', memoir, 1971, private collection.

Leftwich, Joseph. Diary, collection of Tower Hamlets Library, London.

Letters to David Bomberg from (in alphabetical order) Jack Beddington, Muirhead Bone, Kenneth Clark, Thomas Crenan, Arthur Crossland, R. B. Cunninghame Graham, the Earl of Desborough, T. A. Fennemore, David Fincham, Walter Gropius, Charles Holden, Helen Lessore, H. W. Lewis, John Mabbott, Edward Marsh, Lewis Mumford, A. Palmer, R. Patrick, John Perry, E. M. Rich, William Roberts, S. H. Robinson, John Rodker, John Rowlands, E. W. H. Selwyn, A. C. Short, Arthur Stambois, Leonard Stein, Sir Ronald Storrs, John Summerson, E. R. Tongue, Wyndham T. Vint, Harold Watkins, Alfred Willey and Virginia Woolf, collection of the artist's family.

Lipke, William C. 'A History and Analysis of Vorticism', doctoral thesis for the University of Wisconsin, 1966.

Mayes, Alice. 'The Young Bomberg, 1914–1925', memoir dated 1972, collection of the Tate Gallery Archives.

—— Letters to Lilian Bomberg, collection of the artist's family.

—— Letters to Richard Cork, collection of the author.

Mead, Dorothy. 'The Borough Group', memoir, n.d., collection of the artist's family.

Minutes of the Borough Bottega Group, collection of Richard Michelmore, London.

Newmark, Kitty. Letters to Richard Cork, collection of the author.

Nicholson, Ben. Letters to Richard Cork, collection of the author.

Oxlade, Roy. 'Bomberg and The Borough: An Approach to Drawing', MA thesis for the Royal College of Art, London, 1976.

Richardson, Denis. Letter to Richard Cork, collection of the author.

Richmond, Peter. 'David Bomberg', memoir dated October 1979, private collection.

# Index

*Numbers in italics refer to page numbers of illustrations*

abstract form: in *Bomb Store*, 238; as expressive, 19, 67–8, 69, 93; in figures, 80, 105, 130; in Jerusalem landscapes, 149–50, 163; post-war rejection of, 133. *See also* form(s); 'Pure Form'
Adelphi Gallery, exhibition of DB's drawings (1919), 128
Adeney, Bernard, 331 n. 9
Aid to Russia Fund, 251
Aitken, Sir Max, 112
Alba, Duke of, 180
Aldington, Richard, 77
alienation, theme of, 134–7
Allied Artists' Association, 11, 33, 42
Allinson, Adrian, 23, 31, 35
Alma-Tadema, Sir Lawrence, *A Favourite Custom*, 89, *89*
Alpine Club Gallery, Friday Club show (1913), 45
Amdur (Soviet official of VOKS), 197
anti-semitism, 7, 31; in World War One, 110
*Apollo*, 187
Applebee, Leonard, 287
Arcade Gallery, Borough Group exhibition (1949), 280
*Archer, The*, 97–8, 326 n. 74
Archer Gallery, Borough Group exhibitions (1947, 1948), 270, 278
Archipenko, Alexander: *Boxers*, 49, 88; *The Dance*, 88, *88*
*Art and Artists*, review in, 275
art education, parochialism of, 263
*Art News and Review*, review in, 280
Artists International Association, 196, 329 n. 61
Arts Council Gallery, 1958 Bomberg retrospective, 319–20
Ashbee, C. R., 146
'associational bias', 163–4
Asturian mountains, trip to (1935), 215–18
*Athenaeum, The*, review in, 70
Auerbach, Frank, 4, 262, 297, 320; as DB's student, 283–6, 288
automata, as subject, 88
Ayios Chrisostomos, Monastery of, as subject, 278–9

Bailey, Cecil, 261, 288, 297, 303
Baron, Wendy, 15
Bartlett School of Architecture, 258–60
Bayes, Walter, 11, 16, 297
Beaufort, Duke of, 189
Beaux Arts Gallery, offer of show to DB, 318
Beddgelert, trip to (1936), 220
Beddington, Jack, 191
Behr, Louis, 79, 80
Bell, Clive, 34, 70; *Art*, 78, 92–3
Bell, Vanessa, 34, 55–6
Bentwich, Norman, 163
Bellini, Giovanni, *The Agony in the Garden*, 27
Berenson, Bernard, 265
Berger, John, reviews of DB's work, 288, 299, 308–9, 320
Berkeley, Bishop, 266–7; *Essay Towards a New Theory of Vision*, 13, 266, 298
Berkeley Galleries, Borough Bottega exhibition (1953), 297, 298–9
Binder, Pearl, 191–2, 196, 197
Binyon, Lawrence, *The Flight of the Dragon*, 98
Birmingham, Bomberg home in, 5–6
Black, Misha, 329 n. 61
Black Hall, Oxford, exhibition at, 299
Blakeston, Oswell, 275
*Blast*, 32, 62, 77, 98, 105

blitz, London: DB's depiction of, 253–9; and flower-paintings, 250–1
Bloomsbury Gallery, DB exhibition (1932), 195
Boccioni, Umberto, *The City Rises*, 68, *68*, 70
bodily rhythms, emphasis on, 274
bomb store, *see* RAF Fauld
Bomberg, Abraham, 5, 6, 7–8, 9–10, 107–8
Bomberg, Alice (née Mayes): and Canadian War Memorial commission, 118, 119, 122; in Palestine, 146, 148, 149, 157, 158, 160, 161, 167, 168; relationship with DB, 100–3, 106–8, 127, 170–1; quoted, 29, 80, 89, 95, 97, 105, 109, 122, 126, 128, 133, 134; mentioned, 116, 137, 139, 168, 170
Bomberg, David: and anti-Fascism, 220–2, 235; applications for work, 219, 232–3; apprenticeship in chromolithography, 11, 13, 322 n. 53; birth of, and childhood, 5–6; birth of daughter, 214–15; and Borough Bottega, 297–9; and Borough Group, 279–80; communist activity, 196–7, 201; conception of art, 265–7, 275, 298–9, 320–1; critical response to, *see* critical responses; and Cubo-Futurists, 54–8; death of, 318–19; depressions, 248, 311–12, 313; drawing, practice of, 9, 10, 23–9, 103, 263; entrance to Slade, 12–13, 22; evening classes, 13–14; as exhibitor, 75; father, relationship with, 10; financial problems, *see* financial difficulties; and Futurism, 54–5, 75–6, 77, 90–1; health, 297, 302–3, 312–14, 316–18; Lilian Holt, relationship with, *see under* Bomberg, Lilian; home, purchase of, 279, 292–3; and Hulme, 71–4, 91–4; influence of European avant-garde, 33–5, 42, 47–8, 51–2, 139; influence of Sickert, 14–15, 29; and Italian Renaissance, 27, 28, 45, 89–90; and Jerusalem, 146, 163–5, 171–2, 173–4; and Jewish artists, 75, 156–7; and Judaism, 7–8, 41, 307; maturation of style (1929–30), 179–85; Alice Mayes, relationship with, *see under* Bomberg, Alice; military destruction, knowledge of, 235–9, 243, 244–5, 247, 250–1; as model, 13; mother, death of, 36–41; mother, relationship with, 10; move to Beech, Hampshire, 137–8; neglect of, by art establishment, 1–4, 225, 287–8, 310–12; at Omega Workshops, 55–6; at Ormonde Terrace, 95; periods in which he ceased painting, 2, 175, 229–31, 274, 287; personality, 3, 10, 19, 76–7, 209; and politics, 19, 64–6; position in English society, 53; and Post-Impressionism, 15–19; post-war alienation, 128, 139–40; pre-war style, rejection of, 112, 113–15, 125–6, 130–2; problems finding exhibitors, 168, 170, 172–4, 187, 253; problems selling work, 101, 140–3, 173, 219, 229; and rejection of *Sappers at Work*, 118–22; respect for tradition, 11, 45, 76, 89; return to naturalism, 133–4, 151–6; revaluation of, 320; romantic life, 22, 27–8, 191–2; at school, 8; self-inflicted wound, in World War One, 109; at Slade, 31; and Tate Gallery, 1, 225, 310–12, 315, 318; and World War One, 95, 107–12; and World War Two, 3, 231–57; and Zionism, 143–4, 146, 166–7, 276–7
Bomberg, David, *Exhibitions*: Chenil Gallery 1914 (one-man show), 77–95; Adelphi Gallery 1919 (ink-wash drawings), 128–30; Mansard Gallery 1923, 145; Leicester Galleries 1928 (Palestine paintings), 168, 170, 172–4; Bloomsbury Gallery 1932 (*Sixty Imaginative Compositions, Spanish and Scottish Landscapes*), 192–4; Cooling Galleries 1936 (Spanish paintings), 219; Leger Galleries 1943 ('Imaginative Compositions' and flower paintings), 251; Heffer Gallery 1954 ('Bomberg's First Retrospective Exhibition'), 303; Arts Council Gallery 1958, 320; Tate Gallery 1967, 320; Whitechapel Art

Gallery 1979, 320; Israel Museum 1983 (Palestine paintings), 320
Bomberg, David, *Texts*: *Approach to the Teaching of Draughtsmanship*, 300; *Balloons*, 108; foreword to 1914 Chenil Gallery catalogue, 78; foreword to Borough Group show of 1949, 280; foreword to Borough Bottega show of 1953, 298–9; *Winter Night*, 108, 326 n. 24
Bomberg, David, *Works*: *Abstract Design* (1914), 105, 106, *111*; *Abstract Composition* (1914), 105, *111*; *Acrobats*, 62, *62*, 280; *Allotment Grounds*, 53; *Antigone*, 294, *295*; *Arab Girl: Palestine*, 187, *188*; *Architectural Studies* (1913–14), 60, *60*; *Armenian Church*, 164, *165*; *The Baby Diana*, 226, 227; *The Baby Juliet*, 251, *251*; *Bargee* (1921), 137, *142*; *Bargees* drawings (1919–20), 130, 134–5, *134*; *Barges*, 133, 135, *141*, 177; *Barges on the Canal*, *133*, 133–4; *Barnstaple Bay, Devon*, 269, *269*; *Bathing Scene*, 80–2, *81*, 83; *Bedroom Picture* (1911–12), 29–31, *30*, 32, 78, 106; *Belshazzar*, scenery and costumes for, 227, 227–9; *Bideford, Devon*, 268, 269; *Billet*, 103–4, *104*, 106, 303; *Study for Billet*, *104*; *Bomb Store*, 3, 233–47, *236–43*, 320; *Boy's Head*, 45; *Bridge and Gorge, Ronda*, 208, *208*; *Brierloch – Glen Kinrich, Cairngorms*, 194, *200*; *Camels*, 149, *149*; Cangas de Onis, picture of, 221; *La Casa de la Virgen de la Cabeza*, 314, *318*; *Castle Ruins, St Hilarion*, 277, *281*; *The Cathedral, Toledo*, 178, 181–3, *182* (studies); *Chartres Cathedral*, 295, *295*; *Chinnereth*, 73, 73–4; *The Church of San Justo, Toledo: Morning*, 186, 187; *The Church of the Holy Sepulchre*, 163, *164*; *Classical Composition* (1910), *17*, *18*, 17–18; *Composition* (1914), 74, 74–5; *Composition (Green)*, 60–1, *61* (studies); *63*; *Composition with Figures* (*c.* 1913), 58, *59*; *Convent and Tower, San Miguel, Toledo*, 184; *Cubist Composition* (1913), *54*, 58, *58*; *Cuenca from Mount Socorro*, 203, *203*, 214; *The Dancer*, 96–100, *97*; *The Dancer* watercolours, *94*, 95–100, *96*, *99*, *100*; *Dark Street, Ronda*, 213, *213*; *Decorative Experiment*, 105; *Design in Colour*, 105; *Design in White*, 105; *Dinora*, 227, *228*; *Down and Out*, *134*, 134–5; *Drawing: Zin (?)*, *92*, 93–4; *Drawing for a painting*, 84; *Dusk in the Cuenca Hills*, 203, *205*; *East Valley, Cuenca: Morning*, 203, *203*; *English Woman*, 137, *137*; *Evening, Cornwall*, 273, *274*; *Evening from La Casa de la Virgen de la Cabeza*, 314, *314*; *Evening in the City of London*, 255, *255*; *Evening Light, Ronda* (1956), 314, *315*; *The Exit*, 136, *137*; *Family Bereavement*, 37, 38; *Figure Composition* (*c.* 1913), 58, *59*; *Figure Study* (*c.* 1913), 58, *59*; *Figures Helping a Wounded Soldier*, 110, *110*; *Figures watching a clock work machine*, 87, 88; *Fireside*, 128, *130*; flower paintings, *248*, 249, 248–51; *Flowers* (1943), 249, *250*, 252, 287; *Flowers* (1946), 269, *269*; *Ghetto Theatre*, 135–6, *136*; *Grief*, *139*, 139–40; *Gunner Loading Shell*, 115, *115*; *Head of a Girl* (1911), 19, *20*, 21; *Head of a Girl* (1912), 28, 28–9; *Head of a Man*, *Art*, 44, 45, 61, 78; *'Hear O Israel'*, 306, 307–8; *Hills, Toledo*, 184, *185*; *The Holy City*, 162, 163, 172; *Huddled Figures*, *134*, 134–5; *The Hunger Marcher*, 135, 196; *Illustration for 'Richard Feveral'*, 36, 37; *'Imaginative Compositions'*, 138, *138*, *140*, 251, 327 n. 14; *La Inglesia Espiritu Santo*, 301, *302*; ink-drawings (1919), 126–31, *127*, *128*, *129*; *Interior*, 58, *58*; *In the Hold*, 62–71, *63*, *69*, 75, 76, 80, 83, 84, 113, 143, 166, 311, 320; *Study for In the Hold*, 65, *66*, 84; *The Island: Land and Sea*, 138, *138*; *Island of Joy*, 32–4, *33*, 80, *80*; *Jericho*, 157, *157*; *Jerusalem by Moonlight*, 150, *150*; *Jerusalem, looking to Mount Scopus*, 160, 163; *Jewish Theatre*, 43, 43–5, 58, 104, 135, 229, 310; *The Judean*

Hills, 152, *153; Ju-Jitsu (Japanese Play)*, 48–52, *51*, 58, 61, 67, 75, 113, 135; *Study for Ju-Jitsu, 47*, 50; *Kitty* (1929), 179, *179; Landscape Study* (c. 1913), 53, *53; Last Self-Portrait*, 4, 193, 312–14, *317; Lilian*, 193–4, *200; Lilian Painting David (Painting Lilian)*, 179; *London River (Blackfriars Bridge)*, 257, *257; London River after Blitz*, 256, *256; Lyons Café, 24*, 31–2; *The Man from Marrakesh, 190*, 190–1; *Medieval Ruins, Cyprus*, 280; *The Melon Market*, 149; *Messiah* (with Michelmore), 290, 298; *Mist: Mountains and Sea, Santander*, 206, *207; The Monastery of St George, Wadi Kelt*, 167–8, *169*, 180; *Moorish Ronda, Andalucia*, 211, *212; Moorish Wall, Cyprus*, 278, *278; Mother of Venus*, 294, *294; Mountain Road, Near Platres, Cyprus*, 279, *279; Mountains around Cuenca*, 203, *203; Mount of Olives*, 154, 154–6, *155*, 163, 172; *Mount Zion with the Church of the Dormition: Moonlight*, 151–2, *152; The Mud Bath*, 2, 33, 78–90, *82*, *89*, 93, 101, 113, 117, 135, 143, 311, 320; Studies for *The Mud Bath, 81, 82, 83, 84, 85; The Muristan, Jerusalem*, 162, 163; *Nude, 250*, 251; *The Ophthalmic Hospital of the Order of St John*, 171, *171*; 'Orwell' advertisement, 137–8, *138; Outside the Damascus Gate, Jerusalem*, 148, *148; Outskirts of Toledo, 183*, 184; Palestine Restoration Fund Poster, 165, *166; The Pastures of Santillana*, 206; *Pool of Hezekiah, Jerusalem*, 163, *164; Portrait of Dinora, 292*, 293–4; *Portrait of Lilian, 226*, 227; *Portrait of the Artist*, 193, *200*, 312; *Portrait of the artist's sister, Rachel, 9, 9; Primeval Decoration*, 56; *Procession, 57*, 58; *The Procession of 'La Virgen de la Paz'*, 213, *214; Queen's Gate Mews*, 253–4, *254; Racehorses*, 46, *46*, 96; *Reading from Torah, 91* (studies), 93; *Reclining Nude* (with Michelmore), 290, *291; The Red Hat*, 192, *199*, 203; *The Return of Ulysses*, 46–7, *47; Rising Wind*, 296, 302, 308; *River Tajo, Toledo*, 184, *184; Rock Fortress, Cyprus*, 277–8, *281; The Road to the City, Cuenca*, 203, *203; Ronda* (1935, drawing), 208, *208*, 309; *Ronda* (1935, painting), 211, *212*, 220, 229; *Ronda* (1954), 301, *301; Ronda Bridge, The Tajo* (1955), *308*, 309; *Ronda Evening* (1956), *309*, 310; *Ronda, Houses and Bridge* (1955), *308*, 309; Ronda landscapes (1934–5), 4, 208–14, *208*, *210*, *212; Ronda, towards El Barrio, San Francisco*, 293, 302; *Roof Tops, Jerusalem*, 172, *177; Round Church, Middle Temple, 258;* Russian Ballet lithographs, 98, 122–6, *122*, *126; St Paul's and River*, 256, *256; St Paul's and River Thames*, 257, *257; St Paul's Cathedral*, 254, 254–5; *San Juan, Toledo: Evening*, 183; *San Miguel, Toledo*, 184, *189; Sappers at Work*, 2, 125, 127, 140, 232, 238, 326 n. 46; First Version, 112–18, *123*; Second Version, 119–22, *121*; Studies for Second Version, 113–14, *113*, *114*, *116*, *117*, *120*, 225, 287; *Santillana, Northern Spain*, 206, *207; Sea, Sunshine and Rain*, 272, *273; Self-Portrait* (1909), 14, 15; *Self-Portrait* (1913), 45, *45; Self-Portrait* (1919–20), *131*, 132; *The Man from Marrakesh* (self-portrait, 1931), *190*, 190–1; *Man with Pipe: Self-Portrait* (1931), 191, *191; Self-Portrait* (1931), 193, *193; Self-Portrait* (drawing, 1932), *192*, 193; *Self-Portrait* (painting, 1932), 193, *193; Self-Portraits* (1937), *223*, *224*, 227; *Self-Portrait, Last* (1956), 4, 193, 312–14, *317; Shawl: 'The Mud Bath'*, 179, *179*, 329 n. 7; *Siloam and the Mount of Olives*, 152–4, *153; Site of the City, Petra*, 160, *160; Sleeping Men, 23*, 26–7, 225, 287; *Small Painting*, 105; *Soldier Patrolling Tunnel*, 115, *115; Soliloquy, 296*, 303; *The Song of Songs*, 86; *The South East Corner and Mount Zion*, 165, *167; The South East Corner, Jerusalem*, 165, *166; Spires and Towers, Notre Dame de Paris*, 295, *295; Steps to a 'High Place' on al Khubdha, 159*, 161, 172; *Storm Fury, Cuenca, 204*, 205; *Storm over Peñarrubia*, 216, *216*, *217; Studies of the Posed Model and other Compositions* (1911–12), *26*, *26; Study for Memorial to T. E. Hulme*, 109, *109; Study for Ulysses in the Courts of Alcinous*, 324 n. 90; *Study of a door* (1913–14), 60, *60; Study of Barrage Balloons*, 108, *108; Study of Jerusalem*, 164; *Sunlight in the Mountains, Asturias*, 216, 217, *217; Sunset, Bideford Bay, North Devon*, 264, 268–9, 275; *Sunset, Cuenca*, 203, *209; Sunset, Mount Hilarion, Cyprus*, 277, *283; Sunset, Ronda, Andalucia*, 211, *221; Sunset, Toledo*, 182, 183; *Tajo and Rocks*, 312, *316; Talmudist*, 307, *307; The Temple of Isis, Petra: Moonlight*, 161, *161; Thames Barges*, 226, *226*, 229; *Toledo*, 181, *181; Toledo from the Alcazar*, 185, *185; Toledo and River Tajo*, 183, *186; Tredega and Tredog*, 275; *Trees and Sun, Cyprus*, 278, *284; Trees near Talgwyn Farm*, 256; *Trees, Ronda Valley* (1956), *309*, 310; *Tregor and Tregoff, Cornwall*, 278, *284; Trendrine, Cornwall, 264*, 272–3; *Trendrine in Sun, Cornwall*, 271, 271–2, 273, 274; *The Urn Temple*, 161–2, *162; The Valley of Beddgelert*, 220, *220; Valley of La Hermida*, 217, *222*, 299; *The Valley Ronda: Moonlight* (1956–7), *313*, 314; *Vigilante*, 304–7, *305*, 308; *Vision of Ezekiel*, 38–43, *41*, 44, 56, 61, 75, 80, 83; Studies for *Vision of Ezekiel, 38, 39, 40; Wapping*, 229; *War Scene*, 115, *115; Washing of the Feet* (study), 184, *190; The White Mist, 184*, *190; Wind and Water*, 53; *Woman and Machine*, 135, *135; Woman in a Bedroom*, 106, *106; Woman (Lilian)*, 191, *191; Wrestlers,*

49; Zionist settlement pictures, 165–7, *167*, *168*
Bomberg, Diana, 214–15, 218, 227, 271, 273, 276
Bomberg, Israel, 6
Bomberg, John, 7, 8, 10, 36, 190, 308
Bomberg, Kitty, 38, 45, 56, 319; and communism, 196, 197, 201; financial help from, 180; and Alice Mayes, 102; portrait of, 179, *179*; as source, 7, 8, 9, 10, 29, 36, 37, 140, 167
Bomberg, Lilian (née Holt; later Mendelson), 3; birth of daughter, 205, 214–15; and bomb store, 234; and Borough students, 262, 270, 274–5, 276, 282–3, 297, 303; as communist, 196–7, 198, 201; in Cyprus, 276, 278; *David Bomberg, 176;* and death of DB, 318–19; during blitz, 254; and flower paintings, 248; in France, 295; and gift to USSR, 251; *Mother of the Poet*, 298; posing for DB, 193–4, 227; and purchase of home, 279, 292–3; relationship with DB, 175–9, 187, 191–3, 215, 294–5; return to London (1938), 230; return to London (1957), 315–18; at Schevzik's, 80; as source, 10, 56, 77, 119, 138, 145, 173, 201, 211, 213–14, 225–7, 233, 272; in Spain, 183, 185, 186, 203, 204–5, 207, 211–13, 218, 300–12 *passim; The Tajo, Ronda*, 312; on trips with DB, 194, 268, 271, 272, 273; establishment of vegetable shop, 192–3
Bomberg, Mo, 10, 48–9, 70, 187; portrait of, 179
Bomberg, Olive, 248
Bomberg, Queenie, 179
Bomberg, Rachel ('Raie'), 9, 29–31, 322 n. 39
Bomberg, Rebecca, 5, 6, 7–8, 10, 36–8
Bomberg family, 5, 6–7, 10; financial problems, 11
Bone, Muirhead, 116, 122, 225; and DB, 140–4, 168, 170, 190, 195; *The Hall of the Million Shells*, 233–4, *234; St Bride's and the City after the Fire*, 255, *255;* Spanish paintings, 180, 189; and War Artists' Advisory Committee, 232, 233, 243–4
*Bookworm, The*, 275
Booth, Charles, 6; *Life and Labour of the People of London*, 66
Borough Bottega Group, 297–9, 303, 308–9
Borough Group, 269–70, 274–6, 279–83; 1947 show, 270; 1948 show, 275; 1949 show, 280
*Borough of Birmingham Report of the Artizans' Dwellings Committee*, 5, 6
Borough Polytechnic, 4, 260, 261–3, 267–8; 269–71; 279–86; 288–92
Boswell, James, 329 n. 61
Botticelli, Sandro, *Portrait of a Young Man*, 45, *45*
Bradford, collectors in, 202; financial help from, 214
Bradford City Art Gallery, Vint Collection (1936), 219
Bradman, Don, 261
Brancusi, Constantin, 90
Brandt, Bill, *St Paul's Cathedral*, 254, *254*
Braque, Georges, 34, 107
Brasenose College, Oxford, Borough Group exhibition at, 282
BBC, interview with Borough Group on, 276
Brodzky, Horace, 202, 220
Broke, Lord Willoughby de, 234
Bromley College of Art, 288
Brown, Ernest, 173
Brown, Ford Madox, *Work*, 66, *66*, 68
Brown, Professor Fred: interview with DB, 13, 266; at Slade, 23, 27, 35
Browning, Hilda, 197
brushwork, style of, 203–4, 244, 307–8, 312. *See also* pigment, handling of
Bullock, Michael, 299, 309
Burgon, Dean, 158

Cabeza, La Casa de la Virgen de la (house in Spain), 303, 315
Canadian War Memorial Fund, and *Sappers at Work*, 2, 112–13, 115–16, 118–19
Cardiff, Bomberg family in, 6
Cavedale, trip to (1931), 191
Central Institute of Art and Design, 253
Central School of Art and Design, 13–14
Cézanne, Paul, 16, 293, 310
Chagall, Marc, *Cemetery Gates*, 41, *41*
Charteris, Sir Evan, 225
Chartres Cathedral, 295
Churchill, Winston, 237, 251
City and Guilds Institute, 11
Clark, Kenneth, 219, 222–5, 255; patronage of, 229; and War Artists' Advisory Committee, 231, 232
Cohen, Joseph, 22, 31, 32
Cohen Joslen, Sonia, 22, 77, 91, 96
Coke, Captain Desmond, 143
Coldstream, William, *St Giles Cripplegate*, 257, *257*
colour, use of: in later life, 303, 312; in *The Mud Bath*, 83, 86–7; in Palestinian paintings, 173; in *Sappers at*

*Work*, 117; and tactile conviction, 85
communism, in 1930s, 195–201
composition: of *The Mud Bath*, 82–3, of *Sappers* (Second Version), 120
Compton, Susan, 41
Constable, John, 204, 273
Contemporary Art Society, 170
*Contemporary British Painting*, 220
Conway, Agnes, 188–9
Cooling Galleries, DB's Spanish landscapes (1936), 219
Cornwall, trip to (1947), 271–4
crafts, DB's interest in, 14
Craig, Edward Gordon, 128
Creffield, Dennis, 261, 262, 263; and Borough Group, 280; shows, 288, 295, 303; as source, 262, 263, 270–1, 279, 283, 290–1
critical responses and reviews to DB, 73; *In the Hold* (1914), 70–1; to 1914 exhibition, 90–4; to 1919 exhibition (ink-wash drawings), 128–30; to 1923 show, 145; to Palestinian paintings (1938), 172–3; to 1932 show, 195; to Spanish paintings (1936), 219; to flower paintings (1943), 251; to London Group 1951 exhibition, 288
critical response and reviews, to Borough Bottega, 299, 308–9; to Borough Group 1948 show, 275; 1949 show, 280
Crossland, Arthur, 202, 207, 214
Cubism, 16, 34–5, 42–3; and DB, 34–5; and Wyndham Lewis, 42–3
Cubo-Futurists, 54–5, 56–7
Cuenca, trip to (1934), 202–6
Cunard White Star Company, proposal to, 219
Currie, John, 55
Cyprus, trip to (1948), 4, 276–9

*Daily Chronicle*, review of one-man show, 79
*Daily Express*, 194–5
*Daily Mail*, 194
*Daily News*, on 1923 show, 145
*Daily Telegraph*, 70, 173
dance, as subject matter, 95–100, 122–5; and Alice Mayes, 101
David, Jacques Louis, 285
de Kooning, Willem, 274
De Stijl group, 131–2
Degas, Edgar, 15, 285
Dell, Robert, 16
Derain, André, 34, 139
Dewar, John, 190
Diaghilev, Sergei, 125, 126
Diaz, Ignacia, 14
Dickey, E. M. O'Rourke, 233, 239, 243
Dobson, Frank, 310
dockers' strike (1911), 64–5
Dodgson, Campbell, 188
Doré Galleries: *Post-Impressionist and Futurist Exhibition* (1913), 54; *Vorticist Exhibition* (1915), 105
draughtsmanship, from life, 63; instruction of DB in, 8, 23–9; landscape, 211; teaching of, by DB, 260, 263, 289–90
*Drawings and Paintings by The Borough Bottega and L. Marr and D. Scott* (Berkeley Gallery, 1953) 298–9
Drew, Joanna, 332 n. 1
Duchamp-Villon, Raymond, 90
Du Plessis, H. E., 287

Ede, Jim, 189
El Greco: *The Agony in the Garden*, 117; *Christ carrying the Cross*, 307, *307; Christ Driving the Traders from the Temple*, 117–18, *118;* Toledo, vision of, 180, 183; *View and Plan of Toledo*, 183, *183*
Elledge, Sarah, 177
emotion, expression of: in abstract form, 92–3; in self-portraits, 193–4, 313. *See also under* landscape painting
Epstein, Jacob, 47, 48, 51, 53, 219; in *Blast*, 77; and Cubo-Futurism, 56; and Hulme, 71, 72, 73; and Lilian Mendelson, 177; *Rock Drill*, 88, *88; Tomb of Oscar Wilde*, 88
Etchells, Frederick, 34, 73, 77, 112, 136, 331 n. 9; and Futurism, 54, 55, 56; *On Board Ship*, 62
*Evening Standard*, review of London exhibition, 221
Everyman Cinema, exhibition at (1947), 274
*Exhibition of Paintings by The Borough Group* (1947), 270
*Exhibition of Sixty Imaginative Compositions, Spanish and Scottish Landscapes and other work* (1932), 195
*Exhibition of the Camden Town Group and Others* (1913), 56–7
expressiveness, 180–5, 209–13; and natural forces, 203–4; principle of, 17, 19. *See also under* abstract form; pigment, handling of

Fauvism, 34
Fennemore, T. A., 253

Festival of Britain, neglect of DB by, 287
*Field, The,* 189–90
financial difficulties, of DB: during World War One, 105–6, 107; in Palestine, 144, 148, 170; during Depression, 187, 219, 229–31; on second Spanish trip, 206–7, 214, 215
Fischer, Paul, 11, 13, 122, 126, 322 n. 53
Fitton, James, 329 n. 61
Forge, Andrew, 26, 183, 320
form(s): 'constituent', reduction to, 67, 69, 84; early innovations in, 15, 17–18, 19, 25–7, 46–7; emphasis on, in teaching, 288–9; Hulme on, 71, 93. *See also* abstract form; 'Pure Form'
Forster, E. M., 197
Fothergill, John, 25–6, 266
*4 Contemporary Painters* (1951), 288
Foyles Art Gallery, 1937 exhibition, 220
France, trip to (1953), 295
Friday Club, 45, 61
Fry, Roger, 16, 19, 23, 34, 43, 45, 89; and DB, 55–6, 70–1, 78; and Cubo-Futurists, 54, 56, 57; dining room at Borough Polytechnic, 260
Futurists, 42–3, 72, 77. *See also* Cubo-Futurists
*Fyra Engelsman (Four Englishmen),* 1952 exhibition, 295

Gartner, Lloyd P., 6
Gaudier-Brzeska, Henri, 72, 77, 326 n. 5; death of, 107; and Hulme, 73, 91; *Red Stone Dancer,* 98; *The Wrestlers,* 49, *49*
Gauguin, Paul, 16, 19; *The Seaweed Harvesters,* *17,* 19
geometrical style, 125, 133, 138, 265. *See also* abstract form
Gertler, Mark, 20–1, 22, 23, 31, 35, 69; on DB, 61; and East End, 45, 90; and Hulme, 71; *Jewish Family,* 76, *76; Self-Portrait,* 21
Giedion, Siegfried, 311; *Space, Time and Architecture,* 300
Gielgud, John, 189
Gill, MacDonald, 331 n. 9
Gill, Eric, 16, 219
Gilman, Harold, *An Eating House,* 32
Gordon, Ian, 261
Gore, Spencer, 56, 98; *Study for mural of calf,* 38
Gorki, Maxim, 198
Goupil Gallery, London Group show (1914), 61
Gowing, Lawrence, 154
Grafton Galleries, Post-Impressionist exhibitions at, 16, 34
Grafton Group, 45
Graham, R. B. Cunninghame, 189
Grant, Duncan, 34, 105, 255, 331 n. 9
Gray, Stewart, 95, 135
grid, use of, 50–2, 67, 68, 71, 84, 116
Gris, Juan, *The Watch,* 51–2, *52*
Gropius, Walter, 300
Grosz, George, 128
*Group X,* 136
Guevara, Alvaro, 31
Gummesons Konstgalleri (Stockholm), 1952 exhibition, 295

Hamerschlag, Marguerite, 220
Hamilton, Cuthbert, 54, 55, 56, 73
Hamnett, Nina, 106
Hampstead Art Gallery, 1919 exhibition, 135
Harries, Meirion and Susie, 231, 232
Harrison, Austen St B., 151–2, 172, 276, 277
Hatwell, Anthony, 288, 297, 298, 303
Haydon, Mrs (friend of Isaac Rosenberg), 53
Hayward Gallery Annual (1986), 320
Heffer Gallery, Bomberg retrospective (1954), 303
Hepworth, Barbara, 273
Herman, Josef, 183, 201, 250–1
Hitchens, Ivon, *Flower Group,* 249–250, *249,* 255–6
Hitler, Adolph, mentioned, 254, 261
Holbein the Younger, Hans, *Sir John Godsalve,* copied by DB, 8–9, *9*
Holden, Charles, 219, 259
Holden, Cliff: as DB's student, 261, 262, 263, 267–8, 290; and Borough Group, 270, 274, 275, 276, 282; in exhibitions, 288, 295
Holliday, Clifford, 146
Holt, Oliver, 192
Hopper, Edward, *Girl at a Sewing Machine,* 135, *135*
Hulme, T. E., 71–9, 299, 332 n. 49; criticism of DB, 29, 50, 60, 71, 91–4, 325 n. 72; death of, 109; on machine imagery, 87, 88; on *The Mud Bath,* 84, 86–7
human figure: abstraction and fragmentation of, 62, 63–6, 67–8, 73–5, 80, 98, 116; in *Bomb Store,* 240, 243; in *Sappers* (Second Version), 120; in *The Mud Bath,* 80, 83–4, 93; as 'ordered relations', 98; preoccupation with, 61, 105, 127–8, 130–1, 148; returns to, 164, 302–3, 304–7; in Zionist paintings, 166
Hunger Marches (NUWM), 197

Huxley, Aldous, 197

Imago Press, 256
immigrants to East End, and *In the Hold,* 66–7, 68–9
impasto, use of, *see* pigment
Ingres, Jean Auguste Dominique, 285
International Legal Defence, banner for, 196–7
Isle of Wight, trips with Rosenberg, 53
isolation, sense of, in DB's paintings, 251
Israel Museum, 1983 Bomberg exhibition, 320

Jericho, trip to, 157
Jerusalem, 12, 146, 163–5; and DB's change to landscape painting, 148–56; preservation of, by Storrs, 150–1, 162–3
Jewish Agency for Palestine, 188
*Jewish Chronicle,* 'A Jewish Futurist', 2, 57, 67, 72, 75–6, 84, 88–9; reviews in, 46, 76, 173, 219
Jewish culture in Whitechapel, 6–7
Jewish community, opinion of DB's work, 76
Jewish Education Aid Society, 21, *21,* 22, 31
Jewish University, Library of, commission for, 12, 169–70
*Jewish World,* 130
Jews' Free School, 8
John, Augustus, 38; on DB, 61, 90; and Robert van't Hoff, 58, 60; *Moses and the Brazen Serpent,* 42, *42*; and Ormonde Terrace, 95
Judaism, in Bomberg family, 7–8, 107–8

Kamienieska, Christine, 270
Kandinsky, Wassily: *Composition 1,* 33–4, *33; Improvisation Number Six,* 323 n. 38
Katherine Low Settlement, 253
Kauffer, Edward McKnight, 310
Kennington, Eric, 232
*Kensington News,* Borough Group letter to, 232
*Kensington Post,* review in, 275
Keynes, J. M., 197
Mrs Kibblewhite (salon), 71
Kisch, Colonel Frederick, dislike of DB, 146–8, 165, 167
Kisling, Moise, 75, 106, 295
Kodak House Research Laboratory, advice from, 256–7
Kokoschka, Oskar, 173; *Polperro II,* 273–4, *274*
Konody, P. G., 197, 232, 234; and Canadian War Memorials Fund, 112, 118–19, 122, 168; critism by, 61, 172–3
Kossoff, Leon, as DB's student, 286, 288, 290, 297, 320
Kramer, Jacob, 31, 177, 202, 326 n. 5, 329 n. 4
Kramer, Sarah, 31
Kupka, Frantisek, *Amorpha, Fugue in Two Colours,* 97, *97*

labour, depiction of: as heroic, 65–6, 117; and machine age, 68; in *Sappers* (Second Version), 120; as tragic, 135; on Zionist settlements, 165–7
landscape painting and drawing: change to, in Jerusalem, 2, 148–56, 174; freely gestured approach to, 194; and involvement with nature, 274; lack of inspiration for, in England, 134, 138, 191, 268–9, 271–4; later, in Ronda, 301–2, 309–10, 312, 314; maturation of, and emotional response to land, 180–5, 203–4, 209–13, 217–18, 256, 269, 277
Lapithos (Cyprus), 276, 277
Laski, H. J., 189
Lasko, Peter, 262
Lear, Edward, *Petra,* 158, *158*
Lechmere, Kate, 76
Lee, Rupert, 173
Leftwich, Joseph: and politics, 65; as source, 7, 48, 49, 66, 80, 102; and USSR, 251; in Whitechapel, 19, 20, 21
Léger, Fernand, 107, 114–15; *Sappers,* 114, *114*
Leger Galleries, DB exhibition (1943), 251
Leicester Galleries, 219; exhibition of Palestinian pictures (1928), 2, 143, 168, 170, 172–3, 179
Lessore, Helen, 318
Lethaby, W. R., 113–14
Levy, A. B., *East End Story,* 79
Lewis, Wyndham, 32, 34, 72; *A Canadian Gun Pit,* 112, 118; *Christopher Columbus,* 70; DB, relationship with, 43–4, 51, 53, 61, 70, 76–7, 105, 136–7, 280; and Futurism, 54, 55, 56–7; and Hulme, 73, 91; *Kermesse,* 42–3, *42,* 98; *Portrait of an Englishman,* 98, *98*; prose, 110; and Tate Gallery show, 310, 311; and tradition, 90; *Vision of Ezekiel,* 42; and Vorticism, 77, 100; mentioned, 72, 100; mentioned, 72, 83, 130
Liddiard, Jean, 31
light: and night painting, 213, 214; quality of, in DB's work, 154–5, 182–3, 313; role of, in drawing instruction, 267–8
Lingard, Asa, 202, 207
Lipke, William, 320

*Listener, The,* 280
LMS Railway Company, 219
Lockhart's café, 31
Loewy, Emanuel, *The Rendering of Nature in Early Greek Art,* 25
London Co-operative Societies' Joint Education Committee, 227–9
London County Council: DB's proposal to, 229; open-air art exhibition, 276, 282
LCC Institute, 253
London Group: and DB, 173, 220–1, 270, 318; Shows: (1913), 56; (1914), 61, 70; (1919), 133, 135; (1920), 135; (1937), 221; (1943), 251; (1944), 255–6; (1948), 275; (1951), 288
London Impressionists, 23
London University Senate House, 219, 259, *259*
Lonsdale, Earl of, 189
Lowther, C. G., 101
Löwy, Ruth, 35
Lucas, James, 320 n. 61
Luke, Sir Henry, 163

Mabbott, John, 190
MacCarthy, Desmond, 16–17, 19
machine age: and abstract form, 72, 78, 87–8, 105; seen as destructive, after World War One, 2, 4, 110, 114–15, 117, 235–7, 244, 265, 320 n. 1; and manual labour in, 68; and role of art, 298–9
Major, James, 246, 247
*Manchester Guardian:* reviews, 219; on 1948 Borough Group Show, 275
Manet, Edouard, 16
*Manet and the Post-Impressionists,* 16–17, 20, 23
Manheim, Harry, 323 n. 37, 324 n. 64
Mann, Edna, 259, 261, 270, 274, 275
Manners, Lady Diana, 26
Mansard Gallery, 136; DB exhibition (1923), 145, 175
Manson, J. B., 56
Mantegna, Andrea: *The Agony in the Garden,* 27, *27*
Marinetti, Emilio Filippo Tommaso, 54–5, 77, 90–1, 98
mark-making, role of, in DB's teaching, 289; in landscapes, 301
Marr, Leslie, 262, 271, 292; and Borough Bottega Group, 297, 308; and Borough Group, 274, *275*; financial aid to DB, 279, 293; and trip to Cyprus, 276, 277
Marsh, Edward, 61, 110, 140, 150, 189, 328 n. 64
Martin, Marianne, 68
Mason, Bateson, 287
mass, sense of: in architectural drawing, 258–9; dissolution of, 302; as goal, 298, *see also* 'spirit in the mass'; in handling of figures, 47, 65, 75, 127–8; and inertia, 83; and touch, 266; and use of colour, 85
Matisse, Henri, 16, 263; and abstraction, 19; *La Danse,* 34; influence on DB, 88, 139
Mayakovsky, Vladimir, 97
Mayes, Frank, 100
Mayes, John, 102, 107, 139
Mead, Dorothy, 259, 261; and Borough Group, 270, 274, 275; in exhibitions, 288, 295
Meidner, Ludwig, 201, 251
Melnikof, Abraham, 148
Mendelson, Dinora (later Marr, now Davies-Rees), 251, 271, 276, 316; and Borough students, 262, 274, 275, 283, 297, 303; *Levanto, Italy,* 298; portraits of, 228, 293–4; mentioned, 177, 192, 202, 206, 214, 215, 316
Mendelson, Jacob, 175, 176–7, 194
Mendelson, Juliet (later Marr, later McNeill, now Lamont), 271, 276, 293; portrait of, *251; The Windmill,* 273
Metzger, Gustav, 261, 288, 297, 298; *The Clown,* 298
Metzger, Max, 261
Michelangelo: *Bound Slave,* 11; *Battle of Cascina,* 90, *90; Christ Expelling the Moneychangers,* 118, *118; David,* 259; *The Entombment,* 89–90; influence on DB, 27–8, 89–90, 276; *The Last Judgement,* 118; *The Resurrection,* 27, *27*
Michelmore, Richard: and Borough Bottega Group, 297, 303; as DB's student, 259, 288; *Messiah* (with DB), 290, 298; *Reclining Nude* (with DB), 290, *291*
Ministry of Information, and *Bomb Store,* 233
Ministry of Supply, application to, 233
Missen, Dorothy, 261, 275
Missen, Len, 262, 275
Modigliani, Amedeo: *Head,* 48, *48,* 75; *Drawing for Sculpture,* 75
Mondrian, Piet, *Demolished buildings, Paris (c. 1912),* 60, *60*
Moore, George, 34
Moore, Henry, 219, 314; *Underground Shelter,* 231
mortality, prescience of, in DB's paintings, 227, 251, 307, 312–14
Müller, William James, 158
Mumford, Lewis, 299
Museum for Modern Western Art (USSR), 197
Myerscough-Walker, Raymond, 259; *Senate House,* 259

Nadelman, Elie, 75
Nash, Paul, 34, 140, 239; *Moorish Ruin, Ronda*, 210–11, *211; Totes Meer*, 231
naturalism, *see* representation
National Gallery, London, 27, 45, 89, 117–18, 186, 294
National Gallery of Canada: *Contemporary British Painting*, 220
National Society of Painters, Sculptors, Engravers and Potters, exhibition of DB, 187, 194
nature, involvement with, 4, 211, 265–6, 267, 272
Nevinson, Christopher: *The Arrival*, 62, *62*; Canadian War Commission, 112; English avant-garde, 55, 56, 72, 73, 77, 105, 326 n. 5; *Explosion*, 250; *The Rising City*, 68; at Slade, 23, 35, 45; *Tum-Tiddly-Um-Tum-Pom-Pom*, 86, *86*
*New Age, The*, 71, 72; reviews of DB's work, 74, 91
New English Art Club, 11, 53, 56, 104
*New Statesman*: letter to, from DB, 276; reviews of DB in, 133, 288
Newman, James, 79, 158, 319; and Communism, 196, 197
Nicholson, Ben, 90; and DB, 139; *Cortivallo, Lugano*, 139, 327 n. 20; *Mousehole*, *273*, 273
Nicholson, Colonel G. W. L.: *Canadian Expeditionary Force 1914–1919*, 113
Nicholson, Winifred, 139, 219
Nochlin, Linda, 66, 68

*Observer, The*, reviews in, 133, 172
Old Castle Street School, 8
Omega Workshops, 54, 55–6
open-air, painting in, 154, 157, 180; discovery of, 134, 139, 174; DB gives up, 302–3
Orde, Cuthbert: *A Bomb Store*, 245, *245; A Wellington Bombing-Up*, 245
organic forms, change to, 138
Ormonde Terrace, refuge at, 95
Owen, Wilfred, *Strange Meeting*, 120
Oxlade, Roy: as DB's student, 261, 263, 288, 289, 290, 291, 292; and Borough Bottega Group, 297, 298, 303, 308

Palestine: 12, 42; DB in, 2, 143–72
Palestine Foundation, (Keren Hayesod), 144, 151, 165–7
*Pall Mall Gazette*, reviews in, 73, 90
Paris, DB's trips to: (1913), 47–8; (1915), 106–7; (1927), 172
Parson's Gallery, *Four Contemporary Painters* (1951), 288
Pascin, Jules, 75
Patrick, Mr (Head of Borough Art Dept), 260
Pavilion Theatre, Whitechapel, 45, 135
personal response, emphasis on, in teaching, 259, 263
Petra, trip to (1924), 157–62
Phillips, Sir Claude, 34, 41, 70
Picabia, Francis: *Dances at the spring*, 42, *42; Danseuse étoile sur un transatlantique* 98, *98*
Picasso, Pablo, 34, 139, 263; *Girl with Basket of Flowers*, 16; influence on DB, 88, 107; *Portrait of Clovis Sagot*, 16
pictorial space, ambiguity of, 238
pigment, handling of: diversity of, in late paintings, 278, 279; expressive use of, 163, 164, 180–5, 312; freedom of, in Spanish landscapes, 203, 206, 213, 214, 217–18, 312; looseness of, in *Bomb Store*, 238, 244; in *Mount of Olives*, 155; in portraiture, 189, 190; post-war change in, 117, 137; in self-portraits, 193, 312–13; and tactile immediacy, 161
Piper, David, 255
Piranesi, Giovanni Battista, *Carceri, 236*, 237–8
Pissarro, Camille, *Paris, The Boulevard Montmartre at Night*, 213, *214*
Pitchforth, Vivian, 287
Plumer, General, 113
Pollock, Jackson, 274
portraiture, attempts at, 179, 188–90, 225–7
poses, preference for unorthodox, 289–90
*Post-Impressionist and Futurist Exhibition* (1913), 54
Post-Impressionists, 16–19, 54–5
Pound, Ezra, 49, 50–1, 76, 77, 97–8; 'Dogmatic Statement on the Game and Play of Chess', 50; and machinery, 87–8
Pro-Jerusalem Society, 151
'Pure Form', construction of, as aim, 2, 78, 92–4; and figurative approach, 105, 106; as multi-referential, 99–100; as purification, 80. *See also* abstract form; form(s)
purification as theme, in *The Mud Bath*, 80, 86

Queens Gate Mews, 248, 249; drawing of, 253–4, *254*
Quinn, John, 38, 61, 90, 95

Read, Herbert: on DB, 130; *Contemporary British Art*, 1, 287

Rebel Art Centre, 76, 77
*Recent Paintings of Spain by David Bomberg* (1936), 219
Redgrave, Richard and Samuel, 156
Reilly, Sir Charles, 258–9
Rembrandt van Rijn, 193; *Self-Portrait* (1661–2), 313, *313*
Renquist, Torsten, 295
representation: and abstraction, 14, 19, 46–7, 48–52, 67, 71, 83–4; and Canadian War commission, 112, 113–15, 118; post-war move towards, 106, 126; and 'Pure Form', 100; return to, in Jerusalem, 151–6, 164–5, 172, 173–4; in 'Sixty Imaginative Compositions', 138
Richardson, Denis, 100–1
Richardson, Jack, 100, 101, 108
Richardson, Professor (University College London), 260
Richmond, Ernest, 156
Richmond, Nora, 303–4
Richmond, Peter, 262, 279; and DB, in Ronda, 300, 303–4, 311, 316, 318; and Borough Group, 270, 274, 275; in exhibitions, 288, 295; as source, 288, 292, 301, 310, 315
Rico, Pedro, 183
Roberts, David, 158; *Ronda*, 209–10, *211*
Roberts, Sarah, 55
Roberts, William, 95, 106, 136, 202; and *Blast*, 77, 325 n. 94; and DB's work, 38–9; *Dancers*, 77, 98; *David Choosing the Three Days' Pestilence*, 38, *38; The First German Gas Attack at Ypres*, 112, 118, *119*; and Hulme, 73, 91; *Lucy's Dream from 'Richard Feveral'*, 37; at Omega Workshops, 55, 56; *The Return of Ulysses*, 47, *47; Self-Portrait, 31*; at Slade, 23, 26, 27, 31, 34; and Tate Gallery Vorticist show, 310, 311; *Theatre*, 125, *125; The Toe Dancer*, 95, *95*; mentioned, 70, 88
Robertson, Bryan, 269
Robins, William, 13
Rodchenko, Alexander, 97–8
Rodker, John, 21–2, 46, 72, 110; *Poems*, 96–7; and publication of DB's blitz drawings, 256, 257; and trip to USSR, 197, 198; in *The Tyro*, 136; mentioned, 214, 215, 229–30
Rogers, Claude, 318
Ronda (Spain): move to (1954–7), 299–318; trip to (1934–5), 207–15
Rosenberg, Isaac: and DB, 8, 20, 21, 22, 32–3 35, 53, 72, 76, 110; death of, 110–12; *Hark, Hark, the Lark*, 32, *32*; and Hulme, 71; *Self-Portrait*, 20, *20*; at Slade, 31; and World War One, 108
Rothenstein, Albert, 331 n. 9
Rothenstein, Sir John, 310, 311; *Modern English Painters*, 1, 311
Rothenstein, William, 13, 35
Rowe, Cliff, 329 n. 61; 'Hunger Marchers Entering Trafalgar Square', 197
Rowe, Helen, 95
Rowlands, Alan, 164
Rowlands, John, 229
Royal Academy, 56, 89
RAF Fauld (bombstore), 234–5; explosion at, 246–7, 330 n. 40
Russell, Bertrand, 197
Rutter, Frank, 21–2, 42, 54, 98; exhibition of DB's work, 128; on Palestine paintings, 173; *Revolution in Art*, 21–2

Sackville Gallery, Futurist exhibition (1912), 42, 68
St Eloi Craters, mine warfare at, 113
St George Hodjava, 167–8, 277
St Hilarion, ruined castle of, as subject, 277–8
St Martin's School of Art, 13, 286
St Paul's Cathedral, as symbol during blitz, 254–6
Sangallo, Aristotile da, *Copy after Michelangelo's cartoon for the 'Battle of Cascina'*, 90, *90*
Sargent, John Singer, 11–13, 173; *Israel and the Law*, 12
Sassoon, Siegfried, 128; *Memoirs of an Infantry Officer*, 109
Savile Gallery, 193
Scharf, Aaron, 156
Schevzik's Vapour Baths, 79–80
Schiff, Sidney, 109
Scotland, trip to (1932), 194
Scott, David, 261, 297, 298, 303
Scott, Garth, 288
*Second Post-Impressionist Exhibition*, 34
Seddon, Thomas, *Jerusalem and the Valley of Jehoshaphat*, 155–6, *156*
Severini, Gino, 42
Shaw, G. Bernard, 189
Shell-Mex commission, 191
Sickert, Walter Richard: *The Camden Town Affair*, 251, *251*; influence of, on DB, 14–15, 29, 50, 285; *Lazarus breaks his fast*, 193; and Lilian Mendelson, 177; and Post-Impressionist exhibition, 16, 19; *Seated Woman, Granby Street*, 29; *The Servant of Abraham*, 193, *193*
*Slade, The*, 266
Slade School of Art, 23–35, 42, 266
Slade Sketch Club, 26

Smibert, John, *George Berkeley, 266*
Smith, Matthew, *Nude with a Rose, 250*, 251
Socialist Realism, 197, 201
Society for Cultural Relations Between the People of the British Commonwealth and the USSR, 197
*Soirées de Paris, Les*, 98
Solomon, Solomon J., 13
Solomons, Mrs Robert, 194
Soutine, Chaim, 47, 184
*Soviet Life and Letters*, 197
Spain: move to (1954–7), 299–319; trip to (1929), 180–6; trip to (1934–5), 202–18
Spanish Civil War, 218
Spencer, Charles, 304, 312
Spencer, Stanley, 23, 28, 170; 'Man goeth to his Long Home', 27, *27; Moses and the Brazen Calf*, 38, 324 n. 63; *Shipbuilding on the Clyde*, 231
'spirit in the mass, the', as goal, 263, 265, 266, 280, 314
Stambois, Arthur, 260
state patronage, 222, 230
'steel city' environment, 89; and form, 2, 61, 78, 99; re-evaluation of, 265, 299. *See also* urban environment
Steer, Wilson, 23
Stein, Leonard, 143, 144, 146, 165
Stokes, Allen, 262, 270
Storrs, Sir Ronald, 167, 172; enthusiasm for DB, 156, 163, 165; financial help for DB, 180; and Jerusalem, 150–1, 152, 162–3; and trip to Petra, 157, 158, 160, 161, 162; mentioned, 168, 173, 219
Strang, William, *Plaza Mayor, Ronda*, 210, *211*
structure: emphasis on, in teaching, 263, 266; importance of, in DB's work, 15, 17–18, 19, 23, 254–5; loosening of, 302
*Studio, The*, 232, 269
stylistic conflict, in paintings, 33, 173
subject(s): architectural forms as, 58–61, 258–9; Biblical, 17, 19; dance as, 95–100, 122–5; East End as, 48–9, 57, 135–6, 138; flowers as, 248–51, 269; low-life, preference for, 15; ports as, 62–3; teashops as, 32; wrestlers as, 48–9
Summers, Gerald, *Portrait of David Bomberg*, 15, *15*
Summerson, John, 232
*Sunday Times*, review in, 173
Suprematism, 90
Sutherland, Graham, *A Flying-Bomb Depot*, 238–9, *239*
Sylvester, David, 309–10, 320

tactile values, 25, 193, 265, 266; and expressive handling, 161, 182, 184
Talgwyn Farm (Anglesey), 256
Tate Gallery: acquisition of DB's works, 1, 140–3, 225, 287, 309; 1967 Bomberg retrospective, 320; and *Sappers at Work*, 119; *Wyndham Lewis and Vorticism*, 1, 310–12, 315; acquisition of Alma-Tadema, 89
Tawney, R. H., 197
teaching: approach to, 259–60, 262, 270–1, 283–6, 288–92; attempt at, in Spain, 299–301, 303; at Bartlett School of Architecture, 258–60; at Borough Polytechnic, 260, 261–3, 267–8, 269–71, 279–86, 288–92; at City Literary Institute, 261; at Dagenham School of Art, 259
*0.10 – The Last Futurist Exhibition*, 90
Tennyson, Alfred Lord, *Crossing the Bar*, 269
Tenter Buildings, 29–31
theatre, as setting, 128. *See also* 'Pavilion Theatre'
Thomas, James Havard, 13
*Times, The*: DB's letter to, 231; on 1923 show, 145; obituary of DB, 319; on Palestine paintings, 163, 173
Toledo, trip to (1929), 180–6
Tolstoy, Lev, *War and Peace*, 128
Tongue, E. R., 227
Tonks, Henry, 34, 104; teaching of draughtsmanship, 23, 25, 26, 27, 28–9
topographical painting, *see* representation
'Torrington' (home of DB and LB in Hampstead), 279, 292–3
Tretiakov Gallery (USSR), 198
Turner, Joseph Mallord William, 273
*Twentieth Century Art. A Review of Modern Movements*, 47, 75–6
Twenty-One Gallery, Epstein exhibition (1913), 72
*Tyro, The*, 136–7

USSR: art in, 201; DB's gift to, 251; DB's visit to, 197–201
urban environment: desolation of, after blitz, 255; and form, 57–8, 67–8; as subject-matter, 4, 89. *See also* 'steel city'

Vallotton, Félix, 42
Van Gogh, Vincent, 16
van't Hoff, Robert, 58–60, (house of) *60*, 131
Velázquez, Diego: *Los Borrachos*, 205; *Dona Jeronima de la Fuente*, 186, *186; The Rokeby Venus*, 294

Villa Paz (Ronda), 300–1
Vint, Wyndham T., 202, 229, 329 n. 1; exhibition of collection, 219
Vlaminck, Maurice de, 34
Volkelt, 92
Vorticism, 91, 97–8, 100; and DB, 76, 77, 90, 105
Vorticist Exhibition (1915), 105
Vriesland, Van, 146

Wadsworth, Edward, 23, 45, 89, 98, 112, 136; *Blackpool*, 100; *Cape of Good Hope*, 62, *62*; and Futurism, 54, 55, 56; and Hulme, 73, 91; and Tate Gallery Vorticist show, 310
Wajda, Maria, 95
Waley-Cohen, Sir Robert, 22, 106, 107, 170
Walker's Galleries, 1955 Borough Bottega show, 308–9
Wallis, Alfred, 273
war, experience of: and flower paintings, 250–1; and view of armaments, 235–9, 243, 244–5, 247. *See also under*
machine age
War Artists' Advisory Committee, 1, 3, 231–4, 239–44, 245–6
War Office, proposal to, 229
Wells, H. G., 189
Wemyss, Earl of, 12
West, Rebecca, 105
*Westminister Gazette, The*, review in, 70
Whitechapel: and Pearl Binder, 192; conditions in, 6–7; Jewish community in, 19–21, 79; life in, depicted by DB, 29–31, 45, 79–80, 89, 90, 135–6
Whitechapel Art Gallery, 19; 1914 modernist exhibition, 75–6; 1979 Bomberg exhibition, 320
Wildenstein (gallery owner), 288
Willey, Alfred, 202, 206–7, 214
Williams, Raymond, 6
Wilton-Ely, John, 238
Winsten, Clare, 27–8
Wolmark, Alfred, 76

Woolf, Virginia, 189
*Works by David Bomberg* (Chenil Gallery, 1914), 77–95
World War One: DB's experience of, 108–12; effect on artists, 95; effect on DB, 139–40, 236–7, 239, 244; as subject for DB, 103–4
Worringer, Wilhelm, 332 n. 44; *Abstraction and Empathy*, 72, 299
Wundt, Wilhelm, 25

*Yorkshire Observer*, review in, 288
*Yorkshire Post*, review in, 219
Young Socialists League (East End), 19, 21–2

Zadkine, Ossip, 11, 106
Zaritsky, Joseph, 156–7
Zennor (Cornwall), trip to (1947), 271
Zionist Organization, 143–4
Zionist settlements, as subject for DB, 165–7